Dreamland of Humanists

Dreamland of Humanists

Warburg, Cassirer, Panofsky, and the Hamburg School

EMILY J. LEVINE

The University of Chicago Press Chicago and London

EMILY J. LEVINE is assistant professor of history at the
University of North Carolina at Greensboro. Born in New York City,
she lives in Durham, North Carolina.

The University of Chicago Press, Chicago 60637
The University of Chicago Press, Ltd., London
© 2013 by The University of Chicago
All rights reserved. Published 2013.
Printed in the United States of America

22 21 20 19 18 17 16 15 14 13 1 2 3 4 5

ISBN-13: 978-0-226-06168-9 (cloth)
ISBN-13: 978-0-226-06171-9 (e-book)
DOI: 10.7208/chicago/9780226061719.001.0001

Library of Congress Cataloging-in-Publicaion Data

Levine, Emily J., author.
 Dreamland of humanists : Warburg, Cassirer, Panofsky, and the
Hamburg school / Emily J. Levine.
 pages cm
 Includes bibliographical references and index.
 ISBN 978-0-226-06168-9 (cloth : alk. paper) —
ISBN 978-0-226-06171-9 (e-book) 1. Art—Germany—
Hamburg. 2. Warburg, Aby, 1866–1929. 3. Cassirer, Ernst,
1874–1945. 4. Panofsky, Erwin, 1892–1968. I. Title.
 N6886.H3L48 2013
 709.43'515—dc23
 2013022613

An act of thought is certainly a part of the thinker's experience. It occurs at a certain time, and in a certain context of other acts of thought, emotions, sensations, and so forth. Its presence in this context I call its immediacy; for although thought is not mere immediacy it is not devoid of immediacy. The peculiarity of thought is that, in addition to occurring here and now in this context, it can sustain itself through a change of context and revive in a different one.

R. G. COLLINGWOOD, *THE IDEA OF HISTORY*

Contents

Illustrations

Preface

There was a running joke at New York's Trinity School that the crucifix prominently displayed in the chapel stood for the "T" in Trinity. Having started as a solution to Jewish grandparents' vexing question of how to justify the presence of their grandchildren in an Episcopal School, the bon mot retained symbolic power. The previously sacrosanct crucifix now transformed, Jewish teenagers, including myself, could stand and sing in honor of the Trinity Tigers. Laughter mediated the secular and the religious worlds.

Of course, jokes like this one, in isolation, are unfunny and meaningless. In this respect, jokes work the same way images in a painting do for an art historian: they are, as one cultural historian has argued, mute without context. This was the circular logic behind the art historian Erwin Panofsky's famous observation that an "Australian bushman would be unable to recognize the subject of a Last Supper." Without the relevant religious and textual background, the Last Supper, according to Panofsky, would appear as no more than an "excited dinner party."[1] When the Trinity chaplain stood in front of the cross, it would have been difficult, even for a bushman, to argue that it was not a Christian symbol. Yet the cross-as-T joke persisted at the Trinity School because enough Jews insisted on reinterpreting the symbol. In this case something particular—the cross—could be read as universal and therefore as inclusive. The Jewish students managed to deflect the criticism of discontented grandparents and to show their commitment to the dominant culture.

When it comes to the challenge of deciphering concepts and images, we are all bushmen. We constantly engage in debate over how to define symbols—and on whose terms. Because of this, Aby Warburg, Ernst Cassirer, and Erwin Panofsky believed that men were essentially symbol-making animals and Panofsky connected the task of the humanities to understanding this process.[2] These scholars collectively focused on icons and structures of thought, but a similar sensitivity must be applied by intellectual historians who trace ideas over time. What the esteemed British historian R. G. Collingwood called the "peculiarity of thought" captures this paradox: ideas exist in a specific time and place, but they are also remade in different contexts with sometimes drastically different results. Our job as historians is to grasp this mystical transformation, even if the contexts remain malleable and subject to debate.

German Jewish intellectuals in the late nineteenth and early twentieth centuries, among them Warburg, Cassirer, and Panofsky, learned this lesson all too well. As this book shows, these secular Jews embraced the dominant culture of universalism with a German inflection. But they did not so much move "beyond Judaism," to borrow George Mosse's famous phrase, as use German and European culture to mediate their religious identity.[3] It often seemed that being a good Jew meant contributing to the general inquiry of ideas. Similarly, they sought, often discreetly, and with recourse to universalism, to open up their German audiences to the Jewish world.

The familiar story of secular German-Jewish humanists has usually been presented in hindsight as a tale of delusion. But as astute scholars of symbolism, Warburg, Cassirer, and Panofksy not only were attuned to the broader permutations of symbols over time but also were aware of the symbolism of their lives and works. They made conscious choices about their scholarly material and modes of inquiry and presented their work with inflections that differed depending on the audience. It is one of the tragedies of this tale that this scholarly embrace of universalism was almost always interpreted by non-Jews as peculiar to Judaism. Yet that misreading should not take away from the care with which the German-Jewish humanists approached their intellectual lives; it only underscores the importance of context in analyzing their ideas. For to ascertain the complete historical significance of their works, the historian must reconstitute the texture of their individual lives, the web of institutions, and the symbolic valences in which their ideas were produced and first received.

The story that unfolds here is not "only" a Jewish story. Rather, the struggle between the universal and the particular is constitutive of intellectual politics in all pluralist societies, since any pretense of universalism must always contend with the particularity of the context in which ideas are formed.[4] One lesson of the cultural and intellectual history of the Weimar Republic is that the history of ideas is hardly an esoteric matter; it is of central historical importance.

The Trinity School's crucifix, too, has a coda in the struggle over its symbolism. True to some conception of the universal humanist tradition, I became a German historian. But despite this professional identity, those same disapproving grandparents boasted to their friends that their granddaughter was a scholar of Jewish history. In an ironic reversal of the fate held by the crucifix, they inverted my contribution to universalism to give meaning to their particular identity. If the joke in the end was on me, it also speaks to this book's aim—to illustrate why context matters for the emergence, reception, and writing about ideas and how that content is, in turn, modified by these outside forces. To the memory of my grandparents Florence Levine, Lillian Shapiro, and Max Shapiro and in honor of my grandfather Jacques Levine, for the tireless spirit and exceptional grace with which they have lived in these multiple worlds, I dedicate this book.

Acknowledgments

As a scholar interested in the "conditions for the possibility" of knowledge, I would be remiss if I did not recognize that this book has benefited from conditions that were particularly fruitful and rewarding. I am grateful to my editor Doug Mitchell for his initial interest, engaging conversation, and unwavering support throughout a process that was longer than either of us imagined. I am also indebted to several anonymous readers, including, in particular, reader one, whose two very close readings and penetrating methodological challenges deserve much credit for improving the manuscript and present a model of generosity in scholarly practice.

Since I began this book as a young scholar, however, these acknowledgments include early and key input in my intellectual, moral, and professional development, and it is my pleasure to extend thanks to the people, relationships, and institutions that contributed to that process. As an undergraduate at Yale, I had the opportunity of whetting my intellectual curiosity in Directed Studies, a gem of a program in Western history, literature, and philosophy. Here I must thank especially Charlie Hill, Jane Levin, and Norma Thompson, whose energy and passion for the study of ideas were a huge inspiration to me and whose support of my scholarly aspirations—however premature—was truly appreciated. I am especially grateful to Kevin Repp, who showed me how I might turn that passion into a profession and then guided the way to Stanford, where I had the great fortune to pursue my graduate work under three scholars of renown and distinction: James J. Sheehan, Paul

Robinson, and Steven J. Zipperstein. As experts in Germans, Jews, and ideas, Jim, Paul, and Steve were for me the ultimate dream team. I am grateful to Paul for showing in the most elevated way how the intimate is interwoven with the intellectual and to Steve for introducing me to the manifold field of Jewish studies and insisting that I figure out what kind of historian I wanted to be. For his expert dissertation and continuing professional advice, I thank Jim. He rightly forced me to narrow and ground my at times lofty and unwieldy project, and his careful readings and characteristically incisive comments have given me more direction than he will know. Jim's career is truly a model of "Wissenschaft als Beruf," to which I continuously aspire.

The German Academic Exchange Service (DAAD) generously supported me during the academic year of 2005–6 in Hamburg, where I conducted the principal research for this project. I thank Dorothea Frede at the Universität Hamburg and Stephanie Schüler-Springorum, then at the Institut für die Geschichte der deutschen Juden, for being official and unofficial hosts; I am especially grateful to Beate Meyer at the institute for her assistance and reassuring presence. At the Staatsarchiv Hamburg, Helga Wunderlich, Heidelies Wittig-Sorg, and Jürgen Sielemann provided invaluable assistance and Charlotte Schoell-Glass, Karen Michels, Marianne Pieper, and Martin Warnke kindly made the resources of the Warburg-Haus available to me. Eckart Krause, former director of the Hamburger Bibliothek für Universitätsgeschichte, provided the lay of the land and, frequently, a warm cup of tea. Presenting my research in Professors Axel Schildt's and Barbara Vogel's colloquiums at the university was especially useful. Thank you to Frank Bajohr, Christoph Strupp, and Dorothee Wierling for inviting me to return to the Forschungsstelle für Zeitgeschichte in Hamburg in 2007 for the conference "Reading Hamburg: Anglo-American Perspectives," which was instrumental to my historical understanding of the city, and for selecting my paper for publication in *Zeitgeschichte*. Insofar as Hamburg comes alive as a character itself in this book, it is due to my friendships with Regina Muehlhaeuser, Juliane Lachenmayer, Carsten Gericke, Sandra Wachtel, and Anna von Villiez and the women of the Doktorandinnen-Stammtisch, who impressively exuded the "Heart of St. Pauli."

Beyond Hamburg, countless other archivists throughout Germany, as well as in London and Jerusalem, assisted me in my research, including Bern Reifenberg at the Universitätsbibliothek Marburg, Margret Heitmann at the Salomon Ludwig Steinheim-Institut für deutsch-jüdische Geschichte in Duisburg, Michael Wischnath at the Universitätsarchiv Tübingen, and Barbara Wolff at the Albert Einstein Archives

in Jerusalem. Dieter Wuttke kindly answered my questions about Panofsky, and John Michael Krois shared his unsurpassed expertise on Cassirer and documents from his private archive. In addition to their archival assistance, Dorothea McEwan and Claudia Wedepohl also invited me to present at the Annual Warburg Archive Seminar in 2005, where I received helpful advice from Martin Treml. On my final visit to the Warburg Institute in March 2011, Eckart Marchand and Perdita Ladwig attended to my last-minute worries and diligently assisted with compiling photographs for this book. John Prag and Gottfried Schramm graciously granted me access to their respective family archives.

The Andrew W. Mellon Foundation and the Center for Jewish History generously supported the early stages of writing. A number of New York colleagues welcomed me during this period, my "exile" from Stanford. I must thank the Center for Jewish History's Diane Spielmann and Shayne Leslie Figueroa of New York University's Hebrew and Judaic Studies Department for facilitating my New York stay. Marion Kaplan, in particular, graciously included me in her group of junior scholars, offered critical advice on the treatment of gender in my research, and continues to be a mentor and friend. Richard Wolin invited me to present at the New York Area Group in European Intellectual and Cultural History, where he, Sam Moyn, and Jerry Seigel offered meticulous and memorable criticism of my work.

In the fall of 2008, I had the good fortune to return to Yale's Whitney Humanities Center as an Andrew W. Mellon Foundation Fellow. Maria Menochal's lively fellows lunches brought me into contact with a wide variety of illustrious scholars, whose engagement contributed to the breadth of this book. I owe particular thanks to Tony Kronman for his feedback on my book proposal, Ileene Smith for her expert professional advice, and Lincoln Caplan for an early conversation about organizing my table of contents. In this, round two of Yale, I was warmly accepted as a colleague by my former mentors and enjoyed new professional relationships with Adam Tooze, Becky Conekin, Jay Winter, and Chris Wood, whose lunches at Caseus taught me much about Gombrich—and Stilton. I am grateful to Adam's invitation to present my work at the Modern Europe Colloquium and his and Jay's thoughtful feedback on that and other occasions. I especially thank Mia Genoni for tolerating my questions about art history and David Possen for his ever-thoughtful readings and cogent philosophical input, especially in the final stages. Many more Yale colleagues offered intermittent scholarly and professional advice, including Tim Barringer, Howard Bloch, Richard Brooks, Paul Freedman, Geoffrey Hartman, Adina Hoffman,

Paul North, Annabel Patterson, Jim Ponet, Annie Rudermann, Marci Shore, Katherine Slanski, Rachel Teucholsky, and Justin Zaremby. Those relationships and a friendly and supportive staff, including Christina Andriotis, Constance Pascarella, and Sue Stout, made the Whitney a truly wonderful place to rethink and revise this work.

Numerous other scholars played a formative role in my intellectual development in graduate school, including Keith Baker, Allen Wood, Peter Stansky, Martin Jay, and Patricia Mazon, while still others, among them Michael Brenner, Till van Rahden, Thomas Meyer, and Edward Skidelsky, helped in small but critical ways to address specific thematic issues. In fall 2008, Mary Gluck, Meike Werner, and Scott Spector kindly agreed to participate in a panel, "Ideas and the City," at that year's German Studies Association conference, a panel (and then a cluster of papers) that was helpful in revising my understanding of the relationship between place and culture. In a similar way, stimulating conversations with Eugene Sheppard focused my interest on the role of the quotidian in intellectual history, and a presentation of an early version of chapter 7 to the Brandeis Jewish Studies Colloquium refined my treatment of anti-Semitism. I am humbled by the support and encouragement of emeritus professors Lionel Gossman and Peter Gay, the latter of whom diligently read and edited an early version of this manuscript; both of them remain for me exemplary intellectual historians.

Many wonderful friendships have made academia a warmer place over the last decade. Sebastian Barreveld, Julia Cohen, Jennifer Derr, Heather Green, Laura Jokusch, Ruth Kaplan, Nicole Kvale, Philipp Nielson, Daniel Schwartz, Matthew Specter, Noah Strote, Claire Sufrin, and Kerry Wallach already know how much I have appreciated their insight and encouragement along the way. Daniella Doron and Joshua Derman of the Émigré Dissertators Writing Workshop (*Ortgruppe*, Lower East Side!) provided invaluable editorial and emotional support at a critical time. I am especially appreciative to Baerbel Buchelt for speaking to me in German and Henrike Lange for speaking to me in German about Panofsky. For their meticulous editorial and last-minute research assistance, I am grateful to Rachel Engler and Anna Henke.

Since fall 2010 I have been a professor in the history department at the University of North Carolina at Greensboro, and I am thrilled to acknowledge my colleagues there for the warm welcome and tremendous support they have extended me. I am grateful to the university for granting me both a New Faculty Research Grant and a Summer Excellence Research Award in my first year and to Susan Phillips for including me in the New Faculty Mentoring program, where I was introduced

to a wonderful group of junior scholars. Special thanks to Risa Applegarth, Jennifer Feather, and Claudia Cabello for reading early versions of chapters 1 and 2. My department chair, Chuck Bolton, and research mentor Jodi Bilinkoff have both been immensely supportive of my work and helpful to me in navigating the new system. In my first year I benefited enormously from discussing my work with Cheryl Logan, whose pathbreaking career in psychology and intellectual history is an inspiration for anyone committed to interdisciplinarity. I am equally grateful to Karen Hagemann and Konrad Jarausch for their invitation to present at the North Carolina German Studies Seminar and to Malachi Hacohen for welcoming me to the distinguished Triangle Intellectual History Seminar, communities I look forward to participating in for many years to come.

My four remarkable grandparents, Florence Levine, Jacques Levine, Lillian Shapiro, and Max Shapiro, fostered a lively tradition of intellectual and moral betterment in our families and encouraged professional service to the wider community. My parents, Nancy S. Levine and Alan Levine—each in a distinct way—have sustained and enlivened this tradition for me. Mac Levine has done his critical-brother's work of keeping me humble. I am blessed with numerous aunts and uncles, stepparents, stepsiblings, cousins, and in-laws, all of whom make my task worthwhile. I extend a special and enduring thank you to my beloved partner, husband, and best friend, Matthew Rascoff, for insisting that I finish the book already and begin the next chapter, with him.

A final note on sources and translations: When I began my research at the Beinecke Library and the Warburg Institute in the summer of 2003, many of the published materials that are now available on Warburg, Cassirer, and Panofsky did not exist, in particular, John Michael Krois's published and edited edition of Cassirer's letters and the fifth volume of Dieter Wuttke's edited edition of Panofsky's correspondence. For ease and fluidity, I have cited these published sources, relying on my own translations for correspondence and where otherwise useful and noting where I have had the opportunity to first work with the archives. In cases where published and translated works are common, I have relied on the standard translations of these texts, with some alterations where noted. All other translations from non-English works and sources are mine as well, except where otherwise indicated.

Dreamland of Humanists

The Weimar Republic was an idea seeking to become reality.
PETER GAY

[The free cities] were no longer the center of German civilization; the arts had fled from them to take refuge in new cities created by kings, and representing the modern era. Trade had deserted them. Their former energy, their patriotic vigor, had disappeared. Hamburg alone continued to be a great center of wealth and learning; but this flowed from causes peculiar to itself.
ALEXIS DE TOCQUEVILLE

On the eve of the First World War, nearly 40 percent of Germany's total imports and exports passed through Hamburg's port. When Otto von Bismarck himself visited the city in 1896 and surveyed the energy of its bustling harbor, he is rumored to have observed, "It is a new world, a new age." Despite its economic vitality, however, Germany's leading port city was hardly an exporter of ideas. The nineteenth-century German poet Heinrich Heine maligned the mercantile city as a place where it was better to be a dead poet than a live one and often predicted that nothing but cultural philistinism could come from that "nest" of deep-pocketed and dull merchants.[1] From this vantage point, the existence of a serious school of humanist scholarship in Hamburg seemed unlikely. Yet unexpected historical circumstances can sometimes produce conditions conducive to ideas. In Hamburg between 1919 and 1933, the years of Germany's experiment with democracy, this is precisely what happened.

Hamburg's poor intellectual reputation particularly

bothered one Hamburger: Aby Warburg. This banker cum scholar came of age at the dawn of Germany's new empire. He wanted Hamburg to be a place where not only things were made but also ideas were produced. Over the course of the two decades leading up to the war, the young Aby expertly marshaled his brother Max Warburg, a banker, and fed the cultural aspirations of their banker friends. Their goal became, in the words of another local scholar, for Hamburgers not to remain the "laborers and lackeys" (*Kärrner und Handlanger*) of German society but to develop their own ideas as well.[2] Despite the brothers' and other scholars' best efforts in the first decade of the twentieth century, however, it appeared that their "university idea" would be totally destroyed by the First World War. As Max Warburg and Hamburg's mayor Werner von Melle watched the chaos of the workers' revolution unfold from inside the Baroque town hall in November 1918, Max doubted that Hamburg would survive the Weimar Republic's most disruptive uprising. But von Melle saw the Hanseatic predicament in a different light. "I believe that for the university this new turn of events might not be entirely bad," he said.[3] History proved Hamburg's mayor correct.

With Warburg's guidance and with significant funding from private donations, the University of Hamburg opened its doors in May 1919 and, with his personal library, provided a center for humanist scholarship in interwar Germany and throughout Europe. When Hitler came to power in 1933, the Warburg Library and its prominent scholars went into exile. Ironically, Hamburg ultimately became a place where ideas, in addition to market goods, were exported. And this development, this export, had lasting consequences for the humanities in the Anglo-American world.

––––––

The scholarly potential of Germany's second city was undoubtedly determined by the historical moment in which it came to fruition. The University of Hamburg materialized during the months between the cease-fire and the peace treaty, a period that the German scholar Ernst Troeltsch dubbed the "dreamland of the armistice," for it was marked by hope and heightened anticipation.[4] Here, in this uncertain time, Germans entertained fantasies of a lenient "Wilsonian" peace, based on Woodrow Wilson's "Fourteen Points," that might enable Germany to retain its standing within the international system. Although the Weimar Republic's cosmopolitan mission eventually lost steam in the capital to increasingly nationalist politics, the situation in Hamburg

was different. Drawing on the city's natural strength as Germany's "Gateway to the World," Hamburgers sought to create a preeminent international university that would assume a prominent role in post-war Europe. Its intellectual life, in turn, acquired the characteristics of this city in its turbulent historical moment: pioneering in spirit, open-minded, and oriented toward the outside world rather than exclusively toward Germany. Heine's condescension notwithstanding, as a result of its tolerant commercial spirit and civic tradition of cultural philan-thropy, Hamburg quietly and unexpectedly nurtured a revolution in ideas.

It was fitting that Ernst Cassirer should become the first chair of philosophy at the city's new university. Born in 1874, he already had a significant presence by the First World War but could not obtain a full professorship in Berlin, or elsewhere in Germany, because he was a Jew. In the German system that solidified in the nineteenth century, he was not an *Ordinarius*, a professor with complete standing in the university community, but rather a *Privatdozent*, who subsisted on lec-ture fees from students and did not enjoy any institutional rights.[5] That the birth of Hamburg's university coincided with that of a new age might have been enough to land Cassirer a position there. That he promoted an interpretation that placed German thought into the con-text of European intellectual history, however, signaled the potential for a strong partnership with Hamburg's reimagined urban identity. The art historian Erwin Panofsky, born in 1892, soon joined him in 1921 as a teaching assistant. Drawing on the city's cultural autonomy and unconventional spirit, the young Panofsky quickly ascended the ranks of the university. His revolutionary art-historical approach, later called iconology, propelled him to the status of one of Germany's lead-ing art historians and, many years later, made him a prominent scholar in postwar America.

The war permanently challenged firm beliefs held by Europe's lead-ing intellectuals, in particular beliefs regarding the tools and expec-tations of academic work. Scholars faced a daunting set of questions: Were ideas mere projections of the mind? Was artistic genius a reflec-tion of national characteristics? Might a scholar identify the origins of these ideas and images over time? And what were the possibilities and limits of these projects of inquiry? Warburg, Cassirer, and Panof-sky provided a compelling answer to these questions. Drawing on the resources of Warburg's Kulturwissenschaftliche Bibliothek War-burg (Warburg Library for the Science of Culture; hereafter, Warburg Library)—nearly sixty thousand volumes and twenty thousand photo-

graphs at its height—they argued that one could trace the development of what they called "symbolic forms" in art history and philosophy from the classical through the modern period and, from this history, learn about how we as humans have made sense of the world.

The Renaissance held a special place in this inquiry, for it inherited the ambivalent predicament of man's existence—as Panofsky put it, echoing Aristotle's famous dictum, men were valued more than beasts but limited by their mortality. In the realm of *humanitas*, man alone possessed the unique ability to make symbols. Panofsky, accordingly, later connected this to the scholarly work of the humanities, which seeks to analyze "man's signs and structures" as they are detected "emerging from the stream of time."[6] As modes of "meaning-making" from the most elemental, language and myth, to the most sophisticated, images and ideas, symbolic forms offered a window to the great achievements and tragedies that are essential to being human. Warburg, Cassirer, and Panofsky claimed as humanists not only to establish the epistemological foundations of these human processes but also to take account of the destructive consequences wrought by the immediacy of human experience as a result.

While these concerns may sound esoteric, they were far from it. At times, it seemed as if the entire project of German democracy hinged upon the fate of humanism—or what Panofsky also called, with reference to Immanuel Kant, "man's proud and tragic consciousness of self-approved and self-imposed principles."[7] Kant's magisterial philosophical inquiry had given this project its unique meaning in eighteenth-century Germany through transcendental idealism—a tradition that put its faith in scientific systems of thought to unify the world of objects with a newfound self-consciousness on the part of the subject. The consequences of this project for a democratic society were enormous, for, following this logic, political subjects could willingly agree to laws that were also universally valid. In Cassirer's day, a group of scholars found renewed energy in returning to Kant for inspiration; their movement, neo-Kantianism, reopened questions about the nature of philosophy and the proper limits of our knowledge, and it led to mutual investment in these political and philosophical inquiries.

The success of the Weimar Republic, in turn, rested on transforming that democratic "idea seeking to become reality" into a working political system. But without a tradition of democracy, the republic was often criticized for the gaps exposed between its ideals and rooted experience, a critique remarkably similar to those launched in the philosophical realm. This parallel underscores how the trauma of the

Weimar Republic was equally existential, for it exposed the fragility of this humanist project. Nowhere was this clearer than at the height of inflation, when not even the German mark could be said to have any basis. "Practical men have little time to think about the difference between a symbol and the thing symbolized," Panofsky mused years later at the height of the Cold War.[8] Yet in a country in which philosophers were famously kings, that philosophy was now in question signified a grave political moment. In this context, the collective efforts of Warburg, Cassirer, and Panofsky to investigate, revise, and defend humanist scholarship are all the more heroic.

As professors of symbols, these scholars had a special grasp of their country's politics, which they watched politicians prop up with symbols of cultural and intellectual history, while ideas horrifyingly became increasingly politicized. As German-Jewish scholars, their inquiry into the relationship between signs and meaning also took on personal resonance, because they found to their dismay that they were not in control of the ultimate symbolism of their words. When Cassirer and Panofsky were forced to leave the country upon Hitler's ascent to power (Warburg having already died), their work retreated from prominence within the German political reality to the world of ideas, and their ideas lay waiting to be recreated, with new meanings yet to be discovered, in another place and time.

As a story about the relationship between ideas and their outside forces, this "dreamland of armistice," then, was also a kind of classical "humanist dreamland," according to a phrase coined by Fritz Saxl, Warburg's longtime assistant and later director of London's Warburg Institute. With Warburgian attention to symbols and their meanings, Saxl described the fantastical image of an unknown town, tracing its origin and path from antiquity to the modern period. In the labyrinth that ensues, this imaginative humanist dreamland helps artists find new expression for religious experience in the Middle Ages, makes its way into Titian's Renaissance paintings for Alfonso d'Este, and finally arrives at its eighteenth-century French form. At the essay's conclusion, Saxl considers whether this humanist ideal still persists in the modern world, for example for artists like Paul Cézanne. He boldly concludes that, far from the waning of an idea, Cézanne represents a "true humanist," a painter who rejects a "Fool's Paradise [since] reality itself has become a miracle."[9] For Cézanne, according to Saxl, realism was the new imagined ideal.

Composing his lecture in the last months of the Second World War, Saxl must have been aware of the tragic irony of his ode to humanism:

the integrity of man associated with humanism had been destroyed, for now men, far from gods, behaved like beasts. Likewise, the world of Hamburg's humanists was no longer an existing reality but rather an idea that required rebuilding. This book tells the story of those humanists and the evolution of their ideas from the time of their emergence within the unique historical circumstances of Weimar-era Hamburg to their very different reception in postwar America.

Meaning-Making in Art and Ideas

As a schoolboy in Hamburg, Aby Warburg was deeply affected by Gotthold Ephraim Lessing's interpretation of the classic marble sculpture of Laocoön, the Trojan priest, who met a horrific death by two deadly sea serpents.[10] In *Laocoön*, his classic text on aesthetics, Lessing analyzes the varying portrayals of suffering in literature and the visual arts; as opposed to the agonized screams Virgil recounts in the *Aeneid*, the sculptor permits Laocoön no more than a sigh. The question Lessing posed of restraint in visual modes of representation piqued Warburg's interest in the study of art. On one hand, the question that interested him was a narrow disciplinary one: What tropes are available to artists who wish to express human emotion in an inanimate object? On the other, this question posed a fundamental dilemma concerning human understanding: How do we, as humans, use the tools at our disposal to make sense of the world? Warburg's innovation was to connect these two in a new interdisciplinary approach that put the analysis of images at the center of questions about collective memory, historical thinking, and the making of meaning.[11]

This question about the relationship of experience to representation—at once aesthetic, philosophical, and religious—became the collective focus of the Warburg Library and its scholars. Taking their cue from a perennial problem plaguing both classical and early religious artists, they sought to understand how artists and philosophers made the unknowable knowable. That is, they dissected how artists turned spiritual and emotional experience into stone or paint and, alternatively, how philosophers created conceptual symbols that permit our engagement with the world. There are two distinct starting points to this question: if Cassirer and Panofsky showed more interest in the epistemological foundation of this process, then Warburg remained most concerned with its inevitably destructive consequences. In the move from visceral experience to discursive understanding, we gain

order at the cost of the immediacy of experience. That is, the process we rely on for meaning-making often threatens to strip meaning away. This paradox is key to understanding the work of these scholars, and in particular Warburg, who believed that this tension between the discursive mode of meaning-making and the visceral experience of life remade itself over time. Naming this tension the afterlife of antiquity (*Nachleben der Antike*), Warburg sought to trace its various permutations and forms from the classical to the modern period.

In preparation for his path of inquiry, Warburg received formal training in art history at the universities of Bonn and Strasbourg. But he was most inspired by the proponents of the "new cultural history," such as Karl Lamprecht and Jacob Burckhardt, who proposed widening the field of history to include the study of art and culture and promoted the Renaissance as the main epoch for this examination. Warburg was also attracted to their focus on paganism, astrology, and religious cults—elements of a "darker side" (*Schatten*) that these scholars introduced to the legacy of antiquity to challenge the dominant Winckelmannian notion of the classics as the high point of rational civilization. In his dissertation on Sandro Botticelli (1893) and his early essays and lectures "The Art of Portraiture and the Florentine Bourgeoisie" (1902) and "Francesco Sassetti's Last Injunction to His Sons" (1907), Warburg extended the social context around which we analyze images and thereby further complicated the legacy of classical antiquity. Drawing on Burckhardt's observations about festival culture, Warburg not only developed the relationship between art and its preconditions but also significantly showed how life interpreted as aesthetic event could be a source of meaning.[12]

Warburg's preoccupation with the relationship between representation and experience, between art and life, was solidified by an affecting visit to the Hopi Indian reservation in the American West in 1895. His visit convinced Warburg that primitivism persisted, could persist, even in the face of modernization. In his 1912 lecture "Italian Art and International Astrology in the Palazzo Schifanoia, Ferrara," Warburg unveiled a name for the methodology that defined his work, one that sought to trace the vicissitudes of aesthetic symbolism: he called it iconology. To investigate the psychological and cultural role of symbolism in general, Warburg undertook a series of studies in the 1920s, including "Pagan-Antique Prophecy in Words and Images in the Age of Luther" (1920) and "Astrology under Oriental Influence" (1926), works that examined this tension between primitive experience and the rationalizing tendency to order and calculate.[13]

To be a historian of images who defies coherence and lucidity was a difficult feat. Warburg's mammoth and at times unintelligible picture atlas, *Mnemosyne*, which remained incomplete at his premature death in 1929, reveals the challenge of producing a study that resists the destructive consequences of ordering at the risk of slipping into chaos. Unfortunately for Warburg, the struggle between reason and irrationality was also deeply personal, thwarting his productivity and contributing to numerous bouts of mental depression and one major breakdown. As a result of these personal limitations, Warburg's methodology found its greatest realization in his interdisciplinary library, where his frenetic collecting yielded one of the most impressive bibliophilic works of the modern period. It also attracted a group of scholars, including Ernst Cassirer and later Erwin Panofsky, who helped fulfill Warburg's scholarly vision and ultimately surpassed him in fame and influence.

While Warburg never surrendered to an overarching organizing principle and instead fell prey to irrational demons, Cassirer's own navigation of reason's limits and possibilities emerged from the opposite direction as he continually extended reason's web to include nonrational modes of human processing. Cassirer trained with the philosopher Hermann Cohen and was highly influenced by the Marburg school of neo-Kantianism. A philosophical approach that fashioned a particular view of Kant as a philosopher of science, neo-Kantianism is often disparaged or overlooked in contemporary scholarship, although it constituted the predominant philosophical method of the late nineteenth century.[14] If Kant's major innovation was to view objects as conforming to the mind (the so-called Copernican Revolution), the neo-Kantians inherited this focus on epistemology—how can we know what we know?—as well as the solution that objects of knowledge do not exist independent of our judgment. Viewing Kant as a pioneer in providing a logical basis for the empirical sciences, neo-Kantians sought, in turn, to establish universal a priori conditions for scientific research.

Both Cassirer's dissertation on René Descartes's analysis of the natural sciences and his *Habilitation*, which addressed the scientific basis of Gottfried Leibniz's philosophy, placed him within this methodological tendency. Leibniz remained a central thinker for Cassirer, for it was in his work that philosophy seemed to make the crucial shift from subservience to a universal divinity, to seeing the universal as represented in the particularity of experience—an important step required for human participation in the making of meaning. For Leibniz, it was the faculty of reason that permitted human participation in this previously removed process. In this way, Cassirer followed Kant's own path from the

transcendental realism of Descartes to Leibniz, from whom Kant inherited the notion that a "crucial datum . . . lies in the differing origin and the differing type of validity of the principles of our cognition."[15] For Cassirer, Kant's Copernican Revolution was the logical end to these dilemmas, for it was the only way to assure that what we perceive is knowable and objective.

It is easy to see why German Jews like Cohen gravitated to this approach. In limiting the purpose of philosophy to the investigation of the proper methods of science, neo-Kantianism made German philosophy safe for Jews. Shut out of questions of metaphysics and Being by their inability to connect with the German *Geist* of the nation, Jews nonetheless proved themselves excellent critics of the science of philosophy, and those like Cassirer came in droves to study with Cohen.[16] Yet if neo-Kantianism was the starting point of all philosophical discussion, the ensuing interpretations thereof were countless. While the Marburg School's scholars, especially Cohen but also Paul Natorp, distinguished themselves for insisting on the limits set for philosophy, the Southwest School believed that such critical work was a jumping-off point for discussions of value, a distinction that had a major impact on the direction their line of philosophical reasoning took.[17] Such philosophical nuances also gave rise to striking political differences between these schools and thinkers; and in the debates that ensued, the proper interpretation of Kant assumed the utmost importance, although, admittedly, the line between philosophy and politics would never be straightforward.[18]

These differences came to a head after the First World War when, like many of his contemporaries, Cassirer was convinced that reason alone could no longer sufficiently explain human existence and was spurred to consider whether there might be other forms of human expression equally valid. The result was his three-volume *The Philosophy of Symbolic Forms* (1923–29), which extended beyond Cohen's focus on synthetic a priori judgments to offer a broader theory of rational and nonrational modes of human understanding, modes that Cassirer called "symbolic forms." Despite this substantial extension of the initial aims of both Kant and the neo-Kantians, Cassirer's critique ultimately remained for many of his contemporaries too dependent on the primacy of scientific thought. As the philosopher Hans-Georg Gadamer observed, "In the end . . . [Cassirer] remained a disciple of the Marburg School . . . a school of thought which through and through placed itself under the factum of the natural sciences just as Kant had done in the Prolegomena."[19] Cassirer's philosophical approach, in a certain respect, was deemed obsolete before the end of his life.

Notwithstanding this critique, Cassirer's life and work also reveal a different trend in philosophy and history that persists today: the field of *Geistesgeschichte* (intellectual history). After all, the problem posed by the relationship between pure forms of thought and data of the senses also presented a historical challenge: how does one account for the changing approaches to this philosophical problem over time? For Kant, the two were intimately interrelated, and indeed his philosophy of history permitted a progressive (even evolutionary) approach that aligned him with the optimism of the eighteenth-century Enlightenment. Cassirer, for his part, made a tremendous contribution to this line of inquiry with his two-volume *Das Erkenntnisproblem in der Philosophie und Wissenschaft der neuren Zeit* (The problem of knowledge in philosophy and science in the modern age, 1906–7), the first of his many works that traced the historical development of this process of structuring knowledge.[20] In his connection between epistemology and history, Cassirer was also highly influential for his younger colleague Panofsky, a scholar who nurtured similarly lofty methodological goals for the field of art history.

Influenced by both Warburg and Cassirer, then, Panofsky became interested in establishing the epistemological foundations of the arthistorical discipline. Panofsky was all of twenty-three when he began to critique the two main art-historical theories of his day— Heinrich Wölfflin's formalism and Alois Riegl's contextualism—for failing to provide a sufficient disciplinary backbone for scholarly inquiry.[21] In the programmatic essays "The Problem of Style in the Visual Arts" (1915) and "The Concept of Artistic Volition [*Kunstwollen*]" (1920), he critiqued the approaches of Wölfflin and Riegl, respectively, and hinted at the need for a holistic methodology that would take both the artwork and its social and textual context into account. In short, Panofsky aimed to make an art object knowable, to create a historical framework for its analysis, and, by setting the standards of inquiry, to lend the discipline validity. Warburg's approach signaled Panofsky in precisely that direction.

Following his training in Berlin with the art historian Adolph Goldschmidt, and the publication of a prize-winning dissertation on the sixteenth-century German Renaissance artist Albrecht Dürer, Panofsky was appointed *Privatdozent* (1921) and *Ordinarius* (1926) in art history at the University of Hamburg. In connection with Warburg's work on the subject, Panofsky further developed the methodological style that they promoted as iconology. Together with Saxl, Panofsky applied this methodology in *Melancholia I: Eine quellen- und typengeschichtliche Untersuchungen* (Melancholia I: A source and typological inquiry, 1923),

which expounded on the relationship between Dürer's engraving *Melancholia I* and the intellectual and literary history of the condition. Influenced by Cassirer's work, Panofsky also delivered a lecture in 1924, *Perspective as Symbolic Form* (English, 1991), an ambitious attempt to trace the relationship between Western historical epochs and their respective modes of spatial representation. Like Cassirer, Panofsky found that his interest in epistemology led him to produce a series of essays on the theory of art history, essays in which scholars have shown renewed interest today.[22]

Despite their key differences, each scholar in his distinct way struck a middle ground between contextualism and formalism in art history, phenomenology and epistemology in philosophy, and research in multiple disciplines. Precisely because Cassirer did not fit into the schools of analytic and Continental philosophy that formed after the war, his work fell into neglect and relative obscurity for many years.[23] Although he had advocates in such German scholars as Jürgen Habermas, Cassirer's *The Philosophy of the Enlightenment* was not translated into French until the 1960s and, aside from its influence on Peter Gay's "social history of ideas," for many years did not make much of an impression on the American scene.[24] Scholars have only recently shown interest in reviving Cassirer's ideas, though for surprisingly different reasons: one group insists that his notion of symbolic forms is vastly underestimated in its philosophical sophistication, while a second, in contrast, insists that Cassirer remained a neo-Kantian to the end of his life and that it is neo-Kantianism whose reputation has suffered unduly.[25] This hotly contested legacy has been supplemented by a couple of very good recent biographies and the unflagging interest in the "Heidegger Affair" in which Cassirer was regretfully embroiled, an event that has ironically contributed to the misreadings that many of these scholars are actively trying to correct.[26]

The iconological legacy was more uniform and long-standing. In particular, as a tradition of cultural history, iconology came to justify the use of images in a wider tradition of context-based history, a tradition that includes such scholars as Francis Haskell, Frances Yates, and Johan Huizinga. In this vein, Panofsky, the youngest of the Warburg scholars, became famous for his argument that the celebrated realism of such Dutch painters as Jan van Eyck was not realism at all, but rather hid a "religious or moral message presented through the 'disguised symbolism' of everyday objects."[27] Although iconology eventually strayed from its initial Hamburg incarnation, the key characteristic of this approach remained the connection between the "evidence" of the representation

and the preconditions required for understanding it. As Peter Burke reminds us, "To interpret the message it is necessary to be familiar with the cultural codes."[28] That is, images require context to be deciphered. Yet, despite this legacy, the emphasis on context in their reception has been almost entirely absent, leading to a misunderstanding not only of the Warburg scholars but also of Weimar-era culture and ideas at large.

Scholars have acknowledged the contributions of Warburg, Cassirer, and Panofsky to their respective fields, and even have produced several substantial "influence studies" on their collective scholarship, but there has not yet been an assessment of the historical significance of their lives and works.[29] The historian Felix Gilbert aptly summarized the drawbacks of this strictly disciplinary scholarship when he criticized Ernst Gombrich's notable biography on Warburg for its lack of historical context. Having served from 1959 until 1976 as the director of London's Warburg Institute—which became the Warburg Library's home following its institutional exile in 1933—Gombrich possessed complete authority over the Warburg papers. A prolific scholar in his own right, Gombrich often joked about Warburg's undecipherable language—what he called his "Aalsuppenstil" (eel-soup style) of writing, and scholarship on the Warburg circle has remained largely in his shadow. But according to the philosopher Raymond Klibansky, who studied under Ernst Cassirer in Hamburg, "Gombrich did not know Warburg. His way of thinking [*Geistesart*] was foreign to him," and notwithstanding the Hanseatic culinary joke, "[Gombrich] was never in Hamburg. He saw Warburg's papers!"[30] The archives alone do not tell the full story, for Weimar-era Hamburg offered conditions for cultural and intellectual life distinct from those of other German cities. The result was both a tremendous contribution to the humanities and a radically different historical portrait of the Weimar Republic.

Hamburg's Special Case?

Historical studies of the Weimar Republic typically begin by recounting how it was born out of defeat. The Treaty of Versailles, resulting from negotiations in which Max Warburg participated, created conditions unfavorable to recovery, conditions that constituted a republic of compromise more than conviction. This Weimar "Compromise" became characterized by its territorial restrictions, reparations, and a war guilt clause that Eric Hobsbawm has called a "gift to nationalism."[31] But such a fatalistic perspective ignores the positive spirit of hope and democ-

racy that also permeated Germany at the time. It was in this spirit that the new University of Hamburg and its Warburg scholars emerged, a fact that had wide-ranging intellectual and political implications.

When we think of Weimar culture and ideas, we conjure notions of Berlin cabaret and Ernst Ludwig Kirchner's nocturnal street scenes (even though those paintings predate the republic), symbols that recall the precipitous political decline that has been characterized as "dancing on the volcano."[32] The philosopher Martin Heidegger is essential to this portrait. His *Being and Time* (1927) challenged the body of Western philosophy and epitomizes the romantic preoccupation with Being in the interwar period. And, as a philosopher turned Nazi, Heidegger also represents the drastic consequences of politicizing ideas. Most critically, Heidegger's assault on the Western tradition has been an inescapable starting point for all the philosophical approaches that followed. In many ways, Cassirer's own career can be said to have culminated in his 1929 debate in Davos, Switzerland, with Heidegger, a historic moment in the history of philosophy. It has been considered the eclipse of Cassirer's epistemological methodology by Heidegger's phenomenological approach.

Cultural and intellectual portraits of Germany in the interwar period alternatively focus on the intellectual heroes of the Left, including members of the Frankfurt School such as Theodor Adorno, Max Horkheimer, and Walter Benjamin; Benjamin's tragic suicide on the Spanish border in flight from the Nazis symbolizes the other end of the republic. Although politically, the Frankfurt School and Heidegger remained in intense opposition, intellectually they shared a common heritage of profound skepticism toward the Enlightenment. Beginning in the 1920s, the Frankfurt School, like Heidegger, formulated a comprehensive philosophical attack on Enlightenment thought that sought to dismantle the heroes of German idealism, above all, Kant and Hegel. Given both Heidegger's inescapability and the moral quandary his work simultaneously poses, these leftist thinkers have featured prominently in recent cultural and intellectual portraits of Weimar, not the least because as German Jews they seem somehow able to insulate critiques of liberalism and bourgeois modernity from their accompanying unsavory political implications.[33]

Considering this focus on anti-Enlightenment and antiliberal Weimar figures, it is not surprising that Gay assessed the Warburg scholars with a certain confusion: the Warburg scholars of Hamburg do not conform to the two Weimar alternatives described above—those of the Left and the Right locked in intellectual uniformity if political opposition. Therefore, although he lauded the Warburg Library as an expression of

"Weimar at its best," Gay also declared its scholars' work irrelevant to an overall understanding of Weimar culture and politics. "The austere empiricism and scholarly imagination of the Warburg style," Gay observed, "were the very antithesis of the brutal anti-intellectualism and vulgar mysticism threatening to barbarize German culture in the 1920s." Yet, because of its commitment to humanism—in both its Renaissance and its Enlightenment form—the Warburg circle, he concluded, conducted its work in "peaceful obscurity" and "serene isolation."[34]

Gay's relegation of the Warburg circle to cultural irrelevance reflects the Prusso-centric vision of Germany that too quickly equates Weimar culture with Berlin. It also reflects the assumption, shared by George Mosse, among others, that by adhering to humanism in the late 1920s, German Jews sealed their fate as politically obsolete. In each of these respects—geography and intellectual trends—Hamburg provides a helpful corrective. As the historian Carl Schorske reminds us, "Throughout the nineteenth century's intoxication with nationalism, romanticism, and *Machtpolitik* this cool, rationalistic, civil humanism quietly survived. It acquired new life in the Weimar Republic."[35] And its revival was embodied in the Warburg circle and the University of Hamburg around which it organized.

———

Hamburg presents problems for the generalized characterizations of Germany as autocratic, aristocratic, and insular. As an imperial "free city," a legal status awarded by Emperor Frederick I in the twelfth century, Hamburg enjoyed republican self-rule by a local senate whose members stemmed from patrician merchant families and whose politics were characterized by a balance between local and international interests. Scholarship on Hamburg has focused on its exceptionalism, which the Hamburg-born Percy Schramm called its *Sonderfall* (special case) within Germany's supposed *Sonderweg* (special path). The lively debate that has emerged on the subject of Hamburg's alleged liberalism fits squarely within the "regional turn" in German historiography that has largely abandoned Prusso-centric (and teleological) narratives of that nation's history.[36]

Consequently, scholarly research on Hamburg has focused largely on the *Kaiserreich*, for this "British" oasis in Germany challenged the central thesis posed by Hans Ulrich Wehler's *Sozialgeschichte* that the German Empire's failure to develop a middle class was the cause of its

downfall.[37] Marrying this concern with those of the new cultural history, Jennifer Jenkins persuasively demonstrated that Hamburg's middle class was not removed but deeply ingrained in an institutional culture that promoted "provincial" modernism. Despite a different reading of the tastes of the bourgeoisie, Carolyn Kay, too, revealed an expanded circle of involvement in Hamburg's cultural affairs of the imperial period. And Mark Russell's monograph on Warburg draws on his civic role as art critic to "view cultural, social, and political transformations of the Wilhelmine age through local contours and complexities."[38] Now that those studies are complemented by work on such cities as Munich, we have a rich portrait of the regional diversity of Germany's imperial period that defies a traditional center-periphery paradigm and suggests more complicated "paths to modernity."[39]

Notwithstanding these challenges to sweeping narratives of nationalization, however, cultural and intellectual histories of the Weimar Republic still focus almost exclusively on Berlin.[40] To be sure, Berlin remained the capital in the interwar period. But following the war, Berlin arguably diminished in importance—a fact underscored by the republic's namesake, the city of Weimar, where the republican founders took flight. Given the variety of the revolutionary experience, the full effects of "locality" were most significant in the Weimar period.[41] Here, nearly 160 miles northwest of the capital, tucked into a curve of the River Elbe, Hamburg's long tradition of mercantile spirit and cosmopolitanism prevailed in this tumultuous time.

Hamburg was a city in which money mattered. As Heine observed, "It is not the infamous Macbeth who governs here, but Banko." Punning on the double meaning of the German "Banko," which referred not only to Macbeth's nemesis but the distinctive Hanseatic currency, Heine joked that Hamburg's "spirit" was ruled not by religion or witches, but by money. And its "conspicuous leader" was the "high and honorable senate." Heine was not half wrong. Because of a political structure based on *Honoratioren*—volunteers from the "notable" class rather than a professional civil service—political decisions were made according to economic concerns. As the socialist Willi Bredel explained of Hamburg's famous free-city status: "The Hamburg burghers bought their freedom."[42] In the nineteenth century this tradition continued when Hamburg supported Prussia's annexation of the neighboring territory, Schleswig-Holstein, less out of nationalist pride than for purely economic reasons. Political groups within the city also corresponded less to political parties and more to economic interests, including those

of property owners, merchants, shipbuilders, and industrialists. Most important, civil republicanism remained intimately connected with economics. Other urban anxieties, including notably crime, were often articulated in financial narratives. In Hamburg, to be a good merchant also meant to be a good citizen.[43]

Hamburg's thriving mercantile culture arose, in part, from its prime position as a seafaring port located between the North and Baltic Seas. In the thirteenth century, Hamburg joined the Hanseatic League, an association of port cities that wielded tremendous power and influence in international trade through the early modern period. Although the league effectively dissolved by the end of the seventeenth century, the so-called Hansa persisted as a popular myth in Hamburg. Shipbuilding became paramount to Hamburg's local economy by the end of the nineteenth century and the city undertook the construction of large German battleships.[44] Although this activity increased its economic and political ties to Berlin, Hamburg's mercantile interests reinforced its independence, which persisted relatively unchallenged until the late nineteenth century. Even upon joining the German Federation in 1871, Hamburg retained significant control over its free port, a fact critical to the city's prosperity. Maintaining a free trade agenda, not unlike that of England's second city, Manchester, Hamburg successfully lobbied against Germany's protectionist policy in 1878 to ensure that the city's trade could continue without disruption by German tariffs. This uncomfortable "unpatriotic exemption" awkwardly aligned Hamburg's pride in its particular past with the reality of the new empire.[45]

Other provincial port cities did not fare as well against the encroaching tide of nationalization. In his turn-of-the-century epic tale *Buddenbrooks*, Thomas Mann memorialized the progressive decline of his hometown, the neighboring Hanseatic city of Lübeck, which could not keep up with the rise of such new national maritime powers as Sweden and Denmark. Indeed, in Mann's rendering, Hamburg emerges as the modern city in contrast to his native Lübeck.[46] For Hamburg's superior geographical location transformed it into an outpost for commerce in the growing Atlantic trade network, and the city was soon known as Germany's "Gateway to the World" (*Tor zur Welt*). Although Germany's nationalization threatened to marginalize it, Hamburg significantly receded to the periphery without becoming obsolete. Hamburg, as Mann understood all too well, did not become Lübeck.[47]

In its strange emergence in the seventeenth and eighteenth centuries as a provincial city with international significance, Hamburg's cosmopolitanism was its saving grace. Gay echoed de Tocqueville's

observation, saying that Hamburg alone "avoided the decay of most of the others by welcoming foreigners of all nationalities and giving them a share in civic and commercial affairs."[48] As a port city increasingly defined by international trade, Hamburg was also characterized by a willingness to look to the outside world for influence and inspiration. As a result, a city in some ways regional possessed a surprisingly broad-based spirit. Its official religion had been Lutheranism since the sixteenth century, but Hamburg served as a refuge for Calvinists, Catholics, Jews, and Mennonites from Germany and beyond. One writer joked that the city's population was so diverse that it was difficult to find a native Hamburger in Hamburg's city limits.[49]

In the eighteenth century, this cosmopolitan spirit also extended to the scholarly world. Owing to the literary masters Lessing and Friedrich Gottlieb Klopstock, the philosopher Hermann Samuel Reimarus, and the well-known composer Carl Philipp Emanuel Bach, who all spent time in Hamburg during this period, the city earned a wide cultural reputation. At a time when most German cities still lacked a substantial reading public, Hamburg nurtured a group of literary societies. Its prominent Enlightenment-era weekly, the *Patriot*, which reached a circulation of sixty thousand that extended as far as Leipzig and Augsburg, was ultimately published in book form in multiple languages.[50] A Thuringian schoolmaster visiting Hamburg in the eighteenth century was delighted to observe the sheer number of bookstores in Hamburg and departed persuaded that Hamburg remained the "largest, wealthiest, and most populated free Imperial city in all of Germany."[51] When comparing Hamburg to Germany's other renowned cities Mainz and Eisleben, Heine still taunted, "What is the art of printing or the Reformation compared to smoked beef!" His quip seems a bit curious, for Hamburg likely had not one but four publishing houses in 1831 when Heine uttered these words. Moreover, the poet's career would arguably have been unthinkable without his productive and close relationship with Julius Campe of his eponymous house.[52]

While Warburg, like Heine before him, may on occasion have accused Hamburg of cultural philistinism, he understood the city's unique potential as a home for cultural and intellectual life, a feature for which Hamburg's transatlanticism was in large part responsible. In the late nineteenth century, this link to the Atlantic World was reflected in the desire among Hamburg's burghers to emulate the British in matters of taste and culture, and this inclination soon included America. Alfred Vagts, who went on to enjoy a long career as a professor at Yale University, was typical of a Hamburg scholar; he described himself

as more familiar with America than with Prussia, "like a good Hamburger." Subsequently, it was natural that Hamburg should become the home of the Colonial Institute and its World Economic Archives (1908) and the Institute for Foreign Affairs (1923). Rather than begrudge his peculiar origins, Warburg attributed much of his intellectual success to the specific conditions of his *Vaterstadt*. Saxl concurred and ironically viewed Hamburg's progessiveness as a result of its separation from the rest of Germany. "Warburg's foundation shared this isolation," he later recalled, "and the young enterprise grew up undisturbed by the noises of a flourishing university."[53]

Although he never fully explored the implications of this predicament, on a certain level, Gay was correct in his assessment of the Warburg circle's peripheral status. That Hamburg lay on the periphery, however, presented both advantages and disadvantages for intellectual life. Perhaps more than any other city, Hamburg was poised to play a role in the new nation that emerged after the war, and local leaders drew on Hamburg's cosmopolitan heritage to establish a role for the city in the new Germany. Its privately funded university, unburdened by tradition and hierarchy, promoted new ideas, such as iconology, and new kinds of scholars, such as Jews and women. Nonetheless, Hamburg's leading Jewish scholars were not oblivious to the potentially harmful effect that the connection between Jews and mercantilism posed for the city.[54] As it was drawn into the German Empire, Hamburg integrated nationalism into a delicate balance of local and international pride.[55] And, as long as nationalism could remain a secondary expression of the local and the international, the cosmopolitan vision for Hamburg reigned.[56]

Cassirer drew on this unique trinity of the local, the national, and the cosmopolitan to promote a "cosmopolitan nationalism," which dovetailed with the Weimar Republic's political mission.[57] In this respect, the fates of Warburg, Cassirer, and Hamburg were increasingly tied to that of Germany's fledgling democracy. In the 1920s, despite the ascendancy of antihumanism that later signaled an end to the Weimar Republic, the Warburg circle and the Weimar Republic maintained a mutually beneficial relationship. If Adorno and Horkheimer's better-known *Dialectic of the Enlightenment* (1947) presented Kant as the end of all true philosophy, Cassirer's *The Philosophy of the Enlightenment* (1932) and its very different take on the history of Western rationalism emerged from a separate set of circumstances. To be fair, the distinction between Adorno and Cassirer is, to a certain degree, generational, for over the course of the decade that divides their work, the intellectual tide turned against humanism, a fact to which the younger Panofsky

was more attuned. But the contrast between the two men also raises questions about the "conditions for the possibility of knowledge"—urban, religious, familial, and social—elements beyond their control that create circumstances favoring some ideas rather than others.[58]

Hamburg's economic world, however disparaged, and the cosmopolitanism characteristic of the city empowered an intellectual world amenable to humanist scholarship and prorepublican politics. In Hamburg, a city without a Prussian history but with a strong republican tradition and a unique balance between local, national, and cosmopolitan interests, the Weimar Republic and its ideals were more than a "gamble which stood virtually no chance of success."[59] The story of Warburg, Cassirer, and Panofsky gives this "other" Weimar its due.

Fons et Origio

A mercantile free city is not in and of itself a unique setting for intellectual life. Frankfurt, too, was initially a free-city republic that possessed a university founded largely by its merchants.[60] But Hamburg significantly enjoyed its mercantile reputation at the expense of its scholarly one. Notwithstanding the city's brief cultural renaissance in the eighteenth century, disparaging remarks such as Heine's became commonplace, and a strange paradox persisted: intellectuals bemoaned the presence of wealth as an indication of the lack of intellectual life while that very economic infrastructure proved to be a crucial setting for the production of ideas.[61] That this image was fueled by Hamburg's visible and influential merchants and scholars alike echoes the situation in Great Britain, where an equally powerful nonintellectual tradition persisted despite evidence to the contrary.[62] Panofsky, for his part, remained grateful for the opportunities Hamburg offered him and returned the favor by naming the circle that materialized around Warburg, Cassirer, and himself "the Hamburg School" (*Hamburger Schule*).[63] But a historical question remains: How did Hamburg present the particular "conditions for the possibility" of the group of scholars that took its name? In other words, what made this place conducive to a certain set of ideas and not another?

Neither scholarship nor the ideas that constitute its subject emerge ex nihilo. The Warburg scholars made this premise central to their paths of inquiry. Indeed, the motto of the Warburg School might have been fons et origo—an embrace of the classical notion that ideas have a "source and origin."[64] To uncover an aggregation of sources whence

ideas and icons emerge, they spent a lifetime excavating evidence of cultural patronage, urban festivals, and astrological design. In this respect, the intellectual dilemma with which we began, concerning the relationship between representation and meaning, also posed a historical problem. As Panofsky observed in a posthumously published essay, "Reflections on Historical Time," a Tuscan painter and one from Bruges would necessarily paint differently. "And this is precisely what determines the essence of a historical phenomenon: that it represents, on the one hand, an object of knowledge that transcends the scope of natural space and time but is, on the other hand, fixed at a very particular moment in natural time and in a very particular location."[65] To this end, Warburg, Cassirer, and Panofsky struggled to show how ideas and images emerged from a diverse set of sources and, at the same time, to preserve the sanctity of those images and ideas.

Similarly, we read these scholars because of their intellectual contributions, ideas that have, by definition, transcended time and place. Yet scholars can choose to write about some subjects and avoid others. In a certain respect, the Renaissance was a natural choice for their period of study, for it was the moment at which the relationship between symbolism and meaning changed dramatically. Following Burckhardt's work there was good reason to believe this transformation in ideas had something to do with the era's urban, social, economic, and familial context itself. This focus on the Renaissance, however, a period that Cassirer often reminded his readers could not be understood "by looking at it from a one-sidedly national point of view" but required a more cosmopolitan approach, was also no doubt inflected by the cultural and political context of the Weimar Republic.[66]

I do not argue for a one-to-one correlation between ideas and the city any more than between ideas and any other "external" element. I do not suggest that Cassirer's work was simply a philosophical reflection of the politics of German liberalism, any more than Panofsky's work on Rembrandt or Dürer was a direct expression of his personal religio-cultural experience.[67] This book's aim is not so reductive. Not without reason did Gay criticize the scholarly craze surrounding "Vienna 1900" as a historical construction; and of Wolfgang Schivelbusch's study of Frankfurt's eponymous school, Martin Jay rightly warned against "explaining away" ideas with the place and time in which they were formed.[68] However, to call attention to the central role played by context in analyzing the historical contribution of these scholars need not entail exaggerating this role or reducing ideas by way of "sociological explanation."[69] The fact remains that even if Cassirer

had preferred to be in Berlin, anti-Semitism in the academy prevented his holding an official professorship there for thirteen years. His invitation to join the newly established University of Hamburg in 1919, therefore, was a circumstantial event that had enormous ramifications for both his intellectual development and the city's potential as a serious place of scholarship. Moreover, his very appointment and ascent to rector of the university tells us something about Hamburg in the 1920s and broadens our understanding of the cultural and intellectual possibilities of the Weimar Republic. Nurtured by Warburg, Cassirer's "cosmopolitan nationalist" intellectual history found a natural home in Hamburg, a city that, in turn, also epitomized Weimar's republican political mission. For this reason, Warburg identified Cassirer's scholarship and career as intimately linked with both Hamburg's identity and the republic's fate.

This book both presents a rare portrait of Weimar intellectual life and advances a claim about how to think about ideas. Just as a scholar's work reflects his world, that world has a very real influence on that work. For example, to assume that Cassirer's 1932 work *The Philosophy of the Enlightenment* possessed a purely *philosophical* motivation obscures the complete story. The study of political and cultural context can help make evident those conditions that led to a particular presentation of Rousseau's, Kant's, or Fichte's ideas and to an ordering of these ideas that Cassirer, in this instance, might otherwise not have chosen. While we cannot assume that every time one spoke of "neo-Kantianism," it was meant as an anti-Semitic slur, people often did use urban, cultural, and intellectual associations to say things they otherwise could not. In this respect, the anti-Semites were on to something, for, as we will see, there were real reasons that motivated former Jewish bankers to pursue iconology and drew the Jewish philosophers to epistemology. Following such scholars as Steven Aschheim, Fritz Stern, and Richard Wolin, this story spiritedly refutes the notion that ideas should or can be insulated or neutralized from these political concerns.[70]

The eclipse of this unique local environment in 1933, an event that forced the Warburg Library and its scholars to find a new home in exile, underscores that the context of these ideas provided more than mere setting. Indeed, the emigration brings these questions about contexts and ideas into even closer focus as it challenges the extent to which place of origin matters when ideas cross borders. German ideas in postwar America, ideas whose origins lie in the Weimar Republic, raise the question as to what context—Weimar culture or the American academy or the Cold War, to name a few—is the right one to use in evaluating

the texts that propound the ideas.[71] Just as these scholars concerned themselves with the relationship between text and context, they are not exempt from historicization. The latter point is taken up in chapter 10 and the epilogue.

———

During this period of emigration, the ideas of each man—Warburg, Cassirer, and Panofsky—met a different fate. The youngest of the three scholars, Panofsky, became the most recognizable and influential in the English-speaking world. Unlike Warburg, who died in 1929 and was not forced to revise his ideas in light of the Nazi state and the Second World War, and Cassirer, whose works went unnoticed for most of the postwar period, Panofsky spent the majority of his career as an émigré in America. Indeed, Panofsky can be said to have had two careers—one in a German and the other in an American form. His English-language works, including *Studies in Iconology* (1939), *The Life and Art of Albrecht Dürer* (1943), *Early Netherlandish Painting* (1953), and *Meaning in the Visual Arts* (1955), established him as one of America's leading figures in art history and made his importation of the iconological methodology into the American context a central moment in the history of art history. A small but vibrant body of literature deftly illustrates the connections between Panofsky's ideas and Kantian notions of aesthetics, Hegelian ideas of history, and a broader history of style.[72] Insofar as the "Hamburg School" has an American legacy, it is largely due to the fame and influence of its author Panofksy.

Yet the iconology for which Panofsky became known in postwar America emerged as something distinct from the innovative and holistic methodology that he developed in Hamburg and in connection with Warburg. This is partly because the second generation of Warburg scholars, such as Gombrich, used the term *iconology* in a distinctly different way. Suspicious of what he perceived as Panofsky's attempt to read images as an expression of the *Zeitgeist* or worldview, Gombrich narrowed the project to mean simply the "reconstruction of a pictorial programme."[73] As a result, the study of symbolism has been reduced to mere *iconography*, that is, identifying symbols, decoding gestures, and dating, a process of ascertaining facts that would have been regarded as the starting point rather than the end goal in the Weimar period.[74] Panofsky has also garnered criticism more recently because this approach, one that resists face-value interpretation, naturally favors discursive societies.[75]

In contrast to the scholarship of Panofsky and that of Cassirer, which retained their significance largely within disciplinary boundaries, Warburg's eccentric intellectual methodology, which never resembled strict art history, has had its largest impact outside the study of fine arts. Scholars of psychoanalysis have long found Warburg's ideas on memory and movement crucial to their work, and film critics have applied these ideas to the development of a "filmic" analysis.[76] Warburg's scholarship, which balanced analytic rigor with radical innovation, offers for many contemporary art historians a welcome alternative to the more traditional "American Panofsky." While Panofsky is often criticized for his adherence to strict universal standards of judgment and for his Eurocentric assumptions about style, Warburg's collage approach, one that blended high and low art, is frequently hailed as the forefather of new subfields in art history, such as visual studies.[77] Spurred by none other than the changing cultural and political circumstances of the emigration period, Panofsky distanced himself from ideas that possessed negative political connotations.

This critique of Panofsky's one-dimensional methodology and a corresponding hagiography of Warburg both overlook the process of moral reckoning that faced German-Jewish émigrés. A group of German scholars have recently justified a new edition of Warburg's works by their desire to close the gap between research on Warburg and "a tendency towards empathic mimetic Warburg exegesis."[78] Without access to Warburg's writings, the current Warburgmania remains ungrounded. The same thing could be said about the lack of historical context; without that context, one can neither fully appreciate Panofsky's conscious separation from the Weimar period nor understand the resulting translation of iconology into its American form.[79]

———

The central critique of iconology has been that, despite its insistence on bridging contextualism and formalism, the approach ultimately privileges content over form. The skeptical art critic pleads with Panofsky that the grapes of a Dutch still life painting might just be fruit on the table and not symbolic of something deeper. Similarly, a philosopher might challenge the following historical account of these scholars for drawing on a "deeper meaning" beyond philosophical analysis. Instead, I claim a middle ground between realistic interpretation that resists all attempts at representation and moral allegory that overlooks the formal qualities of the work. Peter Burke's cultural history gestures

to such a "third way" between positivists "who believe that images convey reliable information about the external world, and the skeptics or structuralists who assert that they do not." Pierre Bourdieu's attention to the "social conditions of possibility of scientific knowledge" emerges as another good model. And excellent work by Lionel Gossman, Lorraine Daston, and Peter Galison proves that the history of science and thought must be both subjective and objective, both internalist and externalist.[80] Precisely such a mediating spirit was proposed by the Hamburg School in its German incarnation. Neither purely "textualist" nor "contextualist," this book seeks to understand the relationship between these ideas and their outside forces without reducing one to another.[81]

In that sense, the book is as much about the "sociology of knowledge" as it is about the ideas themselves. As a growing number of scholars have attested, these two elements—institutions and ideas—are intimately connected.[82] According to Fritz Ringer, careful historical work in this field can identify the line between the intellectual and the contingent. Helpful for this task is Bourdieu's concept of "habitus" (or academic persona), a concept that he adapted following his translation of Panofsky's work into French. The French sociologist went on to employ this critique against the elitist apparatus of educational and scholarly practices and ultimately parted with Panofsky over what he felt was his lack of sensitivity for the socio-Marxist structure of art. This debate notwithstanding, there is no doubt that the collective influence of this concept, as well as Bourdieu's notion of "force fields," has made an imprint on the field of intellectual history, where scholars increasingly strive to understand the myriad conditions from which ideas emerge.[83]

Although the following account does not employ Bourdieu's theoretical vocabulary explicitly or wholesale, as a story about the conditions of scholarship, it is equally a story about those institutions that produce, disseminate, and authenticate ideas, ideas that "assume their full significance only if you refer to the circumstances in which they were pronounced and the audience to which they were addressed."[84] And in the tradition of Warburg, Cassirer, and Panofsky, the story bridges the purely reductive sociological analysis and the equally reductive pure philosophical approach to present a holistic portrait of the art object or idea in its time and place.

But this book also pushes the accepted focus on institutions further to insist on intimate relationships as integral to our understanding of the production of ideas, a point that much sociological analysis and

network theory regretfully overlook.[85] Following new work by Gadi Algazi, John Randolf, and Deborah Coen, work that treats the family as a legitimate site of scholarship, my account of Warburg, Cassirer, and Panofsky also incorporates the home as one previously neglected, but equally legitimate, precondition of intellectual life.[86] And in the expansion of the institutional framework of ideas to include the home, new historical figures emerge in considering these scholars and their scholarly practices: Aby Warburg's wife, the painter Mary Warburg, and his longtime trusted assistant Gertrud Bing; Ernst Cassirer's wife, Toni Cassirer, the quintessential philosopher's spouse; and Erwin Panofsky's wife Dora Panofsky, who, unlike the other women, remained a frustrated art historian in her husband's shadow. As the story of the Hamburg School and the Warburg Library testifies, intellectual history is not merely about abstract ideas, but also about the questions of who gets to belong to those spaces of intellectual life (for example, Germans, Jews, and women) and how those exclusions and inclusions, in turn, have a very real impact on the scholars' ideas.

Attention to these intimate relationships, and the fate of the women in particular, highlights one casualty of professionalization. Just as Warburg bemoaned the costs to sensory experience that resulted from ordering ideas, so, too, was he preoccupied with the loss of autonomy reserved for amateurism, the price he paid for the legitimation of his scholarship. To the extent that he was less successful than his colleagues Cassirer and Panofsky (the latter of whom promoted his scholarship in a more accessible form), Warburg was right to feel emasculated. For like the hidden women of this story, he did not easily make the transition from the private library to the institutionalized and productive world of the university. In the story that follows, biography, institutions, and scholarly practices are not background but rather are central to our understanding of the historical significance of this school of thought.

Dreamland of Humanists does not offer a traditional philosophical argument, but it does offer a way of thinking about ideas. Similarly, while it is not about art history per se, I venture that art historians should not do without this historical account of iconology's emergence from a wider matrix of cultural, political, and historical concerns. At the beginning of his book on the composer Jacques Offenbach in nineteenth-century Paris, Siegfried Kracauer cautioned that readers "purely interested in music" would be sorely disappointed: "Even though this book does not ignore Offenbach's operetta music, it does avoid, true to its plan, technical musical analyses and interpretations. Its topic is,

rather, Offenbach's social function." Art historians and philosophers have thus similarly—in Kracauer's words—"been forewarned."[87]

This biography of an urban moment shows how the work of Aby Warburg—a man of vision, a family with means, and a civic tradition—inspired an intellectual movement that ultimately transcended its time and place. The contexts of Jewishness, family, money, and the city illuminate certain themes in his work and the work of his colleagues Ernst Cassirer and Erwin Panofsky, just as their ideas offer a new historical portrait of Weimar-era Germany. It is to the origins of those ideas that we now turn.

ONE

Culture, Commerce, and the City

The moment an artistic institution becomes dependent on municipal or state officials in the provinces it is lost: it falls helplessly into the reactionary mire of narrow-minded philistines; liberal men are fired, thrown out, overcome with disgust, and because one only occasionally finds a free-thinking local aristo-crat, who has so often been the creator of rural culture, the provincial philis-tine rules absolutely. There are, of course, exceptions in the larger provincial cities.

KURT TUCHOLSKY, "BERLIN AND THE PROVINCES"

The task of transforming Hamburg, the city "ruled by Banko," into a place of serious scholarship fell to its most famous banker-cum-scholar: Aby Warburg. Poised be-tween a family of bankers and his own scholarly aspira-tions, Warburg played a special role in shepherding the mercantile city toward its new identity. Even as a child, Warburg had demonstrated a shrewd capacity for negotiat-ing between banking and books. At Warburg's funeral, his brother Max recounted the amusing bargain that the two had struck when he was twelve years old and his brother only thirteen, a story that instantly became a family and urban legend. Aby, the eldest of the banker Moritz Max Warburg's seven children, stood to inherit control of the family's banking fortune. According to Max Warburg, Aby relinquished this right in exchange for Max Warburg's agreement to buy his brother's books for the rest of his life. Comparing the bargain to Jacob and Esau's similar ne-gotiation over the privileges of the firstborn, Max Warburg

noted that his brother obtained more than lentil stew. "In my naiveté, I imagined that my father's business would surely be good enough that I could afford some Schiller, Goethe, and perhaps even Klopstock," Max recalled. "This contract was certainly the most careless of my life."[1]

The joke was on Max, for the children's contract laid the foundation for the establishment and cultivation of the sixty-thousand-volume Warburg Library. Max Warburg, for his part, became a shrewder businessman with age and transformed his local family bank into a significant player in the international financial scene. The storied pact between Aby and Max Warburg sealed the relationship between one of the most influential German-Jewish families and their eccentric, intellectual son, who viewed his library as an extension of the family bank and was known to call himself a "scholarly private banker" (*wissenschaftlichen Privatbankier*).[2] But this fraternal negotiation, apocryphal as it might have been, also epitomized Hamburg's distinctive civic landscape—one in which merchant families supported the city's cultural life through their private wealth.[3]

Without the royal court that characterized major nineteenth-century cities, and with no tradition of state-sponsored art or culture, Hamburg lacked any self-evident municipal art world. Instead, the city's merchants emerged as ersatz princely patrons in their overwhelming support of art, culture, and scholarship. In the last third of the nineteenth century, when Aby and Max Warburg were negotiating their respective familial obligations, Hamburg already boasted a general library, several scholarly societies, and two museums, all of which were the outcome of funding and initiatives from Hamburg's local burghers. As prominent members of the *Bürgertum*, the distinctively German class of economic bourgeoisie, the Warburgs possessed a substantial degree of control over this cultural scene. Especially as Jews, they participated in the civic scene in a way unmatched in the capital city, which featured a larger state-sponsored museum, wealthier patrons, and a more complicated political scene than in the provinces.

Warburg was not shy in suggesting that there would have been no university, and certainly no library, without his tireless support.[4] Yet Warburg, too, benefited from his partnership with the city. Hamburg presented a landscape unburdened by tradition where he could pursue his intellectual passions unhindered. While he sometimes mocked the "philistine" cultural taste of Hamburg's burghers, it was this very lack of the state's dominant cultural influence and institutional hierarchy that permitted him to exert the control and creativity he did.[5] In turn, this distinctive institutional infrastructure shaped the intellectual pos-

sibilities open to Warburg, both in his research on the Renaissance and in his vision for a privately funded scholarly institution of his own. This dual experience—both biographical and intellectual—confirmed that the disadvantage of Hamburg's loosely organized and homegrown cultural scene was also its advantage. Culturally speaking, Hamburg was an open book.

Aby Warburg and the Warburg family provide, then, a civic exemplar of Hamburg's unique urban landscape. Merchant families emerged as central to Hamburg's "grand bourgeoisie tradition," and this tradition came to be defined by a productive tension between money and ideas.[6] In exchange for autonomy from the state, Hamburg's cultural crusaders often had to justify their projects through contributions to the city's international trade. And the mercantile spirit of their demands often set the terms for these projects. Moreover, while its loose institutional structure and amateur quality (in particular, the characteristic participation of women) were aspects of the community's strength, these features later became liabilities when its founders aimed to turn these young scholarly enterprises into respectable professions. Despite its flaws, however, Warburg continued to believe that the tension inherent in Hamburg's cultural life was also the source of creative energy, energy that nurtured Warburg's personal library and provided the forum for the protracted debate concerning the University of Hamburg's founding. These intellectual projects bore the influence of the institutional conditions of their birth.

Between Banks and Books

Warburg's bargain with his younger brother placed him at the center of those cultural and commercial interests, both in his immediate family and in the city of Hamburg, which the Warburgs had served for many generations. These relationships also began to define his early intellectual interests. Born in 1866, Warburg spent his early childhood in private schooling at the Warburg home at 17 Mittelweg and in Jewish and secular education at Hamburg's Talmud Torah School, the local Jewish school (generously supported by the Warburgs) that underwent major reforms in the last quarter of the nineteenth century.[7] But his voracious appetite for intellectual life and his bifurcated path between, as he later recalled, "the stolid biblical tradition" and "modern European-German culture" first began to take shape when he was a schoolchild at the Johanneum.[8] Founded in 1529 by a reformer who was a friend of Martin

Luther, the Johanneum was the oldest and most renowned *Gymnasium* in Hamburg. In 1840, the school opened in a new Renaissance-style building in the center of the city, the so-called Hammaburg, where the city's main church stood for most of Hamburg's history. In this historic location, charged with the children of Hamburg's elites, Warburg read such German classics as Lessing and Schiller and cultivated what became his lifelong intellectual interest: the culture of antiquity.

But the Warburg family had another future in mind for their eldest son. As one of the most influential nineteenth-century German-Jewish families in both Germany and the United States, the Warburgs assumed that Aby would take over the family bank. The families in the Hamburg banking tradition followed a standard formula in child-rearing, as historian Richard J. Evans has recounted: after working in a nonfamily bank in Hamburg, sons were sent to intern in family banks in London or New York, and sometimes to manage maritime accounts in locations farther afield, places like South America. When they returned in their mid to late twenties, the sons began to cultivate their own fortunes before marrying a well-chosen daughter from a comparable business dynasty. Those sons who showed less interest in business and some aptitude for studies were encouraged to become lawyers, taking their degrees in Bonn and Heidelberg, since Hamburg did not, at the time, have a university, and then returning to the Hanseatic city to help secure favorable contracts for their family firms. All businesses required lawyers, and a certain number of seats were saved on Hamburg's Senate for those who followed this professional route, although, as Evans observed, within this civic function "there was seldom much doubt as to where the lawyer's family allegiances lay."[9]

But art history was not the law. And as the great-grandson of the founding patriarch, Aby Warburg was poised to assume responsibility for the Mittelweg-Warburgs (so called for the street on which they lived) and join this wider urban tradition.[10] Any plan that the young Warburg would continue his studies was a serious protestation of this fate. His rebellion began when he digested the entire encyclopedia before the age of twelve, as well as all of the books in the family cupboard, including those explicitly forbidden to him.[11] When he expressed intellectual aspirations greater than those represented by a life in banking, his grandmother recommended that he become a rabbi. A religious path seemed the only acceptable alternative to redeem his familial apostasy.

Much to his family's dismay, Warburg announced his intention to become an art historian, a decision that, if nothing else, doomed any scholarly ambitions of his younger brothers; after Aby's rogue behav-

ior, Max and Paul Warburg were bound to a more traditional course.[12] Indeed, the eldest child's decision to pursue scholarship signaled that Hamburg's ruling families risked losing control over the vocational choices of their sons.[13] It was also indicative of Warburg's fierce determination. Because the Johanneum offered no courses in Greek, he was required to spend an additional year after his graduation from the *Gymnasium* acquiring this skill in order to gain entrance to the university. One extra year of studies did not deter him from his chosen profession. When asked on a university questionnaire who he would be if he could be someone else, he responded, "Nobody else."[14]

At the University of Bonn, where Warburg enrolled to study art history, his orbit of intellectual influence vastly expanded. Bonn was the first institution where Warburg experienced the Prussian academic tradition, one he later came to reject. Founded in 1819 as part of the Prussianization of the university system, the University of Bonn embodied many of the nineteenth-century German notions of humanistic reform as first outlined by the education reformer Wilhelm von Humboldt. By the first decade of the twentieth century, the Prussian university came under increasing scrutiny for straying from these idealistic origins. In his studies, Warburg was most drawn to such outliers as the historian Lamprecht, with whom he shared an interest in the new cultural history and the field of the Renaissance. And he eventually developed his own idea of a scholarly institution as a corrective to the overspecialization he experienced there. If Bonn was, as one scholar suggests, an "act of state," the University of Hamburg's founding would reflect an entirely different relationship to the government.[15] But when he arrived at Bonn, the young Warburg was not yet up to this enormous task. His student days were preoccupied with smoking cigars, drinking, and reveling at Carnival in nearby Cologne."[16]

During the time he lived in Bonn and, later, in Strasbourg, Warburg also developed his characteristic balance between outright rebellion from and unquestionable attachment to his family. In the face of new, liberating social and intellectual possibilities, Warburg increasingly defied his family's religious orthodoxy and, as he described it, "attempted to forge a way from medieval, Catholic dogma toward individual freedom, through, on the one hand, Lutheranism and the dissemination of the ideas of the French Revolution, and, on the other hand, through modern science.[17] In a series of letters to his mother, he justified his decision to cast off Jewish dietary laws. "Since I do not arrange my courses of study according to the quality of ritual restaurants

but according to the quality of teachers," he reasoned, "I do not eat ritually."[18] Warburg's religious rebellion was further cemented when he proposed to Mary Hertz, the Protestant daughter of a Hamburg senator; he had met her while conducting research for his dissertation in Florence. Several years later, when Warburg refused to recite the traditional Jewish prayer of mourning at his father's funeral, he pithily explained, "I am a dissident."[19]

The challenge was not only intellectual: it would take a nervous breakdown to fully free him of religion's grip.[20] And in the meantime, despite his flirtations with social and religious noncompliance, Warburg remained dependent on his family for emotional and financial support. When taunted by anti-Semitic derisions from fellow students in Strasbourg, Warburg sought solace with his family in Hamburg, where he had indisputably enjoyed a safe and comfortable upbringing.[21] Warburg remained further reliant on his family for financial support; he had expensive tastes and required his family in order to feed them. As a university student, he received an allowance but increasingly asked for more money, in particular, to support his costly bibliophilic habits. On one occasion, before he completed his studies, Warburg, who was wise to the ways of trading, requested five hundred francs from his banker father, presumably because the French currency could fetch more books and photographs in the volatile Alsatian market, and expressed frustration with his father when he did not oblige his request.[22] Notoriously prone to histrionics, he once protested, "Because I have no more money, I cannot even afford to stamp this letter."[23] But Warburg's family, whose business he eschewed, later found a way to turn their son's habit into a profession. Their solution came from a city where culture had a long-standing history of being supported by private wealth and their belief that family, and their own in particular, should play a central role in this urban tradition.

Hamburg Households

In December 1896, ten months before he was to marry Mary Hertz, Aby Warburg parodied the familial controversy surrounding their engagement in a short play entitled *Hamburgische Kunstgespräche* (Hamburgian art conversations). In the play, performed by the Warburg siblings in their home at 17 Mittelweg on New Year's Eve, a family convenes one summer Sunday afternoon in its house on the Alster River to discuss the upcoming visit of Uncle Edward. The family's daughter, Eva,

is engaged to marry the painter Alfred Runge, but Runge's modernist tendencies clash with Uncle Edward's conservative aesthetic principles and complicate the upcoming marriage. The remainder of the play consists of a clever discussion among family members over the relative merits of modern art.[24]

Hamburgische Kunstgespräche reveals many historical themes characteristic of the late nineteenth century, including the culture wars, the politics of modernism, and the role of public art in fin-de-siècle Germany.[25] But the play is also extremely valuable as a starting point for an analysis of the centrality of the family for cultural and intellectual life during this same period. The notion of family in the play is more than mere metaphor but rather is intimately related to the debate over culture. Uncle Edward makes the link explicit, proclaiming that he is distraught over the effects of modernism because high-quality art is also a sign of a "good Hamburg family."[26] Viewed from this perspective, the play shows how family is critical to understanding the distinctive urban landscape of Hamburg and, in particular, its productive tension between culture and commerce.

Historians generally agree that "if there was any single institution that was central to the cultural life and value systems of the nineteenth-century German bourgeoisie, it was . . . the family."[27] If this was true for Germany's fragmented *Bürgertum* at large, it was particularly the case in Hamburg, a city that shared more with the Anglo-French in its bourgeois tradition than it did with the rest of Germany. To a certain degree, Hamburg was exceptional, for it had a rare combination of both political autonomy and economic strength.[28] This "foreign body in Prusso-Germany" consisted of a self-governing state and a constitution, an eighteen-man senate elected for life and ruled by its most senior member, the *Bürgermeister* (lord mayor), and a Citizens' Assembly, which was responsible for taxation, budget, and treaties.

Hamburg's urban charter of 1712 that expanded the boundaries of sovereignty has been called the "least oligarchical urban charter of the age," and the constitutional reform of 1860 made further progressive changes, including the abolition of the property requirements for citizenship and the widening of the body politic to include taxpaying citizens. However, given that citizenship fees still excluded most of the population and the exclusive senate maintained ultimate power over all branches of governmant, the city continued until the Weimar Republic to be administrated largely by elties.[29] And the institution of the family, which maintained its links to both the private and public world, served a cohesive function in this self-regulating republican system.

The Warburg family shared the central characteristics of Hamburg's other merchant family dynasties: a long, complicated, and illustrious history with foreign flair.[30] The Warburgs traced their roots to an early forefather, Simon von Kassel (died c. 1566), who settled in the North Rhine–Westphalian town of Warburg in 1559 and took the name of the city as his family name. In the seventeenth century, the Warburgs moved to Hamburg, where Moses Marcus and Gerson Marcus Warburg founded the bank M. M. Warburg & Company in 1798. And while many other Hanseatic families were of Dutch origin, the German-Jewish family created a masterful international web of connections through influential marriages to banking families, including the Henriques of Copenhagen, the Gunzbürgs in St. Petersburg, and the Kuhns and the Loebs in New York. With his wife Charlotte, born to Frankfurt's powerful Oppenheim family, Moritz M. Warburg, the grandson of Moses Marcus, had five sons, each of whom took his name: Aby Moritz, Max Moritz, Paul Moritz, Felix Moritz, and Fritz Moritz, as well as two daughters, Olga and Louise. In 1867, following another dominant trend among banking families, the Warburgs moved their business, then a firm of some thirty-six employees, to the office at Ferdinandstrasse 75 where it still exists today, while the family settled in the elegant Harvestehude neighborhood set on the Alster and removed from the city's masses.

Until the end of the nineteenth century, M. M. Warburg & Company was a modestly successful currency exchange and brokerage business. But it was Aby Warburg's generation of the Mittelweg-Warburgs that made an international name for the family. Max Warburg assumed the bank's leadership from the last decade of the nineteenth century until the Aryanization of the firm in 1938. Until Paul's move to America in 1902, he and Max built the business's international commercial business and became involved in large financing and shipping projects such as the Baghdad Railway and investment in central Africa. In America, Paul Warburg helped to create the Federal Reserve and Fritz Warburg became the chairman of the American Joint Distribution Committee. Still in Germany, Max Warburg was counted among the *Kaiserjuden*, a group of wealthy, educated, and assimilated Jews who advised the Kaiser on financial and cultural policy. He enjoyed a personal relationship with Wilhelm II and represented Germany at the Treaty of Versailles. As the chair of the Relief Organization of German Jews in Germany and an advisory member of the Reich's Deputation of German Jews, he did his best to help German Jews emigrate in the 1930s. The Warburg family was as close to royalty as these outsiders could get.

The Warburgs' extensive involvement in national politics was always connected to the opportunities the local scene provided. After the loosening of state restrictions in 1868, Hamburg's Jews enjoyed many rights not yet granted in other German cities. They could live wherever they desired, join previously exclusive trade guilds, and marry Gentiles. The classical Johanneum that Warburg attended was open to Jews as early as 1802, and that opportunity was taken by Jacob Bernays, the son of the Hamburg chief rabbi Isaac Bernays. He went on to become a philologist respected in the Jewish and secular worlds.[31] The Warburg clan benefited from this cross-fertilization. Referred to by local citizens as the "King of Hamburg," Max Warburg served on the Citizens' Assembly between 1904 and 1919 and on the Chamber of Commerce from 1903 to 1933. Max's position as a *Kaiserjude* together with Hamburg's most powerful shipping tycoon, German Jew Albert Ballin, reflects the central role that Jews could play in Hamburg's commerce and trafficking industry. Of the one-third of Hamburg's population that was active in commerce, Jews represented over 17 percent, or nearly five thousand individuals.[32]

Naturally, there were some limits to the acceptance of successful Jews such as Warburg and Ballin by Hamburg's social elite. Like many other German Jews, Aby Warburg experienced his outsider status physically, as suggested by the unavoidable contrast between his dark complexion and short stature and the blond and stocky boys in his Johanneum class.[33] To a certain extent, the visible distinction translated into social exclusion. According to one biography of Ballin, beyond their business obligations, Jews did not mix with Gentiles at the stock market, and the two groups occupied separate tables at the central social location, the Alster Pavilion, both during coffee hours and at the end of the workday.[34] Despite his local patriotism, Moritz M. Warburg believed that such segregation reflected the inevitability of their exclusion as Jews. When the thirty-year-old Max Warburg considered a seat on Hamburg's Senate, his father advised, "That is not for us; you will not be seen as a coequal (*ebenbürtig*)."[35] Despite his public prominence, as an unconverted Jew, Max was still barred from the city's most elite political body. According to one Hamburg-born historian, the Warburgs were only ever "*almost* accepted as belonging to the ruling stratum of lawyers and merchants."[36]

This near acceptance was further complicated by the Warburg family's relationship with converted Jews in Hamburg, a thorny series of negotiations best illustrated by tensions between the Hertzes and the Warburgs. In reality, what divided these potential in-laws was not—as

Aby Warburg's dramatic comedy would have us believe—good art, but rather, good religious values. Neither the German Jews Moritz and Charlotte Warburg nor the Protestant senator Adolf Ferdinand Hertz and his wife, Maria Hertz née Goßler, approved of the marriage between their children Aby Warburg and Mary Hertz. Although the Warburgs were generally accepted by Hamburg's high society, having a Jew in the family was a different matter entirely.[37] Remarkably, the Hertzes were themselves descended from converts from Judaism, but, as a result, the marriage must have represented an even greater threat to their own integration.[38] Nonetheless, as Protestants whose Jewish lineage had been left behind, the Hertzes were understandably unenthusiastic about relinquishing what they viewed as familial progress.

Whether because they recognized the precariousness of their status as Hamburg elite, or out of devotion to their heritage, the Warburg family, for their part, did not turn their back on Hamburg's Jews. According to the income-based dues system, they contributed the most of any Jewish family in Hamburg to the Jewish community. The family custom even dictated that at least one member of the Warburg family serve on the Jewish community's general board, an obligation fulfilled by Fritz Warburg until 1939. They also maintained strict religious observance. The majority of Hamburg's affluent Jews belonged to the *Tempel*, or Reform synagogue, whose dedication in 1818 spurred major controversy because it lacked an overt partition between men and women, untraditionally employed the vernacular in services, and possessed a flashy organ.[39] The Warburg family, in contrast, continued to attend the Orthodox synagogue, supporting its move from the business district to a grand marble structure in a prominent location in Rotterdam, where, as one congregant remembers, "[top]hats were stored in special containers in the coat-room from week to week."[40] The Warburgs' role in the Hamburg Jewish community mediated their relationship to the wider society. As one historian explained, the members of the Warburg family "all felt this attitude as a mark of distinction forming a dignified basis for their contact with Gentile society."[41]

As members of Hamburg's mercantile class, the Warburgs also became philanthropic leaders in the city at large. Along with the Goldschmidts, the Sievekings, and the Schieflers, the Warburgs fostered the intellectual and cultural world of the city from the ground up. Beginning in their daily lives, they created the cultural and intellectual life that became characteristic of the city. When modernist architect Fritz Schumacher arrived in Hamburg in 1909, he first experienced this

"Hamburg sociability" in the Warburg home and soon joined Aby War-
burg, as well as other leading members of Hamburg's publishing and
art world, for a weekly breakfast salon full of lively intellectual and
political conversation.[42] Another familiar "happening," known as the
Schiefler Abende (Schiefler evenings), took place at the home of Gustav
Schiefler, cultural patron and director of Hamburg's district court from
1888 to 1914. These evenings included poetry readings, dance perfor-
mances, and the viewing of contemporary art.[43] The families in atten-
dance understood that if they wanted culture in their city, they would
have to provide it themselves. The result of their efforts was a domes-
tically organized cultural scene that ranged from ritualized evenings
and meetings to *Stammtisch*, or a regular social gathering at a local pub,
and created an urban model for citizen-driven cultural life.

The Hamburg Model

In other German cities, such as Berlin, Munich, and Dresden, royal pa-
trons devoted their resources to making their cities hubs of culture,
establishing artists' academies and ultimately using their court col-
lections as the foundation for prosperous public museums and galler-
ies.[44] Hamburg, without a comparable history of an aristocratic court,
also possessed no state-sponsored cultural institutions, causing musi-
cians such as Bach and poets like Heine to reflect ambivalently upon
their experiences in the city.[45] But while Hamburg lacked state-funded
support, it had plenty of money, and it is thanks to the generosity of
Hamburg's burghers that both the Schumanns and Richard Strauss per-
formed there. Because of such private funding, Hamburg did not want
for culture, although it emerged in a distinctive way. The resulting cul-
tural sphere, which one architectural historian has dubbed the "Ham-
burg model" to describe the strong market and the weak state, can also
be applied to the city's cultural and intellectual world at large.[46]

In the absence of municipal bureaucracies, Hamburg's wealthy mer-
chants and bankers began to establish their own cultural infrastruc-
tures as early as the seventeenth century. Although relatively common
in nineteenth-century America, where private cultural institutions
were the norm, the model that emerged in Hamburg was an anomaly
in Germany. There were other cities, including Frankfurt, Cologne,
Bremen, and Leipzig, where nonprincely patrons, including business-
men, campaigned for local museums, but these efforts were mostly

supplementary to a larger and state-sponsored cultural scene.[47] Such a world of private funding benefited not only independent tastemakers but also those with means and connections to private collections and resources.

The implementation of the Hamburg model, then, relied not only on capital but also on the initiative of Hamburg's burghers, and it was the development of this rich philanthropic tradition that served as a crucial precondition for this cultural world. Hamburg's earliest charitable foundations were almost exclusively religiously motivated. Founded by monasteries and churches for the benefit of local hospitals, schools, and poorhouses, these foundations focused on traditional social welfare and community needs.[48] Motivated by Enlightenment ideals of *Bildung*, the distinctly German concept that combines moral and intellectual betterment, these early religious foundations widened their objectives in the eighteenth century to include educational and professional training, an important prerequisite for cultural philanthropy.[49] By the beginning of the twentieth century, more than 15 million marks were bequeathed in individual wills to secular charitable foundations—or 9 percent of all money left by the deceased.[50]

Inspired by this older model of religious charity, the new tradition of civic philanthropy supported independent societies that focused on specific cultural and intellectual projects. Established by Hamburg businessmen in 1765, the Patriotic Society represented the oldest of such societies and counted among its members several successful politicians, shipbuilders, and bankers—including Aby and Max Warburg. Significantly for the Patriotic Society—and later the university—Jewish and Gentile Hamburgers had long worked with one another for these charitable goals. Among the society's early achievements were the Hamburg Industrial School (1767), the Navigation School (1785), and a general library that possessed thirty thousand volumes by 1818.[51] The Patriotic Society's members included Hamburg's most influential citizens, many of whom went on to found offshoot societies, including the Arts and Crafts Society, the Society for Hamburg History, and the Art Society.

From their citizen-driven origins, each of these societies ultimately engendered one of the city's key cultural institutions. With the nominal support of the Hamburg Senate, the Art Society created a Gallery Commission in 1849, which soon opened the first public gallery, with nearly forty paintings, more than half of which were donated from the private collection of a local citizen. This seed of a gallery formed the foundation for Hamburg's Kunsthalle, which opened in 1869 on Glockengießerwall, a development that was paradigmatic for the advance-

ment of Hamburg's self-generating cultural scene. The first director of the Kunsthalle, Alfred Lichtwark, observed: "In Hamburg, until very recently the main institutions of the state took no initiative in cultural affairs. In all of the fields the course of events was the same. One exposed a need or anticipated it such that an influential man emerged together with his friends at a well-connected association or some loosely connected committee, raised some capital, organized the administration, led it for some time—as long as it was possible with private money— and then turned it over to the state."[52] This "bottom-up" development based on citizens' private initiative befitted visionaries like Lichtwark, whose career was intimately connected to this model and paved the way for Warburg's scholarly project. The 1896 appointment of Lichtwark, a schoolteacher who was initially neither wealthy nor socially influential, as director of the new Kunsthalle showed how Hamburg's openness made possible social mobility and original ideas.[53] Lichtwark, in turn, used Hamburg's lack of tradition as an opportunity to create a museum that both played an important role in the international art scene and retained its local sense of character. When Lichtwark unexpectedly left his post at the Berlin Kunstgewerbemuseum for the position in Hamburg, Berlin intellectuals thought he was out of his mind. For even Lichtwark was known to say, "Hamburgers are proclaimed as the Reich's stupid bourgeois. . . . This is our punishment for having been idle in cultural matters."[54]

At the Kunsthalle, Lichtwark set out to correct this prejudice and carefully went about assembling a one-of-a-kind collection. In addition to purchasing early modern German art of the seventeenth and eighteenth centuries, he also rediscovered nineteenth-century artists, such as Philipp Otto Runge and Caspar David Friedrich, supported Hamburg painters, and—most controversially—collected French impressionist art and commissioned contemporary secession artists, such as Max Liebermann—precisely the art that conservatives in Berlin attacked for its profit-seeking and allegedly Jewish origins.[55] While the Kaiser meddled in the affairs of Berlin's director of the National Gallery, Hugo von Tschudi, blocking his acquisition of secession paintings and ultimately provoking his resignation, Hamburg offered Lichtwark an alternative to the constrained choices of a civil servant in an imperial capital.[56] Not only did he prove skeptical Berliners wrong, but Lichtwark also showed how Hamburg's uncultivated cultural world could provide fertile ground for an ambitious visionary. The end product was not merely Berlin in miniature but rather a cultural world with a distinctive identity.[57]

The Hamburg model awarded Hamburg's local burghers both control over the cultural landscape and recognition for their contributions. Just as all Hamburgers knew that they should thank the generosity of the shipowner Carl Laiesz for the concert hall on Holstenplatz, they also knew that most all of the impressionist paintings in the Kunsthalle, which were less uniformly popular, could be traced to the private collection of the Behrens family.[58] Such proactive citizens had a complicated effect on the city's reputation. It was certainly due to their efforts that Hamburg's Patriotic Society spawned the Natural History Museum in 1843 (out of which sprang the Mineral Geological Institute, the Zoological Museum, and the Botanical Garden and its corresponding institute), the Chemistry and Physics Laboratories (1878 and 1885), and the Museum of Ethnology (1914).[59] Despite these achievements, the reputation of Hamburg as a "cultural wasteland" was difficult to shake.

The Curse of Amateurism

Like the Hamburg model itself, the involvement of the city's women within its cultural life possessed a long civic tradition. While women were excluded from many of Hamburg's nineteenth-century associations, such as the Patriotic Society, women were included in, and nearly always were the ones who organized, the city's thriving domestic cultural scene. Through social networking, writing letters, and hosting salons, the matriarchs of Hamburg's bourgeois families, such as the Sievekings, the Paulis, and the Warburgs, actively participated in the intellectual life of the eighteenth-century city.[60] In order to free their husbands to pursue "otherworldly" goals, the Warburg women also often assumed responsibility for economic matters, a tradition that Aby Warburg's niece Ingrid Warburg-Spinelli recalled as being the result of a deeply embedded religious tradition.[61] These tasks in and of themselves were not unique to Hamburg. In a city where the cultural world had historically developed from the bottom up, however, Hamburg's women's efforts to link the social and cultural spheres were critical to its success.[62]

Yet female participation may have hurt this underdeveloped cultural world as much as it helped. Before marrying Aby and entering his family, Mary Warburg enjoyed a brief period as an amateur artist, filling numerous journals with watercolors, sketches of landscapes, and por-

trait drawings. That the pieces resided in personal sketchbooks rather than on canvas reinforces the prejudice maintained by historians that Mary Warburg's work was never intended for a public audience.[63] Notwithstanding this bias, Hamburg's cultural elite acknowledged her artistic accomplishments. In 1895 Lichtwark invited her to participate in an exhibit for the Society of Hamburg's Friends of the Arts and to design the event's signature poster. This exhibition featured the work of twice as many females as males, a number indicative of the overabundance of women designated as "amateur" artists. Mary Warburg's fourteen works displayed were said to demonstrate a tremendous amount of technical skill.[64]

Following their wedding, Aby and Mary Warburg moved to Florence, where they lived for four and a half years. During this time, Mary continued to sketch and paint watercolors and participated actively in the local community of art historians and artists.[65] But by the time the couple returned to Hamburg in 1904, Mary had given birth to two children, Marietta and Max, and shortly thereafter she exchanged a potential life as an artist for that of wife and mother. According to her third and youngest child, Frede, Mary Warburg took these domestic tasks very seriously.[66] As a full-time mother and wife, she began to treat her pursuit of the fine arts as a hobby. Her work mirrored this shift in its increased focus on representing domestic tasks. Rather than explore the landscape of Florence, Mary took the daily life of her family as the object of her artistic efforts. A series of cartoons in which she depicted her family as animals displays the intimate relationship between children, mother, and father in a humorous and loving way.[67] In this respect, Mary Warburg's career as an artist was typical for female artists in the nineteenth century: she had once possessed the will and drive to make a career from her work but chose, instead, to turn it into a hobby.[68]

Mary's brother Wilhelm Hertz certainly agreed when he observed, "There was in little Mary (Mariechen), the very typical expression of the nineteenth century." He eulogized at his sister's funeral, "[Mary's] optimism and her carefree bravery, her acceptance of life and simple outlook shows this century from her amiable social side."[69] Such sociability and civility—as it was commonly referred to in the nineteenth century—was considered the primary role of women and a firm indicator of society's worth. The nineteenth-century philosopher John Stuart Mill popularized this view when he wrote in 1869 that the status of a nation's women was "the surest test and most correct measure of

the civilization of a people or an age."[70] Aby Warburg subscribed to this philosophy: When in Munich in 1888, he extended his disdain for southern German women to a condescension toward the region in general.[71]

Yet if Mary Warburg's cultural involvement was an asset in Hamburg, her particular experience was also representative of the urban anxiety surrounding amateurism. That Hamburgers themselves fended off the notion of dilettantism made this gender distinction all the more important for such figures as Aby Warburg, who had the "double burden" that he came from a city without a scholarly tradition and was a Jew whose promotion of scholarship threatened to further alienate him from the mainstream. As he fought for the recognition of Hamburg as a serious place for culture and scholarship, Warburg found this amateur spirit to be the source of his creative strength and autonomy and, at the same time, a persistent insecurity to overcome. It might even have led to sexism in the clear drawing of lines dictating who could and could not belong to this intellectual circle.

From Problem Child to Problem Library

Aby Warburg understood that the family provided an essential site for the development of ideas. The Warburg Library, after all, emerged from a deal between brothers and was later supported by their family business. This relationship, between family and culture, however, was not an uncomplicated one, and anxiety about the recent origins of Hamburg's cultural world was doubtless exacerbated by the central role played by such outsiders as Jews and women.

In the works of Heine and Goethe, among others, the trope persisted of the dilettante Hamburg businessmen, lawyers, and senators who spent their leisure time drafting geographical treatises, dabbling in the natural sciences, and investigating constitutional history.[72] The Hamburg-born historian Percy Schramm's description of his family library illustrates the complicated relationship between businessmen and their cultural pursuits. On one hand, the collection of two thousand books was as central a component of a mercantile family as good food and drink. Yet Schramm's own self-consciousness about the dilettantism of enterprise reveals a delicate balance between dignity and idleness.[73]

It was amid these concerns that the Warburgs' eccentric son Aby tried to find a role for his bibliophilic pastimes within the burgeon-

ing cultural scene. Like Lichtwark, the newly appointed director of the city's Kunsthalle, Warburg hoped to take advantage of the relatively open setting to develop his own cultural projects. Although he participated in many of the new privately funded cultural developments, including the Society for Hamburg History, the Museum for Natural History, and the Museum of Ethnology, Warburg clashed with some of the city's leading tastemakers. For instance, although he shared with Lichtwark the inclination that art should move away from the traditional—the Alfred in Warburg's play might not be that fictitious— the fastidious Warburg did not believe that Lichtwark was "academic" enough.[74] Unlike Lichtwark, Warburg did not aim to educate the layman about art.[75]

In the last decade of the nineteenth century, Warburg's taste in modern art and its relative merits also came into conflict with those of Lichtwark and other leading Hamburgers. When Hugo Vogel painted three murals in Hamburg's town hall to celebrate Hamburg's commercial world, Warburg derided them as typical history paintings and a poor representation of Hamburg's cultural potential.[76] After Albert Ballin hired Warburg as a special consultant to his shipping company, the Hamburg-America Line (also known as Hapag), to select paintings for the world's largest passenger ship, Ballin removed the paintings and humiliated Warburg for his unconventional taste.[77] Warburg, who always aimed to find a balance between tradition and modernity and thought himself the best person to determine that midpoint, did not shy away from telling Ballin he had missed an opportunity to showcase the new German modern.[78] Warburg was determined, despite these conflicts, to use the urban landscape to serve his scholarly interests and, conversely, to use his civic influence to promote the city's cultural direction.

Privately funded cultural enterprises such as the library had the potential to make a great public impact because of their smaller scale and uniqueness reflective of the collector's tastes. The library had a long tradition in Hamburg, a city where it was not rare for even a businessman's private collection to grow to nearly five thousand books. The library also bore testament to a long Jewish tradition of book collecting, in which books were seen to be tools in identity-building.[79] Warburg certainly drew on both the local and religious traditions, although, significantly, he collected books with a secular rather than a specifically Jewish purpose. For while it was one thing to be a businessman who enjoyed a library in his free time, it was quite another to devote one's entire energy to this enterprise, and the Warburg elders were eager to

manage the meaning of this endeavor. At first, Moritz and Charlotte Warburg considered their son's library purchases to be opulent. Aby Warburg's brother Max recalled, "The book purchases seemed to be too expensive to father; mother was of the opinion: 'You must write and study, any person can buy a library.'"[80] Overcoming this prejudice was Warburg's first challenge.

Austerity was the general stylistic rule for Hamburg's hardworking Protestant *Bürgertum*, who frowned equally on the *nouveau riches* and on those who took titles of nobility, and those Protestants permitted only modest ornamentation on the facades of their Harvestehude homes.[81] For the Warburg elders, such discretion was even more important; the family viewed it as a preventive measure against possible anti-Semitic backlash for their prominent role in Hamburg's society. As a result, their home, where a bottle of red wine represented a singular luxury, was almost puritanical in its aesthetic.[82] In this respect, it is instructive that Aby Warburg did not push his parents to collect art. That decision is often ascribed to religious restrictions against idolatry, but doubtless it was equally motivated by the family's concern for their visibility as Jews in an austere city. This societal impulse was duplicated on the level of personal humility, as Charlotte Warburg always insisted that her husband was a simple merchant (*Kaufmann*) and not a banker (*Bankier*), lest her children believe they were too privileged.[83] To earn the support of his parents, therefore, Warburg's intellectual project had to be harnessed for the greater social good.

Warburg understood as much when he presented his idea for a library to the family firm as if it were equivalent to any other business investment, persuading them that it was no different from their willingness to fund the Talmud Torah School.[84] Having collected books for more than a decade, Warburg had a growing sense of his mission: on August 4, 1900, he noted in his diary that he had "discussed with Max the idea of a Warburg Library for the Science of Culture; he was not against it."[85] Never one to downplay his accomplishments, he told his father that his growing library was "laying the foundation for future generations."[86] By 1904 the family had determined that the library would be based in Hamburg rather than in Italy or Bonn and began to make arrangements in the event of Aby Warburg's death.[87] That year Aby and Mary Warburg moved from their house on Benediktstrasse, which was, by then, overcrowded with books, to 114 Heilwigstrasse. At the time of their move, Aby Warburg already possessed nearly nine thousand books; within the next decade, he expanded the collection to fifteen thousand.[88]

Warburg viewed the library as "a branch of the M. M. Warburg bank dedicated to cosmological (*kosmologisch*) rather than earthly duties."[89] He ran it accordingly. As early as 1905, he adopted a meticulous carbon-copy system to track his purchases over the course of two decades, the same system used at the time by bankers like his brother to record their financial transactions.[90] The bookkeeping system of this "scholarly private banker" also extended to his relationships with his personnel. A year later, Warburg scolded his new research assistant, Wilhelm Waetzold, as a corporate manager might, over his recent marriage: it was an event that would mean increased pay for Waetzold to support his wife and children.[91] And female students proved a liability because they were certain to abandon their studies once they found husbands. "Statistically to assert how many wrongdoings nuptial love (*Amor nuptialis*) has on its conscience against nascent intellectual life," he wrote in an exasperated entry in the diary of the Warburg Library, would constitute "a dreadfully higher percent even without nuptials."[92] Although the family was undoubtedly to be thanked for the origins of the library, its professionalization required a clear separation between scholarship and intimate life.

Warburg continued to promote an image of himself as a visionary collector and a lone intellectual, a persona well captured in a 1912 photograph that shows him sitting by candlelight poring over a worn manuscript (fig. 1). In truth, however, Warburg would not have been able to accomplish his scholarly or bibliographic goals without a growing team of assistants that he had began to amass four years earlier. The most important of these individuals were a twenty-two-year-old Austrian art history student, Fritz Saxl, whom Warburg met in 1910 and hired a year later for ongoing and critical research, and Gertrud Bing, who entered this scholarly world as a student of Ernst Cassirer in philosophy and aesthetics and rose to become, with Saxl, acting director of the library in 1927. Many years later she became known as the "guardian" of the institute in its postwar British form.[93]

Saxl gained Warburg's attention for his eccentric interest in the symbolism of astrology in such great masters as Rembrandt, an interest that resembled his own. Although he has belatedly received acknowledgment as a scholar in his own right, Saxl is still best known as the handmaiden of Warburg's library.[94] When Saxl arrived, he found an eclectic collection of fifteen thousand books that included works on alchemy and numerology, as well as telephone books and old almanacs. The library was expanding at the rate of six hundred books a year and soon possessed an impressive assemblage of amenities, including

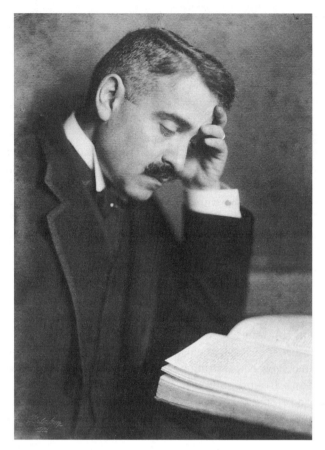

1 Aby Warburg appears as a lone scholar in this 1912 portrait, but his work was supported
 by an increasingly large group of assistants. Warburg Institute, London.

twenty-eight telephones with a direct connection to the post office; the
first such phone in Hamburg had appeared only two decades earlier.
Warburg often bragged, confirming his self-image within the family's
trade, "I am a scholarly private banker, whose credit is as good as that
of the *Reichsbank*."[95]

Perhaps, but this scholarly empire of books also needed the less
glamorous work of Saxl, whose negotiations with the Warburg broth-
ers and precise accounting were essential to the library's success. Over
the course of the 1920s, when Saxl acted, at the initiative of Mary and
Max Warburg, as its provisional director, he ushered the library into
its public stage and earned it a place among likeminded research in-

stitutions of its time. Despite Warburg's protests to the contrary, while the library's collection was certainly reminiscent of a bank, the collective familial structure governed just as strongly in the interwar period. To Saxl, Warburg showed a mix of tough love, as when he denied his requests for more salary, and the gratitude of a "dear friend" and colleague without whom he would never have been able to accomplish his scholarly goals.[96] Since at least one paper that has become a well-known part of Warburg's oeuvre was assembled from nothing more than scattered notes by this trusted assistant, arguably it is not easy today to distinguish between work of the Warburg Library and the work of Warburg alone.[97]

This was made all the more apparent when several persistent forces thwarted Warburg's intellectual ambitions, including physical frailty, mental instability, and a general sense of inadequacy, a condition that seemed to require the ongoing emotional, scholarly, and financial support of an ever-wider of people. Still pressured by his family to pursue a "real" career, Warburg entertained a brief stint in medical research so that he could "at least earn money indirectly, as a doctor or research chemist."[98] He also enlisted in military service in Karlsruhe but was ultimately limited in this endeavor by his inadequate physical stature. Following a case of typhoid fever at age seven, Warburg remained a sickly child and was ever after physically encumbered. This physical fragility was intimately connected with a mental condition: his lifelong struggle with manic depression. At his best, Warburg was funny, clever, and the center of familial and social life. At his worst, his mental illness completely debilitated him, sending him to seek relief and recovery in a series of sanitariums. Like several other intellectual figures of his day, including, for example, Max Weber, Warburg internalized his intellectual struggle.[99] His illness was intimately related to his intellectual inquiry.

And illness also ultimately prevented him from becoming an industrious scholar. In lieu of diligent progress in his academic research, Warburg remained a chronic collector. In 1891, while taking several psychology courses in Berlin, Warburg scribbled down aphorisms on little pieces of paper and arranged them in chronological order in boxes. His picture atlas, *Mnemosyne*, Warburg's largest yet incomplete work, discussed in chapter 4, aimed to assemble a comprehensive catalog of images of classical antiquity appearing in postmedieval art and civilization. Though stunning in its depth, the *Mnemosyne* project reveals his tendency to collect without producing a synthetic work. At Warburg's death, he had assembled several dozen screens and nearly

one thousand photographs. Save for the notes that he dictated for two related lectures, he barely wrote any text for the project. Indeed, besides his doctoral dissertation, Warburg never completed a manuscript in his entire life; he was happiest when conducting bibliographic work, and not necessarily while finishing it.[100] Thus the library was both motivation for and antidote to his deeper unfulfilled psychological and intellectual needs.

It also became the subject of his lifelong scholarly interest in the *Nachleben der Antike*, an idea first developed in his dissertation and pursued in a series of essays and lectures over the course of the 1920s. Why the Renaissance should become the subject of these interests and how it developed out of these urban, familial, and economic institutions is the subject of the next chapter.

Warburg's Renaissance and the Things in Between

The background is for me the main thing, and the background is the subject of cultural history, to which I mainly intend to devote myself.

JACOB BURCKHARDT

Going to Italy meant for him not only living in a better part of the world but also living outside the contemporary world.

FELIX GILBERT ON BURCKHARDT

Money provided the essential conditions for a life analyzing art—this insight Warburg already grasped. However, he and many other scholars besides devoted a lifetime to investigating what this material context meant for the scholarship of art and the preservation of creative genius.[1] Warburg's awareness of those conditions required for scholarship provided both inspiration and at least three of the persistent typologies for his work, in particular the merchant, the widow, and the amateur scholar. In this way, an understanding of Warburg within turn-of-the-century Hamburg, as described in chapter 1, lends much to an interpretation of the impulses central to Warburg's theoretical project and work on Renaissance art. Reciprocally, Warburg's writings on Sandro Botticelli and Domenico Ghirlandaio provide a clarified understanding of the predicament of the German-Jewish private scholar and those familial, political, and economic pressures characteristic of his existence in early-twentieth-century Hamburg.

To begin with, Warburg's decision to study the art of the Renaissance, rather than some other field, requires explanation. One motivation for liberally inclined German scholars was to imagine a more culturally and politically inclusive society of which they could be a part. Nineteenth-century Germany was replete with such historians as Theodor Mommsen, whose anti-Bismarckian study of the Roman Republic presented an explicit transference of his political aspirations. Twentieth-century portraits of Italian civic humanism offered by Hans Baron and Felix Gilbert in exile also reflected this longing.[2] Mommsen's proclamation upon arriving in Italy for the first time—"Italy, holy soil of nature, art, history!"— is typical for the enthusiasm these scholars felt for the southern land. Out of such experiences they crafted an alternative to the narrowness and exclusivity of Germany's dominant Christian culture and stubbornly autocratic society.[3]

Warburg's Italy no doubt presented a "sunny playground" for his "schoolboy imagination," and he felt a similar desire for tolerance (if not social democracy), but his family's active role in Hamburg's cultural and mercantile worlds renders a comparison to Mommsen, Baron, and Gilbert an imperfect analogy.[4] Moreover, although aspects of Warburg's life and work mirror this "Florence 1900" moment, Warburg was quick to distinguish his interests from that general Renaissance mania.[5] While he shared much with Renaissance scholars such as Jacob Burckhardt and Karl Lamprecht, Warburg's contributions to the study of that era were distinct in their scope, presentation, and wider cultural implications.

Warburg's primary methodological preoccupation was the relationship between art and its social context. It made sense, therefore, that the Renaissance would become the object of these studies, for the era served as a compelling context for its own artistic production. It was precisely to this context that Burckhardt referred when he observed that "background . . . [was] the main thing, and . . . the subject of cultural history."[6] Agreeing that Renaissance art had something to do with cultural context was one matter; determining what was meant by that context was an entirely different task. For one thing, the Renaissance was believed to be the origin of heroic genius. However, when this myth of individualism was stripped away, a complex economic and familial infrastructure emerged, provoking a central historical problem: On what basis does the historian account for artistic change over time?

In Warburg's day, the corresponding epistemological problem was articulated as a tension between historians and classicists. While historians aimed to situate the distinctive character of Greek or Renaissance

achievement in its historical circumstances, the classicist, in contrast, asserted the immutable value of this achievement as an aesthetic ideal. This methodological tension, often labeled the "crisis in historicism," posed several questions for the scholar as he sought to situate images in their wider social milieu: How can icons be viewed as both the product of a specific set of historical conditions and also capable of transcending that time and place? How does the historian standardize images so as to situate them throughout time? And what are the implications of this classicizing process on the notion of individual genius? The problem of the Renaissance, then, not only presented a vehicle for the transference of some humanist dream unfulfilled in contemporary life; it also struck at the core of central questions about the relationship between images and history, form and content, and text and context.

Just as background, for these thinkers, formed the primary basis for historical analysis, so too can its exploration situate Warburg's answers to these scholarly questions. In this respect, the Renaissance, as it was portrayed by Warburg and his colleagues, offers some guidance. The art historian Edgar Wind, who studied in Hamburg, suggested, "Warburg always sought and found these in-between levels in those historical epochs that he himself regarded as ages of transition and conflict: the early Florentine Renaissance, late antiquity under Oriental influence, [and] the Netherlandish Baroque."[7] As a city defined by a unique relationship between culture and commerce and opportunely positioned at an international crossroads, Hamburg represented one such "in-between" place. Moreover, as Wind attested, the merchants, "who [were] also lovers of art, and in whom aesthetic taste collide[d] with mercantile interests," represented paradigmatic "in-between" figures.[8] As an institution that linked the private and public worlds and enabled the domestic cultural scene, the family also serves this interstitial function, especially insofar as its mediating tendency was further impacted by a relationship to Judaism. As middlemen, Hamburg's Jewish merchant families and their prominent women were critical to Warburg's investigation of art's social context and, subsequently, reflected some of his work's basic tensions, including those between form and individuality and between tradition and modernity.

The Revival of Antiquities

Crucial to these nineteenth-century historians' vision of the Renaissance was the notion that central tensions of antiquity had been re-

vived in late-fifteenth- and early-sixteenth-century Europe. But what exactly constituted these tensions and whether they were ever resolved was a matter of dispute. In his 1893 dissertation on Botticelli's *The Birth of Venus* and *The Spring*, Warburg argued that the Renaissance had inherited a more complex aesthetic heritage from classical antiquity than was previously assumed. In this, his first scholarly work, Warburg introduced two important concepts that later became characteristic of his studies. First, he identified the source of interest in antiquity among early-Renaissance artists: namely, capturing transitory movement in art. Second, he debuted a scholarly interest in what he called the *Nachleben der Antike*, or the afterlife of antiquity, describing antiquity as the initial source of a formal tension between that dynamic energy and the classical tropes available to convey it, a tension that he thought emerged in different iterations over time. Warburg adapted this second concept from the lesser-known work of the art historian Anton Springer.[9] By setting this concept into the wider framework of cultural history, however, Warburg joined a previous generation of scholars that included Burckhardt and Nietzsche, scholars who promoted a radically new understanding of the classical world.

Germans worshiped the Greeks in the last quarter of the eighteenth century because, as poet and philosopher Friedrich Schiller reflected simply in his 1788 poem "Gods of Greece," their world was "happy, harmonious, and exquisitely beautiful" compared with "the calculating, joyless, and antiartistic present day."[10] Johann Joachim Winckelmann similarly glorified the "noble simplicity" and "calm grandeur" of the ancients and proposed the harmonious world of paganism as a moral and aesthetic model for modernity.[11] That growing neoclassical sentiment was soon visible in a number of buildings designed by the romantic architect Karl Friedrich von Schinkel including the New Guard House (1816–18) and the Old Museum (1823–30), which would become the basis for Berlin's Museum Island. In 1809, the Prussian philosopher and minister of education Wilhelm von Humboldt initiated education reforms that moved the classical model to the center of both lower and higher education and made its study crucial to the fulfillment of *Bildung*. The classicizing of German scholarship and culture seemed complete.[12]

By the last quarter of the nineteenth century, however, there was—in the words of one historian—"trouble in Olympus."[13] While it seemed the Greeks had created archetypal responses to perennial human experiences, addressing the relationship between man and nature and between finitude and the divine, these now deeply ingrained classical tropes were difficult to access and possessed conflicting implica-

tions both for scholarship and for humanity. A split emerged in the increasingly professionalized university over this issue as philology, a discipline devoted to the highly technical linguistic analysis of classical texts, strayed far from its early basis in humanism. Increasingly specialized, *Altertumswissenschaft*, or the "science of antiquity," was focused exclusively in the university rather than in literature and the arts. There emerged two neoclassical schools in Germany, the analysts and the intuitionists, both of whom considered themselves the rightful heirs to the true German philhellenic tradition.[14] Friedrich Nietzsche's abrupt departure from Bonn in 1865 and the subsequent controversy over his famous work *The Birth* of *Tragedy* in 1872 were both symptomatic of these growing divisions in neoclassicism.[15]

For Nietzsche, the scientific approach failed to recognize the suffering and painful truths integral to tragic wisdom. In its place, science brought a certain loathsome notion of "Greek cheerfulness." Like his Basel colleague Burckhardt, Nietzsche believed that Winckelmann and the other eighteenth-century philhellenists had whitewashed and prettified the classical world (*Schönfarberai*), and Nietzsche sought instead to explore the shadowed and darker side (*Schattenseiten*) of the ancients—including their myths, cults, violent worldview, and aristocratic ethos.[16] One could not really appreciate the Greeks, Nietzsche argued, unless one understood their characteristic use of potentially destructive forces for positive purposes. And Burckhardt concurred. "The enthralling neohumanist picture of ancient Greece as a uniquely happy age of mankind, an age of beauty, harmony, and joy," he argued in *The Cultural History of Greece*, was "one of the greatest historical frauds ever perpetrated."[17]

To correct this romanticized historical portrait, the next generation of scholars, which included, among others, the classical archeologist Carl Justi and the philologist Hermann Carl Usener, introduced new elements to the study of antiquity. For these scholars—also Warburg's Bonn professors—classical tropes presented responses to the primal human experiences of terror and fear. These emotions had not so much disappeared as entrenched themselves in the depths of human experience, only to resurface in paganism, astrology, and the persistence of religious cults in the modern period. Although he had been technically assigned to work with Justi at Bonn, Warburg was most influenced by Usener's radical approach to the study of religion, one that drew on anthropological techniques to connect the primitive premises of myths, images, and linguistic forms to more modern religious custom.

When Justi declined to advise Warburg's dissertation in 1889, the

young scholar left Bonn for Strasbourg to continue his research under the Renaissance historian Hubert Janitschek. He expressed little disappointment, for "the treasure trove of books in [Strasbourg's] institutes as well as in the State Library were freely available to students," and his expanded methodology would require a larger array of books.[18] In his thesis, Warburg moved beyond purely formal appreciation of Botticelli's two well-known paintings to incorporate an analysis of the poetry and texts central to Botticelli's Medici circle. Only through combining an understanding of poem and painting, word and image, did Warburg believe that one could ascertain the full meaning of the artworks. In the conclusion of a typical paragraph of his first scholarly work, Warburg announced, "The fact that Botticelli has chosen to paint the very subjects singled out by [the architect] Alberti goes to prove how much he, or his humanist adviser, was 'influenced' by Alberti's ideas."[19]

Admittedly the impulse to achieve a holistic understanding of an artwork in its time was very "Burckhardtian," as Warburg later recalled.[20] His distinctive touch focused on previously overlooked details in these iconic artworks, features that he felt embodied the tension between classical tropes and the persistence of underlying dark forces. Influenced by scientific developments and new aesthetic theories of motion, Warburg argued that simple expressions of motion offered the hidden secret to this complex process of negotiation. Flowing hair or the draping of garments, in particular, revealed an "intensification of outward movement." Sought out by these Renaissance painters, this trope represented what Warburg dubbed the *Pathosformel*, the expressive formula in a work of art that was a dialectically derived product of individual expressive impulse and an inherited repertoire of "predefined" classical forms.[21]

The notion of the *Pathosformel* was Warburg's most innovative contribution to art-historical analysis. Unlike Lessing, who had influenced Warburg greatly in his youth, Warburg came to believe that the statuary classical motif concealed a corrosive process through which emotions battled with inherited traits beneath the surface. And unlike Leon Battista Alberti, whose theory of proportion he referenced and who believed that good art could inspire some element of liveliness in an otherwise inanimate object, Warburg sensed that the emotive formula of antiquity through which artistic figures were conveyed in motion implied the visible expression of human psychic states.

But how on earth could Warburg prove this?

The key to this puzzle was drawing on a new science that accounted for how we as human beings inherit the ability to feel and, in turn, ex-

press emotions over time. Here Charles Darwin's *On the Expression of the Emotions in Man and Animals*, published in German in 1887, provided the crucial missing link. When he encountered this book, Warburg made a note in his diary: "At last a book that helps me."[22] Darwin had described how human facial movements bore a resemblance to those of their animal brethren, or, as he argued, "movements which are serviceable in gratifying some desire, or in relieving some sensation, if often repeated, become so habitual that they are performed, whether or not of any service, whenever the same desire or sensation is felt."[23] Whereas animals reacted to experiences on the basis of survival, trembling, for example, when faced with fear, humans, in turn, inherited the mimetic reaction even if it did not actually help us address the situation at hand.[24] For Warburg this evolutionary theory of expression provided the direct proof he needed to complete his art-historical analysis: "The Darwinian theory of the memory of sensory stimuli had thus to be grasped as a polar, and not a simple, process. In this sense, stylistic transformation had to be understood . . . as a counter-reaction to some tension." Warburg later recalled, "I interpreted this as the 'foreign influence' on Italian art."[25] Artwork became for Warburg the antithesis of an evolutionary development of human emotions that had roots in a primeval time.

The implications of reducing men to beasts were enormous for the scholar of the Renaissance. Simply on a methodological level, the *Pathosformel* represented a direct assault on the Winckelmannian portrait of the classical age, for the *Pathosformel* restored to the Renaissance its darker, violent motifs. Yet Warburg's belief that the *Pathosformel* provided not only a mere mechanism of historical analysis but also, and more importantly, access to primal energies, propelled him not only to the edge of this new historical methodology but also, ultimately, to the limits of his sanity.[26]

Warburg staked out his new methodological ground in "Dürer and Antiquity," a lecture delivered in 1905 to a gathering of philologists that analyzed two famous representations of the *Death of Orpheus*, both acquired by Hamburg's Kunsthalle. Focusing on a 1494 drawing by Albrecht Dürer and the anonymous engraving that served as Dürer's source, Warburg asserted that the Winckelmannian doctrine of "calm grandeur" had until now obscured a "twofold influence of antiquity on the stylistic evolution of early Renaissance art." Instead, Warburg argued that the image from the *Death of Orpheus* directly informed a second emotive current within the renewal of antiquity. "The true voice of antiquity, which the Renaissance knew well . . . stood for the dark

mystery play of Dionysian legend, passionately and knowingly experienced in the spirit and through the woods of the ancients."[27] Neither Warburg's vision of antiquity nor his vision of the Renaissance resembled the "calm grandeur"; instead, they evoked a Dionysian frenzy.

By 1914 Warburg defined this strand of classical antiquity and its opposite even more clearly: "A tragic sense of 'classical unrest' was basic to the culture of Greco-Roman antiquity, which might be symbolized by a 'double herm of Apollo-Dionysus.'"[28] Warburg's ingenuity was to show how a detail, such as Botticelli's painted flowing hair, could reveal both a characteristic trope of the artwork's respective age and some eternal truth of the human experience. Yet this idea, Warburg's own resolution, raised as many problems as it solved. To what extent, for example, could hair reasonably be said to represent the wider social milieu? If Botticelli's details constituted nothing more than a classicizing trope of the age, what did this mean for the notion of the artist's creative genius? And what was the relationship between genius and the time period?

Toward a New Cultural History

To further investigate the questions posed by his thesis, Warburg turned to the work of Jacob Burckhardt. A student of the art historian Franz Kugler and the classicist August Boeckh, as much as of the traditional history of Ranke, Burckhardt aimed to understand art through its cultural context and surrounding circumstances. Among this group of scholars, however, there was still only a vague idea of what this context could mean. Burckhardt's growing belief that everything was related found a methodological paradigm in August Boeckh's "great course" on Greek antiquity, a course that Burckhardt attended in Berlin and the influence of which he credited in his own work on the classical era. For Boeckh, the culture of Greece was a "closed unit, an organism in which a system of ideas was realized. Insight into the relationship of these dominant ideas to activities in all spheres of life—from food and clothing to political institutions and philosophical ideas—[would] reveal the essential nature of antiquity."[29] Following Boeckh, Burckhardt soon attracted local fame on account of his own wide-ranging lectures at the university in Basel, lectures that aimed to present equally holistic portraits of the classical and the medieval period. But it was with his portrait of the Renaissance that Burckhardt made his lasting mark:

Here he began with a change in the artistic world and extrapolated to account for a wider development in society. He subsequently characterized the Renaissance as driven by a dominant set of ideas devoted to heroic individualism—the primary characteristic that made the era "firstborn among the sons of Modern Europe."[30]

But the revolution in ideas that Burckhardt proclaimed did not emerge without context, nor did he describe an ahistorical epiphenomenon. Following Boeckh's model, individualism as a doctrine emerged from the specificity and texture of Italian society. An increase in wealth in the thirteenth and fourteenth centuries had made cultural aspirations a possibility. Central to Burckhardt's historical narrative of fifteenth-century Italy, therefore, were the cities and universities of the various Italian city-states, the nature and participation of such ruling families as the Medici, and the connection of this individualism to a certain set of institutions.

Influenced by Burckhardt, Warburg emphasized the primacy of social context in his own work. As Warburg told an audience at a lecture on Botticelli in 1898, "anyone who is not content to bask in Sandro's artistic temperament, but wants a psychological understanding of him as an artist, must also follow him into the broad daylight of his work as a recorder of an intense and vigorous physical and mental life, and trace the intricate convolutions of the paths he followed as a willing illustrator to cultivated Florentine society."[31] Just as Warburg's analysis of art required both a scientific and an aesthetic approach, so a holistic analysis of Botticelli required both "internalist" and "externalist" perspectives.

Burckhardt's work was also deeply personal for Warburg, for its narrative featured a seemingly familiar civic world and described a self-regulating republic that, like Hamburg, was ruled by prominent mercantile families. A Prussian historian, accustomed to the top-down administration of cultural affairs, would not as easily have favored such an approach. Burckhardt's scholarship was inflected by the provincial city of Basel, where, as Lionel Gossman has shown, the tide of nationalism rendered it a "sanctuary for intellectual practices that ran counter to the reigning orthodoxies of German scholarship." Burckhardt not only defended against the common accusation that the patron Lorenzo the Magnificent was a "protector of mediocrity" but also argued that these tastemakers were essential to enabling this wider cultural transition.[32] It was, after all, in the private homes of Florentine merchants that humanist learning was first undertaken and that dilettantism—the

kiss of death in the professional academy—proved to be an important ingredient for the Renaissance world.[33] In the 1880s, as he surveyed Burckhardt's influential work, reading about this culture of artistic patronage, Warburg might well have imagined himself a modern-day Medici. For as with those Florentine patrons, the question of balancing the autonomy offered by dilettantism with the desire for legitimacy granted by professionalism lurked over Warburg's frenzied career.

Money, Matriarchy, and Melancholy

The advantages and disadvantages of the private scholar, working independently from institutional affiliation, were most evident in Warburg's intimate life. Here converged the tropes of the merchant, the widow, and the amateur scholar. An examination of these themes illuminates Warburg's central aesthetic preoccupations as well as the centrality of the early Renaissance as his main subject of inquiry. Hamburg's intellectual world was a family affair, and while the Warburgs offered the platform for Aby Warburg's cultural and intellectual aspirations, the family money did not fall easily on Warburg's conscience. Although there existed a tremendous amount of love and respect between brothers Aby and Max, their relationship was never an easy one. A group photograph taken in 1929 (fig. 2) shows Aby Warburg putting out his hands like a suppliant to emphasize the parasitic position he always felt himself to hold within the family. The choice of Florence as the setting and subject for his lifelong work might have emerged from Warburg's need to reimagine both his own place in his family and his family's role as patrons and tastemakers in contemporary Hamburg.[34]

Warburg's dissertation, then, also paid tribute to his mercantile upbringing, already visible in his choice of the commercial republic of Florence, the "birthplace of modern, confident, urban, mercantile civilization," as the subject of his research.[35] In "The Art of Portraiture and the Florentine Bourgeoisie," an essay published four years later, Warburg explicitly addressed these themes in an exploration of the new relationship between painters and their patrons in fifteenth-century Florence. "It is one of the cardinal facts of early Renaissance civilization in Florence," Warburg observed, "that works of art owed their making to the mutual understanding between patrons and artists."[36]

In this essay, Warburg showed the effect of the milieu through a contrast between two frescoes: the first was Giotto di Bondone's 1317

2 In this 1929 family portrait, Aby Warburg (at right) plays up his position as suppliant to his banker brothers (left to right) Paul, Felix, Max, and Fritz. Warburg Institute, London.

decoration of the Bardi family's chapel with the legend of Saint Francis and the second a series of frescoes by Domenico Ghirlandaio, 160 years later, also devoted to Saint Francis and commissioned by the merchant Francesco Sassetti for the Sassetti family's memorial chapel in the church of Santa Trinita. Drawing on family documents, including Francesco Sassetti's recovered will, Warburg excavates how Sassetti sought to pay honor to his patron saint. According to Warburg, while Giotto's attention to the body was purely spiritual, Ghirlandaio took the spiritual content as a pretext for reflecting on the beauty and splendor of temporal life. In an illustration of this painterly emphasis on contemporary life, the patron Sassetti not only insisted on including himself and his adult sons within Ghirlandaio's composition but also demanded the inclusion of a painted Lorenzo de' Medici, a close associate and bank partner of the Sassetti family. In this painting, Warburg observed, Ghirlandaio "transforms the legend of the 'eternally poor' into a backdrop for Florence's opulent mercantile aristocracy."[37] That even in spiritual tropes a source could be found for newer material values proved, for Warburg, the "lawful and persistent survival of barbarism," and this previously unknown context "cast a truer and a

more favorable light on the inclusion of portrait likenesses on a church fresco of sacred scenes."[38]

Warburg lauded the Florentine citizen who, at this moment of transition, balanced the old medieval Christian world with a contemporary mercantile one. According to Warburg, the Florentine "rejected the pedantic straightjacket of 'either-or' in every field, not because he failed to appreciate contrasts in all their starkness, but because he considered them to be reconcilable."[39]As an early advocate for the development of Hamburg's cultural institutions, Warburg was himself well aware of the demands placed by merchants on these cultural goals. Like other Hamburg scholars, he was compelled to make arguments for culture with reference to utility. To earn his brothers' financial support for one cultural endeavor, he appealed to their desire to be remembered. "It is certainly risky!" he wrote, "but that is the very beauty of it. Man must have the courage in the face of fear of the world to do something speculative sometimes, also in the intellectual respect: that is the greatest privilege of the private businessman!"[40] Warburg capitalized on the obligation his brothers felt, as private businessmen, to public culture and to ensuring their eternal representations within that culture—a contemporary incarnation of the concerns of Florentine patrons—to galvanize his brothers' support for his cause.

Warburg not only thought that the world of commerce and trade needed to be balanced with that of cultural concerns; he also firmly believed that the particular relationship between these spheres could be a source of creative energy. As he wrote in the same essay, "The artistic products of the resulting compromise between Church and World, between classical antiquity and Christian present, exude all the concentrated enthusiasm of a bold, fresh experiment."[41] Warburg further attributes Sassetti's iconographic accomplishment to his ability "to pay pious homage to the past, relish the fleeting moment, and look the future shrewdly in the eye, all with equal vigor."[42] At this moment of transition between the early and late Renaissance, "in-between" figures, adept at negotiating the demands of two cultural paradigms, could capitalize on change for creative purposes.

Because figures such as Sassetti reflected their period of transition, these Italian merchants provided Warburg with the fertile means to trace antiquity's transformation over time, and in particular those emotional remnants that were never quite reconciled into those classical formulations. But the study of these Italian patrons also revealed central theoretical tensions, and as Warburg wrote of the problem of

portraiture, the "motive forces of evolution do not reside solely in the artist; for there is intimate contact between the portrayer and the portrayed." Insofar as it could represent the dominant type or a unique personality, the typical or the individual, the portrait reflected the rhetorical dilemma of the *Pathosformel*. Sassetti's choice to place the tomb in Santa Trinita embodied this same dilemma. "Once we appreciate the massive outlay of money and of mental energy that Francesco Sassetti invested in getting his way in this matter," Warburg wrote in "Francesco Sassetti's Last Injunction to His Sons," an essay that continues the story of Sassetti's commissioned frescoes, "his combative response to a question of decoration begins to look like an expression of highly individual artistic feeling."[43] If Botticelli's work reflected the hand of a "humanist advisor," now Sassetti's shadow seemed to suggest that the patron's will—rather than that of the artist—reigned.

For Warburg, Hamburg's merchants provided a powerful parallel trope with which to interpret Renaissance patronage. But his essay on Sassetti becomes all the more poignant when considered from the perspective of the family, the other "in-between" body fundamental to Hamburg's long-standing history of grand bourgeoisie. The Warburgs upheld a long tradition of powerful matriarchs that began with Sara Warburg, who assumed control of the family bank in 1856 following her husband's death. Partly through strategic marriages, the Warburgs assumed international fame and prestige. Max Warburg and his wife Alice Magnus were collectively dubbed "Malice"; and it was this and other married couples who supported the young Aby Warburg's scholarly and financial endeavors. When Warburg's own father died in 1920, he elected not to perform the Jewish prayer of mourning, for he felt that his recitation, as a nonpracticing Jew, would not be genuine.[44] Despite this decision, Warburg's filial loyalty persisted in his attachment to his mother, and he corresponded with and confided in her often.[45]

Warburg's short and little-known essay "Matteo degli Strozzi: An Italian Merchant's Son, Five Centuries Ago," published in 1892, offers a seductive allegory of these conflicting parental relationships. In this most revealing essay, in which no artworks are mentioned, Warburg presents a vivid portrait of the domestic life of a fifteenth-century Florentine mercantile family. The essay focuses on a widow's return to Florence after her husband's death and chronicles her struggle to maintain the household as her five sons carry on her late husband's business. When the family's eldest brother summons Matteo degli Strozzi, the

essay's namesake and the youngest son, to assist with the finances, his mother refuses to send him, deeming him too young and sickly for this work, and Matteo contracts a fever and dies within three days.[46]

Whether or not Alessandra Strozzi represents the archetypal or exceptional Italian Renaissance mother is a matter of historical contention among today's scholars of the Renaissance.[47] Notwithstanding this critique, however, the Strozzi letters, published in Italian in 1877, captivated Warburg and his friend Alfred Doren, a Renaissance scholar, who later edited the German edition of the letters.[48] An outsider like Warburg because of his Jewish identity and methodological interests, Alfred "Alfresco" Doren, as Warburg called him, was equally drawn to the economic, familial, and melancholy cultural world undergirding Renaissance art.[49] The published Strozzi letters reveal a forlorn and strong-headed woman who constantly reminds her thirteen-year-old son Matteo, "You should consider how hard it is for me, when I think how I was left while I was still young to bring up five children as young as you all were."[50]

Beyond the narrative's superficial similarities to Warburg's own situation—a late merchant father and a widow's five children—the psychological comparison between Warburg and Matteo degli Strozzi is striking. Warburg also struggled with physical frailty and mental illness, a characteristic that, compounded by a tendency to align with the material, posed a threat to his productivity. The family had learned to mitigate Aby Warburg's neuroses.[51] For the most part, however, Warburg came to rely on a group of women including his mother, his wife, and his assistant Gertrud Bing to both soften the effects of his bouts of depression and enable his intellectual productivity. Despite (or perhaps because of) this dependence, Warburg's melancholy was inextricably linked with his masculinity. Emasculated by his stay in the sanitarium in Kreuzlingen, Switzerland, he often complained that his wife no longer respected his opinion and that, following his hospitalization, his children disobeyed his requests.[52] While he recovered, his wife assumed responsibility for the household and his well-being (fig. 3).[53] Only the death of his own mother, like that of the young Matteo's, was enough to bring Warburg out of his self-pitying and back to the fold: when Charlotte Warburg died, the patient insisted on reprieve from Kreuzlingen, shockingly, to attend synagogue to pay his respects.[54]

In the Renaissance, as in Hamburg, this family setting was simultaneously advantageous and problematic for intellectual life. The family relied heavily on women, women who, perpetuating a rabbinic tradition that Warburg's niece observed continued in the modern period,

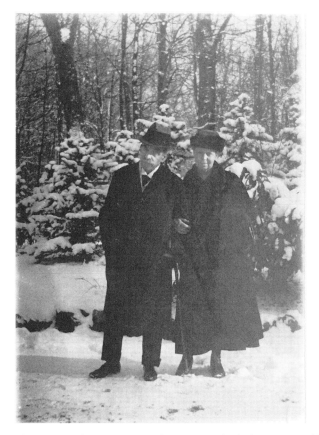

3　Mary Warburg visiting Aby in 1922 in Kreuzlingen, Switzerland; Aby sometimes felt
emasculated by his treatment. Warburg Institute, London.

clearly provided the family's scholar with financial and emotional sup-
port.[55] But women also often participated in and organized the family's
cultural and intellectual affairs. This egalitarian tradition in scholarly
matters mirrored the treatment of women in Renaissance-era families,
where, Burckhardt famously argued, "women stood on a footing of
perfect equality with men."[56] Notwithstanding historical challenges to
this grand claim, there is some truth to the fact that the homegrown
quality of humanism favored girls who read the same books at home as
their brothers.

　　The irony is that, largely owing to the popularity of Burckhardt's vi-
sion of the Renaissance, the myth of heroic individualism as the guid-
ing characteristic of the age persisted even as it obscured precisely the

economic, civic, and familial conditions that initially had so informed this historical portrait. Gombrich suggested that the embellished role of the patrons resulted from a corresponding increase in the professional status of the artist.[57] Drawing on Gombrich's initial challenge to Burckhardt's cult of individualism, one historian has proposed a different explanation, based on the notion of the fifteenth-century workshop or *bottega*, that moves beyond the individual patron to consider the collaborative work that was required for art.[58] In a similar spirit, the family might be understood as a "workshop" for ideas.

But a workshop is often a first step in the development toward professionalization, and as this world became institutionalized, its women were often left behind. Furthermore, the presence of women in such a homegrown world of culture put it at risk for criticisms of amateurism. In this way, even as the Warburg family enabled their son's cultural aspirations, their involvement simultaneously triggered anxieties of dependence and dilettantism. Warburg's good friend the art historian Adolph Goldschmidt made this connection between feminization and productivity explicit when he nagged Warburg during a lag in his scholarly output, "Everyone is waiting to see you come out with a book on the entire Medici household, and [instead] what comes? A little Warburg girl."[59] The congratulations on the birth of his third child, Frede, could only have served to heighten his anxiety about his precarious status. The lack of an official cultural institution was a complicated context for a new scholarly enterprise, and the stereotypical Hamburg merchant who idled his time away with art and books remained the object of much derision in Berlin's presumably more sophisticated and professional scholarly circles.

Warburg remained conflicted about his relationship to amateurism. On the one hand, he dug in his heels more and insisted on his professionalism. When he rejected a kind offer from the owner of an antiquarian bookstore in Munich to advertise his growing book collection, one hears in his antipopulist rejoinder precisely this insecurity. "I need books like instruments in a scholarly laboratory," Warburg demanded, drawing on a metaphor that soon provided the rhetorical armor for the self-fashioning of his institution.[60] But, admittedly, Warburg also considered the dabbling merchant a source of creative energy exactly because of his nontraditional spirit, and in a piece published several years later in the annual journal of the Hamburg Society of Book Lovers, Warburg praised a fellow citizen's private library for the lively intellectual spirit it exuded. "Our amiably dilettantish Hamburg," he said, "has much to learn from our fellow citizen . . . and from his happy

maintenance of the tradition of the old-fashioned, sensitive amateur antiquarian—for whom, in all modesty, an effective contribution to scholarship is both a recreation amid the cares of business and an earnest [example] of individual good faith and self-sacrifice."[61]

The same could perhaps be said about Warburg's own library. The advantages and disadvantages of amateurism came to be revealed in Warburg's antimethodological methodology, the final aspect of his contribution to the study of history.

Methodologies and Antimethodologies

To circumvent the problems of historicism—the tension between the dynamism of the subject matter and the ossification created by historical structure—one needed to embody a paradox: the creation of a scholarly methodology that was highly sensitive to the inherent disadvantages of scholarship. Warburg was up to the task, and he had a growing number of models from whom to learn. Following the publication of *The Birth of Tragedy*, Nietzsche's critics proclaimed him dead as a scholar.[62] A similar insult was launched at Burckhardt and his work when it was claimed, "[His] book doesn't exist for scholarship."[63] Indeed, as the specialized pursuit of science, or *Wissenschaft*, threatened to encroach on life, both Nietzsche and Burckhardt retreated from academics to the private pursuit of *Bildung*, distinctly not *wissenschaftlich* in purpose.

Nietzsche reminded his audience that by using science to "arrange and compare the linguistic forms of ancient masterpieces, to bring them at all events under a morphological law . . . we always lose the wonderful creative force, the real fragrance, of the atmosphere of antiquity; we forget that passionate emotion which instinctively drove our meditation and enjoyment back to the Greeks."[64] For Nietzsche, that the tragic world replaced the Socratic in *The Birth of Tragedy* mirrored his own opposition to the new classicism that supplanted poetic humanism with *Wissenschaft*. Nietzsche—and Warburg—aspired to a scholarship that was, in some senses, unscholarly at its core.

At the center of these methodological disagreements was the relationship between culture and history, a question that had animated a lively scholarly debate at the turn of the century, known as the *Methodenstreit*, or the "dispute about methodology." One of Warburg's other professors in Bonn, the historian Karl Lamprecht, emerged as the main object of criticism in this debate; he was a scholar who eventually at-

tained an *Ordinarius* position in Leipzig despite his highly unconventional scholarship.[65] Lamprecht applied scholarship on art, economics, and society to promote what he called cultural history and described as "the comparative history of socio-psychological aspects of development" that corresponds to the history of language, economy, and art, "as comparative disciplines otherwise relate to their subordinate disciplines."[66] Lamprecht's varied subject matter, grandiose claims, and lack of precision earned him many critics, and he was more popular abroad than in Germany, where the more narrow and traditional political history of Ranke, Meinecke, and Mommsen still reigned as the dominant school. Dubbed "the classic renegade" by the historian Roger Chickering, Lamprecht was not as successful as others, such as those scholars of the *Annales* School, in promoting very similar notions about cultural history; he remained "the great marginal figure in the German historical profession."[67] But Warburg could hardly be said to be mainstream, and although he craved the approval of Burckhardt, whom he called his "secular patron saint," Warburg was attracted to Lamprecht's attempt to connect economic and social change to "general-psychic transitions . . . why, for instance, the rise of finance is regularly connected with the transition to individualism."[68] Lamprecht's answer—his methodological notion of universal history—was extremely influential for the young Warburg.[69]

For most historians of the day, the notion of universal history applied exclusively to the cultured people of Western Europe, if not only to Germany, and an interest in comparative cultural history seemed often to inspire accusations of dilettantism. Although he expressed interest in other cultures and praised the United States for its characteristic internationalism, Lamprecht, too, primarily understood universal history principally to mean the superimposition of the German experience onto the analysis of other cultures.[70] But Warburg was eager to further a comparative study of cultures, and his banking connections facilitated this pursuit.

In 1895, on the occasion of his brother Paul's wedding, Aby Warburg traveled to the United States for the first time. Through a new in-law, the wealthy and eccentric James Loeb, who later founded the Loeb Classical Library, Warburg made several connections, including to the Smithsonian librarian Cyrus Adler, and he privately toured the American Indian collections at both Harvard University and the Smithsonian Institution.[71] The most important of these introductions was undoubtedly to the anthropologist Franz Boas, with whom he shared a revealing correspondence that illustrates the interconnections between art

history and anthropology in his work.[72] Having proclaimed the "emptiness of civilization in the American east," Warburg then traveled west by train to visit the Pueblos in Santa Fe and Albuquerque.[73] Outfitted in a banker's suit with a black vest and watch chain, and adorned with a cowboy hat and kerchief for some local flavor, Warburg studied the Hopi Indians for two weeks.

A central aspect of Warburg's visit was his administration to the tribe's children of a test adapted from Earl Barnes, a child psychologist with whom Warburg met at Stanford in March 1896. Warburg told the children on the reservation one of Heine's German fairy tales, one about a storm, and asked them to draw the lightning described. While most of the children produced a naturalistic portrayal of lightning in zigzag form, two drew it as an arrow-headed snake, according to the tribal custom.[74] Warburg believed that these minority responses confirmed his conviction about the *Nachleben der Antike* and illustrated the persistence of primitivism and myth in the face of reason and modernization. Warburg's new friend Boas made the connection between this experiment and its implications for primitivism, art, and evolutionism explicit some years later: "'There must have been a time when man's mental equipment was different from what it is now, when it was evolving from a condition similar to that found among the higher apes.'"[75]

Yet Warburg was not principally an anthropologist; his interest in the Hopi Indians derived primarily from his desire to understand the mental structure that lay behind the portrayal of this or that image at a particular moment in time. The children who lived on the edge between logic and magic, and therefore on society's cultural and linguistic barrier, provided precisely the "in-between" subjects that Warburg desired for his analysis. Imagining the American Indians as relics of primitive pagan humanity, Warburg asked, "To what extent does this pagan worldview, as it persists among the Indians, give us a yardstick for the development from primitive paganism, through the paganism of classical antiquity, to modern man?"[76] One scholar has successfully connected Warburg's reflections on the Indians with his increasing interest in the East European Jew, a fitting parallel given the connection between Jew and primitivism in medieval art theory.[77] Despite (or perhaps because of) the fabled prohibition on images, Jews developed a mystical notion of "seeing" that went beyond the representational.[78] Warburg also spoke about the American West as his "ancient Greece," insofar as this cultural pilgrimage provided him with material evidence to scientifically make these connections. Although the art historian did not publicly present these findings for almost two decades, his results

made their way into his solidifying art-historical methodology, which he dubbed "iconology."[79]

Unveiled in a series of lectures upon his return to Germany, iconology became Warburg's primary method and a science for identifying and contextualizing the relationship between images and their historical significance over time.[80] Speaking in Ferrara, Italy, in 1912 about the mural cycle in the Palazzo Schifanoia, which consisted of representations of the twelve months of the year, Warburg made a surprising discovery: here he showed that a row of figures marking each month corresponded to astrological characters of Greek deities—"survivals of astral images of the Greek pantheon"—only they were strangely and inexplicably depicted in their Indian incarnation. "Stripping away layer upon layer of unintelligible accretions," Warburg argued that the "Indian trappings have obscured what were originally authentic Greek astral symbols." Warburg's lengthy argument required that he demonstrate how a ninth-century medieval manual with constellations from different ethnic origins migrated, as it were, to the fifteenth-century Ferrara court, and with it, these changing constellations of images. As such, it demanded that he draw on the philology of his student years, new findings in astrology, no less than Darwin's evolutionary psychology, and those of Boas in anthropology to answer this charge. In this way, this lecture was also "a plea for an extension of the methodological borders of our study of art, in both material and spatial terms."[81]

From a methodological perspective, then, Warburg ultimately took his cue neither from Nietzsche's antimethodology nor from Burckhardt's "intuitive generalizations," but rather from outlier Lamprecht's interdisciplinary and holistic approach to universal history.[82] Ever since Warburg's premature death in 1929, scholars have fought to claim Warburg as, on one hand, a serious system builder or, on the other, an eccentric bruchstück-esque thinker.[83] Both of these perspectives overlook a simple fact: fragmentation remained the flip side of wholeness, and like many other scholars in the Weimar era, Warburg was preoccupied with the concept of totality as the only antidote to the state of utter intellectual and political fragmentation in which they found themselves. In response to those who staunchly defended disciplinary boundaries (at Ferrara, Warburg called them *"Grenzwächterei,"* or the border police), Warburg developed a *Kulturwissenschaft*, or "science of culture," that aimed to avoid what he considered the negative impact of specialization in scholarship.[84] Subsequently, Warburg's iconological methodology never resembled strict art-historical analysis, but rather,

truly interdisciplinary in spirit, it aspired to a universal history that is almost unthinkable today.

For such a comprehensive portrait is often unmanageable. While Burckhardt seemed to oppose fragmentation because it threatened to create artificial sections that obscured the texture of real life, he also recognized that a degree of compartmentalization was unavoidable in the pursuit of intelligibility.[85] Insofar as he gravitated toward Burckhardt, Warburg read him through Nietzsche, interpreting both figures as special "seers" with a mystical connection to the past.[86] In this sense, one scholar's description of Warburg as a manic-compulsive who "spoke to butterflies" was justified.[87] This resistance to the most basic disciplinary conventions of scholarship doubtless played a role in Warburg's choice of where to pursue these interests. It is possible that, had anti-Semitic sentiments not blocked Warburg's appointment at Basel, he might have preferred to work in that city, known for its *unzeitgemäß* (or unseasonable) intellectual culture.[88] There is good reason to assume, however, that his eccentric personality and idiosyncratic approach were better suited for an extrauniversity environment. There is a way in which Warburg's methodological aversion to tradition and his belief in the centrality of the amateur spirit dictated that he could promote his scholarly vision only from outside such institutional and methodological borders. Here, too, Lamprecht's career as the consummate outsider-insider provides a revealing comparison for Warburg. He likely showed Warburg how one could get a lot accomplished intellectually if one did not reside in the university, although such a choice also raised the risk of losing the respect of university professors along the way.[89]

As Nietzsche, Burckhardt, and Lamprecht wrote for a wider audience, so an overtly amateur spirit pervaded Warburg's total history. Rather than apologize for the alleged mediocrity that this amateurism engendered, Warburg—just as Burckhardt had with reference to the Florentine merchants—came to perceive independence from the state as central to his intellectual project. His own mercantile city of private scholars eagerly perpetuated this Renaissance tradition, and consequently, Hamburg shared a natural affinity to Warburg's idea of urban culture.

———

Gombrich later bemoaned Warburg's central methodological assumption of the connection between the details in art and the *Zeitgeist*.

Linking Warburg to Burckhardt, Gombrich argued that they both still relied on a Hegelian notion of history in which changing styles of art became the index for a changing societal spirit. At the heart of Burckhardt's thesis was the contrast between the mentality of the Middle Ages and that of the Renaissance, the latter of which provided a forum for man to become a true mind.[90] Similarly, Warburg relied on the assumption that text, image, and context all inspired one another. Just as Lessing had concluded that Virgil influenced the sculptors of the Laocoön Group, Warburg argued that Botticelli's paintings emerged from a wider context of Renaissance poetry.[91]

According to Gombrich, all subsequent historiography of culture attempted to salvage the Hegelian project without accepting Hegelian metaphysics, the assumption that all of the particular elements in the society were working together toward a unified spirit of world history. But subsequent historians did no better to avoid the methodological circular logic of evidence and causation: just as Lamprecht looked for essence not in the material conditions but in the mentality of age, Johan Huizinga sought to understand an age inside out, beginning from the reading of a single painting.[92] And in the fullest expression of this tendency, Wilhelm Dilthey's concept of *Geistesgeschichte* (intellectual history) understood art, literature, and social structure as elements of the same *Weltanschauung*, or worldview.

For Gombrich, the problem with this Hegelian view was that everything must be treated "not only as connected with everything else, but as a symptom of something else." Of course, there remained exceptions, including the classicist Winckelmann, who aimed to preserve the singular importance of sculpture to the exclusion of all other arts, and the formalist Heinrich Wölfflin, who, as we will see, only rarely believed it the art historian's task to move beyond the study of a painting's formal characteristics. But as long as the scholar remained committed to navigating the relationship between an image and its world, the methodological solution offered would ultimately lead to some version of cultural history or another. Even Gombrich once reluctantly admitted, "If cultural history did not exist, it would have to be invented now."[93]

Gombrich's critique of cultural history notwithstanding, it is notable that Warburg's Renaissance largely arose from an attempt to avoid precisely those methodological and epistemological pitfalls that Gombrich later attributed to him.[94] Warburg remained committed to a holistic scholarship that he believed circumvented these problems of text and context, fragmentation and totality, and tradition and modernity. Always attentive to how his analysis would contribute to his new *Kul-*

turwissenschaft, Warburg focused on the city of Florence, where art was undoubtedly implicated in a wider story and could never be appreciated only for its own sake.[95]

Both Warburg's framing of the problem, and its solution, seemed to lie in the places "in between," both from the perspective of a scholarship that insisted on interdisciplinarity in the face of accusations of dilettantism, and in the significance of the merchants and families that made their way into his work. Warburg was eager to see whether his mercantile city, positioned as it was on an international crossroads, could also live up to its historically determined potential. It was here, in Hamburg, that Warburg tried to create an institution—a university—that could simultaneously maintain the creative energy of the amateur spirit and acquire the status of a serious scholarly enterprise.

University as "Gateway to the World"

A little learning does no harm, but should also not be too pricey.
ABY WARBURG

The state must replace by intellectual force what it has lost in physical force.
FREDERICK WILLIAM III

The Renaissance provided a civic model for the redemption of private wealth through cultural contributions. But in Hamburg, the amount of money to be spent and the kinds of institutions to be supported were the source of increasing contention between the city's established merchants and an ever-growing gaggle of local scholars. The latter camp was confronted with conditions less than favorable to their aims. In the nineteenth century, Hamburg's only official academic institution of higher learning was the Akademische Gymnasium, founded in 1613 with a limited selection of post–secondary school courses. However, this "pre-University" lost a sense of purpose with the increased specialization of study that seemed to obviate the two semesters of liberal arts offered. That the Gymnasium was forced to close in 1883 because of poor attendance did not bode well for the city's scholarly prospects.[1] As the historian Lamar Cecil observed, "Things intellectual were not in vogue; Hamburg boasted no university and there was little feeling that one was needed. Young men destined for the world of trade received their education in the offices

72

along the wharves and on ships at sea."[2] University was an unnecessary step in the life of a Hamburg tradesman.

As a scholar born into a prominent banking family, Warburg often mediated between the camps of merchants and academics, a role revealed in his popular slogan, one that reflected a unique position between the worlds of bargaining and of books: "A little learning does no harm, but should also not be too pricey."[3] Although he drew a few laughs for his characteristic dry wit, Warburg's aphorism also struck at the central question of the debate over the purpose of scholarship in a commercial and international city without a scholarly tradition.[4] Warburg entertained visions of an interdisciplinary institute that took advantage of a position outside the state-based Prussian system to break new methodological ground, but to succeed in this endeavor he needed to persuade the city's bankers that a university would emerge from Hamburg's local traditions and represent its commercial interests.

While the university would eschew becoming a training ground for civil servants, it did risk serving another master: money. Constant in these discussions, both as model and as deterrent, was Berlin, whose university was founded in 1810 in the wake of defeat but with a special claim to humanism. The campaign for Hamburg's university was nothing less than a struggle for the heart and soul of the city, and its belated resolution after the First World War had significant implications for the kinds of scholars and types of ideas that it eventually promoted.

Institutional Beginnings

The idea for Hamburg's university was as old as its opposition. Following the end of the Napoleonic occupation, the city of Hamburg, like others in Germany, underwent a series of reforms. As a result of the reorganization of the German states and the subsequent loss of territory, many cities welcomed the possibility of a university.[5] Under such circumstances, Berlin's leaders, including the reformer and humanist Humboldt, succeeded in persuading their fellow Berliners of the benefits of a neohumanist university for the new political landscape.[6] The push for a university gained similar momentum in Hamburg in 1848 as a result of the liberal revolution, whose democratic spirit lent itself to educational reform.[7] But there were no influential local personalities to whom the university mattered, and so no real progress was made toward any specific plan. Despite growing cultural initiatives among

Hamburg's local burghers, Gustav Schiefler, the host of the popular
Schiefler Abende salon evenings, observed, "scholarship was always rel-
egated to the corner of the house."[8] Marginalized by other priorities,
the idea of a university for the city had almost entirely disappeared by
the end of the nineteenth century.

Along with the Schiefler and the Sieveking families, the Warburgs
counted among those of Hamburg's elite who made it their goal to im-
prove the city's scholarly profile. As a member of the Patriotic Society,
Aby Warburg had already been involved in efforts to establish a cultural
infrastructure, including the institutions, laboratories, and collections
a university typically requires. It is also possible that as a student of the
art historian August Schmarsow's inaugural course in the winter term
of 1888 in Florence, Warburg was energized by his professor's efforts to
found a German research institute there.[9] When Warburg and his wife
returned from time abroad in Florence to settle in Hamburg in 1904,
they began to organize *Conventiculi*, or learned societies, in the homes
of various Hamburg families. The *Conventiculi*—a term that stems from
the Latin "convenio" and literally means "men coming together"—
drew on its assumed classical heritage to garner support from the di-
rectors of local museums and institutes.[10] And despite the Latin root's
gendered pronoun, these forerunners to the university classroom held
opportunities for women. Turning in part to the philanthropic meth-
ods of its nineteenth-century predecessors, the *Conventiculi* principally
cultivated intellectual exchange in private homes.[11]

The pursuit of a compensatory professionalism also inspired the cre-
ation of a substantial network of institutions, including libraries, mu-
seums, and lectures outside of the home. In this respect Aby Warburg's
partner was the local politician Werner von Melle, who saw the univer-
sity as central to this mission. Von Melle considered Warburg the most
cherished of his scholarly friends, and over the next several decades,
the two worked closely together on the university's campaign. In his
positions as chair of the Supervising School Authority (Oberschulbe-
hörde) in 1904, deputy mayor (1914, 1917), and mayor (1915, 1918–19),
von Melle balanced the power and privilege of his official posts with
pragmatic, modest achievements.[12]

Convinced that the Senate would never approve a university, von
Melle instead focused on isolated projects, creating the de facto institu-
tional basis for a university, with directors poised to assume leadership
positions if an eventual founding came about.[13] In 1900 extrauniversity
research institutes were still in their infancy in Germany, yet Hamburg
possessed a number of them, including the Botanical Garden (1821),

an Astronomical Observatory (1833), Chemistry and Physics Laboratories (1878 and 1885), and an Institute for Ship and Tropical Disease (1900).[14] Building on the success of these institutes and the home-grown *Conventiculi*, von Melle established a General Lecture Series to which local scholars contributed, including Warburg himself, whose lectures on such Renaissance artists as Albrecht Dürer and Leonardo da Vinci were widely attended. Von Melle's ad hoc university soon offered 395 lectures led by some two hundred *Dozenten*. Resistance to an actual university was still so great, however, that when the architect Fritz Schumacher arrived in Hamburg in 1909, he remarked that pro-university advocates still had to disguise their intentions to turn this institutional infrastructure into a formal university. Apparently their goals were so obfuscated that even young Hamburgers like Warburg's longtime friend and sometime student Carl Georg Heise were surprised to find that one could pursue a "proper course of study" in "such an amusing city."[15] Hamburg's nonuniversity was the best-kept secret in the German Empire.

With the establishment of the university's institutional infrastructure under way, von Melle began to advance the radical idea of a private university (*Stiftungsuniversität*) to be funded exclusively by Hamburg's citizens. And, drawing on the city's long-established philanthropic tradition, von Melle and Warburg moved to establish a fund for this purpose separate from the Senate's control. Under von Melle's tutelage, the Oberschulbehörde also persuaded Max Warburg to join its board. Over the next year, the scholar and the chair wrote a draft of the statute, while Max Warburg, a born negotiator, assembled a first-rate group of potential donors for the cause. Max began with Alfred Beit, the German-British businessman and world-famous "Diamond King," a sign of the university's essential link to the business community and an ample source of funds.

Born and raised in a Hamburg Jewish banking family, Beit was typical of the Hamburg model, as described in chapter 1. An innovative entrepreneur, he earned his fortune in South Africa diamond mining with his business partner Cecil Rhodes (in an enterprise that eventually became the international company De Beers) and along the way made his name as a generous patron of the arts and culture. Von Melle, who also knew Beit from his school days, hoped his old friend would contribute the 25 million marks necessary for the university (Beit's net worth in 1890 was 300 million marks). In December 1905, after careful consideration, Beit pledged only 2 million, a sum that provided the basis for the newly named Hamburg Scientific Foundation (Hamburg

Wissenschaftliche Stiftung). As an honorary gesture toward this cause, he also, at Lichtwark's urging, commissioned a painting by Max Liebermann to portray and legitimate this pro-university camp.[16] Max Warburg, for his part, was not disappointed by Beit's contribution, since he believed that "it was characteristic in Hamburg that there not be one very large fortune that determined the local field, but rather several midlevel fortunes." On April 16, 1907, the Hamburg Scientific Foundation convened its first official meeting in the city's town hall. They had raised nearly 4 million marks for the university cause, an impressive feat, but had still clearly come up short.[17]

That the Warburg–von Melle partnership experienced fits and spurts in its initial efforts is not surprising. The notion of a privately funded university in the context of Germany's state-run university system was extremely rare, and so, too, was the Hamburg Scientific Foundation, which was, at the time, the largest philanthropic organization of its kind in Germany.[18] Because of the inordinate costs involved in running universities, German states gradually assumed financial and administrative control. Lacking separate endowments, universities became dependent on state budgets, and the state, in turn, exercised authority over administrative and scholarly affairs. Fichte and Humboldt had at one point considered making the University of Berlin private, but were forced to abandon that idea out of financial considerations. This institutional predicament was compounded by the process of centralization undertaken in the last quarter of the nineteenth century by Friedrich Althoff, the director of the Prussian Culture Ministry. A "knowledge manager" ahead of his time, Althoff controlled the academic budget of the Prussian state through a series of politicized negotiations between professors at their respective institutions, a practice that was mimicked by other German states. By the close of the nineteenth century, German universities had entirely lost their fiscal independence.[20]

Only a wealthy commercial city could entertain the idea of a private university. In this respect, it is instructive that cities such as Leipzig, Düsseldorf, and Cologne debated the feasibility of a private university in the first decade of the twentieth century but ultimately rejected it. (Only Frankfurt succeeded in founding a private university like that of Hamburg in this time.) In most cities, the state's function as the guardian of the nation's cultural mission came to constitute a German tradition.[21] And while at its best, this system inspired a healthy competitive environment in which scholars might pit states against one another for the best offers, at its worst, scholarship was crippled by the political

battles played out in the university. According to Max Weber, the grip of the Prussian state was so stifling that it was better for a scholar to resign an opportunity in Berlin for more freedom at a small university in the provinces.[22]

By 1907 Hamburg's scholars already had an indication of how the existence of a private university could alter the balance of civic power. The private university introduced a new degree of citizens' control, and, as Lichtwark observed, "Where else could civic servants find a new style so freely and non-academically as the independent burgher uninhibited by any consideration?"[23] But even this museum director knew that this scenario of fiscal independence had its drawbacks, and he often complained that the Kunsthalle's collection was at the mercy of Hamburg's Jews, on whose private money he remained inevitably dependent.[24] Along similar lines, not everyone was pleased with the personage of Beit and his provision of the base sum for the Hamburg Scientific Foundation. The mayor suggested underplaying Beit's contribution, since it would likely be seen as an "unfortunate and shameful situation that a fundamentally affluent city like Hamburg would permit an anglicized Hamburg Jew to contribute the required funds for the fulfillment of our cultural duty."[25] Following the money might reveal unpleasant realities about the key players in the city's scant intellectual life.

Mayor von Melle had reason to be cautious. Not long after the Hamburg Scientific Foundation's inauguration, vocal opponents of the university, such as Ernst Baasch, the director of the Library of Commerce, began to question the integrity of the scholarly movement's participants. Although he did not make his claim more explicit until the height of the 1918 November Revolution, Baasch planted fears earlier that a university would threaten the city with an unsavory "foreign infiltration" (*Überfremdung*).[26] Such fears could not have been quelled by the fact that two-thirds of the money raised by the Hamburg Scientific Foundation came from Jews, including a contribution of 250,000 marks by the Warburgs themselves.[27] These Jewish donors confirmed Albert Ballin's observation about Hamburg's fledgling cultural sphere. "I see completely clearly what it is that this city needs . . . 10,000 Jews. I in no way misjudge the unpleasant characteristics of Jews and, nonetheless, must say that for Hamburg's development 10,000 more of them would be a blessing."[28] And while in the decade before the First World War, the Jews of Hamburg proved willing to take control of cultural production if the state was not equipped to, not everyone, Jews included, felt comfortable with the city's new helmsmen.

A Little Useful Knowledge

Against the backdrop of mounting fears concerning the changing nature of Hamburg's civic life, questions emerged over the justification of scholarship in a commercial city. The pro-university camp increasingly adopted practicality and acumen as key arguments in persuading the business community of the university's merits. They cited the city's preexisting institutions as proof that a university would also play an active role in public life, mentioning the examples of the Library of Commerce, the Institute of Maritime and Tropical Diseases, and the Geographical Institute, all of which facilitated research with a clear value to Hamburg's role in international trade. Drawing on the merits of these institutions, the university proponents claimed that "completely apart from the education of students, the university would have many important practical tasks to fulfill for the city life."[29]

Under these terms, museums and institutions that advanced Hamburg's international trade were easily supported, but a university whose purpose was knowledge for its own sake was harder to defend. The pragmatic von Melle sensed that Hamburgers would only agree to an institution that contributed to its maritime economy. To this end, in 1907 he began to negotiate with Prussian officials over the founding of a Colonial Institute, which would, among other goals, serve to prepare colonial personnel for their work abroad. Initiated by the head of the Colonial Office in Berlin, Bernhard Dernburg, the "Era Dernburg" aimed to establish a "scientific colonialism" and had on its agenda precisely such an institute. The only question was whether it would be located in the imperial capital or in Hamburg.[30] Von Melle saw an opportunity.

In anticipation of such an institution, the Hamburg Scientific Foundation supported the appointment of two professors: a well-known historian of Bismarck, Erich Marcks, and the national economist and Japanist Karl Rathgen, as well as a dozen other lecturers. Von Melle's bargain paid off, for Hamburg soon received a charter from Berlin. The Colonial Institute opened in early 1908 to great local and national interest and soon added more scholars to its ranks, including an Asian expert, Otto Franke, and a historic chair for African language and studies, first filled by Carl Meinhof.[31] And while the Colonial Institute, representing, as it did, the maritime-friendly fields of geography, history, and Orientalism, was a scholarly institution easily supported by Hamburg's merchants, its existence posed as many questions as it resolved.

At the height of the debate, distinct camps emerged, one composed

of those who supported the commercial-friendly institution that would build on von Melle's lecture series and the other made up of those who held out for a full-scale university. Von Melle's "real" intentions were difficult to ascertain and neither the businessmen nor the scholars seemed satisfied with the solution in the end, for upon the Colonial Institute's establishment, professor Marcks announced, in his inaugural lecture, the need to correct the "one-sided" grip that economics held on the city.[32] Marcks's speech was considered a provocation by Ernst Baasch, in particular, who soon retaliated with his own statement advocating the restoration of the mercantile spirit to its rightful place of prominence in Hamburg's history.

Baasch's rebuttal, *Der Einfluss des Handels auf das Geistesleben Hamburg* (The influence of commerce on Hamburg's cultural life), published in 1909, illustrated the intensity of debate. Rather than exaggerate the centrality of Lessing and Klopstock in Hamburg's cultural history, Baasch sought to resurrect lesser-known Hamburg scientists and pastors, individuals whose utilitarianism and pragmatic aims, embodied by the dictum "I've always said I learned more from business or shippers' discourse than I have from any big books" was closer to Hamburg's true spirit. While Warburg did not adore Marcks's patronizing, which he dubbed the "court historiography of the Hanseatic people's soul" (*Hofhistoriograph der hanseatischen Volksseele*), Baasch irked him more, especially since as the director of the Library of Commerce and now the head of the Chamber of Commerce, he purported to advocate for an "ideal Hamburg."[33]

At its best, the Colonial Institute represented a compromise between practical knowledge and knowledge for its own sake, and between business and scholarship. Pointing to its curriculum, one that addressed a real need for colonial training, the economist Karl Rathgen observed, "There is in the higher education system no real opposition between the scholarly and practical lessons because the truly practical ones are always only those which rest on the ground of a full command of scholarship. And therefore, our institution must not simply be a seminar for the training of *some useful knowledge*." The notion that scholarship needed to be "practically useful" confirmed the scholars' worst fears and guaranteed the perpetuation of the "one-sidedness of the Hamburg way," in which "Hamburg's institutions were appointed to the Higher Regional Court to serve commerce and only commerce."[34] When an attempt to appease the interests of Hamburg's mercantile class led to the creation of an advisory board made up exclusively of businessmen, the scholars recognized the depth of this struggle. The Colonial Institute

did not resolve the fight between the intellectuals and the business-men—it merely provided fuel for both sides.

The scholars who bemoaned the institute's pragmatism and the absence of "university *literarum*" found Aby Warburg to be the ideal leader for their dissent. To boost the profile of their cause, Warburg invited scholars like the Orientalist Franz Boll to deliver lectures in Hamburg to "help carry the university movement out of its rut." But in addition to these efforts, Warburg also permitted himself time for social agitation. At a committee meeting devoted to plans for the university in 1910, he attacked his fellow citizens for the pitiful state of cultural affairs and announced, "Perhaps it should be seen as an alarming indication of the consequences of the lack [of culture], that Momme Nissen, the painter from Schleswig-Holstein, a man of the finest intellectual and aesthetic conscience, could not, in this climate, find any position of cultural employment and thereafter converted to Catholicism."[35] Warburg's reference to the case of the well-known artist driven to convert to Catholicism by Hamburg's barren cultural state was not meant as a compliment. His sentiment clearly reflected the bitterness of scholars who felt that von Melle's plans had unduly abandoned their scholarly goals. Yet this provocation, and others like it, ultimately cost Warburg some amount of societal influence.

By 1911, Hamburgers were divided between those who favored the establishment of a business school (*Handelshochschule*) and those who preferred the idea of a university possessing a quality distinctive to Hamburg (*hamburgische Note*). In these debates, Warburg's condescending tone increasingly alienated his fellow citizens. Von Melle recalls one such occasion, when, in the midst of a heated argument with the opponents of the university, Aby Warburg "announced suddenly with a completely serious face: 'There is but a very important thought that has not yet been accounted for. What will happen when, following the establishment of the university, Hamburg's cultural life will become too big?'"[36] Not everyone appreciated Warburg's sarcastic humor.

Warburg's vision for the university was altogether less traditional than that of his Hamburg colleagues. Given his highly unconventional and interdisciplinary scholarship on the Renaissance, it should come as no surprise that Warburg opposed the mass education (*Studentenbearbeitung en masse*) customary of the Prussian academy at the time and instead supported learning that possessed the unabashed aim of self-cultivation (*Forschung um ihrer selbst willen*). Privately, Warburg was still focused on the development of his library, an institution he hoped would eventually conform to precisely these scholarly goals.

Yet, as long as the university movement continued, Warburg aimed to see his vision materialize within its walls. In correspondence with his former professor Lamprecht, Warburg confided his preference for a small cultural historical institution that "in principle only researches and comments," as opposed to a larger university. Lamprecht, who was in the process of expanding his Institute for Cultural and Universal History in Leipzig, urged Warburg to consider a similar possibility in Hamburg. Situated outside the Prussian academic system, Hamburg would be the ideal location for eschewing the "heretofore usual discipline of philology for a general and broader method of cultural historical research and knowledge."[37] With the emperor's announcement of the Kaiser Wilhelm Society, a 10-million-mark foundation for research, the need for a counterweight to Berlin seemed even greater. For Lamprecht, Hamburg had the potential to be the site of the new cultural history.[38]

Despite his recognition from Lamprecht, Warburg considered his ideas and contributions to be unappreciated in Hamburg and constantly complained of his struggle with Hamburg's "square bourgeoisie" (*Spießern*).[39] When the shipbuilder Edmund Siemers announced his dedication of a building to the General Lecture Series in the summer of 1911, a development that provided the university with its first institutional foundations, Warburg hoped to be "more than an audience member."[40] Indeed, the art historian saw himself as a representative of the ideals of "Research, Teaching, Self-Cultivation" (*Forschung, Lehre, Bildung*), to be engraved on the building's arch. But the event's organizers, who failed to send him an invitation to the dedication, vehemently disagreed. "It could not be more clear that one does not officially belong," Warburg announced in an angry letter to Friedrich "Fritz" Bendixen, an economist and fellow member of the Hamburg Scientific Foundation.[41] Although Warburg often felt neglected and spurned, his Hanseatic loyalty was unwavering, and when the University of Halle offered him a position one year later, he turned it down on account of "inner responsibility."[42] Encouraged by confidants like Lamprecht, Warburg decided, for the time being, to remain in the city. After all, as Lamprecht so deftly observed, at least Hamburg was not in Prussia.

Laborers and Lackeys of Germany

Although this was not the primary factor in the university's founding, local pride and anti-Berlin sentiment did lend a new motivation to the

university movement and helped crystallize the direction of the university. Increasingly disenchanted with his city's emphasis on praxis over pure scholarship, Warburg admitted to Bendixen that he felt unappreciated and mustered the biggest insult he could: the Hamburgers were behaving like Prussians. Warburg viewed Max Eduard Förster, the secretary of the Hamburg Scientific Foundation, as particularly symbolic of the problem. "Förster would be ripe for a mayorship in Plön," he taunted. As Plön was a district in Prussian-controlled Schleswig-Holstein, the position of mayor there was not a coveted position for someone from Hamburg. In case the slight wasn't clear, Warburg clarified; "Indeed I don't want to appear near the Prussians!"[43] In Warburg's view, Prussia represented precisely the excessive practical and bureaucratic expertise that the Hanseatic city ought to eschew.

Warburg's evocation of intercity competition was his most powerful argument. It addressed the other unresolved challenge that lingered over the pro-university camp: how to distinguish a Hamburg university from Germany's preexisting universities, many of them steeped in hundreds of years of tradition and long internationally recognized for their scholarship. By the turn of the century, Prussia controlled more than half of Germany's universities, and of those outside the Prussian system, only three were of any great scientific importance: Heidelberg, Leipzig, and Munich.[44] Because it was still unclear what Hamburg's university might contribute to this rich institutional landscape, the city's businessmen remained reluctant to bankroll such an effort. This conundrum mirrored one faced by Lichtwark a decade earlier in his work at the Kunsthalle, the challenge of creating a museum that was more than a replica of the already well-established national museum.

Carl Heinrich Becker, the Colonial Institute's professor of Semitic philology, echoed Warburg's rhetoric when he argued that Hamburg might provide the source of an important new direction in German scholarship. "No university in Germany possesses the potential to create itself anew as brightly as does the tradition-less Hamburg. . . . It seems to me that the task of the university is the most important, to create a new academic family in the sense of the Hamburg ideal." While the opinion of Becker, a prestigious scholar from outside Hamburg, was not unimportant, not everyone in Hamburg agreed. One member of the Chamber of Commerce argued that "even from the perspective of a unique Hamburg," a university in the city would be redundant in comparison to other German universities.[45]

Yet Hamburg's strong identity as a Hanseatic city in competition

with Berlin ultimately swayed the reluctant businessmen. Urban pride prevailed as it had in the late 1880s, when protest against Bismarck's antisocialist laws emerged, less out of a strong alliance with the socialist movement than as a result of anti-Prussian sentiment.[46] By deriding Hamburg's attempts to free itself from Prussian influence, Berliners only further stimulated this urban tradition. In response to reports in the Berlin press that parodied Hamburg's university debate, one Hamburger insisted, "What does the council in Berlin know about the beliefs of Hanseatic businessman?" And that the Kaiser opposed a university in Hamburg on the grounds that the city should retain its emphasis on practical training, which, he admitted, "was one-sided and not very deep," was a further boon to those in favor of the university project.[47]

To appease his colleagues in the business world, Max Warburg reminded them that scholarship and praxis need not be exclusive and that Hamburg would both benefit from the discussion of scholarly issues and derive financial value from the university: "If Hamburg does not want to regress and always be considered a provincial place, it would make a very good setting for a university. [This] would not only enliven the place itself but would also produce scholarly people who are accustomed to practical business life, at least in certain contexts, and would not represent the fossilized opinions of politicians, as now unfortunately so often occurs." Professor and director of the Museum of Ethnology Georg Thilenius agreed. If the people of Hamburg did not want to become the "laborers and lackeys" (*Kärrner und Handlanger*) of German culture, they ought to develop their own ideas as well.[48]

The recently founded Colonial Institute became a familiar reference point in these debates. Some, like Max Warburg, believed that the Colonial Institute presented the opportunity to fulfill Hamburg's intellectual and cultural potential. Von Melle assured his city's residents that the World Economics Research Archive, which was connected to the Colonial Institute, was the envy of many Germans, including even those in Berlin. Von Melle reported, "For the last several years of my conversations with leading members of Berlin society, I have often heard the characteristic remark, 'The Institute has only one drawback. Namely, that it is not in Berlin.'"[49] But others believed that the institute only contributed to Hamburg's subordinate status and warned their fellow citizens that Berliners aimed to capitalize on the success of the Colonial Institute to create a new university at Hamburg's expense. After all, many believed that Berlin had only supported Hamburg's bid for the Colonial Institute because Hamburg was willing to foot the bill.[50]

That the Hamburgers might forever remain the exchequers of the German Empire was doubtless on the minds of many when a detailed proposal for a full university finally came to the senate floor in 1912. To appease the business interests, the program emphasized not "university *literarum*" but the importance of educational programming for "non academic professions, [and] especially businessmen." In fact, the bill authored by von Melle arguably amounted to no more than a "stump-university" (*Rumpfuniversität*) with its intended organization around law, philosophy, natural sciences, and colonial scholarship to the ex-clusion of theology and medicine.[51] Despite this stipulation, the Senate rejected the proposal in the fall of 1913 by a close vote of 80 to 73; in the Senate's reasoning, the image of Hamburg as a mercantile city pre-vailed.[52] Moreover, the Hamburg Scientific Foundation had managed to raise more than 4 million marks, a large sum but still far from the 200 million needed to establish an independent university.[53]

With no university in sight, many of the institute's scholars and professors began to abandon the project. Marcks took a position in Mu-nich; Becker took one in Bonn.[54] In an ironic fulfillment of Warburg's joke about the painter Momme Nissen, Becker left Hamburg and would later hold the position of Prussian Culture Minister. Despite his com-plicated relationship to his colleagues, Aby Warburg was one of the few scholars who remained in Hamburg, a fact that showed both his loyalty to the city and his unwavering faith in the university movement. The summer before, he had participated in the *Kulturwissenschaft* section of the summer school offered by the Colonial Institute. Out of gratitude for this expression of local patriotism, the Hamburg Senate conferred upon Warburg the title of Honorary Professor at the still-nonexistent university.[55]

Dual Birth

The efforts of Hamburg's scholars might have been eternally neglected if not for the outbreak of the First World War, an event that happened to provide both the practical necessity and the intellectual identity re-quired to bring the university project to fruition. That Hamburg re-mained outside the grip of the Prussian system and already possessed a vast institutional scholarly infrastructure created distinct conditions for the possibility for any future intellectual life. But because of the war, the port city became home to Germany's premier international university.

In August 1914, Hamburg's citizens, like many other Germans, turned their attention to international issues. In October, Warburg met with the Hamburg-born Prince Bernhard von Bülow, who was serving as Germany's ambassador to Italy, and offered his services as a mediator between the Germans and the Italians. Warburg succeeded in facilitating the reopening of the German Institute in Florence and presided over its first session in February 1915, but when Italy signed the Treaty of London on April 26, Warburg cut all ties with his beloved Italy.[56]

While the war cut off Warburg's spiritual connection to Italy, it presented a practical catalyst for the university's fulfillment. Following the defeat of Germany, it lost control of the city of Strasbourg, ceded to France, and, with Strasbourg, lost a major university. Students and professors were forced to seek a new institutional home, and returning soldiers required educational and professional training. The university advocates capitalized on these postwar conditions, aiming to provide a new home for Strasbourg's students and young professors. Feeding on the nationalist propaganda typical of this postwar moment, one local Hamburg historian argued: "Just as one day the founding of the University of Strasbourg will be greeted by all of Germany as the best prize won from the war against France in a new Empire, so will the opening of the University of Hamburg be a victorious and a peaceful celebration at the end of our population's immense struggle for life and freedom."[57] In a gesture that capitalized in equal measures on nationalism and local pride, in January of 1919 the Hamburg Senate approved the institution of classes for the returning soldiers on a provisional basis.

In addition to the practical demands it necessitated, the war also created a new intellectual motivation for the university's creation. Germany's military defeat revealed a lack of knowledge about foreign countries and suggested that any future Germany would have to address this weakness. Over the course of its history, Hamburg had hosted several internationally driven intellectual movements, including the study of Orientalism initiated by the expulsion of the Spanish and Portuguese Jews in the fifteenth century; the humanistic outlook of the Calvinists and Mennonites driven from the Netherlands in the sixteenth century; and the cosmopolitanism associated with Gotthold Ephraim Lessing's Enlightenment ideas.[58]

As Hamburg had seemed the logical home for the Colonial Institute, it was also natural to many that Hamburg should assume the responsibility for the new international challenge presented by the end of the First World War. In 1917, however, to the disappointment of many of

Hamburg's citizens, the Prussian Culture Ministry decided that individual Prussian universities should take up the initiative to found a foreign institution. Questioning Hamburg's dominant position on the international scene, one member of the Hamburg Senate wrote an article titled "Is Hamburg Always Ahead?" By recommending an increase in the study of foreign countries, the author anticipated the answer. Hamburg would resume its rightful role as an international connection within the new, postwar Germany.[59]

Although Warburg nurtured the vision for the university, it was in truth the First World War that presented the resolution to the protracted debates between scholars and merchants over the function of knowledge in the city. University supporters justified themselves in terms of the new economic and geopolitical needs of the city and argued that they were best positioned to meet the country's challenges. The new university turned its attention to foreign subjects and languages, fourteen of which could be studied in Hamburg.[60] Even Schumacher's architectural plans for the university, which featured extensive housing for foreign students, contributed to the goal of making Hamburg *the* German international university. In a special pamphlet devoted to the "University Question" and published in 1918, the psychologist Wilhelm Weygandt connected the university's founding to the reconstruction of postwar Germany, arguing that Hamburg would be "an overseas and foreign-oriented university."[61] The longtime dream of Hamburg's scholars was finally becoming a reality.

Hamburg would not relinquish its throne as the cosmopolitan mercantile city; rather, it used this new identity to distinguish its institution from Germany's older universities. "The natural advertising strength that Hamburg possesses in its geographical location as 'Gateway to the World,' its port, its global traffic, its buildings, and its cultural institutions," one university official observed, "must be even more valued than before in order to make up for the decade-long tradition of a university as in Berlin or Heidelberg."[62] The war demanded a new intellectual program, and, literally and physically positioned at an international crossroads, Hamburg stood ready to offer one.

Like its chief adversary, the University of Berlin, the University of Hamburg was founded in the wake of political defeat. And both universities were initially cosmopolitan, fending off the onset of nationalist movements. Shortly after the founding of the University of Hamburg, the newly appointed rector, the economist Rathgen, wrote to the

University of Berlin's rector to initiate a relationship between the two universities: "May I express hope that the youngest sister in the circle of universities be received in a friendly way and especially find sympathy from the University of Berlin, which likewise was founded in times of greatest distress of the fatherland." In his inaugural address, Rector Rathgen even cited Frederick William III's famous words on Berlin, when he claimed that Hamburg, too, would continue "spiritually what Germany had lost materially."[63]

What Hamburg's citizens did not know was that they would soon lose even more. Three months after the university opened, the German delegates signed the Treaty of Versailles, enumerating, among other stipulations, the loss of Germany's colonies. That the university idea had already materialized before these developments reflected the city's decades-long path to create intellectual life discussed above, rather than any immediate reaction to this economic setback.[64] Nonetheless, the irony is that Hamburg's source of capital ultimately enabled it to address this cultural task better than Berlin could have and to emerge as a leader for this new time. The only question was whether the road taken would result in cosmopolitanism or nationalism.

When von Melle rose to speak at the opening ceremony of the University of Hamburg on May 10, 1919, it was clear he represented the internationalist "dreamland of the armistice." At that event, the new rector made the claim "that [the] university, founded in twentieth-century Germany's primary place of international and maritime trade," possessed particular qualities that heralded the city as representative of the new Germany. Asserting "that unrestricted academic and teaching freedom shall combine with the push for the fruitful development of the new," he attempted to calm the fears of those Hamburgers who still bemoaned the absence of a long-standing intellectual urban tradition and suggested that it could signal a new direction not only in Hamburg but also in Germany.[65] In the Weimar Republic, proud Hamburgers like von Melle believed—hoped—that Prussia would follow Hamburg's lead.

In direct opposition to this impulse, however, Berlin's rector Reinhold Seeberg's 1919 address militantly invoked the nationalist phrase "*Invictis victi victuri*" (to those who were never defeated), a dictum later carved onto the university's war memorial.[66] As Hamburg aimed to revive the international spirit of Hamburg's prewar summer school, Berlin's academics entrenched themselves more deeply in nationalist politics.

Birth Pangs

As the First World War came to an end, Hamburg found its true purpose in the eyes of Germany and the world. But the war had taken a toll on Hamburg, and the Weimar Republic's challenges were mirrored in both the university and the city. On November 9, 1918, Warburg's friend and fellow Hamburger Albert Ballin committed suicide. Despite his economic success, Ballin viewed with insurmountable despair his inability to affect the new political order. Whether owing to Anglophobia or anti-Semitism, Ballin found himself on the outside.[67] Ballin's death notwithstanding, 1918 was not only a caesura that signaled an end to a cosmopolitan worldview and Jewish advancement. As Max Warburg and von Melle observed, the end of the war and the socialist revolution were auspicious for the development of Hamburg's university. While Aby Warburg largely receded as a result of mental breakdown and took his more radical ideas of scholarship with him, his vision of an intellectual Hamburg certainly prevailed in the interwar years. Indeed, the belated founding of the university in Hamburg illustrates the contradictory nature of this historical juncture.

As early as July 1917, when the German Parliament passed a Peace Resolution, it was clear to many that imperial Germany would not survive the war. Nevertheless, stalwart supporters of the empire, like Warburg, believed that the war was worth winning at any cost.[68] He eagerly watched the Russian Revolution unfold and wondered what these events would mean for Germany and for Europe.[69] For Warburg, there was more at stake than mere abstract democratic principles. Rumors abounded in Hamburg linking his brother Max to the financing of the Russian Revolution.[70] The Jewish community of Hamburg fought tirelessly to clear their "Kaiser Warburg" from this slanderous connection.[71] The Warburg name was at stake, as was the community's regeneration of German patriotism and local pride.

The loss of his two homes in Germany and Italy, the threat to his family's reputation, and the end of the empire was too much for the sickly Aby Warburg to bear. Debilitated, emotionally distraught, and suffering from paranoiac delusions, he was broken by the war and in November 1918 committed himself to a local hospital. In 1920, with no sign of recovery, Max and Mary Warburg moved Aby to the psychologist Hans Berger's private psychiatric clinic in Jena, and finally, in 1921, to Ludwig Binswanger's sanitarium in Kreuzlingen, Switzerland, where he remained for four years. In Kreuzlingen, Binswanger treated Warburg for what he and other doctors variously diagnosed as schizophrenia

and manic depression. For those four years in Kreuzlingen, Warburg's mental health fluctuated. At his best, he visited the Binswangers for tea in their home, received guests of his own, and pursued his scholarly research. At his worst, he wielded conspiracy theories, became violently restless, and threatened nurses. Throughout these years, which Warburg referred to as his "vacation from the world," he maintained an active interest in Hamburg's affairs, as evidenced by his correspondence and visits from this period.[72]

Nevertheless, Warburg's breakdown illustrates the end of a certain aspect of his dreams for the future. Many of Warburg's cohabitants at Kreuzlingen shared his intellectual and psychosomatic afflictions, symptoms seemingly inseparable from this wider historical context. An account of Kreuzlingen's patients during that era reads like a repository of European modernism, a list that included the painter Ernst Ludwig Kirchner, the dancer Vaslav Nijinski, the poet Leonhard Frank, and the feminist "Anna O."—an all-around cast of upper-class misfit characters whose makeshift society on Lake Constance the author Joseph Roth memorialized in his novel *The Radetzky March*. For these poets, writers, and artists, the trauma of war, disappointment in a failed radical revolution, or disillusionment with nationalism precipitated hysteria on a personal level. Just as art and life blended among these new avant-garde intellectuals, so too was personal illness an internalized form of the current political unrest. As Max Warburg said of his brother's condition, "He had the knack of experiencing the times in a direct and physical way and himself saw the danger terribly clearly. . . . 'I have a prophetic stomach' [he said]."[73] Rather than an isolated case of personal hysteria, Warburg's breakdown represented a reaction to the First World War common to many of his generation.

The spirit of Hamburg was similarly distressed.[74] Because of its prime position on the port and supply lines, the city enjoyed one of the most enviable situations in wartime Germany. Yet Hamburg's citizens were increasingly discontent with the local situation, and in August 1916, protesting the distribution of food, dockworkers plundered stores and caused unrest significant enough to require the intervention of army units. The authorities managed to maintain temporary order, but in November 1918, as defeat loomed, city-dwellers again became agitated. On November 5, 1918, a revolt at a naval base in Kiel, two hours north of Hamburg, incited the city's workers and sailors, as they occupied the Trade Union Hall with chants of "Long Live the Workers' Socialist Republic" and skirmished with local policemen. The demonstrations evolved, and in a forty-eight-hour siege, the workers captured the city.

For the following month, the Workers' and Soldiers' Council, which the workers established, operated as its own parallel government outside the Hamburg Senate.[75] As part of the widespread November Revolution, the riots in Hamburg and Kiel harked back to the revolutionary moment of 1848; the home of some of the worst protests seen in Germany, Hamburg earned its reputation as a hotbed of revolutionary unrest.

Yet, as happened elsewhere in Germany, compromises quickly crippled the revolution's radical phase, and in Hamburg the usual suspects and forces were at play. Negotiations ensued over the course of November between the Workers' and Soldiers' Council and the Senate. The leader of the left wing of the Independent Social Democratic Party of Germany and the chairman-elect of the council government, Heinrich Laufenberg, proposed that the Senate be dissolved. Laufenberg then met with Max Warburg, who tried to convince him that his coalition needed the support of the business interests. That the banker had already secured loans from banks in Frankfurt, Berlin, and New York was a major asset to Laufenberg's economically unstable coalition. As a result of negotiations between Warburg and Laufenberg, the Workers' and Soldiers' Council decided on November 18, 1918, both to reinstate the Senate on a temporary basis and to create an Economic Advisory Council to handle Hamburg's financial matters.[76] This proclamation marked the end of the radical phase of the revolution and reinforced the power of economic leaders, such as Max Warburg, to restore the balance of power to the city's mercantile community.

Despite these compromises, the power won by the Social Democrats was equally fateful for the university. As we have seen, a Hamburg university, if founded, would not answer to a remote state (Prussia or otherwise) but reflect the local politics of the city-state. Historically, that makeup had not been favorable to the university idea. The Social Democrats, outsiders in the bourgeois mercantile city, passed a resolution in 1913 against the university's founding because of the proposal's exclusion of teachers from the *Volkshochschule*, a populist institution of continuing education that focused on adult education.[77] Following the failed revolution, however, the Social Democrats were willing to consider a strategic alliance with the intellectuals—the only other faction similarly alienated by the merchants. In exchange for support of the *Volkshochschule*, this new crop of leaders on the democratically elected Parliament agreed to back the university project. Hamburg's class-based electoral political system had previously excluded these Social Democrats from participating in decision making. Now following this

new alliance and the success of a provisional first semester, on May 28, 1919, the University of Hamburg officially opened its doors.[78]

Like the new Weimar Republic, however, the university was assailed at the outset by both the Left and the Right. In its final incarnation, it resembled a reform university and embodied many elements of the revolutionary political spirit.[79] Most important, the university, like the new constitution, included women, a new group of students whom von Melle addressed specially in his opening address. The number of women at the University of Hamburg rapidly rose from 14 to 25 percent of the student body between 1919 and 1932. And given those negotiations with the Social Democrats, the number of workers' children who attended the university was even more impressive—at nearly 7 percent of the student body in the 1930–31 winter semester, it was twice as high as the national average.[80] For some, however, it was not reform-minded enough, and the new rector launched a small public campaign to quell dissent in the newly prominent worker's movement.[81]

Equally vocal from the other camp was Ernst Baasch, who had once warned his compatriots of the "foreign" threat that a university posed. Now unenthusiastic about the city's new demographics, Baasch soon abandoned the city for a position in Freiburg. In the second volume of his history of Hamburg, published five years later, Baasch conflated the scholarly threat with a political one and claimed that the Jews and the Social Democrats embodied a hostile influence whose takeover of Hamburg was akin to that of the Napoleonic occupation.[82]

In reality, the university embodied the dual identity of the city itself: it was both "bourgeois friendly" and reform minded.[83] According to one of Hamburg's Jewish lawyers, the university symbolized the utilitarian spirit of meritocracy. "In Hamburg's best and most successful years it was oriented . . . according to the quality of humans. Hamburg became better not to a small degree because each and every able individual was given the opportunity to use his power for the general utility."[84] And while not all were as contentions as Baasch, the alliances proved as precarious at the university as they did in politics. As one Hamburg-born historian observed, "The professors did not have an amicable arrangement with either Social Democracy or with commerce."[85] In the political realm, fragmentation had quickly become the norm, and when the university began its spring semester, the Weimar government had already created the second of what soon amounted to its twenty-one different incarnations. The possibility lingered that Hamburg would find itself similarly mired in political and intellectual conflict.

Amid the rhetoric of both sides, it can be easy to exaggerate the revolutionary quality of the university, which in its final composition remained fairly traditional—a fact that Aby Warburg found deeply dissatisfying. Four separate departments—Math and Natural Sciences, Medicine, Philosophy, and Law and Political Science—were founded, using the city's previously existing institutions as the base whenever possible. It was only in its lack of a theology department that the university was somewhat unconventional. As early as 1918, Warburg worried that the energy of the public lecture series would be lost in this new development and remained skeptical that the pro-university camp had the right question in mind—that is, "Is it possible to devise a type of higher education based on a new kind of balance between teaching and research, between the layperson's right to inquire?"[86] Just out of the gate, the university seemed to be falling into the same irreconcilable Humboldtian model of research and teaching that governed in Berlin.

The spiritually broken Warburg did not have the opportunity to register his complaint, and when the university held its inauguration, his seat again remained empty, as it had in 1911. One Hamburger assured Warburg that he should take some consolation in the fact that the "Warburg circle and *Conventiculi* had played a large role in the founding of the university." That the university awarded him a second honorary degree in 1922 confirmed this sentiment of gratitude.[87] Although he was rightly acknowledged this time, however, Warburg's absence signaled a changing of the guard.

Warburg's insistence on a cultural and intellectual world that emerged from the realities of economic life and, above all, his desire for Hamburg's independence from Prussia remained essential characteristics of the young university. Although he was critical to its priorities and materialization, however, Warburg's imprint was most visible not on the university, but on his own library, to which he transferred his energy in the next decade and which took up the mantle of his unique brand of interdisciplinary scholarship. In the meantime, the Warburg family continued to believe that Hamburg's greatest strength lay in its independence from "the old court of Berlin." Writing to his brother Paul, Max Warburg observed that, "independent from the influence of the center, [the university] could create a place for free thought and scholarship."[88] Which scholars would be promoted and what ideas would materialize would become clearer with the university's first major appointment, offered to the philosopher Ernst Cassirer.

Warburg, Cassirer, and the Conditions of Reason

He who would study organic existence,
First drives out the soul with rigid persistence;
Then the parts in his hand he may hold and class,
But the spiritual link is lost, alas!

GOETHE, *FAUST*

Symbol tut wohl.
Symbols do one good.

ABY WARBURG

The First World War revealed what was at stake in the campaign for Hamburg's university. In the daze of nationalist frenzy that followed the war's outbreak in August 1914, Warburg expressed concern to a colleague about Germany's current cultural climate. "Like you, I hope our Germany sees a revitalization of the categorical imperative after the war," Warburg wrote, referring to Kant's concept of universal moral law, "and a return from [Julius] Langbehn and [Houston Stewart] Chamberlain to [the works of] Kant and Fichte." Warburg's fear was warranted: racist tracts such as those of Langbehn and Chamberlain gained momentum during the war and promoted a new wave of *völkisch* pan-Germanism that was threatening to make the eighteenth-century Enlightenment a distant memory.[1] The neo-Kantian Ernst Cassirer would not only fulfill Warburg's vision for Hamburg as a city of serious scholar-

ship, but also—Warburg hoped—might put postwar Germany back on a humanist course.

Warburg was not alone in entertaining high hopes for Hamburg's newly founded university. The art historian Fritz Saxl, who joined his cause in 1913, believed that the university would "form an intellectual center for the Hansa city." Like Warburg, Saxl considered "of particular importance . . . the chair of philosophy, for which Cassirer had been chosen."[2] More than any other, Cassirer's career and scholarship was central to realizing the city's academic ambitions. Nurtured by his wife Toni Cassirer and their veritable domestic salon, and energized by a new web of relationships that soon included Panofsky, the philosopher enjoyed his most prolific period in Hamburg. The war caused Cassirer to reevaluate his philosophical approach, and the young university offered the philosopher the opportunity to carry out this program. In short, the city and the professor developed a mutually beneficial relationship.

Cassirer's arrival was also deeply personal for Warburg, for the philosopher's scholarship validated Warburg's growing private library. Guided by Saxl through its contents during Warburg's absence in Switzerland, Cassirer found that the library of "civilization" provided an indispensable foundation for his new critique of culture. Cassirer's scientific use of the library signaled a unique intellectual partnership between the two men, one that carried Warburg out of his postwar depression. In this setting, the pair pursued parallel—and at times conflicting—lines of inquiry about the conditions of reason, asking, among other questions, what tools human beings use to make sense of the world, whether this process began in the prediscursive moments of myth and language, and whether reason represented the most mature form of this process or simply an alternative mode of human understanding. Although Cassirer expanded Kant's critical philosophical lens to include other symbolic forms, and Warburg, in contrast, struggled to make logical sense of irrationality, the two balanced what was lost and gained in the transition between reason and myth, a tension that had a deep impact on the life and works of each man.

Hermann Cohen's protégé and the revival of Kant

Warburg's and Cassirer's lives collided in the summer of 1919. Broken by the war, Warburg was slowly recovering at one of the several sanitariums where he had spent the early part of the decade. As he operated

in absentia, Warburg's spirit was nonetheless present at the University of Hamburg's opening. That this new institution offered the forty-five-year-old nationally renowned scholar and unconverted Jew Cassirer his first professorship embodied the era's open-minded spirit. One member of Hamburg's Jewish community observed that the city had finally made good on its reputation for "intellectual freedom," a claim also made by the other "Weimar-era" university in Frankfurt. Many of Hamburg's alumni later noted the correlation between the democratic Weimar revolution and the sentiment behind Cassirer's appointment as chair of the new philosophy department.[3]

Although his life and work became symbolic of the postwar revolution, Cassirer's temperament and physical demeanor were anything but revolutionary, and the jubilant public memory of this moment belies the understated yet persistent way that the philosopher negotiated the long and vexed path for Jews in German academia. A half generation younger than his colleague Warburg, Cassirer was the fourth son in a family of successful German-Jewish businessmen in Breslau, the Silesian capital known for its high degree of "mutual acceptance" between Jews and non-Jews.[4] Between 1905 and 1915, Cassirer attended the city's Johanneum, a new elite school characterized by its "boundless tolerance" and—rarer still—its universal humanist education. As a young man with a shock of prematurely white hair, Cassirer more closely resembled the stereotypical judge than he did a professor, an impression only strengthened by his reputation for a "keen sense of fair play and justice." Saxl, too, later evoked this juridical aura in his characterization of the philosopher as "Olympian and aloof."[5] But despite these qualities, Cassirer did not last long in the field of law, the natural choice of study for many German Jews of his class and for which he moved to Berlin in 1892 at age eighteen.

The young student, who possessed "deep sympathy for everything good in the world," felt that the law lacked "a certain degree of depth in understanding."[6] Cassirer quickly realized that his interests lay in the more fundamental problems concerning humanity, an intellectual path he pursued by attending the lectures of the scholar Georg Simmel. Although Simmel was later celebrated as the founding father of sociology, at the time he was recognized for his originality and interdisciplinarity, as evidenced by his innovative doctoral thesis on the origins of music and his later work on the philosophy of money.[7] Influenced by strands of thought in neo-Kantianism and evolutionary biology, Simmel pursued a line of questioning about the source, legitimation, and processes of knowledge that impressed the young Cassirer, as it

did many of his contemporaries. In one of his characteristically wide-ranging lectures, Simmel observed that the foundational thinker for his epistemological inquiry was Kant, and he added that "the best books" on Kant were "written by Hermann Cohen."[8] Not long after that fateful allusion, Cassirer abandoned the study of law and moved to Marburg to study philosophy with Cohen himself, a renowned German-Jewish neo-Kantian. This change of direction proved transformative.

Cohen's influence on both German idealist philosophy and German Jewry in particular is undeniable. By the last quarter of the nineteenth century, Cohen had become a leading proponent of the Marburg School of neo-Kantianism. A methodological approach based on an epistemological reading of Kant, neo-Kantianism reopened central debates in Kantian and post-Kantian philosophy. Kant had earned his place in the canon of modern European thought for his so-called Copernican Revolution. Just as Copernicus inverted our view of the solar system to place the sun at the center, Kant upset our knowledge of the world when he argued that the mind does not conform to objects; instead, objects conform to the mind. In his *First Critique*, Kant presented this solution to explain how so-called synthetic a priori judgments are possible—that is, how what we perceive is both knowable and objective—for as Kant observed, "this object is no more than something, the concept of which expresses such a necessity of synthesis."[9] By incorporating both subject and object in a lawful and coherent system, Kant claimed to have bridged the great divide between empiricist and idealist philosophy.

Yet the cost of materialism—that is, interacting in the world without David Hume's damaging skepticism—was embracing transcendental idealism, or, as Arthur Schopenhauer later observed, "we do not know either ourselves or things as they are in themselves, but merely as they appear."[10] These shortcomings meant that readers were left with no guarantee that the world as it appeared to them (*phenomena*) was, in fact, the world as it was in God's eyes (*noumena*), nor that the rational faculties that Kant claimed existed in our minds to make sense of the world (space and time) were really equipped to do so. Cassirer later argued that the defect in Kant's *First Critique* was that things as they are in themselves "continued to labor under obscurity which was to prove fateful for its reception and its historical development."[11]

Indeed, not everyone was pleased with Kant's solution, and in his own day, Kant was maligned as the "Prussian Hume" whose philosophy was charged with having no real foundation and risked falling into solipsism.[12] Dissatisfied by the limitations that Kant imposed as to what

human beings can know and what questions are appropriate for us to ask, a new generation of philosophers, beginning with Fichte, set out to find alternatives to Kant's transcendental idealism and, specifically, to determine a way around the distinction Kant had made between sensible intuition (what humans can know) and intellectual intuition (what only God can know).[13] Hegel's observation that Kantian transcendental idealism "degrades spirit to the modest state of cattle" reflects this frustration with the reduction of philosophy's purpose.[14] The long period of absolute idealism that followed tried to regain the speculation that Kant had purged from the field; the result was ever-grander systemizations of metaphysics.

The scholars who became Cassirer's mentors slowly tired of such system-building and, following numerous "heterogeneous currents," eventually consolidated into a new movement whose purpose was to do nothing other than "go back to Kant."[15] As the architect of that phrase, the philosopher Otto Liebmann excoriated Fichte and Hegel as "speculative dogmatists" in his 1886 work *Kant und die Epigonen* (Kant and the Epigones) and gave cause to what was already a burgeoning desire to eschew the search for the thing-in-itself in its entirety and to return to Kant's transcendental approach.[16] Crucially, as in all revival movements, neo-Kantians were not Kantians.[17] Neo-Kantians largely overlooked the detailed account of the nature of thinking that Kant provided in the *First Critique* and instead gravitated to Kant's larger vision of philosophy's task as transcendental criticism. As Cassirer described Cohen, his aim was to "philosophize in the spirit of Kant."[18] Moreover, as Cassirer also later did, Cohen collapsed Kant's distinction between sensible intuition and understanding that was crucial for the transcendental method, even as he focused primarily on Kant's inquiry into the preconditions of our knowledge. New developments in mathematics and mathematical sciences set the stage for Kant's second act, and Cohen accordingly expanded Kant's pursuit of the universal a priori conditions of knowledge to include the empirical sciences at large.[19]

In reality, "going back to Kant," meant "going beyond Kant" for many of these Kant enthusiasts; it did not so much solve philosophical quandaries as reopen the previous century's questions about the proper role of philosophy. As the philosopher Wilhelm Windelband observed, "All we nineteenth-century philosophers are Kantians."[20] Yet the movement was so pervasive that it seemed to include everything from Edmund Husserl's transcendental turn to Weber's concern for historicism and value neutrality.[21] Within this new interest in Kant, two main schools of thought crystallized: the Marburg School and the

Southwest School in Baden. The former emphasized the notion that the root of all thinking lay in the mathematical sciences; Heinrich Rickert, the "systematizer" of the Baden School, in contrast, interpreted Kant's transcendental method as license to extrapolate human values from the world. Or, as one scholar has put it, "Whereas Cohen and Natorp emphasize logic and epistemology, the words that are most prevalent in Rickert are 'ontology' and 'values.' Whereas Cohen tried to show that morality and religion must ultimately be reduced to logic, Rickert argued that values lay at the very basis of even theoretical thinking."[22] To be fair, the Marburgers were just as guilty as the Southwesterners of imposing their own preconceptions on these Kant constructions.[23] Yet, in contrast to the Baden School, which sought to anoint philosophy as the source of all human values, the Marburg School always insisted that philosophy should never stray from its sole purpose as guardian of the proper inquiry into truth, a distinction that critically (and intentionally) limited the purpose of philosophy and thus insulated them from the more nationally and racially laden debates about values.

Cohen was certainly the beneficiary of historical developments that were favorable to the emergence of neo-Kantianism: the liberalization of church-state relations in the early years of the Second Reich, the increase in university positions during this period, and the willingness of the liberal minister of education Adalbert Falk to grant positions to this new breed of scholars.[24] That Cohen was the only German professor of Jewish origin to attain the rank of *Ordinarius* in a humanistic field before the war no doubt also stemmed from these new limitations he imposed on philosophy. These restrictions made philosophy as indisputable as the sciences and, crucially, opened the field to Jews who may otherwise not have been trusted with metaphysical questions concerning values and Being. With philosophy now defined as the critical task of ensuring the legitimacy of the sciences, Cohen transformed Marburg, a small Hessian university town, into a crucial step in becoming a rigorous thinker. "Going to Marburg," as the philosopher Hans-Georg Gadamer later recalled, had come to constitute a philosophical rite of passage.[25]

Cassirer adopted several key ideas characteristic of the Marburg School, including a realization that knowledge is not a given fact but rather a task to undertake, the commitment to philosophical inquiry as an analysis of the conditions of knowledge and existence, and the centrality of the sciences as a model and starting point for philosophical inquiry.[26] In this respect, the philosopher René Descartes, who began with the "clear and distinct ideas" of geometry and from there established the foundational principles of existence, was a logical topic

for a neo-Kantian dissertation.[27] Cassirer understood his analysis of Descartes's mathematical and natural scientific knowledge as representative of the seventeenth-century impulse to reduce the universe to clockwork. "Give me matter and I will build you a world," the French philosopher was known to say. Descartes remained a figure in Cassirer's portrait of European culture as the history of critical philosophy until the end of his career.[28]

From 1885 to 1912, Paul Natorp held the Marburg chair in philosophy conjointly with Cohen, yet it was Cohen who weighed heavily on Cassirer's Marburg years. An awe-inspiring figure in the German university system, Cohen is described by his students more often as prophet than as professor.[29] It is of no small significance, therefore, that the illustrious Cohen was taken with Cassirer. "I felt at once," he recalled, "that this man had nothing to learn from me."[30] And although Cassirer later challenged Cohen to expand his critical-transcendental method to probe other kinds of human experience, he remained faithful to his mentor throughout his long career. Cassirer's loyalty is all the more remarkable because his association with the Jewish Cohen marked him as unemployable. The conditions that proved beneficial for his mentor drastically changed by the time Cassirer was looking for a job.

When the historian Heinrich von Treitschke claimed in 1879, "The Jews are our misfortune," it was clear that the short-lived liberal moment had expired, and the devastating pronouncement prompted Cohen's "turn" to Jewish issues.[31] In his essay, "Declaration on the Jewish Question," published shortly thereafter, Cohen was moved to explicitly align the philosophical and the political. "We younger men had the right to hope we would gradually succeed in entering into the 'nation of Kant' . . . that in time it would become possible unconstrainedly to acknowledge within us our love of our fatherland and to feel a conscious pride in being allowed to work as equals to the tasks of the nation."[32] Cohen's face-off with Treitschke was not the last of its sort, and in fact he devoted much of his remaining career to arguing for a synthesis of Judaism and German philosophy, a pursuit that earned him the great distrust of Germans and Jews alike.[33]

In this increasingly hostile climate, the political aspect of Kant's work became equally important for the neo-Kantian position of the Marburg School, and under Cohen's tutelage, cosmopolitanism, social justice, universal humanism, and perpetual peace emerged as key elements of the philosophical movement. In this respect, too, Kant was particularly attractive to German Jews, for, as the German philosopher Jürgen Habermas later observed, "he unfolded the free attitude of criti-

cism based on a rational belief and of cosmopolitan humanity into its most clairvoyant and authentic shape." Indeed, Cohen's brand of neo-Kantianism lends meaning to the German historian George Mosse's claim that neo-Kantianism in this time constituted part of a search for a "Third Force" in German life, an alternative to both capitalism and Marxism and an "idealistic commitment that stood above and beyond present reality," to recapture the belief that history is progressing toward an ideal goal.[34] When Cohen's former student Kurt Eisner led the Bavarian Revolution in 1918, he sealed the relationship between neo-Kantianism and democratic politics.[35]

Treitschke's attack on Cohen only vindicated Cohen's reluctance to expand philosophy's purpose into the realm of values as Rickert proposed, for that would have disrupted the delicate balance that permitted their entry as German Jews into the "nation of Kant." When anti-Semites later highlighted the connection between Jews and neo-Kantianism, they were not altogether incorrect. What they missed was that, far from being naive optimists, the Marburgers exhibited an extreme caution about what philosophy can and should do, and it was the paradox of those limitations that the second generation of scholars like Cassirer exposed.

For, Treitschke's slander of Judaism notwithstanding, there was no question that Cohen's interpretation of Kant led him far astray from Kant's original intentions.[36] If he began with the epistemological question of certainty, Cohen went further than Kant to argue that thought not only determines how we experience the world but also produces its own reality, a line of reasoning that Cohen admittedly traced back to Plato, whom he described as the "early ancestor of the intellectual intuition of transcendental idealism."[37] The Marburg philosophers claimed that they discovered a middle ground between subscribing to an idealist's Platonic world of forms, on the one hand, and the mere cataloging of mental structures, on the other. In fact, Cohen's version of Kant actually inched even closer to the absolute idealism that he originally opposed. And despite his initial insistence on the limitations of knowledge, Cohen, by "accommodating Plato," awarded a much higher status—a divine one, even—to our thought processes than he initially let on.[38] In this way, German academics were right to feel duped by Cohen, whose aim for philosophy was loftier than he pretended.

Cassirer's mentor's philosophical and political profile was as problematic as it was awe-inspiring, and it presented challenges—both philosophical and political—for the young scholar down the line. One thing is for sure: rather than becoming embroiled in political squabbles,

Cassirer devoted himself wholeheartedly to scholarship. He quickly turned his dissertation on Descartes into the introduction of his first published work, a similar treatment of Leibniz's scientific work on the development of his philosophy. When anti-Semitic remarks occurred, as they inevitably did, he insisted on combating them with reason and pure thought alone and maintained a calm disposition and general optimism about his difficult professional prospects.[39]

Recognition came quickly. His multivolume work *Das Erkenntnisproblem* (the first volume of which was published in 1906), solidified his prominence within the intellectual community.[40] Here he considered previously isolated philosophical studies of Descartes and Leibniz within a broader European intellectual history, composing the first of a long series of similar narratives for which he became known. On the eve of the First World War, the first two volumes of this monumental work, which served as Cassirer's *Habilitation*, were awarded the prestigious Kuno-Fischer Gold Medal by the Heidelberg Academy. Cassirer had developed a history of modern philosophy and science that reached from the Renaissance to Kant.

Writing steadily through his wartime service in the Press Office of the Center for Foreign Service, Cassirer published *Substanzbegriff und Funktionsbegriff* (Substance and function, 1910) and *Freiheit und Form* (Freedom and form, 1916) and edited a ten-part series on Kant in 1912 that he later supplemented with a biographical volume of his own (*Kant's Life and Thought*, 1918; English, 1981). In the winter semester of 1911–12, more than one hundred people regularly attended his lectures at the University of Berlin. In the academic year of 1913–14, Cassirer was awarded a visiting lectureship at Oxford and was invited to spend the year at Harvard, the latter an offer that he ultimately turned down out of consideration for his family. For Cassirer was deeply aware of the sacrifices made by those around him to ensure the "appropriate conditions for his continuous work."[41]

The Professor's Wife

Cassirer's ability to maintain the life of a professor despite being restricted to the position of *Privatdozent* was enabled largely by a large and supportive family, including, in particular, his wife, Toni (née Bondy) Cassirer. Toni Cassirer, like Mary Warburg, was an exemplary nineteenth-century bourgeois woman, and, conversely, her educational and professional opportunities had been fundamentally defined by a

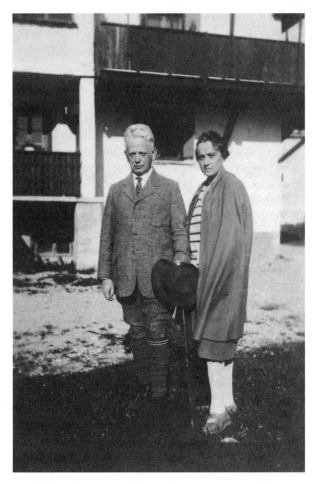

4 Cassirer's student Max Tau said that when Ernst and Toni Cassirer walked in the street,
 "one had the impression that [they were] royalty." Warburg Institute, London.

nineteenth-century code of femininity. While the Warburgs embodied
this intimate paradigm in their positions as artist and art historian, the
Cassirers were a more traditional academic couple, a professor and a
professor's wife. Hamburg's Jewish community may have affectionately
referred to Max Warburg as "Kaiser Warburg," but, as Cassirer's for-
mer student Max Tau recalled, when Toni Cassirer walked in the street
with her husband, "one had the impression that [they were] royalty"
(fig. 4).[42]

Born in Vienna in 1883 to Julie Cassirer and Otto Bondy, a business-

man who founded the first Austrian cable work company, Toni grew up in relative comfort. In 1901, at age eighteen, she traveled to Berlin for a family wedding, and it was on this trip that she became acquainted with her first cousin Ernst Cassirer.[43] Cassirer, at the time a twenty-six-year-old doctoral student, impressed her with discussions of concerts, books, and theater and gave her a copy of his first book on Leibniz, for which the Berlin Academy had recently awarded him the Leibniz Prize. Unfamiliar with philosophy, not to mention Leibniz, Toni Cassirer felt unworthy of this gift. "In our family's home, there was not one philosophical book," she recalled, "and while my Viennese friends spoke much about literature, fine arts, and music, they never discussed philosophy."[44]

In the brief epistolary courtship that followed, Toni Cassirer became even more enamored of her cousin's intellect and the "great freedom with which he esteemed men and things, [which] I found new and exciting." She was relieved also, that her paltry academic background was not a problem for him and recalled, "[Ernst] demanded nothing from me other than that I love him . . . and it did not dissuade him that I was not able to know more than hearsay about the things to which he devoted his whole life." Ernst Cassirer, for his part, expressed desire for his "dumb book" to be finally finished so that his "better life could begin."[45]

Toni Cassirer's modesty notwithstanding, she quickly became a feature in her husband's academic life. Within the year, and following a Jewish marriage in Vienna, the couple lived briefly in Munich before moving to Berlin to pursue the philosopher's career as a *Privatdozent*. He incorporated his wife into this new university life, introducing her to his mentors Cohen and Natorp, for whom she became an immediate favorite. "The bride of Ernst Cassirer is now here, whom we like very much," Hermann Cohen wrote to Paul Natorp in 1902, "[She is] natural, simple, strong, young, and charming." Toni Cassirer was equally forthcoming in her affection for these scholars. She often included a note in her husband's correspondence to the Natorps and on occasion corresponded with Paul Natorp independently.[46] When she gave birth to their first son, named Heinz, the Natorps were among the first to be notified. And while Cassirer's career often demanded that he travel and work long hours, leaving much of the rearing of Heinz, as well as his siblings, Georg and Anne, to his wife, he—no doubt influenced by his university colleague William Stern—assumed an active role in child psychology and pedagogy, integrating these theories into his domestic life.[47]

In Berlin, the young Toni Cassirer was not initially in favor of her husband's "quiet scholarly life."[48] But his first professorship at the University of Hamburg meant a new role for her, a position that she gracefully assumed. The Cassirers moved into a house on Blumenstrasse in the city's most posh neighborhood, but its prestigious address didn't prevent the home from serving the functions of a dormitory, a study hall, and a faculty club to students and professors alike. Throughout the 1920s, the Cassirers hosted many students, including Raymond Klibansky and Max Tau, who remembered, "The students of the young University of Hamburg actually belonged to the families of our teachers." In contrast to Aby Warburg's mentee Carl Heise, who dined with the Warburg family sporadically and only became close with Mary Warburg after her husband's death, Ernst Cassirer's students were treated like the couple's children.[49] Toni Cassirer played a maternal role for the male students, cooking, cleaning, and even regulating their work schedules.[50]

The philosopher's wife also received visiting artists, intellectuals, and professors, evoking, in this way, an eighteenth-century *salonnière*. Tau remembers how Toni Cassirer presided over the intellectual scene: "People bloomed in their apartment. Scholars and students gathered [there] and Toni Cassirer commanded as queen. One almost feared her beauty, pride, and independence."[51] Despite this somewhat active role, Toni Cassirer did not participate in the exchange of ideas. She was also not Marianne Weber, the feminist activist whose Sunday *Jours* in Heidelberg were so popular that it was not uncommon to hear one refer to Max Weber as "Marianne's husband."[52] Nonetheless, that Einstein found the Cassirer home fit for intellectual productivity and that artists and musicians like Max Liebermann, Arthur Schnabel, and Otto Klemperer thought it suitable for cultural exchange was due largely to Toni and her graciousness, not to her reserved husband.[53] As a space that both engendered a familiar private realm stimulating of conversation and boasted the institutional validation of the university, the Cassirer's Blumenstrasse house was an important element in Hamburg's homegrown intellectual world, and it was Toni Cassirer's hospitality, graciousness, and natural charm that enabled its existence.[54]

Critique of Reason, Critique of Culture

Outside the Cassirer home, Hamburg provided a wealth of institutional and personal relationships that made Cassirer's time in the city his

most prolific. But for these elements to converge first required what the philosopher would later describe as "disentanglement" (*Loslösung*) from Cohen's school.[55] Cassirer's suspicion that the neo-Kantian approach was inadequate for all human modes of thought emerged well before the First World War. Indeed, his turn from investigating Descartes's dualism to Leibniz's "pluralist universe" already suggested a broader paradigm for human understanding, even if this work remained within the confines of the epistemology of the Marburg School.[56] Moreover, it foreshadowed a shift that came to be crucial to Cassirer's distinction between the seventeenth and eighteenth centuries in his famous portrait of the Enlightenment.[57] The crux of the problem arose when Cassirer attempted to apply to the cultural sciences his theory of reasoning previously substantiated by the mathematical and scientific material addressed in his 1910 *Substanzbegriff und Funktionsbegriff.* It now became clear that "general epistemology, with its traditional form and limitations, does not provide an adequate methodological basis for the cultural sciences." To achieve this intellectual end, Cassirer argued, "the whole program of epistemology would have to be broadened."[58]

The First World War confirmed Cassirer's belief that synthetic a priori judgments were inadequate, that indeed the "fact of science" could no longer be the starting point for philosophy, if philosophy meant accounting for human experience. Kant, too, had undertaken an extension in the *Third Critique*, which, as we know, led to a long period of idealist philosophy. As Cassirer characterized it, this extension constituted a "deepening that only now makes it feasible to survey the *whole* of natural and spiritual life and to conceive it as intrinsically a single organism of 'reason.'"[59] Although of course the nature of this turn would be different, one has the feeling that Cassirer describes his own such extension here.

The horror of unprecedented human and physical destruction seemed to prove that human behavior could not be entirely explained by reason—not an insignificant realization for a critical neo-Kantian. Yet fortunately for Cassirer, unlike for Warburg, the challenges presented by the First World War were not mental but intellectual. The product—his first major reconsideration of the neo-Kantian position— was outlined in *Freiheit und Form*, a work that he wrote contemporaneously with his contribution to the war effort. That Cassirer understood Germany within the wider context of European thought anticipated the republican political project, a campaign to which he devoted much attention when the future of the Weimar Republic was uncertain at the end of the 1920s. Cassirer also began to rebuild his intellectual system

for understanding the world, a system that took into account human expression outside the bounds of reason alone.

In this respect, Cassirer shared much with a generation of scholars who sought more primitive forms of expression for human experience, and he aligned with intellectuals who felt that philosophy's purpose must be impacted by the unprecedented destruction, the presence of maimed men, and the death of innocent bystanders. Many scholars, including Henri Bergson, Sigmund Freud, and George Sorel took up projects inspired by *Lebensphilosophie* (philosophy of life), an approach that Wilhelm Dilthey developed from Nietzsche's similar concept to capture the organic whole of life. The French philosopher Bergson, for example, proposed *élan* as an antidote to the rational apparatuses that stifled life's natural vitalism; Sorel offered myth as a new type of thought and political action; and Freud, as is well known, suggested that the tools of science could be expanded to uncover the irrational.

This short list alone makes it evident that the era's characteristic "reorientation of European thought"—to borrow the historian H. Stuart Hughes's term—could lead to a variety of positions across the intellectual spectrum. And although scholars have quarreled over the direct relationship of these trends to politics, these intellectual positions without a doubt had substantial political consequences.[60] Cassirer's attempt to balance the importance of reason and myth located him in the middle: indeed Cassirer's philosophy resembled the work of a paradigmatic "modern" scholar like Weber, whose struggle to reconcile this same tension earned him Hughes's title of "noble critic."[61] And his attempt to come to terms with the consequences of *Lebensphilosophie* for neo-Kantian epistemology became his multivolume *The Philosophy of Symbolic Forms*.

To this end, Cassirer soon shifted his focus from reason and rationality to such concepts as myth and language. This reorientation resulted from a transformative realization that a former student relayed came to his professor on a streetcar ride home in 1917: "Suddenly the one-sidedness of the Kant-Cohen theory of knowledge became quite clear to Cassirer. It is not true that only the human reason opens the door which leads to the understanding of reality[;] it is rather the whole of the human mind, with all its functions and impulses, all its potencies of imagination, feeling, volition, and logical thinking which builds the bridge between man's soul and reality, which determines and molds our conception of reality." It is notable that this student, recalling Cassirer's intellectual transformation, presented it in the language of revelation, for Cassirer was also a deeply spiritual man for whom "love as

wide as the universe . . . urged [him to] incessantly . . . explore all material and spiritual things."[62] Cassirer found his inspiration among the nineteenth-century German romantics, whom he described as having been moved by the "extraordinary event" of the Lisbon earthquake toward greater spiritual reflection. And it was Goethe whose work enabled Cassirer to establish an intellectual system that extended beyond Cohen and Kant.[63] That Kant subjected both "poetic art and comparative natural knowledge" to the same form of critical judgment inspired the reactions of both Goethe and a generation of post-Kantian philosophers.[64] Cassirer, in turn, used the lessons of Goethe's work to elevate personal subjectivity from banal human expression to sacred experience.

In his foreword to the first volume of *The Philosophy of Symbolic Forms*, Cassirer asserted that aesthetic expression could constitute a valid articulation of the world. "Instead of investigating only the general premises of scientific *cognition* of the world," Cassirer wrote, "[a holistic critique] would . . . differentiate the various fundamental forms of man's 'understanding' of the world and apprehend each of them as sharply as possible in its specific direction and characteristic spiritual form." Subjectivity was not outside of objective inquiry but rather was "everywhere at work where the phenomenal world as a whole is placed under a specific spiritual perspective, which determines its configuration." But Cassirer was neither Sorel nor Bergson, and in his work he did not simply transform all reason into myth or remove myth entirely from the sphere of the intellect. In contrast, it was exactly a strong faith in science that formed the model for this transformation, for it was the tools of science that first recognized their symbol-making capacity. As Cassirer argued, "The instruments with which it propounds its questions and formulates its solutions, are regarded no longer as passive images of something given but as *symbols* created by intellect itself."[65]

New developments in physics, and particularly the theory of relativity as explored by his friend Albert Einstein, served as a model for Cassirer's critique of culture, and Cassirer first introduced his idea of what later became "symbolic forms" in a 1921 study exclusively devoted to Einstein's theory of relativity. Einstein's work appealed to Cassirer because it seemed to reproduce Kant's "Copernican Revolution" in the physical sciences and solve unanswered questions in Kant to boot. As we have seen, Kant's transcendental idealism rested on the proposition that objects conform to our mind through the mediation of certain mental faculties, a claim that left him open to charges that space and time did not produce uniform reactions in all individuals. Einstein, for his part, claimed to solve this problem by uncovering intelligible

laws for the seemingly unintelligible world, for the universal law of relativity is derived from the particular condition that all perception is relative.[66]

So if art helped to extend our grip on life, then science also showed the symbol-making capacity of art. To explicitly align the projects of aesthetics and science, Cassirer connected Einstein's innovation to Goethe's "anthropomorphism."[67] Citing Goethe in his discussion of Einstein, Cassirer made this point explicit: "'We can observe, measure, calculate, weigh, etc., nature as much as we will, it is still only our measure and weight, as man is the measure of all things.'" The physical laws existed only insofar as humans understood them. To an extent, Cassirer viewed his work as a philosophical version of Einstein's accomplishments in the sciences. But while Einstein's law only isolated one form among many, Cassirer believed that to be free from this "one-sidedness," it was the "task of systematic philosophy" to analyze rational and nonrational modes alike. He wrote: "[Philosophy] has to grasp the *whole system* of symbolic forms, the application of which produces for us the concept of an ordered reality, and by virtue of which subject and object, ego and world are separated and opposed to each other in definite form, and it must refer each individual in this totality to its fixed place."[68] A universal philosophy of symbolic forms was required to fulfill this task. For Cassirer, the valid modes of human inquiry could no longer be limited to reason but suddenly also extended to mythical and religious thinking and artistic and cultural expression, demonstrating that in all of these modes of interaction "there is attained an entirely determinate formation.[69]

These two strands of intellectual influence—Goethe's cultural critique and Einstein's developments in physics—culminated in the first volume of *The Philosophy of Symbolic Forms*. Beginning with a reference to the physical sciences, Cassirer announced the result of expanding this scientific project based on the forms of mass and measure to consider new and nonrational forms of human expression: "Thus the critique of reason becomes the critique of culture. It seeks to understand and to show how every content of culture, in so far as it is more than a mere isolated content, in so far as it is grounded in a universal principle of form, presupposes an original act of the human spirit. Herein the basic thesis of idealism finds its true and complete confirmation."[70]

Crucially, in this new expansion, Cassirer collapsed the distinction between sensible and intellectual intuition that was so critical to Kant's transcendental idealism, a decision that forced Cassirer to provide an account of how he planned to move beyond that distinction

in practice.[71] For the reformed neo-Kantian, a new critique of culture that sought other ways of apprehending the world was in large part the answer, and in this endeavor he discovered an unlikely intellectual partner in Warburg and a valuable resource in Warburg's library. Cassirer's presence in Warburg's life was well timed, and Warburg too benefited from their exchange. As a result of Cassirer's arrival, Warburg both found his way back to reason and discovered a dedicated partner in his scholarly mission.

Library of Civilization

In Hamburg, various relationships and institutions facilitated Cassirer's new project. Together with William Stern, he founded the Hamburg chapter of the Kant Society and between 1920 and 1926 served on the board of the *Volkshochschule*, which was closely connected to the university.[72] But it was the Warburg Library that, of all institutions, most enabled Cassirer's productivity in Hamburg. Upon his arrival in Hamburg Cassirer had already drafted parts of the first volume of *The Philosophy of Symbolic Forms*, which extended his neo-Kantian framework to produce a broad philosophy of culture. Yet it was Warburg's unique collection of books—which in its scope bore an uncanny resemblance to Cassirer's intellectual goals—and his relationship to Warburg himself that enabled Cassirer to transform his innovative and comprehensive "morphology" of culture into a three-volume opus.[73]

Cassirer's introduction to the library was facilitated by Saxl, who had recently returned from his service to the Austrian army, with which he spent four years on the Italian front. Since Warburg had retreated to Kreuzlingen to recover from his mental breakdown, Saxl was the de facto director of the library, a situation that, albeit "indispensable" for the project, was not uncomplicated for these men.[74] Their intellectual priorities were almost always in sync, but tension was inevitable. Warburg teased Saxl, the cosmopolitan Viennese, who had traveled *en bohémien* throughout much of Europe and had a different sensibility from the Hamburg-born Warburg.[75] More seriously, Warburg, increasingly remote and emasculated, resented the warm reception that Saxl received from the Warburg brothers and, though he rejoiced in its accomplishments, also must have felt isolated from the library's new incarnation.

Despite this thorny relationship, both Warburg and Saxl agreed that Cassirer was central to the validation of the library. In the fall of 1920,

soon after the philosopher arrived in Hamburg, Saxl led him through the collection, at the time still housed in the Warburg family home. Initially interested in informing his work for Hamburg's Religious Historical Society, because the library was well equipped for such a topic, Cassirer quickly discovered there was much more there; Saxl's tour sealed the professor's near mystical attraction to the library. Recounting Cassirer's first library visit years later, Saxl remembered, "When Professor E. Cassirer first came to see the Library he decided either to flee from it (which he did for some time) or to remain its prisoner for years (which for a certain period he enjoyed doing in later years)."[76]

In the next six months, Warburg and Cassirer began to correspond, commencing a strong intellectual and personal relationship, though still mediated, to a certain degree, by Saxl. As Toni Cassirer observed, by the time of Warburg's return to Hamburg in the summer of 1924, "countless threads had already been tied between [Aby] and Ernst's work." That summer, Saxl gave Cassirer a copy of Warburg's lecture "Pagan-Antique Prophecy in Words and Images in the Age of Luther." Published in 1920, the lecture carried the imprint of the war, as it registered the persistence of superstition and numerology even at the high point of the Reformation. Although he admitted to being a "layperson" in regard to art history, Cassirer confided in Warburg that he had been working on similar issues for some time and added, "[It was a tremendous] stroke of luck to have come into contact with your library through my appointment in Hamburg, a library to which I already owe many suggestions, and whose worth and meaning is clearer to me every day."[77]

In his correspondence with Warburg, Saxl persistently suggested that Cassirer's idea of the symbol paralleled Warburg's art-historical inquiry; he also encouraged Cassirer to pursue the connections with Warburg's work. In spring 1923, Saxl suggested to Cassirer that "the symbol problem" discussed in the first volume of his *The Philosophy of Symbolic Forms* bore a resemblance to the subject of Warbug's work on the Hopi Indian reservation, an observation that Saxl called a "magical coincidence."[78] While Saxl doubtless was interested in promoting his remote boss and the reputation of their young institution to the well-known philosopher, the connection between Cassirer's philosophical works and Warburg's library was undeniable.

When the Warburg Library eventually opened in a new building adjacent to the Warburg home on May 1, 1926, the connection between Cassirer's philosophy and Warburg's system of organization was even

WARBURG, CASSIRER, AND THE CONDITIONS OF REASON

more evident. Saxl described the library's organization of books across its newly furbished four floors: "The first [floor] began with books on the general problems of expression and on the nature of symbols. From here one was led to anthropology and religion and from religion to philosophy and the history of science. The second floor contained books on expression in art, its theory and history. The third was devoted to language and literature, and the fourth to the social forms of human life—history, law, folklore, and so forth."[79] That the ground level was devoted to symbols meant that library patrons began their bibliophilic journey with the fundamental question of how human beings negotiate their relations to the world and then proceeded through various modes of mediation, from the elemental and visual, magic and art, to the linguistically complex, literature and philosophy. Indeed, Cassirer would have seen how the unique collection of books reflected the philosophy, organization, and substance of his own work, which likewise moved through various "floors" of understanding and expression to produce a holistic portrait of human experience. "It seemed miraculous that Warburg had collected for thirty years with a view to the very problems that Cassirer was then beginning to investigate," Saxl observed.[80] And many years later, Cassirer concurred, "I was strongly impressed by this first inspection; and it was by this impression that I was encouraged to pursue a study that I had been planning for many years—to give a systematic analysis of the problem [of the philosophy of symbolic forms]."[81] The library seemed the embodiment of Cassirer's burgeoning philosophy of culture.

Critique of Pure Unreason

Adopted from Goethe, the idea of the symbolic form came to serve as Cassirer's fundamental method for making the world intelligible. His expansion of the Kantian critical lens to a critique of culture is evident in his description, in 1921, of symbolic forms as "every energy of the mind (*Energie des Geistes*)," through which a "mental content of meaning (*geistiger Bedeutungsgehalt*)" is connected to a "concrete sensory sign (*konkretes sinnliches Zeichen*) and made to adhere internally to it."[82] Intermediaries through which human beings gained access to reality were no longer limited to the Kantian faculties of space and time; rather, symbolic forms could include such prediscursive modes of interaction as language and myth, thereby increasing the scope of human under-

111

standing. In this way, Cassirer's symbolic forms intersected with War-
burg's interest in the development of mental structures that lay behind
symbol-making, from the Hopi Indians to the Florentine painters, a
convergence that Saxl cemented by arranging for Cassirer to deliver the
inaugural lecture for the Warburg Library.[83] But a crucial difference re-
mained: while Cassirer expanded reason to include nonrational modes
of thought, he still emphasized the rational. In contrast, Warburg's real
interest lay in myth, and he constantly bemoaned the loss of vitality
within a seemingly static process of history and interpretation.

This was in part because Warburg's interest in symbols developed,
as did his vast and scattered training, in a way much more idiosyn-
cratic than did that of the neo-Kantian philosopher. Similar notions
of symbols had already been established by the philosopher of aesthet-
ics Friedrich Theodor Vischer, whose work *Ästhetik, oder Wissenschaft
des Schönen* (Aesthetics, or the science of the beautiful, 1851) had at-
tempted to explain art through Hegelian dialectics and the principles
of inner conflict and reconciliation. Adapting the term *Einfühlung*, or
aesthetic sympathy, from his father, the philosopher Robert Vischer
subsequently used his dissertation, "On the Optical Sense of Form: A
Contribution to Aesthetics" (1872), to demonstrate how empathy could
be a topos in artistic analysis.[84] The work of Charles Darwin, as we have
seen, further confirmed Warburg's belief that human emotions might
play a role in the physical representation and analysis of the visual
arts. Upon reading *The Expression of the Emotions in Man and Animals*,
Warburg was persuaded that the expression of human emotions in art
seemed to be not only the outcome of an antique tradition but also the
result of an evolving emotional energy transmitted across generations
and history.

Darwin's influence on German intellectual life in general, and on
Warburg's growing interest in the relationship of symbols to meaning
in particular, has been well charted.[85] But Warburg's belief in the phys-
ical world's capacity to emanate psychic energies was even closer to the
monism of Ernst Haeckel, the Jena Darwinist who hosted the first in-
ternational congress of monism in Hamburg in 1911.[86] Haeckel, him-
self an artist, used monist pantheism to combine aesthetics and science
in a way resembling Warburg's ambivalent position on the aesthetics of
the natural world.[87] For these men, art not only duplicated the physi-
ognomic process of evolution but also fundamentally participated in a
deeply biological and spiritual part of human destiny.

Crucially, a recognition of the primitive animal within man could

either lead to a progressive optimism or inspire a bleak emphasis on primitivism. These opposing sentiments lingered over Warburg's trip to the United States and the Hopi Indian reservation, a trip that confirmed his suspicion that rationality functioned the same way that "primitive" symbols did. That two of the native Hopi children, in response to his test, drew a primitive symbol of lightning rather than its socially conditioned representation confirmed Warburg's hypothesis that primitive symbols could and did persist in the face of widespread rationalization. In this respect, he connected this experiment with his growing formulation of culture as an analytic principle, observing, "The function of the symbol in a culture still pervaded by magic beliefs . . . thus confirm[s] the validity of F. Th. Vischer's ideas. . . . The religious acts of the Pueblo-Indians show the essential quality of the 'causal' reaction of the 'primitive' towards the external world." The visit to the Hopi Indians confirmed what Warburg always knew: he was not exclusively interested in art, but in the broader movement of energies and emotions over time. Following this trip to America, Warburg abandoned the discipline of art history and refashioned himself as a "psychologist of culture."[88]

Warburg's early scholarship attempted to understand the relationship between the poles of reason and irrationality and their parallel development through history. Like Cassirer, Warburg found motivation in the changing political landscape characteristic of the First World War. His path led him to research the struggle between political propaganda and reason in the context of Luther's Reformation; and in "Pagan-Antique Prophecy," which Saxl had shared with Cassirer, Warburg demonstrated that even at the height of the Reformation, astrology gripped friends of Luther, who became embroiled in a interpretative debate regarding the subject of the Protestant reformer's horoscope. Warburg went on to argue that Dürer's prints from this same period reflected a struggle between logic and myth and that in his famous engraving *Melencolia I* (1514), the artist assimilated this prophecy culture and transformed it into an expression of genius. For Warburg, Dürer's accomplishment represented a victory over the demonic forces: "We are in the age of Faust, in which the modern scientist endeavoured— between magic practice and cosmological mathematics—to conquer the realm of reflective reason through an increased awareness of the distance between the self and the external world. Athens must always be conquered afresh from Alexandria" (*Athen will eben immer wieder neu aus Alexandrien zurückerobert sein*).[89] As Warburg's analysis of Dürer

113

showed, the struggle between Athens and Alexandria, and between reason and irrationality, was not complete but rather emerged in different epochs with historically distinct sets of images.

Warburg's mental breakdown suggested that, in his personal struggle between reason and irrationality, he could no longer hold encroaching demons at bay. As Gombrich famously observed, in Warburg's life, "Alexandria seemed to have conquered Athens." The upshot of Warburg's deeply empathetic identification with his material was a vibrant analysis of art. "Only a man like Warburg," Saxl observed, "who suffered endlessly on account of the logic of magic, had the spiritual and bodily capacity (*Organe*) with which to understand most intensively the duality of Hellenism."[90] This extreme empathy, however, also triggered Warburg's self-destructive qualities. At the time of Cassirer's arrival in Hamburg, Warburg had not completed any work longer than an essay in more than a decade. Indeed, his dissertation on Botticelli turned out to be the last monograph he published, composing a significant part of an oeuvre limited to scarcely more than 350 pages. "Warburg's lifelong and often chaotic and desperate struggle to understand the expressions of the mind, their nature, history, and interrelation," Saxl recalled, "ended with the creation of a library system which appeared as natural as if it had been not the result but the starting-point of Warburg's activities." Warburg organized and reorganized his books to reflect innovations in philosophy, for, as Saxl contended, "Books were for Warburg more than instruments of research. Assembled and grouped, they expressed the thought of mankind in its constant and its changing aspects."[91] This library was Warburg's most significant scholarly achievement.

Given Warburg's frustrated productivity, one cannot overestimate the meaning he attributed to Cassirer's work. The knowledge that Cassirer utilized his library in his production significantly enabled Warburg's personal and mental recovery, and that Cassirer spoke of the bond between the two men gave Warburg renewed strength.[92] Still in Kreuzlingen, Warburg referred to his connection with Cassirer as the "light at the end of the tunnel."[93] Hoping to capitalize on this bond, in April 1924 Saxl facilitated a highly anticipated afternoon visit between the two, for which Warburg prepared the entire day.[94]

The central focus of this three-hour conversation was the sixteenth-century mathematician Johannes Kepler, whom Warburg believed had revolutionized modern thought through the introduction of the concept of the ellipse—a model that, with its doubled focal points, Warburg considered an apt representative of creative labor and the relation-

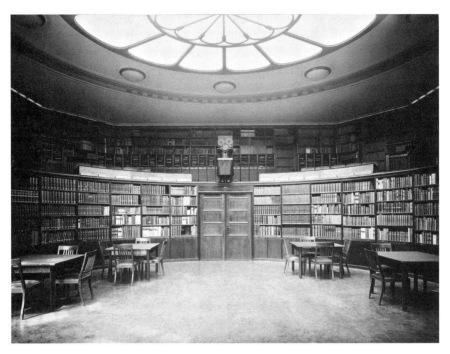

5 Cassirer and Warburg shared their respect for Kepler's discovery of the ellipse, and the library's main reading room assumed this shape. Warburg Institute, London.

ship between the soul and the mind. Cassirer had also cultivated an interest in Kepler, whom he argued used symbols to promote a Platonic idealism that influenced Newton's innovations. At one point in their meeting, when Warburg paused to recall a citation from Kepler's major work, Cassirer recited the corresponding passage from memory and the two men conferred on its meaning for their collective scholarship. This visit and discussion of Kepler reinforced Warburg's decision to build the reading room of his new library in the form of an ellipse—an impractical plan that dismayed the building's architect, Schumacher (fig. 5). More important, as Saxl observed, through this meeting with Cassirer, "[Warburg] learnt . . . that he had not wandered in a pathless wilderness, but that his scientific thought at least was sane."[95]

Cassirer and Warburg's invigorating intellectual exchange notwithstanding, Warburg's internment was closely monitored during his stay at the Bellevue Sanatorium in Kreuzlingen by the finicky Binswanger, who maintained a daily log of Warburg's developments. That Binswanger harbored his own scholarly ambitions, aspiring to unite

psychotherapy with existential ideas, meant he was doubtless taken by the visit from the famous Kant scholar.[96] To capitalize on Cassirer and Warburg's meeting, Saxl solicited a report from Cassirer that presented Warburg as lucid. If Warburg proved to be cogent, Binswanger was willing to release him, and so the report was, as Saxl insisted, extremely critical for "political reasons."[97]

To prove his competence, on April 21, 1923, Warburg delivered a lecture at the sanatorium for an audience of Binswanger, Saxl, a few patients, and the local rabbi, on nothing other than his trip to the Hopi Indian reservation. Warburg did not consider the essay, which he delivered from his 1897 notes, publishable, and he permitted only his wife, his brother Max, and Cassirer to read it. Although the full text of the German lecture was not published until many years later, its content was crucial, as we have seen, for the crystallization of Warburg's iconological approach; arguably, Cassirer had enabled the broken Warburg to make those connections.[98]

Despite the lecture's importance within a larger intellectual project, the outlook for Warburg's recovery was still not good. As Binswanger wrote to his friend and colleague Freud, "I do not believe that a rehabilitation of the condition before the acute psychosis and a resumption of scholarly work will be possible. . . . It is a real shame that it is probable that [Aby Warburg] will not be able to draw more from his immense treasure of knowledge and his enormous library."[99]

That the "immense treasure" formed the foundation for Cassirer's work vindicated the scholar who remained a mere collector. Like Lamprecht, Warburg's impulse to collect reached a mania that belies the usual romanticism ascribed to this activity by invoking Walter Benjamin's well-known essay "Unpacking My Library." Warburg was not permitted the "mild boredom of order" that Benjamin suggested came from books that were already placed securely on their shelves.[100] Instead, a troubled Warburg had "created the tool," and Cassirer, as a "master of systematization," used it to pursue the research for which Warburg himself was physically unfit.[101] In one sense, Cassirer's *The Philosophy of Symbolic Forms* created a structure for Warburg's otherwise uncontrollable thoughts and incorporated them into his neatly organized systematic philosophy. Pursuing the subsequent volumes of this work over the next several years, Cassirer systematically drew on Warburg's collection of books to incorporate language and myth into his theory of culture.[102]

Warburg's own work, in contrast, remained fragmentary and incomplete. His dynamic picture atlas, on which he worked for the remain-

der of the 1920s, represented the antithesis to Cassirer's efforts to create a systematic philosophy. To chronicle the development of images over time, Warburg created large panels that he covered with a black cloth backdrop and then adorned with a collage of images that included reproductions from books and visual material from newspapers and daily life. Beginning in 1924, Warburg presented groups of these screens, devoted to themes such as the relationship between north and south, Florentine civic culture, and the role of astrology, to scholars and friends.[103]

Warburg was optimistic—perhaps too optimistic—about the potential meaning this project held for the scholarly world. Convinced that his picture atlas shared similarities with Einstein's discoveries, Warburg arranged a visit to his home to make his case. After all, the relationship between Cassirer's symbolic forms and Einstein's theory of relativity was well established. Attempting to solidify his parallel to Cassirer further, Warburg even considered naming his picture atlas "The Critique of Pure Unreason" (*Kritik der reinen Unvernunft*).[104] It was a fitting choice that well reflected their overlapping paths of inquiry, for in one review of *The Philosophy of Symbolic Forms*, the philosopher Kurt Sternberg explained that Cassirer, too, embraced the "Logic of the illogical."[105] On the day of Warburg's much-anticipated visit with Einstein, he joked that the weather was only "relatively" good. So was the visit, unfortunately, for Einstein saw no connection between their work.[106] If Cassirer's project aimed to subsume irrationality, Warburg's unraveled because of it. And for Warburg, Cassirer's scholarship was the only thing that helped him find his way back from the "wilderness."

Individuals and the Cosmos

If Warburg's illness demonstrates the personal burdens of intellectual inquiry, then Cassirer's subsequent research demonstrated the possibility of redemption through friendship and shared work. Nowhere was this more evident than in Cassirer's *The Individual and the Cosmos in Renaissance Philosophy*, which he dedicated in 1926 to his friend on the occasion of his sixtieth birthday and published the following year. It was in this work that Cassirer's interest in establishing the epistemological foundations of a cultural critique and Warburg's preoccupation with the history of symbols in the Renaissance joined to form a productive collaboration.

Because it represented a moment when symbol-making was em-

bodied in life, the Renaissance was crucial for Cassirer's narrative of the construction of pure forms of thought and, in this way, linked his scholarship of epistemology with that of Warburg's on the *Pathosformel*. As Cassirer observed, "This process [undergone by the Fortune symbol in the visual arts] has been depicted in the studies by Warburg and Doren. They have shown that the rigidified medieval forms of Fortune were maintained for a long time; but that besides these other motifs emerged with every increasing force. Though these other motifs had their roots in antiquity, they were now imbued with a new spirit and new life. The same thing occurs in the realm of thought."[107] For Cassirer, the Renaissance was characterized by a shift from universal religious thinking to an understanding of the divine's reflection in the particular, a transformation that foreshadowed the development of modern scientific thought. And in this respect, art and thought underwent the same transformation in world outlook.

Cassirer's work not only paid tribute to Warburg's scholarship but also honored his leadership within the scholarly community, a recognition that Cassirer bestowed both in private correspondence and in a published dedication. Though initially intended as a "purely personal expression of [Cassirer's] deep friendship and devotion," the book ultimately spoke for the entire "association" (*Arbeitsgemeinschaft*), for whom Warburg served to facilitate a set of ideal intellectual conditions. Anthropomorphizing Warburg's collection, Cassirer argued that the library was more than mere setting and that, "in her layout with respect to intellectual structure she embodies the thoughts of the methodological unity and the methodological amalgamation of all fields and all directions of intellectual history."[108]

In this dedication to his friend, Cassirer continued, "May the organon of intellectual-historical studies which you have created with your Library continue to pose questions to us for a long time. And may you continue to show us new ways to answer them, as you have in the past." *The Individual and the Cosmos in Renaissance Philosophy* should not, Cassirer insisted to Warburg and his assistants, be viewed solely as the product of one scholar alone but rather as the collective work of the Warburg Library.[109] Yet as a living community of ideas, the "common, friendly collaboration" was bound to experience both intellectual and personal conflict. In particular, the relationship between Saxl, the de facto director, and Warburg, recently returned from Switzerland, presented "a situation in which friction was almost inevitable, and it was aggravated by the fact that nobody fully understood how deeply Warburg felt himself to be a *revenant*." For Bing and the others, it was

as if Warburg emerged from the dead to confront the community of scholars he had engendered but which had nonetheless emerged in his absence. Neither did the community of scholars always share intellectual priorities. And even as Saxl recognized the value of the one philosopher who truly understood their bibliographic project, he also noted Cassirer's residual Kantianism to Warburg in 1921.[110]

A central question regarding the relationship between myth and reason threatened to divide them: Was myth a means to reason or instead a valid alternative to rational thought? And if Cassirer was sure that the critique of reason needed expansion, the question remained as to whether this rendered reason simply another form of human expression, comparable to poetry or painting, or the apex of human achievement. On the one hand, when, in the first volume of *The Philosophy of Symbolic Forms*, Cassirer observed that science had its origins in the "earliest expression and deposit in language and general linguistic concept," he implied that language and myth were elemental forms of human expression. On the other hand, he made his allegiance clear when he observed, "All cultural forms culminate in absolute knowledge; it is here that the spirit gains the pure element of its existence, the concept. . . . Of all cultural forms, only that of logic, the concept, cognition, seems to enjoy a true and authentic *autonomy*."[111]

That Goethe never entirely subsumed Kant in Cassirer's imagination, for some scholars, condemned Cassirer to an evolutionist position, whereas Warburg's persistent interest in myth above all has permitted him to elude this traditional characterization. Yet the library continued to tell a different story, for it "reflect[ed] Warburg's original conviction that the responses of primitive man in language and imagery can lead to what he called 'orientation' in religion, science or philosophy, *or be degraded into magic practice or superstition*."[112] That one literally ascended from books on elementary mythical thinking to those dealing with philosophy meant that the library's architecture confirmed the evolutionary position.

Complicating matters was that Cassirer, too, exhibited Warburg-esque inclinations. In *Language and Myth*, the text in which he came closest to articulating Warburg's point of view, he mourned the loss of innocence that necessarily accompanied this progression from myth to reason: "If language is to grow into a vehicle of thought, an expression of concepts and judgments, this evolution can be achieved only at the price of forgoing wealth and fullness of immediate experience."[113] The difference is that Cassirer considered this to be a professional—and, indeed, human—hazard, something only to be recovered through

artistic and creative expression. It was the scholar's responsibility to guide human beings through this process, even at the risk of losing the vitality of the initial experience. While Warburg was often overcome by despair because of the broken nature of the world, Cassirer continued his work for him. He was joined in this endeavor by Erwin Panofsky, whose crafty use of Hamburg's urban institutions and whose innovations in art history made Warburg's "organon" accessible to an ever-wider audience.

Socrates in Hamburg? Panofsky and the Economics of Scholarship

Klopstocks und Lessings Stadt
Nimmer vergessen hat
Welch-Gut noch höher gilt
Als Geldgewinst.

Klopstock and Lessing's city
Never did forget
What higher good there was
Than earning money.
ANONYMOUS

While it is true that commercial art is always in danger of ending up as a prostitute, it is equally true that noncommercial art is always in danger of ending up as an old maid.
ERWIN PANOFSKY

With a new university and Warburg's burgeoning humanist library, Hamburg seemed to have much to offer Erwin Panofsky, yet the ambitious art historian still needed to be convinced of the city's merits. In a letter to his wife in 1920, Panofsky observed, "Yes, Hamburg is really a very nice city—but I think it will become ever more mysterious . . . that in this milieu there are people who constantly write books on the subject of artistic proportion . . . and that one can belong [to such an intellectual circle] here."[1] Ironically, eight years later, as *Ordinarius* professor of art

history at the University of Hamburg, Panofsky not only wrote on the theory of proportion but also helped to found an art-historical movement known for its iconographical scholarship throughout the postwar period.[2] That there were scholars in Hamburg who wrote on the theory of proportion was "mysterious" because, as Panofsky wrote pseudonymously that same year in the play *Phaedrus Hamburgensis*, Hamburg was generally known not for its intellectual life, but rather for its poor climate, its rich food, and its citizens' insular custom of marrying only locals.

But Hamburg also had money, an asset that not every city could claim, and this private wealth created distinctive possibilities in that city for the relatively new field of art history. Even as these scholars often had to justify their projects in terms of economic goals, as we have seen with the founding of the university, private institutions gave scholars the autonomy necessary to promote new kinds of scholarship. Although Germany developed, in the early twentieth century, institutions that were both privately funded and connected to universities—a tradition of which the Warburg Library was part—this tradition was also a conscious emulation of an American model. Drawing on this institutional context with its new possibilities, Panofsky proved himself truly adept at navigating the tricky poles of "commercialization and old-maidhood," and he expertly shepherded art history from an avocation to an academic and professional discipline.[3] A successor of von Melle's, Mayor Carl Wilhelm Petersen, later remarked with respect to Cassirer that in Hamburg "economics [was] a teacher to philosophy."[4] With Panofsky's arrival, this economic situation also came to benefit art history.

———

In his pursuit of "science as a vocation,"—to borrow Max Weber's well-known phrase—Panofsky made the transition from private scholar to *Privatdozent* at an up-and-coming university, a choice that had both advantages and disadvantages for scholarly life even under the best of circumstances.[5] But his scholarly path was further affected by the inflation crisis that reached its apex in the fall of 1923 and was compounded by national political unrest that November. Although the inflation was primarily a financial predicament, devaluing currency and making it increasingly difficult to purchase goods, it also had an enormous psychological impact on the population and precipitated a widespread loss of faith in the new democratic government.

The crisis was also particularly hard on scholars, as the inflation threatened to devalue their vocation. In both of these respects—financial and psychological—the city turned out to be a source of strength. Hamburg's American-style tradition of philanthropy and, in particular, an influx of American dollars, gave its scholars an advantage over others in addressing these economic challenges. Moreover, as scholars of symbolic forms, Warburg, Cassirer, and Panofsky were well equipped to comment on the collapse of this fundamental relationship between symbol and reality: money. Read in the context of the economics of scholarship, Panofsky's arrival in Hamburg sheds new light on this scholarly circle.

The Economics of Art History

Although he was born in Hanover, Panofsky, like Cassirer, spent the majority of his youth in Berlin. And when he entered the University of Freiburg, Panofsky—again like Cassirer—studied law to please his father. But he soon left the financial security and easy respectability of that profession for the nascent field of art history, a decision that put him on the path that Warburg had blazed from his business-oriented German-Jewish family. Scholars have connected aspects of this common overlap of art and business with the attributes of money lending—evaluations of authenticity, appraisal, and close observation—that made the children of German-Jewish businessmen likely candidates for careers in art history. And the figure of the Jewish banker-turned-art historian was something of a local legend in Hamburg.[6] There were also substantial historical and institutional reasons for this connection.

In the 1840s, the repeal of academic restrictions on Jews coincided with the rise of impressive art collections by wealthy German and Austrian Jewish families, including those of the Goldschmidt, Oppenheim, Pringsheim, and Rothschild families. At the same time, some of these families—notably including the Cassirers, as well as the Heinemanns, the Seligmanns, and the Wertheims—involved themselves in the business of art and established prosperous art dealerships throughout Germany.[7] And so, in his pursuit of art history, Panofsky embodied a generation of prosperous German-Jews who took advantage of this historical coincidence. But it was in his desire to establish the very epistemological foundations of that field that Panofsky distinguished himself, and it was the city of Hamburg, unburdened by tradition and protocol and

privileged with rich local collections and an entrepreneurial spirit, that provided the context for this disciplinary innovation.

Panofsky's transition from the study of law to art history was swift. At the University of Freiburg, he became friendly with the art history student Kurt Badt, who took Panofsky, still in his first semester, to a lecture on Dürer by the art historian Wilhelm Vöge, the director of Freiburg's Institute for Art History. Like many art historians of his day, Vöge worked as both a curator and a scholar. It was following a spat with another curator, Wilhelm von Bode, that Vöge left Berlin for Freiburg, where he was able to create an impressive department and library collection. For Panofksy, Vöge's lecture had a decisive impact, and in 1910, after only two semesters studying law, he turned his attention to art history.

Like Warburg, whom he knew from his studies with Hubert Janitschek in Strasbourg, Vöge pursued an all-inclusive methodology that drew on the fields of history, psychology, and paleography, perhaps in an even less manageable way than did his Hamburg colleague.[8] Unfortunately, in addition to a set of common interests, Vöge, like Warburg, had also been irreparably devastated by the First World War and suffered a nervous breakdown in 1919.[9] Although Panofsky left Freiburg before this neurotic episode, studying in Munich before eventually settling in Berlin, he of course encountered a similarly beleaguered personality in Hamburg.

In 1915, following the completion of his dissertation the year before, Panofsky enrolled in a doctoral seminar led by the art historian Adolph Goldschmidt.[10] During this time, Panofsky received not only substantial training from Goldschmidt but also something ultimately more transformative: his introduction to the Hamburg cultural scene. Goldschmidt, a medievalist, had developed the art history program at the University of Halle before returning to Berlin in 1912 to replace the Swiss art historian Heinrich Wölfflin.[11] A charismatic teacher and lecturer, Goldschmidt cultivated a devoted following of students during his time in the city. Like Warburg, Goldschmidt had been raised in Hamburg and born to a wealthy Jewish family who expected his eventual involvement in the family's bank. But while in London to apprentice in international banking, Goldschmidt spent more of his time drawing and painting than trading and banking.[12] And like Warburg, Goldschmidt forsook the family business to pursue a career in art history, ultimately developing a school of his own that he led for more than two decades. These similarities converged in 1915 when Warburg invited his fellow Hamburger Goldschmidt and Goldschmidt's seminar

of young art historians to meet him and tour his library during their Christmas break. Panofsky was one of those dozen seminar students.[13]

On this trip to Hamburg, Panofsky also visited the city's art museum, the Kunsthalle, and met its current director, Warburg's close friend Gustav Pauli, who, following Lichtwark's death in 1914, had become director of the Kunsthalle. Described as an "incarnation of the Hanseatic noblesse," Pauli had been born in the nearby city of Bremen, where he was a member of the local patrician class, and was a trained art historian.[14] And, in contrast to Warburg and Lichtwark, who had a notably contentious relationship, Pauli and Warburg developed a strong friendship, which presented a united cultural front in the city. Pauli, impressed with Panofsky's dissertation, which was some of the best work on Dürer to date, convinced Warburg that the young scholar showed great promise.[15]

At the time, the field of art history was relatively new, and the marrying of Panofsky's interest in epistemological questions with Warburg's interdisciplinary library, the products of which are discussed in chapter 6, proved wildly productive for the discipline. Panofsky was only twenty-eight when Pauli persuaded him to move to Hamburg, to receive his *Habilitation* from the city's university, and to cultivate an art history department there. The combination of the nascent field and the still up-and-coming institution meant that, following the successful completion of his *Habilitation* on Michelangelo, Panofsky was offered the position of *Privatdozent* rather than of *Ordinarius*, the position Cassirer had been granted in the better-established philosophy department. Despite his nominally junior status, however, Panofsky was given the responsibilities of accepting and examining doctoral candidates, and, in the absence of an *Ordinarius* in art history, Panofsky became the informal director of Hamburg's budding art-historical seminar, a situation that aggravated the ambitious young scholar.[16]

Pauli became responsible not only for bringing Panofsky to Hamburg but also for negotiating the terms of this precarious arrangement with the university's senate. Writing to Mayor von Melle on the young scholar's behalf, Pauli contended, "In the interest of Hamburg and the university it is highly desirable . . . to keep one of the most competent of the new art historians here. In the back of my mind, I nourish the hope that it will be possible to promote Panofsky to the status of professor and to make him an *Ordinarius* following the course of a reasonable trial period." That by 1920 Panofsky had already received offers from other institutions was a sign of his prestige, and Pauli used these offers as leverage to negotiate on his behalf, to secure him an office in

the Kunsthalle as well as full access to the museum's resources, and to gain the promise of a future promotion. Grateful for and aware of his advocate's role in securing his later success, the iconologist later joked in rhymed verse, "St. Petersburg has many icons/but it is good to live under Pauli's guard."[17]

Science as a Vocation

It proved difficult for Pauli to make good on the promise of Panofsky's promotion, since as it happened, the younger man completed his doctorate at the height of the inflation, an economic crisis of legendary proportions. By the end of the First World War and well into the 1920s, the German economy experienced an inordinate rise in the price of goods and a corresponding decline in the purchasing power of the German mark, a situation that at its worst led to the devastating exchange rate of 4.2 trillion marks to the dollar. This nationwide inflation created a particularly onerous economic situation for universities, for it was impossible to raise professors' salaries in compensation for the devalued currency. By 1922 the average academic salary was worth only one-third of its prewar value. On some days, Toni Cassirer, who received her husband's paycheck last because the couple lived at the end of the university messenger's bicycle route, could not afford to purchase a dozen eggs with this income, eggs that by the afternoon would cost ten thousand marks and, therefore, require the proverbial wheelbarrow filled with money to procure.[18]

Students suffered from the postwar situation as well. German universities were overrun by new students, following the demobilization of soldiers from the front. Although in 1918, only 80,000 students were enrolled at German universities, by 1923 this number had increased to 112,000.[19] Hamburg's university movement had benefitted from this need and enrolled 1,729 students in 1919 at the founding, a number that would double by the end of the Weimar Republic.[20] However, the university was challenged with accommodating this new influx of students, and the students confronted an increasingly tight job market upon graduation.

Those students who wished to pursue careers in academia were particularly burdened by this situation, facing economic conditions far worse than had existed before the First World War. As Weber observed, "because of a system that required one to first teach as a low-paid assistant for several years, it was nearly impossible to pursue a career as

an academic without a separate private income."[21] Cassirer's family in Berlin supported him in this way and even published his books, including his ten-volume study on Kant, during the thirteen years that he remained a *Privatdozent*. Following the inflation, though, fewer German families could afford to fund their children's academic pursuits. The economic crisis rendered the path to full professorship far less secure. Success within the academy not only came as the result of skill, politics, and luck but was also directly correlated with available funds.

These difficult economic conditions made continuing in the position of the private scholar (*Privatgelehrter*) a less feasible option for the academic than it had been before the war. Throughout the 1920s, Warburg continued to receive financial support from his family, funding that allowed him to pursue his intellectual pursuits unburdened by the responsibilities that accompany institutional affiliation. But a monograph that had sold at the retail price of four marks in peacetime by January 1923 could not be bought for less than three thousand marks, an economic reality that made it difficult and almost impossible for an individual without significant wealth to acquire books. In his 1923 report "The Distress of German Learning," Georg Schreiber, a delegate of the Center Party in the Parliament, announced accordingly that the private scholar was a dying breed: "He is a disappearing segment of the population. I mean those scholars who are not really connected with the German universities officially or as teachers. Nevertheless, they have often done valuable services for German scholarship as researchers and collectors. One may only remember the areas of history, literary studies and art analysis." The demographic that Schreiber described represented an important social development. For the first time, according to the historian Fritz Ringer, Germany had created "a kind of academic proletariat."[22]

Despite this despondent economic backdrop, Panofsky decided to pursue the life of an intellectual, and for some time, favorable circumstances enabled him to enjoy the life of a private scholar. Panofsky was deemed physically unfit for active military service in 1911 and was able to continue his writing and research throughout most of the First World War. In 1917, however, he was called to serve in the homeland effort and with his wife, Dora Panofsky, whom he had met in Goldschmidt's seminar in 1915, moved to military housing in Kassel. Albert Mosse, Dora's father, teased his son-in-law that this military service could not have been so strenuous if Panofsky had still found the time to compose a Latin poem to celebrate Mosse's nomination as an honorary citizen (*Ehrenbürger*). Erwin Panofsky had also, Mosse joked, "overestimated

the effectiveness of the humanistic education of the *Gymnasium*," since his father-in-law's friends understood only "a word of Latin here or there."[23] As Dora was now in Kassel and pregnant with their first child, the couple increasingly confided their "financial difficulties" with the Mosses, and Panofsky may have felt pressure from the family to choose a more profitable profession.[24]

Many of Panofsky's former students and colleagues have speculated that he would have preferred to be a private scholar, had the change in his financial circumstances not precluded it.[25] Panofsky's own family had amassed enough of a fortune through the coal-mining business to support Panofsky's father's life as a rentier, drawing on the income from his property and securities. In other economic circumstances, as the intellectually minded son of such a rentier, Panofsky might have become a rentier intellectual (*Rentenintellektuelle*), a category that the economist (and brother of Max) Alfred Weber viewed as "the basis of this elite's freedom in relation to the tyranny of the . . . particular job undertaken."[26] Weber noted, however, that this condition would soon be a relic of the nineteenth century, and Panofsky's own family situation seems to reflect this decline.

Given Dora's prestigious pedigree, there is no doubt that Erwin Panofsky would have been attracted to his classmate. Born in 1885 to Albert and Caroline ("Lina") Mosse (née Meyer), Dora Panofsky benefited from the prominence and wealth of her extended family in Berlin. Albert Mosse's brother Rudolf, Dora's uncle, owned a publishing company responsible for newspapers including the prestigious *Berliner Tageblatt*, the *Berliner Morgen-Zeitung*, and the *Berliner Volks-Zeitung*, as well as several publications abroad. The Mosses had held extraordinary influence and were highly respected both among Berlin Jews and within left-wing political communities for four generations, from the imperial period to the Weimar era. Panofsky later embellished the narrative of his own upbringing with stories of eating pheasant and referred fallaciously, on occasion, to his family's noble lineage, but the art historian's modest upper-Silesian father and Hanover-born mother did not hold the Mosse family's panache.[27] Nonetheless, although the Mosse family had amassed a significant fortune from its publishing company, because this wealth was split among so many children and devalued from the inflation, it is unlikely that it could have supported Panofsky's intellectual interests.[28]

That Panofsky needed a paying job was obvious, but the extended Mosse and Panofsky family did not imagine that this position would necessarily be that of a professional academic. Although his family

members wanted him to make money, even Mosse conceded to Panofsky, "That you have at your disposal a gift for teaching, I know by virtue of my own experience." Even as he acknowledged the additional economic hardship that Panofsky's career choice would necessarily bring on him and his family, Mosse was sympathetic with Panofsky's intellectual aspirations, and despite his misgivings, he supported his son-in-law in the decision to abandon a more financially secure profession for the pursuit of scholarship. "I do not doubt that the teaching will not only bring you success but also satisfaction," Mosse wrote to Panofsky. "So in full confidence I can wish you 'luck on the way.' . . . You will hopefully see better times one day, even if it will take awhile."[29] In lieu of approval from his own father, who had passed away when Panofsky was still a student, the blessing of his father-in-law Albert Mosse was significant.

Mosse's anxieties about Panofsky's professional and financial situation were well founded. The promotion from the position of assistant to full professor demanded a particularly lengthy process, one made longer still by Panofsky's histrionics about the matter. In November 1920, Panofsky began lecturing at the University of Hamburg. And as Pauli had anticipated, in just over a year Panofsky received an offer to teach at the university in Dorpat, a position that Pauli persuaded him to decline, promising that his promotion at Hamburg was imminent. Panofsky acquiesced but remained anxious about the cost of living in the wealthy port city, obsessively recording the conversations he had with Pauli and others on the subject and the timeline of his prospective promotion. Panofsky complained that there was never really anything fixed in Hamburg, rather only "half promised" (*halb und halb versprochene*).[30] Being a pioneering scholar had its drawbacks.

Largely owing to the unwavering support of both Pauli and Cassirer, that summer Panofsky was offered a lectureship as well as the fixed salary of an assistant position. This job offer was well timed, for Panofsky's personal fortune had nearly been consumed by the inflation. He later noted the irony of the unique predicament by which he was "made a paid assistant of the very seminar of which [he] was the unpaid director."[31] Yet, despite this curious arrangement, Panofsky was admittedly content with his improved status. "My lectures are enriching my own knowledge very much, and everything would be heavenly, if I had (next to a little more money, but also one should not be immodest) a little more leisure time in addition to my work."[32] Such leisure time, characteristic of the private scholar's life, was a luxury for the professional art historian.

The mercantile city of Hamburg provided the ideal environment for

the young Panofsky's intellectual and professional growth. Over the course of the 1920s, he ascended the ranks of his department in the university, delivering lectures on a wide variety of topics and cultivating a loyal and active contingent of devoted student followers. In January 1926, Panofsky was promoted to the rank of *Ordinarius*, making him one of three German Jews—the others being his teacher Goldschmidt in Berlin and Paul Frankl in Halle—to obtain *Ordinarius* positions in art history before 1933.[33] Three years later, Panofsky served as adviser to some twenty graduate students and spent his evenings answering their questions in his office or apartment, sometimes continuing until well after midnight.[34] Picnics and social affairs, which Dora Panofsky also attended, were a staple of this scholarly scene. The relationships the couple nurtured with students and colleagues continued in the postwar period. As Panofsky later observed, the professor-student bonds were "different" there.[35]

Although he later criticized the excessive administrative duties demanded by American university positions, Panofsky took pride in these tasks in Hamburg, assuming greater organizational responsibility with time.[36] In the 1930–31 academic year, when he was appointed dean of the entire philosophy faculty, Panofsky's administrative roles extended to the university at large, and he began to oversee a wide range of academic affairs. Throughout this time, his in-laws, the Mosses, continued to derisively refer to Panofsky's new home as "noble Hamburg" (*edel Hamburg*), a typical Berliner's insult that reflected the port city's prominent mercantile reputation. Despite his in-laws' teasing, when, in 1929, he received a job offer from the University of Heidelberg, Panofsky was not particularly tempted. It seemed that, as Warburg noted in the library's diary to Saxl and Bing, Panofsky had been "Hamburgized" (*verhamburgert*).[37]

Phaedrus Hamburgensis

In November 1928, almost two years after he was appointed *Ordinarius*, Panofsky attended the annual winter festival organized by the Society for the Friends of the University. With its stated goal as "a closer collaboration between Hamburg and its university as well as the mutual promotion of scholarship and practice," the society served as a fundraising organ for the university. It was following the inflation and its stifling effect on fund-raising efforts that the society, after years of inactivity, reorganized in 1927. Although the economic crisis officially

ended in December 1923 when the German government revalued the mark, Hamburg's university continued to struggle financially for the next several years. Indeed, the university's budget was so limited that its senate decided to lengthen the Christmas holiday on at least two occasions in order to reduce the costs of heating the lecture halls during winter.[38]

In 1928, the society's highly anticipated winter festival constituted the organization's first gala event since the inflation. The evening promised music, theater, and "Hamburgian humor" to raise money for the university's student fund.[39] As part of the celebration, three students presented a one-act play entitled *Phaedrus Hamburgensis*, in which the ancient philosophers Socrates and Phaedrus convene at a modern gas pump in Hamburg's upper-class neighborhood of Harvestehude and offer a satire on Hamburg society. The stage was decorated in Hamburg's colors, red and white, and displayed the society's seal. The play's author was listed anonymously in the program, but many attentive audience members, including Mary Warburg, correctly guessed that the phantom playwright was the art historian and society member Panofsky.[40]

In Panofsky's play, Socrates and Phaedrus pursue a philosophical inquiry about the relationship between the Good and the Beautiful and between good business and good souls. In the foreword to the published version of the play, *Sokrates in Hamburg, oder vom Schönen und Guten* (Socrates in Hamburg, or, of the good and the beautiful), which appeared in the Berlin modernist journal *Der Querschnitt* in 1931, Panofsky revealed that it was a reproduction of an earlier play and for dramatic effect offered an apocryphal account of the play's origins in the Episcopal library in the nearby suburb of Bergedorf. Perhaps because of this story, scholars have not made the connection between the performed and published plays,[41] and without this connection, *Sokrates in Hamburg* has been misunderstood.[42]

In the context of the winter festival for which it was written, the play can best be read as a reflection on the interdependence of commerce and culture in Hamburg—the very object of the evening's celebration. Panofsky wrote satirically in the foreword to the play's 1931 publication that *Sokrates in Hamburg* revealed many unknown facts about fourth-century Hamburg, including, for example, that the number 18 tram was then called the 19 but nevertheless went no faster than its modern successor and that Hamburg's citizens shared a "love for rich and well-prepared food with the ancient Greeks." However, *Phaedrus Hamburgensis* was not a jeremiad of the insidious influence of commerce on the city but rather a playful riff on Hamburg's unique mercantile

spirit. In this respect, Panofsky was inspired by Heinrich Heine, who often mocked Hamburgers for their love of material things, even as he spent much time with his own banking family in Hamburg.[43] *Phaedrus Hamburgensis* not only satirized the commercial republic in a pseudo-Platonic dialogue but also celebrated Hamburg's resilience as a unique place of intellectual life.

In the play's first scene, Phaedrus appears at Socrates's house to invite him to drive to Neinstedten, part of Hamburg's former Danish quarter Altona that lies directly on the Elbe River. When, upon his arrival, Phaedrus discovers that his car has broken down, Socrates, ever the educator, remarks that the car is not broken down, but rather, out of gas. "You appear to come to me as an Ethiopian or an inhabitant of the island of Atlantis," Socrates admonishes Phaedrus, "because you do not know that not that long ago something was established on Mittelweg for precisely this purpose." Socrates and Phaedrus then set off to the gas pump on Mittelweg, where, just as "by the plane tree on the bank of the Ilissus," Socrates suggests that they pursue a philosophical discussion.[44]

Inspired by the "gentle murmur of flowing gas," Socrates begins to investigate the relationship between the Good and the Beautiful as it pertains to the relationship between "good business" and "good souls." The gas pump amazes Socrates because "this tool reports the amount of gas that the seller has given, making it possible to be recognized by the buyer." The question that interests Socrates is whether or not this "good business" of the gas pump implies by extension that the businessman possesses a "good soul." The dialectic, which Phaedrus discovers with Socrates's assistance, is that even if the businessman does have a good soul, he lacks the opportunity to prove this, because the gas pump immediately shows the price to the customer, precluding any cheating on the part of the seller. Socrates exclaims, "Does it not appear to you, my Phaedrus, that this gas pump is just a slave overseer that ensures that the salesman trades according to fair business?"[45]

The play comes full circle when the personified gas pump, called Benzinopompus, claims that his machine is broken and demands a price of thirty "amphore" rather than the twenty that his window displays. Phaedrus suggests to Socrates that he should be pleased with this encounter, even though he was evidently cheated, because the gas pump's demand for more than was accounted for by the machine suggests the existence of a gap between one's soul and one's commercial activities. "Perhaps the will-not-to-cheat could work in precisely the same way," Phaedrus cheerfully remarks.[46]

The play garnered many laughs that night, but as a historical document, it also does much more: it suggests a relationship between the soul and business, parodies the interdependence of culture and commerce characteristic of Hamburg at the time, and comments on the inescapability of local customs in the evaluation of universal principles. In Plato's original *Phaedrus* dialogue, Socrates and Phaedrus meet under a plane tree on the bank of the Ilissus and engage in a philosophical discussion about love. In a typical trope of the Platonic dialogue, Phaedrus rehearses speeches over the course of the conversation delivered on the previous evening. These speeches are concerned with good and bad rhetoric, rather than good and bad business, and what is at stake in Plato's version is ultimately the vindication of philosophy.[47] Good rhetoric, Socrates concludes, is that which engages in a "skillful leading of the soul." And for Socrates, this process is synonymous with philosophy, a practice that must aim to unite truth with the power of persuasion. One scholar notes: "If rhetoric can prove that it has a grasp of truth, it will be a true branch of expertise. But that is an awfully big 'if.'"[48] Similarly, Panofsky's play seemed to suggest that good business and good souls could be aligned if—and this was a substantial contingency—the "will-not-to-cheat" could work in the same way.

In Panofsky's play, Socrates, momentarily satisfied with Phaedrus's lack of objection to the question of good souls and good business, announces his desire to investigate the nature of goodness itself as the quality of something most suited to its goal, an inquiry that parallels the secondary plotline in Plato's *Phaedrus*, the "chariot metaphor." Drawing on the chariot to represent the balance of various impulses in the soul, Socrates reasons, in the original text, "Although our inner ruler drives a pair of horses, only one of his horses is thoroughly noble and good, while the other is thoroughly the opposite. This inevitably makes driving, in our case, difficult and disagreeable." While scholars have speculated as to whether this speech provides an example of good rhetoric, it is made clear that achieving true rhetoric is a challenge when "driving the chariot" is so "difficult and disagreeable."[49]

With the engine not yet full and no chariots in sight, in Panofsky's adaptation, the number 19 tram becomes the object of a discussion on the Platonic categories of the Beautiful and the Good. In particular, the decision of certain city residents to ride the number 19 tram, even though it is neither faster nor more comfortable than other trams, seems to Socrates fertile territory for the exploration of "goodness." Given that local practice leads to assertions of goodness, Socrates concludes that "the Good and the Beautiful are nothing other than the

characteristic, which those men who ride the 19 embody simply because they choose to ride it."[50] In true Socratic form, the Good and the Beautiful appear to be nothing beyond that which the Hamburgers say they are.

While Panofksy's was a circular argument, it was one consistent with Plato; just as in the instance of true rhetoric, the truth must already be known in advance. The play celebrated the context that set the terms for such a debate. In the absence of universal good or bad, values are determined by local customs. And to the extent that the original *Phaedrus* was educational—meaning to persuade Phaedrus to channel his rhetoric toward philosophical truth—so Socrates's presence in Hamburg was enlightening, asserting to the play's audience that achieving good business, like achieving good rhetoric, would continue to challenge Hamburgers as long as their souls remained "difficult and disagreeable."

Anxiety of *Geld* and *Geist*

Panofsky's *Phaedrus Hamburgensis* was, as Heine's work had been, amusing in an incongruous collision, specifically, the juxtaposition of the ancient Socrates with contemporary Hamburg. But what did this collusion of ideas and commerce mean? And how was it affected by the recent economic crisis? These questions were implicit for an audience for whom the absurdity of a Socratic dialogue in Hamburg was only magnified by the geographic location chosen for the meeting—not under the "plane tree on the Ilissus" but rather on Mittelweg in Hamburg's Harvestehude neighborhood. Panofsky deliberately set his play in this neighborhood, one known as the "villa quarter," in reference to the grand, bourgeois, and imposing homes set along the Alster River. Inhabited by senators, shipbuilders, and merchants, Harvestehude had, at the turn of the century, Germany's highest average income per capita; more than half of its households employed live-in servants. Harvestehude was also Warburg's home, and his family came to be known and referred to by their historical connection to this street.[51] The play's setting, then, represented the pinnacle of Hamburg's commercial success and exemplified the city's mercantile identity.

Even though Hamburg's university had been in successful operation for nearly a decade, the city's scholars continued to be anxious about maintaining a corresponding intellectual identity amid such apparent material success and continuously invested energy to promote an

image of the port city as a suitable place for scholarship. The director of Hamburg's Museum of Ethnography, Georg Thilenius, who also served as university rector in the academic year 1920–21, claimed that the challenge of making ideas as important as business in the city was unrelenting: "Commerce and shipping were both the older bearers of political and economic importance of the city-state: how could one integrate science as a third foundation with an equally strong sense of autonomy?"[52] The tension between the city's mercantile heritage and new intellectual ambitions threatened the young university's success, and the revelation of that tension provided the source of the play's comedy.

Written and performed in 1928, between the inflation and the onset of the Great Depression, *Phaedrus Hamburgensis* functions as a cultural artifact of those historical episodes. The period's harsh economic conditions both amplified scholars' concerns that Hamburg's intellectual position was dubious and increased their dependence on those very conditions. The economic crisis invariably created a corresponding set of worries in the realm of culture and scholarship, transferring anxiety about *Geld* (money) into anxiety about *Geist* (intellect). *Phaedrus Hamburgensis*, the product of one of the city's prominent cultural figures, emerged as a prism of modernity through which a collective experience of the inflation was reflected.[53]

As an economic event, the inflation increased Hamburgers' sense of their exceptionalism. Following the First World War, Hamburg businessmen generally opposed further regulation and the efforts to create a centralized Reich bank. Food importers in Hamburg lobbied against quotas of foreign exchange to cover their bills. And when the Republic moved to institute a new currency to address the inflation, Hamburgers resisted. In the academic community, the crisis and its embodiment in the university's changing material circumstances profoundly affected the experience of the city's students and professors, too. In an increasingly volatile economic climate, these scholars developed a sense of unease regarding their personal worth. In addition to this anxiety, the crisis also affected academics practically. For, as Schreiber described in "The Distress of German Learning," the inflation meant "the printing of even a small doctoral dissertation [was] no longer manageable with a sum under a million marks." Schreiber surmised that it must have caused the students psychological distress to invest so much into work that they would never see in print. Professors also translated their apprehension over the economic situation into a general concern for their intellectual and cultural lives. Whereas in 1913 professors earned seven

times the amount that unskilled laborers did, in 1922 they earned only a humiliating 1.8 times as much. As Benzinopompus commented to Socrates and Phaedrus, machines like the gas pump were usurping the jobs of even nonskilled workers.[54]

The physical materiality of the intellectual world was never more apparent than when the standard tools of any university, its microscopes, laboratory equipment, books, and journals, had become rarified commodities difficult for even the universities themselves to procure. Before the First World War, Hamburg's university library had subscribed to nearly five hundred journals, but because of the extraordinary cost of even paper itself, in 1923 it carried only five. In a city where business had always been privileged and in a time when economic concerns influenced every realm, culture risked becoming obsolete—it was of no practical use in a market inundated with goods. Ideas could not purchase a dozen eggs, and a painting was more useful sold than admired.[55]

These sentiments only exacerbated Hamburg's deeply rooted anxieties about its reputation for mercantilism and anti-intellectualism. On the evening of the winter festival and the accompanying dramatic performance, students, professors, and other members of the academic community gathered not only to make light of the tension, but also to take action. The classical trope was a common choice of medium for this humor and it was reflected not only in the university's efforts, but also in the internal politics of the Warburg Library. On a postcard that Percy Schramm sent to Saxl imploring him to send money for the acquisition of books, the Hamburg historian encrypted his message with a Greek transliteration of the German words—Saxl, Help, Money (fig. 6). Broke scholars could certainly poke fun at themselves, but philanthropy required study and Warburg was, in this respect, the most serious student.

Good Souls and Good Business

While the city's residents may have doubted Socrates's arrival in Hamburg, the perceived connection between "good souls" and "good business" was long-standing. Regarding this history, mayor Petersen reminded an audience of businessmen, "Good Hamburg tradition has always encouraged the support of culture's demands through private means where the state was not able to give as generously as desired."[56]

6 "Saxl, Help, Money," is the message on this postcard that Percy Schramm sent in 1924 to
 the Warburg Library's director. Warburg Institute, London.

As a privately funded university that depended on the contributions
of Hamburg's citizens, the University of Hamburg was a product of
this philanthropic spirit. In this sense, the Society for the Friends of
the University, the sponsor of the dramatic evening, was the succes-
sor to the Hamburg Scientific Foundation, the organization that Aby
and Max Warburg had established in 1907 to raise funds for the uni-
versity's founding. But while on the evening of the winter festival the
society raised nearly eighty-five hundred marks for student assistance,

the university still lacked the necessary revenue.[57] Without the aid of local benefactors like the Warburgs, the city's intellectual life would have gravely suffered.

Warburg was both benefactor and recipient of this philanthropic society: he depended on his family's financial support, and because of this backing, he enjoyed a privileged position allowing him to decline job offers from universities outside Hamburg and to establish his own institution. Indeed, this private wealth made Warburg free to spend much of his time expanding and organizing his personal library; he was not consumed by responsibilities to an academic institution. As we know, Warburg did not bask in the enjoyment of his books alone. Out of both his desire to promote an official research institution and his generosity of spirit, Warburg extended fellowships and stipends to colleagues and students alike. Despite Warburg's privileged status, Bing observed that Warburg was not an "otherworldly scholar," the kind who disappeared into the isolation of books and ideas. The apocryphal anecdote that described the young Aby's selling his birthright to his younger brother Max revealed Warburg's deeply pragmatic side. Rather than a whimsical intellectual, Aby had the makings of a shrewd businessman. Max Warburg often commented that Aby would have been a good banker. "He was known to come into the office on occasion and say, 'I hear the wings of bankruptcy rustling,' and he was often right."[58]

In opposition to the divide between good business and good souls threatened by Panofsky's dramatization, it was the Warburgs' good business that enabled the pursuit of their brother's good soul and academic ambition, and ultimately also Panofsky's. According to Carl Georg Heise, Warburg justified the "luxury" of his lifestyle with claims of its intellectual worth. Heise observed: "Warburg's characteristic selling formula in the most intimate circles was: 'Other wealthy families have their horse stables, you have my library—and that is more; because whoever collects material goods is permitted to and must do something for the development of the mind. Also, it is cheaper. And, eventually, one can have just as much fun with it as with horses, and yes, if you want to calculate it so, also win a little fame for this world and the next.'"[59]

But, regardless of these promises of fame in the next world, the Warburg brothers insisted on ensuring the venture's economic viability in this one and argued intermittently about establishing a fixed budget.[60] These sometimes-heated discussions, often mediated by Saxl, occurred on an annual basis, and the decisions, when reached, were not neces-

sarily set in stone. When Warburg returned to Hamburg from Switzerland in August 1924, he negotiated with his brothers over funding the library's new building. That project, for which they had set an upper limit of 100,000 Reichsmark, ultimately cost four times as much once it was completed, an estimation error that could have had something to do with the installation of the library's control panel for its many telephones, the expensive heating and ventilation system, the book conveyor belt, and the elevator. When the brothers expressed practical concerns, Aby saw the comments as evidence of their lack of faith in his project and chastised them for not being committed to his cause. "It is certainly risky!" Aby wrote to his younger brother Felix, "But that is the very beauty of it. Man must have the courage in the face of fear of the world to do something speculative sometimes, also in the intellectual respect: that is the greatest privilege of the private businessman!"[61]

Aby Warburg may have capitalized on his brothers' sense of obligation, but the result was an institution of which the family was certainly proud at the end of his life. In 1929, Warburg announced: "There is scarcely an undertaking in European intellectual history that proceeded so unshakably, even in the heady times of economic boom. And this was not the undertaking of self-indulgent luxury, nor of millionaires, but rather of business people who could surely have spent their money in other ways." To be fair, it was difficult to measure the success of a "reverse alchemist," but he continued, "I believe that if these results are weighed with the gold scale of the intellect and not with the butcher's scale, we can boast of truly excellent outcomes that have often overcome exceedingly difficult obstacles." Max Warburg, too, ultimately expressed gratitude to his brother for the opportunity he presented to contribute to cultural life. "I have never regretted the pact, because not only was Aby's lifework a success, but also it brought an enrichment of meaning to our lives and widened our horizon."[62] Warburg's library provided both the source and the refutation of the play's comedy; his business acumen, after all, led to the fulfillment of "good souls" in Hamburg.

Ironically, if the city's materialism had always been an anxiety-inducing quality for the University of Hamburg, threatening to discredit the authenticity of intellectual life, it was precisely this materialism that came to the rescue of scholarship during and after the inflation. For without the support of Hamburg's business community and its philanthropic tradition, the university might not have survived. The University of Hamburg had always diversified its sources of funding, and this was certainly the case during the inflation, when the *Ham-*

burger Nachrichten reported, "Hamburg's businessmen, industrialists, and scholars now all found themselves at the same table." Addressing a similarly diverse audience on the eve of the winter festival, the rector and professor Heinrich Sieveking appealed, "Scholarship . . . cannot exist today the way it did in Plato's time with one's head in the clouds; we need books and more than anything, in this climate, well heated rooms." While Sieveking's allusion to Aristophanes's *The Clouds*, a play that criticized Plato's otherworldliness, may not have been intentional, he made the clear assertion that "capitalism must serve as a sponsor, or life is not worthwhile."[63]

Americans, You Have It Better Off

Although he died in 1920, Weber's meticulous observations concerning "Science as a Vocation" reveal the contradictory attitudes toward the encroachment of economic values on scholarly life. For Weber, this predicament constituted a distinctive feature of the American academy, a system in which, he claimed, a professor "sells me his knowledge and his methods for my father's money, just as the greengrocer sells my mother cabbage."[64] And if no professor would have chosen the life of a greengrocer, the benefits of a privately funded scholarly enterprise, like that presented by America, were increasingly difficult to overlook. It was fortunate for Hamburg, though not a coincidence, that the Warburgs were among the first to catch on to this trend.

Hamburg businessmen had always felt a special relationship with their American partners. Panofsky used to tell a story about the illustrious Schramm family that reveals just how close this transatlantic connection was: Ruth Schramm, a newly minted nurse who was the daughter of a Hamburg senator, had just accepted a position not one hundred miles away in a nearby Prussian territory. "And when her father told this to one of the other senators, who happened to be a shipping magnate, the latter replied: 'But my dear friend, why did you permit Ruth to go so far away; I could easily have gotten her a job in New York.'"[65] If there were any would-be German philanthropists poised to become early adopters of the American tradition of privately funded scholarship, Hamburg's businessmen were most certainly among them.

The trend can be said to have begun a decade earlier at the one-hundredth anniversary of the University of Berlin with the founding of the Kaiser Wilhelm Society, and the first of a series of institutes, that aimed to promote research in the natural sciences.[66] Here, a new kind

of institution emerged that was semiprivate, as it was connected to the state but supplemented by industry. Designed by the theological historian Adolf von Harnack and the Prussian Culture Minister Althoff, the Kaiser Wilhelm Society and its planned institutes were constructed on the model of such American organizations as the Carnegie Institute and the Rockefeller Medical Institute and with the hope of keeping up with American advancements in biomedical sciences. Lamprecht, too, claimed to be inspired by the American impulse to donate for scholarly purposes, and he aimed to engender a similar sense of commitment in Leipzig. But what was first a desire to take advantage of innovation and opportunities became a necessity in the interwar period; whatever autonomy the Kaiser Wilhelm Society had gained in the previous decade was totally destroyed by the current economic crisis.[67]

The need for private donors, such as the Warburgs, then, became paramount during the inflation crisis when the family was so overwhelmed by solicitations from scholars that at one point in the 1920s they even rejected Albert Einstein's request for financing. In a time when both books and printing were prohibitively expensive, libraries—especially those, like the Warburgs', that were independent of state funding—became indispensable to the perpetuation of intellectual life. The Warburg Library was in an even more privileged position, particularly owing to the brothers Paul and Felix Warburg, who had emigrated to New York and married into the wealthy Loeb and Schiff families. Because, as Toni Cassirer observed, the American brothers had subsidized the library, it was still able to purchase books at a time when private acquisition had become impossible domestically. It was customary for Paul and Felix to kick in an extra five hundred dollars to the annual budget, as they did in 1921, American dollars that could fetch many more books than could the inflated mark.[68]

It was not only American currency that was enviable, but also the growing commitment of American citizens to privately fund culture and research. As we know, Warburg's trip to America in 1895 for his brother Paul's wedding, the trip that included his visit to the Hopi Indian reservation, was fundamental to the development of his intellectual and methodological insights. His visit to America was also important for another reason, since it was from Warburg's new in-laws, in particular the banker James Loeb and the Jewish railroad tycoon Jacob Schiff, that Aby Warburg became familiar with the essentials of American philanthropy.[69] In San Francisco, Warburg identified the tall and proud American as "the descendant of the indigenous race and of the gold-diggers who expelled the Indians: Uncle Sam" (fig. 7). But where

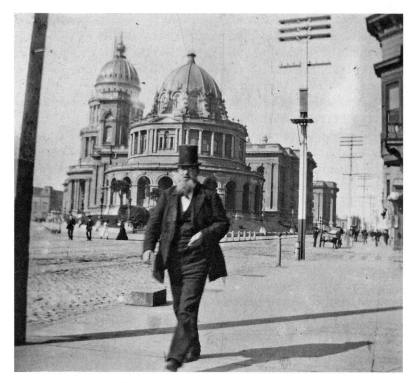

7 Warburg's snapshot of "Uncle Sam" on his 1895–96 trip to America shows the institutional influence of America on the art historian. Warburg Institute, London.

Uncle Sam failed to deliver, Warburg's relatives demonstrated how "out of gold he [could make] ideas."[70]

In the transition from the "Age of Benevolence" to the "Age of Philanthropy," characterized by the foundations of Andrew Carnegie and John D. Rockefeller and culminating in the establishment of the twentieth-century welfare state, a long-standing and unparalleled tradition of American Jewish philanthropy emerged.[71] Figures like Jacob Schiff and Julius Rosenwald made a name for themselves giving to causes both Jewish and secular in orientation. Rosenwald, the president of Sears, hardly one of the nation's richest men in the era of Rockefeller, was said to have given away between $60 million and $70 million over the course of his life.[72] Schiff, for his part, marked his seventieth birthday by donating to charities over a half a million dollars, or nearly one-quarter of his annual income.[73] American Jews had complicated reasons for their charity, and if they were motivated by a strong bibli-

cal tradition to take care of their own, they also used philanthropy to respond to social isolation, to articulate a secular vision of Jewishness, and to engender respectability for Jewish bankers. Many also found that their significant gifts to cultural institutions could secure them places within an otherwise exclusive social hierarchy.[74]

It was not uncommon for educated middle-class Germans to tour America, and their impressions tended to resemble those of Warburg's fellow Hamburger and banker-cum-art-historian Goldschmidt, who in the early 1920s was invited to serve as visiting professor at Harvard and spent the next several years at institutions throughout the country. Goldschmidt's memoir contains wonderful insights into the American academy in the interwar period, but one observation is particularly instructive. He claimed that the main difference between the art scene in America and that in Europe was that while in Europe one built a great museum only after the art had been collected, in America they built big buildings and then filled them with art.[75] The hollowness of the American cultural landscape and its lack of a civic foundation became a persistent theme for many Europeans.

But if others saw a lack of foundation, Warburg saw possibility in this "barbaric country" and even cited it as a source of inspiration for his own institutional mission. When the Warburg Library officially opened in 1926, he went so far as to say that his institution would not have existed had he not had the opportunity "to experience the American altruism over thirty years ago in America itself, and above all that of Jacob Schiff."[76] While he expressed little interest in "Jacob's very pretty daughters," Warburg was fascinated by the American inclination for philanthropy, which showed him that through the "energy of private citizens there need not be any inhibitions between the acceptance of duty and its realized action."[77] To structure his own institution, Warburg may have looked to the newly renovated Boston Public Library and the Library of Congress, both of which he and Saxl found superior to the Prussian State Library. It is possible that even the desire for technical apparatuses for the Warburg Library also emulated these American institutions.[78]

Warburg felt that it was doubtless this "shared ethics of the shipping community" that connected America with his *Heimatstadt*. His fellow Hamburger and Panofsky's patron Pauli, who wrote and published a report on his own American travels, concurred. Warburg confided in Pauli that he continued to believe that the "ship of my life is on course for America."[79] Unlike the skeptical Goldschmidt, Warburg shared with his friend, Pauli understood the "struggle for independence," and War-

burg echoed Goethe's well-known observation about America when he said it was "in this respect, [that] the Americans were better off."[80] Eager to return to that country, Warburg wrote to Felix that he was "working on a book, which [would] make him 'exchangeable for America, if I want.'" And he was devastated when a second trip, proposed for 1928, was stymied for medical reasons.[81]

Although Warburg dubbed this philanthropic tradition "American," it was more Jewish than anything else. Schiff, whom Warburg lauded as "American," for example, spoke himself of the Frankfurt tradition of Jewish philanthropy as his primary motivation.[82] Indeed, it was the overwhelming Jewish source of funding that made these institutions vulnerable to anti-Semitic attack.[83] Perhaps to guard against this, Warburg, like the savvy Hamburg mayor before him who concealed the true origins of the university donors, made America (however also vulnerable) a proxy for the tradition of values that he, as a Hamburger, shared. Chief among these was the necessity of financial independence, and he channeled this spirit in the creation of a privately funded institute of scholarship. Max Warburg, too, emphasized this autonomy as crucial to its success. "My view now, as before, is that the library can only work in its way if it has the flexibility of a real private library and will not be exposed to the dangers of a state administrative body." As early as 1924, Max and Aby Warburg resisted donating the library to the university. Although they did, with Saxl's help, turn the private library into a public research facility, equipped with fellowships, lectures, and a scholarly series, and promoted it as the de facto site of the art history department, the Warburg Library maintained its financial independence until its move to Great Britain in 1933.[84]

Without the burdens of an overpowering state and the requirements necessitated by government funding, the Warburg Library possessed unbridled potential. Of course the library was not entirely on its own. Warburg also sought out the legitimation of the university affiliation at the same time that he insisted on control of its affairs. Writing to the Hamburg State Library in 1916, Warburg already expressed hope that this institution might recognize his growing efforts as a research enterprise and include it in the formal web of municipal institutions.[85] The delicate balancing act of this long-term plan was laid out in a report from the Warburg Library in 1921: "The connection between the library and the university was already grounded in the fact that Professor Warburg was a founder of the university with the knowledge that only through the creation of the university would there be a scholarly

world in Hamburg in general and a transmission possibility for his intellectual world specifically." Of course this did not stop Warburg and Saxl from believing they were entitled to control the faculty of the art history department. In fact, they assumed it appropriate to hire only scholars who were intimately involved with the problems of the Warburg Library.[86]

Despite the sometimes tense discussions with his brothers over funding, then, Aby Warburg found the balance between autonomy and legitimation preferable, for it was easier to present his ideas to a "mercantile milieu," which understood the "ethos of a long preparation . . . rather than to a [municipal] board that would have already preferred a quick success for the sake of the public." Following the library's opening celebration, several local newspapers noted that Hamburg's private library provided culturally what was infeasible for the state, economically.[87] And the Jewish-American librarians and benefactors Cyrus Adler and Charles Kuhn, among others, also made the transatlantic journey in that same year to see the fruits of Warburg's labor.[88]

According to Sieveking, by any reckoning, Hamburg's scholars had benefited from the city's commercial world. One year after the inflation crisis, the rector remarked, "A nagging historian believed that a university would be suffocated in Hamburg's materialism. Now, the time sees to it that this standard of living did not bring its influence to bear too much."[89] Far from having a fatal effect, materialism proved vital to Hamburg's university, and these material conditions had a real impact on the ideas produced there.

Inflation and the Baroque—A Postscript

Although he was aware of the impact of material conditions on his scholarly life, and although his own possibilities were certainly the outcome of this productive tension between culture and commerce, Panofsky largely limited his scholarly inquiry on the economic conditions of art to intimate and often humorous settings.[90] Warburg, in contrast, continued to thematize money in the context of his growing interest in symbols and their relationship to human experience; he further clarified the relationship between collective conditions and scholarly life. Currency, after all, was one of the most foundational systems of symbol-making and relied on a shared understanding of the relationship between the symbol and the sign. In this respect, the inflation

was not only a financial disaster but also an existential one. When the gap between symbol and sign was revealed to be a farce, people's belief in the legitimacy of currency as a symbol was totally shattered.

In a lecture delivered to the Hamburg Chamber of Commerce in 1928, Warburg connected the philosophical dilemma sparked by inflation to his growing interest in symbols and their permutations over time. Before an audience of bankers, he introduced the fundamentals of his approach to the study of antiquity. In layman's terms, Warburg presented the problem of the Renaissance as one about the source of explanation for the transformation of symbols. Everyone agreed that the Renaissance represented a newly liberated moment, but the question remained as to whether this was "a consequence of the repossessed humanistic classical education or whether, in contrast, it was fundamentally the result of a revolution of manly earthliness for which the preemptory temperament of the intellectual education was only a tool in order to build a new world." Whether ideas themselves were means or ends was the central question. Warburg went on to show how the close business relationship between the Low Countries and Italy, and, in particular, land and sea traffic from Bruges to Florence, produced Flemish paintings and rugs, an influx of goods that had an impact on the artistic scene.[91] Economics, then, had played a vital role in aesthetic transformation.

But if economics supplied the conditions for the possibility of art, an excess of currency could also produce bad art. Here, Warburg introduced the example of the Baroque to discuss the pitfalls of the economic inflation, and the inflation to explain the excesses of the Baroque: "But such an act of sublimation and spiritualization remained possible only as long as the contact with the primeval strata to which the symbol owed its original dynamic force remained in being. Once it was cut loose from its roots and emptied of content it became a menace to true human expression."[92] Warburg's connection between the loss of meaning implied by the inflation with that of cultural symbolism first constituted a rhetorical tactic: to explain art history in terms that Hamburg merchants could understand. Warburg was no doubt also motivated by his appreciation for the deeper urban context; a healthy cultural world demanded a healthy economy. If Panofsky's *Phaedrus Hamburgensis* considered economic conditions to be a necessary evil for intellectual life, Warburg viewed a bad economy and bad art as inextricably linked. For Warburg, Dürer's transformation of demonic forces into creative genius constituted the pinnacle of good art. But such a process was possible only in a "good economy" where symbols

of currency retained their intended meaning. In a "bad economy" of symbols, not only was reconciliation impossible, but also the disconnection of symbols from their sources became dangerous. As powerful engines of emotional energy, they could be filled with substances other than those for which they were initially intended. In this respect, inflation was but one example of a wider problem of the relationship between symbols and signs and the challenges posed to modes of human expression.

That the inflation, as a symbolic event, did not favor Hamburg's businessmen was likely on everyone's minds. When charges emerged that they were trading against the economy to take advantage of the turbulent times for their own economic gain, these merchants needed the Hamburg Chamber of Commerce to come to their defense. Moreover, that prominent Jewish businessmen such as Max Warburg emerged as objects of these frustrations could not have been comforting. In November 1923 the price of bread reached 140 billion marks in November 1923 and angry mobs attacked Jews in Berlin. On the heels of this discontent Hitler made his first public appearance connecting the ills of the inflation to Jewish profiteering.[93] Aby Warburg's analysis of the dangerous relationship between empty symbols and emotional energy could be sensed in cries to "beat the Jews to death."

Although the scholar spoke principally about the Baroque, there was much at stake in determining the correct way to situate and interpret a symbol: Was art an expression of individual creative genius or a national ethnic characteristic? Were images an abstraction of an ideal, or were they also embedded in reality? A shared approach to these humanist-inspired questions came to define this growing group of scholars and their iconological method. And in a nod to the conditions that enabled their collective scholarly production, Panofsky named the circle the Hamburg School.

SIX

Iconology and the Hamburg School

God lies in the details.

ABY WARBURG

One thing became clear to me while I myself was alternating my residence between Germany and Italy. This phenomenon of exchange between North and South, which had become so strikingly evident to me, could only be studied at an institute that really brought together the northern and southern threads.

ABY WARBURG

Despite the financial insecurity that pervaded the early 1920s and the challenges it posed for academic life, Panofsky began to see himself as a part of a thriving local intellectual scene. "We have, against all expectations, a very nice and stimulating circle," he shared with Badt, "to some extent composed of men older than myself and contemporary to me, but partly also from 'students' (the oldest, and my favorite, is unfortunately finishing his doctorate[;] his work, the first of the 'Hamburg School,' the faculty has unanimously awarded the grade 'with distinction')."[1] The favorite student, Edgar Wind, completed his doctorate under Panofsky and Cassirer with a dissertation on art-historical methodology and became the Hamburg School's first disciple, an attribution that remained with him even in the postwar period.[2]

Yet, what distinguished the Hamburg School as a group of intellectuals?

No doubt all schools of thought arise, as did this one, to a certain degree, from circumstantial conditions. Those economic, cultural, and familial institutions that enabled its existence, however, also illuminate key features of their intellectual world. Parodied in *Phaedrus Hamburgensis*, the real Hamburg School reflected a new kind of privately funded institution of scholarship in the twentieth century, one that balanced the desire for autonomy that came from its fiscal independence with the legitimation that the university affiliation provided. The school also resulted from the camaraderie and sometimes, more often than not, the productive friction between creative and idiosyncratic personalities. And, of course, they shared methodological concerns.

Cassirer, as we have seen, moved beyond Kant to produce a broader critique of culture; so, too, Panofsky forged a "third way" between the formalist and contextualist approaches of his art-historical mentors. The philosopher dubbed his circle of scholars an "association" (*Arbeitsgemeinschaft*) with Warburg at the helm, and as he considered the library itself chief among their successes. Panofsky, for his part, began in the 1920s to promote a bourgeoning methodology of art-historical criticism that solidified around these scholars' shared interests in symbols and drew on the combined resources of the city: the library's unique index of images, the Kunsthalle's collection of local and modernist art, and the absence of an established and hierarchical department.

Part of the second generation of art historians eager to revise the pioneering works of their teachers, Panofsky and his cohort faced pressing questions on which the future of the discipline lay: How did one legitimately draw general conclusions from empirical evidence? How might these conclusions about specific time periods and cultures connect with others? And could one reasonably argue that these observations constituted anything like a science? The observation "God lies in the details" was a whimsical comment characteristic of Warburg's flair for the dramatic; this epigram also constituted a program for the cultural historian who sought the authority to claim that a particular insight could offer proof of a more general principle. Their answer, iconology—the methodology that promoted a holistic analysis of images over time—became the most lasting collective legacy of the school and its scholars.

———

The approach innovated by Warburg and developed by Panofsky has been criticized in recent years for being both too expansive in its em-

phasis on "style" and too limited in its epistemological authority. Gombrich, most notably, has attacked the method's broad cultural-historical assumption that art is representative of the *Zeitgeist*, and a younger generation of scholars rejects iconology's neglect of prediscursive methods of meaning-making. But Gombrich's criticism ignores that the translation of iconology into the English context (including his own) significantly revised the method's meaning. Moreover, postmodernism's focus on material culture is strangely reminiscent of these early German works. In Weimar Germany, before the emigration of these scholars, the school came to embody a more dynamic approach to the study of images over time. Their collective work converged around key preoccupations of the day, including the revision of Alois Riegl's notion of *Kunstwollen* (artistic volition), the validity of neo-Kantianism, and the problems of interpretation for the humanities at large. As with the conditions of reason discussed in chapter 4, these scholars investigated both the epistemological foundation of those images in their historical context and the damaging effect of that ordering process. In this way, they purported to balance the poles defining the era's familiar debates, mediating between structuralism and progressivism, universalism and particularism, and individual genius and collective attribution in art.

But the Hamburg School also coalesced around more than merely methodology. Although several scholars have mentioned that most of the iconologists (like the neo-Kantians) were Jews, this fact has not been meaningfully explored, in large part because it is difficult to do so without falling into precisely the kind of ethnographic art history that Warburg, Cassirer, and Panofsky fended off in their day. Undeniably, however, within a wider political debate these academic issues had real implications for these scholars' standing in the new democratic republic. The belief that the universal manifested itself in the particular—be it the divine, the aesthetic, or the juridical—was easily, too easily, transferable to contemporary debates concerning ethno-nationalism and cosmopolitanism. The interpretation of Dürer, for example, as either a German, a European, or an individual genius, was, then, more than an art historical inquiry: It was a political question.

Concern for these issues from periodization to methodology was no doubt motivated by Jewishness, although not, it should be added, gender differences. In the balance between autonomy and institutionalization described earlier, the women in this circle largely lost out. Nonetheless, the members of the Hamburg School attempted to avoid embroiling themselves in politicized discussions, even as their scholarship was inevitably inflected by their experiences as secular German

Jews. That the unique constellation of Hamburg's individuals and resources became associated with the cosmopolitan character of the port city was ultimately both a source of the school's strength and its weakness.

The Third Way

As early as 1903, Warburg began to develop the terminology of "style history" and wrote of a burgeoning "iconographic tradition."[3] And, as we know, his 1912 lecture on the Palazzo Schifanoia in Ferrara, Italy, also unveiled the methodology in an international context.[4] Technically speaking, the roots of iconography run even deeper. One scholar has traced the art-historical methodology to the efforts among nineteenth-century religious art movements to represent the divine through identifiable symbols; a logical connection for the need to make visible the invisible followed from the religious desire to gesture to the divine beyond the material object of the painting.[5] Through his interest not only in symbols and their functions, but also in the interpretation of life events themselves, Warburg took this one step further. Insofar as, for example, a festival created meaning from its activity, Warburg, Cassirer, and even Burckhardt saw life as an important source of signification. Panofsky expertly capitalized on these disparate traditions to produce a "third way" between the two dominating schools of the previous generation, an approach that bridged form and context in its dynamic analysis of images over time. So successful was his achievement that one historian has dubbed his career the "primary event" in the history of the field.[6]

As a discipline, art history emerged somewhat belatedly. Only a smattering of works on art appeared before the nineteenth century, including Vasari's *Lives of the Artists* (1550), which, although it largely presented biographical portraits of well-known painters, sculptors, and architects, hinted at a theory of aesthetic perception. Johann Joachim Winckelmann's 1764 work *The History of Ancient Art*, which drew further on notions of art in classical archaeology, laid the groundwork for a future scholarly endeavor. Following Winckelmann, several scholars, such as Karl Friedrich von Rumohr and Gustav Waagen, produced pioneering studies on artists and artistic movements. Many of these authors remained principally engaged in museum work, their interest in art history supported by a group of arts associations (*Kunstvereine*) and scattered publications, and it was only later in the nineteenth century

that art history was considered a true academic discipline. It acquired its first *Ordinarius* appointment in 1860 and convened its first professional conference in 1873.[7]

Although Panofsky boasted that an incumbent of an early chair devoted to art history in Göttingen was filled by a native of Hamburg, by the turn of the century, the still young field was dominated by two major personalities, Heinrich Wölfflin in Berlin and Alois Riegl in Vienna, both based far from that Hanseatic city.[8] According to H. W. Janson, a former student of Panofsky's who later himself became a renowned art historian, Panofsky entered art history at a time when the field was experiencing an identity crisis. In Janson's opinion, the problem for Wölfflin and Riegl's generation was that of analytically accounting for stylistic change over time.[9] Whereas science was clearly the model for such newer fields as art history, less clear was how to explicate a progression of images as one would mathematics. Wölfflin's and Riegl's answers to that question provided the scholarly context for Panofsky's early training and, to a large extent, his entire career.

Significantly for this legacy, neither Wölfflin nor Riegl was trained in a field at all resembling today's art history. Wölfflin had studied cultural history with Burckhardt, whose chair in Basel he assumed in 1897. Drawing on Burckhardt's scholarship on Renaissance art and culture, Wölfflin sought to establish a more systematic art history. Appealing to a theory of vision based on the psychology of artistic appreciation, his answer to the question of style ultimately amounted to the systematic and formal analysis of paintings. In 1901 Wölfflin assumed a post in Berlin and soon published two famous books, *The Art of Albrecht Dürer* (1905) and *Principles of Art History: The Problem of the Development of Style in Later Art* (1915), the latter of which laid the foundations for formalism in art history.

Although his methods varied over time, Wölfflin is often known for his comparisons of two images from distinct periods, an approach that influenced several generations of historians and is still felt today both in the continual usage of the "two-slide" method and in the foundational importance of formalism for artistic appreciation. Wölfflin was criticized by scholars such as Goldschmidt for his "empty phraseology" and by others for his "one-sidedness" and "art-history-without-names." Wölfflin's essay, "In eigener Sache: Zur Rechtfertigung meiner kunstgeschichtlichen Grundbegriffe" (For my own cause: In defense of my art-historical principles, 1920), later published in *Gedanken zur Kunstgeschichte: Gedrucktes und Ungedrucktes* (Thoughts on art history: Published and unpublished, 1941), constituted an attempt to clarify and to

defend his methodology. In the latter work, Wölfflin wrote of derisive accusations of formalism, "I accept this label with pride, since it means I am fulfilling my most important function as an art historian, namely, analyzing perceptible forms."[10]

Riegl's extensive training in law, philosophy, and history in Vienna resulted in a more theoretically oriented aesthetic perspective and a comprehensive systematic approach, both of which still interest scholars today.[11] In Vienna, he also gained curatorial experience at the Austrian Museum for Art and Industry, where he served as the director of the department of textile art from 1887 to 1897—a post that greatly influenced his desire to eradicate the distinction between high and low art. A self-styled intellectual and abstract thinker, Riegl was influenced by the notion of "vitalism" espoused by philosophers such as Henri Bergson in France and Benedetto Croce in Italy, and the impact of all these theories found their way into Riegl's art-historical approach.

Like Wölfflin, Riegl believed that the field of art history had the task of accounting for changes of style over time. Also like Wölfflin, he believed formal analysis was crucial to this charge. Yet, he was more ambitious in attacking the central epistemological dilemma for the field: how an empirical observation could provide a legitimate basis for a more general judgment about an era.[12] As the foundation of style, he developed the category of *Kunstwollen*, or the "specific and purposeful artistic intention," a concept that did the theoretical work necessary to fulfill the art historian's scientific responsibility. In *Problems of Style: Foundations for a History of Ornament* (German edition, 1893), Riegl introduced this concept as a transindividual basis for understanding the particular spiritual aspirations of the age, an idea that earned him significant scholarly attention and a professorship at the University of Vienna.[13] By the time he published *Late Roman Art Industry* eight years later, it was clear just how much work this concept could do. Extrapolating from the analysis of bulls and captors on Mycenaean cups from the second millennium, Riegl deduced a newly "optical" perception of reality in that period. Late Roman art was an era previously designated as a decadent aberration. However, according to Riegl, "To see decline in the late antique transformation is to presume to dictate the path that the human mind ought to have taken in order to arrive at the modern view of nature." Instead, his reading signaled a wider turn that led to the more spiritual Christian art and, via classical Greek art, ultimately arrived at the subject-based art of the modern period.[14]

Riegl's method—by which the historian uncovered the *Kunstwollen* of an individual work of art within the context of the artist's collec-

tive race, will, or whole artistic personality—formed the basis of the first Vienna School of art history. In its breadth and epistemological goals, Riegl's work reflected a "willingness to confront fundamental intellectual problems with radical boldness." As such, this achievement seemed characteristic of Viennese scholars at the turn of the century, whether they were in music or mathematics.[15] Just as Riegl used rhythm as the feature that placed that Roman era in a progressive timeline rather than to designate it an aberration, as it had been treated, fellow Austrian Anton Webern employed the tone (and atonality) to justify modern music in a historical (and even evolutionary) progression.[16] Insofar as this methodology also shared the dynamism with Vienna's local *Jugendstil* movement, Freud's psychoanalysis, and Gustav Klimt's pictorial journey to the unconscious, Riegl's Vienna School was aptly named.[17]

Wölfflin, frustrated with the University of Berlin's Prussian bureaucracy, moved in 1912 to Munich, where he remained for twelve years before returning to Switzerland. He too tried, with less success, to draw greater claims from his formalist analysis—most famously, by connecting the Gothic style of a single pair of shoes to that of the cathedrals of its age—and yet, his long-planned comprehensive history of vision remained incomplete at the end of his life.[18] His students, whose seminar Goldschmidt assumed in Berlin, remained devoted to their former instructor and his strict formalist techniques, and Goldschmidt recalled spending the early part of his Berlin career reforming their views. When he asked one of these students to share what he saw in a dramatic landscape painting by the Dutch painter Jacob van Ruisdael, the student announced, "[I see] a horizontal intersected by a diagonal," to which Goldschmidt replied, with his characteristic humor, "Curious, but I seem to see much more there."[19] If Riegl's contributions didn't reveal their limitations as easily as those of Wölfflin had, they insinuated more than they resolved. When the art historian died at the premature age of forty-seven in 1905, his ideas made a great impact in the field. As one student reflected in the 1920s, "[Riegl's work] created an entirely new theoretical field, namely typology, the nucleus at least for a historical 'cinematic' of art."[20] Yet which direction these ideas would go was to be determined by the next generation.[21]

Panofsky strategically capitalized on both the achievements and the limitations of these developments. As one of Goldschmidt's students in Berlin, Panofsky came into contact with the work of both Riegl and Wölfflin and, coincidentally, completed his dissertation in the same

year that Wölfflin published his programmatic *The Principles of Art History*, the text of which the younger scholar had heard in 1911. Panofsky's dissertation—the extension of a prize-winning paper on Dürer from 1913—as well as his early essays directly responded to and challenged the oeuvres of these two scholars.[22] Although Panofsky believed that Wölfflin's isolation of the problem of style was correct in its general orientation and that its neo-Kantian emphasis on perception was a helpful guide, he also thought it failed to establish the true epistemological foundations of art history. Panofsky explained the shortcoming of this approach in the essay "The Problem of Style in the Visual Arts," published in 1915 contemporaneously with Wölfflin's work: "That one epoch 'sees' in a linear way and another in a painterly way is not the root or cause of style (*Stil-Wurzel oder Stil-Ursache*), but rather a phenomenon of style; *it is not an explanation, but rather requires one.* . . . [It is art history's] task to research the metahistorical and metapsychological sense; that is, to ask what it means according to the metaphysical basic conditions of the creation of art (*Kunstschaffen*) to regard that an epoch represents itself linearly or painterly, in a way laminar or deep."[23] This distinction between the linear and painterly way of analyzing was a central analytic principle in early formalist criticism. But for Panofsky these criteria fell short of producing a complete account of the painting. Anticipating Gombrich's critique of the *Zeitgeist* years later, Panofsky argues that it is not an explanation but rather requires one. Such a holistic analytic principle for assessing stylistic development had yet to be discovered.

Panofsky was attracted to the concept of *Kunstwollen*, yet he found Riegl's formulation too subjective and thus insufficient to meet the demands for a universal category of art that freed the object from the burden of both historical and psychological critique. In one of his most complex theoretical essays, "The Concept of *Kunstwollen*," published in 1921, Panofsky asserted, "We must be able to characterize artistic volition or artistic intention . . . as a concept which can be derived immediately from every artistic phenomenon, no matter how limited, whether it be the total creation of a period, a people, or a particular region, the oeuvre of a particular artist, or finally any work of art at all." Although its study formed the basis of an active intellectual community, art history still lacked an analytic foundation, and Panofsky's ambitious aim, in both his dissertation and his early work, was to establish the epistemological foundations of the very field within which he was a student. For that task Panofsky was interested in drawing on the neo-Kantian

tradition as the epistemological backbone for his revised Rieglian approach, and perhaps he was also just as concerned to locate a school where he could be the leading personality. Hamburg provided for both of these needs.[24]

From Problem Library to the Law of Good Neighbors

As a result of Saxl's dutiful efforts in Warburg's absence, upon the opening of its new building on May 1, 1926, the Warburg Library was "transformed [from] the private library of a lonely scholar into a public research institution."[25] Warburg already assumed the mantle of institutional leadership with his first lecture after returning from Switzerland in the fall of 1924.[26] The expansion of the library into a separate building at Heilwigstrasse 116, however, gave the library an official institutional quality, a fact that has led many contemporaries and scholars to equate the expansion with the library's founding (fig. 8).[27] Present at the inauguration were Mayor Petersen, the president of the university board, and other prominent professors.

The presence of these high-level Hamburg officials was more than symbolic. It also reflected the growing interdependence of the library and the city at large. While Hamburg could not independently compete with Berlin's enormous museums and century-old university, between the Warburg Library, the Kunsthalle, and the Museum of Arts and Crafts, the students of the Art History Seminar at the University of Hamburg had access to a collection of nearly fifty thousand photographs and reproductions as well as another twenty-three thousand books.[28]

This was all the more important because Warburg himself did not collect art, and as impressive as it was, his highly specialized collection of books would have been insufficient on its own to provide for an academic department. The Kunsthalle, at that time under the direction of Pauli, still reflected his predecessor Lichtwark's influence. The museum's collection of newly appreciated nineteenth-century and secessionist artwork offered a compelling alternative to the larger collections typical of an aristocratic city. Panofsky had his office in the Kunsthalle, a concession made by Pauli to keep the scholar satisfied, since, as we know, Panofsky experienced several hurdles early in his career.

As a place that, by the nature of its collection, blended high and low forms of art, the Museum for Arts and Crafts also contributed to the youthful and unconventional spirit of Hamburg's cultural scene, and its directors, Richard Stettiner and Max Sauerlandt, held addi-

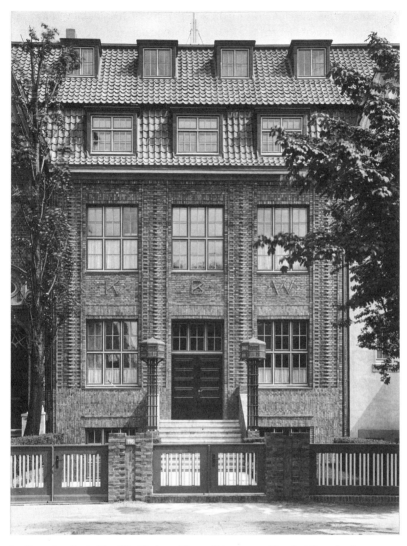

8 Carved on the inside of the Warburg Library, "Mnemosyne" invoked the collective process
 of memory to which the library was devoted. Warburg Institute, London.

tional classes there for the university students. That Sauerlandt and
Pauli, both museum directors, were awarded honorary professorships
in 1922 represented the formalization of these institutional connec-
tions.[29] Conversely, university seminars led by Panofsky, Warburg, and
Saxl were held at the Warburg Library and drew on these collections.[30]

Students could go back and forth: when the Kunsthalle closed at four o'clock, they went over to the Warburg Library, where they stayed until seven, and this access increased over the course of the decade.[31] This unique combination of urban resources presented an enticing alternative to life in Berlin.[32]

Or so Panofsky hoped. In the promotional material for the new department, he wrote that the Warburg Library and the Kunsthalle possessed "the reciprocal complementary relationship with each other that particularly gives the common tradition of art-historical research in Hamburg a special character." Moreover, he touted the new methodology, which was interested in "iconographic" themes: "While working through these one also equally strives to take formal elements into consideration." Warburg echoed those goals when he reported to his brothers that "the Institute was based on the belief that the art object should not be judged as a product of an artist in a studio, but as a product of the factors of its time, in which real life is reflected in its stylistic development. . . . The Institute must freely offer the books and images necessary for such study in a reading room accessible to all."[33] To serve these ends, the reading room was anointed by the Greek word for memory, "*Mnemosyne*," carved on the new building's inside door in Art Deco lettering because Warburg believed it evoked the process of "recollection and reconstruction of origin" to which the library's collective scholarship aspired.[34] As Saxl interpreted Warburg's mission at the library's inaugural lecture series in 1921, "What especially lends the library its specific character is that it is a *problem library*, and that its exhibition is in this way oriented to the problem . . . of the *Nachleben der Antike*."[35] Rather than collect "impartially for the unknown reader," Warburg acquired books particularly devoted in some way to the library's central conceptual "problem," the problem of human understanding over time.[36]

Yet it was also a *problem* library. On one hand, as a library that investigated nothing less than universal history, the collection was entirely too general to be useful; on the other, with its focus on the *Nachleben der Antike*, it was extremely too narrow to be of interest to most students or even other professors. Fortunately for Cassirer, as we have seen, he found the library to be a physical instantiation of his ideas. In his inaugural speech, he echoed Saxl: "Here we are dealing not simply with a collection of books, but rather a collection of problems."[37] The philosopher had reason to be overjoyed; he also benefited from first-class treatment and received new shipments of books delivered to his door.[38] If you were not one of the "privileged," however, it was not at all

that clear how to navigate the library, let alone benefit from its unique contents.[39] Panofsky joked that the "Hamburg School was gradually developing into a 'Society for the promotion of unuseful scholarship . . . which would soon only interest itself."[40]

Here, too, Saxl's assistance was crucial. First, the expansion of the library required the modification of certain customs that had been acceptable when the library was still housed in the Warburg home; there, Warburg would write the titles of books on cards that he filed in a complicated system of boxes.[41] The boxes grew in number—there were nearly eighty—and, as Saxl admitted, were not terribly helpful for anyone other than Warburg. Saxl, or any young student, could have made a bibliographic list much more quickly. But Saxl also recognized the deeper meaning behind Warburg's process—that the boxes were interconnected and told a certain story of his colleague's intellectual journey; according to Saxl, "they [had] become part of his system and scholarly existence."[42]

Although in this initial incarnation, the library was the embodiment of a history of civilization, without alphabetization or standard compartmentalization, sophistication was to no avail: it was impossible for a young student to find a book. Professionalization required normalizing the system and simplifying Warburg's ideas of organization. Therefore, in spite of his sympathy with Warburg, Saxl worked immensely hard to standardize the system in a way acceptable to his friend. He introduced the so-called three-color system he had learned in Vienna, a laborious and ultimately discarded system that placed color-coded paper over the book spine according thematic categories; and when that failed, he worked with the other assistants to conduct the hard work of cataloging Warburg's books.[43]

Saxl also believed it crucial to increase the visibility of the library in the professional and institutional world and expended much energy contacting friends and colleagues about promoting its resources in industry journals. Moreover, in the spring of 1921, Saxl introduced to Max Warburg the idea of founding a lecture series. For about 50,000 marks per year (the total budget for that year was 129,500 marks and 500 dollars), Saxl thought he could fund twelve lectures and, by printing them, give the library a presence beyond Hamburg and a place in the growing national scholarly network. The first of these lectures was delivered to an audience of about one hundred listeners and inaugurated the forum in which the Hamburg School shared its ideas and created a printed legacy. When the library "opened" in 1926, although book acquisition had actually shrunk in recent years owing to the inflation,

it also boasted an increase from 171 to 2,000 visitors, the majority of them students.[44]

Warburg would have been disingenuous to say that he was not content with the fruits of Saxl's labors. Indeed, if there was going to be a lecture series, then Warburg thought that the library should be duly credited; he needed to be reminded by Saxl that not all the lectures that were sent to him in Switzerland to read were in fact delivered at the library.[45] But he was also adamant about maintaining the creative energy of the homegrown intellectual world. Warburg did not want some "big public building in the center of town," as Saxl later recalled, but rather said, "The Library should continue to have a private and personal character in spite of its public functions." So Saxl also made a tremendous effort to preserve some of the serendipity that Warburg initially intended to capture the experience in the library. According to Saxl, in the new building Warburg's books were organized according to "law of the good neighbor," that is, "the book of which one knew was in most cases not the book which one needed."[46]

This preservation of intimacy through the "law of good neighbors" held equally for the organization of the books as for its community of scholars. The Warburg Library soon became a product and project of more than just Warburg. A team of scholars, assistants, indexers, and students were required to further the cycle of lectures, fellowships, publications, and research that an institution promoted, although, to a certain extent, the task of this complex web of relationships continued to promote the singular intellectual persona of the library's creator.[47] The classic embodiment of this unique balancing act between professionalization and intimacy, and between Warburg's collective workshop and the image of him as a lone intellectual, was Gertrud Bing.

A product of the Hamburg Jewish trading *Bürgertum*, Bing fit right into the library's growing circle of scholars wedged between Warburg's intellectual aspirations and the economic demands of his brothers.[48] She proved her intellectual sophistication in an interdisciplinary dissertation on Lessing and Leibniz that bridged literature and philosophy; and, perhaps characteristic of the bourgeois nineteenth-century intellectual woman, she spent her life serving the men of the Warburg School, including her mentor, Cassirer, as well as Saxl and Warburg himself.[49] At Cassirer's recommendation, Bing was put to work in the library in 1921 to help with indexing.[50] When Warburg returned to Hamburg, she became his direct assistant and later accompanied him on trips to Italy (fig. 9).

To a certain degree, Bing held a tremendous amount of responsibility;

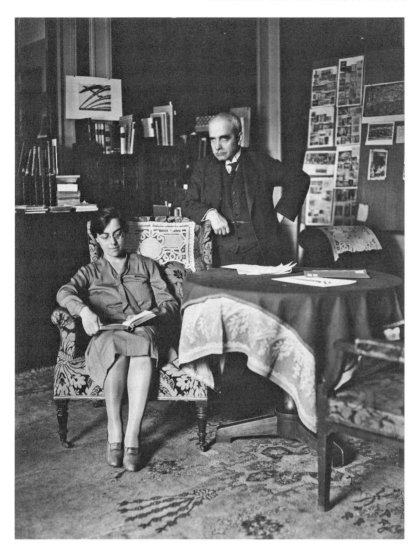

9 A symbol of the "law of good neighbors," the partnership between Aby Warburg and
 Gertrud Bing, shown here in Rome, revealed the unique scholarly practices of the Warburg
 library. Warburg Institute, London.

she was responsible for cataloging the books, managing the *Studies*
published by the library, and organizing the lecture series. As an expert
in the index of all the library's publications, Bing was indispensable.
Without her, Warburg admitted, he would not have been able to com-
plete his work on his multimedia picture atlas.[51] But Bing also embod-

ied the gendered division of the library, in which female scholars were relegated to the somehow "feminine" tasks of organizing, filing, and managing, and female students who sought interest in these studies risked falling into this trap.

While this gender division was not unique to academia, nor to iconology, it is possible that Warburg's own preoccupation with amateurism and Saxl's desire for professionalism made this division all the more important.[52] Bing was a "survivor," as she said later, and a true collaborator, first of Warburg and then of Saxl. Accordingly, Bing was "masculinized" in the way she was formally addressed, which over the course of the library's diary transitioned from "Fraulein Dr. Bing," to "Bing," "Bingia," "Bingius," and finally "Kollegin Bing."[53] But her role in Warburg's life was also deeply personal, and she often dined with the family and traveled with Warburg alone. Adored by both him and Saxl, she jokingly called their relationship the second Warburg trinity.[54]

For Panofsky, who once called women "time robbers," such antics held no interest. Dora Panofsky, though a trained art historian, was largely excluded from working in the library, and he did not come to her defense.[55] Whether this was the secret to his productivity is another question—Panofsky was, by all accounts, more gregarious and social than his elder colleagues—but what is certain is that already by 1921 Saxl realized that in Panofsky he had discovered the key to disseminating Warburg's thoughts to a wider audience.[56] And in these institutional conditions, Panofsky, for his part, found a school he could shape and ultimately lead, a fact that had tremendous consequences for the field of art history.

Icons and Influence

It was in this "special environment" and through his lectures on Dutch, Italian Baroque, and German painting from the fifteenth century, as well as rousing discussions with his students that Panofsky developed his scholarship.[57] As the newly appointed chair of the art history seminar, and with the Warburg Library as his base, Panofsky cultivated contacts with institutions in Cologne, Marburg, and Munich, and as far away as London, Paris, and Moscow. Through these contacts, Panofsky arranged exhibits and lectures for his students and new acquisitions for the library.[58] He also fielded student complaints about the nature of the art history curriculum and defended the department's selection of

courses, in particular, the decision to offer several seminars on distinct periods rather than a survey class on the fundamentals.[59]

This institutional structure facilitated the transmission of ideas and concepts between these three scholars, and the results of their intellectual exchange were evident in the work produced.[60] The youngest of the three scholars, Panofsky, was undoubtedly inspired by Cassirer, whose university lectures he often attended, a fact that itself may have been a cause for the school's enormous productivity.[61] Two years after arriving in Hamburg, in the winter of 1924, Panofsky delivered a lecture at the library entitled *Perspective as Symbolic Form*, which later became one of his best-known art-historical statements. Scholars have often considered this work an application of Cassirer's "symbolic form" to the field of art history.[62] In his mature thought, Cassirer's symbolic forms became the object of analysis for iconology, and Panofsky himself wrote, "In thus conceiving of pure form, motifs, images, stories and allegories as manifestations of underlying principles, we interpret all these elements as what Ernst Cassirer has called 'symbolical' values.'"[63] Although Panofsky revised iconology in the postwar years to describe the "intrinsic meaning" of the work of art, Cassirer's influence on his methodology remained manifest.

In this, his most impressive work up to that time, the young art historian traced the relationship between various Western historical epochs and their respective modes of spatial representation, thus establishing a schematic history of style. Cassirer the philosopher had in *The Philosophy of Symbolic Forms* extended the narrow neo-Kantian critique of the conditions of possibility for knowledge to include a broader morphology of culture. Now Panofsky aimed to understand how all theories of perspective emerged like "symbolic forms" out of their particular historical and cultural moments. In this respect, Panofsky contributed to a debate, begun by Warburg and Cassirer, on the subject of the relationship between structuralism and evolutionism. If every epoch possessed its own perspective, were they all equally legitimate (structuralism), or did each represent an incremental development toward the archetypal form of perspective (evolutionism)? At one point, Panofsky seems to suggest the former when he observes, "It would be methodologically quite unsound to equate the question 'Did antiquity have perspective?' with the question 'Did antiquity have *our* perspective?'"[64] As an investigation of the full implications of "perspectivism," Panofsky's lecture is a characteristic intellectual inquiry of the interwar period, and it shares much with Cassirer's and Warburg's struggles to understand the full consequences of myth for the integrity of reason.

Whether the Renaissance should be considered an ideal or a classical age, something to aspire to and move toward, or merely one period among many, preoccupied scholars interested in these questions.[65] As Panofsky explored further in his next "Warburg Library" work, *Idea: A Concept in Art Theory*, the notion of idealization was menacing, for it seemed to threaten the concept of creative genius. Here, like Cassirer, Panofsky cut across both of these positions, offering both a progressive history of the improvement of the idea of art—its evolution—and a "diversity of solutions" to the problems of idealism and naturalism. If for Cassirer the Renaissance represented philosophy's shift from the divine to the terrestrial, for Panofsky it was the moment at which reality and idea could be located in human consciousness. But Panofsky also moved beyond the Renaissance to conclude his study with a survey of seventeenth-century aesthetics, which he argued had accomplished the transformation of a concept of ideas derived from Plato's doctrine.

Panofsky's *Idea: A Concept in Art Theory* is a work that is best understood in the context of the scholars, setting, and scholarly practices of the Warburg Library. The work was closely connected with a lecture given by Cassirer whose subject was "The Idea of the Beautiful in Plato's Dialogues," and according to Panofsky, it was "the intent of both authors that this connection should be manifest in the way of public presentation." Several decades later, Panofsky still urged readers to place his work in this context and was forthcoming in "his sincerest gratitude to Prof. Cassirer himself for various suggestions and an oft-tried readiness with gracious help," as well as with appropriate thanks to Bing, who "undertook the laborious task of preparing the index."[66]

But Panofsky's *Idea* also reveals the greater influence of Cassirer's *The Philosophy of Symbolic Forms*, which had taken its cue from the central problem that plagues all attempts at "meaning making": the tools with which we understand the world only remove us further from reality. As Panofsky surveys the connection of this problem to art theory, it is instructive to note that Plato believed the dialectician, not the artist, was best equipped to bridge this gap. While the artist could only produce a copy of reality, the philosopher, through rhetoric, could approach a Platonic ideal. Panofsky's *Idea* aims, in a historical survey extending from ancient Greece to the Renaissance, to create room for the idea of art in this reading. He observes: "Although the absolute perfection of this inner model cannot enter into the work he creates, the finished work will reveal a beauty that is more than a mere copy of an attractive 'reality' (which is presented only to the easily deceived senses), yet something else than the mere reflection of a 'truth' essentially acces-

sible only to the intellect."[67] And this new idea of art could forge room for a new art history.

With respect to the challenges posed by this task, there existed a parallel between philosophy and art that Panofsky made explicit: he suggested that the "theory of ideas" in philosophy corresponded to the long-standing "theory of imitation" in art. Philosophers bemoaned "conceptualism," which promoted abstract concepts increasingly at odds with reality itself, and likewise art historians feared "representationism," which reduced art's purpose to mimesis, or mimicry of the world. Riegl aimed to move beyond the search for the philosophical thing-in-itself in art history, as Kant had purported to do with his turn to epistemology.[68] But Riegl had his limitations, as we have seen, and Panofsky believed a new art-historical approach was required to do a better job of connecting our observations of reality with wider statements thereof—that is, to fulfill the task of establishing a firmer epistemological foundation for the field.

If Cassirer provided the epistemological inspiration for a new foundation for art history, Warburg signaled the direction that this disciplinary innovation took. Panofsky's art-historical efforts, then, not only paralleled those of Cassirer's in philosophy; they also moved beyond him to create the central interdisciplinary legacy of the Hamburg School, termed *iconology*. Eager to pursue an intermediary position between formalism and contextualism, Wölfflin's and Riegl's respective schools of thought, Panofsky drew on the analytic foundations laid by Warburg in 1912, a lecture that Saxl argued "did not only aim to solve the problem in the isolated context of a specific time period, but also created a methodology in order to bring together the history of religion and art [in one single form of analysis]."[69]

Warburg's methodology was attractive to Panofsky in its connection between a work of art's form and its context. Warburg ambitiously aspired to unite multiple strands of historical, classical, and religious thought in the analysis of a single work of art. In numerous essays and a multivolume study of Dürer's *Melencolia I* (1514), which he undertook with Saxl in the 1920s, Panofsky eagerly participated in Warburg's aim of establishing a new art-historical methodology.[70] Yet Panofsky's independent scholarly ambition also began to take its own shape. In an epilogue to a study titled "On the Four Master Builders of Reims," published in 1927, Panofsky drew on Simmel's philosophy of history as much as he had on Warburg's ideas to explore the limitations of using solely stylistic criteria to establish chronology. In the essay, published posthumously as "Reflections on Historical Time," Panofsky argued,

"Every attribution of a work of art represents a judgment process by which a temporal and spatial attribution are made all at once, without giving the one precedence over the other." An art historian must instead use "an unending variety of individual frames of reference," and as early as 1929, Panofsky described this new multifaceted art-historical methodology as "iconographic."[71]

In a programmatic lecture Panofsky delivered to the Kant Society of the nearby city of Kiel, titled "On the Problem of Describing and Interpreting Works of the Visual Arts," Panofsky laid out this methodology more explicitly. Drawing on the iconic example that served as inspiration for his elder colleague Warburg, that of Lessing, Panofsky reminded his audience of inadequacies of painting's purely descriptive quality and insisted on the necessity for both formalist and contextualist tools in art-historical analysis. Building on the Kantian vocabulary of his essay "Reflections on Historical Time," Panofsky asserted the need to distinguish between two different layers of meaning in a work of art, the phenomenal meaning (*Sach Sinn*) and the deeper meaning (*Bedeutungs-Sinn*). To achieve the second required additional literary understanding that would contextualize the formal qualities of the artwork in its time, a necessity that was understandable if one considered the following counterfactual: "It is not unthinkable that in the year 2500 the story of Adam and Eve would be exactly so foreign to humans as say those representations that have arisen from the religious allegories of the Counter-Reformation of the humanistic allegories of the Dürer circle; and indeed no one would disavow that it is essential for our understanding of the Sistine Chapel ceiling that Michelangelo painted the fall from grace and not [Monet's] 'The Luncheon on the Grass.'"[72] It was reasonable to assume, Panofsky contended, that a future art historian might need some discursive and historical background to properly distinguish a religious scene from a modernist one. But how would that same historian determine what evidence was reliable and what merely circumstantial?

Panofsky attempted to answer the question through example. Drawing on the sixteenth-century artist Mattias Grünewald's *Isenheim Altarpiece*, a complicated structure containing two sets of folding wings and three statues of saints, Panofsky asserted, "Without specific literary knowledge we cannot know . . . what its *sub specie* meaning represents."[73] That is, to completely grasp the eternal imagery in this complex altarpiece required knowledge of both the history of its predominant images and a textual competence in the Bible and the Gospels. While Wölfflin's students had described lines, shapes, and colors,

Panofsky drew on research in diverse fields to conduct a typological history of the painting's conflation of motifs.

Neither strictly formalist nor contextualist in approach, iconology, the Hamburg School's intellectual legacy throughout the postwar period, required a holistic appreciation of the artwork and its time period. In pursuit of the hidden meanings of rare symbols in Renaissance art, the methodology drew from the expertise of disciplines including religious studies, anthropology, and astrology—scholarship that was conveniently organized within Warburg's library. And in its spirit, the inquiry continued the tradition Warburg had begun with his dissertation and early essays on the economic and social context for art. But Panofsky's essays and lectures, increasingly numerous, also began to depart from Warburg in key ways. The Apollonian and Dionysian tensions that were in constant flux in Warburg's portrait of Dürer, for example, were now reconciled in Panofsky's presentation thereof. As Panofsky described it in one of a series of essays on Dürer in 1921, "In antique art there is neither beauty without movement nor pathos without magic; if one is permitted to say so, the Apollonian of the arrangement is also already Dionysian and the Dionysian of the foundation also already Apollonian."[74] Whether as a result of greater professional ambition or of a distinct intellectual mentality, Panofsky's iconology was both less dynamic and more digestible than that of his elder colleague's. Significantly, Panofsky's version became the public face of the school.

Insofar as iconology represented a departure from both of the accepted perspectives within the emerging art-historical field, according to Panofsky's former student, the well-known art historian Hugo Buchtal, Hamburg provided the ideal place for an inquiry that was "suspect to the establishment": "[Hamburg] was not an important or an old, established university, but it offered unique facilities: the Kulturwissenschaftliche Bibliothek Warburg, as the Warburg Institute was originally called, and the group of outstanding scholars who worked and published in its shadow: Aby Warburg himself, Fritz Saxl, and Ernst Cassirer to name only a few. This was the congenial atmosphere in which young Panofsky found his identity as a scholar. It was a mutual give-and-take; it benefited every [member] of that small circle of scholars, and by implication, his students."[75] The distinctive features of Hamburg's cultural and intellectual world—its financial independence, unique art collection, and "nontraditional" spirit—together with the chemistry of the three scholars and their individual talents, converged to produce this methodological development.

Particulars, Universals, and Polemics

Even as Warburg eschewed the strict delineation of academic disciplines, the greatest collective contribution of these scholars was to the field of art history. The paradox was that, in the process of professionalization, the Warburg Library risked losing its interdisciplinarity, its amateur spirit, and its high female participation—all qualities that made it unique.[76] In this sense, the "purification" of the Hamburg School that occurred as a result of the emigration was already under way by the end of the 1920s. And it resulted both from the perils of institutionalization and from the politicized intellectual debates of the interwar period in which the Hamburg scholars were, as German Jews, deeply (if not enthusiastically) embroiled.

The Warburg Library's status as a privately funded extrauniversity enterprise made it an ideal place for Jews, who had historically been excluded by public, state-run institutions of scholarship.[77] Beyond this institutional connection, discussed in chapter 7, these scholars' experience as German Jews is also felt within iconology, the most visible legacy of this intellectual circle. While these ideas cannot be exclusively attributed to some characteristic "Jewishness," the experience of the secular German Jew clearly informed the scholars' understanding of the relationship between the particular and the universal, one of the central epistemological and methodological issues taken up by scholars in the humanities in their day.

For Cassirer, the central achievement of the Renaissance was the shift from a belief in universal divine knowledge to a confidence in that spirit reflecting itself through the particularity of the world—in a sense, the philosophical acceptance of the proposition "God lies in the details." In *The Philosophy of Symbolic Forms*, he came to define the "fundamental principle of cognition" in precisely these reciprocal terms: "The universal can be perceived only in the particular, while the particular can be thought only in reference to the universal." The study of other "symbolic forms" followed the same path. "In analyzing language, art, myth," Cassirer stated, "our first problem is: how can a finite and particular sensory content be made into the vehicle of a general spiritual 'meaning'?"[78] For Cassirer, this was not just a semantic distinction, for it permitted room for individual participation in universal spiritual meaning. Not only *could* an individual participate, but it was only *through* participation that the true content of infinity was made knowable.

In his narrative of European thought, Cassirer tended to favor thinkers who showed a similar awareness of this problem. Leibniz's great innovation was to see the relationship between God and man in terms of this balance between the particular and the universal. According to his famous observation, "Mens non pars est, sed simulacrum divinitatis, repraesentativum universi" (man is not only a part, but a symbol of the divine, a representation of the universal). What was a boon for secular thought also provided methodological guidance for Panofsky's developing theory of aesthetics. In 1924, Panofsky issued a follow-up to his early theoretical statements on the theory of art. Influenced by Wind, Panofsky described the challenges posed to assessing a work of art: theories of aesthetics are too general insofar as they seek to determine prerequisites, and in contrast, psychological interpretations tend to be so specific as to lack a general foundation. For Panofsky, a formulation was required that viewed the existence of a general problem in the specific analysis of individual works of art. "What applies to the understanding of the fundamental problems applies to a still greater extent to the understanding of the individual problems; artistic problems are only understandable by means of their solutions, that is, the works of art themselves."[79] Just as Kant had arrived at aesthetics in search of an example of a moment in which consciousness reflected the universal lawfulness of the particular, now Panofsky, in a Kantian move, drew on this formulation to further establish the epistemological foundations of the field.[80]

This attempt to see the particular in the universal was not only an abandonment of religious thinking or a challenge to aesthetic analysis; it was also of tremendous political importance, an association that Cassirer increasingly made clear over the course of the decade. The ability to interact with a diverse group of people in a larger unit was contingent on such a balance. As Cassirer later explained: "If we want to not remain perpetually condemned to see the modern cultural and intellectual history only as a fragmented play (*Stück in Stücken*) then we must we try to see directly in the individual distinctiveness, in which each single national culture indisputably dwells, not as a simple particular but rather as a true universal."[81] Connecting Goethe's aesthetic program with a political message, perhaps one adapted from the neo-Kantian school, Cassirer made the greater significance of his intellectual choices explicit.

In this respect, the Hamburg School's project to defend and redefine transcendental idealism in philosophy and epistemology in art history

was also deeply political, and some sense of Jewishness undeniably impacted its members' understanding of these scholarly and methodological issues. That is, viewing aesthetics and philosophy in terms of questions of the universal and the particular made the connection between their intellectual inquiry and the central problem constitutive of modern democracy: the relationship between the individual and the collective. And arguably, insofar as "reaching outward toward a universal modern culture and inward toward the consolidation of Judaism's particular strengths" was also essential to the experience of modern Jewry, as two scholars have argued, these efforts—intellectual and political—informed each other.[82]

These concerns provided the context for the burgeoning debate among the second generation of art historians concerning the proper methodology for assessing art. To a certain degree, the writing of art history was no different from history writing in general, a scholarly activity that possessed a long tradition of entanglement with political dialogue. Warburg's Strasbourg professor Hubert Janitschek, for example, had documented what he considered to be primeval German traits in art to support German unification at the end of the nineteenth century. Such historical practice was so widespread that not even the less prominent fields of paleography and decorative motifs escaped these nationalist efforts. Neither was Riegl free from ideology; he viewed the Institute for Austrian Historical Research as an opportunity to promote the notion of Greater Austria.

According to one scholar, Riegl's program of universal history could even be considered a response to the challenge presented by nationalist historiography. That Riegl presented a heroic and progressive narrative of the discipline also served to justify the "embattled internationalism of the Habsburg Empire, then succumbing to centrifugal nationalist forces."[83] Although he distanced himself from ethno-nationalism, Riegl's successors did not share his broadminded sensibility. As Panofsky came of age in the field, the rereading of Riegl, and in particular, his notion of *Kunstwollen*, seemed to be giving way to a different set of propositions. Although Riegl himself supported an extreme form of formalism and was more careful with the links he made to the external world, the Second (or New) Vienna School, which included such scholars as Hans Sedlmayr, Guido Kaschnitz von Weinberg, and Otto Pächt, treated *Kunstwollen* as a neo-Hegelian creative principle that they drew on to represent this or that other characteristic, including nation or race.

As Panofsky observed with regard to the concept of *Kunstwollen*,

when extrapolated to a culture of the time period, it posed dangers to the autonomy of individuals and the sanctity of art:

Just as a science of art attests that within a certain artistic manifestation all artistic problems are solved in one and the same way, so the humanities in general can attempt to show that within a certain culture (which must itself be determined as regards epoch, region, and the persons involved) all intellectual problems, including the artistic, are solved in one and the same sense. Though one cannot ignore the dangers inherent in the practical application of this process of comparison, today perhaps practiced all too often (*the will to unveil analogies can easily lead to interpreting the phenomenon in question in capricious and even brutal ways*) one cannot deny on purely theoretical ground that it is undoubtedly possible and justifiable.[84]

Panofsky's fears of ethnographic art history turned out to be prescient, for Sedlmayr went so far as to promote an underlying collectivist psychological structure to art. Replacing Riegl's concept of *Kunstwollen* with the idea of structure, he argued that his structure research (*Strukturforschung*) probed two layers of formal analysis to expose an underlying similarity between a group of individuals. This slippage from *Kunstwollen* to nationalist art history was even clearer in Pächt's "Design Principles of Fifteenth-Century Northern Painting," in which he argued that the seventeenth-century Dutch scenic paintings "can be grasped only when we have gotten a glimpse into the essence of the Dutch artistic will (*Kunstwollen*)." In contrast, Panofsky and Wind urged, in typical neo-Kantian fashion, a shift away from issues of artistic creativity to questions of meaning. For they sensed that the turn from Kant to Fichte would likewise signal a turn from law to will that had the potential to enshrine an extreme individualism. While such individualism by itself was not harmful, attaching it to a culture or a people could result in a frenzied nationalism.[85]

Needless to say, Riegl's formalist taxonomy did not necessarily have to lead to racism; conversely, one prominent member of the Second Vienna School, Pächt, was Jewish, although he did not enjoy good relationships with the Jews Panofsky and Gombrich in the postwar period.[86] Panofsky's own career, too, revealed that "style" art historians could be just as prone as formalists were—if not more so—to rely on the *Zeitgeist* as both cause and explanation for aesthetic changes over time.[87] As one art historian has argued, style as a concept ultimately lacks a firm epistemological grounding, since "style is what you make it."[88]

Perhaps, but then all the more reason that Warburg and Panofsky

had cause for concern. If the aesthetic categories of the universal and the particular could easily be replaced by political language, including individual and collective, nationalism and cosmopolitanism, then these scholars were justified in their vigilance. Warburg, for his part, remained optimistic about creating a European methodology for art history that was purged of ethnography and racism. He told his friend the American Jew and anthropologist Franz Boas in 1924, "I believe that I am not mistaken if I sense an intellectual awakening." To Warburg's great relief, Boas did not blame the German intellectual culture in particular. His view was, "Racial prejudices seem at the present time to be epidemic all over the world, and we are not by any means free of [them] here."[89]

In his own work, Warburg tried to balance his resistance to systemization with an underlying vision of humanity that inspired his methodological enterprise. Warburg's Atlas project, whatever its failures as a coherent philosophical statement, clearly also reflected a desire to reduce human expression to its most fundamental and most universal form: images. Along these lines, his lecture on the Palazzo Schifanoia, one that drew on complex astrological imagery of gods and spirits to present a key to the cycle of frescoes, also represented a universal worldview extending from the East to the West. In this respect, the lecture was not only a statement on interdisciplinarity but also a geographic exploration that carried him from Baghdad to Florence in search for the key to a universal meaning of signs and symbols.

While he still intended to avoid a too-tidy solution to this complex problem, Warburg emphasized his interest in the universal aspect of these questions. He asked, "To what extent can the stylistic shift in the presentation of human beings in Italian art be regarded as part of an international process of dialectical engagement with the surviving imagery of Eastern Mediterranean pagan culture?" Warburg's answer indicates the cosmopolitan shades of the Hamburg School's scholarship: "The grandeur of the new art, as given to us by the genius of Italy, had its roots in a shared determination to strip the humanist heritage of Greece of all its accretions of traditional 'practice,' whether medieval, Oriental, or Latin. It was with this desire to restore the ancient world that 'the good European' began his battle for the enlightenment, in that age of internationally migrating images that we—a shade too mystically—call the Age of the Renaissance." The full political implications of Warburg's "good European" were borne out, to a large degree, after his death. If Warburg never faced these consequences, they were inescapable for his colleagues and successors, such as Bing, who could

not help but reinterpret Warburg's aversion to disciplinary borders as political ones.[90]

That Warburg's universalism often fell back on its Eurocentric formulation was doubtless a mark of its time, although it did not stop Gombrich from exposing this as a shortcoming and promoting, in its place, a pluralism that took the accomplishments of the East into consideration.[91] While certainly a position that was more in tune with the postwar period when Gombrich translated and reassessed these works, it is important to remember that the preoccupation with distinction translated into something different in Warburg's time. It was precisely the fear of blanket concepts like universalism that led to the antihumanist and nationalist propositions of the opposing camp. Insofar as *Perspective as Symbolic Form* addressed a plurality of art movements, Panofsky could be said to have been answering this charge. Yet, he never could fully rid himself of critiques from Sedlmayr and others that he was too dependent on reason, which would never capture the underlying dynamic of art. The trend toward overconceptualizing art history was one that Wilhelm Pinder, a Munich art historian and Panofsky's rival, hoped to rectify in 1939 by expelling Jews from the field.[92]

Although these political concerns were not made explicit until the latter part of the decade, in particular, after the onset of National Socialism, such affinities as nationalism and cosmopolitanism were already well in place in the 1920s. It is not surprising, then, that a geographic broadmindedness came to define the Hamburg School, for it was precisely in the combined spirit of the local and the international that Warburg once led the campaign for the university. Writing in 1927, he made the connection between the city and his intellectual project explicit. "It is also perhaps not a coincidence that it was a researcher from Hamburg who has arrived at the dynamic side of this problem, [and that] having experienced the powerful impression made by international traffic in the material world in his home city, directed his attention towards the dynamics of the traffic of the mind."[93] If the Second Vienna School reflected the changing political conditions from the Habsburg Empire to the Austrian Democratic Republic, and Pinder's "Kindergarten" as Panofsky named it, the southern ethnonationalism of Bavaria, then the Hamburg School was, considering its origins, perhaps the natural site for this methodological and geographical interdisciplinarity.[94]

Contemporary art historians who suggest that we reassess Riegl and his successors are correct to alert us to the danger of superimposing

political meaning onto these intellectual projects. Nonetheless, history dictated that a certain degree of political resonance was increasingly inevitable. Hamburg's cosmopolitanism and its scholars' universalist approach soon became a liability. The thesis of the Hamburg School—that context was a necessary ingredient for the study of icons and symbols—found expression, outside of their work, in their own lives. For, despite their best efforts, their own "universalist" and "cosmopolitan" work was ultimately coded as Jewish.

Private Jews,
Public Germans

For about twenty-five years [the Warburg Library] consisted almost entirely of Jews whose Jewish intensity ranged from moderate sympathies to the zero point and even below. I used to define the three groups around the Warburg Library, Max Horkheimer's Institut für Sozialforschung, and the metaphysical magicians around Oskar Goldberg as the three most remarkable "Jewish sects" that German Jewry produced. Not all of them liked to hear this.

GERSHOM SCHOLEM, *FROM BERLIN TO JERUSALEM*

It seems to be the historical mission of the Jews to contribute, like Socrates' gadfly, to the progress of civilization by being a perennial nuisance, and the responsibility for the results rests neither with the gadfly nor with the horse.

ERWIN PANOFSKY TO BOOTH TARKINGTON, 1944

In 1920, the year he was appointed to lead the Prussian Academy of the Arts, the German-Jewish painter Max Liebermann wrote his friend Cassirer that he was delighted to hear that his first lecturing experience in Hamburg was a success: "That speaks very well of Hamburg's culture. It has always seemed to me that the businessmen there are more cultured than, for example, the Berliners, especially the assiduously educated. Only anti-Semitism could be perceived the same here as it is there." Liebermann would know; during his summers spent in the haute villas of Blankenese outside Hamburg, Liebermann cultivated a close relationship with Lichtwark, who commissioned from him a portrait of Mayor Petersen that caused a veritable scandal among the city's bourgeoisie.[1] Despite Lie-

bermann's famous protestation that "painting had nothing to do with Judaism," his life and work were marked with societal claims to the contrary.[2]

But did the Jews of Hamburg truly have it better than those of Berlin? And did the incorporation of Jews into the scholarly world happen any differently as a result?

Warburg seemed to think so, and he later observed that the fact that "someone like Cassirer" could get a job was the result of Hamburg's benefiting from "the inner political change in Germany." And for the young Panofsky, the new art history department served as an exit from what he called the Jewish condition of purgatory: a life as a *Privatdozent*, or lecturer without the stability or privileges of an official university professorship. However, if the city enabled his ascent from that position, it was by no means a purely liberal paradise. When the peace treaty was finalized in the summer of 1919, anti-Versailles rallies raged on the Elbe, as elsewhere, and a statue of the sometime hero of Hamburg's Left, the German-Jewish poet Heine, was defiled. As for the star chair of the philosophy department, one faculty member reasoned, it was "despite Cassirer's Jewish faith" that he got the job at all.[3]

To be fair, Cassirer might have preferred to stay in Berlin, close to his family and at a university steeped in a long German tradition. But in the capital, Cassirer could not get a job because he was a Jew and was resigned to work as a *Privatdozent* for thirteen years. Cassirer's failure to advance in the academy is all the more surprising because he had the support of both his respected mentor Cohen and his large and well-connected Berlin family, which included industrialists, city council members, doctors, and most important for the philosopher, his cousins Bruno and Paul Cassirer, who were publishers and gallery owners.[4] The Cassirer Gallery was single-handedly responsible for bringing impressionism to Berlin at the turn of the century, but its association with modernism earned it as many foes as friends. Moreover, despite Cohen's exceptional intellectual status, his students were stigmatized for their affiliation with him. As Cassirer repeatedly made the short list for every major job in the country and just as often was overlooked, one sympathetic colleague commented on his cruel predicament: "If only he weren't named Cassirer!"[5]

The philosopher seemed doomed to follow the typical German-Jewish experience in Berlin: a rise to prominence on the eve of the First World War followed by the inevitable backlash from that prominence that characterized the Weimar Republic. As the historian Fritz Stern has argued, hostility to Jews increased even as they were progressively in-

tegrated into German culture. In this light, the reputation of Cassirer's family and mentor hurt more than it helped, leading Cassirer to feel, in the words of Stern, the "burden of that success." Considering these prejudices and circumstances, Cassirer's persistent commitment to the traditional academic path was remarkable. With the private wealth of his supportive family and access to his own press, Cassirer could easily have pursued the life of a private scholar.[6] Toni Cassirer believed that her husband was motivated to reject that option by the need to "ensure his external subsistence" and the desire to continue his mentor's legacy.[7] Hamburg's new university offered precisely these opportunities.

So in February 1922, when two right-wing nationalists assassinated the newly appointed Jewish foreign minister Walter Rathenau, it was possible to feel as if that hope was destroyed. A moment historians consider to mark a definitive break in the potential success for Germany's democracy, Rathenau's murder also became overnight the paradigmatic example of the dangers of Jewish visibility. It is not insignificant that the crime sparked hunger strikes, notably in Hamburg, among hundreds of thousands of Social Democrats, who assembled in protest for a day of mourning.[8] Yet for secular Jews like Warburg, Cassirer, and Panofsky, themselves increasingly prominent in their fields, Rathenau provided a lesson they could not ignore.

For the rest of the decade, these scholars cautiously navigated the public meanings of their scholarship and professional activities. For Cassirer, despite his refusal to convert (a choice that would have indicated a definitive separation from the religion) or to leave the community (an option facilitated by nineteenth-century reforms in Hamburg's Jewish communal structure), the professor's "Jewishness" remained a private affair.[9] To prove that Cassirer's philosophical interests had nothing to do with Judaism, Gay has insisted that Cassirer's portrayal of Kant was not a "Jewish Kant," and with respect to pure philosophical considerations, this is correct.[10] But a different view of Jewishness emerges when we study the correspondence between Jews and private diary entries. Here, a private articulation of what it meant to be Jewish is evident—one that differed from the public stance these scholars assumed at German universities and in "mixed" company.

As the case of Panofsky's unpublished lecture "Rembrandt and Judaism" shows, as important as what was said was to whom it was said, or, in some instances, that it was not said at all. With the options of *Privatdozent* or private scholar the only professional alternatives open to the previous generation, Panofsky knew that managing his reception was the key to his success. Often these professors' wives, especially

Toni Cassirer and Dora Panofsky, reminded these scholars of symbols that how their work was "read" in different contexts mattered. As the forces in his life—private scholarship, amateurism, and dilettantism—were compounded by the potential of Jewish symbolism, Warburg, too, strategically attempted to construct a counternarrative for the Hamburg School.[11] However, analyzing the icons of the Renaissance was one thing; controlling the greater symbolism of his life and work was an entirely different matter.

Rembrandt's Jews

To a certain extent, the social perils of Jewish visibility apply to the intellectual predicament of the Hamburg School's scholars, who made great strides at the beginning of the twentieth century in the humanist tradition of the classical, Renaissance, and Enlightenment periods. Drawn to this subject matter that presented an alternative to the exclusivity of both German nationalism and Christian culture, these German-Jewish scholars, at the same time, assumed that their mastery of *Bildung* would lead to their eventual integration into German society. Following the First World War, however, this tradition became not only associated with rootlessness, excessive rationality, and republicanism, but also conflated with the negative influence of Jews on German culture. The intellectual work of these scholars risked succumbing to the burden of its success.

This familiar intellectual story is often told as one of naïveté and delusion: these Jews adhered to civic humanism in the late 1920s and therefore sealed their fate as politically obsolete.[12] However, this narrative fails to capture the texture of the experience epitomized by the Hamburg School and the positive moment of hope and democracy signaled by its new Weimar-era university. Panofsky's life and work is instructive, for while in many ways he seems to fit this paradigm, he also revealed precisely an agility with political positioning that has been denied in the traditional account described above. In a certain respect, he assumed the duality characteristic of the German-Jewish experience of his highly successful in-laws, the Mosses, who seemed to exist in both the secular and the Jewish worlds. Having wielded extraordinary influence for four generations, from the imperial period through the Weimar Republic, the Mosses were exemplary of German-Jewish success. The elder Mosses had assimilated into German high culture but had not converted to Christianity. Dora's sister Martha Mosse de-

scribed the balance in their home as "true to old belief—sometimes in conjunction with the strict adherence to antiquated religious customs and regulations—and the doubtless feeling of belonging to the German state and its citizens, its culture, and its history."[13]

Panofsky recreated this familial duality in scholarship. He drew on Latin, Greek, and Hebrew alike for the foundation of his scholarly and personal identity and often used Latin in his correspondence with Albert Mosse in a boastful and teasing way.[14] Panofsky remained comfortable moving between the two worlds and, on occasion, integrated Hebrew vocabulary into German academic culture. Describing July 2, 1920, the eve of his first trial colloquium in Hamburg, to his wife, he announced it "Erew Jom Hacolloquium" (the evening before the colloquium).[15] Combining the Hebrew phrase *Erew Jom Ha-* with the German scholarly event *Colloquium*, Panofsky irreverently linked the two traditions in a private situation and in a way that only a German Jew, such as his wife, could have appreciated.

If Panofsky's cultural ease reflected a fluidity characteristic of the generation that followed Warburg and Cassirer, unlike his peers Gershom Scholem and Walter Benjamin, Panofsky never developed a scholarly interest in Kabbalah or mysticism. In some ways, his anxiety-free hopefulness echoes an environment of German and Jewish coexistence common to an earlier generation than Cassirer's. In a lecture delivered in 1920 to an overflowing hall at the Berlin Hochschule für die Wissenschaft des Judentums (Berlin school for the science of Judaism), with Liebermann in the audience, Panofsky addressed Rembrandt's portrayal of Jews over the course of the painter's career.[16] Dividing Rembrandt's career into three stages, Panofsky imposed a dialectical reasoning on his development that conformed to the methodological issues with which he was also preoccupied. If the early Rembrandt began by painting the Jews of seventeenth-century Amsterdam as types, the middle Rembrandt—largely through his friendship with such Sephardic Jews as Menassah ben Israel—came to represent Jews as individuals. But it was the late Rembrandt who achieved the goal to which all artists aspired: the portrayal of essence (*Wesen*).[17]

In describing Rembrandt as a painter who captured true metaphysical essence, Panofsky entered a broad debate regarding the cultural and political symbolism of the Dutch painter. A wide range of scholars—from sociologists Simmel and Alfred Weber to curators Bode and Lichtwark—believed that an appreciation of the Dutch painter should be cultivated. Yet, ever since 1890 and the publication of cultural critic Julius Langbehn's pseudoscholarly book *Rembrandt als Erzieher* (Rembrandt

as educator), a debate had raged about whether Rembrandt signified the best of the *Volkstümlichkeit*, expressing the unique qualities of his people and traditions, or, alternatively, constituted a paragon of universalism. This wildly popular book, which sold nearly nine thousand copies in its first year, possessed one central goal: "to condemn intellectualism and science, to denounce modern culture, to praise the 'free' individual and the true Germanic aristocrat, to revive the Germanic past."[18] According to the "Rembrandt German," as he was known, Langbehn announced that the "intellectual life of the German people had found itself presently in a slow, and by other accounts, rapid state of decline."[19] For Langbehn, as for Panofsky, Rembrandt was a contradictory character with metaphysical importance whose opposing elements came to be reconciled in some vague Hegelian dialectics. But in Langbehn's version, the culminating art of Rembrandt, which emerged from the blood and soil, left no room for Jews or professors.[20]

Despite doubts regarding his credentials and motivation, Langbehn was read sympathetically by art historians, including Josef Strzygowski, who concealed his Polish identity and instead promoted a vision of art history as a "series of deadly battles between national spirits." Strzygowski praised Langbehn's account and followed Langbehn in anticipating a modern German artist to follow in his tradition. To counteract Langbehn's cries of national renewal, a group of art historians promoted a different narrative. Inspired by Eduard Koloff, a German émigré writing from Paris, who suggested that Rembrandt's paintings possessed a "Jewish touch," these scholars argued that Rembrandt's proximity to Amsterdam's Jewish population represented an openness that was evident in his artwork and, in particular, in his portrayal of Jews.[21]

Panofsky agreed with Koloff and extended his thesis. "If it is at all possible to compare the thoughtful language of philosophy with the representative language of art," Panofsky declared, "then the greatest German painter at the end of his life represented the world as the greatest Jewish philosopher conceived of it."[22] For Panofsky, Rembrandt's ability to represent the divine in the particularity of human experience was akin to Spinoza's pantheistic vision of transferring the divine to universalism, the sub specie aeternitatis. Echoing Spinoza's concept of eternal perspective that he introduced into his methodological essay "Reflections on Historical Time," Panofsky argued that in such late portraits by the Dutch master as the *Portrait of a Young Jew* (1661), the physical attributes have an empirical quality to them that moves beyond the individual through the general to achieve the truth of the divine.[23]

In arguing that Germans and Jews resembled each other in a deep

spiritual and intellectual way, Panofsky seemed to present a position re-markably similar to that of Cohen's. Indeed, it is easy to see this lecture, therefore, as a symbol of German-Jewish humanism in which "Rem-brandt's openness to the Jews became . . . an ideal or imago for negating the anti-Semitism of their own times."[24] The tradition of German-Jewish art historians who wrote exclusively on the subject of Renaissance hu-manism was one that continued in the period of emigration.[25] When Franz Landsberger published *Rembrandt, the Jews, and the Bible* in 1946, he made this connection between Rembrandt and the Jews explicit. "It has proved a comfort to me in this era of European Jewish tragedy," Landsberger wrote, "to dwell upon the life and work of Rembrandt. Here was a man of Germanic ancestry who did not regard the Jews in Holland of his day as a 'misfortune,' but approached them with friendly sentiments." It seems fitting, then, that Panofsky later observed, "My personal sympathies lie with seventeenth-century Holland."[26]

Yet Panofsky was not Landsberger, who made an explicit turn to Jew-ish art in the 1930s. Moreover, when he noted his cultural attachment to seventeenth-century Holland, it was in 1944, and it was uttered in confidence to a close friend, the author Booth Tarkington, who, despite his friendship with the Panofskys, belittled their concerns about politi-cal anti-Semitism in America.[27] But in 1921, following discussion of his lecture, Panofsky sensed the ramifications of such a comment; he put his text into a drawer where it remained, unpublished, until after his death.[28] Even in the lecture, Panofsky insisted that his interest in Rem-brandt's portrayal of Judaism was a particular expression of a general problem, and therefore "equally interesting not only to Jewish history, but also to the art historian."[29] Most of Panofsky's colleagues, let alone historians, never read this essay, and his decision to refrain from pub-lishing it reveals his attention to precisely the kind of political posi-tioning that German-Jewish humanist scholars have been denied in the past.

Saxl, who received his dissertation on the topic "Rembrandt Stud-ies," fits the traditional narrative more closely and provides a good counterexample to Panofsky's positioning. Having failed to get a job at the state museum in Austria because he was a Jew, he found his way, as we know, to the Warburg Library before the war. That he wrote articles connecting visual culture to Zionism could not have helped his profes-sional prospects even when the Social Democrats took control of the city in 1919.[30] Offered the opportunity by the University of Hamburg to deliver a trial colloquium two years after Panofsky's lecture, he chose to speak about the old master, an event that was not well received.[31]

Although he pursued numerous projects with Warburg after 1925 to present Rembrandt as a European artist poised between two worlds, this narrative remained largely unpopular in the wider art-historical community.[32] In this way, Panofsky's silence is more instructive than any statement he might have added and reflects a consciousness about how he was read and understood in public.

This intellectual choice of omission was supported by certain social and scholarly practices of the Hamburg School, and the "nonstory" of Panofsky's lecture delivered at the main center for Jewish history, a place that also served as a refuge for Jewish scholars who could not secure jobs in academic departments, reinforces the importance of Panofsky's savvy and his determination to retain a position within the university.[33] The members of the Hamburg School were supremely aware of the complicated negotiation between autonomy and legitimation that their status as scholars outside the traditional academic community afforded them. The navigation between the uniquely German position of *Privatdozent* and the role of private scholar became a powerful source of collective identity for an entire subculture of Jews of which they were a part.

Between *Privatdozent* and Private Scholar

Writing in January 1922 to his former classmate Kurt Badt, Panofsky admitted that he would "grab at any opportunity to get out of the Jewish (and that means eternal) *Privatdozent* position." Panofsky wrote to Badt again, six months later, to inform him of an intermediary position he had been awarded through Pauli's negotiation, a position that, while not equivalent to that of *Ordinarius*, nevertheless provided more stability. Thanks to Pauli, Panofsky did not have to "abandon the whole for-a-Jew-in-itself nearly hopeless university situation." In January 1926, Panofsky wrote to his friend the art historian August Grisebach, describing his new status, and insisted that there was a difference between being a *Privatdozent* and an *Ordinarius*, and he had yet to become fully "grown-up." "I know that I have so much more to do before I am truly a 'professor' in the real sense of the word," Panofsky confided to another colleague.[34]

Despite his characteristic exaggeration, Panofsky spent considerably less time in academic "purgatory" than Cassirer had. Both circumstances were far more auspicious still than those of hundreds of other German-Jewish scholars who never made it out of this eternal Jewish position. According to the esteemed sociologist Simmel, who remained

a *Privatdozent* with virtually no influence, his predicament had only one explanation: "hebraeus sum [I am a Jew]."[35] Following the 1847 repeal of the "lex Gans," a regulation that barred unbaptized Jews from the academy, the German university system technically welcomed Jews. But the persistence of anti-Semitism created a series of hurdles that made it nearly impossible to advance beyond the level of a student. To begin with, a graduate student required a professor's approval of the *Habilitation*, but because of anti-Semitism, many young Jewish scholars could not even advance to this stage. Cassirer met this challenge only after the courageous intervention of Wilhelm Dilthey, who managed to persuade his colleagues of the philosopher's cause, but most young Jewish academics were not so fortunate.[36]

With the *venia legendi*, or certification of approval in hand, these young students were then welcomed into the ranks of the *Privatdozenten*, lecturers who were burdened with heavier course loads and time-consuming introductory courses yet bore no rights in the official system.[37] Unsupported by the state, the private instructors increasingly made up the "unofficial university" and could expect to wait at least five to ten years for a chair to open. This hierarchical and inequitable system created an entire generation of overqualified research assistants.

Although Jews were overrepresented in the university in the academic year of 1911–12, they were disproportionately overrepresented in these impermanent non-*Ordinarius* positions. Naturally, "if he is a Jew," Weber wittily observed, "of course one says *lasciate ogni speranza* [abandon all hope]. But one must ask every other man: Do you in all conscience believe that you can stand mediocrity, year after year, climb behind you, without becoming embittered and without coming to grief?[38] *Privatdozenten*, unable to survive on student fees alone, were often required to have an outside income in order to stay afloat. This contradictory economic situation, in which scholars remained privately supported for an unofficial state position, came to define a characteristically German-Jewish predicament.

Many Jews heeded Weber's advice and opted out early, leaving the academy when their resources allowed, and became private scholars (*Privatgelehrter*), an unemployed scholar's only other alternative. Such a position required similar funds, usually from one's family, but came without the university affiliation that, however unjust in its burdensome requirements, still offered some measure of legitimacy. The position of the private scholar was equally populated by German-Jewish men and was unique for the way it represented the opportunities and anxieties of this secular Jewish milieu.

Warburg had expressed an early interest in an official post at the University of Basel, where he could have worked alongside his intellectual role model, Burckhardt. But anti-Semitic sentiments blocked his appointment.[39] Instead, supported by the wealth of his banking family, Warburg wrote and lectured outside the university alongside his childhood friend Paul Ruben, also a banker's son. While the bankers' sons Warburg and Ruben hardly resembled the despised stereotype of the eastern European Jewish peddlers that the historian Heinrich von Treitschke called "pants-selling youth" (*hosenverkaufende Jünglinge*), they were nonetheless unwelcome in the academy.[40] Warburg came to represent the paragon of the private scholar.

To be sure, Warburg maintained a degree of cultural autonomy that he could not have had in a university post, autonomy that possibly was better suited to his idiosyncratic personality. Warburg's affluent and supportive family, and others like it, reasoned that if anti-Semitism barred their children from German universities, they would fund their children's work privately. The impact of their decisions extended far beyond the private lives of their sons. These efforts created both private scholars and private societies, including the Warburg Library and the Kaiser Wilhelm Society in Berlin. Such institutions, which experienced their founding moment on the eve of the First World War, offered havens for frustrated Jewish professors whose entrance to the universities had been refused or rendered impossible.[41] Since Jews constituted 21 percent of all patrons of the Kaiser Wilhelm Society and provided one-third of the total revenue, they were in a position to insist on positions for certain scholars, as was done, for example, for the scientists Alfred Einstein and Fritz Haber. Even Max Weber, who bemoaned the influx of private money in scholarship, observed that the ability to own the "means of production" was transforming his field: "The craftsman owns his own tools (essentially, the [private] library), very much as a craftsman at an earlier time owned his within his trade."[42]

Warburg was clearly in a position to take advantage of such an opportunity and to leave the "mediocrity" of the past behind. Yet this cultural autonomy had its disadvantages. Warburg suffered tremendous bouts of insecurity as a result of his precarious position and was dissatisfied by his brother's constant reassurance that he should be grateful to lead the "English" life of the private intellectual. Goldschmidt, who managed to make the transition from banker's son to art history chair, was equally unsympathetic to the discontented Warburg. When Warburg wrote him in 1915 to inquire about possible positions, Goldschmidt assured his friend that he was better off without the unwanted

burdens of being a university professor, including delivering seven hours of lectures every week. Enumerating locations where Warburg might consider founding a private institution of his own, Goldschmidt observed, with his characteristic dry wit, "It is a pity that no private health resort caters to the history of art; for your library and your scholarly direction could provide a luxuriant convalescent home."[43] It is unlikely that Warburg appreciated Goldschmidt's joke.

Cassirer did not even need to be privy to Warburg's conflicted position, for before the war he was already determined to avoid this fate, even if Cohen expressed the concern that Cassirer "had already sunk to the level of a private scholar" and would soon no longer be employable. Given the difficulty with which German Jews negotiated these equally undesirable alternatives, and the extent to which neo-Kantianism was already closely identified with Jews, Cassirer could not have been expected, once he finally did land a job in Hamburg, to advertise his Jewish heritage in the secular realm. Toni Cassirer always insisted that her husband was first and foremost a *German* philosopher of German students. Although both of them were *German* Jews, she reasoned that "for Cohen the accent lay on the other place." One should not be dissuaded by Toni Cassirer's own positioning to overlook that even the German-*Jewish* philosopher Cohen was aware of the subtleties of perception; after hearing that an essay of his would be published in a Protestant paper, Cohen did not withhold delight that his ideas would be visible outside "the ghetto."[44]

Cassirer and Panofksy, but not Warburg, remained active members of the Jewish community: Warburg and Panofsky both maintained membership in the local B'nei Brith organization, and Panofsky continued his membership in the local chapter of the Akademie für die Wissenschaft des Judentums.[45] And if they viewed these choices to be primarily private activities, they also did not aspire to flatten such distinctions with their integration into the secular realm. Rather, their contributions to the humanities reflected extraordinary pride in the Jewish community. This pride was no clearer than at the height of the so-called Cassirer affair.

The Cassirer Affair

Cassirer's appointment to chair the new philosophy department later assumed the symbolism of a progressive moment. At the time, however, this event was inconceivable to many of Hamburg's Jewish resi-

dents. Cassirer's university appointment particularly surprised William Stern, a Jewish psychologist who had lived and worked in Hamburg since before the university's founding. "Unfortunately, the selection is restricted . . . because I am a Jew," Stern wrote to another Jewish student of Cohen's, Jonas Cohn, adding, "Despite the revolution one cannot expect *two* Jews as representatives of philosophy."[46] Indeed, the university board had not overlooked Cassirer's Jewishness, and one faculty member confirmed Stern's fear by reminding his colleagues that there was "already a representative of philosophy in Hamburg of the Jewish religion." It was, as this member explained, "despite Cassirer's Jewish faith," that he got the job at all.[47] It is tempting to assume Warburg's facilitation of Cassirer's appointment, but given his absence from the city at the time, it is unlikely that he was directly involved, and the meaning Warburg attributed to Cassirer's Jewishness only became apparent later.[48]

Stern was pleasantly surprised by Cassirer's appointment but anxious, nonetheless. The summer of Cassirer's appointment, anti-Semitic students boycotted Stern's lecture. Local Jewish newspapers confirmed this and other acts of hatred in the year of the university's founding.[49] The Viennese Toni Cassirer commented that while such incidents were common in Vienna, they were atypical in Hamburg, a city she described, affectionately, as the "first socialist Republic of the new Germany."[50] Hamburg's professorial board demonstrated "great eagerness for securing [Cassirer's] services."[51] But its students proved far less enthusiastic.

Throughout Germany, students were generally more radical politically than their professors, and Hamburg's students did not hide their anti-Semitic leanings. During the Weimar era, the university enrolled almost five thousand Jewish students, or about 4 percent of the total student population.[52] But many German students protested the inclusion of the Jewish students under the category of "German citizens" in the current student constitution. Warburg's brother-in-law William Hertz reported that, among the faculty, there were also a few anti-Semitic nationalists.[53] One of them, the geologist Siegfried Passarge, frequently defamed Jewish professors, and over the course of the decade, his slander became increasingly aggressive. On one such occasion in 1927, Passarge presented a lecture, "Ethnology of the German People and the Jews," which angered many socialist and Jewish students alike.[54] The university board assumed an anodyne stance of noninterference toward both the students and Passarge. The "intellectual freedom" that supported Cassirer's appointment also protected Passarge's

racist ideas—a sign of both the hope and the apprehension that characterized the period.

It is of no small significance, considering this context, that Cassirer fulfilled Warburg's vision for Hamburg as a city of serious intellectual scholarship. Moreover, through the symbiosis that his scholarship shared with Warburg's personal library, the philosopher brought the art historian up from the depths of his postwar depression. But Cassirer came to save more than Warburg's secular vision for Hamburg. He also fulfilled a unique mission that Warburg held for Hamburg's Jews.

On June 24, 1928, when Warburg read in a half dozen newspapers that Cassirer had received an offer from the rival University of Frankfurt, his reaction was nothing short of hysterical.[55] In the month before Cassirer made a decision, Warburg held long and frantic conversations with Cassirer, Max, Bing, and Saxl over the disquieting "Cassirer affair."[56] Warburg worked tirelessly to persuade the philosopher to remain in Hamburg, privately negotiating with the president of the University of Frankfurt, drafting a public statement for a special issue in the local newspaper the *Hamburger Fremdenblatt*, and persuading Hamburg's mayor and a senator to solicit Cassirer personally.[57] Cassirer was Hamburg's intellectual lifeline, and Warburg would not let the city lose him. And the retention deal that Warburg engineered had enormous cultural and political consequences.

Warburg's correspondence and public statement reveal an anxiety over the significant implications of Cassirer's potential departure for Hamburg's nascent intellectual world. In correspondence with the University of Frankfurt's president, Kurt Reizler, Warburg suggested that Cassirer's leaving would reflect poorly upon Warburg's ability to cultivate Hamburg as a serious intellectual place. Warburg evoked sympathy for Hamburg's young intellectual tradition in comparison with the "Prussian university system" with its "proven traditions, bigger power, and more understanding curators." According to Reizler, Warburg had erroneously turned the prospect of Cassirer's departure into a "prestige question," and he suggested that Cassirer could benefit from a change of scene in Frankfurt. Warburg knew that if Cassirer left, his departure would not be temporary. "Hamburg's attraction would never be adequate to divert his course of life back to the provinces," Warburg wrote. It was difficult enough attracting visitors from the "big city" to his library.[58]

Warburg hastily published an article, "Why Hamburg Should Not Lose the Philosopher Cassirer," and sent copies to local politicians, professors, and influential Hamburg citizens. Warburg argued in the arti-

cle that Hamburg's precarious identity as an intellectual city hinged on Cassirer's decision, and by suggesting that the young university should cultivate its own sense of place and scholarship, he appealed to local pride in the "Hanseatic" city and its competition with its Prussian rival. He urged his fellow Hamburgers to assure Cassirer of his worth, for surely Cassirer would remain, Warburg maintained, "if Hamburg could make our professor believe that the Hanseatic university also needs him as an essential and leading institution whose personal development means an invaluable strengthening of the idea of having a university (*Universitätsgedankens*)."[59] For Warburg, the very idea of the university was unthinkable without Cassirer.

Warburg bemoaned the issue of Hamburg's prestige in an earlier draft of the same article and declared it a victim of big-city bias. "The sluggish population of middle Germany (in this case including Berlin) has not yet managed to go to Hamburg, as readily as it has to remote Amsterdam, London, or Paris."[60] Berliners, maintaining what was, he argued, their cosmopolitan prejudice, viewed Hamburg as a city on the periphery and neglected to appreciate what it offered. Warburg had capitalized on local patriotism and intercity competition in his initial campaign for the university. Now Warburg argued that Hamburg needed Cassirer to maintain it.

Warburg's earnest supplication finally paid off, and, inspired by his example, local politicians also encouraged Cassirer to remain. One longtime member of Hamburg's bourgeoisie and senator, Paul de Chapeaurouge, wrote to Cassirer personally to express his wish "that your greatly recognized talent will remain with our young university as you continue as one of its leading scholars." The Hamburg Senate also invited Cassirer to deliver a high-profile university address in the town hall that August. Saxl, too, reminded Cassirer of his importance to the intellectual climate of Hamburg. He urged him not to forsake Hamburg and enclosed in his letter compliments from colleagues and students.[61]

An offer from Frankfurt's university was difficult to turn down. In addition to a competitive package of teaching responsibilities, salary, and pension, the University of Frankfurt offered Cassirer an opportunity to work in a city with a rich intellectual history. To Warburg's dismay, Hamburg's citizens still celebrated their home as primarily a port city and not as a place for serious scholarship. The university recognized the harbor as the heart of the city and held all of its major academic celebrations on ships.[62] The harbor—not the city's internationally acclaimed intellectual life—earned Bismarck's adoration and the

nickname "Gateway to the World." Frankfurt's commercial reputation, in contrast, did not come at the expense of its intellectual status. Cassirer's friend Ernst Hoffmann, a Heidelberg professor, echoed this sentiment and cautioned Cassirer, "Do not forget that Hamburg is the city of the Hamburg-America Line and Frankfurt the home of Goethe."[63] Given the supreme importance Goethe held for Cassirer, Hoffmann's appeal was enticing.

The Torch of German-Jewish Hamburg

As a result of Warburg's persistence, Cassirer ultimately decided to remain in Hamburg. But Hoffmann's characterization of Hamburg as the city of the Hamburg America Line was more evocative than he knew and more than a mere affront to Hamburg's mediocre intellectual reputation. By alluding to the largest ship line in the world, Hoffmann also highlighted its director, the German-Jewish shipbuilder Albert Ballin. Warburg and Ballin's aesthetic disagreements notwithstanding, Ballin embodied a similar dual identity as a German patriot and an influential Jewish personality, reflecting a unique tradition of Hamburg's German Jews who were integrated into the economic life of the city.[64] Warburg's correspondence with Jewish friends and family from this period indicates that something else was at stake in Cassirer's potential departure: the loss of Hamburg's unique German-Jewish tradition.

Warburg perceived Cassirer's potential departure as a test for Hamburg, but the concerns and stakes he highlighted varied depending on his audience. In his published article and his dialogue with non-Jewish parties, Warburg defended Hamburg's intellectual pedigree. But Warburg also worried that Cassirer's departure would damage Hamburg's purported intellectual openness and could lead to similar flights by the other German-Jewish professors at the Warburg Library. Warburg told his brother Max that Cassirer's departure would represent a loss to the entire German-Jewish community: "If Cassirer goes to Frankfurt, [Cassirer's star pupil Walter Solmitz] surely would follow him and that holds symbolic meaning for the individual: the organic potential for growth and the capacity of the bearer of the inherited German-Jewish constitution (*des alten Erbgutes in deutsch-jüdischer Hand*) would suffer an incurable blow." Warburg echoed this sentiment in the diary that he kept with his assistants. This domino effect was noteworthy, Warburg wrote, because Solmitz was meant to be "a representative of the

next generation [who] would carry on the torch of the German-Jewish spirit."[65] If Cassirer left, he would take Hamburg's German-Jewish present and future with him.

Warburg's allusion to Hamburg's "German-Jewish tradition" and the "torch of the German-Jewish spirit" clearly evokes a tradition extending beyond Cassirer alone.[66] But if most of the scholars who were associated with the Warburg Library in the 1920s were Jewish, none of them pursued Jewish scholarship: neither the traditional study of Jewish texts, nor what came to be called "Jewish Studies."[67] Warburg's understanding of a "German-Jewish tradition" must be found, then, in the domain of secular scholarship or some kind of uniquely Jewish scholarly practices or institutional experience. Moreover, Warburg's musings on the "German-Jewish tradition of Hamburg" amounted to more than an episode in his lifelong fight against anti-Semitism.[68] Warburg's adoration of Cassirer constituted a thoroughly *positive* view of German-Jewish identity. Indeed, his preoccupation with the Cassirer affair shows that it was more than anti-Semitism that defined Warburg's relationship to Judaism. Doubtless, Warburg never would have expressed the meaning Cassirer held for the German-Jewish tradition in "mixed company." But his conversations with Jews reveal that there was something Jewish—albeit opaque to the outside eye—about Cassirer's contribution to the wider secular community.

The obscure Hamburg Jewish identity becomes clearer in contrast to considerations of what Frankfurt meant to Warburg as a competing German-Jewish paradigm. As free cities with "Weimar-era" universities, Hamburg and Frankfurt already maintained a healthy competition, and this urban rivalry was duplicated within the Warburg family itself.[69] But Frankfurt also presented a foil to Warburg's intellectual vision and, it would appear, cultural mission. If Isaac Deutscher later characterized "non-Jewish Jews" as unaffiliated Jews who nonetheless were still tied to a Jewish identity, Warburg treated certain visible Jews with overt Jewish interests as "Jewish Jews."[70] Rather than resemble Deutscher's non-Jewish Jews or Frankfurt's Jewish Jews, Warburg viewed the German-Jewish tradition embodied in Cassirer and the Warburg Library as uniquely possible in Hamburg.

Home to the German-Jewish "Jewish" philosophers of the Freies Jüdisches Lehrhaus, Frankfurt was, in the 1920s, reputed to be *the* place to study Jewish texts. The revitalization of modern Judaism was welcome in the city with "the most famous of all Jewish communities in Germany." In fact, Frankfurt was so receptive to the Jewish community that in the early Zionist debates, one activist proposed it as a solu-

tion to the Jewish problem.[71] This Jewish spirit was also reflected in the city's university. Like Hamburg's university, the University of Frankfurt was privately funded, and in Frankfurt these private donors consisted disproportionately of Jewish families. But the stigma of Jewish influence remained, and because of its association with "Jewish money," the University of Frankfurt earned the noxious label "Jew University" and during the Nazi period was threatened with closure. Although they had raised nearly two-thirds of the money for Hamburg's university, the Warburgs disapprovingly observed that Frankfurt's parallel development had been "anxious and Jewish" (*ängstlich-jüdisch*).[72] That Hamburg's mayor concealed the abundance of its Jewish donors may have been anti-Semitic, but it was also effective institutional positioning. With respect to Jewish participation, perception was more important than fact.

The potentially volatile situation among Hamburg's "Jewish" Jews was similarly managed in a negotiation that came to be called the "Hamburg System." Although the Reform movement broke off from the community in 1818, the community resolved the split by separating membership in the community from denomination affiliation, a unique solution that created the semblance of civility. Hamburg Jews did not disrupt the peace. Warburg similarly strove to manage the perception of his personal library as both secular and oriented toward the good of the city. When Gershom Scholem, a German-Jewish historian and Frankfurt Lehrhaus scholar, reached out to the Warburg Library, Warburg refused to publish his work, even though, as Saxl pointed out, Scholem's perspective was highly relevant to their scholarly goals.[73] For Warburg the purpose of the Lehrhaus and its affiliates was avowedly Jewish and devoted to adult Jewish education.[74] Warburg, in contrast, claimed a *universal* mission for his library. Following similar reasoning, Warburg later turned down a request from the Wissenschaft des Judentums for space because, according to Warburg, his library pursued only "local Hamburg and scholarly purposes."[75] In both cases—his aversive stance to Scholem and his considered distance from the Wissenschaft des Judentums—Warburg kept "Jewish Jews" at arm's length.[76] So when Solmitz reported that Toni Cassirer had expressed interest in moving to Frankfurt, Warburg snidely commented that she sought "ghetto warmth" (*Ghetto-Wärme*).[77]

Warburg believed that Cassirer's career in Hamburg and the Warburg Library's collective scholarship represented a middle ground between the "ghetto warmth" of Frankfurt and the compromising assimilation and, by extension, conversion necessary to succeed in a city like Berlin. Because Hamburg possessed proportionately fewer Jewish residents

than Berlin, Warburg believed that it eluded some of the social conundrums previously discussed. Most of Hamburg's Jewish population lived in one neighborhood, a situation that presented certain advantages for the community. While the percentage of Jews in Hamburg never rose above 1.8 percent, in 1925 Jews made up as much as 14.9 percent of the Eppendorf neighborhood and over 15 percent of Harvesthude and Rotherbaum.[78] Hamburg's residents referred to the area situated loosely around the university not by its official name, Grindelviertel (after its main street), but rather as "Little Jerusalem." And to many prominent Jews in Berlin, Einstein included, Hamburg's Little Jerusalem provided an alternative to the glass ceiling that persisted in the capital. In a 1926 letter to Cassirer, Einstein inquired whether he could facilitate an appointment in Hamburg for a colleague who "has it very hard as an Eastern European Jew [in Berlin]."[79]

But if a Jewish family chose to live outside this neighborhood, as did the Cassirers, their children risked being harassed with anti-Semitic comments on their way home from school. On one such occasion, when Toni Cassirer scolded her neighbor's son for disturbing her father-in-law in the shared backyard, the angered neighbor suggested that the Cassirers return to Palestine. The philosopher's response—an epistolary exchange with his neighbor on the topic of familial respect—showed his characteristic tendency to assuage such anti-Semitic outbursts. His wife, however, was bewildered and upset. Like many other Jewish wives, she took pride in raising respectable children to avoid precisely this kind of attack. For her, Palestine was where narrow-minded religious Jews went, and the Cassirers identified even less with those Jews than they had with Cohen.[80] Despite the haven represented by this Hamburg neighborhood, this tenuous middle ground was difficult to maintain.

The Lessons of Rathenau

Scholem was not entirely off the mark, then, when he described the scholars of the Warburg Library "as the three most remarkable 'Jewish sects' that German Jewry produced." He was less accurate, however, when he glibly offered that "not all of them liked to hear this." For an analysis that exclusively focuses on the public realm, in which Warburg never would have uttered the phrase "German-Jewish tradition," oversimplifies the relationship between these men and their religious affiliation.[81] To be clear, Warburg harbored a deep distaste for official

Jewish life; he left the city's Jewish community and became angered, on more than one occasion, when he was counted in its census.[82] Despite this personal aversion to organized religion, Warburg believed that Cassirer's contribution to secular scholarship kindled a "torch of the German-Jewish tradition," a tradition that he linked to a distinctive urban experience.

For Hamburg's residents, this scholarly tradition was a matter of civic pride. In his public article at the height of the Cassirer affair, Warburg wrote that founding the university so soon after the war was a "symptom of the will to recreate through intellectual action what no Treaty of Versailles could destroy (verschütten)."[83] The university seemed to prove that Weimar's moment of hope persisted despite the crippling effects of Versailles, and he lauded the university for capitalizing on "the inner political change in Germany . . . as an advantage for *someone like Ernst Cassirer* to achieve a leading position that until then was not awarded to him."[84] The phrase "someone like Cassirer," suggests a fear, not of an exodus of Kant scholars from Hamburg, but rather of the loss of a certain kind of German-Jewish scholar unique to the city. This coded language represented a deeper problem that all Jews—not only those in Hamburg—faced, namely, the challenge of achieving integration into the city while simultaneously maintaining the integrity of the Jewish community. If Cassirer left Hamburg for the "more understanding environment" in Frankfurt, his fellow Hamburgers could consider this spirit of tolerance no more than lip service in their city, and Hamburg's Jews could assume that they failed in this endeavor.[85]

To encourage openness and tolerance, Warburg defended the city's intellectual tradition and promoted its support of "someone like Cassirer"; but when he was in the company of "someone like Cassirer," Warburg spoke with a different inflection. What could be understood as normal academic politics was also implicated in the self-fashioning of the city and the cultural positioning of the Jewish community, a series of negotiations that German Jews like the Warburgs, the Cassirers, and the Panofksys made to the best of their ability. These families were acutely aware of the mixed blessings of their hard-earned accomplishments, and in their professional lives, these scholars struggled with the consequences of their influence. In 1912 Warburg declined the opportunity to be the public chair of an international art history conference even though he had effectively organized it, reasoning that "a Jew is not able to be the president of an international organization because that would discredit it."[86] Many prominent Jews like Benjamin agreed with Warburg and felt that it was simply better to turn down such of-

fers, since Jews endangered "even the best German cause for which they [stood] up *publicly*."[87]

To address the unjust yet undeniable predicament of what might be called today the "politics of representation," Jews surrounded themselves with supportive non-Jews and emphasized their contributions to German culture at large. Somewhat disingenuously, Warburg often went out of his way to cultivate non-Jewish relationships and even welcomed a positive review of the Warburg Library in a reactionary journal known for its anti-Semitic views, an act Warburg insisted was the only way to gain credibility.[88] Like Freud, who worried that psychoanalysis would be considered a merely "Jewish" science, Warburg sought legitimation from non-Jewish critics.

German Jews also exhibited true patriotism, and in this vein many assumed positions of prominence in the Weimar Republic: Walter Rathenau became foreign minister; Hugo Preuss authored the Weimar constitution; and Hamburg's own Max Warburg negotiated at the Treaty of Versailles. In the cultural realm, Jewish presence intensified beyond the Cassirer clan's success. As one historian of Weimar provocatively claimed, "Without the Jews there could have been no 'Weimar Culture.'" Nonetheless, despite the prevalence of traditional "outsiders," including, Jews, socialists, and members of the avant-garde, Weimar's "insiders" still represented the dominant authority. Although they considered Cassirer "very much esteemed," what Cohen and Natorp overlooked was how such esteem only intensified hostility.[89]

Concerned by the pervasiveness of anti-Semitism, Einstein urged Rathenau to step down from his position as foreign minister in 1922, observing that he "always thought that the natural conduct [of Jews] in public should be one of proud reserve." When Rathenau was assassinated just a few weeks after Einstein's cautionary words, Max Warburg suggested that Rathenau had been too "Talmudic," a characterization frequently used to describe secular German-Jewish professors such as Simmel.[90] The paradox of Jewish distinction in Berlin threatened to quell the revolution in culture before it had even begun. For some historians, Rathenau's assassination marked the turning point: "A border had been crossed and Germany had entered a new and forbidding territory in which to be Jewish was more than a handicap or a social embarrassment; it was a danger and, not impossibly, a sentence to death."[91]

Rather than announce some definitive meaning, however, the traumatic event signified yet another series of contradictions, as captured by Cassirer's former student Leo Strauss: "The Weimar Republic was weak. It had a single moment of strength, if not of greatness: its strong

reaction to the murder of the Jewish Minister of Foreign Affairs, Walter Rathenau, in 1922. On the whole it presented the sorry spectacle of justice without a sword."[92] The question remained whether prorepublic scholars and politicians would use this sword to capitalize on this popular momentum. In a city with no Prussian past, a less visible Jewish population, and a new "Weimar-era" university, such judicious "outsiders" as Cassirer and Panofsky stood ready to benefit.

Nonetheless, Rathenau's assassination remained vivid in their minds. Cassirer, for instance, insisted on avoiding political confrontation. When the Berlin press slandered Einstein, Cassirer advised him, as he had his wife, to simply ignore such racist denunciations. "German scholarship has nothing to do with the aggression of a few political agitators and scholarly monomaniacs," Cassirer assured him, echoing his confidant Liebermann's dictum about art. Responding to these critics only "helps to hoist these attacks to a totally undeserved significance."[93] This inclination to maintain a low profile reflected the defining aspect of the Hamburg School's cultural infrastructure—its financial and administrative independence from the state. In this respect, Hamburg's cultural marginality provided a source of strength. For the marginality of Jewish academics might just account for their scholarship's "adventurous nature" and "experimental sensibility," qualities that presented a "compensatory reaction to, a protest against, the conformist and behavioral constraints imposed upon [them]."[94] According to this reasoning, their scholarly success resulted from the "advantages of discrimination," the paradoxical benefits of the peripheral and subordinate positions in which Jews often found themselves. As a result of this marginalization, Jewish scholars were able to pursue highly creative research that would have otherwise been impossible.[95]

Yet marginality, be it intellectual, geographic, or religious, was also viewed as a threat to the Hamburg School's credibility and often increased the scholars' fears of isolation. These scholars' Jewish heritage only compounded the anxiety concerning the assumed connection between commerce and intellectual life that both supported the "Jewish" positions of private scholars and funded such institutions as the Hamburg School. However beneficial these arrangements were in practice, the flooding of Jews to previously unoccupied fields and private institutions of scholarship meant that the creative energy afforded by autonomy was quickly outweighed by charges of cultural saturation.[96] The transition these scholars made from private Jews to public Germans should be viewed as attempts to break this cycle and not as evidence of delusional thinking.

Keeping a low profile was a difficult position for an increasingly prominent scholar to maintain; Warburg was not the only member of the Hamburg School who sought recognition for his larger contributions to the scholarly community. As part of Cassirer's retention deal, Warburg arranged for him to deliver a high-profile lecture on the occasion of the ten-year anniversary of the Weimar Republic, and he raised the suggestion that Cassirer become the university's next rector. That Cassirer was a chair in a German university already represented a significant accomplishment. That he might become the first German-Jewish rector of a modern German university was almost unbelievable, even if it was exactly what Warburg had in mind for his free city republic.[97] Toni Cassirer was entirely opposed to her husband taking on a visible role in public or participating in university politics. She believed it would foolishly "abet the dominating and growing defense against the alleged meddling of German Jews in the fate of the nation." Max Warburg, who stood closest to the shadow of Rathenau and, for many, was feared to be the next victim of anti-Semitic violence, concurred.[98]

But the philosopher demurred and, persuaded by Warburg that he would be following his intended mission as a German professor of German students, Cassirer was appointed rector the following year. When, in the same year, Panofsky was offered the deanship of the art history department, he was more cautious. "Two Jews at the same time is a little much for one year," the art historian confided in a friend. Panofsky was not typically paranoid and was widely known among such right-wing scholars as Ernst Jünger and Carl Schmitt for his irreverent comments about extreme nationalism. However, he also understood the dangerous implications of Jewish visibility and applied this lesson to his remarks on the Jewish role in the discipline of art history in Germany. "The administration left everything to a Jewish delegation so that afterwards it could eschew all responsibility," he wrote to his wife from a Belgian art history conference in 1930, "exactly as it happened with the armistice negotiations!"[99]

While Panofsky intended his comparison of academic politics to international diplomacy as a joke, his observation nevertheless revealed a central truth that would soon become evident to Warburg, Cassirer, and Panofsky: in the 1920s, a "stab-in-the-back legend" brewed at the level of the academy as in the political realm. Anti-Semites eagerly discredited certain scholarship—be it neo-Kantianism or iconology—as too Jewish, just as they maligned the Weimar Republic as a "Jew Republic." The politics of ideas tragically came to mirror the politics of the nation, even in this, the "first socialist Republic of the new Germany."[100]

Cassirer's Cosmopolitan Nationalism

The kind of philosophy a man chooses depends upon the kind of man he is.
ERNST CASSIRER QUOTING J. G. FICHTE

Cosmopolitanism did not merely sink to the ground, pale and exhausted; and the new national ideal did not then spring up in its place, unimpeded and victorious. Cosmopolitanism and nationalism stood side by side in a close, living relationship for a long time.
FRIEDRICH MEINECKE, *COSMOPOLITANISM AND THE NATIONAL STATE*

A revolution in ideas swept Hamburg in 1919. The arrival of Panofsky completed the triumvirate of the Hamburg School, a coterie that quickly became known throughout Germany for its collective scholarship on "symbolic forms" in the fields of art history and philosophy. Yet it was Cassirer, above all, whose life and work bore out the political implications of this intellectual circle. In these last years of the Hamburg School, politics were inseparable from the inquiry of ideas.

Hamburg's cosmopolitanism, a product of its international trade, rendered the port city well suited to Cassirer's humanist scholarship. As we have seen, the city was known for its internationalism, and its university was built in this image. Countless other institutions, including the Institute for Foreign Affairs and the Hamburg-America Library, supported an agenda in this same spirit. But Hamburg's distinct urban context was not only important for this intellectual and cultural world; it was also precisely

this local commitment to both nationalism and cosmopolitanism that made the Weimar "Compromise"—the unreasonable conditions imposed by the Allies—more palatable to Hamburg's residents than to other Germans.

This substantive connection between Hamburg and the Weimar Republic was apparent in Warburg's dual political loyalty. Like many other Germans of his generation, Warburg was a nationalist who opposed the Treaty of Versailles; as a Hamburger, however, Warburg was not at all anticosmopolitan. He was equally committed to the local, the national, and the cosmopolitan, and he viewed Hamburg's local and national identities in terms of the city's place in the international sphere. Warburg promoted this international mission for the university and saw it reflected in Cassirer, whose philosophical project to consider German thought within a wider European narrative resonated with an overarching international vision for the port city.

The classical humanism of the eighteenth century, from which Cassirer took his cue, was also the Weimar Republic's intellectual inspiration, and that humanism was therefore doubly burdened by its cosmopolitan heritage. It was therefore almost natural that the philosopher should focus on Leibniz, Lessing, Goethe, and Kant, thinkers for whom a cosmopolitan outlook was central to their life and work. It likewise made sense that the eighteenth-century Enlightenment, as well as the Renaissance, served as the origin of his historical portrait of ideas. Yet it was less obvious to his compatriots that these thinkers and their ideas were "bodenständig," that is, rooted in the native soil of Germany. Warburg was correct, then, when he observed that the fate of Cassirer's project to defend German idealism and that of the Weimar Republic were intertwined, and he was equally prescient to see that their likely urban ally was the city of Hamburg, Germany's "Gateway to the World."

The German philosopher Kant, in particular, became an important symbol in the politico-cultural debate over German idealism's cultural legacy and the question concerning the republic's political legitimacy. If Kant's centrality in the history of philosophy was undeniable, the meaning of his role was contested: How successfully did Kant bridge the empiricist and idealist traditions? Was Kant a representative German scholar, or did he share more with the Anglo-French tradition? What was the meaning of his cosmopolitan universalism for German heritage? And could his defense of constitutionalism persuade Germans of democracy's worth?

As these questions reveal, the philosophical assessment of Kant's

philosophy—the starting point for all philosophical inquiry in the interwar period—quickly slipped into the politically charged context. A philosopher cannot be expected to speak directly about politics; here, Bourdieu's dictum that we should "read between the lines" is instructive.[1] Cassirer's 1928 speech for the Verfassungsfeier (Celebration of the constitution) and his 1929 Davos Debate with the philosopher Martin Heidegger provide such an opportunity. Here the philosopher defended both his intellectual and his political cosmopolitan nationalism, a delicate balance of loyalty to both a distinct cultural group and a wider humanist project. But as ideas were politicized, so, too, lives became symbolic of ideas. Who was presenting the argument became as important as what was argued. These issues plagued Cassirer's rectorship, an academic accolade he assumed as the Weimar Republic crumbled at his feet.

Cassirer's Constitution

The Weimar Republic's legitimacy depended on the compatibility of nationalism and liberalism, a political position best represented by the German statesman Gustav Stresemann and his controversial *Erfüllungspolitik*, which sought to revise the Treaty of Versailles by agreeing to fulfill its demands, including the notorious payment of war reparations.[2] As a member of the National Liberal party, who emerged from the war intent on restoring amicable relations with Europe and the world, Stresemann was, in effect, the political analogue to Cassirer's philosophical project: European in scope and nationalist in spirit. Warburg's own admiration and efforts to honor Stresemann for the Nobel Peace Prize, earned for his work officiating at the Treaty of Locarno in 1926, further cemented this parallel.[3]

The year 1928 represented a great victory for this prorepublican moderate position in Germany. The outcome of the Reichstag elections led to the implementation of a Grand Coalition between the Social Democrats, the Center Party, Stresemann's newly founded German People's Party, and the liberal-left German Democratic Party. This positive spirit was also present on the local level. In Hamburg, Warburg succeeded in securing for Cassirer an invitation to speak in the town hall on August 11, 1928, in honor of the Verfassungsfeier.[4] The speech, "The Idea of the Republican Constitution," demonstrated a philosophical defense of the Weimar Republic at the pinnacle of its success. Echoing contemporary statements of support for Weimar, Cassirer situated German intel-

lectual history in a wider European context and drew on this tradition to prove that Weimar was not "un-German."

Cassirer began his speech by asserting the importance of intellectual life in resolving political problems and went on to outline the relationship between political and legal theory and practice characteristic of German philosophical idealism since the French Revolution. The lengthy and lofty speech that followed offered a brief history of German political thought that extended from Leibniz to Herder. More than one hundred years after the French Revolution, Cassirer contended, the problem in Germany was that the notion of inalienable rights, which had once made their appearance in reality, had now retreated to the purely abstract realm of German philosophy. The mission to realign the worlds of theory and practice lay with Germany's present-day citizens. And the republic—with its foundational constitution—was precisely the regime that could accomplish such a feat. To this end, Cassirer attempted to assuage his audience's fears that the German constitution was a foreign concept. "The constitution as such is in no way a stranger in the totality of German intellectual history, let alone an outside interloper," Cassirer insisted. "Rather much more so it has matured on its own ground, and through its quintessential power, it was nurtured through the power of idealistic philosophy."[5] A German constitution would rightfully reintroduce inalienable rights, a notion evident in German theory, into practice.

Cassirer's insistence on the "Germanness" of the Weimar Republic and its constitution was met with resistance, for German citizens primarily viewed the Treaty of Versailles and the republic's constitution as part of the intolerable conditions imposed by the smug, victorious Allies, and they openly debated the authenticity of democratic deliberation on German soil.[6] Cassirer's efforts to ground the Weimar constitution in a national intellectual tradition were part of the wider political debate on which the republic's legitimacy depended. However, his options for political expression were limited, and after 1919 German universities became strongholds of antirepublicanism.[7] Hamburg possessed only a few openly committed republicans, including Albrecht Mendelssohn-Bartholdy, a political scientist and descendant of the German-Jewish philosopher Moses Mendelssohn, who believed passionately in the Weimar project from its beginning and publicly lent his political support to the regime. Nevertheless, overt republicans such as Mendelssohn-Bartholdy were forced to endure constant scrutiny for their expressions of support from a university board that insisted on

an "apolitical" university, as well as menacing taunts from increasingly radical students.[8]

In this context, it is no surprise that the calm, collected, and rational Cassirer did not assume the mantle of a passionate ideologue. But he was not entirely apolitical either, and to describe him as such undervalues the importance of political context and innuendo in Cassirer's speeches.[9] Like most German-Jewish liberals, Cassirer voted with the Left-Liberal Democrats, but, like a growing number of Germans, he was not interested in party politics.[10] The political options available to him, as an academic, were dictated by the landscape of the time: an academy where the absence of values in the university was perhaps lamentable but altogether unavoidable, given the risk for preaching and propaganda that threatened to destroy the integrity of scholarship.[11]

In that same year, Thomas Mann published *Reflections of an Unpolitical Man*, in which he drew on Goethe, Schopenhauer, and Nietzsche, among others, to present a romantic and nonpolitical basis for intellectual life. The "politicization of the intellect," Mann wrote, "works like poison and orpiment on me."[12] Given the strength of this position, very few active left-liberal public intellectuals emerged.[13] For Cassirer's part, had he been an avid party member, the philosopher would likely have been criticized for his public expression of partisan loyalty, as were his colleagues Mendelssohn-Bartholdy and Rudolf Laun.[14] In 1922, when Mann decided to support the republic, conservatives did not forgive him this change of heart.[15] Thus, Cassirer focused on his primary passion, defending the constitution and the contested tradition of German idealism, causes he argued were related. Believing the constitution to be critical to the republic's success, Cassirer made an enormous effort in his 1928 Verfassungsfeier speech to show that it reflected not only a French tradition but also a German past.[16]

To prove his point, Cassirer evoked the seventeenth-century German philosopher Leibniz, a figure of heroic stature in German intellectual history and of central import in European philosophy. The "Leibniz moment" earned its name, Cassirer opined, because Leibniz represented the first thinker to theorize the principle of the individual's inalienable rights, an intellectual event with obvious consequences for the history of European philosophy. The complex relationship between the individual and the universal was doubtless one of the most investigated quandaries of philosophy and political philosophy, and Leibniz had achieved his status as a great thinker for his contributions to classic topics related to this issue, including materialism, dualism,

and the mind-body problem. Cassirer's examination of Leibniz in his *Habilitation* praised him for his significant role in the tradition of modern philosophical idealism and the application of mathematical structures to an empirically given nature.

As a progenitor of inalienable rights, however, Leibniz seemed to be a poorly considered choice, for, if anything, his atomistic theory of humans as monads creates problems for individuation and free will. Moreover, as Cassirer conceded, Leibniz was not the only thinker to theorize this idea, and he suggested that it was also reflected in English philosophy with William Blackstone's *Commentary on the Laws of England* (1765) and in the American Declaration of Independence (1776) and Bill of Rights (1789). As the result of a friendship between the Marquis de Lafayette and George Washington, these American ideas were reintegrated into French thought.[17] But Cassirer argued that this interaction between thinkers and ideas of different national origins reflected a natural circular journey through intellectual history. While Germany remained at the center of his story, it nonetheless shared in a wider network of ideas with universal influence and meaning.

This was not Cassirer's first or last statement of this nature; already in his work that followed the outbreak of the First World War, Cassirer attempted to envision the evolution of the German spirit within the context of European intellectual history. In 1916, with the appearance of *Freiheit und Form*, Cassirer argued that German history was a continuation of intellectual trends that originated in the Renaissance and the Reformation, and some years later, he repeated this central point in an essay published for a magazine devoted to the cultural relationship between Germany and the foreign world. Beginning with Goethe, Cassirer suggested, "modern European intellectual history was a great fugue in which the voices of single people were placed in a row next to one another, to assert influence in their distinctiveness, in order to constitute precisely in this way an unprecedented harmony." Drawing on his long-standing preoccupation with the philosophical universal and the particular, Cassirer continued to trace how different German thinkers theorized the unity that emerged from multiplicity and to "grasp the working and graphic power of the modern French, English, and German culture and seek to understand each as one in its own evolving unity—as a unity, which is not cobbled together out of pieces, out of single thoughts or motives, but rather which is originally and continuously exhibited as a unity of a specific problem and a specific principle."[18]

Some German thinkers, such as Goethe, were more easily integrated

into this emerging portrait of European intellectual history. And if others, such as Leibniz, seemed somewhat less likely candidates for inclusion, Cassirer argued that one would miss Leibniz's full worth if one did not understand him in this way. Indeed, the unlikely prominence of Leibniz in this story reflects Cassirer's strained project to grant Germany a central position in the history of republican thought. Cassirer reinforced the connection of Leibniz to internationalism a year later in an article titled "Leibniz and Jungius," in which he not only reminded readers of Leibniz's international profile but also introduced the lesser-known Hanseatic scientist Joachim Jungius, about whom Leibniz spoke "with pride not only for his German accomplished deeds," but also "as one of the most important thinkers of contemporary European scholarship."[19] Cassirer not only suggested that German thought saw its greatest fulfillment in the European field but also promoted the popular local argument that Hamburg had played, and would continue to play, a special role in this process.

Balancing Acts

This promotion of a cosmopolitan view of German history was not the result of Cassirer's innovation alone; other historians, including, notably, Ernst Troeltsch and Friedrich Meinecke, challenged the militaristic chauvinism that justified German war aims as spiritual and regarded those of the Allies as mechanistic. Such scholars objected to the prevalent idea that there were certain concepts of freedom, community, and society that were essentially German, as compared to others that were distinctly Anglo-French. Following Germany's defeat in the war, however, this position required revision: as we have seen, the war experience demanded a reworking of such Kantian values as absolute judgment to account for the growing movement of historicism and its emphasis on cultural distinction.[20]

An intellectual divide emerged between those reformers who proposed a cosmopolitan view of European history and the conservatives who sought renewed devotion to the German historical experience and its fallen empire. Although the former group of scholars could be more accurately described as "cosmopolitan nationalists"—for their position was truly a balancing act rather than a wholesale commitment to cosmopolitanism—they were increasingly parodied as ardent promoters of the international cause. Mann's description of Fyodor Dostoevsky's

"cosmopolitan radicalism," for example, which threatened to erase all traces of German culture and create an "empire of human civilization," reflects the knee-jerk fear even liberal Germans shared of this universalist impulse. For Mann himself, on at least one occasion, promoted the spirit of "international nationalism" as emanating from the unique *Bürgertum* of his hometown Lübeck. Apart from Cassirer, cosmopolitan nationalism saw its most sophisticated fulfillment in Meinecke's *Cosmopolitanism and the State* (1907), in which he demonstrated, through references to Humboldt, Fichte, and the romantics, how nationalism and cosmopolitanism developed in intimate contact with one another— rather than in inverse—over the course of German history. Aiming to "restore the debased word" cosmopolitanism, which had been stigmatized unjustly, Meinecke argued, "Cosmopolitanism and nationalism stood side by side in a close, living relationship for a long time."[21]

With the founding of the League for International Understanding in 1911, several scholars made the political consequences of this idea explicit. A moderate pacifist association with connections to French and American peace associations, the league held conferences and delivered talks with the express purpose of easing international tensions through academic partnership. At the organization's 1912 conference, Lamprecht made a plea for universal cultural history to support an international peaceful agenda. "Thus, the theoretical foreign cultural policy easily turns into universal cultural history," Warburg's former mentor argued, "and only a clear understanding of the one allows us to hope for the entirely successful development of the other."[22]

By 1913 the organization had 350 members and included many of Cassirer's former teachers and colleagues: Simmel, Natorp, and Cohen, as well as Max Weber, the liberal politician Friedrich Naumann, the architect of the German constitution Hugo Preuss, and the Protestant theologian Ernst Troeltsch.[23] Yet even among this group there were disagreements; Cassirer, among other scholars, found Lamprecht's declarations academically unfounded and ultimately ahistorical, and his controversial reputation arising from the *Methodenstreit* could not have helped the cause. Conversely, although Cassirer's *Freiheit und Form* represented a contribution to this reformist camp, his cosmopolitanism was too prominent for some and inspired challenges from fellow reformers such as Troeltsch.[24] Unlike some of these other reformers, Cassirer's goal was twofold: echoing Cohen's project to align Judaism and the German spirit, Cassirer aspired both to open German thought to a European narrative and, in turn, to restore German thought to its

rightful place in the Enlightenment legacy. This was an uphill battle if there ever was one, for universal humanism and political cosmopolitanism were increasingly on the defensive in Germany.

Yet this was significantly less true in Hamburg, a city that had a university and, increasingly, a cluster of scholarly institutions that nurtured global ambitions. Chief among these was Mendelssohn-Bartholdy's Institute for Foreign Affairs, founded in 1923, which published *Europäische Gespräche* (European conversations), a journal devoted to foreign policy research. Following his "discovery" of America in 1926, Mendelssohn-Bartholdy also helped to found the Society for the Friends of the United States as well as the *Hamburg-Amerika Post*, a publication that promoted this transatlantic relationship. A library devoted to research on America was opened under Cassirer's rectorship in the summer of 1930.[25] This multi-institutional effort brought scholarly expression to those business relationships that already extended across the ocean in the form of such bankers as Paul M. Warburg and John Pierpoint Morgan, both of whom had contributed to the fund for the library. Mendelssohn-Bartholdy hoped that these institutions would draw on Hamburg's natural history to establish the preeminent center for research in international and American law.

Of course, as we have seen, the privately funded world of American scholarship proved to be immensely influential for Warburg's library, which Warburg on occasion referred to as the "mediator between the scholarly circles of the United States and of Germany."[26] That these Hamburg institutions and their students, in turn, should have been favorably received in America, then, is not surprising. Mendelssohn-Bartholdy's star student Alfred Vagts, who graduated with a dissertation titled "Mexico, Europe, and America, in the Special Consideration of Petroleum Politics," went on to Yale, where he met and married the daughter of the American historian Charles Beard and worked at the Institute of Politics in Williamstown, Massachusetts. Vagts, who called his beloved professor the "crown prince," is one example of the success of this partnership.[27] Lamprecht's cultural history was also certainly less popular in Germany than in America, where it laid the foundation for the long forgotten roots of scholarly developments in the "new history," the precursor to the "new historicism." In 1904, and on the occasion of the World's Fair in St. Louis, Lamprecht, along with Weber and many of the other scholars mentioned above, toured the United States, delivering this message to great interest at Columbia, Harvard and other elite schools.[28]

But whatever headway was made in the first decade of the twentieth century to solidify these transatlantic connections was greatly challenged by the First World War, when, despite the best efforts of those such as Ballin, the United States entered the war against Germany. Likewise, Germany's cultural "integration" into Europe, a vast web of economic, cultural, and political contacts that thrived at the turn of the century, was shattered with the war's outbreak.[29] When Cassirer and his compatriots formed the League for International Understanding, the effort seemed weak and poorly timed. America came to be a refuge for this "other" German tradition that stressed the universal over the particular and cosmopolitanism over nationalism and outlasted the Weimar Republic, albeit outside Germany's borders.

Given this increasingly precarious context for the internationalist position, that Hamburg offered a home in interwar Germany to promote these humanist sentiments is all the more significant. Needless to say, one should not overstate the case for this German oasis; to be fair, Warburg's urban vision became increasingly beleaguered in the years after the war.[30] Moreover, when one-quarter of the articles written for the journal *Europäische Gespräche* were composed by Mendelssohn-Bartholdy himself, one must pause to question just how big this foreign policy circle was. Warburg was aware of this vulnerability and he tempered his invocations of the "good European."[31] On one occasion, he insisted that the "feeling for the European intellectual community" created in Hamburg was positive for intellectual exchange "without ever leading to a chummy blurring of borders"; in Cassirer a similar delicate balance prevailed.[32] Despite their rhetorical efforts, the "Lessing affair" revealed that in the fight to claim symbols as the rightful heir to an intellectual and political tradition, Hamburg's identity was at the crux of the issue.

Lessing University?

In January 1929 the politics of ideas came to a head in Hamburg, revealing the deep political tensions within the academic community and a further assault on the Enlightenment tradition. In that year the University of Hamburg celebrated the two-hundredth anniversary of the birth of the eighteenth-century philosopher Gotthold Ephraim Lessing with an event in Hamburg's Music Hall that included a hymn, a lecture, and a reading from Lessing's play *Nathan the Wise*. The modernist art association the Hamburg Group presented the university with a life-size Art

Deco bronze bust of Lessing, and the University of Hamburg's library further marked the occasion with an exhibition on Lessing's Hamburg period.[33] Celebrations honoring intellectual figures had become a common occurrence and were part of a widespread festival culture in Weimar Germany. Laden with national, intellectual, and cultural imagery and symbols, these celebrations were opportunities to cultivate a tradition around which its professors and students united. Yet members of the decade-old University of Hamburg were not in agreement about what those symbols were or who those thinkers should be.

Lessing's anniversary celebration presented a particular honor for Hamburg because, as Rector Heinrich Sieveking observed, "In Lessing's time, Hamburg was not only a city of business but also a city of intellect, emanating from work and relationships, like no other German city. That is an impressive feeling for a Hamburg resident: it should even be an incentive for today and for the future." Moreover, Sieveking boasted that the exhibition's catalog was "testimony that Lessing's intellect is also living today in Hamburg."[34] Rector Sieveking concluded his comments with the suggestion that the University of Hamburg be renamed "Lessing University." Sieveking's speech, and his suggestion, was met with overwhelming applause.[35] But in the month-long fallout in the press, it became clear that the rector's enthusiasm for Lessing went too far for some.

There were good reasons to honor Lessing, especially in Hamburg. Active during the time of the Enlightenment, Lessing wrote plays and commentaries on issues such as the freedom of thought, the power of reason, and religious tolerance. Lessing also lived in Hamburg from 1767 to 1770, during which time he served as the director of the German National Theater.[36] Because of Lessing's central role in German intellectual history, a celebration of Lessing emphasized Hamburg's role in that history. For those university scholars who struggled throughout the 1920s to alter Hamburg's reputation to that of an intellectual rather than economic city, Lessing remained a crucial symbol of a time when the notion of Hamburg as an intellectual center was not just an ideal but also a reality.[37]

That Lessing was proof of Hamburg's intellectual worth, however, was not enough for many of the city's residents. Many nationalist citizens expressed unhappiness with the university's event, for they argued it did not evoke the appropriate amount of patriotism. In particular, the growing nationalist contingent expressed displeasure with the idea that the university might be associated with a "leftist" thinker such as Lessing. One newspaper commentator approved of this rejection of

Lessing's celebration on nationalist grounds: "This abandonment of the celebration of a man, whom one rejected for 'national' [reasons]," the commentator wrote, "anyhow deserves a preference and is more Lessing-esque than any porridge-in-the-mouth (*Breimauligkeit*) of a great Hamburgian paper, that tried to shape Lessing as a spineless liberal."[38]

The contingent in Hamburg who viewed Lessing as a "spineless liberal" had grown in number since Cassirer's arrival in the city ten years earlier. The antirepublicans who organized anti-Versailles rallies in the early days of the university soon found a voice in the official university journal, the *Hamburger Universitäts-Zeitung*, which often published articles on their discontent with the borders, disarmament, and reparations imposed by the Treaty of Versailles.[39] At the same time, organizations such as the German Protection Agency for Germans Living on the Border and Abroad, which agitated for a return to prewar territorial borders, gained ground. In 1921 that agency organized an exhibition entitled "What the Peace Treaty Has Taken from Us."[40] This growing group, composed of individuals who vehemently opposed the Versailles Treaty, presented an increasingly vocal and strong obstacle to republican professors, such as Cassirer, who embraced a university heralded by Lessing's image. The idea of "Lessing University" also provoked a debate regarding the appropriate leadership for the university. The rector did more than represent the university symbolically; he also wielded executive power. During debates in 1921 concerning which flag to hang at the university—the empire's black-white-red flag or the republic's black-red-gold one—it had been decided, for example, that the decision would be left to the rector's discretion.[41] And no less than six months prior to Cassirer's rectorship, the debate surrounding Lessing's anniversary revealed the symbolic power the rector held.

More important still, the controversy over "Lessing University" was principally a controversy concerning the intellectual legacy of the Enlightenment. Sieveking's suggestion that the university be renamed "Lessing University" was more than a bid for Hamburg's intellectual life—it was also a plea for an open and liberal environment in Germany. Lessing's most famous work, *Nathan the Wise*, an excerpt from which was performed at the anniversary festival, was a statement of tolerance figure-headed by a Jewish hero, whom contemporaries assumed to have been based on the eighteenth-century Jewish philosopher Moses Mendelssohn. In fact, contemporaneous with the University of Hamburg's celebration, liberal German Jews organized their own events to mark the two-hundredth anniversary of Lessing's birth and the Lessing-Mendelssohn partnership, a testimony to the promise of

tolerance and inclusion that this relationship still held in the modern period. At one such event held by Hamburg's Jewish community, Cassirer even delivered the honorary lecture.[42]

Yet, on this occasion, the philosopher unexpectedly took the opportunity to talk not of the similarities of this illustrious pair. In fact, in a sketch of their respective lives that emphasized the stark differences between Lessing and Mendelssohn, Cassirer insisted that in their vast correspondence, the pair talked about aesthetics, philosophy, and criticism, but never religion. Cassirer made the point of the speech at the Jewish community the uniqueness of the eighteenth-century Enlightenment that had enabled such a friendship between opposites, a milieu made possible by none other than Leibniz's major achievements in "universally exposing the concept of the truth to its deepest roots." Henceforth religion must face the "double obligation" (*Doppelheit*) of existing in the unity of the eternal and temporal, the rational and the historical, and the secular and religious.[43] Cassirer seemed determined to insist on not only the cosmopolitanism of German nationalism, but also the universalism of Judaism.

That Cassirer spoke at the "Lessing-Mendelssohn Honorary Celebration of the German-Jewish Community" made it hard to separate these two events: the particular Jewish celebration of the Lessing-Mendelssohn partnership and the plea for a university that invoked the former's name. Even if Cassirer insisted on a universalism that welcomed the differences of distinct individuals, identity obscured the message, and the celebration of Lessing the "Jew-lover" presented a red flag to the anti-Semites. That the right-wing camp did not want a "spineless liberal" like Lessing to be associated with the university, therefore, was more than a symbolic war. It was also more than a fight between the politics of Left and Right. Rather the characterization antiliberal, just as anticosmopolitan, was a code for the anti-Semitism that Cassirer's presence provoked. These intellectual designations became merely proxy for the more politically controversial subjects of religion and identity. When the Nazi-controlled Jewish Cultural League performed Lessing's *Nathan the Wise* in 1933, Nathan's message for tolerance was no longer heard.[44]

Kant: German, European . . . Jewish?

If Lessing was an important figure for Hamburg because he recalled a time when culture was central to this mercantile city, Kant possessed

central importance for German philosophy and European history at large. Kant's Enlightenment was located between French and German thought, cosmopolitanism and nationalism, the particular and the universal, and theory and practice. More than any other figure, Kant is "ever-present in the pages of [Cassirer's] writing."[45] But Kant was also a more difficult figure for Cassirer, because he often incited the ire of the growing nationalist camp. In the 1920s, Cassirer's interpretation of Kant, which, like his treatment of Leibniz, promoted universalism and situated German intellectual history in a wider European development, was increasingly under attack.

It is difficult to overstate Kant's impact on modern European thought. His profound confidence in man's capacity to reason, his reflection on his task as a philosopher for a particular moment in history, and above all, his commitment to ethical universalism are paradigmatic of the "Enlightenment Project." But if these features have made his thought a natural ally of political liberalism, social ethics, and deliberative democracy, Kant has also been blamed for the French Revolution, totalitarianism, European imperialism, and the most aggressive forms of capitalism. Kant's work made it possible to think about human beings living together in something like society as we know it and even suggested that in theory anyone could participate—women, Jews, non-Europeans—as long as they proved themselves to be autonomous rational beings and assumed responsibility for their actions. Later critics argued that the same confidence that human beings were malleable supported a domination of nature that would, in the end, be turned on man himself. But this was not the criticism held at the time or by Cassirer's contemporaries.

Rather, whether or not one valued Kant depended on one's perception of the French Revolution, that initial moment of liberal social and political life: whether this was a good thing or whether it supported an excess individualism that undermined a sense of community. Located at the crossroads between French and German thought, Kant and the eighteenth-century Enlightenment naturally became the primary epoch over which this intellectual debate between the particular and the universal and between cosmopolitanism and nationalism played out—it was an era rightly understood as the moment when the seeds of both ideas emerged. As Isaiah Berlin has observed, already present in Kant was the potential slippage to romanticism—one need only change the emphasis on freedom of the law to freedom of will. Such a shift in emphasis had radically different political implications and

could be used to support Enlightenment humanism or to advocate for a romantic nationalism.[46]

Germany had always possessed a unique strand of the Enlightenment that blended reason with more romantic ideas, as in Goethe's novels and plays of the late eighteenth century. Especially after the Napoleonic wars and the resurgence of nationalism that followed, the Enlightenment's cosmopolitanism was increasingly unpopular in Germany. And if the Weimar Republic reinvigorated the Enlightenment tradition in Germany, it always remained on the defensive. The conservatives wanted to draw a sharp line between the Germans and the French and relegate the entire Enlightenment tradition to the latter. The liberals, in contrast, aimed to locate a German source of the Enlightenment and to demonstrate that the German tradition possessed both a nationalist and a cosmopolitan basis. Cassirer felt a responsibility to save the Enlightenment from Teutonic disrepute.

Just as the republic's reputation was undermined because of its foreign origins, so Kant's intellectual nationality became suspect in the 1920s. In the 1928 Verfassungsfeier speech, Cassirer contended that the issue was largely a matter of influence: "The question of whether and in what way the intellectual foundation from which Kant's theoretical philosophy and his ethics were developed, draws on the same tendencies that produced the revolutionary movement in France."[47] Some connections between Kant and the French Revolution were undeniable, but Cassirer went to great lengths to argue that Kant's ideas were generated independently from those of the French, and he cited as proof the publication of Kant's 1784 work *The Idea of a General History with a Cosmopolitan Purpose*, which appeared five years prior to the outbreak of the revolution.[48] Kant and his ideas, he argued, were German-born and bred.

But Kant's patriotism was not obvious to everyone, and antirepublicans criticized the philosopher for his unequivocal embrace of the French Revolution, connecting his thought to the Weimar Republic and the hidden Francophone constitution. Moreover, that Kant's universal humanism was appealing to such German Jews as the neo-Kantian Cohen and his students cast further doubt on Kant's "native" affinity with German culture. These hostilities, which originated during the First World War, meant that Kant subsequently became the focus of a series of "affairs" touching on issues of identity, politics, and nationalism in the academy and culminating in the Davos Debate. Cohen found himself at the center of the controversy, which revolved around

accusations of the "Judaizing" (*Verjudung*) of Kant scholarship. In 1916, in what became known as the "Bauch Affair," the nationalist and right-wing Kant scholar Bruno Bauch publicly criticized Cohen for his use of Kant to support the union between the German and Jewish intellectual traditions and even analogized the Jewish "takeover" in German philosophy to political Zionism.[49]

It should be said that Kant was not entirely deserving of these "attacks" of cosmopolitanism and Jewishness. The Enlightenment philosopher's perspective on the world was doubtless limited by the fact that he never left the Baltic port town of Königsberg, where his days were confined to walks taken around his square block. And in his own writings, he showed little affection for Judaism, even equating it at one point with radical evil.[50] These details notwithstanding, Jews gravitated toward neo-Kantianism's critical and epistemological project, and Cohen made a powerful attempt to demonstrate the "inner harmony" between Kant and Judaism, an argument that displeased Bauch and his allies, to say the least.[51] Just as important to Bauch as what Cohen argued was that a German Jew was arguing it.

Cassirer entered this debate in his characteristic sober manner, one that constituted both his strength and his weakness. He was cool, collected, and rational—nearly to the point of boredom. Cassirer wrote a rebuttal in which he criticized Bauch for his ethnic interpretation that spuriously attributed Kant's universal ethics to the exclusive domain of the German people. By interpreting Germans and Jews through their "essence" (*Wesen*), Bauch the detractor—not the Jewish neo-Kantians who supported humanism—was wrongly essentialist.[52] But a Jew speaking to Germans of essence, as we saw with Panofsky's excursion into Rembrandt, was a lost cause. Like that essay, following negotiations with the Kant Society, Cassirer's rebuttal was never published.[53] Instead, the matter was resolved when Bauch resigned from the Kant Society, but not without objecting, in a public statement, to the so-called higher Jewish censorship of the publications board (*jüdischen Oberzensurbehörde*).[54] In contrast to Cohen's run-in with Treitschke, Cassirer's scholarship following this exchange distanced itself from the more overtly Jewish scholarship on similar themes. Yet while Cassirer's work extended well beyond Cohen's initial neo-Kantian framework, the relationship between the two men linked Cassirer to this school and its fraught history. Try as he did to distance himself, for many, Cassirer always remained Cohen's student and mired in the same inescapable dilemma.

Philosophy on Magic Mountain

In March 1929, in a context increasingly hostile to Enlightenment humanism, Cassirer traveled from Hamburg to Davos, Switzerland, to publicly debate the philosopher Martin Heidegger. Sponsored by the French, German, and Swiss governments, the three-week event was ostensibly an "International University Course," the purpose of which was to reconcile French- and German-speaking intellectuals. The debate between Cassirer and Heidegger—and the controversy that surrounded it—was no doubt the highlight and has since achieved mythical status in the history of European thought. Although we should be wary, as some scholars have suggested, "to read back a dramatic political conflict into the encounter," the debate followed in the pattern of events discussed thus far: the extreme politicization of the academy.[55] And this tendency had reached new heights just a month earlier when the right-wing Viennese philosopher Othmar Spann revived the issue of the "Judaizing" of Kant through accusations similar to Bauch's in a lecture at the University of Munich. On this occasion, he mentioned Cassirer by name and, as in the earlier slander of Cohen, accused the Jewish philosopher of his role in a wider cultural crisis that resulted from the "foreign" infiltration of the academy.[56] The Davos conversation, it is safe to say, would—could—no longer be purely philosophical.

For observers, the pair seemed to represent two worldviews: donning the black suit that evoked a peasant ethos, and showing much more interest in skiing than in the pretenses of the academy, Heidegger was the paragon of a new provincialism, while with his refined snow-white hair, traditional academic dress, and widely recognizable Berlin name, Cassirer was the embodiment of cosmopolitanism (fig. 10).[57] The two cultures of Weimar, the one motivated by an Enlightenment-era universalism and the other by nationalism, had been kept in balance by various compromises throughout the 1920s, but now, seemingly, they were put on stage for all to judge. That contemporary reaction to the debate unanimously favored Heidegger did not bode well for Cassirer or the Warburg clan.

The subject of the debate, the proper interpretation of Kant, was a topic on which both philosophers had written extensively. Having both been trained in neo-Kantian schools, they were aware of each other's work. They had even met before, in 1923 at an event of the Hamburg Kant Society, a visit when Heidegger was a guest at the home of Clara and William Stern and even toured the Warburg Library.[58] Now, before

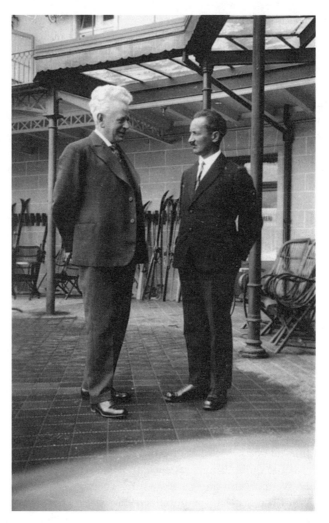

10 For many spectators, Cassirer and Heidegger represented two dramatically different worldviews in addition to opposing philosophical positions in Davos, Switzerland, in 1929. Warburg Institute, London.

an audience of nearly three hundred students and professors, Heidegger began by accusing Cassirer and the neo-Kantians of an erroneous interpretation of Kant that focused on the rules of science rather than the presence of beings.[59] Heidegger went on to argue that Kant was less interested in providing a theory of science than he was in highlighting the problematic of ontology, the study of which scholars had yet to

pursue. Cassirer, for his part, argued that Heidegger was making neo-Kantianism the "scapegoat of the new philosophy." The real issue, Cassirer insisted, was not a distinction between "the kind of philosophy as a dogmatic doctrinal system; rather, it [is] a matter of the direction taken in question-posing."[60]

In the two-hour debate that followed, Cassirer and Heidegger argued the finer points of Kant's intended meaning. Cassirer aimed to minimize the gap between them as one of mere "question-posing." "As I had not expected to find it in him," Cassirer asserted, "I must confess that I have found a neo-Kantian here in Heidegger."[61] Yet Heidegger emphasized his challenge to transcendental philosophy, the keystone of neo-Kantian methodology: Cassirer, like Cohen, collapsed the distinction between substance and function and viewed the questions of Being and the thing-in-itself (*Ding an sich*) through their functional role. As we have seen, the Marburgers were intent on keeping philosophy in a critical mode and avoiding questions of metaphysical speculation. Heidegger, in contrast, believed that this distinction was unfounded, as was the transcendental rational subject that this distinction presupposes. Moreover, Heidegger argued, this move evaded important ontological questions.

In contrast to the neo-Kantian framework that relied on the false reign of reason, Heidegger proposed a new concept of *Geworfenheit* (Being-thrown), which embodied the prerational human state and the problem of existence without the benefit of reason's orientation.[62] In his own day, Kant was called "the great destroyer," for doing away with absolute reason and insisting on autonomy of thought.[63] Now having dissolved both sensibility and understanding into a "common root," and with it Kant's transcendental schematism, Heidegger aimed to take down the whole of Western metaphysics with it.[64] As one scholar has argued, "We are not here confronted with an exercise in Kant interpretation at all, but rather with Heidegger's own radical attempt finally to bring the neo-Kantian tradition to an end."[65]

Thus, while the interpretation of Kant was ostensibly at the crux of the issue, Heidegger's interpretation of Kant as an unfinished project and a path to phenomenology expanded the debate's implications, suggesting the conflict between two distinct philosophical worldviews. While Cassirer's epistemological scholarship focused on the process of knowledge and was grounded in the transcendental subject, Heidegger's was phenomenological and grounded in his concept of *Geworfenheit*. Even as he warded off criticism of his functional rather than substan-

tive inquiry, Cassirer insisted that the difference between the two only amounted to the "direction taken in question-posing," that is, between phenomenology and epistemology—the very Kantian move of which Heidegger accused him.

Contemporaries concluded that the intellectual gulf between the two men was also essentially generational: while Cassirer represented an older form of scholarship that valued objectivity and sobriety, in particular by focusing on forms and functions, Heidegger's preaching style and natural charisma supported his radical new ideas of Being-thrown and Being-there. Heidegger provided a philosophical foundation for this younger generation, a generation of Germans who showed an increasing preference for nature, the fatherland, and a "hunger for wholeness"—a romantic impulse that remained unfulfilled in the Weimar Republic's parliamentary government and its dry, left-liberal publications such as the *Frankfurter Zeitung*. The philosopher Karl Löwith famously described him as the "magician of Messkirch" (Heidegger's birthplace), who "cast a spell" on his listeners.[66]

Despite Heidegger's own concerns over the Judaizing of the academy, young German-Jewish scholars such as Leo Strauss, Emmanuel Levinas, and Franz Rosenzweig too seemed to have fallen under his spell.[67] Indeed, with the exception of Hans-Georg Gadamer, nearly all of Heidegger's young followers were Jewish.[68] Among these young students, Strauss received his doctorate under Cassirer in 1922 but that same year already referred to himself as a "doubting and dubious adherent of the Marburg School of neo-Kantianism" and was increasingly frustrated with Cassirer's attachment to bourgeois liberal ideology.[69] The Weberian position of value-free scholarship, which paralleled Cassirer's own insistence on objectivity and neutrality in scholarship, was fast losing its grip in relation to this new kind of scholar. As Strauss recounted to Rosenzweig, in comparison to Heidegger, "Weber appeared to me as an 'orphan child.'"[70] Heidegger's effect on the youth was undeniable.

The challenge Heidegger posed represented more than the end of a philosophical era.[71] As one member of the audience explained, the contrast between the interlocutors was "not theoretical, but human." For if Cassirer represented the "liberal culture of Central Europe" and the "epoch of Kant, of Goethe, and of Kleist," he observed, then the other "gigantic intellectual," Heidegger, promoted a completely different worldview, one characterized by its "firm rootedness and peasant genuineness."[72] One commentator remarked that the debate represented a philosophical enactment of the worldviews presented in Mann's

Magic Mountain, published five years earlier, the famed novel in which the fictional Hans Castorp also traveled southward from Hamburg to Davos, where he experienced a clash of these two worlds.[73] Moreover, the accusations hurled at the rootless, cosmopolitan, and liberal tradition of the Enlightenment were further coded anti-Semitic attacks on this tradition, one that had become closely associated with Jews, notwithstanding Heidegger's active Jewish following. As a distinguished urban, Jewish intellectual whose family name was synonymous with cultural modernism in Berlin, Cassirer was a symbolic target for this reactionary movement. Threatening to overturn Cassirer's Enlightenment project, Heidegger's interpretation of Kant as a stepping-stone to a new metaphysics signaled a pending change extending beyond academic discourse.

The Private Life of the Debate

The Davos Debate retained a powerful mythic hold on German-speaking philosophers, a significance that continued to the postwar period. Habermas recalls that a student put three questions to Cassirer and that each of his responses closed with a citation from Goethe. "The theme was Kant, but in truth the end of an epoch was up for discussion." Even though all historical evidence suggests that his attendance in Davos was impossible, Strauss later recalled the debate as an essential, formative moment for scholars of his generation.[74] And Levinas spearheaded a theatrical reenactment of the debate in which he donned a powder-white wig and mocked Cassirer's sober manner. Levinas later regretted having sided with Heidegger over Cassirer, a fact that seemed in poor taste after the old Jewish philosopher's adversary became a Nazi.[75] While Davos was principally a debate about ideas, a fact that has been clouded by allegoric interpretations like that of Habermas's observation above, one of the reasons why Heidegger has become the preoccupation of so many philosophers is that his life and work challenges the sanctity of ideas. One scholar has recently made a noble effort to strip away these memories and politicizing—what he calls "ramifying"—to discuss the actual ideas involved.[76] If we cannot do this, after all, what is left of intellectual history?

But ideas do not debate ideas—people debate people—and Davos was not only a debate of ideas but also an event of individuals. In this respect, it is revealing that Cassirer continued to display personal loyalty to Cohen, defending him at Davos even though he had significantly

departed from him philosophically and perhaps stood much closer to his adversary than he let on.[77] One scholar extends this argument so far as to claim that Heidegger shared much with Cassirer's mentor Cohen, whom he constantly critiqued, his opposition to him a sign of his serious engagement with his ideas.[78] Nonetheless, there existed substantial differences between the men, as has been rightly contended. Ultimately, Cassirer maintained his belief in spontaneous human creativity, a position Heidegger opposed.[79] Yet this technical philosophical distinction does not account for the full extent of the debate's reception and appeal. For Habermas supplanted Cassirer's Kantian-based "spontaneity" with his own discourse-based notion of subjectivity that was essentially intersubjective. Yet he critically remained on the side of Cassirer in his promotion of normative standards, even if he arrived at that conviction by a different route.[80]

If some scholars fear the tendency to irresponsibly allegorize the debate, on one hand, equally problematic seems to be the insulation of the debate from political and cultural symbolism, on the other. Just as symbols were invoked to represent individuals, individuals became symbolic of politics and ideas. In this respect, Cassirer's rhetorical reference to Goethe simultaneously presents a historical portrait, a biographical allegory, and a political position, a synthesis intimately intertwined with his intellectual argument. Consequently, as Bourdieu argues, the best analysis of Heidegger—as of any intellectual figure— "must accommodate a dual refusal, rejecting not only any claim of the philosophical text to absolute autonomy, with its concomitant rejection of all external reference, but also any direct reduction of the text to the most general conditions of its production." Along this line of reasoning, philosophers do not act only in the field of philosophy but also interact with other "fields," including the academic and the political. Although we cannot expect a philosopher to "express himself in the raw, using the crude language of politics," we must learn to read between the lines.[81]

But this applies as much to the public memories and to political overlays in the reception as it does to the private life, which happens behind the scenes and sets the stage for their performance. Of course, historians are often not privy to what happens in private, but we can sometimes get a glimpse, often through women, who themselves can broach topics otherwise prohibited in the public realm, where the pretense is neutrality and objectivity. Toni Cassirer understood this much when she shared the details of Cohen's mistreatment with her husband's interlocutor the day before the debate. She, after all, claimed to

have already heard of Heidegger's "inclination towards anti-Semitism," and so, when, on account of her husband's severe cold, she sat alone in the audience on the second day of the conference, the philosopher's wife took the opportunity to impact the conversation.[82]

Serendipitously seated next to Heidegger himself, "the strange fellow" (*dem sonderbaren Kauz*), she aimed "to outwit the sly fox, as he was notoriously known":

I began a very naive discussion with [Heidegger] since I knew not the least—neither about his philosophical nor personal leanings. I asked him about our mutual acquaintances, above all about his knowledge of Cohen as a man, and anticipated already in the question his self-understood recognition. Unsolicited, I described for him totally Ernst's relationship to Cohen; I spoke about the shameful treatment that this impressive scholar received as a Jew; I told him how no single member of the Berlin faculty would have followed him to the grave. I even chatted about all sorts of vital elements from Ernst's life, his compliance allegedly secure, and had the pleasure of seeing this hard dough soften like a bread roll that one has dipped in warm milk. When Ernst rose from his sick bed, it was a difficult situation for Heidegger, who now knew so much about him personally, to follow through his planned hostile position.[83]

Her likening Heidegger's softening to "a piece of bread" is telling in its use of domestic language to justify her public exchange with the professor. Toni Cassirer was no Hannah Arendt, Heidegger's student and a political philosopher. She did not use her time alone with the philosopher to discuss varying interpretations of Kant.[84] But she did use her "domestic" tools—here, the art of conversation—to shape the tone of the following's day's debate. Had Ernst Cassirer himself been present, it is unlikely that she would have been able to engage with Heidegger in the way she did. It was precisely because she was a woman that she could approach another professor with such a familiar conversation and engage in this wider context of intellectual manipulation.[85]

Whether or not Toni Cassirer's "naive chatter" had the desired effect must remain unanswered, since even the question of whether Heidegger declined to shake Cassirer's hand after their debate cannot be verified.[86] If Heidegger did decline, that is not a superficial matter, for it would imply an unacceptable incivility that resonated deeply with many, especially after the war. It is precisely such retroactive symbolism that we must avoid, according to some scholars, who insist that Heidegger was still sympathetic to Cassirer in 1929 and may even have reached out to him when he was ill.[87] Toni, for her part, mistakenly refers to Davos as

occurring in 1931, which might indicate that Cassirer had further contact with his adversary later than has been thought.[88] Needless to say, her account should be subjected to a scrutiny similar to that of Levinas and Strauss above, for the philosopher's wife had good motivation to aggrandize her husband. If the focus on the private realm raises as many problems as it solves, it does remind us that pure ideas are elusive and the purity of intellectual debate is as well; both must be analyzed from the perspective of multiple fields to achieve a holistic analysis of philosophy and politics. Heidegger and Cassirer were not only symbols of worldviews but also individuals whose lives had previously crossed. But individual lives could and did become symbolic of ideas. Just as Cassirer's emphasis on universalism at the Lessing-Mendelssohn celebration was continually read by his adversaries as a threat posed by difference, so too, at Davos the elements of identity and politics were the lens through which the debate on Kant was filtered.

––––––

In this context, in which both private and public moments were politicized, Kant failed to protect Cassirer as he had Cohen. Cohen found that reinventing philosophy as more rigorous than mathematics permitted the entry of Jews into the "nation of Kant." However, Cassirer wanted to turn philosophy into a discipline that was permitted to critique culture, too, and yet he hoped to benefit from the protections implied by the limitations of the epistemological approach. To a certain degree Heidegger trapped Cassirer in the paradox he created: Cassirer sought the expansion of philosophy's role—his "critic of culture." However, he also did away with the distinction between the *noumenal* and the *phenomenal*, and sensible and intellectual intuition, precisely the distinctions that had enabled Kant to participate in a meaningful discussion of ethics. Humanists were expected to speak to ethics. Cohen suggested that ethics could be derived from logic, a somewhat strange idea, but a nod to the need to close this apparent gap in his thinking. Cassirer for his part was surprisingly quiet on the subject, an absence that his audience never forgave him.

Heidegger's own relationship to Kant was loose at best. His notion that he would dissolve the sensible and intellectual intuition into a common root presupposed that Kant was ever interested in this project—but he was not. He, too, used Kant as a platform for his new philosophical preoccupation with a romanticized notion of Being. This particular and rooted concept opened precisely the line of inquiry into

values that the Marburgers had—with good reason—sought to avoid. With the debate redrawn along these lines, Heidegger was destined to win. Cassirer would never satisfy the "hunger for wholeness."

The philosophical differences between these men notwithstanding, then, Kant provided a platform for two drastically different positions on philosophy and the world. Viewed from the public side as philosophers whose differences signified cultural change or from the private side as men who stood personally closer to each other than previously assumed, the central lesson of Davos is the same: intellectual inquiry was inseparable from the man. Despite all evidence to the contrary, however, in his last years in Germany, Cassirer continued to insist otherwise.

The Enlightened Rector and the Politics of Enlightenment

Over a hundred years ago, the German poet Heine warned the French not to underestimate the power of ideas: philosophical concepts nurtured in the stillness of a professor's study could destroy a civilization.

ISAIAH BERLIN

The republic should avoid ceremonies; they are not suited to this type of government. It is like a governess dancing a ballet. All the same, the whole occasion had something touching and, above all, tragic about it. This petty drama as conclusion to the tremendous events of the war and the revolution! Pondering the deeper significance of it can bring tears very close.

COUNT HARRY KESSLER

Warburg understood Cassirer's intellectual agenda to be intimately intertwined with his own vision for Hamburg—a belief that Mayor Petersen confirmed when he laid the rector's chain on the professor's chest at his installation ceremony (Rektoratswechsel) in November 1929 (fig. 11). Alluding to Warburg's successful campaign to persuade Cassirer to choose Hamburg's university over the one in Frankfurt, Petersen declared, "We are indeed very lucky that we succeeded in keeping you, esteemed Mr. Cassirer, up here with us." While Cassirer was not born in Hamburg—a distinction locals maintained with great pride— Petersen was willing to grant him this honorary status. He announced, "[I] can assure that you will be just as

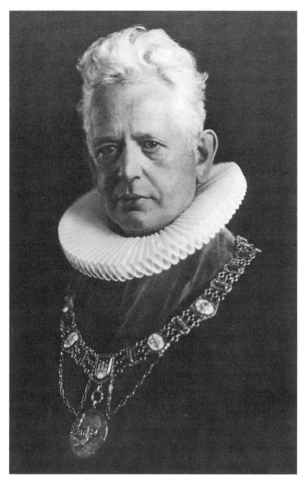

11 As the first German-Jewish rector of a modern university, Cassirer still holds tremendous symbolism for the tragedy of German Jewry. Universität Hamburg.

good of a rector as if you came from Hamburg." When he addressed the crowd the next evening, Cassirer highlighted the uniqueness of the city where the university was established.[1] Warburg himself was not there; he had died more than a year earlier, and with him the prospect of their shared vision.

In 1928, when Cassirer delivered the Verfassungsfeier speech in honor of the constitution, a different kind of cosmopolitanism was still possible in Hamburg, and the reciprocal relationship that Warburg engineered between the professor and the city also had the potential

to produce substantial political consequences. Hamburg enjoyed independence for much of its history, independence that was both an asset and a hindrance for its intellectual and cultural life. The city's ability to maintain its unique blend of the local and the cosmopolitan was also the central factor in preventing the intrusion of the growing tide of nationalism. As historians have demonstrated, had it not been for the political infiltration on the local level, the Nazi revolution never would have taken place.[2]

This short-lived yet vibrant world came to an end on October 1, 1929, when Warburg noted in the Warburg Library's diary, "The indispensable, valiant, distinguished, and admired Stresemann has died; a loss of incalculably dark consequences."[3] Shortly thereafter, on October 26, Warburg retired to his study after dinner and, suffering a heart attack, suddenly died. His brothers and he had often remarked that his state of health always mirrored the financial health of the market.[4] And, true to form, three days after Warburg's death, the stock market crashed on Wall Street, beginning a world economic crisis.

Even during the stable years, between 1924 and 1928, the anti-republican faction at Hamburg's university steadily gained ground. The coinciding deaths of Warburg and "Weimar's Greatest Statesman" symbolized the end of the republican era from which both Cassirer and the Hamburg School had benefited. Stresemann and Warburg had facilitated the uneasy transition from the political and intellectual worlds of the empire to the Weimar Republic, and their achievements were manifest in the 1928 victory for moderation. In the absence of Warburg, the most influential advocate for a balance between nationalism and cosmopolitanism, issues such as Jewishness and Hamburg's link to the wider world came under scrutiny. A new intellectual climate descended, one that was unfavorable to reason, the Enlightenment, and objectivity in scholarship. Whatever political headway the republican camp had made was subsequently overshadowed by the new problems of the global economic crisis, an event that resonated with Germans in a way that seemed to confirm the illegitimacy of the political regime.[5] In July 1930, the Weimar coalition fell, signifying the republic's end as a working parliamentary system.

Even a history of ideas should not underestimate the importance of the economic crisis, without which, as the British historian Eric Hobsbawm argued, there would have been no Hitler.[6] Having barely recovered from the inflation, Hamburg was particularly devastated by the Great Depression, especially since, as we have seen, economic trends

were connected with the city's cultural and political health; as such, it was unlikely that the Hamburg School would persist unaffected. To begin with, Warburg's death altered the public face of the institution, and 1929 brought the tensest discussions yet about the financing of the library.[7] It also marked the end of the powerful intellectual partnership, as Saxl recalled: "When Warburg died in 1929, it was Cassirer who spoke at his grave: a commemoration of the strange and fruitful meeting of two thinkers of almost diametrically opposed character and tendency . . . [who] had one great goal in common: to understand the nature and history of the symbolic expression of the human mind."[8]

Cassirer's tenure as rector during the academic year of 1929–30, which bridged these events, represented one last attempt to carry on Warburg's Hamburg. As the last prorepublican rector of the young university, Cassirer's career also symbolized the final "republican moment" in scholarship and politics. These two strands had converged because of historical accident, a set of institutional possibilities, and the "magical" camaraderie among young scholars. And although Warburg was no longer alive to witness the moment, Mayor Petersen, long a friend of the Warburg family, carried this vision further at Cassirer's installation ceremony. The Petersen-Cassirer partnership was further poignant because Petersen's own ascent from chairman of the German Democratic Party to mayor of Hamburg, despite his claim to having one Jewish parent, reflected the unique local experience of Hamburg's Jews. Despite Petersen's enthusiasm about the crowd who gathered before Cassirer— "What this could mean that in Germany and in Hamburg at one time 2,000 people should truly be in agreement about anything"—Cassirer soon faced conditions vastly different from those that had enabled his appointment and cherished school.[9]

In a certain sense, Cassirer's tenure as rector was both Warburg and Cassirer's greatest collective achievement and an afterthought to the real cosmopolitan humanist Hamburg. As soon as he assumed this position, the German-Jewish rector encountered fierce nationalism, anti-Semitism, and antirepublicanism from his community, especially the students. In this increasingly hostile climate, the philosopher's greatest mistake was, ultimately, his confidence in the objective and neutral reception of his scholarship. Despite the increasing politicization of ideas, Cassirer continued to insist, as he always had, that philosophy remained necessarily distinct from personal identity. Even his scholarly awareness of the power of symbols could not persuade him of his inability to control the symbolism of his own ascent.

A parallel to the politico-philosophical "Kant wars" that culminated in the Davos Debate now played out between the republic and the university. Although it cannot be assumed that every accusation of "neo-Kantianism" was a signifier for anti-Semitism and every intellectual difference a mask for political concerns, it cannot be denied that cosmopolitanism and nationalism were attributes not only of politics but also of ideas. In this contradictory political climate, prorepublicanism was deemed inappropriately political, while nationalism, presumed to be apolitical, quickly assumed the aura of patriotism. Overlooked because his epistemology eschewed questions of Being for the function of "question posing," Cassirer was also unable to compete in a new climate that favored the charismatic and nationalist professorial ideal.

But unlike those criticisms of the democratic republic that it passively withered away, Cassirer did not entirely abstain from a fight. Within these institutional constraints, Rector Cassirer tried to create a context and reception for a Weimar festival and ceremonial culture, even if that was, as the well-known German art dealer Count Harry Kessler observed, as incongruous as a "governess dancing a ballet."[10] And in the scholarly realm, the professor sublimated his politics in academic writing and urged his fellow citizens to recall their Enlightenment heritage. The result—*The Philosophy of the Enlightenment*, published in 1932, is both a classic text read, even today, for its compelling portrait of eighteenth-century thought and a powerful reflection of the bleak political and intellectual conditions of the time.

Celebrating the Nation, Celebrating the Republic

Cassirer's first formal appearance as rector was as the presiding official at the Reichsgründungsfeier (Celebration of the nation's founding), an annual holiday that was scheduled to occur in the first months of the academic year. It soon became clear, however, that Cassirer possessed a different notion from that of other university members of what it meant to honor the German nation's achievements. The negative reaction to Cassirer's perspective revealed that the university had become a hotbed for a counterrevolutionary movement.

Speeches at the Reichsgründungsfeier traditionally lauded Chancellor Otto von Bismarck's unification of the German people and expressed solidarity with Germans living outside Germany's borders. Speakers usually presented the Treaty of Versailles as an oppressive set

of circumstances that the German nation would eventually overcome.[11] The university's republicans, in contrast, considered this celebration of the nation to be an affront to the Weimar Republic and its ideals. At one such celebration in 1923, republican students were enraged that the republican flag was not displayed at the event.[12] The Reichsgründungsfeier was the source of much disagreement, and Cassirer's speech only added to the controversy.

To the discontent of many present, Cassirer opened his speech at the Reichsgründungsfeier on January 18, 1930, the anniversary of the founding of the *Kaiserreich*, with a surprising suggestion. In contrast to speakers in previous years, Cassirer used the occasion to gather support for the republic—even the disputed constitution—at a moment of its waning popularity. "Thus let it be granted to us with joy and confidence," Cassirer asserted, "that we might preserve the unity of the nation through this confusion and the perennial argument, and *to establish its civic constitution on more secure ground*." Alluding to a proverb by Goethe, Cassirer asserted that it was never appropriate to dwell in the past. "There is no past for which one is permitted to yearn, there is only an eternally new one, which is formed from the wider elements of the past, and the true aspiration must always be working to create a new better one." Dwelling on the lost *Reich* was not an option for Germans, Cassirer pronounced, rather, "a new feeling and new consciousness of freedom should arise directly out of this bond [with the past]."[13] Cassirer exhorted his fellow professors and students to prove their loyalty to the nation with a new commitment to the republic.

As with Lessing's two-hundredth anniversary celebration, described in chapter 8, a nationalist right-wing contingent boycotted the event entirely.[14] And those antirepublicans who did attend were unhappy with Cassirer's message. Their primary discontent was not with the festivity—it would have been difficult for the nationalist camp to dispute a holiday that was, in essence, an embodiment of their position—but rather with the speaker himself. As one commentator explained in the nationalist *Hamburg Universitäts-Zeitung*, "This year's Reichsgründungsfeier gives cause for the most difficult reservations, reservations that have to do with the lecturer. The discrepancy between the meaning of the celebration and the content was too wide."[15] The reader was only assuaged that the more radical students redirected the event's energy. In the end, that the republican Cassirer spoke at this nationalist event was considered by many to be fundamentally objectionable.

The opposition to Cassirer's January 1930 speech showed the dan-

gerous alignment of the antirepublican opposition with an anti-Semitic boycott of Cassirer as the university official at the event. This anti-Semitism was also reflected in debates on the university board, where the faculty often split along republican and antirepublican lines. But even here this political distinction was tinged with anti-Semitism. Concerning the suspension of one student's dissertation on the account of such a political dispute, Cassirer remarked, "It was a pure party-issue: Jew or non-Jew."[16] This trend in the academy mirrored accusations, in the political realm, that the Weimar Republic was the "Jew Republic." The more Jews like Cassirer became entrenched in German culture— even as the official bearers of its legacy—the worse the reception of them. In the case of Cassirer, according to one contemporary, his international recognition and visibility was "taken as a proof of unreliability, especially if on top . . . [there] was a non-Aryan."[17] The result ultimately became the same "burden of success" that prominent Jews in Berlin, such as his own family, tragically experienced. As rector, Cassirer continued to receive vocal support from those, like Petersen, who believed that he represented the best of Hamburg. Petersen was among some five hundred guests three days later at a reception hosted by the new rector.[18] But despite this impressive showing, in an increasingly fragmented city, the anti-Semitic opposition to him was only increasing.

Republic without Republicans, University without Students

In the months that followed Cassirer's first official speech as rector, the Weimar Republic collapsed. In March, the newly appointed chancellor, Heinrich Brüning, dissolved the parliamentary coalition and called for new elections in September. The Weimar Republic's legitimacy was at a low point, and this condition was reflected at the University of Hamburg, which, like other universities, was officially encouraged to institute an official holiday in honor of the Weimar Republic.[19] Very few complied.

Cassirer was determined to garner support for the weakening government and campaigned to implement a Verfassungstag (holiday in honor of the constitution) before the end of his tenure. But the implementation of a holiday honoring the Weimar Republic was just as controversial as the Reichsgründungsfeier had been. Discussions commenced in May and continued for two months in the university senate about whether to celebrate the holiday at all. Many objected in principle to honoring the constitution, on the grounds that the Weimar

Republic itself was illegitimate. Following a suggestion by Professor Sieveking, the university board decided to celebrate the Verfassungstag in conjunction with the Tag der Räumung des Rheinlands (The day of the evacuation of the Rhineland). Several members of the Right opposed this dual holiday, because it aligned the end of the Allied occupation of the Rhineland, an event that was a minor victory for the anti-republicans, with a celebration of the republic. The Nationalist Student Association, which by the 1929–30 academic year had earned a majority in the student parliament, or the Allgemeiner Studenten Ausschuss (AStA), declined to participate. In a petition that was joined by a host of other radical associations, its members expressed their belief that "universities should not support political parties."[20] Following a logic that later became the norm, the students insisted that the celebration of their own government was an inappropriate expression of allegiance to a political party.

For his part, Cassirer would have preferred to celebrate the Verfassungstag independently, not in conjunction with any other occasion, and he stressed the importance of a holiday that was an exclusive tribute to the constitution.[21] Writing to his increasingly skeptical wife, who would have preferred that he avoid such public appearances altogether, Cassirer pleaded, "I know that you would be the last person to advise me in these matters of principle to make a rotten peace (*faulen Frieden*) for any purpose."[22] If Versailles was once viewed in these terms, Cassirer now felt that it was similarly shameful *not* to fight for the republic.

Reflecting anti-Weimar popular opinion, newspaper commentaries were sympathetic to the right-wing students over Cassirer's efforts to align the university with the republican government. "For the last several years, one in Germany thereby reinterprets the Weimar Compromise in 1919 with celebrations, parades, and rallies as a civil political deed. . . . But in previous years, the students expressed their understanding to the Prussian Culture Ministry in a more unambiguous way that the university does not exist for party propaganda."[23] Such an event could "only be a melancholy examination" because of its association with the evacuation of the Rheinland.[24] A government that was no more than a "compromise" did not warrant a celebration.

Thus, to a half-empty auditorium on July 22, 1930, at the celebration of "The Nation's Constitution and the Liberation of the Rhineland," Cassirer delivered his speech entitled "Wandlungen der Staatsgesinnung und der Staatstheorie in der deutschen Geistesgeschichte" (Changing ideas about state convictions and state theory in German intellectual

history), in which he again enlisted the German intellectual legacy to combine nationalist and cosmopolitan sentiment in support of the republic. Cassirer began by claiming that the late-eighteenth-century philosopher Fichte was the first German thinker to translate assumptions about natural law into a theory of state. Cassirer told his audience that the twenty-eight-year-old Fichte, who was preoccupied with the events of the French Revolution, wrote Kant regarding the problem that Kant had tried to solve in the *Critique of Pure Reason*, "namely to produce a draft of a constitution 'that draws on the greatest human freedom according to the law, which ensures that every freedom is equally valued.'"[25] As Cassirer presented him, Fichte appeared to be something of a republican.

He was also, in effect, a cosmopolitan. According to Cassirer, "Here [Fichte's perspective] is consistently universally public spirited. . . . This form tolerates no particulars, no individual or national limitations."[26] Even in the winter of 1807–8, when he delivered his *Addresses to the German Nation* following the Prussians' humiliating defeat by Napoleon, "Fichte was never actually untrue to his first cosmopolitan mindedness, to his ethical universalism."[27] German right-wing nationalists had considered Fichte a heroic icon since the outbreak of the First World War, and in Hamburg the Fichte Hochschule, an academy named in the philosopher's honor, was the center of much nationalist activity.[28] In his speech, however, Cassirer linked Fichte with the "non-German" philosopher Kant and presented Fichte as the cosmopolitan par excellence. Moreover, Cassirer insisted that the idea of the constitution was intrinsically German, although there was nothing that necessarily limited it to the national framework—the idea of a constitution was a general principle applicable to many nations. As he had done in his speech at the beginning of the year at the Reichsgründungsfeier, Cassirer combined nationalism and cosmopolitanism in support of the republic.

Cassirer similarly subsumed the Rhineland celebration under a republican banner. He praised the Rhineland for its spirit of solidarity and argued, "[This spirit] is also the demand which the constitution of the German Empire places on us." Cassirer maintained, "The constitution may, as an emergency production, be inadequate in details—in its entirety it will always remain living proof that the German people preserve their inner composure in times of most frightful pressure and the highest danger—and that the collective will inside us has not died."[29] By connecting the nationalism of the Rhineland's evacuation with sup-

port for the Weimar Republic, Cassirer achieved a minor victory for prorepublicanism.

Notably poor attendance at the speech, however, was a setback to Cassirer's achievement. Newspaper commentators unilaterally placed the onus on the university to "educate its students to become good republicans."[30] One newspaper commentator observed that the radicalization of the students, which emerged from international socialism and nationalist, anti-Semitic attitudes, could no longer be ignored and indeed brought shame to the university.[31] As happened elsewhere, the radicalized students, more than the professors, were largely responsible for bringing right-wing nationalist views into the university.[32] That the event continued as planned was considered a success in its own right, but, as many accounts stressed, a university celebration without much of the university present was hardly an official celebration. According to the contemporary adage, "A Republic needs republicans."[33] "A University Celebration without Students," as one newspaper article was titled, insinuated that the professors had failed to make good republicans of their students.[34] In sum, the event only reinforced the lack of unity and growing radical public opinion.

National Socialists managed to forge the solidarity that Cassirer sought through a new kind of politics and political symbolism. Their use of flags, festivals, and ceremonies was a large part of fascism's appeal.[35] In contrast, liberal democracies such as the Weimar Republic were viewed as decrepit, antiquarian, and obsolete. As historians observe, for most of its history, the republic did not celebrate any days of commemoration. According to the Weimar-era civil servant Arnold Brecht, "German democracy lacked the richness of symbols in which other democracies rejoiced."[36] Supporters of the Weimar Republic, such as Warburg and Cassirer, actively tried to create these symbols. Weimar required a strong individual hero to help establish unity—a fact that Cassirer himself conceded in his Verfassungstag speech.[37] Warburg sought to honor Stresemann with the production of a commemorative postal stamp—a medium he exclaimed would function as the new "political ceremony in the twentieth century!"[38] Following Warburg's death, Cassirer continued his republican mission by instituting a holiday in honor of the constitution. However, Cassirer's sober and rational arguments were overrun by more charismatic displays of leadership, as they had been at Davos. In this context, right-wing nationalist groups easily claimed thinkers such as Fichte as their own. While the republic was failing to create republicans, the republican university was failing to maintain its students.

The Politics of the Apolitical

In his final speech as rector, Cassirer attempted to persuade the students to transfer their loyalty from the historic German nation to the Weimar Republic. He also tried to assert that objectivity and neutrality were scholarly goals worthy of patriotic support and that the intrusion of politics into the university was detrimental to intellectual integrity. Cassirer insisted: "The German universities are not political organizations and institutions—they must never serve and be enslaved to particular political goals; they will rather fulfill their duty regarding the state only if they always remember that they are standing under the other law: the law of truth." For Cassirer, it was clear that professors should not be "preachers of patriotism" (*Prediger des Patriotismus*). Their task, he argued, was not "to proclaim, but rather to teach, not to induce, but rather to persuade."[39] While other Hamburg professors agreed that the university should not be a political place, the definition of *political* became a matter of contention. Only two years after Cassirer's rectorship ended, support for Weimar was conclusively considered an inappropriate display of "political" allegiance in an intellectual context, while nationalism was encouraged as an expression of patriotic sentiment.

Historians have employed the terms *apoliticism* and *antipolitics* to describe the aversion to mass political parties and the fractiousness created by Germany's parliamentary politics.[40] This description fits the University of Hamburg's officials' objectives, which aimed to prevent factional politics from leaking into the academy. To this end, they sought to exclude any ideas, organizations, and events deemed "political" from its institutional environment. The university board passed several resolutions in the early 1920s prohibiting partisan politics in the university, regulations that forbade students to wear their uniforms, forbade the use of lecture halls for political rallies, and oversaw AStA's exclusion of political groups from its organization.[41] But if the republican and antirepublican professors tended to agree with these innocuous regulations, on the subject of political content there was far less consensus.

As rector, Cassirer presided over numerous debates addressing definitions of politics and fought nationalist attempts to manipulate these regulations toward anti-Semitic ends. Cassirer's rectorship coincided with the unprecedented intensification of National Socialist student politics and activism at the University of Hamburg. As was evident fol-

lowing their boycott of both of Cassirer's speeches and the increasing influence of National Socialism in AStA, the radicalization of the students became a liability. These new National Socialist student leaders confirmed Toni Cassirer's worst fears when they interpreted the Jewish Cassirer's election to the position of rector as a provocation. The group's new director, Gerd Retiz, took every opportunity to challenge Cassirer's regulations.[42] Already by 1925, AStA successfully excluded both the Socialist Student Group and the Jewish group, Kadimah, because of their alleged "political" content.[43] And under Cassirer's watch, the Zionist Student Group was also excluded on similar ground.[44]

The next year, the exclusion of "political" events despite the persistence of political unrest was almost uncanny. In June 1931 students demonstrated against the Treaty of Versailles and hung a Swastika in front of the university.[45] Despite this egregious political affront, "politics" remained such a taboo that in 1932 the Zionist Student Group, an organization whose sole purpose was to advocate for the Zionist political cause, now regrouped, arguing that it, too, was "apolitical" in order to be accepted as an official university organization.[46]

Loyalty to the republic was never considered patriotic, but instead always interpreted as partisan.[47] Cassirer's own attempts as rector to invert this assumption proved unsuccessful, and the terms of the debate ultimately silenced the prorepublican camp. Nationalists swiftly presented themselves as the sole "apolitical" voice that extended beyond parliamentary political strife, while prorepublicans consciously disguised, muted, or discarded their political message. Given these conditions, it is no wonder that a massive wave of self-censorship swept over the Weimar Republic in 1930 and that, out of "fear of outspoken right-wing politicians," even "when Hitler's appointment as chancellor in January 1933 was by no means certain," the prorepublican camp shut itself down.[48] But what options were available for a republican intellectual after 1930? If Cassirer remained first and foremost an intellectual historian, his philosophy of the Enlightenment, undeniably imbued with politics, offers one example.

Politics of Enlightenment

In a context in which patriotism was encouraged but "politics" excluded and "academic freedom" often interpreted favorably only for nationalists, the intellectual choices available for republicans were fur-

ther constricted. No longer in the university's public eye, Cassirer returned, following his term as rector, to the domain of scholarship but crucially did not withdraw to the realm of abstract ideas. *The Philosophy of the Enlightenment*, drafted in the summer of 1932 and published a few months later, presents a fascinating historical testimony of a republican intellectual's negotiation of political alternatives.

Cassirer's preface carefully situated him amid the debates between the traditions of cosmopolitanism and nationalism, Enlightenment and romanticism, and epistemology and phenomenology. As he explains, this work is part of a "broader historical and philosophical theme not enlarged upon here," the structuring of human knowledge, but it also reveals the central importance of the Enlightenment for this theme. As the movement that shifted the problem from "fixed and finished forms into active forces, from bare results into imperatives," the Enlightenment was not only a milestone in that process but also reflected the very theoretical position that Cassirer assumed.[49] For Cassirer, therefore, the history of philosophy was divided into before and after the Enlightenment, and in the latter period, the process of acquiring knowledge had gone seriously awry. Post-Enlightenment criticism had become abstracted and unrelated to the world itself.

This intellectual problem was further reflected in the tools used to understand the very period in question, since criticism had now lost the ability to synthesize. Rather than present a sum total of a story's parts, Cassirer argued, the historian must strive "not to record and describe bare results, but rather to elucidate *the inner formative forces*."[50] While Cassirer was highly aware that the lack of any nuanced historical methodology harmed an understanding of the dynamic quality of ideas, he disagreed with Meinecke's view, shared by romantics at large, that the lack of historical impulse in the Enlightenment was to blame.[51] Instead, he saw a solution in a return to the original power of the self-criticism and ordering process that the Enlightenment philosophers revealed:

More than ever before, it seems to me, the time is again ripe for applying such self-criticism to the present age, for holding up to it that bright clear mirror fashioned by the Enlightenment. Much that seems to us today the result of "progress" will to be sure lose its luster when seen in this mirror; and much that we boast of will look strange and distorted in this perspective. But we should be guilty of hasty judgment and dangerous self-deception if we were simply to ascribe these distortions to opaque spots in the mirror, rather than to look elsewhere for their source.[52]

As a timeless metaphor for the Enlightenment motto *sapere aude*, the mirror should not be discarded for its opaque blemishes but rather dusted off and repaired. Doubtless, this caveat was more than intellectual. Cassirer urged, "We must find a way not only to see that age in its own shape but also to release again those original forces which brought forth and molded this shape." Read as a final appeal to his German compatriots to resuscitate the European tradition of critical reasoning, tolerance, and science, it is clear that more than the Enlightenment's legacy was at stake. Despite the undeniable political subtext of this appeal, however, the ban on "politics" led Cassirer to insist that his work had no "polemical intentions."[53]

Cassirer was less coy about his intellectual agenda. He aimed to overturn the romantics' caricature-like description of the Enlightenment as shallow and naive and to put an end to their accusations of its "very pride in 'knowing better.'" Cassirer explained that "[s]uch an explanation is the first and indispensable step toward a revision of the verdict of the Romantic Movement on the Enlightenment."[54] To prove his point, Cassirer sought to broaden the Enlightenment's scope, arguing that less "rational" figures, such as Jean-Jacques Rousseau and Johann Gottfried Herder, who were traditionally relegated to the "counter-Enlightenment" or proto-romantic tradition, were, in fact, a crucial part of the Enlightenment tradition itself.[55] While admitting that Herder "parts company with the age," Cassirer nevertheless stressed that "his progress and ascent were possible by following the trails blazed by the Enlightenment." Likewise, Cassirer concluded that Rousseau's philosophy did not overthrow the Enlightenment but rather only "transferred its center of gravity to another position."[56]

By including such contentious figures as Herder and Rousseau in his narrative of the Enlightenment's development, Cassirer displaced what was called the "Shallow Enlightenment" with a more nuanced and complex movement that he identified as the "Critical Enlightenment." He also emphasized the structure rather than the substance of thought. Cassirer's well-known distinction between seventeenth- and eighteenth-century philosophies supported this narrative. He argued that the Enlightenment supplanted the seventeenth-century *esprit de système* (spirit of systems), in which reason was the realm of "eternal verities," with the eighteenth century's more modest *esprit systématique* (systematic spirit).[57] Enlightenment thinkers abandoned a maximalist notion of rationality and its theological aspirations, adopting a perspective that was more aware of its limitations and focused instead on what it *could* know.

Thus, Cassirer made a "Kantian" move in his methodology and in his argument, presenting less a *philosophy* than an *epistemology* of the Enlightenment. Reason, Cassirer made clear, was not "a sound body of knowledge, principles, and truths, but . . . a kind of energy, a force which is fully comprehensible only in its agency and effects." Cassirer reiterated this perspective in Lessing's own words: "reason is to be found not in the possession but in the acquisition of truth."[58] Just as he had done in the Davos Debate, Cassirer shifted the conversation from philosophical musings to a discussion of the philosophical tools themselves, from an investigation of rationality's essence to that of reason's function. Rather than subjecting the ideas to a higher principle, Cassirer focused on the structures of logic, a methodology that he attributed to the Enlightenment's "critical tendency."[59]

That same year, he echoed his treatment of Rousseau in a lecture delivered to the French Society of Philosophy, a presentation that made clear the implications of this position. Interpreting Rousseau as Kant's predecessor, Cassirer argued that the key to Rousseau's conception of freedom lay in its rational and moral foundations. "Rousseau's ethics is not an ethics of feeling, but the most categorical form of pure ethics of obligation (*Gesetzes-Ethik*) that was established before Kant. In the first draft of the *Contrat social*, the law is called the most exalted of all human institutions."[60] Revising Rousseau's irrational and radically individualist philosophy as Kant's categorical imperative *avant la lettre* insulated Cassirer from the dangerous political consequences of the more unwieldy aspects of the French philosopher's thought. It also seemed, to some, a bit far-fetched.

Meinecke, who praised Cassirer's work overall, did not accept this argument and thought Cassirer's view of the Enlightenment made it seem more historical than it was; he also thought Cassirer's portrait of Rousseau's "deep inner tensions were too smoothly polished" (*glatt geplättet*).[61] Cassirer did not reply, but he probably was not surprised: Kant was the only German, he said elsewhere, who truly understood Rousseau.[62] By incorporating a Kantian Rousseau into his portrait of the Enlightenment, Cassirer sought to have his cake and eat it too: he achieved a less simplistic Enlightenment than previously assumed— one that was less limited in how we apprehend the world—and yet, it also remained a critically disciplined inquiry, whose limitations protected it from unbridled mysticism and irrationality.

What others found further controversial, however, was this familiar cosmopolitan nationalism. As he had in his previous speeches, Cassirer

linked cosmopolitan and nationalist intellectual moments in this work. In a book that devoted substantial energy to French thinkers, Cassirer concluded his history of Enlightenment thought with a tribute to the German aesthetic tradition in a discussion of Lessing. However, Cassirer stressed, "[Lessing's] merit is vastly underestimated and deprived of its real meaning in intellectual history, if one finds in his criticism only a national, not a European achievement."[63] The German ending to the Enlightenment's story was, for Cassirer, inclusive.

Cassirer's cosmopolitan history celebrated the culmination of the European tradition in the German aesthetic tradition with a methodology borrowed, in part, from Kant, but Kant remains suspiciously in the background of the work.[64] It seemed that however far Cassirer moved away from Kant, his new critique of culture remained indebted to Kant's critique of reason. Yet, given the controversy surrounding the political symbolism of Kant and the rift revealed in the methodologies of Cassirer and Heidegger over Kant's proper interpretation, Cassirer chose a different rhetorical emphasis. Rather than stress the Enlightenment's culmination in Kant, he concluded his work with Lessing.

As the most vocal advocate of universal tolerance and the almost mascot of the University of Hamburg, Lessing was a powerful symbol for Cassirer's final political appeal. The choice of Lessing and the placement of the German aesthetic tradition as the culmination of the European narrative reflected the delicate balance between nationalism and cosmopolitanism maintained throughout the work. The impact of the dénouement is softened somewhat by several dozen pages devoted to Alexander Baumgarten's aesthetics, a move that presents a much more nuanced Enlightenment than the reason-focused ideology often attributed to him.[65] It is also a move not at all typical of an impassioned political plea. One historian observes that, given the emphasis placed on philosophical agency, it is surprising that politics is so distant.[66]

But it is important to remember that *The Philosophy of the Enlightenment* was also fundamentally a work of *Geistesgeschichte* and not of political propaganda. Felix Gilbert's assessment of Meinecke's work on historicism, which he calls a "purely private demonstration necessary for the preservation of the author's self-respect without suggesting or asking for political changes or political action," proves a useful comparison.[67] Cassirer's political message is further confirmed by the work's reception. In a review published four years later, the philosopher Max Wundt criticized Cassirer for his "pan-European" perspective and assured readers that a new history of the Enlightenment would soon be written that

was properly situated "on German soil" (*auf deutschen Boden*).[68] Like Heidegger's calls for indigenous (*bodenständig*) interpretations of Kant, one could be sure that Cassirer's contribution would not qualify.

Cassirer's *The Philosophy of the Enlightenment* presents a historical testimony to the perennial tension: ideas transcend their time and place and yet also remain a product of their unique cultural and political moment. When Cassirer's work was published in its first English translation, the philosopher Isaiah Berlin, also a European émigré, responded with a mixed review: "The book as a whole remains lucid, civilized and agreeable." But Berlin did not necessarily mean this as a compliment, for Cassirer's portrayal of the Enlightenment was "almost cloudlessly happy." According to Berlin, "Anyone desiring to learn about the sharp conflicts and crises of which the age was full—the mysticism and fanaticism underneath the surface, the subversive forces, rational, skeptical, romantic-religious, of which contemporary observers were only too uneasily aware, and which were so soon destined to destroy the 'heavenly city' for ever—he must turn elsewhere, for there is no trace in this book of the mounting tide of pessimism, nor of its causes, or the reasons for it."[69]

Insofar as he objected to Cassirer's prettified account of the age, Berlin's critique echoed Meinecke's frustration expressed some decades earlier. Berlin's critique is somewhat more surprising, however, for one might have said the same thing about the Central European émigré. Notwithstanding his "counter-Enlightenment," Berlin's portrait no more escaped his historical moment than did Cassirer's. If Cassirer's Enlightenment bore testimony to the impending political catastrophe of 1933, then Berlin's Enlightenment would be a product of Cold War liberal ideology.[70] That politics was at stake in each of these attempts to properly narrate a story of ideas does not diminish the importance of the intellectual projects but rather shows how certain contexts could be constructive for ideas. In Cassirer's case, the interwar politics of Enlightenment remained ever present in his intellectual portrait of the eighteenth century.

Unenlightened Politics

Things ended badly for Cassirer in Hamburg, though, it should be added, not as badly as for some people, as evidenced by the high number of suicides among Hamburg scholars of his generation.[71] The philosophical politics epitomized by the debates about Kant and the Lessing

controversy at the university reached its highest register in the Weimar Republic's last phase. Warburg had long hoped that Germany would return from its diversion in radical thought to its solid foundation in Kant and Fichte after the war, but that did not happen.[72] The "Bauch Affair" and Bauch's subsequent resignation from the Kant Society helped support a philosophical "stab-in-the-back" (*Dolchstosslegende*) legend that the Jewish infiltration of Kant scholarship had conspired to oust Bauch.[73] After the brief "Jewish" victory, the Kant Society became an organ of the Right that was more hospitable to Heidegger's interpretation of Kant than to that of Cassirer.

Anti-Semitism was thus strengthened in the academy in the 1920s and legitimated by scholarly discourse.[74] When rationalism was attacked as Jewish, Cassirer, in turn, aimed to argue that universalism and nationalism, seemingly in opposition, were not mutually exclusive. But as "politics" was increasingly frowned upon, Cassirer and his left-liberal colleagues were powerless to defend themselves. Even if conversation remained on the level of ideas, it was hardly abstract or isolated. Cassirer was not politically passive and never recoiled in fear: censorship—even self-censorship—could be enabling as well as constraining for culture.[75] As *The Philosophy of the Enlightenment* testifies, Cassirer cleverly engaged in the highly polemical debate according to the terms of political discourse.

Cassirer's message remained consistent; in his unpublished rebuttal to Bauch ten years earlier, Cassirer had emphasized that he wrote "not as a Jew, rather as a scholarly researcher"; it was crucial for a scholar to focus on ideas and not people.[76] What he found most distasteful about Bauch's attack on Cohen was how he cast his political prejudice in the guise of a philosophical argument. Thus, Cassirer beseeched his colleagues, "In political daily struggles, certain sharp and imprudent words are allowed and excusable after all; but whoever appears before us as a philosopher, who takes it upon himself to speak to us as a 'teacher in ideals,' he should weigh his words carefully."[77] As rector, Cassirer's speeches and actions repeatedly attempted to ward off the intrusion of national politics into Hamburg's local intellectual, cultural, and political life. The rectors who succeeded Cassirer before 1933 all consistently ignored his advice and defended the role of nationalist politics in their official positions.

This change was starkly illustrated by the tone of his successor's message at the installation ceremony in November 1932, where the newly appointed Albert Wigand spoke not about the University of Hamburg's unique role in Germany and the world, but rather, exclusively about

the German nation. Solidifying the connection already implicit in the university's rhetoric, he assured his audience that an aversion to *party* politics did not necessitate an aversion to *national* politics: "Thus, [the university] should strive to powerfully satisfy its responsibility to the national leadership of the youth, because the University of Hamburg's old motto is "Truth and Fatherland."[78] For Rector Wigand and his successors, Hamburg's mission would be strictly fulfilled in the nation.

The national elections of September 1930 and July 1932 reflected that local Hamburgers too soon turned their attention to this attractive nationalist option.[79] In the first of these elections, the National Socialists received a significant 6.5 million votes, an increase from 2 to 18 percent since 1928. Following the unsuccessful attempts of Heinrich Brüning to maintain a coalition over the next two years, the National Socialists doubled their gains yet again in the July elections of 1932, receiving 13.5 million votes, or a total of 37 percent, a percentage that secured them 230 seats in the Reichstag.[80] With a single exception, support for the National Socialists exceeded the citywide average in all of the upper-middle-class districts in Hamburg, including, in particular, in Harvestehude and Rotherbaum, the neighborhoods surrounding the university that had once been referred to as "Little Jerusalem." In the crucial elections of July 1932, the percentages in these well-off districts were over 40 percent, which was higher than the citywide figure of 33.3 percent. The election confirmed what the university's climate already implied: nationalism had usurped local pride.

Eight days before Paul von Hindenburg appointed Hitler chancellor, Cassirer quietly delivered a speech in a Berlin synagogue that turned out to be his last in Germany. Speaking about his late mentor Hermann Cohen, Cassirer warned his audience of the dangers of myth and explained how Cohen's treatment of Judaism avoided precisely these pitfalls. Characteristic of his earlier stance toward Judaism, Cassirer's speech that touched on explicitly Jewish themes occurred in the private confines of the Jewish community and only appeared in the community's own publication.[81] Cassirer may have misinterpreted Cohen here, as he did later in his essay "Judaism and the Modern Political Myths."[82] Nevertheless, Cassirer rightly sensed the political danger and began to reevaluate his relationship to Germany, a reckoning that continued until his death in 1945. After failing to convince his compatriots of the merits of reason, Cassirer turned to explicating the dangers of myth.

Three months after he assumed power, Hitler passed the Law for the Restoration of the Professional Civil Service, which prohibited "non-

Aryans" from working at German universities. When the University of Hamburg was founded, university officials had seriously debated the advantages and disadvantages of following suit with national institutional trends, but Hamburg's flexibility in this regard now remained seriously limited. In May, Saxl, who took over Warburg's library after his death, explained that any individual choice was limited to Professor Adolf Rein, the "Führer of National Socialists at the University as the official advocate of the political university," whose opinion "would be decisive for Cassirer's . . . position." That Rein's idea of scholarship was centered on a "political university," did not bode well for the Jewish scholars.[83]

A few voices representing the old Hamburg expressed their regret at this transformation. Gustav Schieffler, Warburg's former colleague and a patron of the arts, wrote to the National-Socialist Rector Leo Raape expressing his hope that the University of Hamburg "could once again present the image for a new German university, which now in the disfavor of the times probably is not possible." However, in that month, National Socialists began burning books in Hamburg, as elsewhere in Germany. Instigated by the students and implemented by the university board, Hamburg then canceled the lectures of seven Jewish professors.[84] The university also expelled twenty-nine students because of their "communist" tendencies and, in accordance with the Law for the Overcrowding of German Schools and Universities, stopped matriculating non-Aryan students. The Nazis' goal was to lower the proportion of Jewish students in relationship to the rest of the student body; at a university such as that in Hamburg with a high proportion of Jewish professors and students, such laws had a devastating impact on the community.[85]

With one unsuccessful exception, launched on behalf of Panofsky, there was little opposition to the institution-wide purge. As Saxl sadly remarked, what Warburg "found to be the best of Germany" soon disappeared. Upon hearing that Panofsky had been fired, Schumacher was devastated: "The news that we are losing you in Hamburg has affected me very deeply, and it presses on me to say that to you. The spirit of Aby Warburg appears before me again and again and I see his sad eyes."[86] Perhaps also feeling the gaze of the late Warburg, Cassirer himself did not wait to be fired. Two days before the implementation of the law, he wrote to the university board and requested a leave of absence from his teaching responsibilities.[87] The local press soon reported that he was on leave for "personal reasons," an announcement that many of his students received with confusion and disappointment.[88] On

March 12, the Cassirers boarded a train to Switzerland. They planned to travel further to Vienna, where, remaining with Toni Cassirer's family, they would wait out the political unrest. Because of pressure from colleagues, however, including Saxl, who felt abandoned by Cassirer, the Cassirers returned.[89]

In a letter to Albrecht von Wrochem, a member of the university board, Cassirer clarified his "leave of absence," which, since his departure, had been rumored to be because of illness. Cassirer assured Wrochem that his reasons for leaving Hamburg were "in no way 'private,' but were purely based on principle." Since he was no longer treated as an equal, he was unable to participate in the faculty's work. The tone of the letter was resolved and forlorn. "Despite all the deep sadness of the events of the last week and about the fate of German Jews," Cassirer concluded, "the feeling of inner connection with the duties and the fate of the University of Hamburg has not left me." Wrochem had reason to share Cassirer's disappointment. Shortly after receiving Cassirer's letter, Wrochem too, was replaced.[90]

Cassirer and his family departed suddenly and with a bitterness felt by his former students and colleagues. According to his esteemed student Solmitz, who at one point had represented, to Warburg, Hamburg's next generation of the "German-Jewish spirit," Cassirer was deeply affected by this experience. "Cassirer appeared to have been very shaken by the events," Solmitz remembered, "and only with difficulty was able to preserve his philosophical composure." Nonetheless, Cassirer remained committed to Warburg's open and liberal Hamburg, the city that had initially accepted him and had become the home of his cosmopolitan scholarship. The next fall, in a letter to von Melle, Cassirer expressed his gratitude to the founder of Hamburg's university for his support, a genuine reflection of the collective spirit of the "old Hamburg professors" that he would never forget.[91] Because of its strong mercantile focus, Hamburg had not been known for its ideas; but this very same economic life afforded its scholars a unique degree of cultural autonomy. Now this cultural autonomy—initiated by Warburg's vision and fulfilled in the Hamburg School—came to an end.

Following the university purge, students met at the homes of their expelled Jewish professors to complete their exams and attended lectures sponsored by the recently established Franz Rosenzweig Foundation, where at least one of Cassirer's former students was now lecturing.[92] In this way, the university purge created a kind of subculture of German-Jewish scholars and their students, and this spontaneous and domestic intellectual culture was oddly reminiscent of Hamburg's pre-

university intellectual life, which characteristically emerged from individual initiative and supported nontraditional scholars and unconventional scholarship. Ever cosmopolitan in spirit, the Hamburg School was soon successfully exported to another intellectual world, by its new leading scholar, Panofsky.

The Hamburg-America Line: Exiles as Exports

There are seven illustrious Schools,
Competing for Pan like wild mules.
But they all quite agree
That the best thing would be
If the *others* would take him, the fools.[1]
ERWIN PANOFSKY

It was a strange adventure to be landed with some 60,000 books in the heart of London and to be told: "Find friends and introduce them to your problems."
FRITZ SAXL

As a result of wartime emigration, Hamburg finally became in Warburg's vision a "Gateway of Knowledge," a place from which ideas, like goods, were exported. That the Hamburg School proved so easily exportable was testament to the cosmopolitan quality of its scholarship, which flourished in Hamburg so long as the city's cosmopolitan identity reigned. Although these scholars found new homes, oases from the war when a national imperative usurped this Hanseatic tradition, they did not believe that the cities of their exile—London, New York, Princeton—were their final destinations. In 1936 Panofsky, then at Princeton, wrote to Saxl in London, "Incidentally, I am planning a reunion for our whole circle of friends in Honduras or Liberia, at some point in the year 1940. Then things will probably have advanced so far that Jews and

liberals will no longer be desired even here."[2] Should the political situation once more become unfavorable, the cosmopolitan intellectual circle planned to relocate. The Hamburg School had become a humanist dreamland, to exist only in the minds of its members. An examination of their ideas during the period of their emigration reveals how a changing set of geographical, cultural, and political contexts were both constructive and destructive for their intellectual trajectories.

With the onset of National Socialism in Germany, Warburg, Cassirer, and Panofsky each met a different fate. Warburg, who had died in 1929, escaped the trauma of the Second World War, and his early death exempted him from the postwar reflection that forced the reconsideration of so much of interwar philosophy. The Warburg Library, too, went into exile: following negotiations between the American Warburgs, various London donors, and the Nazis, nearly sixty thousand books and photographs, along with various machinery, were piled onto two ships of the Hamburg line, the *Hermia* and the *Jessica*, and sailed to the London port in December 1933. In 1944, supported by the English philanthropist and art collector Samuel Courtauld and a rising interest in the use of images in historical study, the library would be incorporated into the University of London, where it subsequently was used for several decades of collaborative research. But in 1933, at the time of the exile, the library's security was not a sure thing, for soon after the books left the port, as Bing recalled, "responsibility for decisions on emigration passed from the Hamburg authorities to the central party offices in Berlin."[3]

The Cassirers, too, escaped only just in time. After his brief return to Hamburg in the summer of 1933, Ernst Cassirer emigrated with his family first to Oxford and then in 1935 to Sweden, whose academic culture he assimilated in a remarkably short period of time.[4] After the outbreak of the Second World War and the Nazi occupation of France, the Cassirers managed to catch the last boat departing from Sweden.[5] Once in the United States, Cassirer taught at Yale and Columbia universities and lived in New York until his death in 1945. Although, during this period of exile, Cassirer held out hope that there might, eventually, be some means of rebuilding "old Hamburg" in a new place, the still young Panofsky, whose experience was radically different from that of his elder colleagues, had other options.[6] In 1931 he had already begun to teach alternate semesters as a visiting professor at New York University's Institute for Fine Arts and was poised to embark on a different path—the proverbial "expulsion to Paradise."[7]

Panofsky believed that without the Warburg Library, the future of art

history in Hamburg was "unthinkable."[8] Scheduled to spend another semester in New York in the spring of 1933, he considered appealing to Hamburg's university board to request a leave of absence.[9] However, Panofsky, too, soon received notification of his dismissal. The cable was sealed with "Cordial Easter Greetings, Western Union." "These greetings," he liked to recall, "proved to be a good omen."[10] Building on his New York experience, Panofksy established himself anew as an art historian at the Institute for Advanced Study in Princeton, New Jersey, and was, until his death in 1968, one of the leading postwar scholars in America.

Generational distinctions provide an important organizing principle for German history in general and the Weimar Republic in particular, and the generational differences between these scholars were manifest in the trajectory of their ideas in exile.[11] In short, whether a German-Jewish refugee experienced expulsion *from* or *to* paradise largely depended on his age. Different political loyalties and religious and cultural sensibilities also created distinct conditions for this, the last chapter of their intellectual and cultural life. Consequently, their intellectual trajectories also represent different stories with distinct endpoints, from which we can draw unique meaning for the history of ideas.

———

Warburg's life and career symbolized the rise and fall of Germany's imperial period. As one historian recalls, "When Aby Warburg was born in 1866 the *Kaiserreich* did not yet exist, and when he died in 1929, it had already been gone for over a decade."[12] And because he was never forced to revise his ideas in the early 1930s, in the wake of totalitarianism and war, it should be no surprise that his oeuvre, reified in the volatile moment of Weimar culture, should look different from those of his peers who outlived him. In contrast, Cassirer championed the Weimar Republic's politics and ideas, and his life and career were paradigmatic of the republic's tragic fate. The philosopher represented the corresponding intellectual failure of the most common political critiques of the republic: its ineffectual ceremony and inability to use the sword. Panofsky, whose work had the most lasting influence in the United States, represents the Hamburg School's afterlife (*Nachleben*) and the complex process of translating this scholarship to postwar America. As such, he also represents a central problem of exile, and

his story makes evident the complexity involved in the translation of ideas from one context to another. Part of a group of émigré scholars who have been the subject of unending fascination, Panofsky represents a different end to the story than is often given to Weimar culture and politics. Here in postwar America, the Warburg circle—the other Weimar—persisted.

Since they both had the opportunity to continue their intellectual work in the 1930s, Cassirer and Panofsky's trajectories provide a compelling point of comparison for the relationship between ideas and their changing contexts. Cassirer's moral reckoning led him to all the more forcefully reiterate the views to which he committed himself in the 1920s. He continued to insist on the necessity for neutrality and objectivity in scholarship, the preservation of a balance between nationalism and cosmopolitanism in intellectual history, and the adherence to an epistemological critique in his philosophical anthropology. As presented in his postwar works *An Essay on Man* (1944) and *The Myth of the State* (1946), this perspective ultimately limited his ability (in the postwar period, as in the 1920s) to provide a formidable philosophical defense against irrational and nationalist scholarship.

Panofsky, in contrast, always shared more with the less "rationalist" Warburg in a collaborative endorsement of what they called iconology, a methodology that bridged contextualism and formalism and high and low art and conveyed an awareness of the danger wrought by static interpretation on the dynamic quality of works of art. Touting iconology, the German Panofsky was initially welcomed by American art historians eager to provide the art-historical discipline with more analytic rigor.[13] Yet iconology, a nuanced methodology, became largely diluted in its American form and subsequently was the object of rejection and ridicule. While art historians return to Warburg as an antidote to Panofsky, they do so often without awareness of the change in historical context that accounted for the vast differences between the two men. Moreover, they frequently propose criticism of the American Panofsky, criticism that uncannily echoes the ideas of the Hamburg School in its earlier, Weimar moment.

This final chapter addresses the varying trajectories of Cassirer and Panofsky in exile, and the epilogue turns to the complicated legacy of Warburg's reception; moving outside the boundaries of Germany (let alone Hamburg) and the German language, these developments present a challenge to a context-based history of ideas. For as one former student of Panofsky observed on the occasion of a lecture his professor

delivered at Duke University in 1967, "To hear Panofsky, is therefore, also to be attuned to a significant phase in the history of American cultural thought."[14] However, far from undermining the principle of the fons et origo of ideas with which we began, the moment of exile is also a continuation of the Hamburg School's development in another key; it brings the question of context and ideas into further relief. While the dreamland of Hanseatic humanists never received institutional recognition nor historical canonization equivalent to that of the Frankfurt School, the significance of the school was consolidated in exile and became even more meaningful in the minds of its members. If the Hamburg School did not continue institutionally, it was perpetuated in the private correspondence, writings, and jokes exchanged within this imaginary community. Our assessment of their ideas in exile permits a final reflection on the impact of this changing context for the historical significance of these scholars' ideas.

The Hamburg School in Three Keys

A contemporary of Kaiser Wilhelm II, Warburg formed his political views during the Bismarck era and often invoked its corresponding German patriotism and distanced himself from the Austrian Saxl's predicament under Franz Ferdinand. Critically, Warburg, like his political analogue Stresemann, supported the Weimar Republic because it was the best alternative to revolution, civil unrest, and dictatorship. Even long after its end, he abided by many of the empire's trappings. When his nephew Eric Warburg asked to borrow his revolver for field artillery training, for example, the stubborn art historian insisted that Eric also take his pearl-studded sword, an archaic weapon that Eric abandoned in a Hamburg streetcar out of embarrassment before mounting the train to report for military duty.[15] Eric Warburg knew better than to challenge his uncle's practices, however old-fashioned.

Throughout most of the 1920s, Warburg continued to insist that the Weimar Republic lacked the kind of imperial pageantry symbolized by the pearl-studded sword. When Stresemann toured the Warburg Library and remarked upon a historic stamp portraying a figure he identified as Johann Wolfgang von Goethe, Warburg corrected his observation, revealing once again this generational and political prejudice. "Falsely read, Mr. Reich's Chancellor. Does it not say here 'Joh. Wolfg. Goethe'? And that is precisely the complete misfortune of our Weimar Republic, that here everything is abbreviated and, therefore,

all too brief."[16] Warburg lamented the Weimar Republic's lack of pomp and ceremony—a void too easily filled by National Socialism's spirited parades, marches, flags, and emblems.

Although he bemoaned the republic's deficiencies, it would be disingenuous if Warburg did not admit that he also benefited from the Weimar Republic's promotion of Hamburg's open and liberal spirit. Both leader and dissident, Warburg used his family's funds and his hometown's cultural autonomy to create an institution devoted to a highly unconventional form of scholarship and to promote an unduplicable balance of German and Jewish identities. Warburg's death on October 29, 1929, "Black Friday," also foreshadowed the end of Hamburg's local culture and of the Weimar Republic's potential in the Hanseatic city.

Unlike Warburg, Cassirer unambiguously believed in the Weimar Republic's mission. Born during the decade of the *Gründerzeit*, Cassirer was greatly shaped, personally and in his professional life, by the First World War. The war provided an impetus for one of his first main works, *Freiheit und Form*, in which Cassirer presented German ideas as part of a greater cosmopolitan and humanistic heritage—a cause he continued to promote as a scholar and as rector at the young University of Hamburg. *Freiheit und Form* also initiated Cassirer's long process of revising his neo-Kantian philosophy to establish a broader critique of culture. Even if (or perhaps because) he insisted on the ceremony of the republic, Warburg, in turn, believed that Cassirer represented the best possibility for the Weimar "compromise." And Hamburg's cosmopolitan spirit not only made the city amenable to Cassirer's scholarship but also nurtured his republican-minded intellectual interests and politics. Using the resources that Warburg had helped establish, Cassirer enjoyed the most prolific period of his life there.

Cassirer's career was also greatly affected by his identity as a German Jew. While he never converted, Cassirer kept a public distance from Judaism and, as we have seen, with his wife, closely monitored the perception of his public persona. To this end, he rarely explicitly addressed Jewish topics in his scholarship while in Germany. Even on the occasion of Cohen's death, an opportunity for Cassirer to reconsider and reflect upon his contribution to Judaism, the philosopher neglected this religious matter and instead, primarily discussed the intersections between Goethe and Cohen and the influence of Goethe on Cohen's thought.[17] If Cohen might have been horrified, Cassirer—even if for strategic reasons—aligned his mentor with classical humanism rather than with Jewish philosophy. Cohen had tried to combine the

Jewish and German traditions, much to the chagrin of both groups; Cassirer strove to unite German culture and Europe in a similar balance of symbiosis, but perhaps—to echo his wife's comment on Cohen—the accent lay in the other place. Panofsky, in contrast to either Warburg or Cassirer, was simultaneously bolder in his attempts to construct a cultural and intellectual narrative that remained nationalist and inclusive, more realistic—and perhaps even careerist—about the need to manage his visibility.

These distinctions between the three scholars were borne out in their respective trajectories in America.

Cassirer on Men and Myths

Cassirer's commitment to the power of interpretation and the importance of creating precise intellectual narratives is increasingly evident in the postwar period. In his first postwar work, *An Essay on Man*, Cassirer attempted to present a succinct and simple version of his three-volume *The Philosophy of Symbolic Forms* for an English-speaking audience. While Cassirer was neither entirely satisfied with his English nor content with this process of cultural translation, *An Essay on Man* remains, nonetheless, an impressive work. The text begins with Socrates's dictum "know thyself," but it is not Plato, rather Aristotle, whom Cassirer emphasizes here, for he attempted to explain an ideal vision in terms of the world. In the famous Renaissance painting *The School of Athens* (c. 1510) Plato is depicted pointing toward the heavens while Aristotle directs our attention to the earth. Ultimately, Cassirer sought a synthesis of the two, a balance between self-knowledge and understanding of the world, between feeling and thinking. His intellectual heroes, Goethe and Kant, had also explained it thus, and the philosopher carried this charge with him to the end of his life.[18]

Cassirer continued to trace the vicissitudes of this primitive anthropology and cosmology from the classical to the modern world. When, in this narrative, he arrives at the present, Cassirer laments the anarchic state of scholarship in the modern period. Echoing Weber's "Science as a Vocation," he observes that as a result of specialization, scholarship lacks a central authority; in its stead, the personal factor has become increasingly present. He reflected, "That this antagonism of ideas is not merely a grave theoretical problem but an imminent threat to the whole extent of our ethical and cultural life admits no doubt."[19] Because the historian seeks unity in apparently contradictory events, a

project that requires a delicate balance between the universal and the particular, this contemporary crisis remains of particular relevance to the study of history.

According to Cassirer, Ranke, despite criticisms by such romantic and nationalist historians as Treitschke, who viewed him as objective and emotionless, gracefully embodied this balance. "Ranke once expressed the wish to extinguish his own self in order to make himself the pure mirror of things," Cassirer argued, "in order to see the events in the way in which they actually occurred."[20] Cassirer's defense of Ranke, whose work both was personal and subscribed to a universal compassion that enabled the discussion of a wide variety of topics, could easily be read as an autobiographical creed. Even the metaphorical evocation of the mirror recalls Cassirer's similar analogy of the Enlightenment's self-criticism in *The Philosophy of the Enlightenment*.[21] Rejecting Treitschke's objection to Ranke's lack of "political passion," Cassirer insisted: "Such an attitude may be understandable and excusable in a political pamphleteer or propagandist. But in a historian it symbolizes the breakdown and bankruptcy of historical knowledge."[22]

Through its preservation of this balance between individualism and nationalism and between the particular and the universal, *An Essay on Man* reiterated Cassirer's interwar position, a system of beliefs that culminated in *The Philosophy of the Enlightenment*. This work also represented Cassirer's strongest statement for the necessity of neutrality and objectivity in scholarship and his rejection of the intermingling of politics and philosophy. But because of the changes within the political and cultural world, Cassirer was compelled to address the ethical implications of his philosophical anthropology, a task that he had eschewed throughout most of the 1920s. As World War II came to a close, the question "What is man?" suddenly became a more loaded one, and Cassirer's second and final English-language work, *The Myth of the State*, revealed the limits of his position.

Finished days before he died and published posthumously, *The Myth of the State* aimed to address the relationship between myth and reason, a fundamental issue left unresolved in *An Essay on Man*. While in *The Philosophy of Symbolic Forms*, Cassirer had expanded the critique of reason to include other rational and irrational modes of human understanding to describe man's relationship to the world, the relationship between these forms themselves fluctuated.[23] At the end of *An Essay on Man*, Cassirer asserted, "Science [was] the last step in man's mental development and it may be regarded as the highest and most characteristic attainment of human culture." But simultaneously, he always

insisted on the fundamental similarity between science and the other arts to the extent that their *function* was the concern. "In language, in religion, in art, in science, man can do no more than to build up his own universe—a symbolic universe that enables him to understand and interpret, to articulate and organize, to synthesize and universalize his human experience."[24] This balancing act continued in *The Myth of the State*, in which Cassirer presented myth as a "symbolic form." Less focused on content than on the role it served in society, he argued how, from this functional perspective, myth and reason were in fact the same.

Except when they were not. As long as myth could perform as reason, Cassirer was happy to elevate it to the highest level of human expression, but when faced with bad political myths, he had his hands tied. If he held true to his epistemological focus, with its emphasis on structures and functions, Cassirer was hard-pressed to critique such myths on substantive grounds. This limitation is evident in his critique of Heidegger's rejection of logical philosophy and his corresponding notion of man's *Geworfenheit* in the world: "I do not mean to say that these philosophical doctrines had a direct bearing on the development of political ideas in Germany." The issue was not whether Heidegger's ideas were correct but rather whether they had contributed to an undesirable outcome. "A philosophy of history that consists in somber predictions of the decline and the inevitable destruction of civilization and a theory that sees in the *Geworfenheit* of man one of his principal characters . . . renounces its own fundamental theoretical and ethical ideals. It can be used, then, as a pliable instrument in the hands of the political leaders."[25] Rather than accuse the philosopher based on the *substance* of his ideas, Cassirer placed the blame with their *function* in society.

In other words, in trying to defend himself against Heidegger's irrationalism, Cassirer found himself restricted by his epistemological position. And just as in the Weimar Republic, Cassirer's position revealed the fundamental failure of neo-Kantian philosophy to develop a formidable defense against Heidegger's existentialist critique. If Leo Strauss's objection to neo-Kantianism was typical, Cassirer's criticism focused on the function of modern myths at the risk of ignoring the substance.[26] As we have seen, Strauss made a similar critique of the Weimar Republic's politics, which, despite its formidable reaction to the abhorrent assassination of Rathenau, "presented the sorry spectacle of justice without a sword."[27] Warburg may have bemoaned the lack of "the sword" in Weimar, but he also supported his colleague the philosopher, whose work ultimately represented its very absence. Until his

death, Cassirer tirelessly advanced the cause of a pure scholarship untainted by politics, a cause that tragically left him unable to fight his political enemies.

Cassirer came to address the dangers of political myth all too late, but when he did, his analysis was intimately intertwined with a reconsideration of his Jewish identity. According to Arthur Hertzberg, a rabbi and historian who participated in Cassirer's last seminar at Columbia, Cassirer "regretted not having been throughout his life more involved in Jewish learning and not having made his Jewish self more central to his entire being." Even if this was "reacting to his own biography as an exile," as Hertzberg suspected, at the end of his life, Cassirer significantly requested that a rabbi officiate at his funeral, and Hertzberg obliged.[28] When the Hebrew University honored him in 1945, Cassirer wrote to its librarian, the philosopher Hugo Bergmann, "It makes me feel rather ashamed that I have done so little for the Jewish cause, which has always been very dear to me."[29]

Hertzberg and Bergmann, of course, had their own motivations to present a portrait of the regretful humanist German-Jewish scholar who, at the end of his life, finds his way back to Judaism. In a different register, this is the story, after all, that Rosenzweig promoted of his mentor Cohen.[30] As is often the case, the story reflects more on the narrator than on the subject of narration. For different reasons, Habermas, too, has found Cassirer central to his personal narrative, since Cassirer's end-of-life work reveals his turn from scientific inquiry to religious enlightenment as an antidote to the potential violence wrought by political myths.[31]

In the 1920s, it seemed that "good myths" were those, like good "symbolic forms," which behaved like reason. But now Judaism came to fill this role. The religion in which Cassirer had previously shown little interest from an intellectual point of view, in the 1930s provided for Cassirer the possibility that there could be myth that espoused universalism at the expense of particularity. According to an article Cassirer published in the last year of his life in the *Contemporary Jewish Record*, Judaism had survived the rejection of image-making, otherwise the substance of myth, and instead drew on ethical thought for its mythical creed.[32] This ethical basis for the religion critically promoted the universalism of mankind over the particularity of one specific race or nation. Believing he echoed Cohen, Cassirer argued that the Jews, not the Greeks, were the first to promote the universalism that culminated in Kant's "perpetual peace."[33]

Yet if Judaism itself evaded the pitfalls of ethno-nationalism, this universalist religion found itself in opposition to the dominant nationalist strand of myth, and in the German nation this tension was irreconcilable. As Cassirer observed, "The political myths enthrone and deify a super-race; the prophets predict an age in which all the nations shall be united under the worship of one God. There is no point of contact and no possible reconciliation between these two conceptions." That Cassirer concluded his 1944 essay with the observation "No Jew whatsoever can and will ever overcome the terrible ordeal of these last years" suggests the urgency of both his personal transformation and this intellectual revelation.[34] The philosopher was also confident that Judaism's sacrifice was not in vain:

What the modern Jew had to defend in this combat was not only his physical existence or the preservation of the Jewish race. Much more was at stake. We had to represent all those ethical ideals that had been brought into being by Judaism and found their way into general human culture, into the life of all civilized nations. And here we stand on firm ground. These ideals are not destroyed and cannot be destroyed. They have stood their ground in these critical days. If Judaism has contributed to break the power of the modern political myths, it has done its duty, having once more fulfilled its historical and religious mission.[35]

Speaking significantly as a "modern Jew" himself, Cassirer suggested that the ethical mission of Judaism served some larger cosmological function. Whether or not Cassirer's theory of symbolic forms has an ethical substance is debatable.[36] But it is clear that at the end of his life he began to see, however belatedly, the need for an ethics at its core. If reason was not necessarily like myth, in order to fight myth it had, at least, to be primal, to squash the potentially harmful forces in civilization.

In the end, the philosopher of symbolic forms found that his life and work—and even his death—were not beyond symbolism. On April 13, 1945, a day after Franklin D. Roosevelt died, Cassirer, the champion of German liberalism, collapsed from a heart attack on the steps of Columbia's library. "If it had happened in Rome or Athens," Panofsky wrote of Cassirer's death, "it would now be read in [a work by] Valerius Maximus or Diogenes Laertius." The philosopher viewed his life as an odyssey, and the afterlife of his ideas was reinterpreted in various permutations for generations to come.[37]

Economics of Exile

Even in Hamburg, Panofsky represented an intellectual tradition distinct from that of his colleagues. Panofsky's young students were fed up with the neo-Kantian monopoly on the academy and with an intellectual tradition they viewed as ossified and irrelevant to essential philosophical questions. Panofsky empathized with this younger generation's frustrations. According to Wind's recollection of his doctoral examination, at which he faced the most stringent questioning of this sort, "Cassirer proved to be weak on this occasion, but Panofsky settled the matter by his suggestion (as chairman) that they were meeting as a university committee, and not as a 'neo-Kantian Inquisition' [*neukantianisches Inquisitionsgericht*]." "Inquisitions" like these turned many younger students, including Strauss and Benjamin, away from neo-Kantianism and onto Heidegger's phenomenological approach. Echoing Heidegger's accusations of Cassirer in Davos, these young scholars felt that Cassirer's lectures failed to engage in "true *questioning* instead of label-sticking."[38]

Yet Panofsky seemed closer to their concerns. In his 1932 essay "On the Problem of Describing and Interpreting Works of the Visual Arts," Panofsky engaged with Heidegger's hermeneutics and his reading of Kant, an approach highlighting that "every interpretation [*Interpretation*] must necessarily use violence."[39] Panofsky concurred with the philosopher and expressed the hope that his own analysis, which emphasized the "documental sense" (*Dokumentsinn*) of the image, might somehow mitigate this necessary violence.[40] A lecture delivered at the Kant Society, "On the Problem of Describing," is a document that bridges many scholarly traditions and trends, including the interwar debates concerning neo-Kantianism, the sociological problem of interpretation, and the art-historical subfield of iconology.[41] Significantly, Panofsky revised this statement in its English-language incarnation with drastically different epistemological consequences. Yet at the time, notwithstanding (or perhaps because of) the recent debate between his colleague Cassirer and Heidegger, it seemed that the art historian's preaching style and charismatic leadership represented, for this generation, an alternative to stringent neo-Kantianism, the negative association of which Cassirer did not elude.

In the final days of the Weimar Republic, Panofsky's and Cassirer's different attitudes toward Hamburg further revealed the widening generational gap between them. In contrast to Cassirer's abrupt depar-

ture, an event that saddened and bewildered colleagues and students, Panofsky maintained intimate contact with and responsibility for his students. Distancing himself from Cassirer's behavior and ill feelings, Panofsky reported to a colleague that "Cassirer has grudgingly left for Vienna, of which I (to speak openly) do not entirely approve, because so long as the *personal* friends and students remain loyal, one has reason for sorrow, I suppose, especially if one loves his country and people so genuinely as we do, but not actually reason for bitterness." In the summer of 1933, Panofsky heroically traveled from America back to Germany in order to hold the doctoral examinations of three students in his home, an event that he "went about . . . in the most dignified manner," recalled one of the examined students, Hugo Buchtal.[42]

It was easy for Panofsky to disapprove of his elder colleague's bitterness, for he was the only scholar in Hamburg on behalf of whom a formal petition was issued in 1933 that would have permitted him to remain at the university. Rather than be "one of the first . . . to be done away with by the idiots," as Panofsky predicted in jest, he remained for two months following the law barring Jewish professors from German universities. The letter of recommendation submitted by Panofsky's colleagues praised him for both his research and his teaching. Furthermore, his colleagues insisted that not only would Panofsky's departure be a loss to Hamburg, but also, "in the last years of his art history seminar, [Panofsky] was considered to be the best [of the professors] of all the German universities."[43]

Just as, in the late 1920s, Warburg had viewed Cassirer as a symbol of Hamburg's liberal intellectual life, so now these art historians perceived Panofsky as fundamental to Hamburg's academic reputation. They contended, "Panofsky has substantially contributed to the meaning of the young University of Hamburg and to its distinction in the world." That New York University invited him twice as a visiting scholar validated Panofsky's international esteem.[44] Yet, as in the case of Cassirer, being designated "international" threatened his pure German bona fides. His supporters hoped that his honorable mention in a nationally endorsed handbook on aesthetics proved that "Panofsky's works [were] held in an intellectual spirit, which [was] impossible for one to describe as 'corrosive' and 'foreign.'"[45] Despite additional letters expressing concern that Panofsky might not be allowed to work in Germany, however, Panofsky was fired on June 28, 1933.[46]

Notwithstanding this turn of events, Panofsky continued to believe that Hamburg was exempt, to a certain extent, from the dark politics

that quickly enveloped the nation in the spring of 1933. In May of that year, Panofsky wrote to his new American confidante, Margaret Barr, the wife of the art patron and first director of the Museum of Modern Art Alfred H. Barr, "Hamburg is really a very decent place and is generally considered an oasis as far as the human condition is concerned." Dora Panofsky, too, cherished their scholarly circle of friends, rare in a moment when "most of the intellectual spirit was drowned out by demagoguery."[47] It was far from Hamburg's finest hour, but the Panofskys remained aware of their good fortune.

In the midst of the mounting persecution, various relief agencies materialized, including the Academic Assistance Council in London and the Emergency Committee in Aid of Displaced Scholars in New York, whose objective became to facilitate the emigration of scholars from Germany and to secure permanent entry visas for them, a difficult task accomplished only for a fortunate few.[48] The Hamburg School's case emerged as unique for the great international interest in preserving the safety not only of its scholars, but also of its collection of books. The Warburgs were first faced with the challenge of proving that the Warburg Library was American property, an important task that would require the Nazi leadership to let it go.[49] Yet the question of where these scholars and their books would relocate was still an open one.

During this era, the Warburg Library benefited tremendously from a decade of international connections, most notably in London and the United States. But Bing and Saxl, left with the responsibility of directing the library, could not get a firm commitment from anyone to provide the library with a new home.[50] Moreover, following Warburg's death in 1929, it became increasingly difficult to retain the financial support of even the Warburg brothers, who quickly lost interest in their late brother's eccentric project. The negotiations between the parties, a constant struggle during Warburg's life, reached a crisis at the height of the world economic crisis in 1931 when the resources of scholarly institutions everywhere became limited. The Warburgs were discouraged by the possibility of relocation to New York, a city where, they imagined, they would face a lack of understanding about the library's goals. Italy seemed the most natural cultural connection, although the hostile political situation made a move there unlikely. And Holland, which offered hospitality, did not have sufficient funds to sustain the extravagant collection.[51]

Panofsky's growing reputation as a scholar proved crucial to the Warburg Library's fate. The art historian Millard Meiss, then a gradu-

ate student at the Institute for Fine Arts in New York with an interest in iconology, urged the faculty to invite Panofsky there in 1931. Using his visiting lectureship in America and his new connections to that country's wealthy and intellectual elite, Panofsky actively mediated the situation with the American Warburg brothers. Together with Wind, Panofsky accompanied several potential donors from London to visit the library in Hamburg. Fortunately, the members of the Academic Assistance Council came away from their visit at the "Warburg" with a favorable impression. Soon thereafter, Saxl went to London to consult with Max Warburg and, most crucially, received a formal letter, signed by a group of English supporters of art and scholarship, that extended an invitation to the library for a period of three years. Based on the authority of this document, the National Socialist authorities ultimately yielded their claim to the books.[52]

An American home for the scholars was slightly more difficult to negotiate. Panofsky believed that New York was poised to become the next capital of art-historical study. Because of both its distance from Europe and its financial resources at a moment when finances were otherwise scarce, New York seemed to Panofsky to possess all of the requisite urban preconditions for art-historical scholarship.[53] Art history required money, and to a certain extent, the interests established by the wealthy German-Jewish families persisted in the postwar period in America. Indeed, Panofsky's description of 1930s New York as a city on the periphery that turned its disadvantaged cultural scene and deep pocketbooks into an opportunity could have been written about Weimar-era Hamburg. Panofsky might also have mentioned the role of Jewish patrons, including Felix and Paul Warburg, who had already been engaged in the collection of art for several years.[54]

But Panofsky found the American donors, so crucial to his livelihood, more difficult to understand. Even though Warburg always claimed that American philanthropy, based on a richer history of giving deeply entrenched in social life, was the source of his inspiration for privately funded scholarship, American donors had many causes from which to choose. Alluding to the increasingly fashionable patronage of the arts, Panofsky thought it was "quite pardonable that the New York millionaires [were] dead sick of supporting fat Jewish professors and [would] rather subsidize ballet-girls."[55]

The mounting anxiety over the relationship between scholarship and economics played out on one evening in the winter of 1931 in the Rockefellers' New York City living room. Panofsky, serving then as a visiting professor at New York University, was invited to present

the "Hamburg idea" to several potential donors. Among those in atten-
dance were the Warburgs, as well as, in Panofsky's opinion, "more hon-
orable Christian people." Many American-Jewish families, such as the
Lehmans, the Schiffs, and the Speyers, provided funds for temporary
appointments for refugee scholars, but many non-Jews also showed in-
creasing willingness to contribute. For Panofsky, reporting to Saxl in
London, the reason for "mixed" Jewish and Gentile philanthropists
was clear: "If my psychological experience with Jewish people is not
mistaken, the vote of confidence from such society presents a much
more effective pressure on the American Warburg pocketbook than
ten expert reports, which demonstrate the scholarly meaning of the
Warburg Library in all cardinal directions. Because if the Cranes and
the Rockefellers are explicitly and greatly interested . . . it would be
impossible for the [Warburg] brothers to leave the Warburg Library in a
lurch without being made out to be fools in front of the Christians."[56]
The volatile trinity of culture, commerce, and Jews, so delicately pre-
served in the port city, didn't seem so evident on the other side of the
Atlantic.

Panofsky's "psychological experience" in his new setting reflected
his resentment of the Warburgs (perhaps always latent but newly ex-
posed) because of their lackluster support, despite their great fortune.
Of course, an awareness of the material conditions of scholarship was
a constitutive part of Panofsky's consciousness from his journey as pri-
vate scholar to *Privatdozent*. The situation of exile now depressed him
anew because he hated "the position of a 'réfractaire' supported out
of sheer charity" and especially being dependent on "rich Jews." Dis-
couraged by the state of his own financial affairs, Panofsky unwisely
considered returning to Hamburg. As he explained to Margaret Barr,
"If I can find a job here—good. If not—bad, but at least not 'undigni-
fied.' One can be an emigrant, or even a refugee, but no *déserteur*—even
when running the risk of being detained upon returning."[57]

Fortunately for Panofsky, New York University professor Walter S.
Cook was on the case. Known to all as a "genial hearty gentleman of
the Old School," Cook raised enough money to create an "emergency
professorship" for Panofsky, among others, and thus saved him from
the "undignified" status of a refugee. In the process, he transformed
the Institute for Fine Arts into a faculty of almost exclusively illustri-
ous exiled scholars.[58] Money was still short, and the makeshift de-
partment convened in the basement of the Metropolitan Museum.
Panofsky joked, "When they were kicked out they went to a speakeasy
on 52nd St."[59] Eventually, what had ironically become an "Institute

for Refugees" found backing. As Cook recalled, "I just passed the hat around." In addition, Paul Warburg donated his home on East Eightieth Street to serve as the institute's main building; it was a fitting act, considering that many of these new scholars emanated from the circle of his elder brother.[60]

The American art-historical landscape was not without scholars of its own, but the field had already felt the influence of German developments for some time and therefore welcomed these genuine incarnations of the scholarly culture par excellence.[61] Moreover, art history was experiencing a crisis in America that made it amenable to the iconological approach, which lent the field the academic rigor that it required to become a serious discipline. Cook famously joked, "Hitler is my best friend, he shakes the tree and I collect the apples."[62] Owing to Charles Rufus Morey's efforts in Princeton's Department of Art and Archaeology, the other major site for art history in the United States came to be Princeton, New Jersey, where, the author Rebecca Goldstein has wittily recounted, "some of the choicest apples have ended up rolling." Essential to that superior peck, Panofsky began lecturing at Princeton before being appointed in 1935 to the nearby Institute for Advanced Study, founded by the pedagogue Abraham Flexner three years earlier. Unlike the University of Hamburg, which once had to justify its practicality to the city's businessmen, Flexner promoted scholarship touted as "useful for its uselessness."[63] Here, too, it is significant that Panofsky was appointed to the institute and not the university, where Jews were still largely unwelcome. Panofsky, for his part, became a staunch defender of the "ivory tower," in which he assumed an integral role.[64] And the Institute for Advanced Study was, in turn, strengthened by the presence of Paul Frankl, Charles de Tolnay, and Kurt Weitzmann, all of whom envisioned an interdisciplinary approach to art history.

Princeton quickly became the Panofsky family's second home, and Erwin and Dora Panofsky, or "PanDora," as they were known locally, became a staple of the intellectual scene (fig. 12). They enrolled their sons, Hans, then seventeen, and Wolfgang, only fifteen, in the university. Those two, whom the elder Panofskys referred to as "the plumbers" (*die Klempner*) because they preferred the sciences over the humanities, became, respectively, a world-renowned engineer and a physicist.[65] The move to Princeton from Hamburg also proved particularly transformative for Dora Panofsky, who had the opportunity to resume her career as an art historian, an ambition that had been put on hold on account of her husband. Emboldened by her husband's lengthy absence and preoccupation with American women ("Overall your letters increas-

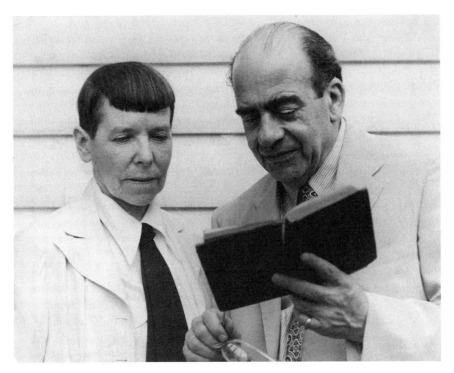

12 A classic feature of the Hamburg School in exile was "PanDora," or Erwin and Dora Panofsky, at Princeton in the late 1950s. Warburg-Archiv des Kunstgeschichtlichen Seminars, Universität Hamburg.

ingly give the strong impression that America is a pure matriarchy!"), Dora Panofsky eschewed the typical refugee path of the "university-educated housewives" as she took up her belated career as a scholar in the United States.[66]

At Princeton there was only one female professor in the 1950s, the archaeologist Hetty Goldman, of whom Erwin Panofsky used to say, "Miss Goldman is the only gentleman here."[67] This gentleman's world, which included the leading scientists and literary giants of the postwar world, warmly accepted Dora Panofsky. When she contracted an unknown and painful illness in the 1940s, this coterie of scholars visited her bedside. One member of the Princeton community recounted, "She was unable to sleep, and her sole distraction was having someone read to her. A three-man shift was set up to provide the reading. It consisted of Dr. Panofsky, Dr. Albert Einstein, and Thomas Mann."[68] The Panofsky's new "oasis" was a star-studded book club.

261

Over the following years, Panofsky visited Bryn Mawr and Vassar colleges and Harvard, Northwestern, Princeton, and Yale universities, as well as St. Vincent College, where he delivered a lecture, later published as *Gothic Architecture and Scholasticism* (1951). Following the first appearance of the "American Panofsky" in 1933, marked by the publication of Saxl and Panofsky's joint essay on classical mythology in medieval art, the American audience eagerly received his work. In 1939 Panofsky published *Studies in Iconology: Humanistic Themes in the Art of the Renaissance*, itself a revision of the ideas laid forth in the 1932 essay "On the Problem of Describing." With these publications the "Warburg method" was brought to wide English and American audiences, albeit with key differences. Panofsky observed that in America one was permitted (compelled even) to "write books on whole masters or whole periods instead of—or besides—writing a dozen specialized articles," and so he followed suit.[69] In addition to his magisterial work *The Life and Art of Albrecht Dürer* (1943), Panofsky's *Early Netherlandish Painting: Its Origins and Character* (1953) and *Meaning in the Visual Arts* (1955) earned him his widest audience.[70] Panofsky's English-language works established him as a "founder" in the disciplinary development of art history within the United States and his intrigue as a scholar was equally important in securing a home for the Warburg Library. His influence was felt throughout American historical scholarship, especially in literature and musicology.[71] In contrast to Cassirer, who never felt entirely at home in Oxford, Sweden, or America, nor with the English language, Panofsky's youth and adaptability allowed him to begin a new career in a foreign environment.

Yet in their translation—both cultural and linguistic—Panofsky's ideas underwent vast changes.

Iconology in Exile

Panofsky's relationship to Hamburg and Germany became convoluted, and these relationships had a direct impact on the translation of his ideas. As late as 1939, when *Studies in Iconology* first appeared, he viewed his scholarship as a direct continuation of his collaboration with Warburg and the Hamburg School and admitted that it was "hard to separate the present from the past, 'nostrasque domos, ut et ante, frequentat.'"[72] But Panofsky also needed a clean break from his Hamburg life. He never wrote again in German, a decision he attributed to his hatred of translation, a process he described as "comparable to the

ruinous habit of most modern sculptors of merely modeling their statues in clay while leaving the execution in marble to a 'technician.'"[73] As a scholar of untranslatable icons, this was indeed symbolic. Even on the occasions of his two postwar return trips to Germany, on which he received honorary degrees in Bonn and Freiburg, he insisted on lecturing in English, much to the dismay of his German audiences and friends, who could not help but take this linguistic choice as a personal affront.[74]

Moreover, while he ascribed to Hamburg a "kind of nostalgic glow in my memory," that only increased with age, when the University of Hamburg offered him the opportunity of a position in April 1946, Panofsky declined. On neither trip following the Second World War would he step foot in Hamburg; he went so far as to travel on an overnight train through the city to avoid a lengthy visit. Dora Panofsky had recently died, and he married Gerda Soergel, a non-Jewish German woman from Princeton. Many of Panofsky's closest friends commented that he would not have made the trip back at all, had not Gerda urged him to go. And despite this, according to Roxanne Heckscher, "he was very plagued by having gone."[75]

His final German trip was complicated further by the strange circumstances of receiving a third honor and the highest given by the German government, the Order of the Pour le Mérite, in this, the last year of his life. Panofsky's German supporters promoted his name beginning in the early 1960s, but the concern remained whether or not a German-Jewish émigré would accept the award at all. That Panofsky had recently remarried a non-Jewish German woman and returned to Germany, initially to visit his new in-laws, signaled to his former academic community his willingness to make peace.[76]

But not all injury was evaded. The issue remained not only whether it was appropriate for a Jewish scholar to accept the award from postwar Germany; in addition, as Panofsky later joked, it was "a little bit weird" "to have the blue Max laid around his neck by [Percy Schramm] the private-Thucydides of Herr Hitler."[77] If Schramm's wartime activities as the official historian of the *Wehrmacht* were already known in 1967, what Panofsky could not have known, and scholars have learned only recently, is that as he delivered his remarks in the Zentralinstitut für Kunstgeschichte, itself the former administrative center of the Nazi party in Munich, Panofsky's long-lost *Habilitation* on Michelangelo lay locked in the basement. Presumably brought to Munich by his former Hamburg student and then director of the center Ludwig H. Heydenreich, the manuscript remained there, unpublished and hidden from

view for a half century. Why Heydenreich never told his former professor of its whereabouts or returned it presents something of a mystery that may never be fully understood.[78] Yet these personally fraught relationships—in particular, the broken trust and sustained loyalty of those who left and those who remained—led to an ambivalence that is palpable in the postwar work of these scholars.[79]

———

This ambivalence was deeply felt in Panofsky's work on Dürer, the sixteenth-century artist to whom he devoted substantial attention over the course of his career, especially in his interwar study of the history of melancholy. Unlike Warburg, Panofsky had always emphasized the reconciliation rather than the duality of Dürer's mentality. Not only did the artist bridge the north and the south, but also the Dionysian and the Apollonian. However, Panofsky also did not shy away from the psychological vocabulary of nationalism that was characteristic of his time. Even when speaking of Rembrandt, Panofsky used the term *Wesen*, or essence, a word also employed by his ethno-nationalist adversaries. This language assumed different valences in the 1940s and 1950s.

At the outset of his tremendous work *The Life and Art of Albrecht Dürer*, which went through multiple printings in the postwar period, Panofsky appears to align himself with Germany and laments that it "never brought forth one of the universally accepted styles the names of which serve as headings for the chapters of the History of Art," resulting from the Germans' national characteristics; instead, "so easily regimented in political and military life, [Germans] were prone to extreme subjectivity and individualism in religion, in metaphysical thought and, above all, in art."[80] As an artist who managed to rise above the particular predilections of his countrymen to achieve universal importance, Dürer alone emerged as the exception to this rule. Crucial to this development was the influence that Italian humanism had on his work, but, as Panofsky shows, the conflict between a focus on subjectivity and a tendency toward universal abstraction remained. Panofsky's interpretation of Dürer's *Melencolia I*, which repeated many of his findings from the interwar period, attested to this tension:

Thus Dürer's most perplexing engraving is, at the same time, the objective statement of a general philosophy and the subjective confession of an individual man. It fuses, and transforms, two great representational and literary traditions, that of

Melancholy as one of the four humors and that of Geometry as one of the Seven Liberal Arts. It typifies the artist of the Renaissance who respects practical skill, but longs all the more fervently for mathematical theory—who feels inspired by celestial influences and eternal ideas, but suffers all the more deeply from his human frailty and intellectual finiteness. It epitomized the Neo-Platonic theory of Saturnian genius as revised by Agrippa of Nettesheim. But in doing all this it is in a sense a *spiritual self-portrait* of Albrecht Dürer.[81]

That Dürer signed all of his works, including those he did not intend to sell, further demonstrated "the specifically German preference for the particular against the universal, for the curious as against the exemplary, and for the personal as against the objective."[82] Like Cassirer, Panofsky viewed this question concerning the relationship between the particular and the general, and the individual and universal, as crucial to forging the epistemological basis for a discipline. Doubtless, he also understood the cultural and political implications of this choice. In this way, Panofsky's interpretation of Dürer's art as a "spiritual self-portrait," as one art historian has argued, was actually autobiographical.[83] In assessing Panofsky's own loyalty, however, the question remains as to whether Panofsky viewed Dürer as an alternative to the limitations of German nationalism or whether, conversely, Dürer's experience finally gave Germany its long-overdue position in the canon.

What is clear is that Panofsky remained attached to an abstract version of Germany. As late as the 1950s, he lauded the tradition of classical humanism as German and claimed that his most important influences were the teachers at his German *Gymnasium*: "I know full well whatever little I may have achieved in my field is largely due to the nine years I spent in a decent school [Joachimsthalsche Gymnasium, Berlin]."[84] Panofsky believed that this German commitment to classical humanism provided the inspiration for his own scholarship, and indeed, Panofsky's aestheticization of his life as an ancient epic tale, as in the bit of verse he adapted from Homer, reflected his continual commitment to this tradition.[85]

In fall 1933, when his future remained uncertain, Panofksy and a Hamburg colleague composed a timely rhyme that drew explicitly on this tradition: "'Et in Arcadio ego' gemeint 'auch in Arkadien ich.' Was aus uns wird, wissen wir immer noch nicht" ("Et in Arcadia ego" means "even I am in Arcadia." What will become of us, we still do not know).[86] This private joke turned on Panofsky's analysis of the seventeenth-century French artist Nicolas Poussin's painting *The Arcadian Shepherds*, also known as *Et in Arcadia Ego*. Panofsky famously

interpreted the painting to signify a change in Western iconography of the region in central Greece, Arcadia, from its association with harsh primitivism to "sweetly sad" melancholy. Panofsky argued that the phrase meant not "I was also in Arcadia," but rather, "Death is even in Arcadia," a meaning that only Poussin correctly captured. In contrast to the Renaissance pictorial depiction of the "Death in Arcadia" theme that was still steeped in the medieval moralizing tradition, Poussin's subjects engaged in calm and pensive discussion about the Arcadian tomb. "The Arcadians are not so much warned of an implacable future," Panofsky wrote, "as they are immersed in mellow mediation of a beautiful past." The same could be said about Panofsky and his exiled colleagues, who continued to exhibit a similar "undisguised elegiac sentiment" regarding their German past.[87]

Despite his occasional romanticization of an abstract Germany, however, Panofsky was wary of "retroactive patriotism."[88] The obvious irony here is that Panofsky risked becoming the bearer of a tradition that ultimately had failed to protect him.[89] Equally bewildered by this development, one German reporter made the same observation in an anti-Semitic article, "Jews and Émigrés Pursuing German Scholarship," in which seven of the scholars mentioned hailed from Hamburg.[90] (These observations echoed similar paranoid observation about Jews and Weimar culture.) Panofsky's highly accented English, reported on both sides of the Atlantic, seemed the perfect metaphor for this in-between space that Panofsky occupied together with many other German Jewish émigrés.[91] There was also a further irony, that until recently Panofsky seemed to have escaped. With his proclamations of broad, sweeping national aesthetic characteristics, the American Panofksy inched closer to Riegl's *Kunstwollen* and the New Vienna School's similar tendencies to detect an ethnic component in artwork, a tendency that, as we have seen, the German Panofsky vehemently opposed. As the art historian Jaś Elsner observes, "it is hard not to see his 1955 reworking of "Iconography and Iconology" as designed precisely to inflate iconology with all the mystical baggage he had once resisted."[92]

Yet the Second World War was not the only context in which Panofsky's postwar work assumed new meaning. Panofsky's *Early Netherlandish History*, which began by summarizing his 1924 lecture *Perspective as Symbolic Form* for an English-speaking audience, continued the debate concerning structuralism and evolutionism in which that German text was embroiled in the interwar period. The new context that gave meaning to this set of issues was the academic politics of the American academy. Clearly influenced by Cassirer's notion of "symbolic forms"

and deeply engaged with Warburg's understanding of the relationship between works of art and their social and intellectual contexts, Panofsky argued that pictorial representations of perspective developed in close connection with the philosophical theories of space prevalent in their corresponding time periods. Following from this reasoning, since the Greeks and Romans possessed no understanding of an "actual" infinite, their art similarly lacked the pictorial representation of an infinite continuum that all postmedieval art possesses.

Arguably, a crucial epistemological shift takes place here, however, a change that has important implications for the development of art history.[93] Where he previously saw perspective as a symbolic form, now Panofsky advocated a clear value judgment: There existed a "correct" representation of perspective that dictated certain rules for its construction, and these were best explicated by the fifteenth-century Italian art theorist Leon Battista Alberti and his mathematical formula that made painting appear to be a "view through a window." As a result, "the Greeks and Romans," as Panofsky explained, "not to mention non-European peoples, never arrived at the 'correct' construction because they never arrived at the modern conception of a three-dimensional continuous and infinite space."[94] Unlike Cassirer, who remained confined by his neutral and value-free Weberian mode of scholarship, Panofsky now clearly advanced the Italian Renaissance mode as the "correct" one. In this revised narrative, rather than "symbolic forms" Panofsky promoted a teleological view that resembled more traditional Enlightenment narratives of progress, narratives that viewed all historical developments as antecedents to a presupposed modern and correct conclusion.

Although Panofsky's mammoth works tracing long-range historical developments of various motifs were initially welcome in the American academy, they have recently suffered from a general backlash against such metahistorical narratives and absolute standards of judgment. Most notably, Svetlana Alpers, in her groundbreaking work *The Art of Describing: Dutch Art in the Seventeenth Century*, reveals the problem that arises from applying a method of interpretation that was developed in the Italian case to all other works of art. Alpers's innovation lies in her distinction between Italian painting that is primarily narrative and therefore conducive to text-based analysis, and the contrasting northern practice of description. The primary culprit here is naturally Panofsky, who, lacking the appropriate language to describe images that do not fit the Italian model, unfairly assessed the otherwise remarkable art of the Flemish painter Jan van Eyck as "static" based on "ordinary

standards."[95] Alpers's point is precisely that this observation reveals the fundamental assumption in Panofsky's work of Italian superiority over Netherlandish inferiority, an assumption that has too long limited art historians.

More complicated has been the importation of iconology's main methodological contribution: the belief that the true meaning of a work of art lies behind its formal properties. On one hand, this assumption was entirely assimilated into art history, among other fields.[96] However, the study of symbolism has subsequently been reduced to mere *iconography*, that is, identifying symbols, decoding gestures, and dating, a process of ascertaining facts that would have been regarded as the starting point rather than the end goal in the Hamburg School; and "this pedagogically reduced version of European art history largely set the limits for the entire discipline in its postwar American translation."[97] Parodying this mode of analysis, one assuming that every formal detail is a stand-in for some larger theoretical concept, Alpers writes, "Vermeer's woman by the window reading a letter is engaged in extra- or premarital sex. Merry drinkers are gluttons, sluggards, or more likely the victims of the pleasures of the sense of taste, as music-makers are victims of the pleasure of the sense of hearing."[98]

Panofsky is not entirely without blame for this false translation. The French art historian Didi-Huberman captures the striking difference between the German and the American Panofsky well: "It's a bit like a desire to pose all questions having suddenly been replaced by a desire to give all the answers."[99] But perhaps Panofsky had his reasons. In the 1932 essay "On the Problem of Describing," Panofsky showed an affinity with Heidegger's hermeneutics, an approach that won him admirers among the younger generation beleaguered by the neo-Kantian Cassirer's "mere question posing." Yet in his own rewriting of this position, an approach that became his statement on iconology to the Anglo-American world, the demands of a different audience prevailed.

Both in his introduction to *Studies in Iconology* and in a subsequent essay in *Meaning in the Visual Arts*, published in 1939 and 1955, respectively, the discussion of Heidegger disappeared. Although the editors of the German edition attribute this to a matter of context—the discussion of Heidegger's interpretation of Kant was appropriate for the Kant Society, where Panofsky initially delivered this lecture in 1931—perhaps this context needs to be widened.[100] Even if the full extent of Heidegger's complicity in National Socialism did not force a major reconsideration of this philosopher until the first "Heidegger Affair" of

1945–46, for many German Jews of his generation, the betrayal already impacted their scholarly choices.[101]

It remains difficult to know whether Panofsky integrated Heidegger to begin with as a rhetorical ploy to assimilate the arguments of his opponents, as he was wont to do, or whether he was, as the art historians Elsner and Lorenz insinuate, "flirting with the beginnings of a shift in direction that might—in a hypothetical Weimar trajectory that continued through the 1930s—have taken his Warburgian neo-Kantianism much closer to the forceful drives of being."[102] That such questions move scholarship into the realm of ethics and personal responsibility further complicates a potential answer, especially since any analysis inevitably hinges on the subtleties of rhetoric and conjecture. However, even if Panofsky belatedly ended up on the "correct" side of Davos, one casualty of this self-imposed censorship may have been a less sophisticated approach to the analysis of images. In the end, the American version of iconology showed little to no care for the violence done by interpretation, a staple of the original Hamburg School. Without a doubt, our complete understanding of this journey requires an analysis beyond the recent critique of Panofsky's one-dimensional methodology, an analysis that examines how these ideas were adapted, both by their authors and in their reception, to different contexts.

One way out of such reductionist methodology, according to Alpers, is to "see art as a social manifestation, but also to gain access to images through a consideration of their place, role, and presence in the broader culture." The irony, however, is that in appealing to a more holistic and nuanced methodology, Alpers's description comes remarkably close to Warburg's original theorization of iconology. This is fitting, as Warburg did not live to revise his ideas as did his colleagues Cassirer and Panofsky. As a result, his scholarship survived unaffected by the process of translation. Indeed, the notion of "visual culture," which Alpers credits to Michael Baxandall, himself a student of the Warburg Institute, is, in large part, indebted to the Hamburg School.[103] Today's historians who regret the lack of Panofsky's theoretical backbone have suggested Warburg as an alternative.[104]

The German Panofsky might equally serve the same function.[105] The art historian Hans Belting gives us some indication as to how Panofsky's *Perspective as Symbolic Form*, inspired by its original influence in Cassirer's broader understanding of this concept, could be repurposed for a multinational context.[106] Moreover, traces of the subversive approach remain in the American Panofsky, nuances that are often overlooked. For example, in his 1962 essay "The Ideological Antecedents

of the Rolls-Royce Radiator," which is typically read as a lighthearted American work, the émigré offers a subtle satire on the polemics of the ethnic component of art. Here the "iconological" evidence of this argument is to be found not in the movement of hair, as Warburg once observed in Botticelli's *Birth of Venus*, but in the wind-blown "Silver Lady" symbol on the hood of a car. Panofsky concludes that essay with the words "the 'face' of the Rolls-Royce has . . . continued to reflect the essence of the British character for more than half a century. May it never be changed." But are we to take him at face value for his endorsement of such nationalist scholarship? More likely it seems that the art historian once identified by Ernst Jünger for his off-color joke about the Nazis now similarly thumbed his nose at the whole ethno-political debate in art.[107]

Notwithstanding this rare exception, perhaps it is the sad truth that one tragedy of the emigration is that the linguistic and cultural translation of Panofsky's scholarship ultimately yielded ideas purified of their subtlety and blunted in their impact. If the First World War caused Cassirer and Panofsky, inspired by Warburg, to stretch the critical function of the scholar, then the Second World War had an opposite effect: the fear of human destruction through irrationality demonstrated the importance of absolutes.

Schools of Art, Homes for Ideas

The translation of iconology into a new context reinforces the importance of origins in assessing the impact of ideas. Following 1933, "Weimar on the Pacific," as well as Weimar on the Seine and on the Hudson, transported this world to a new national setting. According to Gay, "the exiles Hitler made were the greatest collection of transplanted intellect, talent, and scholarship the world has ever seen." Nowhere was this more apparent than in the field of art history, since nearly one-half of the 250 expelled German art historians immigrated to the United States. The result of this exodus was, as Panofsky later recalled, the "providential synchronism between the rise of Fascism and Nazism in Europe and the spontaneous efflorescence of art history in the United States."[108]

One element remained central to Panosfky's coping mechanism: humor. The satire evident in the "Ideological Antecedents of the Rolls-Royce Radiator" echoed the satire present in the combination of

anxiety and celebration concerning Hamburg's unique conditions of scholarship. In a poem composed with his students, titled "Art Historical Alphabet" (*Kunsthistorische Alphabet*), which was likely performed at an evening of conversation and festivities at the Warburg Library in Hamburg, Panofsky made this connection between place and art the source of immense humor to those trained to understand its reference points.

Composed of rhyming couplets in which the subject-words of the couplets begin with sequential letters of the alphabet, it plays on the connection between place and art history. For example, we learn that "The Isle de France was the birthplace of the Gothic and Italy that of the Renaissance" ("Italien schuf die Renaissance,/Den Gotikstil die Isle de France"). Other stanzas humorously equate local Hamburg figures with art-historical icons, as in the following, where Panofsky favors the resident expressionist painter Anita Rée over the Italian master Raphael: "Raphael's art is not bad,/Anita Rée is also commendable" ("Raffaels Kunst ist unverächtlich,/Auch die Anita Rées beträchtlich"). When he arrives at *H*, Panofsky turns the joke on Hamburg itself. He claims that the famous ninth-century cathedral (*Dom*) in the Lower Saxon town of Hildesheim may be large, but Hamburg's amusing fairground, situated in the heart of the sordid St. Pauli red-light district (also known locally as the *Dom*), is splendid: "The Cathedral in Hildesheim is enormous,/ The "Cathedral" in Hamburg is impressive" ("Der Dom in Hildesheim ist gross,/Der Dom in Hamburg ist famos").[109] Panofsky's deadpan joke, comparing a brilliant work of architecture to a decrepit field in one of Hamburg's seediest districts, colorfully captures his deep anxiety about his host city's lack of culture.

Context had always been, and remained, a source of Panofsky's understanding of art and ideas, and this connection became not less but more important in the postwar period when Panofsky, among émigrés, used a shared sense of humor as a way to address issues otherwise too difficult to discuss directly.[110] Ditties such as the one Panofsky adapted from Homer deflected the anxiety in this new foreign home of uncertainty and perpetuated bonds begun in another land. That jokes were often untranslatable reinforced the importance of context in deciphering their meaning. But place constituted only part of his analysis of culture. Even before these transmutations took place, Panofsky recognized that the connection between place and art history was elusive. The "youthful adventurousness" that Panofsky associated with the conditions necessary for the development of innovative and unconventional scholarship could naturally exist anywhere people were open-minded

enough to support it. In both New York and Hamburg, a certain cosmopolitanism welcomed these developments.

And yet, despite his growing skepticism over his German roots—which, he insisted to former colleagues, was not "bitterness"—Panofsky continued to associate this free intellectual environment with Hamburg. In 1933 Panofsky declared confidently that the Hanseatic city was "still 'different,' even now."[111] That sentiment lingered throughout the postwar years. Although he attended a *Gymnasium* in Berlin, Panofsky strongly associated the tradition of classical humanism with Hamburg. He reinforced this position by corresponding in Latin with his former Hamburg students and colleagues, a practice from the 1920s that he greatly enjoyed and continued throughout the postwar period.[112] And he fondly referred to the fruits of his former students' labors in America as a continuation of the "Hamburg tradition."[113]

That former Hamburg residents Goldschmidt and Pauli were among the first Germans to teach in America in the 1920s, well before the "Great Exodus" of scholars from Germany, confirmed the adventurous spirit that Panofsky believed characterized the *Hansestadt*. Many of these scholars, such as William Heckscher, who taught in Iowa, and Walter Horn, of the University of California–Berkeley, were not among those expelled because of their Jewishness.[114] Panofsky's former Hamburg student Janson represented one of the several "loyal and intelligent Aryans" whom Panofsky assisted in finding a home at the Institute for Fine Arts, where he was a leader in art history for the next several decades. To Panofsky, it was a source of pride that "Hamburgers in [America] continue to play a role quite different from that which this word would suggest in the minds of an American radio audience."[115] To demonstrate this local pride, Panofsky still donned the "traditional garb of a high Hamburg dignitary" in New York and Princeton. One student suggested that he aimed to call attention to the "courage that is required to preserve the life of the intellect."[116] This "privilege of the ruff," as he called the university professor's white gown, remained principally connected to Hamburg's classical humanism.[117]

New Yorkers seemed to agree. Shortly after the announcement in April 1933 that Jewish professors would be let go from their university positions, the *New York Times* published an article entitled "Hamburg Regrets Anti-Jewish Issue." The reporter observed: "Hamburg is Germany's window toward the outside world. It is Hanseatic, cosmopolitan, patrician and full of old traditions. It has none of Berlin's famed volubility; it is Western European rather than Central European, and it reacts accordingly. . . . Today Hamburg is embarrassed, sheepish and

apologetic." Warburg certainly believed that Hamburg was never Berlin. Cassirer's career depended on this distinction, and Panofsky knew that art history would not have been the same without it. The New York reporter confirmed that many of Hamburg's citizens expressed nothing but "sincere, although helpless, regret," over a fact explained not entirely by the city's exceptional moral stance over Berlin. "For where moral considerations fail to persuade," the reported surmised, "another more substantial argument convinces the sentimentally impervious: the anti-Jewish drive has severely affected Hamburg's pocketbook."[118] In Hamburg, the mercantile "spirit of Banko," which Heinrich Heine insisted long ruled the city, prevailed.

As such, the tolerance that resulted from Hamburg's cosmopolitanism remained wedded to commercialism. Indeed, many of the early refugees who flocked to Hamburg in the sixteenth century received a warm welcome because of their vocational value to the city. The changing political tide at the end of the 1920s revealed the limits of this we'll-do-business-with-anyone tolerance.[119] When conducting business with Jews was no longer an option in 1938, for example, Hamburgers' tolerant spirit burned not as bright. Although it was not altogether noble, it was certainly consistent with the city's urban identity that during the Third Reich, Hamburg's local authorities administered anti-Jewish policy on the basis of economic rather than racial concerns.[120]

Money turned out to be less damaging for culture and ideas than Heine predicted, even promoting a cosmopolitan, humanistic, and unconventional intellectual climate for a substantial period of time. Hamburg's mercantile focus also conferred on this cultural world its defining characteristics of cultural autonomy and cosmopolitanism. Early supporters of the university such as Warburg and its later scholars, such as Cassirer and Panofsky, eagerly tried to reconcile Hamburg's mercantile life with their desire for an intellectual one. Yet it was precisely Hamburg's economic conditions—its philanthropic tradition and its international trade—and its lack of an institutionalized cultural world that enabled the Hamburg School's success.

The hallmarks of the school's collective scholarship were its innovation in methodological approach, its use of multiple disciplines, and a yearning for comprehensive epistemological foundations. The historical significance of Hamburg was its unique ability to provide these scholars with the resources, tools, and support to bring their scholarship to fruition. Like Warburg's library, an institution that offered more than a static collection of books, the city, too, provided more than mere setting. The irony is that the Hamburg School became more, not less,

important in the postwar period when, once the context was removed form the ideas, the meaning of this collaboration between ideas and place was formed. Yet the separation, and the exile, also invited new identifications of ideas and symbols and lives and meaning. As they had at the end of the 1920s, in the emigration period Warburg, Cassirer, and Panofsky became the object of meaning-making in narratives over which they had no control.

Nachleben of an Idea

There is no better way of finding out what a writer meant than to attempt to state his meaning in different words, preferably in another language.

ERNST GOMBRICH

One of the greatest misfortunes that can affect a writer of great intellectual seriousness and strong ethical passions is to have his ideas "naturalized" by the English.

ALLAN JANIK AND STEPHEN TOULMIN

Panofsky, who was once concerned with the "undignified" status of being a refugee, also could not bear the thought of being a "revenant." Dismissing an invitation to speak in Hamburg as a return from the dead, Panofsky worried that "so many of my former friends are absent from the scene and that those few who may still remember me, would find it difficult to adjust their recollection to present re-alities." In the late 1960s, former students already referred to interwar Hamburg as the "Panofsky Era." In a moment of wistfulness, Panofsky mused that it might be better to let well enough alone. "Perhaps it is preferable to remain what Warburg used to call a 'beautiful memory.'"[1] Since he did not have to adapt his ideas to changing cultural, political, and national contexts, Warburg seemed, for at least a moment, to have had it good.

Yet, as soon as he died in October 1929, the struggle began over what Bing called the "Myth of Warburg." The crux of the matter was that Warburg left behind very little written work. Outside his dissertation on Botticelli, War-burg did not publish a single monograph, and his assorted

lectures and essays amounted to scarcely more than 350 pages. Reviewing the *Gesammelte Schriften* (collected writings), which Bing and Saxl hurriedly published in 1932, the Dutch historian Johan Huizinga observed, "despite the elevation of his intellect and the excellence of his work . . . there is something tragic, something not fully developed, about the figure of Aby Warburg."[2]

No doubt the tragedy had an upside. For if his younger colleague Panofsky fully immersed himself in the English language and achieved great fame for his English-language scholarship in the postwar period, he did so only at the expense of the complexity, nuance, and sophistication of his work.[3] On the other hand, while Warburg did not have the opportunity to reconsider his ideas in the period of emigration, the debate that ensued over his reception was equally emblematic of the postwar politics of ideas. The contrast between Warburg's reception and Panofsky's in striking, for despite his great presence in the English-speaking scholarly world, the latter seemed no better poised to ward off (mis)readings of his work.

An investigation of the *Nachleben* (afterlife) of these scholars in the period of emigration sets in relief the issue with which this study began: the dynamic relationship between ideas and their contexts. This final line of inquiry also poses the following lingering questions: How do these scholars' ideas get remade for different purposes over time? Do these ideas retain content separately and apart from the world? And what defines a successful *Nachleben* of an idea? In this coda to the history of the Warburg Library, these scholars and their ideas become the object of their own analysis.

———

Panofsky's legacy is difficult to assess definitively. Revisions to his methodology have shifted focus from the textual sources that were the object of the Hamburg School's analysis to an emphasis on the prediscursive and material relationships to art objects. In another way, Panofsky's influence extends much wider—to the epistemological bases for multiple fields across the humanities in the twentieth century.[4] Without the relevant religious and textual background, the Last Supper, according to Panofsky's iconological approach, would appear as no more than an "excited dinner party."[5] But what was considered legitimate context? In short, providing an answer to this question, as Burckhardt had outlined it a century earlier, constituted the main goal of the cultural historian. In this pursuit, Panofsky himself was known to warn his own students

to "beware the boa constructor," that subtle yet powerful beast that overlooked facts to provide a too-tidy theoretical structure.[6] Notwithstanding the tremendous inroads he made in this area, Panofsky's own attempts to identify context were, in the last decade of his life, already on the defensive for too simply reducing epiphenomena to the world.

The principal critic in this regard was Gombrich, whose distinct perception of iconology developed from the Austrian art historian's adaptation, which took a different route from the German to the English-speaking world. For Gombrich, Panofsky's grand narratives, however impressive, risked amounting to no more than a scholarly house of cards. Despite all of his interest in iconology, the German émigré remained, in the end, a "style" art historian, wholly dependent on a Hegelian concept of history that erroneously connected all strands of cultural output to the same source.[7] Although much of art history, and cultural history for that matter, seemed to fall into this trap, Gombrich insisted—echoing Panofsky's critique of Wölfflin three-quarters of a century earlier—that the Zeitgeist must be explained; it does not explain itself.[8]

Even though Panofsky had acknowledged the "hazards" of precisely the kind of "intrinsic analogy" he made between architecture and philosophy in *Gothic Architecture and Scholasticism*, by 1957 he was already preoccupied with staving off misunderstandings of his work.[9] Panofsky maintained that he avoided that "old specter of an all-determining *Zeitgeist*" and instead aimed to "replace the postulate of the above-mentioned *Zeitgeist* bv an investigation of morphological and psychological principles and of the mechanism by which these principles may have come to create a certain 'habit' in the minds of people living at the same time and in the same environment, though practicing entirely different professions."[10] Panofsky, for his part, believed that whatever analogies he drew between art and society were grounded on actual social and intellectual connections.

That Panofsky and the Hamburg School were the subject of misreadings can be in part attributed to the conflicting schools of the *Nachleben* of Warburg's ideas. Judging from Panofsky's friend and fellow émigré Siegfried Kracauer's own experience with the Warburg Institute in postwar London, these politics were in full force in the early 1960s. "Bing emphatically warned against absorption in iconography as an end in itself. Warburg Inst. should not be identified with this trend (so strongly favored by Panofsky)," Kracauer noted in his diary while visiting the library in the summer of 1962. "Abe [*sic*] Warburg himself thought of iconography only as a means to an end. Bing palpably worried about Gombrich's emphasis on psychology." Kracauer himself was

frustrated that the Warburg Institute seemed to blow him off despite the obvious connections between his work and that of the school's, and he left with the impression that for Bing the only pure approach to cultural history was offered by Warburg. "Bing wants the Warburg Inst. to get away from its naïve concern with the 'History of Ideas.' She is now doing a little piece expressing her doubts about the tacit assumption of the coherence of stylistic periods and sequences of ideas."[11] Her protestations notwithstanding, Gombrich's and Panofsky's competing versions of iconology persisted undeterred.

Kracauer had his own charges of reductivism to fend off—he was, at the time, the object of very similar critiques by Adorno and Benjamin that he relied on simple analogies of art and society in his work—and so was eager for Panofsky's answer to his question: "Do contemporaries themselves need to be aware of the identity of their time period to make it legitimate?" Panofsky assured him that historical periods can indeed have a physiognomy even if they do not claim one, although he continued, "As a matter of fact, so far as I know it was only the Renaissance that developed this queer self-consciousness (*thereby* laying the foundations of all *our* historical efforts)."[12] Still this does not explain Gombrich's animosity toward Panofsky, an animosity that likely had more to do with his own emergence as leader of this new art-historical school. Gombrich proudly reported having received approval from Panofsky of his new work *Art and Illusion*, but privately Panofsky expressed that he (Panofsky) was "too old to participate in this safari into the 'theories of information and communication' and [could] forsee that Gombrich's method, if applied by less competent hands, [might] also have what the doctors call[ed] 'undesirable side effects.'"[13] For Panofsky, the best course was to keep his distance.

Of course, not all scholars were wholly critical: Lucien Febvre of France's Annales School was more inclined to criticize those who isolated ideas from the conditions of social life, and although he may not have been thinking specifically of Panofsky, he argued that "a Gothic cathedral, the market hall of Ypres . . . are daughters of a single epoch." The connection between Panofsky and another Frenchman was even more explicit: Spurred by the translation of *Gothic Architecture and Scholasticism*, for which he also offered a postscript, Bourdieu developed a similar concept of habitus or scholarly persona. Although Bourdieu equivocated on whether Panofsky himself achieved this feat, the French sociologist argued that scholarly reductivism could be avoided if one also passed up "superficial, purely formal and sometimes accidental analogies that one can isolate from the concrete realities in which

they both express themselves and hide the structures among which can be established the comparison that is intended to reveal common properties."[14] As a scholarly mechanism, "habitus" seemed to provide a legitimate link between art and society.

In his countless allusions to the "boa constructor," one gets the feeling that only Gombrich is exempt from this danger, a danger that he tells us "Panofsky courted." Only in a rare genuine moment does Gombrich admit the helpful point that "the true methodological problem . . . is that we cannot ever do without the Boa Constructor. It may present a danger sometimes, indeed often, but it is also an indispensable friend and helpmate . . . perception is a constructive process, not a passive one."[15] Every cultural historian would like to believe she is above these dangers. Yet the thing about the boa "constructor" is that no one is immune to its bite.

This was true even for Warburg, though the bite came after his death, and the culprit, oddly enough, was Gombrich himself. The opening arose from the paucity of Warburg's writings, a tragedy that left his legacy undefined. Bing and Saxl immediately turned their attention to the *Gesammelte Schriften* as a means to bolster the image of Warburg as a "legitimate" scholar with a coherent system of thought. As the director of the Warburg Institute from 1959 to 1976, Gombrich expressed a similar concern; he subsequently smoothed out many of the possible tensions in Warburg's work and "inverted" all sources of discord to represent harmony and balance, a process that, as we have seen, was arguably begun by Panofsky in the 1920s. In Gombrich's portrait of Warburg, nary a hint of the struggle or tormented soul remains.

In the past couple of decades, such scholars as Michael Steinberg have opposed this "fortress rationality" interpretation of Warburg's work, an approach also endorsed by the German-Jewish émigré George Mosse. The problem for many art historians is simply how to access Warburg without Gombrich, whose chief concern was not bad art history but "unreason." According to Steinberg, these refugees with "firsthand experience of European fascism [were] . . . led . . . to abjure negotiation with cultural demons by adopting this strict posture."[16] Today, in contrast, scholars have returned to Warburg's intellectual and personal struggles in order to construct a portrait that emphasizes fragmentation, disenchantment, and the irrational. They present him not as a Freudian figure, resolving the irrational through the means of the rational, but rather, as is argued by the French scholars Didi-Hubermann and Michaud, "toujours nietzschenne." Warburg has subsequently appeared in studies alongside such likeminded bruchstück-esque thinkers

as Benjamin. His art-historical concepts have featured in postmodern studies on psychoanalysis and film and as inspiration for avant-garde notions of cultural memory; his library is presented not as a scholarly tool but rather as a repository for human experience.

A scholar championed by some as a poster child of the Enlightenment and hailed by others as an impassioned Dionysian enthusiast, Warburg has become a symbol of his own intellectual struggle with the "eternal seesaw" of ideas. As Spyros Papapetros rightly observes, however, both positions exclude specific and key details of Warburg's life to make their hedgehoglike point. If Gombrich smoothes over Warburg's illness, the Warburg "French Renaissance" ignores his long-standing study of Kant and the strong model presented by Simmel to unite the two positions. Ultimately, Gombrich and Didi-Hubermann tell us as much, or more, about Viennese logical positivism of the 1950s and French poststructuralism of the 1970s, respectively, than they do about the details of Warburg's own life and work.[17]

This erratic reception is further illuminating because it mirrors the politico-philosophical dialogue of the interwar period in which Warburg was, in his life, embroiled. Indeed, these permutations of lives as symbols for political ends would not have been a shock to the master of iconology any more than to the philosopher of symbolic forms. In his *Essay on Man*, Cassirer reminds us that the history of ideas is not static but rather a dynamic process of interpretation and reinterpretation, a fact he illustrates with the example of the changing portrait of Plato. Over the course of intellectual history, there has existed, for example, the Plato of neo-Platonism, a Christian Plato, the Plato of Augustine, a rationalistic Plato, the Plato of Moses Mendelssohn, and a Kantian Plato.

To these portraits we might add Cassirer's Plato, not to mention Cassirer's Kant and Cassirer's Rousseau, an ethical portrait that never would have endorsed a totalitarian general will. In this respect, Cassirer's Enlightenment prefigures the works of modern pro-Enlightenment scholars, replete with pet heroes and a clear agenda.[18] Taken as a whole, Cassirer's work also conveys the message that how we, as historians, present thinkers and order ideas deeply matters. Toward the end of his life, he reflected, "The history of philosophy shows us very clearly that the full determination of a concept is very rarely the work of that thinker who first introduced that concept."[19]

Yet, as Cassirer's fateful *The Philosophy of the Enlightenment* also proves, ideas have consequences, but so do contexts—be they national, economic, or social. In the case of Warburg, Cassirer, and Panofsky, a longer trajectory emerges, in which we can see how context can be

both productive and destructive. Against all odds, the German context proved productive for ideas, promoting formulations and collaborations that might otherwise not have occurred. Cassirer's famous depictions of Rousseau and Kant, then, resulted as much from the cultural and political necessity of his historical moment as from the philosopher's intellectual interests. Similarly, the iconology that Warburg and Panofsky developed reflected a contemporary need for a rigorous analytic foundation that remained simultaneously skeptical of imposing an excessively static system of interpretation on dynamic works of art. As context defined the production of these ideas, the same is true for their reception. If Cassirer read Kant through Goethe and then Rousseau through Kant, so are Cassirer and Warburg doomed to be filtered through Gay and Gombrich and whoever else succeeds them.

However, if the previous generation can be charged with clinging too often to an "unreflective, regulative notion of 'rationalism,'" our recent efforts to correct this one-sidedness may have swung too far in the other direction, a turn that, where Weimar is concerned, has the potential to create historical distortion.[20] As the historian Steven Aschheim reminds us: Historians do not love all Weimar thinkers equally. "Why, for instance, do Scholem and Rosenzweig presently attract more respectful attention than, say, Martin Buber? Why is it that Arendt and Strauss are so much more audible than, say Ernst Cassirer? Why, for that matter, do we hear far more today of Adorno and Benjamin than Ernst Bloch and even Herbert Marcuse?" "Ernst Cassirer, though by no means entirely neglected," offers Aschheim, "somehow seems too classically 'liberal,' too conventionally 'bourgeois' to make his way into the current pantheon."[21] For Aschheim this omission further poses the question of the relationship of ideas to politics. "Why do we elevate as icons thinkers that seem so critical of—or at best, indifferent to—liberalism in an intellectual and academic culture that in many ways conceives itself to be essentially a liberal one?"[22] Although Edward Skidelsky extols Cassirer as the "last philosopher of culture" and presents Habermas as carrying on the mantle of liberalism, Hans Sluga's judgment is more typical when he observes, "Attempts to revive [Cassirer's] fortunes are, I am afraid, doomed to failure."[23] In this sense, Heidegger emerged in the second half of the twentieth century as the victor of the 1929 debate.

In a similar vein, today's art historians routinely criticize Panofsky's adherence to strict universal standards of judgment and look instead to revive Warburg's sensitivity to the primal energies of images, an approach more commonly associated with antiliberal Weimar thinkers whose politics were far less progressive than his own. In this way, just as

there has been a turn to Heidegger in philosophy, so too, in art history, there has been a renewed interest in the New Vienna School, which, despite its reactionary politics, promoted an art-historical methodology that was more critical of the transcendental rational subject and more sensitive to the vitality of the moving image. Numerous art historians advocate "reading through" the Nazism of such art historians as Hans Sedlmayr to see what their art-historical concepts might have to offer our epistemologically beleaguered age.[24]

In these politicized dramas, German Jews who supported such programs that are now deemed politically reprehensible are trotted out to make these inquires more palatable.[25] In the case of Warburg, however (and one could say the same about Benjamin and Rosenzweig, who often appear in this company), this reasoning is highly problematic, not the least because, as I have suggested, since Warburg died in 1929 he did not have to revise his ideas in relation to the Second World War, the Holocaust, or the impact of exile.[26] Instead, his reception, as described above, has fallen prey to debates about the legacy of modernism and antimodernism, a victim of precisely the empty symbols and emotional energy that he and his colleagues Cassirer and Panofsky investigated in an earlier time.

The road between metaphysics and politics is doubtless twisted. In the case of the pro-Enlightenment scholars, their heuristic devices risk taking on a life of their own, ignoring the trees that do not fit in the forest, or worse, failing to provide any historical explanation for the origins of ideas.[27] Pretending that these heuristics conform to a higher reality (or any reality at all) risks putting good history in service of a political goal. But equally disingenuous is to act as if ideas existed in a world untouched by politics. Wolin argues that "Heidegger's supporters do him no service by treating his more questionable and portentous insights and claims with reverence rather than subjecting them to the open-minded critical scrutiny that all thought deserves." In this respect, such movements as left-Schmittianism, which seek to insulate ideas from politics, ignore the road altogether—a choice that is ahistorical at best. Rather, it seems wise to insist on historical contextualization as necessary to understand Habermas's relationship to Schmitt in particular and to ideas and politics in general.[28]

This preoccupation with antimodernist and illiberal thinkers—besides being however unsavory—has left us with a lopsided portrait of Weimar culture. In fact, a strange disconnect has emerged between Weimar-as-myth and Weimar-as-historical-reality, as evidenced by the respective trajectories of Warburg and Panofsky. Perpetuated by

the unlikely bedfellows Allan Bloom and Theodor Adorno, the myth suggests that in the 1930s and thereafter, Weimar-era ideas from the violent world of "Mack the Knife" to Heideggerian philosophy made their way into American culture. For the Chicago professor, this "value relativism" was lamentable and reeked of no-good Nazism, whereas for Adorno, American culture's enslavement of the individual was equally as sinister as totalitarianism.[29] Whatever one thinks of his pronouncements of the American academy—Bloom's hypocrisy is itself noteworthy, for he was an admiring student of the German-Jewish "Weimar" thinker Strauss—Bloom's observation is relevant insofar as he demands a heightened awareness to the origins of our ideas. Of course, if he wanted a Weimar antidote to this reckless perspectivism, Bloom need only to have looked as far as the American Panofsky, who, as we have seen, promoted a universalism based on the Renaissance that moved beyond both plurality and relativity. Despite his paranoia, the real Weimar was fast making a different headway into the American academy. And if we believe Adorno, who had his own misgivings about the watering-down of critical theory in America, then the translation of German ideas into the English language was, in large part, to blame.[30]

For the most part, transformations, like those of Adorno's work, were not willful distortions but rather the natural result of changing political, cultural, and geographic contexts for ideas.[31] Nonetheless, an irony remains: while Weimar ideas have, in some form or another, established the basis for countless fields in the humanities in postwar America, we continue to promote a mythical portrait of Weimar culture that emphasizes the antihumanist, irrational, and illiberal. And, according to Aschheim and others, we do so only by knowingly overlooking or neutralizing the political implications of those ideas. In this sense, Weimar does not end with the republic, in 1933, but continues in a different iteration in the American landscape. If nothing else, a better historical understanding is required of how those German ideas were purified, sanitized, and generally blunted in their American incarnation.

The *Nachleben* of Warburg scholarship itself reveals that, aided by the perspective, healing, and maturity (not to mention the possibility for revenge) that come with the passage of time, Weimar ideas continue to branch in many directions. In contemporary Hamburg, which acquired and renovated the Warburg Haus in 1993, a group of art historians led by Dieter Wuttke apply Warburg's methods to analyze the political iconography of the National Socialist period. Exhaustive in its thematic coverage, their "handbook of political iconography" betrays both the promises and the pitfalls of Warburg's *Mnemosyne* atlas proj-

ect. Elsewhere on the continent, Didi-Huberman draws on Warburg's approach as central to explaining not how the great catastrophe could have happened but how we make sense of the images of this terror, not least the now-pervasive images from Auschwitz.[32]

A separate institutional *Nachleben*—that is, London's Warburg Institute—also brings into focus the question of the material conditions of scholarship at a time when the financial situation of the library is in dire straits.[33] The prospect of returning the library to its original home in Hamburg has once again put the relationship between the conditions of scholarly production—issues with which Warburg actively engaged—back on stage. So once again contexts will provide new homes in which ideas and their meanings will crystallize, the full consequences of which cannot yet possibly be known.

Inspired by the turn to "locality" in the German tradition of writing history, the story about the Hamburg School offers a corrective to our portrait of Weimar that is both geographical and intellectual.[34] Doubtless, there exists no consensus on how to interpret these figures any more than there is consensus on the constitutive role played by politics for ideas, nor, least of all, on the perennial issue of the relationship between text and context at large. Eschewing the myths and abstracted symbolism of their lives, a phenomenon that Warburg, Cassirer, and Panofsky desperately resisted, I have instead introduced the texture of intellectual life and scholarly relationships and institutions, all of which together created the powerful preconditions for this particular set of ideas.

For if these scholars shared something, it was an awareness of the challenges posed by understanding ideas in the world from which they emerge, from their "conditions for the possibility of knowledge." And it is their enthusiasm for that project that I have tried to bring to their story—the story of how Hamburg, a mercantile city, became a haven for German-Jewish intellectuals who quietly led one of the most significant intellectual revolutions of the twentieth century. That story—biographical, theoretical, and now here, historiographical—also reminds us of what intellectual history can, and should, be.

Notes

ABBREVIATIONS USED IN THE NOTES

AEA Albert Einstein Archives, Jewish National &
University Library

BRBML Beinecke Rare Book and Manuscript Library,
Yale University

ECK 17 Ernst Cassirer. *Gesammelte Werke*. Vol. 17,
Aufsätze und Kleine Schriften, 1927–1931. Ed-
ited by Birgit Recki. Hamburg: Felix Meiner,
2004.

ECWB Ernst Cassirer. *Ausgewählter wissenschaftlicher
Briefwechsel*. Nachgelassene Manuskripte und
Texte. Vol. 18. Edited by John Michael Krois.
Hamburg: Felix Meiner, 2009.

EPDA Karen Michels and Martin Warnke, eds.
Erwin Panofsky: Deutschsprachige Aufsätze.
2 vols. Studien aus den Warburg-Haus. Ber-
lin: Akademie, 1999.

EPK Erwin Panofsky. *Erwin Panofsky Korrespondenz
1910 bis 1968: Eine kommentierte Auswahl in
fünf Bänden*. 5 vols. Edited by Dieter Wuttke.
Wiesbaden: Harrasowitz, 2001–8.

LBI Leo Baeck Institute, New York

NNL Natorp Nachlass, Universitätsbibliothek
Marburg

StA HH Staatsarchiv Hamburg

SUB Staats- und Universitätsbibliothek Hamburg
Carl von Ossietzky

TKBW Aby Warburg, Gertrud Bing, and Fritz Saxl.
*Tagebuch der Kulturwissenschaftlichen Biblio-
thek Warburg*. Edited by Karen Michels and

Charlotte Schoell-Glass. In *Gesammelte Schriften: Studienausgabe*, edited by Horst Bredekamp, Michael Diers, Kurt W. Forster, Nicholas Mann, Salvatore Settis, and Martin Warnke. Berlin: Akademie, 2001.

UB Heidelberg	Universitätsbibliothek Heidelberg
UAL	Universitätsarchiv Leipzig
UAT	Universitätsarchiv Tübingen
WHH	Warburg-Archiv, Warburg-Haus Hamburg
WIA, FC, GC	Warburg Institute Archive; Family Correspondence; and General Correspondence

PREFACE

1. Peter Burke, *Eyewitnessing: The Use of Images as Historical Evidence* (Ithaca, NY: Cornell University Press, 2011), 34; Erwin Panofsky, *Studies in Iconology: Humanistic Themes in the Art of the Renaissance* (New York: Oxford University Press, 1939), 15.
2. Erwin Panofsky, "The History of Art as a Humanistic Discipline," in *Meaning in the Visual Arts*, by Erwin Panofsky (1955; reprint, Chicago: University of Chicago Press, 1982), 5–6.
3. George Mosse, *German Jews beyond Judaism* (Bloomington: Indiana University Press, 1985).
4. For a discussion of the universal and the particular, see Till van Rahden, *Jews and Other Germans: Society, Religious Diversity, and Urban Politics in Breslau, 1860–1925*, trans. Marcus Brainard (Madison: University of Wisconsin Press, 2008), 4–11. I am indebted to his December 2009 workshop "The Universal and the Particular" for the opportunity to think through these concepts.

INTRODUCTION

1. A. J. P. Taylor, *The Course of German History: A Survey of the Development of German History since 1815* (London: Routledge, 2001), 169; Heinrich Heine, "Aus den Memoiren des Herren von Schnabelewopski: Erstes Buch," in *Historisch-kritische Gesamtausgabe der Werke*, ed. Manfred Windfuhr (Hamburg: Hoffman und Campe, 1994), 5:169. For a description of Hamburg as dull, see, for example, the poem "Himmel grau und wochentäglich" (Gray skies and every weekday, 1831), ibid., 2:30. For a depiction of a materialist and culturally unaware Hamburg banker, see "Die Bäder von Lucca," ibid., 7:94. On Heine's "stylizations" such as that of the "nest," see Bernd Kortländer, "During the Day a Big Accounting Office and at Night a Huge Bordello: Heine and Hamburg," in *Patriotism, Cosmopolitanism, and National Culture: Public Culture in Hamburg, 1700–1933*, ed. Peter Uwe Hohendahl (Amsterdam: Rodopi, 2003), 173.

2. Georg Thilenius, "Die Wissenschaft," *Hamburg in seiner politischen, wirtschaftlichen und kulturellen Bedeutung*, ed. Deutsche Auslandsarbeitsgemeinschaft Hamburg (Hamburg: L. Friederichsen, 1921), 125.

3. Max M. Warburg, *Aus meinen Aufzeichnungen* (New York: Eric M. Warburg, 1952), 68.

4. Literally the "dreamland of the cease-fire period" (*Das Traumland der Waffenstillstandsperiode*). Ernst Troeltsch, *Spektator-Briefe: Aufsätze über die deutsche Revolution und die Weltpolitik 1918–1922*, ed. Hans Baron (Tübingen: F.C.B. Mohr, 1924), 69.

5. The English "full professor" does not quite capture the meaning of *Ordinarius*. In the complex and rigid hierarchy of the German university, the *Ordinarien* were the only professors with any stability, including full benefits and retirement packages. The *Privatdozenten* received no steady salary or benefits but relied on student fees for pay. The *Außerordentlichen* enjoyed some senior status but no real benefits. Charles McClelland, *State, Society, and the University in Germany, 1700–1914* (Cambridge: Cambridge University Press, 1980), 164–181.

6. Panofsky, "History of Art as a Humanistic Discipline," 5. For a useful discussion of this essay, see J. A. Emmens and Gary Schwartz, "Erwin Panofsky as a Humanist," *Simiolus* 2 (1967–68): 109–113.

7. Panofsky, "History of Art as a Humanistic Discipline," 1.

8. Erwin Panofsky, "In Defense of the Ivory Tower," *Centennial Review* (1953): 119.

9. Fritz Saxl, "A Humanist Dreamland," in *A Heritage of Images: A Selection of Lectures*, ed. Fritz Saxl, Hugh Honour, and John Fleming (Harmondsworth: Penguin, 1970), 104.

10. Hans Kurig and Uwe Petersen, *Aby Warburg und das Johanneum Hamburg* (Hamburg: Gesellschaft der Bücherfreunde, 1991), 13; Ernst Gombrich and Fritz Saxl, *Aby Warburg: An Intellectual Biography*, 2nd ed. (Chicago: University of Chicago Press, 1986), 23.

11. Gotthold Ephraim Lessing, *Lessing's Laocoön*, trans. E. C. Beasley (London: George Bell and Sons, 1888), 2. I have adopted the term *meaning-making* from recent literature on material culture. See, for example, David Morgan, introduction to *Key Words in Religion, Media, and Culture* (New York: Routledge, 2008), 3–10. Although Morgan and others use it to point to the flaws in an iconological approach that favors the discursive over experiential meaning, part of my goal is to show how early iconologists like Warburg and Panofsky anticipated many of these more recent critiques.

12. Jacob Burckhardt, *The Civilization of the Renaissance in Italy*, trans. S. G. C. Middlemore (New York: Phaidon, 1995), 261.

13. The publication history of Warburg's disparate works is lengthy and diffuse. In 1932, Gertrud Bing edited Aby Warburg, *Gesammelte Schriften: Die Erneuerung der heidnischen Antike*, vols. 1 and 2 (Leipzig: B.G. Teub-

ner, 1932). In the 1990s a group of art historians (Martin Warnke, Horst Bredekamp, and Michael Diers) connected with Hamburg's Warburg-Haus, the postwar reconstruction of the original Kulturwissenschaftliche Bibliothek Warburg, began a multivolume project to publish Warburg's works; the first volumes were a reprint of the 1932 edition. See Aby Warburg, *Die Erneuerung der heidnischen Antike: Kulturwissenschaftliche Beiträge zur Geschichte der europäischen Renaissance*, vols. 1.1. and 1.2, rev. ed., ed. Horst Bredekamp and Michael Diers, in *Gesammelte Schriften, Studienausgabe*, ed. Horst Bredekamp et al. (Berlin: Akademie, 1998); a subsequent volume has reproduced Warburg's picture atlas project. See Aby Warburg, *Der Bilderatlas: Mnemosyne*, vol. 2.1, 2nd ed., ed. Martin Warnke (Berlin: Akademie, 2003). With this project stalled, a separate group of scholars from the Berliner Zentrum für Literatur- und Kulturforschung have published an excellent and impressively edited volume of Warburg's works that is organized thematically with extensive introductions and linguistic explanations. See Martin Treml, Sigrid Weigel, and Perdita Ladwig, eds., *Aby Warburg: Werke in einem Band* (Berlin: Surhkamp, 2010). Kurt Forster, who worked on the *Studienausgabe*, has produced an English volume of Warburg's main works with nuanced translations by David Britt: Aby Warburg, *The Renewal of Pagan Antiquity: Contributions to the Cultural History of the European Renaissance*, trans. David Britt, with an introduction by Kurt W. Forster (Los Angeles: Getty Research Institute for the History of Art and the Humanities, 1999). For consistency and clarity, longer passages quoted in subsequent text and notes rely on this English-language edition.

14. "The near-total *neglect* that Neo-Kantianism has suffered, then, by no means reflects a clear *overcoming* of their influence in the twentieth century." Rudolf A. Makkreel and Sebastian Luft, introduction to *Neo-Kantianism in Contemporary Philosophy*, ed. Rudolf A. Makkreel and Sebastian Luft (Bloomington: Indiana University Press, 2009), 14. The chapters of this volume aim to show how neo-Kantianism has systematically contributed to a variety of issues of continuing value to philosophy today.

15. Ernst Cassirer, *Kant's Life and Thought*, trans. James Haden (New Haven, CT: Yale University Press, 1981), 101.

16. On the relationship between Jews and neo-Kantianism, see Andrea Poma, "Hermann Cohen: Judaism and Critical Idealism," in *The Cambridge Companion to Modern Jewish Philosophy*, ed. Michael L. Morgan and Peter Eli Gordon (Cambridge: Cambridge University Press, 2007), 80–101.

17. Michael Friedman, *A Parting of the Ways: Carnap, Cassirer, and Heidegger* (Chicago: Open Court, 2000), 29–36.

18. Ibid., 157–158. Natorp's turn to *völkisch* concepts of *Gemeinschaft* reveals that "neo Kantian precepts did not guarantee immunity against chauvinism and xenophobia." Thomas Willey, *Back to Kant: The Revival of Kantianism in German Social and Historical Thought, 1860–1914* (Detroit: Wayne State University Press, 1978), 173.

19. Hans-Georg Gadamer, "Reflections on My Philosophical Journey," in *The Philosophy of Hans-Georg Gadamer*, ed. Lewis Edwin Hahn, The Library of Living Philosophers, vol. 24 (Chicago: Open Court, 1997), 21.

20. Ernst Cassirer, *Das Erkenntnisproblem in der Philosophie und Wissenschaft der neueren Zeit* (1906–57), 4 vols. (Darmstadt: Wissenschaftliche Buchgesellschaft, 1971–74). Volume 4 appeared first in 1950 in an English translation as *The Problem of Knowledge: Philosophy, Science, and History since Hegel*, trans. William H. Woglom and Charles W. Hendel (New Haven, CT: Yale University Press, 1950).

21. Although art historians tend to describe Alois Riegl's approach as one of extreme formalism, I have employed the term *contextualism* here to draw a contrast between Wölfflin's classic formalism, which focused on color, shape, and lines, and an approach that sought explanation outside these issues, be they psychological, spiritual, or ethnic.

22. Christopher S. Wood translated Panofsky's 1924 lecture as Erwin Panofsky, *Perspective as Symbolic Form* (Cambridge, MA: MIT Press, 1991). Citations are to this edition. Jaś Elsner and Katharina Lorenz have recently translated two of Panofsky's theoretical essays for an English-speaking audience: "On the Problem of Describing and Interpreting Works of Visual Arts," *Critical Inquiry* 38 (2012): 467–482; and "On the Relationship of Art History and Art Theory: Towards the Possibility of a Fundamental System of Concepts for a Science of Art," *Critical Inquiry* 35 (2008): 43–71.

23. This is a matter of some regret for Michael Friedman, who seeks to draw on Cassirer to bridge this gap in current philosophy. *Parting of the Ways*, xii.

24. According to Jürgen Habermas, writing in 2001, Cassirer had "not yet found the echo amongst younger thinkers which [he] deserve[d]." *The Liberating Power of Symbols: Philosophical Essays*, trans. Peter Dews (Boston: MIT Press, 2001), vi. For Cassirer's lack of an imprint on intellectual history in the United States, see Robert Darnton, "The Social History of Ideas," in *The Kiss of Lamourette: Reflections in Cultural History* (New York: Norton, 1991), 220–222.

25. For the first camp, see the essays in Jeffrey Andrew Barash, ed., *The Symbolic Construction of Reality: The Legacy of Ernst Cassirer* (Chicago: University of Chicago Press, 2008); and Gregory B. Moynahan, "The Davos Debate, Science, and the Violence of Interpretation: Panofsky, Heidegger, and Cassirer on the Politics of History," in *Exile, Science, and Bildung: The Contested Legacies of German Emigré Intellectuals*, ed. David Kettler and Gerhard Lauer (New York: Palgrave, 2005), 111–124. For the second group, see, for example, Massimo Ferrari, "Is Cassirer a Neo-Kantian Methodologically Speaking?" in Makkreel and Luft, *Neo-Kantianism in Contemporary Philosophy*, 293–314.

26. Two new biographies on Cassirer include Edward Skidelsky, *Ernst Cassirer: The Last Philosopher of Culture* (Princeton, NJ: Princeton University Press, 2008); and Thomas Meyer, *Ernst Cassirer* (Hamburg: Ellert & Richter, 2007). For a book-length explication of the Cassirer-Heidegger debate, see

Peter Eli Gordon, *Continental Divide: Heidegger, Cassirer, Davos* (Cambridge, MA: Harvard University Press, 2010); notably, according to Barash, Heidegger's polemics against Cassirer are to blame for our misunderstanding of symbolic forms. *Symbolic Construction of Reality*, xi.

27. Burke, *Eyewitnessing*, 35.

28. Ibid., 36.

29. See, for example, Sylvia Ferretti's *Cassirer, Panofsky, and Warburg: Symbol, Art, and History*, trans. Richard Pierce (New Haven, CT: Yale University Press, 1989); and Carl Landauer's "The Survival of Antiquity: The German Years of the Warburg Institute" (PhD diss., Yale University, 1984), both of which make an invaluable contribution to the interconnections in the thought of these scholars. Landauer's subsequent essay "Erwin Panofsky and the Renascence of the Renaissance," *Renaissance Quarterly* 47 (1994): 255–281, is more similar to this author's methodological approach than was his unpublished dissertation.

30. Felix Gilbert, "From Art History to History of Civilization: Gombrich Biography of Aby Warburg," *Journal of Modern History* 44 (1972): 381; Gombrich, "Aby Warburg: His Aims and Methods: An Anniversary Lecture," *Journal of the Warburg and Courtauld Institutes* 62 (1999): 268. Scholarship on Warburg has largely been written by second-generation "Warburg scholars," many of whom were students in Hamburg before emigrating to Great Britain in the early 1930s. For a thorough review of the history of scholarship on Warburg in recent years, see Michael Diers, "Warburg and the Warburgian Tradition of Cultural History," *New German Critique* 65 (1995): 59–73. Raymond Klibansky and Patrick Conley, "Die Grenzen des akademischen Lebens sprengen: Ein Gespräch über Ernst Cassirer und die Bibliothek Warburg," *Merkur* 50, no. 3 (March 1996): 276.

31. Warburg, *Aus meinen Aufzeichnungen*, 21; Eric Hobsbawm, *The Age of Extremes: A History of the World, 1914–1991* (New York: Vintage Books, 1994), 98.

32. Thomas W. Kniesche and Stephen Brockmann, *Dancing on the Volcano: Essays on the Culture of the Weimar Republic* (Columbia, SC: Camden House, 1994).

33. Steven E. Aschheim, *Beyond the Border: The German Jewish Legacy Abroad* (Princeton, NJ: Princeton University Press, 2007), 93. Of course there is a lively debate on the relationship of the Frankfurt School to Heideggerian thought. For an alterative view see Anson Rabinbach, "'Letter on Humanism' as Text and Event," in *In the Shadow of Catastrophe: German Intellectuals between Apocalypse and Enlightenment* (Berkeley: University of California Press, 2001), 97–128.

34. Peter Gay, *Weimar Culture: The Outsider as Insider* (Westport, CT: Greenwood Press, 1981), 33–34.

35. Carl Schorske, "Survivor of a Lost World," Review of *A European Past: Memoirs, 1905–1945*, by Felix Gilbert, *New York Review of Books* 35, no. 17 (November 10, 1988): 4, online edition, www.nybooks.com/articles/

archives/1988/nov/10/survivor-of-a-lost-world/?pagination=false (accessed February 23, 2013).

36. Percy Ernst Schramm, *Hamburg: Ein Sonderfall in der Geschichte Deutschland* (Hamburg: Christians, 1964); James J. Sheehan, "What Is German History? Reflections on the Role of the Nation in German History and Historiography?" *Journal of Modern History* 53 (1981): 1–23; Celia Applegate, *A Nation of Provincials: The German Idea of Heimat* (Berkeley: University of California Press, 1990).

37. The full extent of this debate cannot be discussed here. For a summary of his position in English, see Hans-Ulrich Wehler, *The German Empire, 1871–1918*, trans. Kim Traynor (Dover, NH: Berg, 1985); and for the most forceful and famous critique of this position, see David Blackbourn and Geoff Eley, *The Peculiarities of German History: Bourgeois Society and Politics in Nineteenth-Century Germany* (New York: Oxford University Press, 1984).

38. Jennifer Jenkins, *Provincial Modernity: Local Culture and Liberal Politics in Fin-de-Siècle Hamburg* (Ithaca, NY: Cornell University Press, 2003); Carolyn Helen Kay, *Art and the German Bourgeoisie: Alfred Lichtwark and Modern Painting in Hamburg, 1886–1914* (Toronto: University of Toronto Press, 2002); Mark A. Russell, *Between Tradition and Modernity: Aby Warburg and the Public Purposes of Art in Hamburg, 1896–1918* (New York: Berghahn Books, 2007), 7.

39. Peter Jelavich, *Munich and Theatrical Modernism: Politics, Playwriting, and Performance, 1890–1914* (Cambridge, MA: Harvard University Press, 1985); Kevin Repp, *Reformers, Critics, and the Paths of German Modernity: Anti-Politics and the Search for Alternatives, 1890–1914* (Cambridge, MA: Harvard University Press, 2000).

40. Eric D. Weitz, *Weimar Germany: Promise and Tragedy* (Princeton, NJ: Princeton University Press, 2007), esp. 41.

41. Berlin's preeminence, unlike London's and Paris's, did not survive World War I. Jay M. Winter and Jean-Louis Robert, eds., *Capital Cities at War: Paris, London, Berlin, 1914–1919*, 2 vols. (Cambridge: Cambridge University Press, 2007), 2:478–479.

42. Heine, "Aus den Memoiren," 153. For an overview of Heine's time in Hamburg, see Joseph A. Kruse, *Heines Hamburgerzeit* (Hamburg: Hoffmann und Campe, 1972). Willi Bredel, *Unter Türmen und Masten: Geschichte einer Stadt in Geschichten* (Schwerin: Petermänken-Verlag, 1960), 16.

43. The anti-Semite Wilhelm Marr's provocation that Hamburg should be annexed by Prussia—also for economic reasons—was, however, too much for most Hamburgers. Moshe Zimmerman, *Wilhelm Marr: The Patriarch of Anti-Semitism* (Oxford: Oxford University Press, 1986), 63–64. Mary Lindemann, *Liaisons Dangereuses: Sex, Law, and Diplomacy in the Age of Frederick the Great* (Baltimore: Johns Hopkins University Press, 2006), 26–28, 46.

44. According to Rhiman A. Rotz, "The decline of the Hanseatic League remains to some extent an unsolved historical problem, but most modern authors at least agree that it must be seen as a gradual process with roots stretching back some 250 to 300 years before the last Hanseatic diet of

1669." "The Lubeck Uprising of 1408 and the Decline of the Hanseatic League," *Proceedings of the American Philosophical Society* 121 (1997): 1–45, quotation on 2. On Hamburg's medieval status as a Free Hanseatic City as the source of its particularism in the nineteenth and early twentieth centuries, see Maiken Umbach, "A Tale of Second Cities: Autonomy, Culture, and the Law in Hamburg and Barcelona in the Late Nineteenth Century," *American Historical Review* 10 (2005): 666. On the development of Hamburg's economy, see the following: Niall Ferguson, *Paper and Iron: Hamburg Business and German Politics in the Era of Inflation, 1827–1927* (New York: Penguin Books, 2005); Werner Jochmann, "Handelmetropole des Deutschen Reiches," in *Hamburg: Geschichte der Stadt und ihrer Bewohner: Vom Kaiserreich bis zur Gegenwart*, ed. Werner Jochmann and Hans-Dieter Loose (Hamburg: Hoffmann und Campe, 1986), esp. 2:15–35; and Eckart Kleßmann, *Geschichte der Stadt Hamburg* (Hamburg: Hoffmann und Campe, 1981), esp. 100–110, 447–454.

45. Maiken Umbach argues that the inherently contentious relationship between city and nation-state, center and periphery, is particularly detectable—here, in architectural choices—in the case of "second cities." "Tale of Second Cities," 662–666, quotation on 666.

46. Thomas Mann, *Buddenbrooks: The Decline of a Family*, trans. John E. Woods (New York: Knopf, 1993). For more on Mann's conflicting representations of Hanseatic culture, see Hans Rudolf Vaget, "The Discreet Charm of the Hanseatic Bourgeoisie: Geography, History, and Psychology in Thomas Mann's Representation of Hamburg," in Hohendahl, *Patriotism, Cosmopolitanism, and National Culture*, 193–205.

47. Mann's reference to the "international Nationalism" of Lübeck in 1926 seems more like wishful thinking. "Lübeck als geistige Lebensform," in Mann's *Gesammelte Werke in dreizehn Bänden*, vol. 11, *Reden und Aufsätze* (Frankfurt am Main: Fischer, 1974), 384. Bremen, too, desperately tried in the late nineteenth century to dredge its way to international importance by controlling the Weser River, but was unable to manage the social and political challenges of urban growth. See Dieter K. Buse, "Encountering and Overcoming Small-City Problems," *Journal of Urban History* (2008): 39–52. Thanks to James J. Connolly for this citation.

48. Peter Gay, *The Enlightenment: An Interpretation*, vol. 2, *The Science of Freedom* (New York: Knopf, 1969), 47.

49. Siegfried Lenz, *Leute von Hamburg* (Hamburg: Hoffmann und Campe, 1968), 5.

50. Of the broadening of the literary space for the bourgeois public, Herbert Rowland observed, "History no doubt favored Hamburg for this task." "The Journal *Der Patriot* and the Constitution of a Bourgeois Literary Public Sphere," in Hohendahl, *Patriotism, Cosmopolitanism, and National Culture*, 56–69, citation and circulation numbers on 68.

51. Franklin Kopitzsch, *Grundzuge einer Sozialgeschichte der Aufklarung in Ham-

burg und Altona (Hamburg: Christians, 1982), 135–137, quotation on 135. Thanks to Jerry Seigel for this citation.

52. Heine, "Aus den Memoiren," 154. A library union catalog search for the year 1831 yields at least four publishing houses active in Hamburg. See also Jeffrey L. Sammons, "Thinking Clearly about the Marriage of Heinrich Heine and His Publisher, Julius Campe," in *Publishing Culture and the 'Reading Nation': German Book History in the Long Nineteenth Century*, ed. Lynne Tatlock (Rochester, NY: Camden House, 2010), 213–229, esp. 214–219.

53. Andrew Francis Bell, "Anglophilia: The Hamburg Bourgeoisie and the Importation of English Middle Class Culture in the Wilhelmine Era" (PhD diss., Brown University, 2001), 8. Angela Bottin and Rainer Nicolaysen, eds., *Enge Zeit: Spuren Vertriebener und Verfolger der Hamburger Universität* (Hamburg: Universität Hamburg, 1991), 38. For Vagts's own account of the Warburg bank in German history, see "M.M. Warburg & Co.: Ein Bankhaus in der deutschen Weltpolitik, 1905–1933," *Vierteljahrsschrift für Sozial- und Wirtschaftsgeschichte* 45 (1958): 289–398. Saxl, "The History of Warburg's Library," in Gombrich and Saxl, *Aby Warburg*, 326.

54. This connection and the fascination with Jewish merchants was sustained under the Nazis and lasted to the postwar period. One scholarly case of "exceptional" continuity is Hermann Kellenbenz's *Sephardim an der Unteren Elbe: Ihre wirtschaftliche und politische Bedeutung vom Ende des 16. bis zum Beginn des 18. Jahrhunderts* (Wiesbaden: Franz Steiner, 1958), the research for which was begun with a fellowship in 1938 from the Reich Institute to study "Finance Jewry in Hamburg." See Alan E. Steinweis, *Studying the Jew: Scholarly Antisemitism in Nazi Germany* (Cambridge, MA: Harvard, 2006), 159. Thanks to Noah Strote for bringing this phenomenon to my attention.

55. Hamburg's complementary relationship between localism and cosmopolitanism echoes recent scholarship in German anthropology and colonialism. Blackbourn and Retallack, introduction to *Localism, Landscape*, 17. See also Deborah Neill and Lisa M. Todd, "Local History as Total History," *German History* 20 (2002): 373–378.

56. In this respect, not Berlin, but Vienna is the more appropriate counterpoint to Hamburg; in Vienna assimilated Jews like the philosopher Karl Popper imagined a cosmopolitan Habsburg Empire based on a multinational and not an ethno-national identity. Malachi Haim Hacohen, "Dilemmas of Cosmopolitanism: Karl Popper, Jewish Identity, and 'Central European Culture,'" *Journal of Modern History* 71 (1999): 105–149.

57. I have adapted this term from Thomas Mann's less favorable description of Dostoevsky's "cosmopolitan radicalism." Ulrich Beck has also recently used the term, albeit positively, in *The Cosmopolitan Vision* (Malden, MA: Polity, 2006), 49.

58. The phrase is adapted from Pierre Bourdieu's the "social conditions of possibility of scientific knowledge." *The Field of Cultural Production: Essays*

on *Art and Literature*, ed. Randal Johnson (New York: Columbia University Press, 1993), 4.

59. Gerald D. Feldman, "Weimar from Inflation to Depression: Experiment or Gamble?" in *Die Nachwirkungen der Inflation in der deutschen Geschichte 1924–1933*, ed. Gerald D. Feldman (Munich: Oldenbourg: 1985), 385.

60. Frankfurt's independence, unlike Hamburg's, was dissolved in 1806. For more on the comparisons between Hamburg and Frankfurt, see Helmut Böhme, *Frankfurt und Hamburg: des Deutschen Reiches Silber- und Goldloch und die allerenglischste Stadt des Kontinents* (Frankfurt am Main: Europäische Verlagsanstalt, 1968).

61. Sammons's description of Heine is apt here: "With his skill in image management he managed to create, especially for posterity, the persona of a downtrodden, chronically impoverished poet, struggling to maintain himself against a rapacious publisher." "Thinking Clearly about the Marriage of Heinrich Heine and His Publisher," 219.

62. Stefan Collini calls this tension the "paradoxes of denial." *Absent Minds: Intellectuals in Britain* (Oxford: Oxford University Press, 2006), 1–12.

63. Erwin Panofsky to Kurt Badt, July 24, 1922, in *EPK*, 1:117.

64. The concept is Burckhardt's: "This is where I stand on the shore of the world—stretching out my arms towards the *fons et origio* of all things, and that is why history to me is sheer poetry." Letter to Karl Fresenius in 1842, excerpted and translated in *The Letters of Jacob Burckhardt*, ed. and trans. Alexander Dru (New York: Pantheon, 1955), 51. Michael Ann Holly also cites and discusses this quotation in the context of her discussion of the paradox of history writing. *Melancholy Art* (Princeton, NJ: Princeton University Press, 2013), 96.

65. Erwin Panofsky, "Reflections on Historical Time," trans. Johanna Bauman, *Critical Inquiry* 30 (2004): 698; and "Zum Problem der historiscen Zeit" initially appeared as an epilogue to "Über die vier Meister von Reims," and both were republished in *EPDA*, 2:100–140.

66. Ernst Cassirer, *The Individual and the Cosmos in Renaissance Philosophy*, trans. Mario Domandi (Chicago: University of Chicago Press, 1963), 47.

67. The first argument is made by David Lipton in *Ernst Cassirer: The Dilemma of a Liberal Intellectual in Germany, 1914–1933* (Toronto: University of Toronto Press, 1976).

68. Peter Gay, *Freud, Jews, and Other Germans: Masters and Victims in Modernist Culture* (Oxford: Oxford University Press, 1978), 34; Wolfgang Schivelbusch, *Intellektuellendämmerung: Zur Lage der Frankfurter Intelligenz in den zwanziger Jahren: Die Universität, das Freie Jüdische Lehrhaus, die Frankfurter Zeitung, Radio Frankfurt, der Goethe-Preis und Sigmund Freud, das Institut für Sozialforschung* (Frankfurt: Insel, 1982); and Martin Jay, "Urban Flights," in *The University and the City: From Medieval Origins to the Present*, ed. Thomas Bender (New York: Oxford University Press, 1988), 231–248.

69. For such a critique, see Hubert Dreyfus and Paul Rabinow, "Can There Be a Science of Existential Structure and Social Meaning?" in *Bourdieu:*

A Critical Reader, ed. Richard Shusterman (Oxford: Blackwell, 1999), 84–93.

70. See, for example, Steven E. Aschheim, *In Times of Crisis: Essays on European Culture, Germans, and Jews* (Madison: University of Wisconsin Press, 2001); Fritz Stern, *The Politics of Cultural Despair: A Study in the Rise of German Ideology,* 2nd ed. (Berkeley: University of California Press, 1974); and Richard Wolin, *The Politics of Being: The Political Thought of Martin Heidegger* (New York: Columbia University Press, 1992).

71. A growing body of literature explores the way ideas are "translated" from the interwar period to various postwar contexts with drastically different consequences. See, for example, Lawrence A. Scaff, *Max Weber in America* (Princeton, NJ: Princeton University Press, 2011); Jennifer Ratner Rosenhagen, *American Nietzsche: A History of an Icon and His Ideas* (Chicago: University of Chicago Press, 2011); and Martin Woessner, *Heidegger in America* (Cambridge: Cambridge University Press, 2010).

72. Michael Ann Holly, *Panofsky and the Foundations of Art History* (Ithaca, NY: Cornell University Press, 1984); Ferretti, *Cassirer, Panofsky, and Warburg*; Keith Moxey, *The Practice of Persuasion: Paradox and Power in Art History* (Ithaca, NY: Cornell University Press, 2001), 90–102; and Karen Lang, *Chaos and Cosmos: On the Image in Aesthetics and Art History* (Ithaca, NY: Cornell University Press, 2006).

73. Ernst Gombrich, *Symbolic Images*, 3rd ed. (Chicago: University of Chicago Press, 1985), cited in Burke, *Eyewitnessing*, 36.

74. In an attempt to deal with this confusion, Panofsky explained that "iconology" meant the "intrinsic meaning" of a work of art and represented the culmination of several methodologies including formalism and "iconography," or mere description. He also presented a complex synoptical chart to represent this new methodological system. *Studies in Iconology*, 14–15; Udo Kultermann, *The History of Art History* (New York: Abaris Books, 1993), 19–20.

75. See, for example, Sol Cohen, "An Innocent Eye: The 'Pictorial Turn,' Film Studies, and History," *History of Education Quarterly* 43 (2003): 250–261.

76. Louis Rose, *The Survival of Images: Art Historians, Psychoanalysts, and the Ancients* (Detroit: Wayne State Press, 2001). It is telling that the first book to be written about Warburg in French (only in the past decade, no less) was written not by an art historian, as the scholar himself notes, but by a film critic. Philippe-Alain Michaud, *Aby Warburg and the Image in Motion*, trans. Sophie Hawkes (New York: Zone Books, 2004), 9.

77. While citations of Warburg have risen between 1930 and 2000, there has been a "precipitous decline in citations of Panofsky and Gombrich." See the graph in James Elkins, *Is Art History Global?* (New York: Routledge, 2007), vi; On the importance of Warburg for the new subfield of visual studies, see Thomas Crow, "The Practice of Art History in America," *Daedalus* 135 (2006): 89.

78. Treml, Weigel, and Ladwig, *Aby Warburg*, 25.

79. Keith Moxey urges art historians to recognize that Panofsky's interpreta-
 tion was written from the perspective of his social, cultural, and political
 perspective and calls for a more extensive examination of precisely these
 historical factors. *The Practice of Theory, Poststructuralism, Cultural Politics,
 and Art History* (Ithaca, NY: Cornell University Press, 1994), 66.
80. Burke, *Eyewitnessing*, 184. Bourdieu's concept of the "objectivity of the
 subjective" further bridges internalist and externalist explanations. *Field
 of Cultural Production*, 4. Lionel Gossman, *Towards a Rational Historiography*
 (Philadelphia: American Philosophical Society, 1983); *Basel in the Age of
 Burckhardt: A Study in Unseasonable Ideas* (Chicago: University of Chicago
 Press, 2000); Lorraine Daston and Peter Galison, *Objectivity* (Cambridge,
 MA: Zone Books, 2007).
81. Needless to say, the emphasis on contexts doesn't resolve questions of
 meaning so much as pose the question Whose meaning and for whom?
 The Warburg scholars, and Panofsky in particular, were later criticized
 for ignoring the social context of peasants for the higher class. See, for
 example, Jonathan Alexander, "*Labeur* and *Paresse*: Ideological Represen-
 tations of Medieval Peasant Labor," *Art Bulletin* 72 (1990): 436–452, esp.
 438–439.
82. See, for example, Fritz Ringer's studies of scholarly practices, *Toward a
 Social History of Knowledge* (New York: Berghahn, 2000); Peter Becker and
 William Clark's works on the "conditions of knowledge production": *Little
 Tools of Knowledge: Historical Essays on Academic and Bureaucratic Practice*
 (Ann Arbor: University of Michigan Press, 2011); and Clark, *Academic
 Charisma and the Origins of the Research University* (Chicago: University of
 Chicago Press, 2006), and the growing field devoted to the history of the
 book, promoted by Anthony Grafton, who incidentally has identified the
 Warburg Library as an excellent place for such a contextualized intellec-
 tual history, in *The Footnote: A Curious History* (Cambridge, MA: Harvard
 University Press, 1999), 234.
83. Ringer, "The Intellectual Field, Intellectual History, and the Sociology of
 Knowledge," in Ringer, *Toward a Social History of Knowledge*, 21; Pierre Bour-
 dieu's postface to Erwin Panofsky, *Architecture gothique et pensée scolastique*,
 trans. Pierre Bourdieu (Paris: Minuit, 1967), 133–167. For a definition of
 habitus, see Pierre Bourdieu, *The Logic of Practice*, trans. Richard Nice (Stan-
 ford, CA: Stanford University Press, 1990), 29; and Bourdieu, "The Genesis
 of the Concepts of Habitus and of Field," *Sociocriticism* 1 (1985): 11–24; for
 Bourdieu's influence on intellectual biography, see Volker R. Berghahn and
 Simone Lässig, eds., *Biography between Structure and Agency: Central Euro-
 pean Lives in International Historiography* (New York: Berghahn, 2008), 6–7.
84. Bourdieu follows the same logic of his subject matter when talking about
 his own scholarship. Preface to *In Other Words: Essays Towards a Reflexive
 Sociology*, trans. Matthew Adamson (Stanford, CA: Stanford University
 Press, 1990), ix.

85. Although he does not exclude the family altogether, Bourdieu's interest is limited to class and status issues. See, for example, *The Inheritors: French Students and Their Relation to Culture*, by Bourdieu and Jean-Claude Passerson, trans. Richard Nice (Chicago: University of Chicago Press, 1979; published in French, 1964). Gadi Algazi, who takes Bourdieu into the context of the family, is a powerful exception. "Scholars in Households: Refiguring the Learned Habitus, 1480–1550," *Science in Context* 16 (2003): 9–42.

86. John Randolf, *The House in the Garden: The Bakunin Family and the Romance of Russian Idealism* (Ithaca, NY: Cornell University Press, 2007); and Deborah R. Coen, *Vienna in the Age of Uncertainty: Science, Liberalism, and Private Life* (Chicago: University of Chicago Press, 2007). See also Emily J. Levine, "PanDora, or Erwin and Dora Panofsky and the Private History of Ideas," *Journal of Modern History* 83 (2011): 753–757.

87. Siegfried Kracauer, *Jacques Offenbach and the Paris of His Time,* trans. Gwenda David and Eric Moshbacher (New York: Zone Books, 2002), 23.

CHAPTER ONE

1. "Aby Warburg's Kindheit," undated, III.1.5, WIA. This anecdote also later appeared in a memorial volume and in Max Warburg's privately published memoir, "Rede, gehalten bei der Gedächtnis-Feier für Professor Warburg am 5. Dezember 1929," in *Mnemosyne: Beiträge zum 50. Todestag von Aby M. Warburg*, ed. Stephan Füssel (Göttingen: Gratia, 1979), 26, and in his *Aus meinen Aufzeichnungen*, 6.

2. Treml, Weigel, and Ladwig, introduction to *Aby Warburg*, 11.

3. Peter Fischer-Appelt, "Wissenschaft in der Kaufmannsrepublik: Utopische Grundlagen, reale Entwicklungen, ideale Ausdrucksformen," in *Universität im Herzen der Stadt: Eine Festschrift für Dr. Hannelore und Prof. Dr. Helmut Greve*, ed. Jürgen Lüthje (Hamburg: Universität Hamburg, 2002), 80.

4. See Aby Warburg's record of his contributions to Hamburg, in Michael Diers, "Der Gelehrte, der unter die Kaufleute fiel: Ein Streiflicht auf Warburg und Hamburg," in *Aby Warburg: Akten des internationalen Symposions Hamburg 1990*, ed. Horst Bredekamp, Michael Diers, and Charlotte Schoell-Glass, Schriften des Warburg-Archivs im Kunstgeschichtlichen Seminar der Universität Hamburg (Weinheim: VCH/Acta Humaniora, 1991), 45–53.

5. Jenkins describes a similar set of conditions for Hamburg's museum world, and, as we will see, this provided a model for Warburg. *Provincial Modernity*, 41–42.

6. The term is Richard Evans's, although I depart from Evans insofar as he sees women as having played only a subservient role in this paradigm. Here I defer instead to more recent literature on the role of gender in these familial processes, reflected in notes 60 and 62. Richard J. Evans, "Family and Class in the Hamburg Grand Bourgeoisie, 1815–1914," in *The German*

Bourgeoisie: Essays on the Social History of the German Middle Class from the Late Eighteenth to the Early Twentieth Century, ed. David Blackbourn and Richard J. Evans (London: Routledge, 1991), 115–139.

7. The Talmud Torah School followed the general development of Jewish education described by Marion Kaplan: progressive incorporation of secular subjects and civic education. *Jewish Daily Life in Germany, 1618–1945* (New York: Oxford University Press, 2005), 121–126. The school earned international recognition when the illustrious rabbi Dr. Joseph Carlebach took charge of it in the 1920s. It is still in existence today as the Talmud Tora Realschule at No. 30 Grindelhof.

8. Warburg explains his intellectual progression in various places, including a curriculum vitae that he crafted in the last year of his life; it is notable for addressing explicitly his relationship to Judaism. The document has recently been published as "Vom Arsenal zum Laboratorium," in Treml, Weigel, and Ladwig, *Aby Warburg*, 683. The translation is from Warburg, "From the Arsenal to the Laboratory," trans. Christopher D. Johnson and annotated by Claudia Wedepohl, *West 86th* 19 (2012): 113.

9. Evans, "Family and Class," 127–128, 120–123.

10. The other side of the family was known as the Alsterufer Warburgs. For a short academic overview, see Frank Bajohr, "Die Warburg Familie," in *Das Jüdische Hamburg: Ein historisches Nachschlagewerk*, ed. Institut für die Geschichte der deutschen Juden (Hamburg: Wallstein, 2006), 270–272. For a popular family history, see Ron Chernow, *The Warburgs: The Twentieth-Century Odyssey of a Remarkable Jewish Family* (New York: Random House, 1994); for a personal and nonacademic history of the bank, see E. Rosenbaum and A. J. Sherman, *M.M. Warburg and Co., 1798–1938: Merchant Bankers of Hamburg* (New York: Holmes and Meier, 1979).

11. Kurig and Petersen, *Aby Warburg und das Johanneum Hamburg*, 22; "Aby Warburg Anecdotes," III.134.1.6, WIA.

12. Warburg, *Aus meinen Aufzeichnungen*, 6, 10.

13. Ferguson, *Paper and Iron*, 58.

14. Michels, *Aby Warburg im Bannkreis der Ideen* (Munich: C.H. Beck, 2007), 33.

15. McClelland, *State, Society, and the University*, 146.

16. Bernd Roeck, *Der Junge Aby Warburg* (Munich: C.H. Beck, 1997), 8.

17. Warburg, "Vom Arsenal zum Laboratorium," 683–684, translation from Warburg, "From the Arsenal," 113.

18. Cited and translated in A. M. Meyer, "Aby Warburg in His Early Correspondence," *American Scholar* 57 (1998): 447. For the excerpted Bonn letter of January 26, 1887, revealing Aby Warburg's decision not to keep kosher, see Charlotte Schoell-Glass, *Aby Warburg und der Antisemitismus: Kulturwissenschaft als Geistespolitik* (Frankfurt am Main: Fischer Taschenbuch, 1998), 253; published in English as *Aby Warburg and Anti-Semitism: Political Perspectives on Images and Culture*, trans. Samuel Pakucs Willcocks

(Detroit: Wayne State University Press, 2008). Subsequent citations are to the German edition.

19. Cited and translated in Meyer, "Warburg in His Early Correspondence," 452.

20. Warburg, "From the Arsenal," 113.

21. Schoell-Glass, *Warburg und die Antisemitismus*, 255.

22. Gombrich and Saxl, *Aby Warburg*, 45; on the volatility of the Alsatian market, see Pierre des Essars, Arthur Raffalovich, and Byron Edmund Walker, *The Banks of Alsace-Lorraine after the Annexation*, ed. Journal of Commerce and Commercial Bulletin. Part X of *A History of Banking in All the Leading Nations*, vol. 3 (New York: Journal of Commerce and Commercial Bulletin, 1896), http://oll.libertyfund.org/title/2239/212186 (accessed February 19, 2013).

23. "Aby Warburg Anecdotes," III.134.1.6, WIA.

24. Aby Warburg, *Hamburgische Kunstgespräche*, no. 628, December 31, 1896, WHH.

25. Russell, *Between Tradition and Modernity*, 56–86.

26. Warburg, *Hamburgische Kunstgespräche*.

27. Evans, "Family and Class," 115.

28. As Evans observes, Bremen and Lübeck possessed the former but lacked the latter, for example, and Frankfurt and Leipzig had the latter but lacked the former. Ibid., 118.

29. Gay, *Enlightenment*, 2:47–48; Gay is cited by Jenkins, who takes up this debate about to what extent Hamburg really was more liberal than the rest of Germany with a nuanced discussion of citizenship in this period. *Provincial Modernity*, 17–19, 34–37, quotation on 18.

30. Here I follow Evans in using "the family as a kind of prism through which facets of the broader history of the German bourgeoisie are refracted," "Family and Class," 118.

31. Germans began compulsory education between 1816 and 1870, although most Jews tried to open their own schools rather than attend Christian ones. That "most Christian parents took their children out of school when Jews began to attend around 1800" in Trier was the more common reaction. Kaplan, *Jewish Daily Life in Germany*, 121, quotation on 123. On Jacob Bernays, see Arnaldo Momigliano, "Jacob Bernays," in *Essays on Ancient and Modern Judaism*, ed. Silvia Berti, trans. Maura Masella-Gayley (Chicago: University of Chicago Press, 1994), 148–170, esp. 154.

32. Helga Krohn, *Die Juden in Hamburg: Die politische, soziale, und kulturelle Entwicklung einer jüdischen Grossstadtgemeinde nach der Emanzipation 1848–1918*, Hamburger Beiträge zur Geschichte der deutschen Juden 4 (Hamburg: Christians, 1974), 71.

33. Michels, *Warburg im Bannkreis*, 25; Gombrich and Saxl, *Aby Warburg*, 7. On the expression of Jewish self-hatred and its connection to physicality see Sander L. Gilman, *Jewish Self-Hatred: Anti-Semitism and the Hidden Language of the Jews* (Baltimore: Johns Hopkins University Press, 1990).

34. Lamar Cecil, *Albert Ballin: Business and Politics in Imperial Germany, 1888–1918* (Princeton, NJ: Princeton University Press, 1967), 37.
35. "Aby Warburg Anecdotes," III.134.1.6, WIA. Indeed, unconverted Jews did not become senators until after the revolution of 1918. Leo Lippmann, *Mein Leben und meine amtliche Tätigkeit: Erinnerungen und ein Beitrag zur Finanzgeschichte Hamburgs* (Hamburg: Christians, 1964), 103.
36. Hans Liebeschütz, "Aby Warburg (1866–1929) as Interpreter of Civilization," *Leo Baeck Institute Year Book* 10 (1971): 225 (my emphasis).
37. According to Hamburger Julius von Eckardt's memoir, there was little anti-Semitism in Hamburg among the upper class and many prominent Jews held government and city positions. Yet Eckardt cautions that "the old Hamburg families ostracized the Jewish element as far as social life was concerned." Cited in Richard J. Evans, *Death in Hamburg: Society and Politics in the Cholera Years, 1830–1910* (London: Penguin Books, 1987), 393.
38. Mary's grandfather was Jacob Hertz, born a Jew and the son of a stockbroker, who became a successful entrepreneur and ship owner. Liebeschütz, "Aby Warburg," 227.
39. The New Israelite Temple Association, "Constitution of the Hamburg Temple" (December 11, 1817), in *The Rise of Reform Judaism: A Sourcebook of Its European Origins*, vol. 1, ed. W. Gunther Plaut (New York: World Union for Progressive Judaism, 1963), 31.
40. According to Manfred R. Lehmann, whose parents sat across from the Warburgs at synagogue. "The Warburgs," www.manfredlehmann.com/news/news_detail.cgi/52/0 (accessed July 24, 2012).
41. Liebeschütz, "Aby Warburg," 226.
42. Fritz Schumacher, "Aby Warburg und seine Bibliothek," in *Mnemosyne: Beiträge zum 50. Todestag von Aby M. Warburg*, ed. Stephan Füssel (Göttingen: Gratia, 1979), 42–46.
43. Gustav Schiefler was a Hamburg magistrate, art collector, and patron, who also campaigned for the university from the end of the nineteenth century through the first third of the twentieth century. Hans Wilhelm Eckardt, "Kritik und Engagement: Gustav Schiefler im öffentlichen Lebens Hamburg," in *Gustav Schiefler: Der schriftliche Nachlaß*, ed. Staats- und Universitätsbibliothek Hamburg Carl von Ossietzky (Hamburg: Kulturstiftung der Länder, 1999), 37–49.
44. Jenkins, *Provincial Modernity*, 42.
45. Bernd Kortländer's "During the Day a Big Accounting Office and at Night a Huge Bordello," in Hohendahl, *Patriotism, Cosmopolitanism, and National Culture*, 167–179; Annette Richards, "Carl Philipp Emanuel Bach and the Intimate Poetics of Public Music," ibid., 105–114.
46. Volker Plagemann, *Kulturgeschichte der Stadt Hamburg* (Hamburg: Junius, 1995), 9–14. Jenkins also links Plagemann's model to her review of Hamburg's lack of state-sponsored cultural infrastructure for the museum world. *Provincial Modernity*, 41–42.

47. James J. Sheehan, *Museums in the German Art World: From the End of the Old Regime to the Rise of Modernism* (Oxford: Oxford University Press, 2000), 83–84.

48. Hugbert Flitner, "Stiftungen für Wissenschaft und Kunst in Hamburg," in *Universität im Herzen der Stadt: Eine Festschrift für Dr. Hannelore und Prof. Dr. Helmut Greve*, ed. Jürgen Lüthje (Hamburg: Christians, 2002), 96. Accounting for about one-third of the eight hundred total foundations in Hamburg's history, these religious organizations were responsible for such renowned projects as the Hospital of the Holy Spirit. Michael Eissenhauer, *Die Hamburger Wohnstiftungen des 19. Jahrhunderts* (Hamburg: Universität Hamburg, 1987), 9.

49. The Israelitische Freischule and the Hermann Heineschen Foundation were examples of these Enlightenment-era foundations. Angela Schwarz, "Stiftungen," in *Das Jüdische Hamburg*, ed. Institut für die Geschichte, 243.

50. Ferguson, *Paper and Iron*, 65.

51. Johannes Gerhardt and the Hamburgische Wissenschaftliche Stiftung, *Die Begründer der Hamburgischen Wissenschaftlichen Stiftung*, Mäzene für Wissenschaft (Hamburg: Hamburg University Press, 2007), 14.

52. Ibid., 18.

53. Sheehan makes a similar point about Lichtwark's advancement in Hamburg. *Museums in the German Art World*, 162.

54. Cited and translated in Kay, *Art and the German Bourgeoisie*, 23.

55. Lichtwark purchased more paintings by Liebermann than did any other public gallery in Wilhelmine Germany. Ibid., 6. Their correspondence discusses various commissions for Hamburg. See, for example, Birgit Plugmacher, ed., *Der Briefwechsel zwischen Alfred Lichtwark und Max Liebermann* (Hildesheim: Georg Olms, 2003), 249, 254. On the nationalist attacks on the secessionists, see Peter Paret, *The Berlin Secession: Modernism and Its Enemies in Imperial Germany* (Cambridge, MA: Belknap Press of Harvard University Press, 1980), 109–110.

56. Kay, *Art and the German Bourgeoisie*, 4; Karl Scheffler, introduction to Alfred Lichtwark, *Eine Auswahl seiner Schriften* (Berlin: Bruno Cassirer, 1917), viii.

57. Sheehan, *Museums in the German Art World*, 163. See also Jenkins, *Provincial Modernity*, 181–188. Kay focuses on the public controversies surrounding Lichtwark's aesthetic selections. *Art and the German Bourgeoisie*, esp. 6–7, 41–49, 58–59, 70.

58. Ferguson, *Paper and Iron*, 65.

59. Gerhardt recounts the histories of the overlapping societies that led to these developments. *Die Begründer*, esp. 16–17.

60. Tamara Zwick describes how women transformed their homes in the seaside community of Hamburg's Neumühlen into a *Geisteskultur zu Hause*, "the specific culture of visiting 'open tables' and evening societies," frequented by well-known figures such as Goethe, Lessing, and Hum-

boldt. "Correspondence between Public and Private: German Women, Kinship, and Class in 19th-Century Hamburg" (PhD diss., University of California–Los Angeles, 2005), esp. 148–178. See also Zwick, "The Bat at the Ball: Bourgeois Culture as a Written Practice in the Letters of Magdalena Pauli to Johanna Sieveking, 1786–1824," in *Challenging Separate Spheres: Female Bildung in Eighteenth and Nineteenth-Century Germany*, ed. Marjanne E. Gooze (Oxford: Peter Lang, 2007), 137–156.

61. One recalls Glückel, born in Hamburg in 1645 into a prominent patrician family, who assumed responsibility for all practical matters in her arranged marriage to Chayim of Hameln and even carried on his business and financial enterprises after his death in 1689. *The Memoirs of the Glückel of Hameln* (New York: Schocken Books, 1977). According to Max M. Warburg, Glückel was a "forefather" of the Warburgs. *Aus meinen Aufzeichnungen*, 1.

62. Zwick calls this space between the private and public spheres "semi-private." "Correspondence between Public and Private," 149. Women also played special roles in other aspects of Hamburg's history. Katherine Aaslestad, "Republican Traditions: Patriotism, Gender, and War in Hamburg, 1770–1815," *European History Quarterly* 37, no. 4 (2007): 582–602.

63. One art historian suggested that Mary Warburg would have been surprised by Ghandchi's master's thesis, which viewed Mary's work as a subject of historical interest. Sabina Ghandchi, "Die Hamburger Künstlerin: Mary Warburg, geb. Hertz," (master's thesis, Universität Hamburg, 1986), 2.

64. Mary filled fourteen sketchbooks, totaling almost six hundred pages. Ibid., 3. Twelve of these books are in the *Nachlaß Mary Warburg* at the Hamburg Kunsthalle. Mary's work has been shown twice since then: first, in a private show in 1985, "Mary Warburg Zur Sache 11"; and second, in a 2006 exhibit devoted to female artists in Hamburg, "Künstlerinnen der Avant-garde (I) in Hamburg 1890–1933." In 1930 Mary also completed a bronze bust of Aby's head that sits on display at the Warburg-Haus in Hamburg.

65. Ghandchi, "Die Hamburger Künstlerin," 13.

66. As told to Ghandchi by Frede Prag (née Warburg). Ibid., 18.

67. Mary Warburg Personal Archive, 622–1/514, Familie Warburg, 1918–1923, StA HH.

68. In 1971 Linda Nochlin famously argued that the historical reality of female social responsibility provides a greater explanation for the artistic idea of "genius" than the history's roster of "great" artists. "Why Have There Been No Great Women Artists?" in *Women, Art, and Power: And Other Essays* (New York: Harper & Row, 1988), 145–178.

69. Wilhelm Hertz, *Nachruf für Mary Warburg*, 1934, reprinted in Ghandchi, "Die Hamburger Künstlerin."

70. John Stuart Mill, *On Liberty, with the Subjection of Women and Chapters on Socialism*, ed. Stefan Collini, Cambridge Texts in the History of Political Thought (Cambridge: Cambridge University Press, 1989), 138.

71. Aby Warburg to Charlotte Warburg, June 20, 1888, FC, WIA.

72. The description comes from Ernst Baasch's *Des Einfluss des Handels auf das Geistesleben Hamburg* (Leipzig: Duncker & Hamblot, 1909), paraphrased in Gerhard Ahrens, "Hanseatische Kaufmannschaft und Wissenschaftsförderung: Vorgeschichte, Gründung und Anfänge der 'Hamburgischen Wissenschaftlichen Stiftung' von 1907," *Vierteljahrschrift für Sozial und Wirtschaftsgeschichte* 66 (1979): 217. Baasch is discussed further in chapter 3.

73. Percy Schramm, *Neun Generationen: Dreihundert Jahre deutscher "Kulturgeschichte" im Lichte der Schicksale einer Hamburger Bürgerfamilie, 1648–1948* (Göttingen: Vandenhoeck & Ruprecht, 1963–64), 320.

74. Carl George Heise, *Persönliche Erinnerung an Aby Warburg* (New York: Eric M. Warburg, 1947), 9; Russell, *Between Tradition and Modernity*, 64.

75. Gombrich contrasts Warburg with the more populist head of the English Art and Crafts movement, John Ruskin. Gombrich and Saxl, *Aby Warburg*, ix.

76. Russell examines this among other local events that reveal Aby Warburg's role as a late-nineteenth-century cultural critic. *Between Tradition and Modernity*, 135–136, 156–157.

77. Chernow, *Warburgs*, 126.

78. Russell, *Between Tradition and Modernity*, 169–171.

79. Peter Freimark, "Jüdische Bibliotheken und Hebraica-Bestände in Hamburg," *Tel Aviver Jahrbuch für Deutsche Geschichte* 20 (1991): 459–467.

80. "Aby Warburg Anecdotes," III.134.1.6, WIA.

81. Evans, "Family and Class," 130–131.

82. "Aby Warburg Anecdotes," III.134.1.6, WIA.

83. The firm itself changed the name of its business from *Geldwechsler* (money changers) to *Bankiers* in 1863. Warburg, *Aus meinen Aufzeichnungen*, 1.

84. Aby Warburg to Felix Warburg, June 17, 1908, FC, WIA.

85. Tilmann von Stockhausen, *Die Kulturwissenschaftliche Bibliothek Warburg: Architektur, Einrichtung und Organisation* (Hamburg: Döllig und Galitz, 1992), 19; quotation in Gombrich and Saxl, *Aby Warburg*, 129.

86. Saxl, "History of Warburg's Library," in Gombrich and Saxl, *Aby Warburg*, 325.

87. Gombrich and Saxl, *Aby Warburg*, 138–139.

88. Saxl, "History of Warburg's Library," in Gombrich and Saxl, *Aby Warburg*, 327.

89. Warnke, foreword to *Aby Warburg im Bannkreis der Ideen*, 11.

90. Michael Diers says that it was no coincidence that Warburg took up this system when he returned to Hamburg from Florence in 1904. *Warburg aus Briefen: Kommentare zu den Kopierbüchern der Jahre 1905–1928* (Weinheim: VCH, 1991), 27–28.

91. Heise, *Persönliche Erinnerungen*, 24.

92. *TKBW*, 186. For additional information, see Michels and Schoell-Glass,

"Die Literatur- und Kulturwissenschaftlerin: Gertrud Bing (Hamburg 1892–1964)," in *Frauen im Hamburger Kulturleben*, ed. Elsbeth Weichmann Gesellschaft e.V. (Hamburg: Christians, 2002), 31; Michels, "Kunstgeschichte, paarweise," *Kritische Berichte* 2 (2002): 32.

93. The relationship between Saxl and Warburg is well charted by Dorothea McEwan in the two-volume edited correspondence between the two. See *Ausreiten der Ecken: Die Aby Warburg–Fritz Saxl Korrespondenz, 1910–1919* (Hamburg: Dölling und Galitz, 1998); and *"Wanderstrassen der Kultur": Die Aby Warburrg–Fritz Saxl Korrespondenz 1920 bis 1929* (Munich: Dölling und Galitz, 2004); Arnaldo Momigliano provides a wonderful description of Bing, especially from these postwar years, in "Gertrud Bing (1892–1964)," in *Essays on Ancient and Modern Judaism*, ed. Silvia Berti, trans. Maura Masella-Gayley (Chicago: University of Chicago Press, 1994), 209–212.

94. The title of this recent volume underscores that Saxl's position as Warburg's assistant has been difficult to surpass. Dorothea McEwan, *Fritz Saxl Eine Biografie: Aby Warburgs Bibliothekar und erster Direktor des Londoner Warburg Institutes* (Vienna: Böhlau, 2013). For his own view, see Saxl, "History of Warburg's Library," in Gombrich and Saxl, *Aby Warburg*, 330.

95. Warnke, foreword to *Aby Warburg im Bannkreis*, 11.

96. McEwan argues that this relationship was not one of master-student but rather "dear friends," as they addressed each other. *"Wanderstrassen der Kultur,"* 24.

97. Warburg's famous lecture on the serpent ritual, discussed in the next chapter, for example, came from scattered notes and was largely compiled by Saxl. Treml, Weigel, and Ladwig, *Aby Warburg*, 19–20.

98. Meyer, "Warburg in His Early Correspondence," 447.

99. This is H. Stuart Hughes's portrait of Max Weber. *Consciousness and Society* (New Brunswick, NJ: Transaction, 2003), 288. Neurosis also plays the central role in Joachim Radkau's analysis of Weber. *Max Weber: Die Leidenschaft des Denkens* (Munich: Carl Hanser, 2005). Disappointingly, Bernd Roeck's article on the brief correspondence that Warburg and Weber shared concerning capitalism and the Renaissance does not address this psychological similarity. "Aby Warburg und Max Weber: Über Renaissance, Protestantismus und kapitalistischen Geist," *Die Renaissance als erste Aufklärung* 3 (1998): 189–205.

100. Gombrich and Saxl, *Aby Warburg*, 8, 67, 283.

CHAPTER TWO

1. This interest in patrons crystallized in the work of Bernard Berenson in his *Aesthetics and History* (London: Pantheon, 1948), and the economics of art remains a vibrant subfield in Renaissance studies. See, for example, Richard A. Goldthwaite, "The Empire of Things: Consumer Demand in Renaissance Italy," in *Patronage, Art, and Society in Renaissance Italy*, ed.

F. W. Kent and Patricia Simons (Canberra: Humanities Research Centre, 1987), 153–175. For a recent survey of this literature, see Creighton E. Gilbert, "What Did Renaissance Patrons Buy?" *Renaissance Quarterly* 51 (1998): 392–450.

2. Theodor Mommsen's transference of his political aspirations onto his scholarly work on the Roman Republic is widely documented. According to Egon Friedell's account, Mommsen mapped German socialists, French princes, and conservative royalists onto his Roman characters. *A Cultural History of the Modern Age: The Crisis of the European Soul* (New Brunswick, NJ: Transaction, 2010), 3:225. On Felix Gilbert, in particular, see his *European Past: Memoirs, 1905–1945* (New York: Norton, 1998). On Hans Baron, see Riccardo Fubini, "Renaissance Historian: the Career of Hans Baron," *Journal of Modern History* 64 (1992): 541–574. For James J. Sheehan there was a "touch of autobiography" in Gilbert's observation about Burckhardt. See "The German Renaissance in America," in *The Italian Renaissance in the Twentieth Century: Acts of an International Conference,* Villa i Tatti, The Harvard University, Center for Renaissance Studies, ed. Allen J. Grieco, Fiorella Gioffredi Superbi, and Michael Rocke (Florence: Olschki, 2002), 57.

3. Cited in Gay, *Style in History: Gibbon, Ranke, Macaulay, Burckhardt* (New York: Norton, 1988), 204.

4. The quotations are from Gay's description of German historians who found themselves in Italy. Ibid.

5. Bernd Roeck, *Florence 1900: The Quest for Arcadia*, trans. Stewart Spencer (New Haven, CT: Yale University Press, 2009).

6. Jacob Burckhardt to Gottfried Kinkel, March 21, 1842, cited in Felix Gilbert, "Jacob Burckhardt's Student Years: The Road to Cultural History," *Journal of the History of Ideas* 47 (1986): 249. Translation altered by author.

7. Edgar Wind, "Warburgs Begriff der Kulturwissenschaft und seine Bedeutung für die Ästhetik," *Zeitschrift für Ästhetik und allgemeine Kunstwissenschaft* 25 (1931): 163–179. Cited and translated in Kurt Forster's introduction to Warburg, *Renewal of Pagan Antiquity*, 39. Incidentally, Hayden White observed of Warburg's great influence, Jacob Burckhardt, that he was "all middle." Cited in Sheehan, "German Renaissance in America," 50.

8. Forster, introduction to Warburg, *Renewal of Pagan Antiquity*, 39.

9. Anton Springer, *Bilder aus der Neueren Kunstgeschichte* (Bonn: A. Marcus, 1867), 1:28; See also Forster, introduction to Warburg, *Renewal of Pagan Antiquity*, 5; also Michael Podro, *The Critical Historians of Art* (New Haven, CT: Yale University Press, 1982), 152–157.

10. Friedrich Schiller, "Die Götter Griechenlands" (orig. 1788). The description is Suzanne L. Marchand's in *Down from Olympus: Archaeology and*

Philhellenism in Germany, 1750–1970 (Princeton, NJ: Princeton University Press, 1996), 3.

11. Sheehan, *Museums in the German Art World*, 11.

12. Anthony Grafton, "Germany and the West, 1830–1900," in *Perceptions of the Ancient Greeks*, ed. Kenneth James Dover (Oxford: Blackwell, 1992), 234.

13. Marchand, *Down from Olympus*, 116–151. For neoclassical architecture in Berlin, see Can Bilsel, *Antiquity on Display: Regimes of the Authentic in Berlin's Pergamon Museum* (Oxford: Oxford University Press, 2012).

14. The history of neoclassicism in Europe is too long and complex to recap here. The first classical revival dates to the fifteenth and sixteenth centuries in Italy and France and was mostly focused on Greek civilization through the eyes of Latin civilization. The second began in the seventeenth century and continued through 1914 but was especially vital in late-eighteenth-century Germany. For an overview see Hugh Lloyd-Jones, *Blood for Ghosts: Classical Influences in the Nineteenth and Twentieth Centuries* (Baltimore: Johns Hopkins University Press, 1982), 168–169.

15. Nietzsche supported Ritschl, a strict analyst, insofar as he believed that Ritschl's philology was relevant to more than merely textual criticism. James Whitman offers a more nuanced treatment of this controversy than is usually given. "Nietzsche in the Magisterial Tradition of German Classical Philology," *Journal of the History of Ideas* 47 (1986): 461–465; Grafton, "Germany and the West," 234.

16. Ingo Gildenhard and Martin Ruehl, introduction to *Out of Arcadia: Classics and Politics in Germany in the Age of Burckhardt, Nietzsche, and Wilamowitz*, Institute of Classical Studies Supplement 79 (London: Institute of Classical Studies, School of Advanced Study, University of London, 2003), 2.

17. Cited in Gossman, *Basel in the Age of Burckhardt*, 302.

18. Warburg, "From the Arsenal," 114–115. According to Warburg, Justi eventually came to appreciate his work.

19. Warburg, "Sandro Botticelli's Birth of Venus and Spring: An Examination of Concepts of Antiquity in the Italian Early Renaissance," in Warburg, *Renewal of Pagan Antiquity*, 114.

20. Warburg, "From the Arsenal," 115.

21. Warburg, "Botticelli's Birth of Venus," in Warburg, *Renewal of Pagan Antiquity*, 89; Among the places the concept of the *Pathosformel* appears is in Warburg, "Francesco Sassetti's Last Injunction to His Sons," in Warburg, *Renewal of Pagan Antiquity*, 249.

22. Gombrich, "Warburg: His Aims and Methods," 272.

23. Charles Darwin, *The Expression of the Emotions in Man and Animals*, introduction, afterword, and commentaries by Paul Ekman (New York: Oxford University Press, 1998), 345.

24. Ibid., 70.

25. Warburg, "From the Arsenal," 115.

26. Incidentally, the rationalist Gombrich claims that Bonn lecturer Hermann Usener drew Warburg's attention to the work of Titto Vignoli, who argued that reason triumphed over fear in evolution, and that this had a stronger influence on Warburg than any primal energies. "Warburg: His Aims and Methods," 272–273.

27. Aby Warburg, "Dürer and Italian Antiquity," in Warburg, *Renewal of Pagan Antiquity*, 553, 555. Originally published as "Dürer und die italienische Antike," in *Verhandlungen der achtundvierzigsten Versammlung deutscher Philologen und Schulmänner in Hamburg vom 3. Bis 6. Oktober 1905* (Leipzig, 1906), 55–60.

28. Aby Warburg, "The Emergence of the Antique as a Stylistic Ideal in Early Renaissance Painting," in Warburg, *Renewal of Pagan Antiquity*, 273.

29. Gilbert, "Burckhardt's Student Years," 263–264.

30. Burckhardt, *Civilization of the Renaissance*, 87.

31. Warburg, "Botticelli's Birth of Venus," in Warburg, *Renewal of Antiquity*, 157–164, quotation on 157.

32. Gossman, *Basel in the Age of Burckhardt*, 8; Burckhardt, *Civilization of the Renaissance*, 140.

33. This was particularly true for the world of science. Burckhardt, *Civilization of the Renaissance*, 91, 183.

34. The connection between commerce and art theory is, to a certain degree, also thematized by the following works: Gombrich and Saxl, *Aby Warburg*, 105; Landauer, "Survival of Antiquity," 33; and Martin Warnke, foreword to *Aby Warburg im Bannkreis*, 11–18.

35. Aby Warburg, "The Art of Portraiture and the Florentine Bourgeoisie: Domenico Ghirlandaio in Santa Trinita: The Portraits of Lorenzo de' Medici and His Household," in Warburg *Renewal of Pagan Antiquity*, 187. Originally published as "Bildniskunst und florentinisches Bürgertum" (Leipzig: Hermann Seemann Nachfolger, 1902).

36. Warburg, "Portraiture," in Warburg, *Renewal of Pagan Antiquity*, 187.

37. Ibid., 189.

38. Ibid., 190–191.

39. Ibid.

40. Aby Warburg to Felix Warburg, June 17, 1908, FC, WIA.

41. Warburg, "Portraiture," in Warburg, *Renewal of Pagan Antiquity*, 202.

42. Ibid., 200.

43. Ibid., 187; Aby Warburg, "Francesco Sassetti's Last Injunction to His Sons," in Warburg, *Renewal of Pagan Antiquity*, 229.

44. Aby Warburg believed that, as someone no longer officially connected to the Jewish community, he would be somehow disingenuous in reciting the *Kaddish* for his father. "The Mourner's Kaddish is a matter for the eldest son: it signifies not only an external act, but at this public memorial service demonstrates acceptance of the moral inheritance. I will not make myself guilty of such public hypocrisy." Cited and translated in Meyer,

"Warburg in His Early Correspondence," 452. Gombrich interprets this decision as one of Warburg's clear decisive breaks from Judaism, an assertion I do not accept. Gombrich and Saxl, *Aby Warburg*, 11, 20. Warburg's relationship to Judaism is discussed in chapter 7.

45. All of the private letters from Aby Warburg's university years in Bonn and Strasbourg were addressed to Charlotte Warburg alone. See FC, WIA. Also, Dr. Ludwig Binswanger, "Krankengeschichten," Bl. 18, 441/3782 223a, UAT.

46. Aby Warburg, "Matteo degli Strozzi: An Italian Merchant's Son, Five Centuries Ago," in Warburg, *Renewal of Pagan Antiquity*, 264. Originally published as "Matteo de' Strozzi: Ein italienischer Kaufmannssohn vor 500 Jahren," in *Hamburger Weihnachtsbuch* (Hamburg, 1892), 236.

47. Christiane Klapisch-Zuber draws on demographic data from 1427 to show that because of marriage and death patterns and inheritance laws, women were, in reality, suspended between their natal and conjugal homes. As a result, what emerges is not a heroic widow but the "cruel mother" who is forced to abandon her children after her husband's death. *Women, Family, and Ritual in Renaissance Italy*, trans Lydia Cochrane (Chicago: University of Chicago Press, 1985), esp. 117–131. Thanks to Annie Ruderman for alterting me to this reference.

48. Alfred Doren, *Briefe, herausgegeben und eingeleitet von Alfred Doren* (Jena: Eugen Diederichs, 1927).

49. For Alfred Doren on his friend, see "Aby Warburg und sein Werk," *Archiv für Kulturgeschichte* 21 (1931): 1; For more on Alfred Doren, see Gerald Diesener and Jaroslav Kudrna, "Alfred Doren: Ein Historiker am Institut für Kultur- und Universalgeschichte," in *Karl Lamprecht weiterdenken: Universal–Kulturgeschichte heute*, ed. Gerald Diesener, Beiträge zur Universalgeschichte und vergleichenden Gesellschaftsforschung, 3 (Leipzig: Leipzig Universitätsverlag, 1993), 60–85.

50. Alessandra Macinghi Strozzi, *Selected letters of Alessandra Strozzi*, trans. Heather Gregory (Berkeley: University of California Press, 1997), 43.

51. Max Warburg, "Aby Warburg Anecdotes," III. 134.1.3, 1929, WIA.

52. Dr. Ludwig Binswanger, "Krankengeschichte," January 28, August 23, September 30, 1923, 441/3782 223a, UAT.

53. Deborah Hertz argues that anti-Semitism played a critical role in the psychological suffering of Jewish men. "Männlichkeit und Melancholie in der Biedermeierzeit," in *Deutsch-jüdische Geschichte als Geschlechtergeschichte zu 19. und 20. Jahrhundert*, ed. Hamburger Beiträge zur Geschichte der deutschen Juden (Göttingen: Wallstein, 2006), 276–292.

54. Dr. Ludwig Binswanger, "Krankengeschichte," October 17, 1921, 441/3782 223a, UAT.

55. Ingrid Warburg-Spinelli, *Die Dringlichkeit und die Einsamkeit, nein zu sagen: Erinnerungen 1910–1989* (Hamburg: Dölling und Galitz, 1990), 49–50.

56. Burckhardt, *Civilization of the Renaissance*, 254.

57. Gombrich used historical documents to show that while Cosimo Medici was an active patron, his grandson Lorenzo was more interested in cultivating his image as a connoisseur than in actually supporting art. "The Early Medici as Patrons of the Art," in *Italian Renaissance Studies*, ed. E. F. Jacob (London: Faber and Faber, 1960), 279–311. See also Melissa Meriam Bullard, "Heroes and Their Workshops: Medici Patronage and the Problem of Shared Agency," in *The Italian Renaissance: The Essential Readings*, ed. Paula Findlen (London: Blackwell, 2002), 301.
58. Bullard, "Heroes and Their Workshops," 301, 311–316.
59. Adolph Goldschmidt to Aby Warburg, November 29, 1904, GC, WIA.
60. Aby Warburg to J. Halle, January 24, 1918; excerpted in McEwan, *Ausreiten der Ecken*, 16.
61. Aby Warburg, "A Specialized Heraldic Library," in Warburg, *Renewal of Pagan Antiquity*, 720. Originally published as "Eine heraldische Fachbibliothek," in *Gesellschaft der Bücherfreunde in Hamburg: Bericht über die Jahre 1909–1912* (Hamburg, 1913). Here Warburg almost sounds like Lichtwark, whose popular outreach he disdained, and who promoted dilettantism as a source of cultural regeneration. See Lichtwark, "Dilettantismus und Volkskunst," in *Erziehung des Auges: Ausgewählte Schriften*, ed. Eckhard Schaar (Frankfurt am Main: Fischer Taschenbuch, 1991), 86–89.
62. This comment was made by Hermann Usener in Leipzig. Cited in Whitman, "Nietzsche in the Magisterial Tradition," 455.
63. Cited in Gossman, *Basel in the Age of Burckhardt*, 306–307.
64. Nietzsche, "Homer and Classical Philology," in *On the Future of our Educational Institutions; and Homer and Classical Philology*, in *The Complete Works of Friedrich Nietzsche*, ed. Oscar Levy, trans. J. M. Kennedy (London: T.N. Foulis, 1909), 4:148.
65. According to Roger Chickering's excellent biography, *Karl Lamprecht: A German Academic Life, 1856–1915* (Atlantic Highlands, NJ: Humanities Press International, 1993), the *Methodenstreit* lasted effectively for Lamprecht's entire career. See especially 146–240.
66. Cited and translated in Hinrich C. Seeba, "Cultural History: An American Refuge for a German Idea," in *German Culture in Nineteenth-Century America: Reception, Adaptation, Transformation*, ed. Lynne Tatlock and Matt Erlin (New York: Camden House, 2005), 13.
67. Chickering, *Karl Lamprecht*, 22. Although Peter Burke thinks that the claim that Marc Bloch and Lucien Febvre took their ideas from Lamprecht wholesale is an exaggeration, Lamprecht's influence on the *Annales* school and cultural history in France in general is undeniable. Burke, "The *Annales* in a Global Context," *Interntional Review of Social History* 35 (1990): 430.
68. Karl Lamprecht, "Problems of University History," in *What Is History? Five Lectures on the Modern Science of History* (London: Macmillan, 1905), 189.
69. Aby Warburg to Max Warburg, June 30, 1900, FC, WIA; Liebeschütz, "Aby

Warburg," 234; Kathryn Bush, "Aby Warburg and the Cultural Historian Karl Lamprecht," in *Art History as Cultural History: Warburg's Projects*, ed. Richard Woodfield (Amsterdam: Gordon and Breach, 2011), 65–92.

70. Chickering, *Karl Lamprecht*, 343–344.

71. Felix Warburg married Frieda Schiff, the daughter of Kuhn-Loeb senior partner Jacob Schiff. Paul Warburg's new wife, Nina Loeb, was the sister of James Loeb. Since Nina Loeb was Frieda Schiff's maternal aunt, this marriage made Paul Warburg his brother's uncle. Chernow, *Warburgs*, 45–56, esp. 54.

72. Aby Warburg, Franz Boas, and Benedetta Cestelli Guidi, "Aby Warburg and Franz Boas: Two Letters from the Warburg Archive: The Correspondence between Franz Boas and Aby Warburg (1924–1925)," *Anthropology and Aesthetics* 52 (2007): 221–230 (special issue: *Museums: Crossing Boundaries*). Claude Imbert argues that Warburg's Mnemosyne project needs to be understood as mediated through his conversations with American anthropologists such as Boas. Claude Imbert, Nima Bassiri, and Michael Allan, "Aby Warburg, between Kant and Boas: From Aesthetics to the Anthropology of Images," trans. Nima Bassiri, *Qui Parle* 16 (2006): 38–39.

73. Claudia Naber reconstructs this visit, including his relationships, influences, and the paintings viewed at the Peabody, in great detail. "Pompeji in Neu-Mexico: Aby Warburgs amerikanische Reise," *Freibeuter* 38 (1988): 88–97.

74. Michael P. Steinberg, "Aby Warburg's Kreuzlingen Lecture: A Reading," in *Images from the Region of the Pueblo Indians of North America*, by Aby Warburg and Michael P. Steinberg (Ithaca, NY: Cornell University Press, 1995), 63.

75. Cited by Gombrich, "Warburg: His Aims and Methods," 274.

76. Warburg and Steinberg, *Pueblo Indians*, 4.

77. Steinberg, "Warburg's Kreuzlingen Lecture," 85–86. For Jews in medieval art, see Kalman P. Bland, *The Artless Jew: Medieval and Modern Affirmations and Denials of the Visual* (Princeton, NJ: Princeton University Press, 2000), 11.

78. Bland, *Artless Jew*, 6.

79. Saxl and Bing published an annotated and translated version of the lecture after Warburg's death. Aby Warburg, "A Lecture on Serpent Ritual," *Journal of the Warburg Institute* 2, no. 4 (1939): 277–292. The full German text was published in 1988. Aby Warburg, *Schlangenritual: Ein Reisebericht*, with an afterword by Ulrich Raulff (Berlin: Klaus Wagenbauch, 1988).

80. The first of these was his 1912 lecture, "Italienische Kunst und Internationale Astrologie im Palazzo Schifanoja zu Ferrara," in Warburg, *Die Erneuerung der heidnischen Antike*, 1.1:459–486. Published in English as "Italian Art and International Astrology in the Palazzo Schifanoia," trans.

David Britt, in Warburg, *Renewal of Pagan Antiquity*, 565–592. Subsequent citations are to this edition.

81. Aby Warburg, "Italian Art and International Astrology in the Palazzo Schifanoia," 565, 569, 585.

82. Peter Burke credits Warburg and Lamprecht for being early pioneers in interdisciplinarity. *"Annales* in a Global Context," 427.

83. Gombrich was known to "invert" all sources of discord in Warburg's work to present Warburg as a "legitimate" scholar of system-building, whereas later studies emphasize discord and chaos in his work. See, for example, Michaud, *Warburg and the Image*; and Georges Didi-Hubermann, *L'image survivante: Histoire de l'art et temps des fantômes selon Aby Warburg* (Editions de Minuit, 2002). These varying approaches to Warburg's work are discussed in the epilogue.

84. Warburg, "Italian Art," in Warburg, *Renewal of Pagan Antiquity*, 585.

85. Burckhardt, *Civilization of the Renaissance*, 1.

86. In summer 1927 Warburg gave a seminar on Burckhardt in which he made this connection. See Treml, Weigel, and Ladwig, introduction to "Schlussitzung der Burckhardt Uebung 27.7.1927," in *Aby Warburg*, 667.

87. Michaud, *Warburg and the Image*, 14.

88. Gossman, *Basel in the Age of Burckhardt*, 8.

89. Chickering insinuates that this was Lamprecht's fate. In fact, his tremendously successful publishing run was inversely proportional to the respect he received from his colleagues. *Karl Lamprecht*, 87, 89, 193.

90. Ernst Gombrich, "In Search of Cultural History," in *Ideals and Idols: Essays on Values in History and in Art* (Oxford: Phaidon, 1979), 24–59, here 38–41. For Ferretti, Gombrich confuses what she calls Warburg's "unitary scheme" with Burckhardt's "history of spirit." *Cassirer, Panofsky, and Warburg*, xviii.

91. Ferrettii, *Cassirer, Panofsky, and Warburg*, 23. See also Lessing, *Lessing's Laocoön*, 33–43.

92. Gombrich called this "Hegelianism without Metaphysics." "In Search of Cultural History," quotation on 42, 43–45. For more on Huizinga, see Christoph Strupp, *Johan Huizinga: Geschichtswissenschaft als Kulturgeschichte* (Göttingen: Vandenhoeck & Ruprecht, 2000); and Edward Peters and Walter P. Simons, "The New Huizinga and the Old Middle Ages, *Speculum* 74 (1999): 607–612.

93. Gombrich, "In Search of Cultural History," 46. In a revealing interview with Burke about "In Search of Cultural History," Gombrich conceded that while historians required models, these should not be all-pervasive. "There is a such a thing as turbulence. But it doesn't mean that there are no currents." Gombrich, "Ernst Gombrich Discusses the Concept of Cultural History with Peter Burke," *Listener* 90 (December 27, 1973): 881–883, http://gombricharchive.files.wordpress.com/2011/04/showdoc19.pdf (accessed February 19, 2013).

94. Burke points out the irony that the greatest innovation in history came from outside history proper. *What Is Cultural History*, 2nd ed. (Cambridge: Polity Press, 2008), 11.

95. According to Gombrich, this interest led Warburg to focus on Florence, while Saxl, whose "sympathy lay with the scholars and artists of the Renaissance who had endeavoured to recover classical culture for its own sake," inspired him to study Venice. Gombrich, introduction to Saxl, Honour, and Fleming, *A Heritage of Images*, 11.

CHAPTER THREE

1. Rainer Nicolaysen, *"Frei soll die Lehre sein und Frei das Lernen": Zur Geschichte der Universität Hamburg* (Hamburg: DOBU, 2007), 11–13. According to McClelland, such hybrid scholarly institutions were common in premodern Germany. *State, Society, and the University*, 19.

2. Cecil, *Albert Ballin*, 4.

3. The German version—"Bildung schadet nichts, sollte aber nicht zu teuer sein"—further emphasized its Hamburgized formulation. "Warburgismen," assembled by Max M. Warburg, III.17.2, WIA, also cited in Michels, *Warburg im Bannkreis*, 21.

4. In this respect, the history of Hamburg's university was more like that of the "red brick universities" of Great Britain's industrial cities, including Manchester and Liverpool, universities that developed in a different way from those of Oxford and Cambridge. A. L. Mackenzie and A. R. Allan, introduction to E. A. Peers, *Redbrick University Revisited: The Autobiography of "Bruce Truscot"* (Liverpool: Liverpool University Press, 1996).

5. Jürgen Bolland, "Die Gründung der 'Hamburgischen Universität,'" in *Universität Hamburg 1919–1969*, Festschrift zum 50. Gründungstag der Universität Hamburg (Hamburg: Universität Hamburg, 1969), 23–24.

6. McClelland, *State, Society, and the University*, 104.

7. Bolland, "'Hamburgischen Universität,'" 24.

8. Gustav Schiefler, *Eine Hamburgische Kulturgeschichte 1890–1920: Beobachtungen eines Zeitgenossen*, ed. Gerhard Ahrens, Hans Wilhelm Eckardt, and Renate Hauschild-Thiessen (Hamburg: Verein für hamburgische Geschichte, 1985), 350.

9. Warburg was one of nine students to participate in this course, which led to both the creation of the Kunsthistorisches Institut in Florenz, now a Max Planck Institute, and the creation of the Friends of the Kunsthistorisches Institut in Florenz, of which Warburg was a member. See "History of the Institute" at Kunsthistorische Institut in Florenz, www.khi.fi.it/en/institut/geschichte/index.html, and Doreen Tesche, *Ernst Steinmann und die Gründungsgeschichte der Bibliotheca Hertziana in Rom* (Munich: Hirmer, 2002).

10. Eduard Hallier to Aby Warburg, January 26, 1905, GC, WIA.

11. In 1916, on behalf of the *Conventiculi*, Warburg arranged to purchase the library of a wealthy Hamburger and to donate the books to two local grammar schools. Eric Ziebarth to Aby Warburg, March 6, 1916, GC, WIA; Aby Warburg to Elizabeth Wegehaupt, March 7, 1916, GC, WIA.

12. Werner von Melle, *Dreißig Jahre Hamburger Wissenschaft 1891–1921: Rückblicke und persönliche Erinnerungen* 2 (Hamburg: Hamburgische Wissenschaftliche Stiftung, 1924), 244. In 1921, von Melle was awarded an honorary rectorship (*Rector magnificus honoris cause*) in recognition of his work for the university. Gerhardt, *Die Begründer*, 86.

13. *Jahresbericht 1929 für die Hamburgische Universitätsgesellschaft* (Hamburg: Hamburger Studentenhilfe e.V. Akademische Auslandstelle Hamburg, 1930), 31.

14. Nicolaysen, *"Frei soll die Lehre sein und Frei das Lernen,"* 13. On the development of research institutions in Germany, see Bernhard vom Brocke, "Die Kaiser-Wilhelm Gesellschaft im Kaiserreich: Vorgeschichte, Gründung und Entwicklung bis zum Ausbruch des Ersten Weltkriegs," in *Forschung im Spannungsfeld von Politik und Gesellschaft: Geschichte und Struktur der Kaiser-Wilhelm/ Max-Planck-Gesellschaft*, ed. Rudolf Vierhaus and Bernhard vom Brocke (Stuttgart: dva, 1990), 17–162, esp. 84–114.

15. Nicolaysen, *"Frei soll die Lehre sein und Frei das Lernen,"* 16; Heise, *Persönliche Erinnerungen*, 4.

16. Ahrens, "Hanseatische Kaufmannschaft," 223; Gerhardt, *Die Begründer*, 7–13; Birgit Pflugmacher, "Max Liebermann—sein Briefwechsel mit Alfred Lichtwark" (PhD diss., Universität Hamburg, 2001), 163.

17. Max M. Warburg to Senator Otto Westphal, 1904, GC, WIA.

18. Until the founding of the Kaiser Willhelm Gesellschaft with capital of 10 million marks in 1910, the Hamburgische Wissenschaftliche Stiftung was the single largest foundation in Germany. Vom Brocke, "Die Kaiser-Wilhelm Gesellschaft im Kaiserreich," 110–111.

19. McClelland, *State, Society, and the University*, 145, 148–149, 126, 141.

20. Under Althoff the university budget increased exponentially but at tremendous cost to autonomy. Bernhard vom Brocke, "Hochschul- und Wissenschaftspolitik in Preußen und im Deutschen Kaiserreich, 1882–1907" in *Bildungspolitk in Preußen zur Zeit des Kaiserreichs*, ed. Peter Baumgart (Stuttgart: Klett Cotta, 1980), 19, 74–75; Peter Burke, *A Social History of Knowledge: From the Encyclopédie to Wikipedia* (Cambridge, UK: Polity Press, 2012), 2:228.

21. Gerhardt, *Die Begründer*, 19. The University of Frankfurt had the most similar history to that of Hamburg because it was also privately funded (*Stiftungsuniversität*) in this time, though in the postwar period it converted to become a public university. It only reverted to its previous private status in 2008. For a history of the university see Notker Hammerstein, *Die Johann Wolfgang Goethe-Universität Frankfurt am Main*, 2 vols. (Göttingen:

Walsltein, 2012). For the parallel role played by local Jews in the founding of the university see the discussion in chapter 7 of this volume.

22. On competition see Sheehan, *German History, 1770–1866* (New York: Oxford University Press, 1989), 807. Weber himself made the decision to stay in Freiburg for similar reasons, despite (or because of) Althoff's relentless pressure to the contrary. Marianne Weber, *Max Weber: A Biography*, trans. Harry Zohn (New Brunswick, NJ: Transaction, 1988), 199–200. On Weber's critique of Althoff and the benefits of remaining in the provinces, see Max Weber, "The Bernhard Case," in *Max Weber's Complete Writings on Academic and Politics Vocations*, ed. John Dreijmanis (New York: Algora, 2008), 54.

23. Schiefler, *Hamburgische Kulturgeschichte*, 18.

24. Lichtwark remained envious of Tschudi's more generous benefactors— "almost exclusively Israelites." Kay, *Art and the German Bourgeoisie*, 119. On the large number of Jewish patrons of modern art, see Peter Paret, "Bemerkungen zu dem Thema: Jüdische Kunstsammler, Stifter und Kunsthändler," in *Sammler, Stifter und Museen: Kunstförderung in Deutschland im 19. und 20. Jahrhundert*, ed. Ekkehard Mai and Peter Paret (Cologne: Böhlau, 1993), 173–185.

25. Schiefler, *Hamburgische Kulturgeschichte*, 357.

26. Joist Grolle, "Blick zurück im Zorn: Das Revolutionstrauma des Ernst Baasch," in *Hamburg und seine Historiker*, ed. Joist Grolle (Hamburg: Verlag Verein für Hamburgische Geschichte, 1997), 120.

27. The other major donation, a sum of approximately 100,000 marks, came from the Lewisohns, a family that also financed a building for City College of New York and donated artwork to the Metropolitan Museum of Art. Despite their interest in the United States, they continued to support projects in Hamburg, including, for example, the Jewish Community Hospital. Gerhardt, *Die Begründer*, 4, 25; Krohn, *Juden in Hamburg: Die politische, soziale, und kulturelle Entwicklung*, 120. Interestingly—and revealingly—none of the primary sources discuss who donated the remaining 1.3 million marks to the cause.

28. Krohn, *Juden in Hamburg: Die politische, soziale, und kulturelle Entwicklung*, 121.

29. Wilhelm Weygandt, ed., *Die Universität Hamburg in Wort und Bild: Herausgegeben im Auftrag des Akademischen Senates* (Hamburg, 1927), 47; Gerhard Lassar, "Hamburg University as Link with the World," in *Hamburg's Worldwide Activities*, ed., Heinrich Pfeiffer and Kurt Johannsen (Hamburg: Verlag der 'Prismen,' 1930), 69; quotation in Wilhelm Weygandt, "Ist die Hamburger Universität ein Wagnis?" *Sonderheft zur Universitätsfrage* 4, no. 5 (1918): 163.

30. Jens Ruppenthal discusses the "Era of Dernburg" in connection with corresponding reform occurring in Great Britain. *Kolonialismus als 'Wissenschaft und Technik': Das Hamburgische Kolonialinstitut 1908 bis 1919* (Stuttgart: Franz Steiner, 2007), 58, 116–120.

31. Gerhardt, *Die Begründer*, 19–20; von Melle, *Dreißig Jahre*, 1–7.
32. Erich Marcks, "Hamburg und das bürgerliche Geistesleben in Deutschland Antrittsrede," cited in Grolle, "Blick zurück im Zorn," 111.
33. Grolle, "Blick zurück im Zorn," 112, 111.
34. Bolland, "'Hamburgischen Universität,'" 39 (my emphasis); Schiefler, *Hamburgische Kulturgeschichte*, 378.
35. Ernst Schwedeler-Meyer to Aby Warburg, July 4, 1909, GC, WIA; Aby Warburg to Franz Boll, June 27, 1913, Heid. Hs. 2108, UB Heidelberg; Warburg quoted in Schiefler, *Hamburgische Kulturgeschichte*, 369.
36. Von Melle, *Dreißig Jahre*, 244.
37. Diers, "Der Gelehrte," 46, Warburg quotation on 47; Lamprecht quoted in Schieffler, *Hamburgische Kulturgeschichte*, 395.
38. On hearing this news, Lamprecht agitated fellow Leipzigers with his intercity competitive spirit. Chickering, *Karl Lamprecht*, 352, 379. Similarly, in Hamburg, some continued to favor a research institute rather than a university and inquired with Lamprecht regarding his opinion. See an unsigned copy of a letter to Lamprecht titled "Fragen betreffend Einrichtung von Forschungsinstituten am Kolonialinstitut," November 27, 1913, NL Lamprecht Nr 35, UAL. On this debate, see Arnt Goede, "Forschungsinstitut oder Universität? Der Streit um eine angemessene Wissenschaftsorganisation in Hamburg," in *Lebendige Sozialgeschichte: Gedenkschrift für Peter Borowsky*, ed. Peter Borowsky, Rainer Hering, and Rainer Nicolaysen (Wiesbaden: Westdeutscher Verlag, 2003), 615–632.
39. Aby Warburg to Percy Schramm, May 23, 1918, 622–1/151 Familie Schramm, L 230 Band 11, StA HH.
40. Gerhardt, *Die Begründer*, 25.
41. Diers, "Der Gelehrte," 47–48.
42. Ibid., 50; Gombrich and Saxl, *Aby Warburg*, 192.
43. Diers, "Der Gelehrte," 47–48.
44. McClelland, *State, Society, and the University*, 235–236.
45. Schiefler, *Hamburgische Kulturgeschichte*, 380, 383–384.
46. Richard A. Comfort, *Revolutionary Hamburg: Labor Politics in the Early Weimar Republic* (Stanford, CA: Stanford University Press, 1966), 14.
47. Bolland, "'Hamburgischen Universität,'" 79; Warburg, *Aus meinen Aufzeichnungen*, 32.
48. Max Warburg to Paul Warburg, 1904, FC, WIA; Thilenius, "Die Wissenschaft," 125.
49. Bolland, "'Hamburgischen Universität,'" 34; von Melle quote in Sitzung Protokolle der Hochschulbehörde, Universitätt I 364-5 I B3 Band 1 1922–1929, StA HH.
50. Schiefler, *Hamburgische Kulturgeschichte*, 398. Bernhard Dernburg and Johannes Semler both argued that Hamburg would be the best location for the institute because the Hamburgers could get the money together quickly. A complicated arrangement emerged in which Hamburg was fi-

nancially responsible for its own employees, who in turn were recognized by the empire. Ruppenthal, *Kolonialismus*, 116–117.

51. Nicolaysen, *"Frei soll die Lehre sein und Frei das Lernen,"* 16–17; Bolland, *"'Hamburgischen Universität,'"* 91.

52. Nicolaysen, *"Frei soll die Lehre sein und Frei das Lernen,"* 16; and Grolle, "Blick zurück im Zorn," 114.

53. Gerhardt, *Die Begründer,* 20.

54. Schiefler, *Hamburgische Kulturgeschichte,* 385.

55. In the summer of 1913 Warburg delivered two lectures under the general title "The Ancient World of Star Constellations in Early Modern Art." Treml, Weigel, and Ladwig, introduction to *Aby Warburg,* 326–348. See also Warburg, "From the Arsenal," 119. Gombrich and Saxl, *Aby Warburg,* 192.

56. Gombrich and Saxl, *Aby Warburg,* 206–207.

57. Bolland, *"'Hamburgischen Universität,'"* 79.

58. Fischer-Appelt, "Wissenschaft in der Kaufmannsrepublik," 86–89.

59. Schiefler, *Hamburgische Kulturgeschichte,* 397.

60. Lassar, "Hamburg University as Link," 69.

61. Fritz Schumacher was the right architect for the job, too, for he was known to balance sensitivity to local trends with the so-called international style that was currently in vogue. See Umbach, "Tale of Second Cities," 675. *Jahresbericht 1929 für die Hamburgische Universitätsgesellschaft,* 7; Weygandt, "Ist die Hamburger Universität ein Wagnis?" 163.

62. *Jahresbericht 1929,* 7.

63. McClelland, *State, Society, and the University,* 142–143; Karl Rathgen to Rector of the University of Berlin, March 29, 1919, Universität I 364-5 I C 10.8 Band 1, StA HH; inaugural address cited in Werner von Melle and Karl Rathgen, *Hamburgische Universität Reden, gehalten bei der Eröffnungsfeier am 10. Mai 1919 in der Musikhalle* (Hamburg: Boysen, 1919), 14–15. See also Barbara Vogel, "Anpassung und Widerstand: Das Verhältnis Hamburger Hochschullehrer zum Staat 1919 bis 1945," in *Hochschulalltag im Dritten Reich: Die Hamburger Universität, 1933–1945,* ed. Eckardt Krause, Ludwig Huber, and Holger Fischer, Hamburger Beiträge zur Wissenschaftsgeschichte, 3 (Berlin: Reimer, 1991), 40.

64. Ruppenthal, *Kolonialismus,* 258.

65. Cited in Bolland, *"'Hamburgischen Universität,'"* 86.

66. Winter and Roberts, *Capital Cities at War,* 277.

67. Cecil, *Albert Ballin,* 356.

68. Aby Warburg to Franz Boll, September 15, 1916, Heid Hs. 2108, UB Heidelberg.

69. Aby Warburg to Percy Schramm, March 23, 1917, 622-1/151 Familie Schramm, L 230 Band 11, StA HH.

70. "Lokale Nachrichten: Warburg gegen seine Verleumder," *Hamburger Familienblatt für die Israelitische Gemeinden Hamburg, Altona, Wandsbeck und Hamburg* 15, April 12, 1923.

71. "Warburg, der heimliche Kaiser," *Hamburger Familienblatt für die Israeliti-sche Gemeinden Hamburg, Altona, Wandsbeck und Harburg* 24, June 14, 1923.

72. Max Warburg to Prof. Berger, March 10, 1921, 441/3782 43, UAT. Karl Königseder's article also offers a good overview of the timeline of War-burg's illness and a rich portrait of Kreuzlingen. "Aby Warburg im Belle-vue," in *Aby M. Warburg: "Ekstatische Nymphe, trauernder Flussgott" Portrait eines Gelehrten*, ed. Robert Galitz and Brita Reimers, Schriftenreihe der Hamburgischen Kulturstiftung (Hamburg: Dölling Görlitz, 1995), 74–98, 82; Aby Warburg to Ludwig Binswanger, September 9, 1918, GC, WIA.

73. Königseder, "Warburg in Bellevue," 81. Joseph Roth wrote of that "insti-tution on Lake Constance where spoiled, wealthy madmen underwent careful and expensive treatments, and the attendants were as nurturing as midwives." *The Radetzky March*, trans. Joachim Neugroschel (New York: Overlook Press, 1995), 187. "Aby Warburg Anecdotes," III.134.1.6, WIA.

74. Such conscious personification is found in Daniel A. Bell and Avner de-Shalit, *The Spirit of Cities: Why the Identity of Cities Matters in a Global Age* (Princeton, NJ: Princeton University Press, 2011).

75. Comfort, *Revolutionary Hamburg*, 30–41.

76. Ibid., 47.

77. Bottin and Nicolaysen, *Enge Zeit*, 14. See also Tim Schleider, "Die Haltung der Sozialdemokratie zur Gründung der Hamburgischen Universität" (master's thesis, Universität Hamburg, 1989), 248.

78. Nicolaysen, *"Frei soll die Lehre sein und Frei das Lernen,"* 16–18.

79. Vogel argues that the University of Hamburg in its hierarchical organiza-tion was no more liberal than other German universities. "Anpassung und Widerstand." A different perspective is presented by Michael Grüttner, "Hort der Reaktion oder Hochburg des Liberalismus? Die Hamburger Universität in der Weimarer Republik," in *Eliten im Wandel*, ed. Christian Führer, Karen Hagemann, and Birthe Kundrus (Münster: Westfälisches Dampfboot, 2004), 179–197.

80. Von Melle and Rathgen, *Hamburgische Universität Reden*, 8; Barbara Vogel, "Philosoph und liberaler Demokrat: Ernst Cassirer und die Hamburger Universität von 1919 bis 1933," in *Ernst Cassirers Werk und Wirkung Philoso-phie*, ed. Dorothea Frede and Reinold Schmücker, Kultur und Philosophie (Darmstadt: Wissenschaftliche Buchgesellschaft, 1997), 201.

81. See untitled document from Rector Georg Thilenius, December 9, 1920, requesting support from the faculty at the University of Leipzig in this growing public debate. Phil Fak E3, Bd 2, Film 1227, UAL.

82. Grolle, "Blick zurück im Zorn," 122.

83. Nicolaysen, *"Frei soll die Lehre sein und Frei das Lernen,"* 18.

84. Lippmann, *Mein Leben*, 104. Also cited in Krohn, *Juden in Hamburg: Die politische, soziale, und kulturelle Entwicklung*, 121.

85. Bottin and Nicolaysen, *Enge Zeit*, 38.

86. Only mathematics required the creation of professorial faculty. Vogel, "Philosoph und liberaler Demokrat," 199. Aby Warburg, "Das Problem liegt in der Mitte," in Warburg, *Die Erneuerung der heidnischen Antike*, 1.2:611–614. Translation from Aby Warburg, "The Problem in Between," in Warburg, *Renewal of Pagan Antiquity*, 727.

87. Eric Ziebarth to Aby Warburg, August 9, 1919, GC, WIA; Erich Marcks to Werner von Melle, February 18, 1912, Nachlass von Melle, Bl. 175–8, SUB; "Ernennung von Honorarprofessoren," 1921, Universität I 364-5 D 30.2, StA HH.

88. Max Warburg to Paul Warburg, 1904, FC, WIA.

CHAPTER FOUR

1. Aby Warburg to Werner Weisbach, April 3, 1915, GC, WIA; Fritz Stern, "Julius Langbehn and Germanic Irrationalism," in *The Politics of Cultural Despair: A Study in the Rise of German Ideology*, 2nd ed. (Berkeley: University of California Press, 1974), 97–204.

2. Fritz Saxl, "Ernst Cassirer," in *The Philosophy of Ernst Cassirer*, ed. Paul Arthur Schilpp, Library of Living Philosophers (New York: Tudor, 1958), 47.

3. "Die Universität Hamburg," *Hamburger Familienblatt für die Israelitische Gemeinden Hamburg, Altona, Wandsbeck und Harburg*, March 31, 1919, 1; Dimitry Gawronsky, "Ernst Cassirer: His Life and His Work: A Biography," in Schilpp, *Philosophy of Ernst Cassirer*, 26.

4. Till van Rahden, *Jews and Other Germans*, 3–6.

5. Other illustrious alumni of the Johanneum include the sociologist Norbert Elias. Ibid., 154, 155–157; Gawronsky, "Ernst Cassirer," 3; Saxl, "Ernst Cassirer," 51.

6. Gawronsky, "Ernst Cassirer," 4, 36.

7. Mogens Blegvad, "A Simmel Renaissance?" *Acta Sociologica* 32 (1989): 203–209, esp. 206.

8. Gawronsky, "Ernst Cassirer," 7.

9. Immanuel Kant, *First Critique*, see A 106 III, 616, cited in Cassirer, *Kant's Life and Thought*, 170.

10. Arthur Schopenhauer, "Sketch of a History of the Doctrine of the Ideal and the Real," *Parerga and Paralipomena: Short Philosophical Essays I*, ed. and trans. E. F. J. Payne I (New York: Oxford University Press, 2001), 1–28, citation on 12.

11. Cassirer, *Kant's Life and Thought*, 216.

12. Ibid., 369.

13. This microhistory of 1781 to 1794 is told as a debate concerning the authority of reason by Frederick C. Beiser, *The Fate of Reason: German Philosophy from Kant to Fichte* (Cambridge, MA: Harvard, 1987).

14. Literally, the *"Bescheidenheit des Viehs."* G. W. F. Hegel, foreword to Hinrich's *Religion* (1822), in *Theologian of the Spirit*, by G. W. F. Hegel, ed. Peter C. Hodgson, (Minneapolis: Augsburg Fortress, 1997), 163.

15. Klaus-Christian Köhnke has argued against a teleological approach to the history of neo-Kantianism. *The Rise of Neo-Kantianism: German Academic Philosophy between Idealism and Positivism*, trans. R. J. Hollingdale (New York: Cambridge University Press, 1991), 137.

16. In Köhnke's revision, Liebmann is the culmination rather than the beginning of neo-Kantianism. Ibid., 138–148. The confusion occurs, in part, because Liebmann "understood reason in a rather un-Kantian way as a product of nature." Kuhn, "Interpreting Kant Correctly: On the Kant of the Neo-Kantians," in Makkreel and Luft, *Neo-Kantianism in Contemporary Philosophy*, 114.

17. Although they embraced epistemology, the neo-Kantians' works bore the influence of post-Kantian idealism in their understanding of how objects conform to our minds. For Kant, the a priori structures that mediated between the pure forms of judgment and pure forms of sensible intuition were space and time. Both versions of neo-Kantianism rejected the idea of an independent faculty of pure intuition and also followed post-Kantian idealism in opposing this dualistic conception of mind. Friedman, *Parting of the Ways*, 27–28.

18. Ernst Cassirer, "Die Erneuerung der Kantischen Philosophie," *Kant-Studien* 17 (1912): 252–273, also cited by Kuhn, "Interpreting Kant Correctly," 116.

19. See, for example, Friedman, "Ernst Cassirer and Thomas Kuhn: The Neo-Kantian Tradition in the History and Philosophy of Science," in Makkreel and Luft, *Neo-Kantianism in Contemporary Philosophy*, 177–191; and Gregory B. Moynahan, "Herman Cohen's *Das Prinzip der Infinitesimalmethode*, Ernst Cassirer, and the Politics of Science in Wilhelmine Germany," *Perspectives on Science* 11 (2003): 35–75.

20. Willey, *Back to Kant*, 131.

21. On Husserl's correspondence with Cassirer, see Makkreel and Luft, introduction to *Neo-Kantianism in Contemporary Philosophy*, 6; on the Southwest School's influence on Weber (as well as on Dilthey, Troetlsch, and Meinecke), see Willey, *Back to Kant*, 164.

22. The Marburg School's emphasis on logicism led them to wage battle against anything resembling subjectivism and psychology. Rickert, in contrast, believed that values existed prior to our beginning to think. Kuhn, "Interpreting Kant Correctly," 121, 122; quotation on 123.

23. Cohen and Natorp replaced Kant's static version of synthetic a priori judgments with a more genetic (*erzeugende*) conception of scientific knowledge more conducive to contemporary developments in science. Friedman, "Ernst Cassirer and Thomas Kuhn," 178.

24. While unkind to the Catholics, minister Falk appointed many neo-Kantians among their ranks, including Friedrich Albert Lange and, following his death, Hermann Cohen. Köhnke, *Rise of Neo-Kantianism*, 220–221.
25. Cited in Peter Eli Gordon, *Rosenzweig and Heidegger: Between Judaism and German Philosophy* (Berkeley: University of California Press, 2003), 29–30.
26. Lipton, *Ernst Cassirer*, 23.
27. Cited in Ernst Cassirer, *The Philosophy of the Enlightenment*, trans. James P. Pettegrove and Fritz C. A. Koelin (Princeton, NJ: Princeton University Press, 1968), vii, 51. Originally published in German as *Die Philosophie der Aufklärung* (Tübingen: J.C.B. Mohr, 1932). Citations are to the English edition.
28. Gideon Freudenthal, "The Hero of the Enlightenment," in Barash, *Symbolic Construction of Reality*, 189–213.
29. See, for example, Gershom Scholem, *From Berlin to Jerusalem: Memories of My Youth*, ed. and trans. Harry Zohn (New York: Schocken Books, 1988), 68.
30. Gawronsky, "Ernst Cassirer," 7.
31. Hartwig Wiedebach, *Die Bedeutung der Nationalität für Hermann Cohen* (Hildesheim: Georg Olms, 1997).
32. Hermann Cohen, "Ein Bekenntnis zur Judenfrage" (1880), in *Der Berliner Antisemitismusstreit*, ed. Walter Boehlich (Frankfurt: Insel, 1965), 124–125, cited and translated in Köhnke, *Rise of Neo-Kantianism*, 274–275.
33. Poma, "Hermann Cohen," 82.
34. Jürgen Habermas, "The German Idealism of the Jewish Philosophers," in *Philosophical-Political Profiles*, by Jürgen Habermas, trans. Frederick G. Lawrence (Cambridge, MA: MIT Press, 1985), 21–43, quotation on 27; Mosse cited in Willey, *Back to Kant*, 5. See also Mosse, *Germans and Jews: The Right, the Left, and the Search for a Third Force in Pre-Nazi Germany* (Detroit: Wayne State University Press, 1987), 179–182.
35. Arguably, this work was already set in motion by the first generation of neo-Kantians and Cohen's senior colleague Lange, known as the "Kantian democrat," who, by replacing Hegel's dialectical monism with Kant's ethic of freedom, offered a philosophical justification for revisionist socialism. Willey, *Back to Kant*, esp. 83, 89, 174.
36. Ibid., 109. One scholar has gone so far as to say that while he may have been a neo-Kantian, Cohen was not a Kantian. Köhnke, *Rise of Neo-Kantianism*, xiii.
37. Willey, *Back to Kant*, 108; Köhnke, *Rise of Neo-Kantianism*, 183–193, Cohen's translated quotation on 183.
38. Kuhn, "Interpreting Kant Correctly," 117–120.
39. Gawronsky, "Ernst Cassirer," 22; Paul Natorp to Albert Görland, September 24, 1904, SUB, in Hermann Cohen and Paul Natorp, *Der Marburger Neukantianismus in Quellen: Zeugnisse kritischer Lektüre, Briefe der Marburger, Dokumente zur Philosophiepolitik der Schule*, ed. Helmut Holzhey (Basel: Schwabe, 1986), 329.

40. Cassirer eventually published four volumes, only the last of which is known, but misunderstood, argues John Michael Krois, in the English-speaking world. "A Note about Philosophy and History: The Place of Cassirer's *Erkenntnisproblem*," *Science in Context* 9 (1996): 191–194.

41. John Michael Krois, "Ernst Cassirer: 1874–1945," in *Die Wissenschaftler: Ernst Cassirer, Bruno Snell, Siegfried Landshut*, by John Michael Krois, Gerhard Lohse, and Rainer Nicolaysen (Hamburg: Verlag für Hamburgische Geschichte, 1994), 15, 16; Toni Cassirer, *Mein Leben mit Ernst Cassirer* (Hildesheim: Gerstenberg, 1981), 108; quotation in Gawronsky, "Ernst Cassirer," 13.

42. "Warburg, der heimliche Kaiser," *Hamburger Familienblatt für die Israelitische Gemeinden Hamburg, Altona, Wandsbeck und Harburg*, June 14, 1923; Max Tau, "Mit Familienanschluß bei Cassirers—Studium nach den Ersten Weltkrieg," in *Fremd in der eigenen Stadt: Erinnerungen jüdischer Emigranten aus Hamburg*, ed. Charlotte Uekert-Hilbert (Hamburg: Junius, 1989), 67.

43. Cassirer, *Mein Leben mit Ernst Cassirer*, 16. Julie Cassirer's older brother Eduard Cassirer was Ernst's father.

44. Ibid., 22–26, quotation on 26.

45. Ibid., 29 (first quotation), 26–27.

46. Hermann Cohen to Paul Natorp, March 21, 1902, in Cohen and Natorp, *Der Marburger Neukantianismus in Quellen*, 276; Toni Cassirer to Paul Natorp, November 2, 1902, Ms 831 Nr. 668, NNL; Ernst Cassirer and Toni Cassirer to Paul Natorp, January 23, 1914, Ms 831 Nr. 651a, NNL.

47. Ernst Cassirer to Paul Natorp, August 11, 1903, Ms 831 Nr. 617, NNL. Ernst Cassirer's colleague the psychologist William Stern researched developmental psychology and pedagogy, subjects that greatly interested Cassirer. Helmut E. Lück, "'Noch ein weiterer Jude ist natürlich ausgeschlossen': William Stern und das Psychologische Institut der Universität Hamburg," in *Die Juden in Hamburg 1590 bis 1990: Wissenschaftliche Beiträge der Universität Hamburg zur Ausstellung "Vierhundert Jahre Juden in Hamburg,"* ed. Arno Herzig and Saskia Rohde, Die Geschichte der Juden in Hamburg, 2 (Hamburg: Dölling und Galitz, 1991), 409; Cassirer, *Mein Leben mit Ernst Cassirer*, 104.

48. Cassirer, *Mein Leben mit Ernst Cassirer*, 105.

49. Tau, "Mit Familienanschluß bei Cassirers," 72; Heise, *Persönliche Erinnerungen*, 12; Cassirer, *Mein Leben mit Ernst Cassirer*, 143.

50. Tau, "Mit Familienanschluß bei Cassirers," 67.

51. On the eighteenth- and nineteenth-century salon, see, for example, Deborah Hertz, *Jewish High Society in Old Regime Berlin*, Modern Jewish History Series (Syracuse, NY: Syracuse University Press, 2005); Tau, "Mit Familienanschluß bei Cassirers," 67.

52. Marianne Weber did not limit herself to the role of facilitator but instead used her *Professorenfrau* status to acquire auditing privileges and

NOTES TO PAGES 104–107

to establish Heidelberg as a center of the women's movement. Christa Krüger, *Max und Marianne Weber: Tag- und Nachtgeschichten einer Ehe* (Zürich: Pendo, 2001). For a discussion of the Sunday *Jours*, see Gesa von Essen, "Max Weber und die Kunst der Geselligkeit," in *Heidelberg im Schnittpunkt intellektueller Kreise: Zur Topographie der 'geistigen Geselligkeit' eines 'Weltdorfes': 1850–1950*, ed. Hubert Treiber and Karol Sauerland (Opladen: Westdeutscher, 1995), 467–80.

53. Cassirer, *Mein Leben mit Ernst Cassirer*, 135; Albert Einstein to Toni Cassirer, August 1, 1951, 8-397, AEA; Toni Cassirer to Albert Einstein, August 9, 1951, 8-398, AEA; Tau, "Mit Familienanschluss bei Cassirers," 66; Raymond Klibansky, *Erinnerung an ein Jahrhundert: Gespräche mit Georges Leroux* (Frankfurt am Main: Insel, 2001), 11, 43.

54. For a discussion of the semiprivate and semipublic world of salons, see Hertz, *Jewish High Society*, 18.

55. Cassirer, *Mein Leben mit Ernst Cassirer*, 94; also cited in John Michael Krois, "Why Did Cassirer and Heidegger Not Debate in Davos? in *Symbolic Forms and Cultural Studies: Ernst Cassirer's Theory of Culture*, ed. Cyrus Hamlin and John Michael Krois (New Haven, CT: Yale University Press, 2004), 246.

56. Friedman, *Parting of the Ways*, 89.

57. This is the distinction Cassirer makes (discussed further in chapter 9) between the eighteenth century's "value of system, the 'esprit systématique'" and the seventeenth century's "love of system for its own sake, the 'esprit de système.'" Cassirer, *Philosophy of the Enlightenment*, 8.

58. Ibid., 69.

59. Cassirer, *Kant's Life and Thought*, 360.

60. The traditional interpretation inspired by Hughes was that the Bergson-Sorel position was protofascist, while Freud and Weber lay on the liberal side of the spectrum. This position was supported by studies such as that of Zeev Sternhell, *The Birth of Fascist Ideology*, trans. David Maisel (Princeton, NJ: Princeton University Press, 1994), although it is worth noting that more recent scholarship seeks to return Sorel to the wider framework of liberal France. See Eric Brandom, "Georges Sorel, Autonomy and Violence in the Third Republic," a dissertation submitted to the Department of History, Duke University, October 2012.

61. Although Hughes does not mention Cassirer, the term seems appropriate. Hughes, *Consciousness and Society*, 204.

62. Gawronsky, "Ernst Cassirer," 25, 36.

63. Cassirer, *Kant's Life and Thought*, 59. Gawronsky suggests that Cassirer's intellectual similarity to Goethe extended to a physical resemblance. "Ernst Cassirer," 24. On Goethe's intellectual influence on Cassirer, see Cyrus Hamlin, "Goethe as a Model for Cultural Values: Ernst Cassirer's Essay on Thomas Mann's *Lotte in Weimar*," in Hamlin and Krois, *Symbolic Form and Cultural Studies*, 185–203; Lang, *Chaos and Cosmos*, 87–88.

64. Goethe cited by Cassirer, *Kant's Life and Thought*, 273.
65. Ernst Cassirer, *The Philosophy of Symbolic Forms*, trans. Ralph Manheim, 3 vols. (New Haven, CT: Yale University Press, 1955–57), 1:69, 75. Originally published as *Philosophie der symbolischen Formen*, 3 vols. (Berlin: Bruno Cassirer, 1923–1929).
66. Ernst Cassirer, *Substance and Function* (1910) *and Einstein's Theory of Relativity* (1921) (both books bound as one), trans. William Curtis Swabey and Marie Collins Swabey (Mineola, NY: Dover, 2003), 445–447.
67. Skidelsky shows how Cassirer was influenced by the "new anthropology" proposed by the "Romantics" Herder, Schiller, Humboldt, and Goethe and their respective work on language, myth, and culture. *Ernst Cassirer*, 72.
68. Cassirer, *Substance and Function and Einstein's Theory of Relativity*, 445, 447.
69. Cassirer, *Philosophy of Symbolic Forms*, 1:79–80.
70. Ibid., 1:80.
71. Friedman, *Parting of the Ways*, 143–144.
72. Vogel, "Philosoph und liberaler Demokrat," 206.
73. Cassirer, *Philosophy of Symbolic Forms*, 1:69.
74. Gertrud Bing, "Fritz Saxl (1890–1948): A Memoir," in *Fritz Saxl (1890–1948): A Volume of Memorial Essays from His Friends in England*, ed. D. J. Gordon (London: Nelson, 1957), 1–46.
75. Warburg occasionally mocked his Austrian accent. McEwan, introduction to *Ausreiten der Ecken*, 31.
76. Fritz Saxl to Aby Warburg, November 28, 1920, in *ECWB*, 241; Saxl, "History of Warburg's Library," an essay in Gombrich and Saxl, *Aby Warburg*, 331.
77. Saxl, "Ernst Cassirer," 49–50; Cassirer, *Mein Leben mit Ernst Cassirer*, 126; Ernst Cassirer to Aby Warburg, June 26, 1921, in *ECWB*, 53.
78. Fritz Saxl to Ernst Cassirer, March 21, 1923, in *ECWB*, 55.
79. Saxl, "History of Warburg's Library," in Gombrich and Saxl, *Aby Warburg*, 334.
80. Cassirer, *Mein Leben mit Ernst Cassirer*, 48.
81. Ernst Cassirer, "Critical Idealism as a Philosophy of Culture: Lecture to the Warburg Institute, 26 May 1936," in *Symbol, Myth, and Culture, Essays and Lectures of Ernst Cassirer, 1935–1945*, ed. Donald Verene (New Haven, CT: Yale University Press, 1979), 90–91.
82. Ernst Cassirer, "Der Begriff der Symbolischen Form in Aufbau der Geisteswissenschaften," in *Vorträge der Bibliothek Warburg* (Leipzig: B.G. Teubner, 1923), 1:11–39, translation by J. M. Krois, *Symbolic Forms and History* (New Haven, CT: Yale University Press, 1987), 50.
83. Fritz Saxl to Ernst Cassirer, July 15, 1921, box 2, folder 31, Ernst Cassirer Papers—Addition, Gen Mss 355, GC, BRBML.
84. Robert Vischer, "On the Optical Sense of Form: A Contribution to Aesthetics," in *Empathy, Form, and Space; Problems in German Aesthetics, 1873–1893*, ed. Harry Francis Mallgrave and Eleftherios Ikonomou (Santa Monica,

CA: The Getty Center for the History of Art and the Humanities, 1994), 89–123. Originally published as *Über das optische Formgefühl: Ein Beitrag zur Ästhetik* (Leipzig: Credner, 1872).

85. Gombrich, in particular, believes this adaptability presents the possibility for the "inversion" of hostile emotions to expressions of heroism. Gombrich and Saxl, *Aby Warburg*, 72–75; Forster, introduction to Warburg, *Renewal of Pagan Antiquity*, 38. According to Robert J. Richards, Darwin was essentially a German romantic. *The Romantic Conception of Life: Science and Philosophy in the Age of Goethe* (Chicago: University of Chicago Press, 2002).

86. Darwin's work appeared simultaneously in English and German in 1872. Ernst Haeckel was largely responsible for popularizing "Darwinism" in Germany. Robert J. Richards, *The Tragic Sense of Life: Ernst Haeckel and the Struggle over Evolutionary Thought* (Chicago: University of Chicago Press, 2008); and "General Congress of Monists," *Monist* 21 (1911): 307.

87. Marsha Morton, "From *Monera* to Man: Ernst Haeckel, *Darwinismus*, and Nineteenth-Century German Art," in *The Art of Evolution: Darwin, Darwinism, and Visual Culture*, ed. Barbara Larson and Fae Brauer (Hanover, NH: Dartmouth College Press, 2009), 59–91, esp. 59–61.

88. Cited in Gombrich and Saxl, *Aby Warburg*, 90–91.

89. Cited and translated ibid., 214; Warburg, *Die Erneuerung der Heidnische Antike*, 1.2:534.

90. Gombrich and Saxl, *Aby Warburg*, 215; Fritz Saxl to Ernst Cassirer, April 12, 1923, in *ECWB*, 59.

91. Saxl, "History of Warburg's Library," in Gombrich and Saxl, *Aby Warburg*, 334, 327.

92. Ernst Cassirer to Fritz Saxl, March 24, 1923, in *ECWB*, 56.

93. Aby Warburg to Ernst Cassirer, March 27, 1923, in *ECWB*, 57, also cited in Cassirer, *Mein Leben mit Ernst Cassirer*, 150.

94. Saxl, "Ernst Cassirer," 49–50.

95. Ibid., 50.

96. Michael Foucault translated Binswanger's 1930 work *Dream and Existence* into French and added a substantial introduction. *Dream and Existence*, ed. Keith Hoeller, Studies in Existential Psychology and Psychiatry (Atlantic Highlands, NJ: Humanities Press International, 1993).

97. Fritz Saxl to Ernst Cassirer, March 27, 1923, in *ECWB*, 58.

98. Warburg was also animated by Franz Boll at this time and was disappointed by his premature death in 1924 because he would not be able to connect him with Cassirer. When he returned to Hamburg, Warburg would deliver a lecture in memory of Boll. See Aby Warburg, "Per Monstra ad Sphaeram: Sternglaube und Bilddeutung," in *Vortrag in Gedenken an Franz Boll und andere Schriften 1923 bis 1925*, ed. Davide Stimilli and Claudia Wedepohl (Munich: Dölling und Galitz, 2008), 42.

99. Ludwig Binswanger to Sigmund Freud, November 8, 1921, in Sigmund Freud, Gerhard Fichtner, and Ludwig Binswanger, *The Sigmund Freud–*

Ludwig Binswanger Correspondence, 1908–1938 (New York: Other Press, 2003), 175.

100. Chickering describes this avid collecting as a kind of mania (*efriger Sammelwut*). *Karl Lamprecht*, 7. But as it relates to Warburg at least, I disagree with the comparison to Walter Benjamin's famous essay "Unpacking My Library," in *Illuminations*, ed. Hannah Arendt, trans. Harry Zohn (New York: Schocken Books, 1969), 59–67, here 59.

101. Saxl, "Ernst Cassirer," 48; Davide Stimilli and Claudia Wedepohl, introduction to Aby Warburg, "Per Monstra ad Sphaeram: Sternglaube und Bilddeutung," 20.

102. Cassirer, *Philosophy of Symbolic Forms*, 1:72.

103. Warburg reorganized these images in different iterations over the next several years and presented them in exhibits such as the "Rembrandt Exhibit" (1926) and the "Ovid Exhibition" (1927). Inexplicably, Warburg eventually removed the text from these images. Gombrich and Bing tried to restore the images to their original organization and added explanatory text. For the publication history of the *Bilderatlas*, see Warburg, *Der Bilderatlas*, vii–viii.

104. *TKBW*, 144, also cited in Schoell-Glass, "'Serious Issues': The Last Plates," in Woodfield, *Art History as Cultural History*, 185.

105. Kurt Sternberg, "Cassirer, Ernst: Prof. an der Universität Hamburg: Die Begriffsform im mythischen Denken," *Kantstudien* 20 (1925): 194–195, also cited in Peter Eli Gordon, "Myth and Modernity: Ernst Cassirer's Critique of Heidegger," *New German Critique* 94 (2005): 139.

106. This episode is described in Horst Bredekamp, "'4 Stunden Fahrt. 4 Stunden Rede': Aby Warburg besucht Albert Einstein," in *Einstein on the Beach: Der Physiker als Phänomen*, ed. Michael Hagner (Frankfurt am Main: Fischer Taschenbuch, 2005), 165–182.

107. Cassirer, *Individual and Cosmos*, 75.

108. Ibid., 91–92.

109. Ernst Cassirer, dedication to Aby Warburg, *Individual and Cosmos*, xiii, translation altered by author. Ernst Cassirer to Aby Warburg, Fritz Saxl, and Gertrud Bing, September 21, 1927, in *ECWB*, 99.

110. Bing, "Fritz Saxl," 16; Fritz Saxl to Aby Warburg, December 8, 1921, in *ECWB*, 242.

111. Cassirer, *Philosophy of Symbolic Forms*, 81, 83.

112. Gombrich and Saxl, *Aby Warburg*, 324 (my emphasis).

113. Ernst Cassirer, *Language and Myth* (New York: Dover, 1946), 98.

CHAPTER FIVE

1. Erwin Panofsky to Dora Panofsky, July 3, 1920, in *EPK*, 1:76–77.

2. Panofsky's first lecture at Hamburg explored the development of the idea of proportion in the Egyptian, Greek, medieval, and modern periods.

Erwin Panofsky, "Die Entwicklung der Proportionslehre als Abbild der Stilentwicklung," in *EPDA*, 1:31–72. His public entrance lecture for his *Habilitation* occurred on November 10, 1920 and was titled "Michel Angelo und Lionardo: Ein Gegesatz der künsterischen Weltanschauung." See the advertisement for the lecture in *EPK*, 1:86.

3. Erwin Panofsky, "Style and Medium in the Motion Pictures," in *Three Essays on Style*, ed. Irving Lavin (Cambridge, MA: MIT Press, 1997), 93–123, quotation on 120.

4. See Carl Petersen's speech at Cassirer's induction ceremony on November 8, 1929. "Rektoratswechsel," Staatliche Pressestelle I–IV 135-I I–IV 5377, November 9, 1929, StA HH.

5. For a good biographical overview of Panofsky, see Michels and Warnke, foreword to *EPDA*, 1:ix–xvii.

6. It should be mentioned, however, that the greater number of sons of bankers that embarked on this path only precluded the option for their young brothers, as Fritz E. Oppenheimer shared with Erwin Panofsky. October 15, 1966, in *EPK*, 5:911. On the anecdotal resonance of this phenomenon see also Colin Eisler, "*Kunstgeschichte* American Style," in *The Intellectual Migration: Europe and America, 1930–1960*, ed. Donald Fleming and Bernard Bailyn (Cambridge, MA: Harvard University Press, 1969), 554.

7. Ibid.; Karen Michels, "Erwin Panofsky und das Kunsthistorische Seminar," in Herzig and Rohde, *Die Juden in Hamburg*, 389.

8. According to Panofsky, Vöge's scholarly interests and multifaceted career resisted characterization. "Wilhem Vöge, 16. Februar 1868–30. Dezember 1952," in *EPDA*, 2:1121–1122.

9. Kultermann, *History of Art History*, 196–198.

10. Erwin Panofsky to Hohe Philosophische Fakultät der Hamburgischen Universität (Prof. Dr. Max Lenz), March 11, 1920, in *EPK*, 1:69.

11. Frustrated with the strict Prussian university system, Wölfflin left Berlin in 1912 to return to Munich and recommended his young colleague Goldschmidt for his former position. Goldschmidt's now vacant chair in Halle was then offered to Warburg, and Warburg declined the position out of seeming loyalty to Hamburg. Kathryn Brush, "Adolph Goldschmidt (1863–1944)," in *Medieval Scholarship: Biographical Studies on the Formation of a Discipline*, vol. 3, *Philosophy and the Arts*, ed. Helen Damico et al (New York: Garland, 2000), 247.

12. Ibid., 245. Goldschmidt also discusses this transformation in his memoir. *Lebenserinnerungen*, ed. Marie Roosen-Runge et al. (Berlin: Deutscher Verlag für Kunstgeschichte, 1989), 45–46.

13. Following this visit, Panofsky and Warburg exchanged at least two letters about their shared research interests. Erwin Panofsky to Aby Warburg, November 9, December 8, 1915; December 18, 1925, in *EPK*, 1:28–29, 32, and 34.

14. Hans Kauffmann to S. H. Herrn Geheimrat (Friedrich Kauffmann), December 28, 1915, in *EPK*, 1:34–35; William S. Heckscher, "Erwin Panofsky: A Curriculum Vitae," in *Record of the Art Museum, Princeton University* 28 (1969): 10. Panofsky concurred with Hecksher's assessment. "Gustav Pauli *Nachruf*," in *EPDA*, 2:1119.

15. Gustav Pauli to Erwin Panofsky, December 31, 1919, Hamburg Kunsthalle, in *EPK*, 1:6.

16. Erwin Panofsky, "Three Decades of Art History in the United States: Impressions of a Transplanted European," in Panofsky, *Meaning in the Visual Arts* (Chicago: University of Chicago Press, 1982), 336. At the time of this book's preparation, a draft version of Panofsky's *Habilitation*, "Die Gestaltungsprinzipien Michelangelos in ihren Verhältnis zu Raffael," never published and long thought to be missing, was discovered in the basement of the Zentralinstitut für Kunstgeschichte in Munich, but it has not been made available to this author for her perusal. For more on this discovery see Williband Sauerländer, "Es war ein viel zu ehrgeiziger Versuch," *Süddeutsche Zeitung*, September 6, 2012: 13.

17. Panofsky was particularly concerned about the apartment situation in Hamburg, and Pauli had tried in vain to secure for him the apartment that Siegfried Wedells had bequeathed to the city. Gustav Pauli to Bürgermeister von Melle, November 19, 1920, StA HH; also in *EPK*, 1:88; Erwin Panofsky to Dora Panofsky, July 9, 1920, in *EPK*, 1:78–79; the verse quoted in "Kunsthistorisches Alphabet," nr. 149, undated, Kunstgeschichtlichen Seminars der Universität Hamburg, WHH.

18. For a comprehensive history of the inflation, see Gerald D. Feldman, *The Great Disorder: Politics, Economics, and Society in the German Inflation, 1914–1924* (New York: Oxford University Press, 1993). For a review of Hamburg's situation during the inflation, see Ferguson, *Paper and Iron*. Toni Cassirer pleaded with her husband to request that the bicycle route alternate directions. *Mein Leben mit Ernst Cassirer*, 128.

19. Bernd Widdig, *Culture and Inflation in Weimar Germany* (Berkeley: University of California Press, 2001), 181.

20. Peter Freimark, "Juden an der Hamburger Universität," in Krause, Huber, and Fischer, *Hochschulalltag im 'Dritten Reich': Die Hamburger Universität 1933–1945*, 1: 136.

21. Max Weber, "Science as a Vocation," in *From Max Weber: Essays in Sociology*, ed. and trans. H. H. Gerth and C. Wright Mills (New York: Oxford University Press, 1946), 129–130 (quotation), 132.

22. Georg Schreiber, "The Distress of German Learning," in *The German Inflation of 1923*, ed. Fritz Ringer, Problems in European History: A Documentary Collection (New York: Oxford University Press, 1969), 105–107, quotation on 109; Fritz K. Ringer, *The Decline of the German Mandarins: The German Academic Community, 1890–1933* (Middletown, CT: Wesleyan University Press, 1990), 65.

NOTES TO PAGES 128–130

23. Erwin Panofsky to Hohe Philosophische Fakultät der Hamburgischen Universität (Prof. Dr. Max Lenz), March 1, 1920, in *EPK*, 1:70; Albert Mosse to Dora and Erwin Panofsky, June 23, 1917, LBI; also in *EPK*, 1:50.

24. Lina Mosse to Dora and Erwin Panofsky, April 7, 1917, LBI; also in *EPK*, 1:48.

25. Heckscher, "Erwin Panofsky," 10; and Horst W. Janson, "Erwin Panofsky," in *Biographical Memoirs in American Philosophical Society Yearbook 1969–70* (Philadelphia: George H. Buchanan, 1970), 152.

26. Michels and Warnke, foreword to *EPK*, 1:ix; Alfred Weber, "The Predicament of Intellectual Workers," in *The Weimar Republic Sourcebook*, ed. Anton Kaes, Martin Jay, and Edward Dimendberg (Berkeley: University of California Press, 1994), 295.

27. Richard Cándida Smith, "A Secretary's Recollections of Erwin Panofsky: Roxanne S. Heckscher," Heckscher Archiv 19, 1994, WHH; Richard M. Ludwig, ed., *Dr. Panofsky and Mr. Tarkington: An Exchange of Letters, 1938–1946* (Princeton, NJ: Princeton University Press, 1974), 51.

28. Elisabeth Kraus makes this argument about the Mosse family inheritance. *Die Familie Mosse: Deutsch-jüdisches Bürgertum im 19. und 20. Jahrhundert* (Munich: C.H. Beck, 1999), 537.

29. Albert Mosse to Dora and Erwin Panofsky, October 30, 1920, LBI; also in *EPK*, 1:85.

30. Erwin Panofsky, "Notizzettel wegen Besoldung," July 14, 1922, or shortly thereafter, in *EPK*, 1:116; quoted phrase in Erwin Panofsky to Kurt Badt, July 24, 1922, in *EPK*, 1:117.

31. Panofsky, "Three Decades of Art History," 336.

32. Erwin Panofsky to Kurt Badt, July 24, 192, in *EPK*, 1:117.

33. Paul Frankl became *Ordinarius* in 1921. Karen Michels, "Art History, German Jewish Identity, and the Emigration of Iconology," in *Jewish Identity in Modern Art History*, ed. Catherine M. Soussloff (Berkeley: University of California Press, 1999), 170.

34. Erwin Panofsky to A. Grisebach, November 26, 1929, Staatliche Museen Berlin- Kunstbibliothek. By the end of his tenure at the University of Hamburg, Panofsky had supervised almost forty dissertations, although eight of these were formally finished after his 1933 departure from Hamburg. "Dissertations completed under Panofsky," 13, undated, WHH. Panofsky said that he often held private seminars in his home that ran from ten in the evening to two the next morning. Erwin Panofsky to Henri M. Peyre, December 7 1955, in *EPK*, 3:876.

35. Erwin Panofsky to Bruno Snell, March 27, 1952, Hochschulwesen Dozenten und Personalakten 361–6 IV 1204, StA HH.

36. Erwin Panofsky to Henri M. Peyre, December 7, 1955, in *EPK*, 3:876.

37. University Senate Minutes, Universität I 364-5 C 20.4.1 Band 5a, July 24, 1931, StA HH; University Senate Minutes, Universität I 364-5 I 20.4.1 Band 5a, June 19, 1931, StA HH; Lina Mosse to Dora Panofsky, July 21, 1927, LBI; also in *EPK*, 1:237; *TKBW*, 268.

38. Staatliche Pressestelle I–IV 135-I 5396, Gesellschaft von Freunden der Hamburgischen Universität, 1923–1929, StA HH; University Senate Minutes, Universität I 364-5 I C 20.4.1 Band 5a, August 7, 1931, StA HH.

39. University Senate Minutes, Universität I 364-5 I C 20.4.1 Band 5a, August 7, 1931, StA HH.

40. Staatliche Pressestelle I–IV 135-I 5396, Gesellschaft von Freunden der Hamburgischen Universität, 1923–1929, StA HH; Mary Warburg to Aby Warburg, November 17, 1928, FC, WIA. The minutes from the society's meetings and newspaper reports of the event also revealed that Panofsky had authored the play. "Gesellschaft von Freunden der Hamburgischen Universität, Staatliche Pressestelle I–IV 135-I 5396, 1928, StA HH. By 1928 the total number of the society's members had reached more than four hundred and included patrons such as Aby Warburg and his brothers; the membership included most of the university's professors. Professors also encouraged their students to join at a lower fee. *Hamburgische Universitätsgesellschaft: I. Jahresbericht erstattet für die Zeit von der Gründung der Gesellschaft bis zum 31. Dezember 1928* (Hamburg: March 1929), 6, 12.

41. Erwin Panofsky, *Sokrates in Hamburg, oder vom Schönen und Guten* (Hamburg: Gesellschaft der Bücherfreunde zu Hamburg, 1991), originally published under the pseudonym A. F. Synkop, in *Der Querschnitt* 2 (1931): 593–599. Apart from Edith Oppens's memoir and Beate Noack Hilgers's clever Greek translation, the scholarly literature devoted to this play has overlooked this reference. Oppens, *Der Mandrill*, 67; Hilgers, "Platons Phaidros und der Kunsthistoriker Erwin Panofsky: Rezeption und Retroversion eines geistreichen und humorvollen Essays," in *Präsentation der Reihe: Platons Phaidros und der Kunsthistoriker Erwin Panofsky*, ed. Beta Noack-Hilgers, Subsidia Classica (St. Katharinen: Scripta Mercaturae, 1998), 1–10. Kai Kibbel's master's thesis, however, includes the play in his discussion of the university's festival culture during the Weimar Republic. "Das Selbstverständnis der Ordinarius an der Hamburgischen Universität in der Weimar Republik" (master's thesis, Humboldt Universität zu Berlin, 2005), 112. Thanks to Eckart Krause for alerting me to the newspaper accounts of this event in StA HH.

42. *Phaedrus Hamburgensis* should not be understood, as Karl Landauer suggests, as an expression of Panofsky's preference for Berlin's fast-paced intellectual scene over the provincial *Hansestadt*. "Survival of Antiquity," 244. Nor does it make sense to view the play as an obituary for Panofsky's colleague Warburg, since the original context of the play's production predates Warburg's death on October 25, 1929. Heinrich Dilly, "Sokrates in Hamburg: Aby Warburg und seine kulturwissenschaftliche Bibliothek," in Bredekamp et al., *Aby Warburg*, 126.

43. Panofsky, *Sokrates in Hamburg*, 5; Heinrich Heine, "Aus den Memoiren," 169.

44. Panofsky, *Sokrates in Hamburg*, 10, 11.

45. Ibid., 12, 13.
46. Ibid., 20.
47. R. Hackforth, *Plato's Phaedrus*, Library of Liberal Arts (Indianapolis: Bobbs-Merrill, 1952), 9; Plato, *Phaedrus*, ed. and trans. Robin Waterfield, Oxford World's Classics (Oxford: Oxford University Press, 2002), xxxiii.
48. Ibid., 261a, xxxiii.
49. Ibid., 246b.
50. Panofsky, *Sokrates in Hamburg*, 19.
51. In 1897, no fewer than thirteen of the eighteen-member senate lived in Harvestehude. Evans, *Death in Hamburg*, 56. The house at Mittelweg 17 belonged first to Charlotte and Moritz Warburg and later to Aby's younger brother Fritz and Anna Beata Warburg. The other side of the Warburg family, stemming from Siegmund and Théophilie, lived a few blocks away at Alsterufer 18. Chernow, *Warburgs*, 19–20.
52. Georg Thilenius, "Vom Akademischen Gymnasium zur Hamburgischen Universität," in *Festschrift der Hamburgischen Universität ihrem Ehrenrektor Herrn Bürgermeister Werner von Melle* (Hamburg: J.J. Augustin, 1933), 4.
53. The scholar Bernd Widdig has recently argued that the inflation should not be understood as an independent economic occurrence but rather as a prism through which the various "anxieties of modernity" were reflected. *Culture and Inflation*, 16. See also Gerald Feldman, "Weimar Writers and the German Inflation," in *Fact and Fiction: German History and Literature: 1848–1924*, ed. Gisela Brude-Firnau and Karin J. MacHardy, Beiträge zur deutschen und vergleichenden Literaturwissenschaft (Tübingen: Francke, 1990), 173–183.
54. Feldman, *Great Disorder*, 262, 688, 803; Schreiber, "Distress of German Learning," 109; Widdig, *Culture and Inflation*, 181. Some historians have argued that closing the disparity in income between skilled and unskilled labor led to a democratizing effect. Feldman, "Weimar Writers," 175; Panofsky, *Sokrates in Hamburg*, 11.
55. Widdig, *Culture and Inflation*, 180, 189.
56. Staatliche Pressestelle I–IV 135-I 5396, Gesellschaft von Freunden der Hamburgischen Universität, 1923–1929, StA HH.
57. *Hamburgische Universitätsgesellschaft*, 12.
58. Gertrud Bing, *Aby M. Warburg: Vortrag von Frau Professor Bing anläßlich der feierlichen Aufstellung von Aby Warburgs Büste in der Hamburger Kunsthalle am 31. Oktober 1958 mit einer vorausgehenden Ansprache von Senator Dr. Hans H. Biermann-Ratjen* (Hamburg: H. Christian, 1958), 12; Max M. Warburg, "Der Gedächtnis-Feier für Professor Warburg," 27.
59. Heise, *Persönliche Erinnerungen*, 22–23.
60. Although the Warburgs led several discussions about establishing a budget, to the best of my knowledge, Aby Warburg organized his funds following periodic negotiations with his brothers on an annual basis. Max Warburg to Aby Warburg, October 21, 1926, FC, WIA.

61. See, in particular, the reports on the budget from 1921. Stockhausen, *Die Kulturwissenschaftliche Bibliothek Warburg*, 131, the costly "extras" on 74; Aby Warburg to Felix Warburg, June 17, 1908, FC, WIA.
62. Aby Warburg, "From the Arsenal," 119, 120; Max Warburg, "Aby Warburg's Kindheit," III.1.5, undated, WIA.
63. "Gesellschaft von Freunden der Hamburgischen Universität," Staatliche Pressestelle I–IV 135-I 5396, 1928, StA HH.
64. Weber, "Science as a Vocation," 149.
65. Erwin Panofsky to Francis Wormald, December 17, 1963, in *EPK*, 5:431–432.
66. Fritz Stern, *Einstein's German World* (Princeton, NJ: Princeton University Press, 1999), 106–110. Notwithstanding the disciplinary differences— Warburg was engaged in the humanities and the Kaiser Wilhelm Society in the sciences—these institutions, of which Lamprecht's too should be included, can be said to have been part of a wider movement to infuse scholarly institutions with private money. Admittedly, Warburg was the most successful at maintaining autonomy from the state.
67. Notker Hammerstein, *Die Deutsche Forschungsgemeinschaft in der Weimarer Republik und im Dritten Reich: Wissenschaftspolitik in Republik und Diktatur* (Munich: C.H. Beck, 1999), 21; Kristie Macrakis, *Surviving the Swastika: Scientific Research in Nazi Germany* (New York, 1993), 13–16, 201. For Lamprecht, see his observations on his 1904 trip to America on the occasion of the St. Louis World's Fair. *Americana: Reiseeindrücke, Betrachtungen, Geschichtliche Gesamtansicht* (Freiburg: Hermann Heyfelder, 1906), 90.
68. Albert Einstein to Max Warburg, December 8, 1920, 36–248; and Max Warburg to Albert Einstein, February 8, 1921, 36–250, AEA; Cassirer, *Mein Leben mit Ernst Cassirer*, 127. See *Bericht über die Bibliothek Warburg für das Jahr 1921*, excerpted in Stockhausen, *Die Kulturwissenschaftliche Bibliothek Warburg*, 131.
69. McEwan documents the familial and scholarly connections from which Warburg benefits in "Facetten einer Freundschaft: Aby Warburg und James Loeb, Verwandte, Freunde, Wissenschaftler, Mäzene," in *James Loeb 1867–1933: Kunstsammler und Mäzen: Eine Sonderausstellung im Schloßmuseum Murnau 7. April bis 9. Juli 2000*, ed. Brigitte Salmen (Munich: Schloßmuseum des Marktes Murnau, 2000), 75–98.
70. For his description of "Uncle Sam," see Warburg, "Lecture on Serpent Ritual," 292; For the quotation about Warburg as a "reverse Alchemist," see Dorothea McEwan, introduction to *"Wanderstrassen der Kultur,"* 117.
71. Derek Penslar, "The Origins of Modern Jewish Philanthropy," *Philanthropy in the World's Traditions*, ed. Warren Frederick Ilchman, Stanley Nider Katz, and Edward L. Queen (Bloomington: Indiana University Press, 1998), 197–214, esp. 210.
72. Hasia Diner, *In the Almost Promised Land: Jews and Blacks, 1915–1935* (Baltimore: Johns Hopkins University Press, 1997), 167; Rosenwald had

$80 million at the time of his death and ranks at 57, according to Michael Klepper and Michael Gunther, who have ranked America's richest men in relationship to the GDP. *The Wealthy 100: From Benjamin Franklin to Bill Gates—A Ranking of the Richest Americans, Past and Present* (Secaucus, NJ: Carol, 1996), xii.

73. A year later Forbes estimated Schiff's private fortune at $50 million and his annual income at $2.5 million. Naomi W. Cohen, *Jacob Schiff: A Study in American Jewish Leadership* (Hanover, NH: University Press of New England/Brandeis University Press, 1999), 23, 59, 69, 256.

74. Diner, *In the Almost Promised Land*, 125; Penslar, "Origins of Modern Jewish Philanthropy," 210.

75. Goldschmidt, *Lebenserinnerungen*, 266. The same ironic distance and condescension were reflected in the era's other popular books about America, such as Adolf Halfeld, *Amerika und der Amerikanismus* (Jena: E. Dietrichs, 1927). Aby Warburg to Gustav Pauli, February 25, 1929, GC, WIA.

76. Aby Warburg to Keller-Huguenin, September 1, 1926, GC, WIA.

77. Aby Warburg to Peter Petersen, January 21, 1928, GC, WIA.

78. Stockhausen, *Die Kulturwissenschaftliche Bibliothek Warburg*, 107. Warburg was part of a growing transatlantic public library movement, albeit he defined the public more narrowly than did the Boston Public Library that was famously open to all Massachusetts citizens. On the history of municipal lending libraries from a transatlantic perspective see Thomas Adam, *Buying Respectability: Philanthropy and Urban Society in Transnational Perspective, 1840s to 1930s* (Bloomington: Indiana University Press, 2009), 31–38.

79. Aby Warburg to Keller-Huguenin, September 1, 1926; Aby Warburg to Gustav Pauli, February 15, 1929; Aby Warburg to Gustav Pauli, February 25, 1929, all in GC, WIA.

80. Goethe said, "Amerika, du hast es besser/Als unser Kontinent, das alte," (America, you are better off than our continent, the old one) (1824). For the complete poem, see Johann Wolfgang Goethe, *Sämtliche Werke, Briefe, Tagebücher und Gespräche*, ed. Karl Eibl (Frankfurt am Main: Deutscher Klassiker-Verlag, 1987), 2:739–741. Aby Warburg to Gustav Pauli, February 25, 1929, GC, WIA.

81. Aby Warburg to Felix Warburg, December 21, 1909, Kopierbuch III, 266, 267, 269, 270, 268, FC, WIA. Due to his worsening diabetes, Aby was not able to go to America in 1928 nor to attend the congress of Americanists in New York that same year. Mary Warburg to Aby Warburg, May 10, 1928; Aby Warburg to Max Adolf, May 22, 1928, FC, WIA. Tragically, it seems that the importance of America for Warburg was just becoming clear to Saxl and Bing when Warburg died just prior to the Hamburg Congress of Americanists. See Forster's introduction to Warburg's *Renewal of Pagan Antiquity*, 42.

82. Penslar, "Origins of Modern Jewish Philanthropy," 210; Cohen, *Jacob Schiff*, 60.

83. This was certainly the case for the Kaiser Wilhelm Society, which received 35 percent of its original contributions from Jews and, in turn, was later attacked for being founded by "Jewish sponsors" and promoting "Jewish" science. Stern, *Einstein's German World*, 110; Macrakis, *Surviving the Swastika*, 13.

84. Max Warburg to Aby Warburg, October 21, 1926, FC, WIA. Indeed, its independence is what enabled the library's emigration in 1933, although it also prohibited Bing from receiving *Wiedergutmachung* funds from the university after the Second World War. See Stockhausen, *Die Kulturwissenschaftliche Bibliothek Warburg*, 24.

85. McEwan, introduction to *Ausreiten der Ecken*, 45.

86. *Bericht über die Bibliothek Warburg und ihre Entwicklung zu einem öffentlichen Forschungsinstitut*, 13.1.1921, WIA, cabinet 1, drawer 3, Misc. 1918–1921. According to Stockhausen, who excerpts this document in his book, this was likely written by Saxl. *Die Kulturwissenschaftliche Bibliothek Warburg*, 119 (quotation), 120.

87. Aby Warburg to Dr. Franz Stuhlmann, July 1, 1927, FC, WIA; "Warburg Haus," Staatliche Pressestelle I–IV 135-I 5451, 1925–1930, StA HH.

88. Stockhausen, *Die Kulturwissenschaftliche Bibliothek Warburg*, 29.

89. Heinrich Sieveking, "Ansprache bei der Lübecker Tagung," 33.

90. This was the crux of the disagreement with Bourdieu discussed in the introduction and chapter 10. He accused Panofsky of not being sensitive to questions of cultural capital and market conditions in analyzing art.

91. Aby Warburg, Festwesen, III.III.2, WIA.

92. Cited in Gombrich and Saxl, *Aby Warburg*, 249–250.

93. Feldman, *Great Disorder*, 780; Widdig, *Culture and Inflation*, 227. Of course, the reality was that the impact of the inflation on Jews was just as uneven as on everyone else. If anything, the concentration of Jews in trade, commerce, and the liberal professions left Jews more vulnerable than farmers and industrial workers, among whom there were only a "handful of Jews." Donald L. Niewyk, "The Impact of Inflation and Depression on the German Jews," *Leo Baeck Institute Yearbook* 28 (1983): 20.

CHAPTER SIX

1. Erwin Panofsky to Kurt Badt, July 24, 1922, in *EPK*, 1:117.

2. Edgar Wind became a *Privatdozent* himself in Hamburg in 1930 and assisted the Warburg Library's emigration to London in 1933. There he helped found the *Journal of the Warburg and Courtauld Institute* in 1937 and played a key role in bringing the Hamburg School's iconological method to the Anglo-American world.

3. The letter from Aby Warburg to Adolph Goldschmidt, August 9, 1903, contains an elaborate graph. See Treml, Weigel, and Ladwig, *Aby Warburg*, 672–679.

4. Kultermann dates the origin of "iconology" to Warburg's 1912 essay. *History of Art History*, 211.

5. Cordula Grewe, *Painting the Sacred in the Age of Romanticism*, Histories of Vision (Burlington, VT: Ashgate, 2009); Jan Bialostocki, "Iconography," in *The Dictionary of the History of Ideas II*, ed. Philip P. Wiener (New York: Scribner's, 1973), 524–540, esp. 529.

6. Holly, *Panofsky*, 10.

7. Sheehan, *Museums in the German Art World*, 89–90.

8. Panofsky assures the reader that despite his name, Johann Dominic Fiorillo (1798–1820) was a native Hamburger. "Three Decades of Art History," 323.

9. Janson, too, studied with Panofsky in Hamburg. Janson, "Erwin Panofsky," 154.

10. Cited in Kultermann, *History of Art History*, 177–178.

11. Jaś Elsner, "From Empirical Evidence to the Big Picture: Some Reflections on Riegl's Concept of Kunstwollen," *Critical Inquiry* 32 (2006): 741–766.

12. For Elsner, this is what makes Riegl so critical to the essence of art history. "Riegl's greatness as an art historian lies in his absolutely acute awareness of this problem and his own sense of being pulled in both directions— towards the satisfyingly described single object and at the same time the fully elaborated historical picture." Ibid., 748.

13. Kultermann, *History of Art History*, 163.

14. Alois Riegl, "The Main Characteristics of the Late Roman *Kunstwollen*" (1901), in *The Vienna School Reader: Politics and the Art Historical Method in the 1930s*, ed. Christopher S. Wood (New York: Zone Books, 2000), 97.

15. Elsner compares Riegl to the mathematicians Russell and Whitehead. "From Empirical Evidence," 754.

16. Anton Webern, *The Path to the New Music*, ed. Willi Reich, trans. Leo Black (Bryn Mawr, PA: Theodore Presser, 1963), 7–56, esp. 21.

17. Margarit Olin makes the compelling case that Riegl's work emerges from the political and cultural concerns of late Habsburg Vienna. "Alois Riegl: The Late Roman Empire in the Late Habsburg Empire," in *The Habsburg Legacy: National Identity in Historical Perspective*, ed. Ritchie Robertson and Edward Timms (Edinburgh: Edinburgh University Press, 1994), 107–120. As Elsner points out, this interpretation is "actually a very Rieglian form of historicism." Elsner, "From Empirical Evidence," 754.

18. This famous passage appears in Wölfflin's dissertation, "Prolegomena to a Psychology of Architecture." Heinrich Wölfflin, *Prolegomena zu einer Psychologie der Architektur* (1886), reprinted in Wölfflin, *Kleine Schriften* (Basel: B. Schwabe, 1946), 44.

19. Cited in Kultermann, *History of Art History*, 195. Panofsky's essay shares similar anecdotes of Goldschmidt's humor. "Goldschmidt's Humor," in *EPDA*, 2:1152–1156.

20. Cited in Kultermann, *History of Art History*, 163.
21. Just as Panofsky responded to both Wölfflin and Riegl, Adorno and Benjamin contended with Wölfflin's "cathedrals and shoes." Frederic J. Schwartz, "Cathedrals and Shoes: Concepts of Style in Wölfflin and Adorno," *New German Critique* 76 (1999): 3–48.
22. Joan Hart argues that Wölfflin is often wrongly understood as a positivist and that he must be interpreted in the context of the neo-Kantianism of the late nineteenth and early twentieth centuries. For Hart, Wölfflin and Panofsky similarly attempted to use psychology and hermeneutics to establish an art-historical interpretation that bridged positivism and metaphysics. "Reinterpreting Wölfflin: Neo-Kantianism and Hermeneutics," *Art Journal* 42 (1982): 292.
23. Erwin Panofsky, "Das Problem des Stils in der bildenden Kunst," in *EPDA*, 2:1017 (my emphasis). That Panofsky had also clearly moved beyond Wölfflin already by 1915 publicly could also potentially explain why he chose never to publish his *Habilitation*, which still bore the imprint of his teacher. See chapter 5, page 125, note 16.
24. Holly, *Panofsky*, 95; Erwin Panofsky, "Der Begriff des Kunstwollens," in *EPDA*, 2:1026–1027, translation from Kenneth J. Northcott and Joel Snyder, "The Concept of Artistic Volition," *Critical Inquiry* 8 (1981): 25–26.
25. Gombrich and Saxl, *Aby Warburg*, 229.
26. Warburg also singles out Cassirer in this lecture. See Warburg, "Zum Vortrage von Karl Reinhardt über 'Ovids Metamorphosen' in der Bibliothek Warburg am 24. Oktober 1924," in Treml, Weigel, and Ladwig, *Aby Warburg*, 680–681.
27. Saxl, "History of Warburg's Library," in Gombrich and Saxl, *Aby Warburg*, 333.
28. Erwin Panofsky, "Das Kunsthistorische Seminar," in *Die Universität Hamburg in Wort und Bild*, ed. W. Wegandt (Hamburg: Universität Hamburg, 1927), 97.
29. "Hamburgische Universität Verzeichnis der Vorlesungen," Z 561 8, Sommersemester 1922, StA HH.
30. Panofsky, "Das Kunsthistorische Seminar," 97.
31. By 1928 the library was also open on Tuesdays and Thursdays until nine in the evening and students writing dissertations could also come in the morning. Stockhausen, *Die Kulturwissenschaftliche Bibliothek Warburg*, 27.
32. Heise, *Persönliche Erinnerungen*, 10.
33. Panofsky, "Das Kunsthistorische Seminar," 96–97; Warburg, "From the Arsenal," 118.
34. Ernst Cassirer, "Critical Idealism as a Philosophy of Culture, Lecture to the Warburg Institute, 26 May 1936," in *Symbol, Myth, and Culture: Essays and Lectures of Ernst Cassirer, 1935–1945*, by Ernst Cassirer and Donald Phillip Verene (New Haven, CT: Yale University Press, 1979), 78–79.

35. Saxl, "Die Bibliothek Warburg und Ihr Ziel," in *Vorträge der Bibliothek Warburg*, 1:9–10 (my emphasis).
36. Saxl, "History of Warburg's Library," in Gombrich and Saxl, *Aby Warburg*, 334.
37. Ernst Cassirer, "Der Begriff der Symbolischen Form," 11.
38. Stockhausen, *Die Kulturwissenschaftliche Bibliothek Warburg*, 28.
39. Hugo Buchtol quoted in ibid., 94.
40. Erwin Panofsky to August Grisebach, December 14, 1927, in *EPK*, 5:23.
41. These slip boxes (*Zettelkasten*), replete with hundreds of pieces of paper, often with illegible scrawls, are still housed today in the Warburg Archive of the Warburg Institute in London.
42. Saxl, "History of Warburg's Library," in Gombrich and Saxl, *Aby Warburg*, 329.
43. Dorothea McEwan, foreword to *"Wanderstrassen der Kultur,"* 15.
44. Saxl to Warburg, Rep. Kurtatorium, KBW, 27/12/1926 Report, also excerpted in McEwan, foreword to *"Wanderstrassen der Kultur,"* 166–177, numbers on page 170.
45. McEwan, foreword to *"Wanderstrassen der Kultur,"* 30.
46. Saxl, "History of Warburg's Library," in Gombrich and Saxl, *Aby Warburg*, 333, "law of the good neighbor" on 327.
47. Hans-Michael Schäfer's work of library science on the Warburg Library makes this point, although he does not fully explore the implications of this organization. *Die Kulturwissenschaftliche Bibliothek Warburg: Geschichte und Persönlichkeit der Bibliothek Warburg mit Berücksichtigung der Bibliothekslandschaft und der Stadtsituation der Freien u. Hansestadt Hamburg zu Beginn des 20. Jahrhunderts* (Logos: Berlin, 2003).
48. Momigliano, "Gertrud Bing," 209.
49. Michels and Schoell-Glass argue that the motto of Bing's life could have been "I serve" (*Ich diene*). "Gertrud Bing," 29.
50. McEwan, foreword to *"Wanderstrasse der Kultur,"* 25.
51. Ibid., 30; Aby Warburg to Toni Cassirer, March 6, 1929, GC, WIA.
52. This is certainly the case for botanical illustration, in which a female assistant becomes the "tool in the hand" for the male scientist. Daston and Gallison, *Objectivity*, 89.
53. Michels and Schoell-Glass argue that this permitted Bing access to the library. "Gertrud Bing," 33.
54. Heise, *Persönliche Erinnerungen*, 56. The first of these trips is documented in *TKBW*, 345. Disagreement about the propriety of the relationship between Warburg and Bing is documented in the following letters: Aby Warburg to Max Warburg, July 22, 1929; and Aby Warburg to Toni Cassirer, March 6, 1929, FC, WIA. Also excerpted in Thomas Meyer, "Gertrud Bing an die Cassirers: Florenz, 1. June 1929," *Trajekte* 10 (2005): 16–17. For the Warburg trinity, see Momigliano, "Gertrud Bing," 209.
55. For this incident and more on "PanDora," see Levine, "PanDora," 753.

56. Fritz Saxl to Aby Warburg, January 25, 1921, cited in McEwan, foreword to *"Wanderstrassen der Kultur,"* 24.

57. "Hamburgische Universität Verzeichnis der Vorlesungen," Z 561 8, 1919–1933, StA HH; Erwin Panofsky to Henri M. Peyre, December 7, 1955, in *EPK*, 3:876.

58. Kunsthistorisches Seminar File, 1927–1928, Warburg-Archiv, Hamburg.

59. Monika Wagner and Dietmar Rübel, eds., *Antwortschreiben Panofskys vom 12. Dezember 1927 an die Hamburger Hochschulbehörde*, Sonderdruck aus Material in Kunst und Alltag (Hamburg, December 12, 1927).

60. For example, in 1922, Cassirer delivered a lecture entitled "Eidos und Eidolon: Das Problem des Schönen und der Kunst in Platons Dialogen" (Eidos and Eidolon: The problem of the beautiful and art in Plato's Dialogues), which was published two years later in the Warburg Library's lecture series. The published version of this lecture cites Panofsky's *Idea: A Concept in Art Theory*, in which Panofsky reveals that he developed his ideas about art in conjunction with Cassirer's lecture on this topic. "Eidos und Eidolon: Das Problem des Schönen und der Kunst in Platons Dialogen," in *Vorträge der Bibliothek Warburg*, 2:27.

61. As told to Landauer by William Heckscher. "Survival of Antiquity," 224. Burke argues that the attendance by professors of their colleagues' lectures in the Lazarsfeld-Merton Era of Columbia in the 1940s was a sign of its scholarly productivity. *A Social History of Knowledge*, 243.

62. Holly, *Panofsky*, 130. Allister Neher's essay examines what Panofsky's idea of symbolic form understood through Cassirer would actually look like. "How Perspective Could Be a Symbolic Form," *Journal of Aesthetics and Art Criticism* 63 (2005): 359.

63. Erwin Panofsky, "Iconography and Iconology: An Introduction to The Study of Renaissance Art," in Panofsky, *Meaning in the Visual Arts*, 31.

64. Panofsky, *Perspective as Symbolic Form*, 43; see also Jonathan Gilmore, *The Life of a Style: Beginnings and Endings in the Narrative History of Art* (Ithaca, NY: Cornell University Press, 2000), 59–60.

65. Ferretti, *Cassirer, Panofsky, and Warburg*, 42.

66. Erwin Panofsky, foreword to the second German edition of *Idea: A Concept in Art Theory*, trans. Joseph J. S. Peake (Columbia: University of South Carolina Press, 1968), vii.

67. Panofsky, *Idea*, 11.

68. Ibid., 125–126.

69. Saxl, "Die Bibliothek Warburg," 3.

70. The Warburg Haus published the first volume in 1923 to an underwhelming reaction within the community of art historians. The second volume faced theoretical, practical, and financial difficulties and was not published until 1964. Erwin Panofsky and Fritz Saxl, *Dürer's "Melencholia I," eine quellen- und typengeschichtliche Untersuchung* (Leipzig: B.G. Teubner, 1923); Raymond Klibansky, Erwin Panofsky, and Fritz Saxl, *Saturn und Me-*

lancholy: Studies in the History of Natural Philosophy, Religion, and Art (New York: Basic Books, 1964).

71. Panofsky, "Reflections on Historical Time," 696; Erwin Panofsky to A. Grisebach, November 26, 1929, Staatliche Museen zu Berlin-Kunstbibliothek.

72. Erwin Panofsky, "Zum Problem der Beschreibung und Inhaltsdeutung von Werken der bildenden Kunst," in EPDA, 2:1066.

73. Ibid.

74. "Dürer's Stellung zur Antike," in EPDA, 1:280.

75. Hugo Buchtal, in A Commemorative Gathering for Erwin Panofsky at the Institute of Fine Arts, New York University, in Association with the Institute for Advanced Study, March the Twenty-First, 1968 (New York: New York University, 1968), 12.

76. Lotte Labowsky provides perhaps an exception to this exclusion, although to a certain degree an exception that proves the rule. Even the title of this recent study emphasizes her relationship to the men with whom she worked. Regina Weber, Lotte Labowsky (1905–1991)—Schülerin Aby Warburgs, Kollegin Raymond Klibanskys: Eine Wissenschaftlerin zwischen Fremd- und Selbstbestimmung im englischen Exil (Berlin: Dietrich Reimer, 2012).

77. Shulamit Volkov argues that the institutes of the Kaiser Wilhelm Society became a haven for Jewish professors whose entrance into the university was refused. Die Juden in Deutschland 1780–1918, Enzyklopädie Deutscher Geschichte (Munich: R. Oldenbourg, 1994), 55. Interestingly, this was also apparently the case for women scholars who happily found that the Society was not governed by the same legal restrictions that limited their advancement in the university system. Annette Vogt, "Barrieren und Karrieren—am Beispiel der Wissenschaftlerinn," in Frauen in der Wissenschaft—Frauen an der TU Dresden: Tagung aus Anlass der Zulassung von Frauen zum Studium in Dresden vor 100 Jahren, ed. Hildegard Küllchen (Leipzig: Leipziger Universitätsverlag, 2010), 161–179.

78. Cassirer, Philosophy of Symbolic Forms, 86, 93.

79. Panofsky, "Relationship of Art History and Art Theory," 55.

80. Cassirer, Kant's Life and Thought, 304. Bialostocki aptly names this text a "Prolegomena to Any Future Art History Which Could Claim to Be a Science." "Erwin Panofsky (1892–1968): Thinker, Historian, Human Being," Simiolus 4 (1970): 73.

81. Ernst Cassirer, "Deutschland und Westeuropa im Spiegel der Geistesgeschichte," (1931), in ECK 17, 207, originally published as Inter Nationes: Zeitschrift für die kulturellen Beziehungen Deutschlands mit dem Auslande 1 (1931): 57–59.

82. So argue Willi Goetschel and David Suchoff in their introduction to Hermann Levin Goldschmidt, The Legacy of German Jewry, trans. David Suchoff (New York: Fordham University Press, 2007), 9.

83. Olin, "Alois Riegl," 109.

84. Panofsky, "Relationship of Art History and Art Theory," 65 (my emphasis). See also Lorenz and Elsner, "Translators' Introduction," *Critical Inquiry* 35 (2008): 37.

85. See, for example, Hans Sedlmayr, "Towards a Rigorous Study of Art," 133–179; Otto Pächt, "Design Principles of Fifteenth-Century Northern Painting," 243–321, quotation on 281, both in Wood, *Vienna School Reader*. Wood makes a similar observation in his introduction to the *Vienna School Reader*, 26. For an interpretation of this debate as neo-Kantians versus neo-Hegelians, see Henri Zerner, "Alois Riegl: Art, Value, and Historicism," *Daedalus* 105 (1976): 177–188.

86. Claire Farago, "Vision Itself Has Its History: Race, Nation, and Renaissance Art History," in *Reframing the Renaissance: Visual Culture in Europe and Latin America, 1450–1650*, ed. Claire Farago (New Haven, CT: Yale University Press, 1995), 67–88.

87. According to Lorenz and Elsner, Panofsky arguably fell into the same trap of generalization that he first accused his interlocutors of. "Translators' Introduction," 38–40.

88. For Svetlana Alpers, what Riegl called style Panofsky absorbed into questions of meaning, questions that he dubbed alternatively iconography, intrinsic meaning, and "Cassirerian" *symbolic form*. "Style Is What You Make It: The Visual Arts Once Again," in *The Concept of Style*, ed. Berel Lang (Ithaca, NY: Cornell University Press, 1987), 148.

89. Aby Warburg to Franz Boas, December 13, 1924, excerpted and translated in Warburg, Boas, and Guidi, "Aby Warburg and Franz Boas," 225; Franz Boas to Aby Warburg, January 14, 1925, ibid., 229.

90. Warburg, "Italian Art," in Warburg, *Renewal of Antiquity*, 586; Gertrud Bing, editorial foreword to Warburg, *Renewal of Antiquity*, 81–82.

91. Gombrich, "Warburg: His Aims and Methods," 279.

92. Wilhelm Pinder's works were widely read in the Nazi period, and he was himself a promoter of "German scholarship." See Pinder and Alfred Stange, eds., *Festschrift Hitler—Deutsche Wissenschaft, Arbeit und Aufgabe: Dem Führer und Reichskanzler legt die deutsche Wissenschaft zu seinem 50. Geburtstag Reichenschaft ab über ihre Arbeit im Rahmen der gestellten Aufgaben* (Leipzig: Hirzel, 1939); and Edith Hoffmann, "Wilhelm Pinder," *Burlington Magazine for Connoisseurs* 89, no. 532 (1947): 198. Pinder's and Sedlmayr's critiques of Panofsky's inability to uncover the deeper meaning in art anticipated similar anti-Semitic utterances of Ernst Jünger and Carl Schmitt in later years. See, for example, *Ernst Jünger/Carl Schmitt, Briefwechsel*, ed. Helmuth Siesel (Stuttgart: Klett-Cotta, 1999), 164–167.

93. Aby Warburg to Heinrich Pfeiffer, August 19, 1927, GC, WIA.

94. On Munich as a counterweight to Hamburg, see Karen Michels, "Norden versus Süden: Hamburger und Münchner Kunstgeschichte in den zwanziger und dreißiger Jahren," in *200 Jahre Kunstgeschichte in München: Posi-*

tionen, Perspektiven, Polemik 1780–1980, ed. Christian Drude and Hubertus Kohle (Munich: Deutscher Kunstverlag, 2003), 131–138.

CHAPTER SEVEN

1. Kay emphasizes that the scandal spurred in 1892 by Liebermann's realistic portrait of Hamburg's elderly mayor was caused as much by the desire to challenge Lichtwark's goals for Hamburg's Kunsthalle as by anti-Semitism. *Art and the German Bourgeoisie*, 49, 74, 134.

2. "Was hat die Malerei mit dem Judentum zu tun?" cited in Bernd Küster, *Max Lieberman: Ein Malerleben* (Hamburg: Ellert & Richter, 1988), 213.

3. Warburg, III.29.2.2.4, WIA; Abraham Landsberg, "Last Traces of Heinrich Heine in Hamburg," *Leo Baeck Oxford Journals* (1964): 364; "Gutachten für die philosophische Professor," Hochschulwesen II 361-5 II A I 3:8, June 1919, StA HH.

4. Family members included the industrialist and city council member Max Cassirer, the neurologist Richard Cassirer, and the composer and conductor of the Berliner Komischen Oper Fritz Cassirer.

5. Paul Natorp to Albert Görland, January 1, 1911, SUB, in Cohen and Natorp, *Der Marburger Neukantianismus in Quellen*, 390.

6. Fritz Stern, "The Burden of Success: Reflections on German Jewry," in *Dreams and Delusions: The Drama of German History* (New Haven, CT: Yale University Press, 1999), 97–114. Bruno Cassirer published several of Ernst Cassirer's works before 1919, including *Das Erkenntnisproblem* (1906–7); *Substanzbegriff und Funktionsbegriff* (1910); *Freiheit und Form* (1916); and the multivolume study of Kant (1912) and Cassirer's biographical supplement *Kants Leben und Werke* (1918).

7. Cassirer, *Mein Leben mit Ernst Cassirer*, 39.

8. Carole Fink, "The Murder of Walther Rathenau" *Judaism* 44, no. 3 (1995): 259–269.

9. That one could be a nonbeliever and remain a member of the Jewish community may have persuaded Cassirer to remain. On the uniqueness of the Hamburg Jewish community, see Ina Lorenz, "Die jüdische Gemeinde Hamburg 1860–1945," in *Die Geschichte der Juden in Hamburg, 1590–1990*, ed. Saskie Rohde and Arno Herzig (Hamburg: Dölling und Galitz, 1991), 2:77–100.

10. Gay, *Weimar Culture*, vi.

11. Owing to his self-expressed hostility to the particularity of his own Jewish experience, Gombrich wrote Warburg's Jewishness out of his story. Scholarship on the Warburg circle has subsequently accepted Gombrich's assessment that Warburg's "emancipation from Jewish orthodoxy" constituted a conclusive break with Judaism. Gombrich and Saxl, *Aby Warburg*, 11, 20. He was himself an Austrian Jewish émigré but preferred to identify as "Central European." Emil Brix, preface to Gombrich, "The Visual Arts

in Vienna c. 1900 and Reflections on the Jewish Catastrophe," vol. 1 of
Occasions (Austrian Cultural Institute) (London: Austrian Cultural Insti-
tute, 1997), accessed online at http://gombricharchive.files.wordpress
.com/2011/04/showdoc28.pdf.

12. George Mosse refers specifically to Warburg and Cassirer in this discus-
sion. Mosse, *German Jews beyond Judaism*, 50–54.

13. Martha Mosse, "Erinnerungen," B Rep. 235-07 MF 4170-4171, Novem-
ber 29, 1963, p. 1, Landesarchiv Berlin. Mosse became an employee of
the Jewish Community and then a department head of the controversial
Reichsvereinigung, the Jewish organization consolidated by the Nazis that
was responsible for the relocation and deportation of Jews in Germany.
See Beate Meyer, "The Inevitable Dilemma: The Reich Association (Reichs-
vereinigung) of Jews in Germany, the Deportations, and the Jews Who
Went Underground," in *On Germans and Jews under the Nazi Regime: Essays
by Three Generations of Historians*, ed. Moshe Zimmerman (Jerusalem:
Hebrew University Magnes Press, 2006), 297–312.

14. Erwin Panofsky, "Three Decades of Art History," 341.

15. Erwin Panofsky to Dora Panofsky, July 2, 1920, in *EPK*, 1:74.

16. The lecture was reported in the *Vossisches Zeitung*, on January 5, 1921,
2 Beilage, not on January 4, as the published version of this report incor-
rectly states. "In Memoriam Erwin Panofsky: March 30, 1892–March 14,
1968," *Mededelingen der Koninklijke Nederlandse Akademie van Wetenschap-
pen* 35 (1972): 238. Thanks to Anna Henke for locating this reference for
me. In a letter to Reiner Haussherr, Panofsky recalled that Liebermann
was in the audience for this lecture; July 6, 1964, *EPK*, 5:499.

17. Erwin Panofsky, "Rembrandt und das Judentum," in *EPDA*, 2:993–994.

18. Stern, "Julius Langbehn and Germanic Irrationalism," in Stern, *Politics of
Cultural Despair*, 98.

19. For a revised, more modern edition with an introduction about the book's
reception history, see Julius Langbehn, *Rembrandt als Erzieher, von einem
Deutschen*, ed. Gerhard Krüger (Berlin: T. Fritsch, 1944), quotation on 51.

20. According to Langbehn, "A Jew was as little able to become a German as a
plum was to turn into an apple." Ibid., 409.

21. On Josef Strzygowski, see Olin, "Alois Riegl," 115. This interpretation of
Eduard Koloff, "Rembrandt's Life and Work, Portrayed according to New
Documents and Viewpoints" (1854) is drawn from Michael Zell's *Refram-
ing Rembrandt: Jews and the Christian Image in Seventeenth-Century Amster-
dam* (Berkeley: University of California Press, 2002), 43. Panofsky also
cites and develops Koloff's phrase "Anflug von Jüdelei" in "Rembrandt und
das Judentum," in *EPDA*, 2:972.

22. Panofsky, "Rembrandt und das Judentum," in *EPDA*, 2:1002.

23. Ibid., 2:996. According to Steven M. Nadler, *sub specie aeternitas* refers
to the ability to "know things not from a relative, durational perspec-
tive, according to how they may be related in time to my existence, but

from an absolute, atemporal perspective." *Spinoza's "Ethics": An Introduction*, Cambridge Introductions to Key Philosophical Texts (Cambridge: Cambridge University Press, 2006), 174. Incidentally, Wittgenstein also applied this concept to art, although Panofsky makes no mention of him. *Notebooks, 1914–1916*, trans. G. E. M. Anscombe (Oxford: Blackwell, 1961), 83e.

24. Zell, *Reframing Rembrandt*, 45.

25. Michels, "Art History," 167–179.

26. Franz Landsberger, *Rembrandt, the Jews, and the Bible*, trans. Felix N. Gerson (Philadelphia: Jewish Publication Society of America, 1946), ix; Erwin Panofsky to Booth Tarkington, November 11, 1944, in Ludwig, *Dr. Panofsky and Mr. Tarkington*, 58.

27. Ludwig, introduction to *Dr. Panofsky and Mr. Tarkington*, xiii.

28. For the publication history of this lecture, see Gerda Panofsky's explanation in *EPK*, 2:971.

29. Panofsky, "Rembrandt und das Judentum," in *EPDA*, 2:994.

30. Fritz Saxl, "Die Jüdische Jugend und die bildende Kunst," *Jahrgang* 1 (1918–19): 314; on Saxl's challenges in Vienna, see McEwan, foreword to *"Wanderstrassen der Kultur,"* 12.

31. McEwan, foreword to *"Wanderstrassen der Kultur,"* 24, 52.

32. According to Karen Michels in her unpublished paper "Rembrandt, sachlich gesehen: Fritz Saxl und die Rembrandt-Forschung des Warburg-Kreises," from the 2000 Rembrandt Conference in Jerusalem.

33. The Wissenschaft des Judentums presents, in this sense, also the story of a privately funded institute outside the university in which scholars promoted the burgeoning field of Jewish studies, not yet considered part of the university. Suzanne Marchand discusses the "even longer road to 'scientific' Judaism" insofar as it intersects with her story about the professionalization of Orientalism from an interdisciplinary enterprise supported by extrauniversity institutions to a proper scholarly field of study. *German Orientalism in the Age of Empire: Religion, Race, and Scholarship* (Cambridge: Cambridge University Press, 2009), 113–117, quotation on 113.

34. Erwin Panofsky to Kurt Badt, January 7, 1922, in *EPK*, 1:110; Erwin Panofsky to Kurt Badt, July 24, 1922, in *EPK*, 1:117; Erwin Panofsky to A. Grisebach, January 12, 1926, Staatliche Museen Berlin-Kunstbibliothek; Erwin Panofsky to Max Sauerlandt, January 14, 1926, in *EPK*, 1:184.

35. Scholem, *From Berlin to Jerusalem*, 67.

36. Stern discusses the difficulty for even the best Jewish scientists to find support, in *Einstein's German World*, 71–73; Thomas Meyer, "Ernst Cassirer—Judentum aus dem Geist der universalistischen Vernunft," *Ashkenaz* 10 (2001): 463.

37. Chickering, *Karl Lamprecht*, 73.

38. In 1909, Jews made up 10 percent of German *Privatdozenten*, 7 percent of *Außerordentlichen*, and only 2 percent of *Ordinarius* professors. Volkov,

Die Juden in Deutschland, 54, translation from Weber, "Science as a Vocation," 134.

39. Aby Warburg to Wilhelm Vöge, September 16, 1910, GC, WIA.

40. Björn Biester, *Der Innere Beruf zur Wissenschaft: Paul Ruben (1886–1943)*, Studien zur deutsch-jüdischen Wissenschaftsgeschichte (Berlin: Dietrich Reimer, 2001); Hans Liebeschütz, "Treitschke and Mommsen on Jewry and Judaism," *Leo Baeck Institute Year Book* 7 (1962): 153–182.

41. Volkov, *Die Juden in Deutschland*, 55.

42. The Jewish businessman Leopold Koppel was the second-largest donor for the Kaiser Wilhelm Society and, subsequently, ensured that Haber would be the director of the newly founded the Kaiser Wilhelm Institute for Physical Chemistry and that Einstein would find a home in Berlin as well. Stern, *Einstein's German World*, 86–87, 110–111, 130; Weber, "Science as a Vocation," 131, translation altered by the author.

43. Max Warburg to Aby Warburg, February 1, 1907; and Max Warburg to Aby Warburg, November 3, 1900, both in FC, WIA; Adolph Goldschmidt to Aby Warburg, September 7, 1915, GC, WIA.

44. Hermann Cohen to Paul Natorp, January 2, 1902, NNL, also in Cohen and Natorp, *Der Marburger Neukantianismus in Quellen*, 269; Cassirer, *Mein Leben mit Ernst Cassirer*, 133, quotation on 94; Hermann Cohen to Paul Natorp, June 21, 1917, in Cohen and Natorp, *Der Marburger Neukantianismus in Quellen*, 484.

45. Steinhal-Loge-B'nei Brith, Amtsgericht Hamburg-Vereinregister 231-10 B 1968–44, 1929, StA HH; *Verzeichnis der Mitglieder der Drei Hamburger Logen U.O.B.B. Henry Jones Loge Steinthal Loge und Nehemia Nobel Loge*, 1932–33; on Panofsky and the Ortskomitee Hamburg der Akademie für die Wissenschaft des Judentums, see *EPK*, 5:1290.

46. William Stern to Jonas Cohn, May 7, 1919, in *Der Briefwechsel zwischen William Stern und Jonas Cohn: Dokumente einer Freundschaft zwischen zwei Wissenschaftlern*, ed. Helmut E. Lück and D. J. Löwisch (Frankfurt am Main: Peter Lang, 1994), 122 (my emphasis). Cohn also hoped to be considered for the position. For more on Stern and this exchange, see Lück, "'Noch ein weiterer Jude,'" 407–417.

47. "Gutachten für die philosophische Professur," Hochschulwesen II 361–5 II A I 3:8, June 6, 1919, StA HH.

48. Meyer, *Ernst Cassirer*, 99.

49. William Stern to Ernst Cassirer, June 30, 1919, box 3, folder 71, Ernst Cassirer Papers–Addition Gen Mss 355, GC, BRBML; "Antisemitische Strömungen in der Hamburger Studentenschaft," July–August 1919, *Hamburger Echo*, in Ina Susanne Lorenz, *Die Juden in Hamburg zur Zeit der Weimarer Republik: Eine Dokumentation*, Hamburger Beiträge zur Geschichte der Deutschen Juden, no. 13 (Hamburg: Hans Christians, 1987), 1115.

50. Cassirer, *Mein Leben mit Ernst Cassirer*, 124.

51. Gawronsky, "Ernst Cassirer," 26.

52. This statistic is derived from the academic year of 1930–31. Lorenz, *Die Juden in Hamburg*, 1109, 1133.
53. University Senate Minutes, Universität I 364-5 I C 20.4.1 Band I, November 11, 1919, StA HH; William Hertz to Aby A. Warburg, November 27, 1921, FC, WIA.
54. The archives of StA HH contain at least ten files, all devoted to complaints launched against Passarge over the course of the 1920s. The incident in 1927 was one of a number of anti-Semitic lectures that spurred a public controversy over the issue of "academic freedom." Sitzungsprotokolle der Hochschulbehörde, Universität I 364-5 I B3 Band 1, July 12, 1927, StA HH. See related documents in Lorenz, *Die Juden in Hamburg*, 1120–1128. For more on Passarge and the history of Hamburg's geology department, see Holger Fischer and Gerhard Sandner, "Die Geschichte des Geographischen Seminars der Hamburger Universität im 'Dritten Reich,'" in Krause, Huber, and Fischer, *Hochschulalltag*, 1197–1222.
55. Among the newspaper clippings in Warburg's personal collection are these: *Essener Allgemeine Zeitung*, June 22, 1928; *Neue Badische Landeszeitung* (Mannheim), June 23, 1928; *Breslauer Zeitung*, June 23, 1928; *Ostdeutsche Morgenpost* (Beuthen, now Bytom), June 24, 1928; *Der Tag* (Berlin), June 24, 1928; and *Kölnische Zeitung*, June 23, 1928, III.29.2.6, WIA.
56. A. Warburg, record of his own thoughts, June 3, 1928, GC, WIA; III.29.2.7, WIA; and A. Warburg to Max M. Warburg, June 13, 1928, FC, WIA.
57. Kurt Reizler to Aby Warburg, July 16, 1928; Aby Warburg to Kurt Reizler, July 19, 1928, box 3, folders 78a and 78b, Ernst Cassirer Papers–Addition Gen Mss 355, TPC, BRBML; Verfassungsfeier Festrede, box 2, folder 44 Ernst Cassirer Papers–Addition Gen Mss 355, GC, BRBML.
58. Aby Warburg to Kurt Reizler, July 19, 1928, box 3, folder 78b, Ernst Cassirer Papers–Addition Gen Mss 355, TPC, BRBML.
59. Aby Warburg, "Warum Hamburg den Philosophen Cassirer nicht verlieren darf," *Sonderdruck aus dem Hamburger Fremdenblatt*, June 23, 1928, 3.
60. Warburg, III.29.2.2, WIA.
61. Paul de Chapeaurouge to Ernst Cassirer, June 23, 1928, box 2, folder 44, Ernst Cassirer Papers–Addition Gen Mss 355, GC, BRBML; Warburg, *TKBW*, 287; Fritz Saxl to Ernst Cassirer, June 12, 1928, box 2, folder 31, Ernst Cassirer Papers–Addition Gen Mss 355, GC, BRBML.
62. Staatliche Pressestelle I–IV 135-I 5396, June 17, 1928, StA HH.
63. Cassirer, *Mein Leben mit Ernst Cassirer*, 169.
64. Ballin also married a non-Jewish woman, but he never converted. Cecil, *Albert Ballin*, 37; Susanne Wiborg, "Albert Ballin," in *Das Jüdische Hamburg*, ed. Institut für die Geschichte, 30.
65. A. Warburg to Max M. Warburg, June 13, 1928, FC, WIA; also in *TKBW*, 263.
66. Claudia Naber's article draws on these sources in her tribute to the German Jews of Hamburg, although she does not distinguish between private and

public utterances of Jewishness. "'Die Fackel deutsch-jüdischer Geistigkeit weitertragen': Der Hamburger Kreis um Ernst Cassirer und Aby Warburg," in Herzig and Rohde, *Die Juden in Hamburg 1590 bis 1990*, 393–406.

67. In addition to Ernst Cassirer, "Warburg" scholars Erwin Panofsky, Fritz Saxl, Gertrud Bing, Hans Liebeschütz, Walter Solmitz, Paul Ruben, Richard Salomon, and Edgar Wind were all registered with Hamburg's Jewish community.

68. Scholars have thoroughly documented Warburg's obsession with anti-Semitism, his watchful eye over "Jew eaters" (*Judenfressers*), and his wartime archive of anti-Semitic news coverage. Warburg's research cartons, preserved at the WIA and devoted to such topics as "Jews," and "anti-Semitism," also reflect his profound interest in the topic. According to Schoell-Glass, anti-Semitism, above all, is the explanatory principle in his art-historical scholarship. Schoell-Glass, *Warburg und der Antisemitismus*, esp. 53.

69. Meyer, "Warburg in His Early Correspondence," 446.

70. It is worth noting that by "Jewish Jews," Warburg of course did not mean the observant, but those who promoted a public project of reconciling Judaism with the demands of Western philosophy and the modern world, such as Scholem, Buber, and Rosenzweig, and therefore threatened Warburg's more distinct and separate-spheres model of secular and religious worlds. Thanks to the participants of the Jewish Students Colloquium at Brandeis University for a particularly fruitful discussion on this issue.

71. Scholem, *From Berlin to Jerusalem*, 131–132.

72. Arno Lustiger, ed., *Jüdische Stiftungen in Frankfurt am Main* (Frankfurt am Main: Jan Thorbecke Verlag Sigmaringen, 1988), 74; Fritz Warburg to A. Warburg, November 28, 1913, FC, WIA.

73. Ina Lorenz, "Das 'Hamburger System' als Organisationsmodell einer jüdischen Grossgemeinde: Konzeption und Wirklichkeit," in *Jüdische Gemeinden und Organisationsformen von der Antike bis zur Gegenwart*, ed. Robert Jütte and Abraham P. Kustermann (Vienna: Böhlau, 1996), 221–255. Scholem remarked that Cassirer's work was of tremendous interest to a Kabbalist. Gershom Scholem to Fritz Saxl, October 11, 1928, GC, WIA.

74. Michael Brenner argues that such learning represented one way that modern Jews expressed their Jewishness. *The Renaissance of Jewish Culture in Weimar Germany* (New Haven, CT: Yale University Press, 1996), 69–70.

75. Warburg, *TKBW*, 184.

76. In his personal life, too, Warburg expressed a similar disdain for such "Jewish Jews." As a student at the university in Bonn, Warburg repeatedly complained in letters to his mother about the Jews who spoke Yiddish and possessed the bad table manners common to Jews. A. Warburg to Charlotte Warburg ("Mama"), October 25, 1886, FC, WIA.

77. Joist Grolle, *Bericht von einem schwierigen Leben, Walter Solmitz, 1905–1962: Schüler von Aby Warburg und Ernst Cassirer*, Hamburger Beiträge zur Wissenschaftsgeschichte 13 (Berlin: Reimer, 1994), 12; *TKBW*, 278.

78. Peter G. J. Pulzer, *Jews and the German State: The Political History of a Minority, 1848–1933* (Detroit: Wayne State University Press, 2003), xvi.

79. Sielke Salomon, "Grindelviertel," in *Das Jüdische Hamburg*, ed. Institut für die Geschichte, 96; Albert Einstein to Ernst Cassirer, March 6, 1926, box 55, folder 1086, Ernst Cassirer Papers, GC, BRBML.

80. Cassirer, *Mein Leben mit Ernst Cassirer*, 130, 131.

81. Scholem, *From Berlin to Jerusalem*, 131. Indeed, perhaps they were more like Scholem than he cared to admit, for he often spoke in different cadences to different audiences. Bourdieu, preface to *In Other Words*, ix.

82. Aby Warburg to Deutsch-Israelitische Gemeinde, September 1, 1918, GC, WIA.

83. Aby Warburg, "Warum Hamburg," 1.

84. Warburg, III.29.2.2.4, WIA (my emphasis).

85. Aby Warburg, "Warum Hamburg," 3.

86. Heise, *Persönliche Erinnerungen*, 32.

87. Cited in Aschheim, *Beyond the Border*, 3.

88. A. Warburg to Fritz and Max M. Warburg, January 23, 1926, FC, WIA.

89. Warburg, *Aus meinen Aufzeichnungen*, 71; Walter Laqueur, *Weimar, A Cultural History, 1918–1933* (London: Weidenfeld and Nicolson, 1974), 73; Paul Natorp to Albert Görland, January 1, 1911, SUB.

90. Einstein cited in Aschheim, *Beyond the Border*, 3; Max Warburg to Paul Warburg, June 24, 1922, FC, WIA. Scholem observes that Simmel was often derogatorily referred to as "Talmudic." *From Berlin to Jerusalem*, 67.

91. Gordon A. Craig, *The Germans* (New York: Penguin Group, 1991), 143.

92. Leo Strauss, *Spinoza's Critique of Religion*, trans. Elsa M. Sinclair (Chicago: University of Chicago Press, 1997), 1. Thanks to Eugene Sheppard for this reference.

93. Ernst Cassirer to Albert Einstein, September 28, 1920, AEA.

94. Aschheim, *Beyond the Border*, 4.

95. Shulamit Volkov, "The Social Origins of Success in Science: Jews in 19th Century Germany," in *Juden in der deutschen Wissenschaft*, ed. Walter Grab, Jahrbuch des Instituts für Deutsche Geschichte, Beiheft, 10 (Tel Aviv: M. Zuckermann, C. Templer, 1985), 181–183.

96. This argument is made by David Hollinger about American Jews in the sciences in *Science, Jews, and Secular Culture*, Studies in Mid-Twentieth Century American Intellectual History (Princeton, NJ: Princeton University Press, 1996).

97. The Jewish rector Cassirer was preceded by Julius Bernstein of Halle (rector, 1890–91). Ernst-August Seyfarth, "Julius Bernstein (1839–1917): Pioneer Neurobiologist and Biophysicist," *Biological Cybernetics* 94 (2006): 7.

98. Cassirer, *Mein Leben mit Ernst Cassirer*, 174; Warburg, *TKBW*, 265.

99. Erwin Panofsky to Wolfgang Stechow, July 15, 1929, in *EPK*, 1:312; Ernst Jünger to Carl Schmitt, August 24, 1943, in Jünger and Schmitt, *Ernst*

Jünger/Carl Schmitt, Briefwechsel, 167; Erwin Panofsky to Dora Panofsky, September 21, 1930, in *EPK,* 1:373.

100. Cassirer, *Mein Leben mit Ernst Cassirer,* 124.

1. Pierre Bourdieu's observation about Heidegger's texts is equally valid for Cassirer. *The Political Ontology of Martin Heidegger,* trans. Peter Collier (Stanford, CA: Stanford University Press, 1991), 37.

2. Detlev Peukert, *The Weimar Republic: The Crisis of Classical Modernity* (New York: Hill and Wang, 1992), 55–56. Carole Fink offers an overview of the broad range of scholarship on Stresemann in her review of *Gustav Stresemann: Weimar's Greatest Statesman,* by Jonathan Wright, *Journal of Modern History* 77, no. 2 (2005): 487–489. For an interpretation of Stresemann as a *Vernunftrepublikaner* and his conversion from "pragmatic conservatism" to republicanism, see Henry Ashby Turner, *Stresemann and the Politics of the Weimar Republic* (Princeton, NJ: Princeton University Press, 1963), 68–114, 263. For Stresemann in relation to continuity and discontinuity in German history, see Edgar Feuchtwanger, "Hitler, Stresemann, and the Discontinuity of German Foreign Policy," *History Review* 35 (1999): 14–19.

3. Warburg tried in vain to have a postal stamp issued in Stresemann's honor, an idea he referred to as the "idea Victrix." *TKBW,* 23, 25; Ulrich Raulff, "Der aufhaltsame Aufstieg einer Idee: Warburg und die Vernunft in der Republik," in *Wilde Energien: Vier Versuche zu Aby Warburg,* Göttinger Gespräche zur Gesichtswissenschaft (Göttingen: Wallstein, 2003), 72–86.

4. *TKBW,* 287.

5. Ernst Cassirer, *Die Idee der republikanischen Verfassung: Rede zur Verfassungsfeier am 11. August 1928* (Hamburg: Friederichsen, De Gruyter M.B.H., 1929), 24.

6. This position was strengthened by the fact that the German constitution was only one of many new constitutions that extended across Central and Eastern Europe to the Balkans, including, for example, those of the new Austrian Democratic Republic and the Czecho-Slovak Republic. Mark Mazower, *Dark Continent: Europe's Twentieth Century* (New York: Knopf, 1999), 3.

7. Peukert, *Weimar Republic,* 226.

8. Mendelssohn-Bartholdy often delivered overtly political statements in favor of the Weimar Republic, for which the university board, on at least one occasion, reprimanded him. For his lectures and the related controversy, see Bottin and Nicolaysen, *Enge Zeit,* 44, 155.

9. Joseph Mali argues that Cassirer was generally silent on political issues, closely following the Weberian model of *Gelehrterpolitik,* an accommodationist practice that was highly disturbing. "Ernst Cassirer's Interpretation of Judaism and Its Function in Modern Political Culture," *Juden in der*

deutschen Wissenschaft, ed. Walter Grab (Tel Aviv: Das Institut für deutsche Geschichte, 1986), 206. Krois argues, in contrast, that, as a real believer in the Weimar Republic, Cassirer resembled a *Herzenrepublikaner* (republican of the heart) in "Ernst Cassirer: 1874–1945," 26.

10. Vogel, "Philosoph und liberaler Demokrat," 194. According to Pulzer, the implementation of the DDP (and, after 1930, the DStP) in Hamburg in general, and among Hamburg Jews in particular, was even stronger than in the rest of Germany. *Jews and the German State*, 299–300. On Cassirer's distaste for "party politics," see Klibansky and Conley, "Ein Gespräch über Ernst Cassirer," 276.

11. Weber, "Science as a Vocation," 151.

12. Thomas Mann, *Reflections of a Nonpolitical Man*, trans. Walter D. Morris (New York: Frederick Ungar, 1983), 17.

13. According to Hannah Arendt, Karl Jaspers was a notable exception as "the first and only philosopher who ever protested against solitude, to whom solitude appeared 'pernicious' and who dared to question 'all thoughts, all experiences, all contents' under this one aspect: What do they signify for communication?'" Cited in Rabinbach, "The German as Pariah: Karl Jaspers's *The Question of German Guilt*," in *In the Shadow of Catastrophe*, 139.

14. The university board initiated an inquiry in 1924 following a speech by Rector Laun in which he expressed support for the Social Democrats. "Rektoratswechsel," Staatliche Pressestelle I–IV 135-I I–IV 5377, 1923–1933, StA HH.

15. Walter D. Morris, introduction to Mann, *Reflections of a Nonpolitical Man*, xii.

16. Klibansky and Conley, "Ein Gespräch über Ernst Cassirer," 276.

17. Cassirer, *Die Idee der republikanischen Verfassung*, 16–21.

18. Cassirer, "Deutschland und Westeuropa," 207, 208;

19. Ernst Cassirer, "Leibniz und Jungius," in *ECK* 17, 361.

20. Hughes, *Consciousness and Society*, 37–39, 234–235.

21. For Mann on Dostoevsky, see *Reflections of a Nonpolitical Man*, 20, 23. For his reflections on Lübeck, see "Lübeck als geistige Lebensform," quotation on 384. As a liberal non-Jewish historian who advocated political intellectual history, Meinecke presents an interesting foil to Cassirer. Friedrich Meinecke, *Cosmopolitanism and the National State*, trans. Robert B. Kimber (Princeton, NJ: Princeton University Press, 1970), 94.

22. Cited in Seeba, "Cultural History," 12.

23. Ibid; and Michael Hänel, "Exclusions and Inclusions of a Cosmopolitan Philosopher: The Case of Ernst Cassirer," in *Crossing Boundaries: The Exclusion and Inclusion of Minorities in Germany*, ed. Larry Eugene Jones (New York: Berghahn Books, 2001), 121.

24. Of Lamprecht's theory of history, Cassirer observed that it was not a theory of history at all, but a "scientific 'nowhere' (utopia) and 'nowhen'

(uchronia)." Cited in Chickering, *Karl Lamprecht*, 334. In contrast to Cassirer, Troeltsch argued that the Enlightenment, the Renaissance, and the Reformation constituted independent historical moments and that Germany represented an idea of freedom distinct from that of the Western European tradition. This characterization of Troeltsch's critique of Cassirer is drawn from Lipton, *Ernst Cassirer*, 58. For Lipton Cassirer's work was essentially an intellectual protest against "what the war was doing to Germany." Ibid., 35.

25. Bottin and Nicolaysen, *Enge Zeit*, 155, 24.

26. Gustav Pauli, "In Memory of Aby M. Warburg, (1866–1929)," *Hamburg Amerika Post* 10 (1929): 346–348.

27. Bottin and Nicolaysen, *Enge Zeit*, 38.

28. Seeba, "Cultural History," 13.

29. Ute Frevert, "Europeanizing Germany's Twentieth Century," *History and Memory* 17 (2005): 87–116, esp. 89.

30. I do not entirely agree with Vogel, however, that the Hamburg School was a refuge within the city at large. "Philosoph und liberaler Demokrat," 208.

31. Aby Warburg to Toni Cassirer and Ernst Cassirer, September 6, 1928, 614, 31–33, WHH.

32. Warburg, "From the Arsenal," 119.

33. For more on the Hamburg Group's contribution to the event, see Rüdiger Schütt, *Bohemiens und Biedermänner: Die Hamburger Gruppe 1925 bis 1931* (Hamburg: Edition Fliehkraft, 1996), 111–116. For the event's plans, see "Erinnerungs- und Gedächtnisfeiern—Lessing Feier," Universität I 364-5 I A 170.8.9, January 1929, StA HH.

34. "Erinnerungs- und Gedächtnisfeiern—Lessing Feier," Universität I 364-5 I A 170.8.9, January 1929, StA HH.

35. Staatliche Pressestelle I–IV 135-I 5375, Lessingfeier, 1929, StA HH.

36. The relationship between Lessing and Hamburg was, in fact, more ambiguous. John McCarthy argues that the Hamburg Senate's lack of involvement in cultural projects proved disastrous for Hamburg's National Theater. "Lessing and the Project of a National Theater in Hamburg: 'Ein Supplement der Gesetze,'" in Hohendahl, *Patriotism, Cosmopolitanism, and National Culture*, 71–90.

37. "Erinnerungs- und Gedächtnisfeiern—Lessing Feier," Universität I 364-5 I A 170.8.9, January 1929, StA HH.

38. "Lessingsfeier der Universität: Künstlergruppe stiftet eine Büste: Rektor wünscht den Namen Lessing-Universität," January 23, 1929, *Hamburger Echo*, in "Erinnerungs- und Gedächtnisfeiern—Lessing Feier," Universität I 364-5 I A 170.8.9, January 1929, StA HH.

39. On the anti-Versailles rallies, see Universität I 364-5 I M 50.17, January 3, 1920, StA HH. Hamburg's university newspaper also contains frequent articles on Germany's political situation. *Hamburger Universitäts-Zeitung* Z 561 1, W-Sem 1924–25 Nr. 1 6 Jahrgang, Heft 6, 1924, StA HH.

40. University Senate Minutes, Universität I 364-5 C 20.4.1 Band 2, February 25, 1921, StA HH.

41. Philosophical Faculty Minutes, 364-13 Fakultäten/Fachbereiche der Universität Phil Fak P 3, November 26, 1921, StA HH; Vogel, "Anpassung und Widerstand," 27–28.

42. Gemeindeblatt der Deutsch-Israelitischen Gemeinde zu Hamburg Z 680 4b, 1929, StA HH. For a discussion of how Jewish community leaders drew on figures such as Lessing and Mendelssohn to create a useful past for their members, see Guy Miron, "The Emancipation's 'Pantheon of Heroes' in the German-Jewish Public Memory in the 1930s," *German History* 21 (2003): 476–504.

43. Ernst Cassirer, "Die Idee der Religion bei Lessing und Mendelssohn," *ECK* 17, 95, 1010.

44. Sander L. Gilman and Jack Zipes, eds., *Yale Companion to Jewish Writing and Thought, 1096–1996* (New Haven, CT: Yale University Press, 1997), 508.

45. Charles W. Hendel, introduction to Ernst Cassirer, *An Essay on Man* (New Haven, CT: Yale University Press, 1974), 1.

46. Isaiah Berlin, "Kant as an Unfamiliar Source of Nationalism," *The Sense of Reality: Studies in Ideas and Their History,* ed. Henry Hardy (New York: Farrar, Straus and Giroux, 1998), 232–248.

47. Cassirer, *Die Idee der republikanischen Verfassung,* 8.

48. Ibid., 22. Meinecke made a similar argument in a review of the historian Alfred Stern's work, *Der Einfluss der französischen Revolution auf das deutsche Geistesleben,* which failed to show how the German tradition could have developed on its own. *Historische Zeitschrift* 139 (1929): 599. See also Jonathan Knudsen, "The Historicist Enlightenment," in *What's Left of Enlightenment: A Postmodern Question,* ed. Keith Baker and Peter Hanns Reill (Stanford, CA: Stanford University Press, 2001), 47.

49. The controversy arose from the publication of Cohen's lecture "Deutschtum und Judentum" in 1915, for which he was starkly criticized by all sides. Bauch's essay "Vom Begriff der Nation," which was contemporaneously published with his anti-Semitic letter, received much attention. Bauch subsequently founded the Deutsche Philosophische Gesellschaft, whose purpose was to fight against the influence of foreigners (*Überfremdung*) in German philosophy. Ulrich Sieg, "Deutsche Kulturgeschichte und Jüdischer Geist: Ernst Cassirers Auseinandersetzung mit der völkischen Philosophie Bruno Bauchs, ein unbekanntes Manuskript," *Bulletin des Leo Baeck Instituts* 82 (1989): 61; Barbara Vogel, "Judentum und 'deutscher Geist': Kant-Studien im Ersten Weltkrieg," in *Die Dritte Joseph Carlebach-Konferenz: Toleranz im Verhältnis von Religion und Gesellschaft,* ed. Miriam Gillis-Carlebach and Barbara Vogel (Hamburg: Döllig und Galitz, 1997), 71. Bauch went on to become a key intellectual supporter of the Nazis. Hans Sluga, *Heidegger's Crisis: Philosophy and Politics in Nazi Germany* (Cambridge, MA: Harvard University Press, 1993), 82–85, 92–95, 210–214.

50. Michael Mack, *German Idealism and the Jew: The Inner Anti-Semitism of Philosophy and German Jewish Responses* (Chicago: University of Chicago Press, 2003), 108, 16.

51. That Hermann Cohen saw the answer to the German-Jewish problem in Kant was *despite* Kant's view of Jews as the opposite of "autonomous reason." Cohen's own work was compelled to first engage in a "polite inversion of idealism's prejudicial aspects." Ibid., 31, 116; see also Poma, "Hermann Cohen," 91.

52. Moynahan makes this point to argue that Cassirer's notion of "symbolic forms," too, is given less credit than it deserves. "Davos Debate," 120.

53. Cassirer submitted his article to Hans Vaihinger of the Kant Society and threatened that he and Cohen would resign if the society did not distance itself from Bauch. Since the article was not accepted unconditionally and Cassirer did not want to become embroiled in a public controversy, he withdrew the article from publication. Sieg, "Deutsche Kulturgeschichte und Jüdischer Geist," 71. Cassirer's rebuttal was not published until 1991. "Zum Begriff der Nation: Eine Erwiderung auf den Aufsatz von Bruno Bauch," *Bulletin des Leo Baeck Instituts* 88 (1991): 73–91.

54. On Bauch's resignation, see Sieg, "Deutsche Kulturgeschichte und Jüdischer Geist," 63; Vogel, "Judentum und 'deutscher Geist,'" 71.

55. Friedman, *Parting of the Ways*, 1, quotation on 5. For the most recent literature on the Davos debate, see the essays in *Cassirer-Heidegger 70 Jahre Davos Disputation* 9, ed. Dominic Kaegi and Enno Rudolf, Cassirer-Forschungen (Hamburg: Felix Meiner, 2002).

56. Krois, "Why Did Cassirer and Heidegger Not Debate?" 247.

57. Martin Heidegger to Elfride Heidegger, March 21, 1929, in *Letters to His Wife, 1915–1970*, ed. Gertrud Heidegger, trans. R. D. V. Glasgow (Cambridge: Polity Press, 2008), 119.

58. Heidegger studied with Heinrich Rickert in the Southwest School of neo-Kantianism. In 1928 Heidegger reviewed the second volume of Cassirer's *Philosophy of Symbolic Forms*. In this review, he lauded Cassirer's investigation of myth insofar as it represented a positive example of research into myth but criticized the ultimate conclusion that myth was incapable of ever achieving *philosophical* understanding. He also expressed doubt that neo-Kantianism could ever grasp the foundation of myth. Martin Heidegger, "Appendix II," in *Kant and the Problem of Metaphysics*, 5th ed, trans. Richard Taft (Bloomington: Indiana University Press, 1997), 180–190, esp. 186. Heidegger's *Being and Time*, published initially in 1927, also cited Cassirer. Martin Heidegger, *Being and Time*, trans. John Macquarrie and Edward Robinson (New York: Harper and Row, 1962), xi, 490. For a description of the 1923 meeting, see Meyer, *Ernst Cassirer*, 154–155.

59. Heidegger's students Otto Bollnow and Joachim Ritter published a transcript of the debate from their notes. All translations from the debate are from this version unless otherwise noted. Martin Heidegger, "Davos

Disputation between Ernst Cassirer and Martin Heidegger," in *Kant and the Problem of Metaphysics*, 193–207.

60. Translation altered by author. Heidegger, "Davos Disputation," 193.

61. Ibid.

62. Leo Strauss's description of the distinction between the two is helpful: "Cassirer had been a pupil of Hermann Cohen, the founder of the neo-Kantian school. Cohen had elaborated a system of philosophy whose center was ethics. Cassirer had transformed Cohen's system into a new system of philosophy in which ethics had completely disappeared. . . . [Heidegger] declared that ethics is impossible, and his whole being was permeated by the awareness that this fact opens up an abyss." Leo Strauss, "An Introduction to Heideggerian Existentialism," in *The Rebirth of Classical Political Rationalism: An Introduction to the Thought of Leo Strauss* (Chicago: University of Chicago Press, 1989), 28.

63. So named by Mendelssohn, according to Cassirer, *Kant's Life and Thought*, 369.

64. As Kuhn argues, it is not that Kant failed to bring unity to sensibility and understanding; it is that Kant never thought that we could do this. "So, though Heidegger believed that he was solving the problem that neither Kant nor the Marburg Neo-Kantians could solve, he actually posed an entirely different problem." "Interpreting Kant Correctly," 127.

65. Friedman, *Parting of the Ways*, 61.

66. Gay, *Weimar Culture*, 77; Karl Löwith, *Mein Leben in Deutschland vor und nach 1933* (Stuttgart: J.B. Metzler, 1986), 43; also cited in Richard Wolin, *Heidegger's Children: Hannah Arendt, Karl Löwith, Hans Jonas, and Herbert Marcuse* (Princeton, NJ: Princeton University Press, 2003), 34–35. For the English version, see Löwith, *My Life in Germany before and after 1933* (Urbana: University of Illinois Press, 1994), 45.

67. Ulrich Sieg discovered a letter in which Heidegger complained of the Judaizing of Kant philosophy. "'Die Verjudung des deutschen Geist': Ein unbekannter Brief Heideggers," *Die Zeit*, December 29, 1989, 19. Strauss, a former student of Cassirer's, believed that the debate "revealed the lostness and emptiness to everyone who had eyes." Strauss, "Heideggerian Existentialism," 28. In addition to his mentor Edmund Husserl and his most famous pupil, Hannah Arendt, Heidegger seemed to be surrounded by Jews. Saul Friedländer, *Nazi Germany and the Jews*, vol. 1, *The Years of Persecution, 1933–1939* (New York: Harper Collins, 1997), 52–54.

68. Richard Wolin attributes this to the "false consciousness" of German Jews, whose self-hatred led them to affiliate with the philosopher, while Samuel Fleischacker explores the "Jewish affinities" in Heidegger's work. Samuel Fleischacker, "Introduction: Heidegger's Affinities with Judaism," in *Heidegger's Jewish Followers: Essays on Hannah Arendt, Leo Strauss, Hans Jonas, and Emmanuel Levinas*, ed. Samuel Fleischacker (Pittsburgh, PA: Duquesne University Press, 2008), 1.

69. Jacob Klein and Leo Strauss, "A Giving of Accounts," *Jewish Philosophy and the Crisis of Modernity in Modern Jewish Thought*, ed. Kenneth H. Green (Albany: State University of New York Press, 1997), 460. As an investigation of a "Counter-Enlightenment" thinker, Strauss's doctoral dissertation, "The Problem of Knowledge in F. H. Jacobi's Philosophical Teaching," would have already been viewed as a departure from his *Doktorvater*. Responding to Cassirer's *Die Begriffsform im mythischen Denken* two years later, Strauss directly criticized Cassirer in "Zur Auseinandersetzung mit der europäischen Wissenschaft," *Der Jude* 8 (1924): 613–17; reprinted in Leo Strauss, *Gesammelte Schriften*, vol. 2, *Philosophie und Gesetz: Frühe Schriften*, ed. Heinrich Meier (Stuttgart: J.B. Metzler, 1996), 341–350. For more on the strained relationship between Strauss and Cassirer, see Eugene R. Sheppard, *Leo Strauss and the Politics of Exile: The Making of a Political Philosophy*, Tauber Institute for the Study of European Jewry Series (Waltham, MA: Brandeis University Press, 2006), 22–26.
70. Leo Strauss, "An Introduction to Heideggerian Existentialism," 27.
71. Gordon cautions against allegorizing this event without an attention to its philosophical content. Peter Gordon, "Continental Divide: Ernst Cassirer and Martin Heidegger at Davos, 1929—An Allegory of Intellectual History," *Modern Intellectual History* 1, no. 2 (2004): 219–248. Krois observes that there existed less of a philosophical gulf between Cassirer and Heidegger at Davos than both contemporaries and scholars have emphasized, an argument that reinforces the *symbolic* rather than philosophical importance of the debate. "Why Did Cassirer and Heidegger Not Debate?" 248.
72. Hendrik J. Pos, "Recollections of Ernst Cassirer," in Schilpp, *Philosophy of Ernst Cassirer*, 67–68.
73. Kurt Riezler, "Davoser Hochschulkurse 1929," *Neue Zürcher Zeitung*, Saturday, March 30, 1929, Morgenausgabe, no. 609. Cited in Krois, "Why Did Cassirer and Heidegger Not Debate?" 244.
74. Habermas, "German Idealism," 32. Despite his later recollections, Strauss's own attendance at the debate is dubious. Sheppard, *Strauss and the Politics of Exile*, 39.
75. However, as both Peter Gordon and Leora Batnitsky show, Levinas arguably continued to pursue philosophy engaged and compatible with Heideggerian phenomenology. See the summary of their essays in Fleischacker, *Heidegger's Jewish Followers*, 22–23; and Gordon, "Continental Divide," 227.
76. Gordon, *Continental Divide*, 3–6, 19.
77. Krois, "Why Did Cassirer and Heidegger Not Debate?" 245–46, 248.
78. Fleischacker characterizes the pair as "endless seekers" for whom the elusiveness of God and Being presented a parallel project. Introduction to *Heidegger's Jewish Followers*, 3–6, 12.

79. This distinction between thrownness and spontaneity is also, for Gordon, a distinction between two radically different views of humanity. Gordon, *Continental Divide*, 362–364.

80. According to Craig J. Calhoun, "where [Habermas's] *Structural Transformation* located the basis for the application of practical reason to politics in the historical specific social institutions of the public sphere, the theory of communication action locates them in transhistorical, evolving communicative capacities or capacities of reason conceived intersubjectively as in its essence a matter of communication. The public sphere remains an ideal, but it becomes a contingent product of the evolution of communicative action, rather than its basis." "Introduction: Habermas and the Public Sphere," in *Habermas and the Public Sphere*, ed. Calhoun (Cambridge, MA: MIT Press, 1992), 1–48, quotation on 32.

81. Bourdieu, *Political Ontology*, 2, 37.

82. Cassirer, *Mein Leben mit Ernst Cassirer*, 182. Richard Wolin argues that Toni's otherwise dubious assertion of Heidegger's early anti-Semitic leanings is substantiated by a letter written on behalf of one of his students in the same year. He wrote, "At stake is nothing less than the urgent awareness that we stand before a choice: once again to provide our *German* spiritual life with genuine, indigenous [*bodenständige*] manpower and educators, or to deliver it over definitively . . . to increasing Judification [*Verjudung*]." Wolin, *The Politics of Being*, 4–5.

83. Cassirer, *Mein Leben mit Ernst Cassirer*, 183.

84. The four-year love affair between Arendt and Heidegger that began when Arendt was only eighteen years old had already subsided by this point. Elisabeth Young-Bruehl, *Hannah Arendt: For Love of the World* (New Haven, CT: Yale University Press, 1982), 53–56.

85. Her deceptive modesty and sly efforts recall those of Shakespearean women, efforts that, having taken place in the private realm, had a powerful impact on the public. Kate, in Shakespeare's *Taming of the Shrew*, is the classic example of this female trope. See the section on "Women and Authority" in Juliet Dusinberre, *Shakespeare and the Nature of Women*, 2nd ed. (London: Macmillan, 1996), 77–110.

86. Pos, "Recollections of Ernst Cassirer," 69.

87. According to unpublished letters from Heidegger's wife, Elfride Heidegger, her husband had warm feelings toward Cassirer in 1923 and again in 1929. Meyer, *Ernst Cassirer*, 156. See also Meyer, "Am Abgrund wandernd, Unbekannte gestoßen: Das Davoser Treffen von Ernst Cassirer und Martin Heidegger hat eine bislang unbekannte Vorgeschichte in Hamburg 1923," *Frankfurter Allgemeine Zeitung* 44 (2006): 45. Thanks to Meyer, who holds these unpublished letters in his possession, for his advice on this matter.

88. Toni also contradicts herself in the passage concerning her previous knowledge of Heidegger's "philosophical and personal leanings." Cassirer, *Mein Leben mit Ernst Cassirer*, 181–189; Friedman, *Parting of the Ways*, 6.

CHAPTER NINE

1. "Rektoratswechsel," Staatliche Pressestelle I–IV 135-I I–IV 5377, November 9, 1929, StA HH.
2. William Sheridan Allen argues that the Nazis' intrusion into the pseudonymously named town "Thalburg" exposed the social divisions within the communities; Rudy Koshar shows how the Nazis drew on Marburg's organizational life and its citizens' aversion to "party politics" to build a strong source of support for their cause. Allen, *The Nazi Seizure of Power: The Experience of a Single German Town, 1922–1945*, rev. ed. (New York: Franklin Watts, 1984); Rudy Koshar, *Social Life, Local Politics, and Nazism: Marburg, 1880–1935* (Chapel Hill: University of North Carolina Press, 1986).
3. Warburg, in *TKBW*, 541.
4. Ferguson, *Paper and Iron*, 408.
 As Ferguson charts it, Warburg's illness began in 1914, intensified in October 1918, and continued for the next four and a half years, with his recovery miraculously coinciding with the stabilization of the German mark. Ibid., 432.
5. Peukert, *Weimar Republic*, 249, 57.
6. Hobsbawm, *Age of Extremes*, 91. Niall Ferguson goes further and argues that it was "the inflation which led from Wilhelmine grandeur to Weimar collapse." Ferguson, *Paper and Iron*, 408.
7. Bing, "Fritz Saxl," 22.
8. Saxl, "Ernst Cassirer," 50.
9. According to Peter Pulzer, Petersen is an example of how outside Berlin, Jews could hold positions of prominence. Interestingly, the other prominently Jewish mayor in Germany in the Weimar period was Ludwig Landmann in Hamburg's sister city Frankfurt. *Jews and the German State*, 274. "Rektoratswechsel," Staatliche Pressestelle I–IV 135-I I–IV 5377, 1929–1933, StA HH.
10. Harry Kessler, *The Diaries of a Cosmopolitan: Count Harry Kessler, 1918–1937* (London: Weidenfeld and Nicolson, 1971), 109.
11. "Rektoratswechsel," Staatliche Pressestelle I–IV 135-I I–IV 5377, 1929–1933, StA HH.
12. Ibid.
13. Ernst Cassirer, "Ansprache zur Reichsgründungsfeier der Hamburgischen Universität am 18 Januar 1930," box 35, folder 693, pp. 1, 3, Ernst Cassirer Papers, Gen Mss 98, BRBML (my emphasis). This version of the speech is found in a folder marked "Draft A." A different version exists in a folder marked "Draft B." All citations are of Draft A.
14. "Reichsgründungsfeier," Universität I 364-5 I A 170.6.9, 1929–1930, StA HH.
15. Hans Beyer, "Akademische Reichsgründungsfeier," *Hamburger Universitäts-Zeitung* 8 (February 1930): 182.
16. Fritz Saxl to Erwin Panofsky, February 15, 1924, in *EPK*, 1:138.

17. Pos, "Recollections of Ernst Cassirer," 69–70.

18. "Reichsgründungsfeier," Staatliche Presestelle I–IV 135-I I–IV 5377 1923–1933, StA HH.

19. On July 23, 1919, the University of Hamburg's rector received a memo from the Senatskomission für die Reichs- und Auswärtigen Angelegenheiten appealing to universities to celebrate the writing of the constitution of Weimar. "Verfassungsfeier," Universität I 363-5 I A 170.8.2, 1919–1930, StA HH.

20. Rainer Nicolaysen, "Geistige Elite im Dienste des 'Führers': Die Universität zwischen Selbstgleichschaltung und Selbstbehauptung," in *Hamburg im "Dritten Reich": Herausgegeben von der Forschungsstelle für Zeitgeschichte* (Göttingen: Wallstein, 2005), 339. The organizations that boycotted Cassirer's speech included Burschenschaft Allemania, Burschenschaft Germania, Corps Franconia, Corps Suevo Borussia, Landsmannschaft Wartburgia, Landmannschaft Hammonia, Verein Deutscher Studenten, and the Akademische Turnverbindung Hegelingen. "Verfassungsfeier," Universität I 364-5 I A 170.8.2, 1919–1930, StA HH.

21. "Verfassungsfeier," Universität I 364-5 I A 170.8.2, 1919–1930, StA HH.

22. Cited in Bottin and Nicolyasen, *Enge Zeit*, 161.

23. "Verfassungsfeier," Staatliche Pressestelle I–IV 135-I I–IV 5392, July 1930, StA HH.

24. Ibid.

25. Ernst Cassirer, "Wandlungen der Staatsgesinnung und der Staatstheorie in der deutschen Geistesgeschichte," in Bottin and Nicolaysen, *Enge Zeit*, 163.

26. Ibid.

27. Ibid., 165. Johann Gottlieb Fichte, *Addresses to the German Nation*, ed. George Armstrong Kelly, trans. R. F. Jones and G. H. Turnbull (New York: Harper & Row, 1968). Meinecke offers a similar interpretation of Fichte in *Cosmopolitanism and the National State*, 71–88, esp. 73.

28. The creation of a Fichte Society in 1914 spurred a "Fichte Renaissance" in the Weimar Republic, a movement that educated and nurtured the Right. Vogel, "Judentum und 'deutscher Geist,'" 74. Hamburg also possessed a local chapter of this society founded in 1921. University Senate Minutes, Universität I 364-5 C 20.4.1 Band 2, February 25, 1921, StA HH.

29. Cassirer, "Wandlungen der Staatsgesinnung," 168–169.

30. "Verfassungsfeier," Staatliche Pressestelle I–IV 135-I I–IV 5392, July 1930, StA HH.

31. "Verfassungsfeier," Universität I 364-5 I A 170.8.2, 1919–30, StA HH.

32. For the increasing politicization of the German student body between the wars, see Geoffrey J. Giles, *Students and National Socialism in Germany* (Princeton, NJ: Princeton University Press, 1985), 14–26.

33. This statement is commonly attributed to Walter Rathenau. Paul Bookbinder, *Weimar Germany: The Republic of the Reasonable* (Manchester: Manchester University Press, 1996), 146.

34. "Universitätsfeier ohne Studentenschaft," *Hamburger Nachrichten*, July 21, 1930. See also the June 6, 1930, *Hamburger Nachrichten*, where it is reported that the goal was to make good republicans of students in universities. "Verfassungsfeier," Universität I 364-5 I A 170.8.2, 1919–30, StA HH.

35. On the "new politics," see, for example George L. Mosse, *The Nationalization of the Masses: Political Symbolism and Mass Movements in Germany from the Napoleonic Wars through the Third Reich* (New York: Howard Fertig, 1975).

36. Arnold Brecht, *The Political Education of Arnold Brecht: An Autobiography, 1884–1970* (Princeton, NJ: Princeton University Press, 1970), 215–216. Cited in Bookbinder, *Weimar Germany*, 150.

37. Cassirer, "Wandlungen der Staatsgesinnung," 166.

38. Warburg, in *TKBW*, 25.

39. Cassirer, "Wandlungen der Staatsgesinnung," 169.

40. Koshar, *Social Life*, xiv, 6. For a good explanation of "antipolitics," see Repp, *Reformers*, esp. 36.

41. On June 12, 1925, for example, the University Senate debated whether "political" groups could use university buildings. University Senate Minutes, Universität I 364–5 I C 20.4.1 Band 3, 12 June 1925, StA HH.

42. Giles, *Students and National Socialism*, 49–52. For a further discussion of the particular student dilemmas that plagued Cassirer's rectorship, see Geoffrey J. Giles, "The Academic Ethos in the Face of National Socialism," *Minerva* 18 (Spring 1980): 171–179.

43. University Senate Minutes, Universität I 364-5 I C 20.4.1 Band 3, July 31, 1925, StA HH.

44. "Deutsch-jüdischer Studentenbund," Universität I 364-5 I O 30.5.105, November 28, 1930, StA HH.

45. Staatliche Pressestelle I–IV 135-I I–IV 5391, June 1931, StA HH.

46. "Zionistische Studenten," Universität I 364-5 I O 30.5.551, November 11, 1932, StA HH.

47. Vogel, "Philosoph und liberaler Demokrat," 203; Nicolaysen, "Geistige Elite," 337.

48. Peter Jelavich, *Berlin Alexanderplatz: Radio, Film, and the Death of Weimar Culture* (Berkeley: University of California Press, 2006), xii.

49. Cassirer, *Philosophy of the Enlightenment*, vii. All citations are of the English edition.

50. Ibid., vi (my emphasis). Cassirer also expressed this historicist position in later works, including *Essay on Man*, 183.

51. This view of history in general and the Enlightenment in particular is expressed in Friedrich Meinecke's *Historicism: The Rise of a New Historical Outlook*, trans. J. E. Anderson (London: Routledge and Kegan Paul, 1972). Although he praised Cassirer's scholarship, Meinecke, in contrast, viewed the Enlightenment as ahistorical. Friedrich Meinecke, review of *Die Philosophie der Aufklärung*, by Ernst Cassirer, *Historische Zeitschrift* 149 (1934): 586. See also Knudsen, "Historicist Enlightenment," 48; and Peter

Gay on Cassirer's critical method of *Verstehen* in his introduction to Ernst Cassirer, *The Question of Jean-Jacques Rousseau*, ed. and trans. Peter Gay (Bloomington: Indiana University Press, 1967), 21.

52. Cassirer, *Philosophy of the Enlightenment*, xi.

53. Ibid., xi–xii, "polemical intentions" on x.

54. Ibid., x, xi.

55. Although Isaiah Berlin presented his argument of the "Counter Enlightenment" first in 1973, the term *Gegenaufklärung* was already in circulation in the 1780s. "Counter-Enlightenment," in *Dictionary of the History of Ideas* (New York: Scribners, 1973), 2:100–112 and then in *Against the Current: Essays in the History of Ideas*, ed. Henry Hardy and Roger Hausheer (Princeton, NJ: Princeton University Press, 1979), 1–24; on the earlier history of this concept see Wolfgang Albrecht, "Gegenaufklärung," in *Lexikon zum Aufgeklärten Absolutismus in Europa*, ed. Helmut Reinalter (Vienna: Böhlau, 2005), 256–259.

56. Cassirer, *Philosophy of the Enlightenment*, 233, "center of gravity" on 274.

57. Ibid., vii, 13.

58. Ibid., 13, 14.

59. Ibid., 93. The shift Cassirer observed between seventeenth- and eighteenth-century philosophy also embodied this transformation from metaphysics to epistemology. While the historian of the seventeenth century could illustrate the spirit of the age with a sum total of philosophical content, a historian of the eighteenth century could not employ a similar method, "for the system as such has now lost its power to synthesize and represent the various elements of philosophy." Ibid., ix.

60. Cassirer, *Question of Jean-Jacques Rousseau*, 96; see also 58, 70, and 82. The essay first appeared in the *Archiv für Geschichte der Philosophie* 41 (1932): 177–213, 479–513; and in French as "L'Unité dans l'úuvre de Jean-Jacques Rousseau," *Bulletin de la Société Française de Philosophie* 2 (1932): 46–66.

61. Meinecke, review of *Die Philosophie der Aufklärung*, 586.

62. Presumably, he would count himself in this category, too. Cassirer, *Kant's Life and Thought*, 89.

63. Cassirer, *Philosophy of the Enlightenment*, 359.

64. Although Cassirer pays tribute to Kant throughout (see, for example, ibid., 133, 276–278), his decision to conclude with a discussion of German aesthetics in Baumgarten and Lessing appears deliberate. Lipton makes a similar observation in his biography of Cassirer. *Ernst Cassirer*, 165.

65. Fania Oz-Salzberger argues that Cassirer's writings on aesthetics and religious faith do not square with the scathing critique's of Cassirer's rational Enlightenment. "Cassirer's Enlightenment and Its Recent Critics: Is Reason out of Season?" in Barash, *Symbolic Construction of Reality*, 163–173.

66. Johnson Kent Wright, "'A Bright Clear Mirror': Cassirer's *The Philosophy of the Enlightenment*." In *What's Left of Enlightenment? A Postmodern Question*,

ed. Keith Baker and Peter Hanns Reill (Stanford, CA: Stanford University Press, 2001), 94.

67. Felix Gilbert, review of *Historicism*, by Friedrich Meinecke, *History and Theory* 13 (1974), 59–64, here 61.

68. Max Wundt, "Die deutsche Philosophie im Zeitalter der Aufklärung," *Zeitschrift für Deutsche Kulturphilosophie* 2 (1936): 227. Thanks to Peter Gordon for alerting me to the citation.

69. Isaiah Berlin, review of *The Philosophy of the Enlightenment*, by Ernst Cassirer, trans. F. C. A. Koelnn and J. P. Pettegrove," *English Historical Review* 68 (1953): 617–619, quotation on 619.

70. James Schmidt, "Inventing a Counter-Enlightenment: Liberalism, Nihilism, and Totalitarianism," prepared for presentation at the meetings of the American Historical Association, Boston, January 6, 2011, 15.

71. Bottin and Nicolaysen, *Enge Zeit*, 48–49.

72. Aby Warburg to Weisbach, April 3, 1915, GC, WIA.

73. Sieg, "Deutsche Kulturgeschichte und Jüdischer Geist," 64.

74. Vogel makes a similar argument about anti-Semitism in the academy. "Judentum und 'deutscher Geist,'" 81.

75. Jelavich, *Berlin Alexanderplatz*, xvi.

76. Cassirer, "Zum Begriff der Nation," 73, 82.

77. Ibid., 87.

78. "Rektoratswechsel," Staatliche Pressestelle I–IV 135-I I–IV 5377, 1923–33, StA HH.

79. Koshar describes how this situation enabled National Socialists to usurp local politics, drawing on its infrastructure and presenting itself as an "apolitical" and extraparliamentary alternative. *Social Life*, xiv.

80. Frank B. Tipton, *A History of Modern Germany since 1815* (Berkeley: University of California Press, 2003), 411.

81. Its hidden nature is confirmed by the fact that it was discovered only recently by Thomas Meyer, according to whom the speech was titled "Hermann Cohens Philosophie der Religion und ihr Verhältnis zum Judentum" and appeared in the *Gemeindeblatt* of the Jewish community in Berlin. Now published in Ernst Cassirer, *Gesammelte Werke*, vol. 18, *Aufsätze und kleine Schriften (1932–1935)*, ed. Birgit Recki (Hamburg: Felix Meiner, 2004), 255–264. Meyer, *Ernst Cassirer*, 205.

82. Leo Strauss, in particular, believed that Cassirer's understanding of the role of myth in religion represented an unfortunate departure from Hermann Cohen's thought and publicly criticized him for this as early as 1924. Sheppard, *Strauss and the Politics of Exile*, 25.

83. Bottin and Nicolaysen, *Enge Zeit*, 28; Fritz Saxl to Max M. Warburg, May 6, 1933, in *EPK*, 1:597; Adolf Rein, *Die Idee der politischen Universität* (Hamburg: Hanseatische Verlagsanstalt, 1933).

84. Gustav Schieffler to Leo Raape, January 6, 1933, SUB Hamburg; Bottin and Nicolaysen, *Enge Zeit*, 31. The canceled lectures included, in addition

to that of Cassirer, those of Eduard Heimann, Richard Solomon, William Stern, Erwin Panofsky, Theodor Plaut, and Walter A. Berendsohn. Minutes of the Philosophy Faculty, April 7, 1933. Ibid., 28.

85. The progressive challenges posed to non-Aryan students at Hamburg are detailed in Nicolaysen, "Geistige Elite," 345. For a general overview of the expulsion of Jewish students at German universities see Béla Bodo, "The Role of Antisemitism in the Expulsion of non-Aryan Students, 1933–1945," *Yad Vashem Studies* XXX (2002): 189–228. In contrast to such universities as Tübingen, which had fewer Jews to let go and ultimately lost only 4 percent of its faculty, Hamburg expelled more than 21 percent between 1933 and 1945. Michael Grüttner, "Die 'Säuberung' der Universitäten: Entlassungen und Relegationen aus rassistischen und politischen Gründen," in *Universitäten und Studenten im Dritten Reich: Bejahung, Anpassung, Widerstand: XIX Königswinterer Tagung vom 17.–19. Februar 2006*, ed. Joachim Scholtyseck and Christoph Studt (Berlin: Lit, 2008), 23–39. For a chart comparing universities, see 39.

86. Panofsky's case is discussed in greater detail in the epilogue. On the lack of protest in general, see Nicolaysen, "Geistige Elite," 342. Fritz Saxl to Fritz Schumacher, May 6, 1933, 461, WHH; Fritz Schumacher to Erwin Panofsky, June 2, 1933, in *EPK*, 1:622.

87. Cassirer, *Mein Leben mit Ernst Cassirer*, 193.

88. Edgar Wind to Ernst Cassirer, April 10, 1933, Staatsbibliothek zu Berlin-Preußischer Kulturbesitz.

89. Cassirer, *Mein Leben mit Ernst Cassirer*, 197–198.

90. Ibid., 203–204.

91. Grolle, *Bericht von einem schwierigen Leben*, 25; Ernst Cassirer to Werner von Melle, November 16, 1933, SUB.

92. Walter Solmitz offered lectures in the 1933–34 academic year at the Rosenzweig Foundation, established in Hamburg shortly after Rosenzweig's death in 1929. Grolle, *Bericht von einem schwierigen Leben*, 27. Cassirer served on its board until his departure from Germany. Gemeindeblatt der Deutsch-Israelitischen Gemeinde zu Hamburg Z 680 4b, November 10, 1930, StA HH.

CHAPTER TEN

1. Panofsky adapted this poem about his emigration experience (in Greek and English) from a diptych in Homer's Iliad in which seven towns claim to be the historic offspring of Homer (*Iliad*, 14.204). Erwin Panofsky to Margaret Barr, December 14, 1933, in *EPK*, 1:684–685.

2. Erwin Panofksy to Fritz Saxl, December 7, 1936, in *EPK*, 1:952–953.

3. Bing, "Fritz Saxl," 23.

4. Within only a few years, Cassirer produced a study on a major Swedish legal philosopher, the founder of the Uppsala School, *Axel Hägerström: Eine*

Studie zur schwedischen Philosophie der Gegenwart (Göteborg: Wettergren & Kerbers Förlag, 1939), and a penetrating essay on Descartes's relationship with Queen Christina of Sweden. For an overview of Cassirer's years in Sweden, see John Michael Krois, "Ernst Cassirer's Late Philosophy: An Unknown Chapter in Intellectual History," *Kungl. Vitterhets Historie Och Antikvitets Akademien* (2005): 73–94. Jonas Hansson and Svante Nordin also provide an excellent account of this period including Cassirer's relationship to the local Jewish community, *Ernst Cassirer: The Swedish Years* (Bern: Peter Lang, 2006), 55–65.

5. The Cassirers' boat was actually threatened by German solders. Klibansky, "Erinnerung an ein Jahrhundert," 51.
6. Ernst and Toni Cassirer to Erwin Panofsky, July 31, 1933, in *ECWB*, 131.
7. In 1947 Panofsky spoke of the "expulsion" from the "European paradise" as a "blessing in disguise." Erwin Panofsky to Wilhelm Vöge, December 12, 1947, in *EPK*, 2:1188. A few years later he adopted the description popularized by Einstein in the late 1930s as "Exile in Paradise." Erwin Panofsky to Pia Wilhelm, September 3, 1950, in *EPK*, 3:65. See also Wuttke's footnote 10 on the same page of *EPK*, for a discussion of the history of this phrase.
8. Erwin Panofsky to Gertrud Bing, January 24, 1932, in *EPK*, 1:477.
9. Erwin Panofsky to Hochschulbehörde, April 19, 1933; in *EPK*, 1:593.
10. Panofsky, "Three Decades of Art History," 321.
11. Peukert, *Weimar Republic*, 14; Mark Roseman, "Introduction: Generation Conflict and German History: 1770–1968," in *Generations in Conflict: Youth Revolt and Generation Formation in Germany, 1770–1968*, ed. Mark Roseman (Cambridge, MA: Cambridge University Press, 1995), 2.
12. Roeck, *Der Junge Aby Warburg*, 9.
13. Irving Lavin, "The Crisis of 'Art history,'" in "Art History and Its Theories," by Mieke Bal et al., *Art Bulletin* 78 (1996): 13.
14. William S., introductory remarks to the lecture "Text and Images: The Value of Error in the History of Art," November 4, 1967, in *EPK*, 5:1094.
15. Aby Warburg to Franz Boll, September 15, 1916, Heid Hs. 2108, UB Heidelberg; Nicholas Mann and Martin Warnke, introduction to McEwan, *Ausreiten der Ecken*, 28; Eric M. Warburg, *Erinnerungen an Meinen Onkel Aby M. Warburg* (published privately, 1965), WHH.
16. "'Falsch gelesen, Herr Reichkanzler. Sehen Sie mal, steht hier nicht Joh Punkt, Wolfg Punkt Goethe (Joh. Wolfg. Goethe)? Und das ist eben das ganze Unglück mit unserer Weimarer Republik, dass hier alles abgekürzt und deshalb zu kurz ist.'" Cited in Raulff, "Der aufhaltsame Aufstieg einer Idee," 78.
17. Ernst Cassirer, "Hermann Cohen: Worte Gesprochen an Seinem Grabe am. 7. April 1918 von Ernst Cassirer," in *Gesammelte Werke*, vol. 16, *Aufsätze und kleine Schriften (1922–1926)*, Hamburger Ausgabe (Hamburg: Felix Meiner, 2003), 286–287.

18. Cassirer cites Goethe's discussion of synthesizing Aristotle and Plato at length in *Kant's Life and Thought*, 417.
19. Cassirer, *Essay on Man*, 21–22.
20. Ibid., 187.
21. Cassirer, *Philosophy of the Enlightenment*, xi. See page 234 of the current volume.
22. Cassirer, *Essay on Man*, 190.
23. Gordon argues that Cassirer makes this crucial shift in the introduction to part 3 of *The Philosophy of Symbolic Forms*, in which he unequivocally promotes a "doctrine of secularization" and argues that philosophy can only achieve truth once it abandons its linguistic and mythical worlds and asserts itself in opposition to them, a process that Heidegger emphatically disowned. "Myth and Modernity," 144–145.
24. Cassirer, *Essay on Man*, 207, 220.
25. Ernst Cassirer, *The Myth of the State* (New Haven, CT: Yale University Press, 1969), 293.
26. Leo Strauss, *What Is Political Philosophy? And Other Studies* (Chicago: University of Chicago Press, 1988), 292–296. Gordon observes the contradiction in this criticism, however, by arguing that Cassirer's position is actually not purely functional but already normative in assuming that humans have the capacity for spontaneity and reason. "Myth and Modernity," 161–162.
27. Strauss, *Spinoza's Critique of Religion*, 1.
28. Rabbi Arthur Hertzberg officiated at the ceremony, even though Ernst Cassirer was still cremated in contrast to Jewish law, as was his wish. Hertzberg, whose own position should be taken into account when assessing these sources, went so far as to argue that Cassirer was a Talmudist who did not know it. Arthur Hertzberg, "A Reminiscence of Ernst Cassirer," *Leo Baeck Institute Year Book* 15 (1970): 246–247.
29. Cited in Ludwig Marcuse, Obituary of Ernst Cassirer, *Aufbau*, April 20, 1945, 9a (Walter-A.-Berendsohn-Arbeitsstelle für Exilliteratur, Hamburg).
30. Franz Rosenzweig, introduction to *Jüdische Schriften*, ed. Bruno Strauss (Berlin: C.A. Schwetschke, 1924), 1:xxviii.
31. Speaking of Cassirer, Habermas observes, "They [political myths] draw on the exotic substance of a stratum of mythical images which is anchored in the symbolic constitution of human existence itself. The haunting of these satyr songs can only be dispelled by an enlightenment which is conscious of the dialectical nature of symbolization. Enlightenment must be able to acknowledge its own roots in the first phobic stirrings of the civilizing process." Habermas, *Liberating Power of Symbols*, 26.
32. Ernst Cassirer, "Judaism and the Modern Political Myths," *Contemporary Jewish Record* 7, no. 2 (1944): 117.
33. Ibid., 123–124; in contrast to Cohen, Cassirer emphasized the gap between German and Jewish cultures. See Joseph Mali, "Ernst Cassirer's In-

terpretation of Judaism and Its Function in Modern Political Culture," in *Juden in der deutschen Wissenschaft*, ed. Walter Grab, Jahrbuch des Instituts für Deutsche Geschichte, Beiheft, 10 (Tel Aviv: Universität Tel Aviv, 1985), 187–215, esp. 209.

34. Cassirer, "Judaism and the Modern Political Myths," 124, 126.

35. Ibid., 126.

36. Skidelsky discusses the debate between Krois ("for Cassirer the ethical point of view is a symbolic form") and Jürgen Habermas and Birgit Recki who take the opposing view, which Skidelsky, too, shares. *Ernst Cassirer*, 254n.

37. Ludwig, *Dr. Panofsky and Mr. Tarkington*, 77–78 (quotation); Bottin and Nicolaysen, *Enge Zeit*, 79.

38. For a good synopsis of this generation's attack on Kant and its turn to rebellious intellectual figures, see Gordon, *Rosenzweig and Heidegger*, 28–32. Edgar Wind to William Heckscher, November 3, 1968, WHH. Walter Benjamin cited in Gershom Scholem, *Walter Benjamin: The Story of a Friendship*, trans. Harry Zohn (New York: New York Review Books, 1981), 43.

39. Martin Heidegger, *Kant and the Problem of Metaphysics*, 5th ed., trans. Richard Taft (Bloomington: Indiana University Press, 1997), 141.

40. Erwin Panofsky, "Zum Problem der Beschreibung und Inhaltsdeutung von Werken der bildenden Kunst," in *EPDA*, 2:1072–1073. The notion of "Dokumentsinn" Panofsky took from Karl Mannheim. For the further influence of Mannheim on Panofsky, see Lubomr Koneêny, "On the Track of Panofsky," *Journal of Medieval and Renaissance Studies* 4 (1974): 29–34.

41. Jaś Elsner and Katharina Lorenz, "The Genesis of Iconology," *Critical Inquiry* 38 (Spring 2012): 483–512.

42. Erwin Panofsky to Julius Stenzel, May 30, 1933, in *EPK*, 1:612. The other examined students were Adolf Katzenellenbogen and Walter Horn. Ibid.; Hugo Buchtal in *Commemorative Gathering for Erwin Panofsky*, 13.

43. Erwin Panofsky to Walter Friedländer, June 2, 1932, in *EPK*, 1:504.

44. *Gutachten* for Prof Panofsky, June 20, 1933, StA HH, Akte HWD PA IV 2542; also in *EPK*, 1:619.

45. *EPK*, 1:620.

46. B[ernhard] Schweitzer to Erwin Panofsky, April 23, 1933, in *EPK*, 1:593–594.

47. Erwin Panofsky to Margaret Barr, May 17, 1933, in *EPK*, 1:601 (original in English); Dora Panofsky to Walter Friedländer, March 8, 1933, in *EPK*, 1:572.

48. At least five art historians were deported to concentration camps. Karen Michels, *Transplantierte Kunstwissenschaft: Deutschsprachige Kunstgeschichte im amerikanischen Exile* (Berlin: Akademie, 1999), 15. For Panofsky's case, see ibid. The literature on this chapter of emigration history in general is substantial. See, for example, Helga Pross, *Deutsche Akademische Emigration nach den Vereinigten Staaten 1933–1941* (Berlin: Dunckner and Hum-

boldt, 1955), 46. The following exhibition catalog contains essays on the struggles of various artists to secure entry into the United States. Stephanie Baron, *Exiles and Emigrés: The Flight of European Artists from Hitler* (Los Angeles: Los Angeles County Museum of Art, 1997).

49. Dieter Wuttke, "Die Emigration der Kulturwissenschaftlichen Bibliothek Warburg und die Anfänge des Universitätsfaches Kunstgeschichte in Großbritannien," *Artibus et Historiae* 5, no. 10 (1984): 133–146; Michels, *Transplantierte Kulturwissenschaft,* 28–34.

50. Memorandum for Chancellor Chase and Mr. Strauss, NYU 3, November 16, 1933, WHH.

51. Bing, "Fritz Saxl," 22.

52. Eisler, *"Kunstgeschichte* American Style," 558; Margaret Wind, Biographical Notes to Edgar Wind's Life, February Oxford 1992. 1657, WHH; Bing, "Fritz Saxl," 22–23.

53. Panofsky, "Three Decades of Art History," 327.

54. Crow, "Practice of Art History," 77; Eisler, *"Kunstgeschichte* American Style," 569.

55. Erwin Panofsky to Margaret Barr, November 30, 1933, in *EPK,* 1:678 (original in English).

56. Eisler, *"Kunstgeschichte* American Style," 568; Erwin Panofsky to Fritz Saxl, November 26, 1931; also in *EPK,* 1:430.

57. Erwin Panofsky to Margaret Barr, April 16, 1933, in *EPK,* 1:591–592 (original in English).

58. At various points, Panofsky's colleagues included Henri Focillon, Marcel Aubert, Richard Ettinghausen, Karl Lehmann, Walter Friedländer, Richard Krautheimer, and Julius S. Held. Kultermann, *History of Art History,"* 228.

59. Panofsky, "Three Decades of Art History," 331.

60. Eisler, *"Kunstgeschichte* American Style," 570, 572.

61. Winckelmann's *History of Ancient Art* was translated into English, and in 1874 Harvard's Charles Eliot Norton announced, "No student who is unable to use a German text-book will be admitted to Fine Arts 2 or 3." Eisler, *"Kunstgeschichte* American Style," 548–550.

62. Crow, "Practice of Art History," 76; Lavin, "Crisis of 'Art history,'" 13; Cook quoted in Panofsky, "Three Decades of Art History," 332.

63. Rebecca Goldstein, *Incompleteness: The Proof and Paradox of Kurt Gödel* (New York: Norton, 2005), 14–15 (includes Flexner quote). Goldstein offers a charming portrait of Princeton during these years. In the postwar period, the only other department that rivaled both the Institute for Fine Arts and Princeton's Institute for Advanced Study was Harvard University and its Fogg Museum, which included the immigrants Jacob Rosenberg, George Swarzenski, and Otto Benesch and nurtured a new generation of American scholars including James Ackerman, John Coolidge, Sydney Freedberg, and Seymour Slive. Kultermann, *History of Art History,* 229.

64. The public assault on Princeton's anti-Semitism came in 1948 with the publication in 1948 of Carey McWilliams, *A Mask of Privilege*. Jerome Karabel, *The Chosen: The Hidden History of Admission and Exclusion at Harvard, Yale, and Princeton* (New York: Houghton Mifflin, 2005), 243. Erwin Panofsky, "In Defense of the Ivory Tower," 111–122.

65. Wolfgang K. H. Panofsky, *"Unmittelbar nach der Explosion schlief ich ein,"* interview by Prof. Dr. Hartwig Spitzer and Dr. Michael Schaff, *Yousee* 4 (2006): 18; Wolfgang K. H. Panofsky, *Panofsky on Physics, Politics, and Peace: Pief Remembers* (Hamburg: Springer, 2007), 1.

66. Dora Panofsky to Erwin Panofsky, November 29, 1931, in *EPK*, 5:45; Sybille Quack, "Everyday Life and Emigration: The Role of Women," in *An Interrupted Past: German-Speaking Refugee Historians in the United States after 1933*, ed. Hartmut Lehmann and James J. Sheehan (Cambridge: Cambridge University Press, 1991), 103. Dora Panofsky's American work, nonetheless, bears the gendered conditions of scholarship. See Levine, "PanDora," 25–31.

67. Smith, "A Secretary's Recollections of Erwin Panofsky," Heckscher Archiv 19, 1994, WHH.

68. "Dr. Erwin Panofsky, Versatile Art Historian, Princeton Institute Scholar, Dies," [Princeton Paper?], 1968, PU 106 USA/K/E, WHH.

69. Eisler, *"Kunstgeschichte* American Style," 582; Panofsky, "Three Decades of Art History," 330.

70. The recent discovery of Panofsky's *Habilitation* in the Zentralinstitut für Kunstgeschichte in Munich seems, to some scholars, to be reason to reconsider whether this trajectory from formal analysis to iconology would indeed have occurred if Panofsky had not emigrated to America. However, as we have seen, Panofsky proved himself adaptable already in the 1920s. While I would not go so far as Sauerländer to call the *Habilitation* an "opus juvenile," I think it is fair to say that Panofsky did not search for the manuscript because he had moved on to other issues. Sauerländer, "Es war ein viel zu ehrgeiziger Versuch," 13. Thanks to the participants in the November 2012 conference "Exile and Interpretation" at Wake Forest University for bringing these issues further into focus.

71. In Lang's disciplinary history of art history and the study of aesthetics in general, Panofsky plays a significant role. *Chaos and Cosmos*, esp. 12–40; Eisler, *"Kunstgeschichte* American Style," 582.

72. Panofsky, preface to *Studies in Iconology*, v–vi.

73. Ludwig, *Dr. Panofsky and Mr. Tarkington*, 6.

74. Herbert and Lotte von Einem and Kurt Bauch all expressed regret concerning Panofsky's language choice, although Panofsky tried to persuade the von Einems that this decision was not meaningful. See Erwin Panofsky to Herbert and Lotte von Einem, December 1, 1967, in *EPK*, 5:1106; and Kurt Bauch to Gerda Panofsky, April 10, 1969, in *EPK*, 5:1167.

75. Erwin Panofsky to Erich Jahn, April 27 1967, *EPK*, 5:1011. "Erwin Panofsky: Zum Tod des Kunsthistorikers," *Die Welt*, March 19, 1968. "Panofsky hatte Berufung nach Hamburg," *Die Welt*, March 27, 1968. Panofsky referred to his overnight train through Hamburg as his "peregrinatio Germaniae." Erwin Panofsky to Walter Clemens, September 6, 1967, Hamburger Bibliothek der Universitätsgeschichte; Heckscher cited in Smith, "A Secretary's Recollections of Erwin Panofsky." On his second trip to Germany, the rector of Hamburg's university wrote Panofsky belatedly to invite him to speak at the university; Panofsky declined but assured him that Hamburg was "in the best sense his alma mater" and that "the relationship between Hamburg and me [had] in no way changed." Erwin Panofsky to Wöflgang Schöne, July 2, 1967, in *EPK*, 5:1040.

76. The Order of the Pour le Mérite dates to the Prussian monarch of the eighteenth century but expanded in the nineteenth century to honor extraordinary cultural achievements. For a history of the medal, see Horst Fuhrmann, *Pour le Mérite: Über die Sichtbarmachung von Verdiensten: Eine historische Besinnung* (Sigmaringen: Thorbecke, 1992). Kurt Bauch first mentions the possibility of the award in 1961, in *EPK*, 5:3525. Gert von Osten to Rudolf Hillebrecht on their previous "secret" conversation concerning Panofsky's candidacy, June 20, 1966, in *EPK*, 5:864. Herbert von Einem, November 1966, in *EPK*, 5:930, assures Percy Schramm that Panofsky will accept the award. Ludwig H. Heydenreich mediates the delivery of the award in Munich in the summer of 1967 in conjunction with the twentieth anniversary of the Zentralinstitut für Kunstgeschichte. Heydenreich to Erwin Panofsky, June 5, 1967, in *EPK*, 5:1023–1024.

77. In typical Panofsky fashion, however, he softened the joke with a mock Berliner accent. Williband Sauerländer, *Bürokratie und Kult: Das Parteizentrum der NSDAP am Königsplatz in München: Geschichte und Rezeption*, part 2, ed. Julia Rosenfeldt and Piero Steinle (Munich: Deutscher Kunstverlag, 1995), 181–196, quotation on 187. According to William Heckscher, Panofsky received the award only "with great misgivings," especially since Schramm was "a Nazi avant la letter." William Heckscher to Roxanne Forster, February 13, 1968, in *EPK*, 5:1118. For Gerda Panofsky, that Schramm delivered the award, a fact she claimed they did not know until it was too late to object, was so traumatizing for her late husband that it caused his premature death. Gerda Panofsky to Percy Schramm, April 5, 1968, in *EPK*, 5:1141–1142. In Panofsky's public acceptance, he was gracious and diplomatic and thanked Schramm for representing the good memories of their Hamburg years. See Erwin Panofsky, "Dankesworte aus Anlaß der Aufnahme in den Orden Pour le Mérite: München, Zentralinstitut für Kunstgeschichte," *EPK*, 5:1061–1062. The "Blue Max" referred to the color of the award ribbon.

78. Heydenreich maintained friendly contact with Panofsky and visited him in Princeton in April 1967. See Ludwig H. Heydenreich to Erwin Panofsky,

March 27, 1967, in *EPK*, 5:981. He even, strangely, inquired with Panofsky at one point about a possible study on Michelangelo, an inquiry that Gerda Panofsky suggests can only be explained by his bad conscience. Julia Voss, "Gerda Panofsky im Gespräch: 'Ein Ausdruck des schlechten Gewissens,'" *Frankfurter Allgemeine Zeitung*, Feuilleton, online edition, www.faz.net/aktuell/feuilleton/kunst/gerda-panofsky-im-gespraech-ein-ausdruck-des-schlechten-gewissens-11873504.html (accessed February 22, 2013). One sensationalist account of this finding goes so far as to call Heydenreich a "thief." Julia Voss, "Sensationelle Entdeckung in München: Der Fund im Panzerschrank." *Frankfurter Allgemeine Zeitung*, Feuilleton (August 31, 2012), online edition, www.faz.net/aktuell/feuilleton/sensationelle-entdeckung-in-muenchen-der-fund-im-panzerschrank-11873507.html (accessed February 22, 2013).

79. Not all relationships were broken. When asked to recommend a German scholar for the project of democraticization after the war, Toni Cassirer gave the name of Theodor Litt to an unnamed "committee." Toni Cassirer to Theodor Litt, July 12, 1946, B 1-0418, Film F 7, UAL.

80. Erwin Panofsky, *The Life and Art of Albrecht Dürer* (Princeton, NJ: Princeton University Press, 1955), 3.

81. Ibid., 171 (my emphasis).

82. Ibid., 284.

83. Keith Moxey, "Panofsky's Melancholia," chapter 4 of his *Practice of Theory*, 74.

84. Erwin Panofsky to Bruno Snell, June 10, 1955, Ana 490. B. VI Panofsky, Erwin, no. 5, Bayerische Staatsbibliothek München; also in *EPK*, 3:771–772.

85. Homer *Iliad*, 14.204; Erwin Panofsky to Margaret Barr, December 14, 1933, in *EPK*, 1:684–685. Panofsky also translated this ditty into French and Latin. Erwin Panofsky to Margaret Barr, January 2, 1934, in *EPK*, 2:694.

86. Erwin Panofsky to A. Grisebach, September 21, 1933, Staatliche Museen zu Berlin-Kunstbibliothek.

87. Erwin Panofsky, "Et in Arcadio Ego: Poussin and the Elegiac Tradition," in Panofsky, *Meaning in the Visual Arts*, 296, 304, 313.

88. Panofsky, "Three Decades of Art History," 323.

89. Carl Landauer makes a similar point in his article "Panofsky and the Renascence of the Renaissance," 255–281.

90. The scholars included Ludwig Heinrich Heydenreich, Elsbeth Jaffé, Lotte Labowsky, Hans Liebeschütz, Paul Ruben, Richard Salomon, and Walter Solmitz. *Völkischer Beobachter* No. 5, January 5, 1935. Grolle, *Bericht von einen schwierigen Leben*, 29; Bottin and Nicolaysen, *Enge Zeit*, 51.

91. Panofsky's Germanic English was reported in both the German and the American press, including in Panofsky's *New York Times* obituary. See the clippings excerpted in *EPK*, 5:1167.

92. For Elsner, this makes "Panofsky's iconology . . . a direct descendant of *Kunstwollen* by reaction, antithesis, and, ultimately, emulation." Elsner, "From Empirical Evidence," 762.

93. My examination of the historical reasons for Panofsky's transition are motivated by Keith Moxey's discussion of Panofsky's puzzling art-historical trajectory, "Perspective, Panofsky, and the Philosophy of History," in Moxey, *Practice of Persuasion*, 90–100, esp. 91–93.

94. Erwin Panofsky, *Early Netherlandish Painting: Its Origins and Character* (New York: Icon Editions, Harper & Row, 1971), 1:5–6.

95. Svetlana Alpers, *The Art of Describing: Dutch Art in the Seventeenth Century* (Chicago: University of Chicago Press, 1983), xx, also xxiii–xxiv; Panofsky, *Early Netherlandish Painting*, 182.

96. Lavin, "The Crisis of 'Art history,'" 13.

97. To address this confusion, Panofsky explained that "iconology" meant the "intrinsic meaning" of a work of art and represented the culmination of several methodologies including formalism and "iconography," or mere description. He also presented a complex synoptical chart to represent this new methodological system. *Studies in Iconology*, 14–15; quotation from Crow, "Practice of Art History in America," 77.

98. Alpers, *Art of Describing*, xix.

99. Georges Didi-Hubermann, *Confronting Images: Questioning the Ends of a Certain History of Art* (University Park: Pennsylvania State University Press, 2004), 102. Wood echoes this frustration: "Panofsky's writings of the 1920s had reflected the full complexity of German-speaking art history . . . but little of it traveled with [him]." "Art History's Normative Renaissance," in Grieco, Superbi, and Rocke, *Italian Renaissance in the Twentieth Century*, 80–81.

100. Panofsky, "Zum Problem der Beschreibung," in *EPDA*, 2:1077. Lang also notes this change in the text. *Chaos and Cosmos*, 38.

101. As the art historians Elsner and Lorenz point out, Panofsky also omitted the references to his interwar opponent Sedlmayr, substituted the discussion of Kant for Cassirer's "symbolic forms," and replaced the pictorial examples with ones that required less textual knowledge; the result was an essay more "didactic, even authoritarian . . . than the German essay on which it is based." "Genesis of Iconology," 495.

102. Ibid., 511. Admittedly, Panofsky's case is diminished by emendations he made in the 1955 version of the same article—no longer "iconographical analysis in a deeper sense" but "iconology as opposed to iconography"— emendations that suggest he was all too aware of positioning himself for changes in the scholarly climate. For Elsner and Lorenz, the changes in the 1955 text "appear to imply (in ever highfalutin terms) that he may no longer fully believe in anything he is saying, and perhaps he never had." Ibid., 512.

103. Alpers, *Art of Describing*, xxiv, xxv. Baxandall's works all assert the importance of intellectual and social context and, specifically, the vocabulary

relevant to the pieces, in order to analyze the corresponding works of art. See, for example, his discussion of the vocabulary of movement in dance and its relationship to the pictorial representation of bodily movement, in his *Painting and Experience in 15th Century Italy: A Primer in the Social History of Pictorial Style* (Oxford: Clarendon Press, 1972), 120–126, 195–212, 223–224.

104. On the lack of theoretical underpinnings of current social art history, see Crow, "Practice of Art History," 87; and Lavin, "Crisis of 'Art history,'" 14. This is particularly true of those German and French art historians trained in the tradition of *Bildwissenschaft*, or image history, such as Georges Didi-Huberman and Horst Bredekamp, where the tradition never fell victim to a similar kind of dilution. For a discussion about the relationship between Warburg's Mnemosyne and the contemporary avant-garde, see Didi-Hubermann, *L'image survivante*; Horst Bredekamp, "A Neglected Tradition? Art History as Bildwissenschaft," *Critical Inquiry* 29 (2003): 418–428.

105. Elsner and Lorenz's collaborative work to translate, publish, and comment on Panofsky's German theoretical essays do precisely that.

106. "To my knowledge, until now no one has posed the fundamental question of whether other 'symbolic forms' exist—least of all in other cultures—as I do in the *Blickwechsel* at the end of each of the last two chapters." Hans Belting, *Florence and Baghdad: Renaissance Art and Arab Science*, trans. Deborah Luce Schneider (Cambridge, MA: Belknap Press of Harvard University Press, 2011), 8.

107. Erwin Panofsky, "The Ideological Antecedents of the Rolls-Royce Radiator," in *Three Essays on Style*, ed. Irving Lavin (Cambridge, MA: MIT Press, 1997), 166.

108. Peter Gay, "Weimar Culture: The Outsider as Insider," in Fleming and Bailyn, *Intellectual Migration*, 12; Michels, *Transplantierte Kunstwissenschaft*, 15.

109. "Kunsthistorisches Alphabet," nr. 149, undated, WHH.

110. As recounted by the historian Atina Grossman, such language play was common among recent German immigrants, who habitually read a jokes column in the weekly *Aufbau* that recapped the linguistic mishaps of their neighbors on New York's Upper West Side. "German Jews as Provincial Cosmopolitans: Reflections from the Upper West Side," *Leo Baeck Oxford Journals* 53 (2008): 157–168.

111. Erwin Panofsky to Bruno Snell, March 11, 1957, Ana 490. B. IV Panofsky, Erwin, no. 7, Bayerische Staatsbibliothek München; Erwin Panofsky to Margaret Barr, April 16, 1933, in *EPK*, 1:592.

112. Panofsky's Latin correspondence partners consisted principally of Adolf Katzenellenbogen, then a professor at Vassar, as well as former Hamburg scholar Richard Salomon, who became a scholar at Kenyon College in Ohio. Erwin Panofsky to Bruno Snell, June 10, 1955, Ana 490. B. VI

Panofsky, Erwin, no. 5, Bayerische Staatsbibliothek München; also in *EPK*, 3:771–772.

113. Speaking of Adolf Katzenellenbogen: Erwin Panofsky to Wolfgang Schöne, January 16, 1962, in *EPK*, 5:117.

114. Eisler, "*Kunstgeschichte* American Style," 556.

115. Erwin Panofsky to Alfred Barr, October 14, 1934, in *EPK*, 1:765; Erwin Panofsky to Bruno Snell, June 10, 1955, Ana 490. B. VI Panofsky, Erwin, no. 5, Bayerische Staatsbibliothek München; also in *EPK*, 3:772.

116. John Coolidge, in *Commemorative Gathering for Erwin Panofsky*, 16.

117. Erwin Panofsky to Wilbur H. Ferry, January 10, 1962, in *EPK*, 5:115; This was also clearly a nod to his friend Eka (aka Ernst Kantorowicz), who developed this idea in response to the loyalty oaths of the 1950s. See Ernst H. Kantorowicz, *The Fundamental Issue: Documents and Marginal Notes on the University of California Loyalty Oath*, June 14, 1949 (San Francisco: Parker, 1950), sec. 5.

118. "Hamburg Regrets Anti-Jewish Issue," *New York Times*, April 16, 1933, sec. 2E. Hamburg also appeared in an article following the boycott of Jewish businesses. "Boycott Exceeds Untermyer's Hope," *New York Times*, April 1, 1933, sec. C, p. 5, cited in Bottin and Nicolaysen, *Enge Zeit*, 35. This article was likely included in the letter of the same day from Erwin Panofsky to Margaret Barr, April 16, 1933, in *EPK*, 1:592.

119. Francesca Trivellato's excellent work *The Familiarity of Strangers: The Sephardic Diaspora, Livorno, and Cross-Cultural Trade in the Early Modern Period* (New Haven, CT: Yale University Press, 2009) presents, to a certain extent, an argument about the limits of this kind of tolerance in another port city in a different time.

120. According to Bajohr, the implementation of regional interests is visible in the treatment of M.M. Warburg & Co. Due largely to the bank's international prestige and foreign credit lines, Hamburg's Nazis "made every effort to keep the bank functioning as an important factor in Hamburg's economy." *"Aryanization" in Hamburg: The Economic Exclusion of Jews and the Confiscation of Their Property in Nazi Germany*, Monographs in German History 7 (New York: Berghahn Books, 2002), 80 (quotation on 207).

EPILOGUE

1. Erwin Panofsky to Margaret Barr, April 16, 1933, in *EPK*, 1:591–92; Walter Clemens to Erwin Panofsky, February 14, 1968, in *EPK*, 5:1121; Erwin Panofsky to Alfred Hentzen, April 27, 1964, in *EPK*, 5:479.

2. Forster, introduction to Warburg, *Renewal of Pagan Antiquity*, 46.

3. Kracauer had a famous disagreement with Adorno about whether English was fully capable of expressing philosophical ideals—the latter was wary. Kracauer to Adorno, September 5, 1955, in Theodor Adorno, *Briefwechsel*,

1923–1966, vol. 7, *Briefe und Briefwechsel*, ed. Wolfgang Schopf (Frankfurt: Suhrkamp, 2008), 484.

4. Lavin, "Crisis of 'Art history,'" 13.

5. Panofsky, *Studies in Iconology*, 15.

6. While Vöge loved footnotes, perhaps too much, Paul Frankl, in contrast, earned this title. Erwin Panofsky to Hans Butzmann, October 7, 1958, in *EPK*, 4:323.

7. Ernst Gombrich, review of *Three Essays on Style*, by Erwin Panofsky, ed. Irving Lavin, *New York Review of Books*, February 15, 1966, 29–30.

8. Gombrich, however, does not mention Panofsky's similar critique. "In Search of Cultural History," 42; for Roger Chartier, this is what differentiates such historians as Panofsky and Febvre from Burckhardt. Roger Chartier, "Intellectual History and the History of Mentalités: A Dual Re-evaluation," in *Cultural History: Between Practices and Representations*, by Roger Chartier, trans. Lydia Cochrane (Ithaca, NY: Cornell University Press, 1988), 23.

9. Erwin Panofsky, *Gothic Architecture and Scholasticism* (Latrobe, PA, Archabbey Press, 1951), 2.

10. Erwin Panofsky to Robert Marichal, March 22, 1965, in *EPK*, 5:639.

11. Siegfried Kracauer, excerpt from "Conversations in Europe" July–October 1960s, in Siegfried Kracauer, *Siegfried Kracauer–Erwin Panofsky Briefwechsel 1941–1966*, ed. Volker Breidecker (Berlin: Akademie, 1996), 107. For Kracauer's frustration with the Warburg Institute's lack of interest in his work, see his letter to Bing, April 11, 1962, in ibid., 114.

12. Siegfried Kracauer to Erwin Panofsky, March 3, 1962, in *EPK*, 5:146; Erwin Panofsky to Siegfried Kracauer, March 7, 1962, in *EPK*, 5:152–153. It is worth noting, too, that both works under attack by Panofsky and Kracauer, *Scholasticism and Architecture* and *Jacques Offenbach and the Paris of His Time*, were, by academic standards, huge commercial successes. Moreover, both men also left Germany and, despite the foreboding claims by Adorno and others of the philosophical inferiority of English, chose never to write in German again. See the conflation of reductivism, the English language, and commercial accessibility in Adorno, *Briefwechsel*.

13. The contrast between Gombrich's account of Panofsky's private approval to him and Panofsky's skepticism as reported to Leopold Ettlinger is jarring. See Gombrich, review of *Three Essays on Style*, 30; and Erwin Panofsky to Leopold D. Ettlinger, February 5, 1962, in *EPK*, 5:132–135.

14. Febvre quoted in Chartier, "Intellectual History," 23; Translation of Bourdieu's postface to Panofsky by Laurence Petit, "Appendix II: Postface to Erwin Panofsky: Gothic Architecture and Scholasticism," in *The Premodern Condition: Medievalism and the Making of Theory* (Chicago: University of Chicago Press, 2005), 221–242, quotation on 223. Bourdieu was less positive about Panofsky's own ability to achieve this middle ground, as

he wrote in "The Field of Cultural Production; or, The Economic World Reversed," in *The Field of Cultural Production: Essays on Art and Literature*, ed. Randal Johnson (Oxford: Polity Press, 1993), 29–73.

15. Gombrich, *Tributes: Interpreters of Our Cultural Tradition* (Ithaca, NY: Cornell University Press, 1984), 106; Gombrich, "The Evidence of Images," in *Interpretation: Theory and Practice*, ed. Charles S. Singleton (Baltimore: Johns Hopkins University Press, 1969), 71.

16. Gombrich, "Review of *Kunstgeschichte und Kunsttheorie im 19 Jahrhundert (Probleme der Kunstwissenschaft, 1)*, ed. Hermann Bauer et al., *Art Bulletin* 46 (1964): 420; Steinberg, "Aby Warburg's Kreuzlingen Lecture," in Warburg and Steinberg, *Images from the Region of the Pueblo Indians*, 111.

17. Spyros Papapetros, "The Eternal Seesaw: Oscillations in Warburg's Revival," review of *L'image survivante: Histoire de l'art et temps des fantômes selon Aby Warburg* (2002), by Georges Didi-Huberman, *Oxford Art Journal* 26 (2003): 169–174, esp. 171–174.

18. One is reminded of Isaiah Berlin's classic essays that claim Herder and Vico for his "Counter Enlightenment," or such modern versions as Jonathan Israel's invention of Spinoza's "radical Enlightenment" and Zeev Sternhell's ideological "Franco-Kantian" Enlightenment. Each scholar engages in this discursive battle for control over the true depiction of ideas, in which getting the story right is of the utmost importance. Jonathan Israel, *A Revolution of the Mind: Radical Enlightenment and the Intellectual Origins of Modern Democracy* (Princeton, NJ: Princeton University Press, 2010); and Zeev Sternhell, *The Anti-Enlightenment Tradition*, trans. David Maisel (New Haven, CT: Yale University Press, 2010).

19. Cassirer, *Essay on Man*, 180.

20. Aschheim, *Beyond the Border*, 77.

21. Ibid., 89–90.

22. Ibid., 113.

23. Skidelsky, *Ernst Cassirer*, 235; Hans Sluga, review of *Continental Divide: Heidegger, Cassirer, Davos*, by Peter Gordon, Notre Dame Philosophical Reviews, http://ndpr.nd.edu/review.cfm?id=22849 (accessed February 23, 2011).

24. Wood, introduction to *Vienna School Reader*, 14–18, 44–48, quotation on 44.

25. In the case of the New Art History, Otto Pächt is the case in point. Ibid., 36.

26. Aschheim makes a similar point about Benjamin and Rosenzweig, arguing that their inclusion serves, in part, to make the otherwise politically questionable critiques of their contemporaries more palatable or *salonfähig*. *Beyond the Border*, 93. Similarly, according to Wood, Benjamin's interest in the new Vienna school signals that there exists "no *intrinsic* peril in the allegorical method, no preprogrammed bias toward spiritualism, nationalism, or cultural nostalgia." Introduction to *Vienna School Reader*, 44.

27. See, in particular, Samuel Moyn's review, "Mind the Enlightenment," *Nation*, May 31, 2010, online edition, www.thenation.com/article/mind -enlightenment# (accessed February 22, 2013).

28. Wolin, review of *Continental Divide: Heidegger, Cassirer, Davos,* by Peter Gordon, *American Historical Review* (April 2012): 600; Gopal Balakrishnan's biography of Carl Schmitt, *The Enemy: An Intellectual Portrait of Carl Schmitt* (London: Verso, 2002), goes a step further than ahistoricism and appropriates Schmitt's ideas as "timely antidotes to the inebriating consensus on the big issues of war and peace in a new world order" (265). Even if the left-Schmittians do not appeal to fascism in their work, there is good reason to believe, as Matthew Specter has argued, that "anti-imperialist politics errs in trying to adapt Schmitt to its purposes." "Perpetual War or Perpetual Peace? Schmitt, Habermas, and Theories of American Empire," a lecture delivered at the Internationales Forschungszentrum Kulturwissenschaften in Vienna, April 26, 2004, and available online at www.politicaltheory.info/essays/specter.htm. See also Specter, *Habermas: An Intellectual Biography* (Cambridge: Cambridge University Press, 2010), 28–29; Ellen Kennedy, "Carl Schmitt and the Frankfurt School," *Telos* 71 (1987): 37–66.

29. In Bloom's reading, Woody Allen's "inner directed" *Zelig* and Rock 'n Roll's "stay loose" motto are both American incarnations of Heideggerian philosophy. "Lusting after the joy of the knife," Americans bask in the "smiling face" of Louis Armstrong's "Mack the Knife" with a sense of nostalgia but no awareness of the darker side of totalitarianism that was the ultimate conclusion of these aesthetic and cultural sentiments. Allan Bloom, "The German Connection," in *The Closing of the American Mind* (New York: Simon & Schuster, 1987), 141–156, esp. 144–151; Theodor Adorno and Max Horkheimer, "The Culture Industry: Enlightenment as Mass Deception," in *The Dialectic of the Enlightenment: Philosophical Fragments*, ed. Gunzelin Schmid Noerr, trans. Edmund Jephcott (Stanford, CA: Stanford University Press, 2007), 94–136.

30. Theodor Adorno, "A European Scholar in America," trans. Donald Fleming, in Fleming and Bailyn, *Intellectual Migration*, 351.

31. Well before the "Great Exodus" of 1933, Germans and their ideas nurtured a tradition of being "deradicalized" in their American form. Nineteenth-century American historians largely generalized Ranke for their own academic purposes; Talcott Parsons promoted a unique brand of Weberian Marxism, "routinized" in its American form; and psychoanalysts streamlined their findings on the other side of the Atlantic. On Rankean ideas in America, see Peter Novick, *That Noble Dream: The "Objectivity Question" and the American Historical Profession* (Cambridge: Cambridge University Press, 1988), 31; on the codification of the Weberian canon by Talcott Parsons, see Scaff, *Max Weber in America*; and on the streamlining of psychoanalysis, see Nathan G. Hale Jr., *The Rise and Crisis of Psycho-*

analysis: Freud and the Americans, 1917–1985 (Oxford: Oxford University Press, 1995).

32. Martin Warnke, *Handbuch der politischen Ikonographie*, 2 vols. (Munich: C.H. Beck, 2011); George Didi-Huberman, *Images in Spite of All: Four Photographs from Auschwitz* (Chicago: University of Chicago Press, 2008).

33. What began as a plea from Anthony Grafton and Jeffrey Hamburger in the *New York Review of Books* ("Save the Warburg Library!" September 30, 2010) has led to a collection of essays on scholars' reflections of the library and institute. Grafton and Hamburger, eds., "The Warburg Institute: A Special Issue on the Library and Its Readers" *Common Knowledge* 18 (2012).

34. For the elasticity of locality as a concept and its connection to German history, see Blackbourn and Retallack, introduction to *Localism, Landscape*, esp. 9.

Selected Bibliography

ARCHIVAL COLLECTIONS

ENGLAND

Warburg Institute, London
Warburg Institute Archive (WIA); Family Correspondence (FC);
 General Correspondence (GC); assorted papers.

GERMANY

Bayerische Staatsbibliothek München
Deutsches Exilarchiv 1933–1945 Frankfurt am Main
Hamburg
Hamburger Bibliothek für Universitätsgeschichte
Hamburg Kunsthalle
Hamburg Staatsarchiv (StA HH)
Staats- und Universitätsbibliothek Hamburg (SUB)
Walter A. Berendsohn Forschungsstelle für Deutsche Exillitera-
 tur Bibliothek
Warburg-Archiv, Warburg-Haus Hamburg (WHH)
Warburg-Archiv des Kunstgeschichtlichen Seminars der
 Universität
Landesarchiv Berlin
Münchner Stadtbibliothek Monacensia
Salomon Ludwig Steinheim-Institut für deutsch-jüdische
 Geschichte an der Universität Duisburg-Essen
Jonas-Cohn Archiv
Schleswig-Holsteinische Landesbibliothek Kiel
Staatliche Museen zu Berlin—Kunstbibliothek
Staatsbibliothek zu Berlin—Preußischer Kulturbesitz

Staats und Universitätsbibliothek Bremen
Universitätsarchiv Leipzig (UAL)
Universitätsarchiv Tübingen (UAT)
Universitätsbibliothek Heidelberg (UB Heidelberg)
Universitätsbibliothek Marburg
Natorp Nachlass (NNL)
Universitäts- und Landesbibliothek Bonn

ISRAEL

Albert Einstein Archives, Jewish National & University Library, Jerusalem
(AEA)

UNITED STATES

Beinecke Rare Book and Manuscript Library, Yale University (BRBML)
Ernst Cassirer Papers
Leo Baeck Institute, New York (LBI)
Manuscripts and Archives, Princeton University
Erwin Panofsky to the Burrages, 1938–1969

PUBLISHED SOURCES

Aaslestad, Katherine. "Republican Traditions: Patriotism, Gender, and War in Hamburg, 1770–1815." *European History Quarterly* 37, no. 4 (2007): 582–602.
Adorno, Theodor. *Briefwechsel, 1923–1966.* Vol 7, *Briefe und Briefwechsel.* Edited by Wolfgang Schopf. Frankfurt am Main: Suhrkamp, 2008.
———. "A European Scholar in America." Translated by Donald Fleming. In Fleming and Bailyn, *Intellectual Migration,* 338–370.
Adorno, Theodor, and Max Horkheimer. "The Culture Industry: Enlightenment as Mass Deception." In *The Dialectic of the Enlightenment: Philosophical Fragments,* edited by Gunzelin Schmid Noerr and translated by Edmund Jephcott, 94–136. Stanford, CA: Stanford University Press, 2007.
Ahrens, Gerhard. "Hanseatische Kaufmannschaft und Wissenschaftsförderung: Vorgeschichte, Gründung und Anfänge der 'Hamburgischen Wissenschaftlichen Stiftung' von 1907." *Vierteljahrschrift für Sozial und Wirtschaftsgeschichte* 66, no. 2 (1979): 216–230.
Alexander, Jonathan. "*Labeur* and *Paresse*: Ideological Representations of Medieval Peasant Labor." *Art Bulletin* 72 (1990): 436–452.
Algazi, Gadi. "Scholars in Households: Refiguring the Learned Habitus, 1480–1550." *Science in Context* 16 (2003): 9–42.

Allen, William Sheridan. *The Nazi Seizure of Power: The Experience of a Single German Town, 1922–1945*. Rev. ed. New York: Franklin Watts, 1984.

Alpers, Svetlana. *The Art of Describing: Dutch Art in the Seventeenth Century*. Chicago: University of Chicago Press, 1983.

———. "Style Is What You Make It: The Visual Arts Once Again." In *The Concept of Style*, edited by Berel Lang, 137–162. Ithaca, NY: Cornell University Press, 1987.

Applegate, Celia. *A Nation of Provincials: The German Idea of Heimat*. Berkeley: University of California Press, 1990.

Aschheim, Steven E. *Beyond the Border: The German-Jewish Legacy Abroad*. Princeton, NJ: Princeton University Press, 2007.

———. *Culture and Catastrophe: German and Jewish Confrontations with National Socialism and Other Crises*. New York: New York University Press, 1996.

———. *In Times of Crisis: Essays on European Culture, Germans, and Jews*. Madison: University of Wisconsin Press, 2001.

———. "'The Jew Within': The Myth of 'Judaization' in Germany." In *The Jewish Response to German Culture: From the Enlightenment to the Second World War*, edited by Jehuda Reinharz and Walter Schatzberg, 212–242. Boston: Brandeis University Press, 1985.

Baasch, Ernst. *Der Einfluss des Handels auf das Geistesleben Hamburg*. Leipzig: Duncker & Hamblot, 1909.

Bahr, Ehrhard. *Weimar on the Pacific: German Exile Culture in Los Angeles and the Crisis of Modernism*. Weimar and Now: German Cultural Criticism, 41. Berkeley: University of California Press, 2007.

Bajohr, Frank. *"Aryanisation" in Hamburg: The Economic Exclusion of Jews and the Confiscation of Their Property in Nazi Germany*. Monographs in German History, 7. New York: Berghahn Books, 2002.

Balakrishnan, Gopal. *The Enemy: An Intellectual Portrait of Carl Schmitt*. London: Verso, 2002.

Balderston, Theo. "Gerald D. Feldman Analyzes the German Inflation." *Central European History* 27, no. 2 (1994): 205–217.

Barash, Jeffrey Andrew, ed. *The Symbolic Construction of Reality: The Legacy of Ernst Cassirer*. Chicago: University of Chicago Press, 2008.

Bauch, Bruno. "Vom Begriff der Nation." *Kant-Studien: Philosophische Zeitschrift* 21 (1917): 139–162.

Baxandall, Michael. *Painting and Experience in 15th Century Italy: A Primer in the Social History of Pictorial Style*. Oxford: Clarendon Press, 1972.

Beck, Ulrich. *The Cosmopolitan Vision*. Malden, MA: Polity, 2006.

Becker, Peter, and William Clark. *Little Tools of Knowledge: Historical Essays on Academic and Bureaucratic Practice*. Ann Arbor: University of Michigan Press, 2011.

Beiser, Frederick C. *The Fate of Reason: German Philosophy from Kant to Fichte*. Cambridge, MA: Harvard University Press, 1987.

Bell, Andrew Francis. "Anglophilia: The Hamburg Bourgeoisie and the Importation of English Middle Class Culture in the Wilhelmine Era." PhD diss., Brown University, 2001.

Bell, Daniel A., and Avner De-Shalit. *The Spirit of Cities: Why the Identity of Cities Matters in a Global Age.* Princeton, NJ: Princeton University Press, 2011.

Benjamin, Walter. "Unpacking My Library." In *Illuminations*, edited by Hannah Arendt and translated by Harry Zohn, 59–67. New York: Schocken Books, 1969.

Benz, Wolfgang, Arnold Paucker, and Peter Pulzer, eds. *Jüdisches Leben in der Weimarer Republik: Jews in the Weimar Republic.* Schriftenreihe wissenschaftlicher Abhandlungen des Leo Baeck Instituts, 57. Tübingen: Mohr Siebeck, 1998.

Berenson, Bernard. *Aesthetics and History.* London: Pantheon, 1948.

Berghahn, Volker R., and Simone Lässig, eds. *Biography between Structure and Agency: Central European Lives in International Historiography.* New York: Berghahn, 2008.

Berlin, Isaiah. "Counter-Enlightenment." In *Against the Current: Essays in the History of Ideas*, edited by Henry Hardy and Roger Hausheer, 1–24. Princeton, NJ: Princeton University Press, 1979.

———. "Kant as an Unfamiliar Source of Nationalism." In *The Sense of Reality: Studies in Ideas and Their History*, edited by Henry Hardy, 232–248. New York: Farrar, Straus and Giroux, 1998.

———. Review of *The Philosophy of the Enlightenment*, by Ernst Cassirer, translated by F. C. A. Koelnn and J. P. Pettegrove. *English Historical Review* 68 (1953): 617–619.

Bialostocki, Jan. "Erwin Panofsky (1892–1968): Thinker, Historian, Human Being." *Simiolus* 4 (1970): 68–89.

———. "Iconography." In *The Dictionary of the History of Ideas II*, edited by Philip P. Wiener, 524–540. New York: Scribner's, 1973.

Biester, Björn. *Der innere Beruf zur Wissenschaft: Paul Ruben (1866–1943).* Studien zur deutsch-jüdischen Wissenschaftsgeschichte. Berlin: Reimer, 2001.

Bing, Gertrud. "Aby M Warburg." *Journal of the Warburg and Courtauld Institutes* 28 (1965): 299–313.

———. *Aby M. Warburg: Vortrag von Frau Professor Bing anläßlich der feierlichen Aufstellung von Aby Warburgs Büste in der Hamburger Kunsthalle am 31. Oktober 1958 mit einer vorausgehenden Ansprache von Senator Dr. Hans H. Biermann-Ratjen.* Hamburg: H. Christian, 1958.

———. "Fritz Saxl (1890–1948): A Memoir." In *Fritz Saxl (1890–1948): A Volume of Memorial Essays from His Friends in England*, edited by D. J. Gordon, 1–46. London: Nelson, 1957.

Binswanger, Ludwig. *Aby Warburg: Die unendliche Heilung: Aby Warburgs Krankengeschichte.* Edited by Chantal Marazia and Davide Stimilli. Zurich: Diaphanes, 2007.

Blackbourn, David, and Geoff Eley. *The Peculiarities of German History: Bourgeois Society and Politics in Nineteenth-Century Germany.* New York: Oxford University Press, 1984.

Blackbourn, David, and James N. Retallack. Introduction to *Localism, Landscape, and the Ambiguities of Place,* edited by David Blackbourn and James Retallack, 3–38. Toronto: University of Toronto Press, 2007.

Bloom, Allan. *The Closing of the American Mind.* New York: Simon & Schuster, 1987.

Böhme, Helmut. *Frankfurt und Hamburg: Des Deutschen Reiches Silber- und Goldloch und die allerenglischste Stadt des Kontinents.* Frankfurt am Main: Europäische Verlagsanstalt, 1968.

Bolland, Jürgen. "Die Gründung der 'Hamburgischen Universität.'" In *Universität Hamburg 1919–1969,* 17–105. Festschrift zum 50. Gründungstag der Universität Hamburg. Hamburg: Universität Hamburg, 1969.

Bookbinder, Paul. *Weimar Germany: The Republic of the Reasonable.* Manchester: Manchester University Press, 1996.

Bottin, Angela, and Rainer Nicolaysen, eds. *Enge Zeit: Spuren Vertriebener und Verfolgter der Hamburger Universität.* Hamburg: Universität Hamburg, 1991.

Bourdieu, Pierre. *The Field of Cultural Production: Essays on Art and Literature.* Edited by Randal Johnson. Oxford: Polity Press, 1993.

———. "The Genesis of the Concepts of Habitus and of Field." *Sociocriticism* 1 (1985): 11–24.

———. *In Other Words: Essays towards a Reflexive Sociology.* Translated by Matthew Adamson. Stanford, CA: Stanford University Press, 1990.

———. *The Logic of Practice.* Translated by Richard Nice. Stanford, CA: Stanford University Press, 1990.

———. *The Political Ontology of Heidegger.* Translated by Peter Collier. Stanford, CA: Stanford University Press, 1991.

———. Postface to *Architecture gothique et pensée scolastique,* by Erwin Panofsky, 133–167. Translated by Pierre Bourdieu. Paris: Minuit, 1967.

Bourdieu, Pierre, and Jean-Claude Passerson. *The Inheritors: French Students and Their Relation to Culture.* Chicago: University of Chicago Press, 1979.

Bouvier, Nicolas, Gordon A. Craig, and Lionel Gossman. *Geneva, Zurich, Basel: History, Culture, and National Identity.* Princeton, NJ: Princeton University Press, 1994.

Brauer, Ludolph, Albrecht Mendelssohn-Bartholdy, Adolf Meyer-Abich, and Johannes Lemcke. *Forschungsinstitute: Ihre Geschichte, Organisation und Ziele.* 2 vols. Vaduz/Lichtenstein: Topos, 1980.

Bredekamp, Horst. "'4 Stunden Fahrt. 4 Stunden Rede': Aby Warburg besucht Albert Einstein." In *Einstein on the Beach: Der Physiker als Phänomen,* edited by Michael Hagner, 165–182. Frankfurt am Main: Fischer Taschenbuch, 2005.

———. "A Neglected Tradition? Art History as Bildwissenschaft." *Critical Inquiry* 29 (2003): 418–428.

Bredekamp, Horst, Michael Diers, Andreas Beyer, and Charlotte Schoell-Glass, eds. *Aby Warburg: Akten des internationalen Symposions, Hamburg 1990.* Schriften des Warburg-Archivs im Kunstgeschichtlichen Seminar der Universität Hamburg. Weinheim: VCH/Acta Humaniora, 1991.

Bredel, Willi. *Unter Türmen und Masten: Geschichte einer Stadt in Geschichten.* Schwerin: Petermänken-Verlag, 1960.

Brenner, Michael. *The Renaissance of Jewish Culture in Weimar Germany.* New Haven, CT: Yale University Press, 1996.

Breuilly, John. "Liberalism in Mid-Nineteenth Century Hamburg and Manchester." In *Labour and Liberalism in Nineteenth-Century Europe: Essays in Comparative History,* edited by John Breuilly, 197–227. New York: Manchester University Press, 1992.

Brix, Emil. Preface to "The Visual Arts in Vienna c. 1900: Reflections on the Jewish Catastrophe," by Ernst Gombrich. Austrian Cultural Institute, Occasions I. London: Austrian Cultural Institute, 1997. Available at http://gombricharchive.files.wordpress.com/2011/04/showdoc28.pdf.

Brühl, Georg. *Die Cassirers: Streiter für den Impressionismus.* Leipzig: Edition Leipzig, 1991.

Brush, Kathryn. "Adolph Goldschmidt (1863–1944)." In *Medieval Scholarship: Biographical Studies on the Formation of a Discipline,* vol. 3, *Philosophy and the Arts,* edited by Helen Damico, Joseph Zavadil, Donald Fennema, and Karmen Lenz, 265–279. New York: Garland, 2000.

Bullard, Melissa Meriam. "Heroes and Their Workshops: Medici Patronage and the Problem of Shared Agency." In *The Italian Renaissance: The Essential Readings,* edited by Paula Findlen, 299–316. London: Blackwell, 2002.

Burckhardt, Jacob. *The Civilization of the Renaissance in Italy.* Translated by S. G. C. Middlemore. London: Phaidon, 1995.

———. *The Letters of Jacob Burckhardt.* Edited and translated by Alexander Dru. New York: Pantheon, 1955.

Burke, Peter. "The *Annales* in a Global Context." *International Review of Social History* 35 (1990): 421–432.

———. *Eyewitnessing: The Use of Images as Historical Evidence.* Ithaca, NY: Cornell University Press, 2011.

———. *A Social History of Knowledge: From the Encyclopédie to Wikipedia.* Vol. 2. Cambridge, UK: Polity Press, 2012.

———. *What Is Cultural History?* 2nd ed. Cambridge: Polity Press, 2008.

Buschendorf, Bernhard, Michael Diers, and Staats- und Universitätsbibliothek Hamburg Carl von Ossietzky. *Porträt aus Büchern: Bibliothek Warburg und Warburg Institute, Hamburg–London 1933.* Kleine Schriften des Warburg-Archivs im Kunstgeschichtlichen Seminar der Universität Hamburg. Hamburg: Dölling und Galitz, 1993.

Bush, Kathryn. "Aby Warburg and the Cultural Historian Karl Lamprecht." In Woodfield, *Art History as Cultural History,* 65–92.

Cantor, Norman F. *Inventing the Middle Ages: The Lives, Works, and Ideas of the Great Medievalists of the Twentieth Century.* New York: Morrow, 1991.

Careri, Giovanni. "Rituel, Pathosformel et forme intermédiaire." *L'Homme* 165, *Image et Anthropologie* (2003): 41–76.

Cassirer, Ernst. *Ausgewählter wissenschaftlicher Briefwechsel (ECWB).* Nachgelassene Manuskripte und Texte, vol. 18. Edited by John Michael Krois. Hamburg: Felix Meiner, 2009.

———. "Critical Idealism as a Philosophy of Culture, Lecture to the Warburg Institute, 26 May 1936." In Cassirer and Verene, *Symbol, Myth, and Culture,* 64–91.

———. "Der Begriff der Symbolischen Form in Aufbau der Geisteswissenschaften." In *Vorträge der Bibliothek Warburg,* 1:11–39.

———. "Deutschland und Westeuropa im Spiegel der Geistesgeschichte" (1931). In *Gesammelte Werke,* 17:207–217. Originally published in *Inter Nationes: Zeitschrift für die kulturellen Beziehungen Deutschlands mit dem Auslande* 1 (1931): 57–59.

———. *Die Idee der republikanischen Verfassung: Rede zur Verfassungsfeier am 11. August 1928.* Hamburg: Friederichsen, De Gruyter, 1929.

———. "Eidos und Eidolon: Das Problem des Schönen und der Kunst in Platons Dialogen." In *Vorträge der Bibliothek Warburg,* 2:1–27.

———. *An Essay on Man.* New Haven, CT: Yale University Press, 1974.

———. *Freiheit und Form.* Berlin: Bruno Cassirer, 1922.

———. *Gesammelte Werke.* Vol. 16, *Aufsätze und kleine Schriften (1922–1926).* Edited by Birgit Recki. Hamburger Ausgabe. Hamburg: Felix Meiner, 2003.

———. *Gesammelte Werke.* Vol. 17, *Aufsätze und kleine Schriften (1927–1931)* (ECK 17). Edited by Birgit Recki. Hamburger Ausgabe. Hamburg: Felix Meiner, 2004.

———. *Gesammelte Werke.* Vol. 18, *Aufsätze und kleine Schriften (1932–1935).* Edited by Birgit Recki. Hamburg: Felix Meiner, 2004.

———. "Hermann Cohen: Worte Gesprochen an Seinem Grabe am. 7. April 1918 von Ernst Cassirer." In *Gesammelte Werke,* vol. 16.

———. *The Individual and the Cosmos in Renaissance Philosophy.* Translated by Mario Domandi. Chicago: University of Chicago Press, 1963.

———. "Judaism and the Modern Political Myths." *Contemporary Jewish Record* 7, no. 2 (1944): 115–126.

———. *Kant's Life and Thought.* Translated by James Haden. New Haven, CT: Yale University Press, 1981.

———. *Language and Myth.* New York: Dover, 1946.

———. *The Myth of the State.* New Haven, CT: Yale University Press, 1969.

———. *The Philosophy of Symbolic Forms.* Translated by Ralph Manheim. 3 vols. New Haven, CT: Yale University Press, 1955–57. Originally published as *Philosophie der symbolischen Formen,* 3 vols. (Berlin: Bruno Cassirer, 1923–29).

———. *The Philosophy of the Enlightenment.* Translated by James P. Pettegrove and Fritz C. A. Koelin. Princeton, NJ: Princeton University Press, 1968. Originally published in German as *Die Philosophie der Aufklärung* (Tübingen: J.C.B. Mohr, 1932).

———. *The Question of Jean-Jacques Rousseau.* Translated and edited by Peter Gay. Bloomington: Indiana University Press, 1967.

———. *Substance and Function and Einstein's Theory of Relativity.* Translated by William Curtis Swabey and Marie Collines Swabey. Dover Phoenix Editions. Mineola, NY: Dover, 2003.

———. "Wandlungen der Staatsgesinnung und der Staatstheorie in der deutschen Geistesgeschichte." In Bottin and Nicolaysen, *Enge Zeit,* 161–169.

———. "Zum Begriff der Nation: Eine Erwiderung auf den Aufsatz von Bruno Bauch." *Bulletin des Leo Baeck Instituts* 88 (1991): 73–91.

Cassirer, Ernst, and Steve G. Lofts. *The Logic of the Cultural Sciences: Five Studies.* New Haven, CT: Yale University Press, 2000.

Cassirer, Ernst, and Donald Phillip Verene. *Symbol, Myth, and Culture: Essays and Lectures of Ernst Cassirer, 1935–1945.* New Haven, CT: Yale University Press, 1979.

Cassirer, Toni. *Mein Leben mit Ernst Cassirer.* Hildesheim: Gerstenberg, 1981.

Cecil, Lamar. *Albert Ballin: Business and Politics in Imperial Germany, 1888–1918.* Princeton, NJ: Princeton University Press, 1967.

Chartier, Roger. "Intellectual History and the History of Mentalités: A Dual Re-evaluation." In *Cultural History: Between Practices and Representations,* by Roger Chartier, translated by Lydia Cochrane, 19–52. Ithaca, NY: Cornell University Press, 1988.

Chernow, Ron. *The Warburgs: The Twentieth-Century Odyssey of a Remarkable Jewish Family.* New York: Vintage Books, 1994.

Chickering, Roger. *Karl Lamprecht: A German Academic Life, 1856–1915.* Atlantic Highlands, NJ: Humanities Press International, 1993.

Clark, William. *Academic Charisma and the Origins of the Research University.* Chicago: University of Chicago Press, 2006.

Coen, Deborah R. *Vienna in the Age of Uncertainty: Science, Liberalism, and Private Life.* Chicago: University of Chicago Press, 2007.

Cohen, Hermann. *Deutschtum und Judentum.* In *Hermann Cohens Jüdische Schriften,* edited by Bruno Strauss, 2:237–301. Berlin: C.A. Schwetschke, 1924.

———. "Ein Bekenntnis zur Judenfrage." In *Der Berliner Antisemitismusstreit,* edited by Walter Boehlich, 124–149. Frankfurt am Main: Insel, 1965. First published in 1880.

Cohen, Hermann, and Paul Natorp. *Der Marburger Neukantianismus in Quellen: Zeugnisse kritischer Lektüre, Briefe der Marburger, Dokumente zur Philosophiepolitik der Schule.* Edited by Helmut Holzhey. Basel: Schwabe, 1986.

Cohen, Naomi W. *Jacob Schiff: A Study in American Jewish Leadership.* Hanover, NH: University Press of New England/Brandeis University Press, 1999.

Cohen, Rachel. *A Chance Meeting: Intertwined Lives of American Writers and Artists, 1854–1967.* New York: Random House, 2004.

Cohen, Sol. "An Innocent Eye: The 'Pictorial Turn,' Film Studies, and History." *History of Education Quarterly* 43 (2003): 250–261.

Collingwood, R. G. *The Idea of History.* Rev. ed. with lectures 1926–28. Edited by Jan van der Dussen. New York: Oxford University Press, 2005.

Collini, Stefan. *Absent Minds: Intellectuals in Britain.* Oxford: Oxford University Press, 2006.

Comfort, Richard A. *Revolutionary Hamburg: Labor Politics in the Early Weimar Republic.* Stanford, CA: Stanford University Press, 1966.

A Commemorative Gathering for Erwin Panofsky at the Institute of Fine Arts, New York University, in Association with the Institute for Advanced Study, March the Twenty-First, 1968. New York: New York University, 1968.

Cowan, Brian. "Ideas in Context: From the Social to the Cultural History of Ideas." In *Palgrave Advances in Intellectual History,* edited by Brian Young and Richard Whatmore, 171–188. Palgrave: Houndmills, 2006.

Craig, Gordon A. *The Germans.* New York: Penguin Group, 1991.

———. *The Triumph of Liberalism: Zurich in the Golden Age, 1830–1869.* New York: Collier Books, 1990.

Crow, Thomas. "The Practice of Art History in America." *Daedalus* 135 (2006): 71–89.

Darnton, Robert. "The Social History of Ideas." In *The Kiss of Lamourette: Reflections in Cultural History,* 219–252. New York: Norton, 1991.

Darwin, Charles. *The Expression of the Emotions in Man and Animals.* Introduction, afterword, and commentaries by Paul Ekman. New York: Oxford University Press, 1998.

Daston, Lorraine, and Peter Galison. *Objectivity.* Cambridge, MA: Zone Books, 2007.

Didi-Hubermann, Georges. *Confronting Images: Questioning the Ends of a Certain History of Art.* University Park: Pennsylvania State University Press, 2004.

———. *Images in Spite of All: Four Photographs from Auschwitz.* Chicago: University of Chicago Press, 2008.

———. *L'image survivante: Histoire de l'art et temps des fantômes selon Aby Warburg.* Paris: Les Editions de Minuit, 2002.

Diers, Michael. "Der Gelehrte, der unter die Kaufleute fiel: Ein Streiflicht auf Warburg und Hamburg." In Bredekamp et al., *Aby Warburg,* 45–53.

———. "Kreuzlinger Passion." *Kritische Bericht* 7 (1979): 5–14.

———. "Warburg and the Warburgian Tradition of Cultural History." *New German Critique* 65 (1995): 59–73.

———. *Warburg aus Briefen: Kommentare zu den Kopierbüchern der Jahre 1905–1918.* Schriften des Warburg-Archivs im Kunstgeschichtlichen Seminar der Universität Hamburg. Weinheim: VCH, 1991.

Diesener, Gerald, and Jaroslav Kudrna, "Alfred Doren: Ein Historiker am Institut für Kultur- und Universalgeschichte." In *Karl Lamprecht weiterdenken: Universal–Kulturgeschichte heute*, ed. Gerald Diesener, 60–85. Beiträge zur Universalgeschichte und vergleichenden Gesellschaftsforschung, 3. Leipzig: Leipzig Universitätsverlag, 1993.

Dilly, Heinrich. "Sokrates in Hamburg: Aby Warburg und seine kulturwissenschaftliche Bibliothek." In Bredekamp et al., *Aby Warburg*, 125–140.

Doren, Alfred. "Aby Warburg und sein Werk," *Archiv für Kulturgeschichte* 21 (1931): 1–25.

Downs, Laura Lee. *Writing Gender History, Writing History*. New York: Oxford University Press, 2004.

Dreijmanis, John, ed. *Max Weber's Complete Writings on Academic and Political Vocations*. Translated by Gordon C. Wells. New York: Algora, 2008.

Dreyfus, Hubert, and Paul Rabinow. "Can There Be a Science of Existential Structure and Social Meaning?" In *Bourdieu: A Critical Reader*, edited by Richard Shusterman, 84–93. Oxford: Blackwell, 1999.

Easton, Laird M. *The Red Count: The Life and Times of Harry Kessler*. Weimar and Now: German Cultural Criticism, 30. Berkeley: University of California Press, 2002.

Ebbinghaus, Angelika. *Kein abgeschlossenes Kapitel: Hamburg in "Dritten Reich."* EVA Wissenschaft. Hamburg: Europäische Verlagsanstalt, 1997.

Eckardt, Hans Wilhelm. "Kritik und Engagement: Gustav Schiefler im öffentlichen Lebens Hamburg." In *Gustav Schiefler: Der schriftliche Nachlass*, edited by Eckardt, Indina Woesthoff, Jürgen Neubacher, and the Staats- und Universitätsbibliothek Hamburg Carl von Ossietzky, 37–49. Berlin: Kulturstiftung der Länder, 1999.

Eckardt, Julius von. *Lebenserinnerungen*. 2 vols. Leipzig: S. Hirzel, 1910.

Eggers, Walter, and Sigrid Mayer. *Ernst Cassirer: An Annotated Bibliography*. New York: Garland, 1988.

Eisler, Colin. "*Kunstgeschichte* American Style." In Fleming and Bailyn, *Intellectual Migration*, 544–628.

Eissenhauer, Michael. *Die Hamburger Wohnstiftungen des 19. Jahrhunderts*. Hamburg: Universität Hamburg, 1987.

Eksteins, Modris. *The Rites of Spring: The Great War and the Birth of the Modern Age*. New York: Anchor Books, 1990.

Elkins, James. *Is Art History Global?* New York: Routledge, 2007.

Elon, Amos. *The Pity of It All: A History of Jews in Germany*. New York: Henry Holt, 2002.

Elsner, Jaś. "From Empirical Evidence to the Big Picture: Some Reflections on Riegl's Concept of Kunstwollen." *Critical Inquiry* 32 (2006): 741–766.

Elsner, Jaś, and Katharina Lorenz. "The Genesis of Iconology." *Critical Inquiry* 38 (2012): 483–512.

Emmens, J. A., and Gary Schwartz. "Erwin Panofsky as a Humanist." *Simiolus* 2 (1967–68): 109–113.

Endelman, Todd M. "The Social and Political Context of Conversion in Germany and England, 1870–1914." In *Jewish Apostasy in the Modern World*, edited by Todd M. Endelman, 83–107. New York: Holmes and Meier, 1987.

Errichtung einer Universität in Hamburg: Antrag des Senats an die Bürgerschaft vom 20. Dezember 1912. Betreffend Ausbau des Kolonialinstituts und des Allgemeinen Vorlesungswesens zu einer Universität. Hamburg: Lütcke & Wulff, 1912.

Essen, Gesa von. "Max Weber und die Kunst der Geselligkeit." In *Heidelberg im Schnittpunkt intellektueller Kreise: Zur Topographie der 'geistigen Geselligkeit' eines 'Weltdorfes': 1850–1950*, edited by Hubert Treiber and Karol Sauerland, 467–480. Opladen: Westdeutscher Verlag, 1995.

Evans, Richard J. *Death in Hamburg: Society and Politics in the Cholera Years, 1830–1910.* London: Penguin Books, 1987.

———. "Family and Class in the Hamburg Grand Bourgeoisie, 1815–1914." In *The German Bourgeoisie: Essays on the Social History of the German Middle Class from the Late Eighteenth to the Early Twentieth Century*, edited by David Blackbourn and Richard J. Evans, 115–139. London: Routledge, 1991.

———. "'Red Wednesday' in Hamburg: Social Democrats, Police, and *Lumpenproletariat* in the Suffrage Disturbances of 17 January 1906." In *Rethinking German History: Nineteenth-Century Germany and the Origins of the Third Reich*, 248–290. London: Allen and Unwin, 1987.

Farago, Claire. "Vision Itself Has Its History': Race, Nation, and Renaissance Art History." In *Reframing the Renaissance: Visual Culture in Europe and Latin America, 1450–1650*, edited by Claire Farago, 67–88. New Haven, CT: Yale University Press, 1995.

Feilchenfeldt, Rahel E., and Thomas Raff, eds. *Ein Fest für Künste: Paul Cassirer: Der Kunsthändler als Verleger.* Munich: C.H. Beck, 2006.

Feldman, Gerald D. *Consequences of Inflation.* Berlin: Colloquium, 1989.

———. "Weimar Writers and the German Inflation." In *Fact and Fiction: German History and Literature, 1848–1924*, edited by Gisela Brude-Firnau und Karin J. MacHardy, 173–183. Tübingen: Franck, 1990.

Ferguson, Niall. *Paper and Iron: Hamburg Business and German Politics in the Era of Inflation, 1827–1927.* New York: Penguin Books, 2005.

Ferrari, Massimo. "Is Cassirer a Neo-Kantian Methodologically Speaking?" In Makkreel and Luft, *Neo-Kantianism in Contemporary Philosophy*, 293–314.

Ferretti, Sylvia. *Cassirer, Panofsky, and Warburg: Symbol, Art, and History.* Translated by Richard Pierce. New Haven, CT: Yale University Press, 1989.

Fichte, Johann Gottlieb. *Addresses to the German Nation.* Edited by George Armstrong Kelly. Translated by R. F. Jones and G. H. Turnbull. New York: Harper & Row, 1968.

Fink, Carole. Review of *Gustav Stresemann: Weimar's Greatest Statesman*, by Jonathan Wright. *Journal of Modern History* 77, no. 2 (2005): 487–489.

Fischer, Holger, and Gerhard Sandner, "Die Geschichte des Geographischen Seminars der Hamburger Universität im 'Dritten Reich.'" In Krause, Huber, and Fischer, *Hochschulalltag*, 1197–1222.

Fischer-Appelt, Peter. "Wissenschaft in der Kaufmannsrepublik: Utopische Grundlagen, reale Entwicklungen, ideale Ausdrucksformen." In *Universität im Herzen der Stadt: Eine Festschrift für Dr. Hannelore und Prof. Dr. Helmut Greve*, edited by Jürgen Lüthje, 80–95. Hamburg: Christians, 2002.

Fleischacker, Samuel, ed. *Heidegger's Jewish Followers: Essays on Hannah Arendt, Leo Strauss, Hans Jonas, and Emmanuel Levinas*. Pittsburgh, PA: Duquesne University Press, 2008.

Fleming, Donald, and Bernard Bailyn, eds. *The Intellectual Migration: Europe and America, 1930–1960*. Cambridge, MA: Harvard University Press, 1969.

Flitner, Hugbert. "Stiftungen für Wissenschaft und Kunst in Hamburg." In *Universität im Herzen der Stadt: Eine Festschrift für Dr. Hannelore und Prof. Dr. Helmut Greve*, edited by Jürgen Lüthje, 96–103. Hamburg: Christians, 2002.

Forster, Kurt W., and David Britt. "Aby Warburg: His Study of Ritual and Art on Two Continents." *October* 77 (1996): 5–24.

Frede, Dorothea, and Reinold Schmücker, eds. *Ernst Cassirers Werk und Wirkung Philosophie*. Kultur und Philosophie. Darmstadt: Wissenschaftliche Buchgesellschaft, 1997.

Freidenreich, Harriet Pass. *Female, Jewish, and Educated: The Lives of Central European University Women*. Bloomington: Indiana University Press, 2002.

Freimark, Peter. *Juden in Preußen, Juden in Hamburg*. Hamburger Beiträge zur Geschichte der Deutschen Juden. Vol. 10. Hamburg: Christians, 1983.

———. "Jüdische Bibliotheken und Hebraica-Bestände in Hamburg." *Tel Aviver Jahrbuch für deutsche Geschichte* 20 (1991): 459–467.

Freud, Sigmund, Gerhard Fichtner, and Ludwig Binswanger. *The Sigmund Freud–Ludwig Binswanger Correspondence, 1908–1938*. New York: Other Press, 2003.

Freudenthal, Gideon. "The Hero of the Enlightenment." In Barash, *Symbolic Construction of Reality*, 189–213.

Friedell, Egon. *A Cultural History of the Modern Age: The Crisis of the European Soul*. Vol. 3. New Brunswick, NJ: Transaction, 2010.

Friedlander, Saul. *Nazi Germany and the Jews*. Vol. 1, *The Years of Persecution, 1933–1939*. New York: Harper Collins, 1997.

Friedman, Michael. "Ernst Cassirer and Thomas Kuhn: The Neo-Kantian Tradition in the History and Philosophy of Science." In Makkreel and Luft, *Neo-Kantianism in Contemporary Philosophy*, 177–191.

———. *Kant and the Exact Sciences*. Cambridge, MA: Harvard University Press, 1992.

———. *A Parting of the Ways: Carnap, Cassirer, and Heidegger*. Chicago: Open Court, 2000.

Fritzsche, Peter. "Did Weimar Fail?" *Journal of Modern History* 68 (1996): 629–656.

———. "Landscape of Danger, Landscape of Design: Crisis and Modernism in Weimar Germany." In *Dancing on the Volcano: Essays on the Culture of the Weimar Republic*, edited by Thomas W. Kniesche and Stephen Brockmann, 29–46. Columbia, SC: Camden House, 1994.

Fubini, Riccardo "Renaissance Historian: The Career of Hans Baron." *Journal of Modern History* 64 (1992): 541–574.

Funkenstein, Amos. "Hermann Cohen: Philosophie, Deutschtum und Judentum." In *Jüdische Integration und Identität in Deutschland und Österreich 1848–1918*, edited by Walter Grab, 355–365. International Symposium, April 1983. Tel Aviv: Universität Tel Aviv, 1984.

Gadamer, Hans-Georg. "Reflections of My Philosophical Journey." In *The Philosophy of Hans-Georg Gadamer*, edited by Lewis Edwin Hahn, 3–63. The Library of Living Philosophers, 24. Chicago: Open Court, 1997.

Gawronsky, Dimitry. "Ernst Cassirer: His Life and His Work: A Biography." In Schilpp, *Philosophy of Ernst Cassirer*, 3–36.

Gay, Peter. *The Bourgeois Experience: Victoria to Freud*. Vol. 1, *Education of the Senses*. New York: Norton, 1984.

———. *The Enlightenment: An Interpretation*. 2 vols. New York: Knopf, 1969.

———. *Freud, Jews, and Other Germans: Masters and Victims in Modernist Culture*. Oxford: Oxford University Press, 1978.

———. Introduction to *The Question of Jean-Jacques Rousseau*, by Ernst Cassirer, edited and translated by Peter Gay. Bloomington: Indiana University Press, 1967.

———. *Style in History: Gibbon, Ranke, Macaulay, Burckhardt*. New York: Norton, 1988.

———. *Weimar Culture: Outsider as Insider*. Westport, CT: Greenwood Press, 1981.

———. "Weimar Culture: The Outsider as Insider." In Fleming and Bailyn, *Intellectual Migration*, 11–93.

Gerhardt, Johannes, and the Hamburgische Wissenschaftliche Stiftung. *Die Begründer der Hamburgischen Wissenschaftlichen Stiftung. Mäzene für Wissenschaft*. Hamburg: Hamburg University Press, 2007.

Ghandchi, Sabina. "Die Hamburger Künstlerin Mary Warburg, geb. Hertz." Master's thesis, Universität Hamburg, 1986.

Gilbert, Creighton E. "What Did Renaissance Patrons Buy?" *Renaissance Quarterly* 51 (1998): 392–450.

Gilbert, Felix. "From Art History to History of Civilization: Gombrich Biography of Aby Warburg." *Journal of Modern History* 44 (1972): 381–391.

———. "Jacob Burckhardt's Student Years: The Road to Cultural History." *Journal of the History of Ideas* 47 (1986): 249–274.

———. Review of *Historicism*, by Friedrich Meinecke. *History and Theory* 13 (1974): 59–64.

Gildenhard, Ingo, and Martin Ruehl, eds. *Out of Arcadia: Classics and Politics in Germany in the Age of Burckhardt, Nietzsche, and Wilamowitz*. Institute of Classical Studies Supplement 79. London: Institute of Classical Studies, School of Advanced Study, University of London, 2003.

Giles, Geoffrey J. "The Academic Ethos in the Face of National Socialism." *Minerva* 18 (Spring 1980): 171–179.

———. *Students and National Socialism in Germany*. Princeton, NJ: Princeton University Press, 1985.

Gilman, Sander L. *Jewish Self-Hatred: Anti-Semitism and the Hidden Language of the Jews*. Baltimore: Johns Hopkins University Press, 1990.

Gilman, Sander L., and Jack Zipes, eds. *Yale Companion to Jewish Writing and Thought, 1096–1996*. New Haven, CT: Yale University Press, 1997.

Gilmore, Jonathan. *The Life of a Style: Beginnings and Endings in the Narrative History of Art*. Ithaca, NY: Cornell University Press, 2000.

Glückel of Hameln. *The Memoirs of the Glückel of Hameln*. New York: Schocken Books, 1977.

Goede, Arnt. "Forschungsinstitut oder Universität? Der Streit um eine angemessene Wissenschaftsorganisation in Hamburg." In *Lebendige Sozialgeschichte: Gedenkschrift für Peter Borowsky*, edited by Peter Borowsky, Rainer Hering, and Rainer Nicolaysen, 615–632. Wiesbaden: Westdeutscher Verlag, 2003.

Goethe, Johann Wolfgang. *Sämtliche Werke, Briefe, Tagebücher und Gespräche*. Vol. 2. Edited by Karl Eibl. Frankfurt am Main: Deutscher Klassiker-Verlag, 1987.

Goldschmidt, Adolph, Marie Roosen-Runge, Kai Robert Möller, et al. *Lebenserinnerungen*. Jahresgabe des Deutschen Vereins für Kunstwissenschaft. Berlin: Deutscher Verlag für Kunstgeschichte, 1989.

Goldschmidt, Hermann Levin. *The Legacy of German Jewry*. Translated by David Suchoff. New York: Fordham University Press, 2007.

Goldstein, Rebecca. *Incompleteness: The Proof and Paradox of Kürt Gödel*. New York: Norton, 2005.

Goldthwaite, Richard A. "The Empire of Things: Consumer Demand in Renaissance Italy." In *Patronage, Art, and Society in Renaissance Italy*, edited by F. W. Kent and Patricia Simons, 153–175. Canberra: Humanities Research Centre, 1987.

Gombrich, Ernst. "Aby Warburg: His Aims and Methods: An Anniversary Lecture." *Journal of the Warburg and Courtauld Institutes* 62 (1999): 268–282.

———. "The Early Medici as Patrons of the Art." In *Italian Renaissance Studies*, edited by E. F. Jacob, 279–311. London: Faber and Faber, 1960.

———. "The Evidence of Images." In *Interpretation: Theory and Practice*, edited by Charles S. Singleton. Baltimore: Johns Hopkins University Press, 1969.

———. "Icon." Review of *Three Essays on Style*, by Erwin Panofsky, edited by Irving Lavin. *New York Review of Books*, February 15, 1966, 29–30.

———. "In Search of Cultural History." In *Ideals and Idols: Essays on Values in History and in Art*, 24–59. Oxford: Phaidon, 1979.

———. Review of *Kunstgeschichte und Kunsttheorie im 19 Jahrhundert (Probleme der Kunstwissenschaft, 1)*, edited by Hermann Bauer, Lorenz Dittmann, Friedrich Piel, Mohammed Rassem, and Bernhard Rupprecht. *Art Bulletin* 46 (1964): 418–420.

———. *Symbolic Images*. 3rd ed. Chicago: University of Chicago Press, 1985.

———. *Tributes: Interpreters of Our Cultural Tradition*. Ithaca, NY: Cornell University Press, 1984.

———. "The Visual Arts in Vienna c. 1900 and Reflections on the Jewish Catastrophe." Vol. 1 of *Occasions* (Austrian Cultural Institute). London: Austrian Cultural Institute, 1997.

Gombrich, Ernst, and Fritz Saxl. *Aby Warburg: An Intellectual Biography*. 2nd ed. Chicago: University of Chicago Press, 1986.

Gordon, Peter Eli. "Continental Divide: Ernst Cassirer and Martin Heidegger at Davos, 1929—an Allegory of Intellectual History." *Modern Intellectual History* 1 (2004): 219–248.

———. *Continental Divide: Heidegger, Cassirer, Davos*. Cambridge, MA: Harvard University Press, 2010.

———. "Myth and Modernity: Ernst Cassirer's Critique of Heidegger." *New German Critique* 94 (2005): 127–168.

———. *Rosenzweig and Heidegger: Between Judaism and German Philosophy*. Weimar and Now: German Cultural Criticism, 33. Berkeley: University of California Press, 2003.

Gossman, Lionel. *Basel in the Age of Burckhardt: A Study in Unseasonable Ideas*. Chicago: University of Chicago Press, 2000.

———. *Towards a Rational Historiography*. Philadelphia: American Philosophical Society, 1983.

Grab, Walter, and Julius Schoeps, eds. *Juden in der Weimar Republik*. Stuttgart: Burg, 1986.

Grafton, Anthony. *The Footnote: A Curious History*. Cambridge, MA: Harvard University Press, 1999.

———. "Germany and the West, 1830–1900." In *Perceptions of the Ancient Greeks*, edited by Kenneth James Dover, 225–245. Oxford: Blackwell, 1992.

———. "The History of Ideas: Precept and Practice, 1950–2000 and Beyond." *Journal of the History of Ideas* 67 (2006): 1–32.

———. "Momigliano's Method and the Warburg Institute: Studies in His Middle Period." In *Worlds Made by Words: Scholarship and Community in the Modern West*, by Anthony Grafton, 230–254. Cambridge, MA: Harvard University Press, 2009.

Grafton, Anthony, and Jeffrey Hamburger, eds. "The Warburg Institute: A Special Issue on the Library and Its Readers." *Common Knowledge* 18 (2012).

Grewe, Cordula. *Painting the Sacred in the Age of Romanticism*. Burlington, VT: Ashgate, 2009.

Grieco, Allen J., Fiorella Gioffredi Superbi, and Michael Rocke, eds. *The Italian Renaissance in the Twentieth Century: Acts of an International Conference.* Florence, Italy: Leo S. Olschki, 2002.

Grolle, Joist. *Bericht von einem schwierigen Leben, Walter Solmitz (1905–1962): Schüler von Aby Warburg und Ernst Cassirer.* Hamburger Beiträge zur Wissenschaftsgeschichte, 13. Berlin: Reimer, 1994.

———. "Blick zurück im Zorn: Das Revolutionstrauma des Ernst Baasch." In *Hamburg und seine Historiker,* edited by Joist Grolle, 99–122. Hamburg: Verein für Hamburgische Geschichte, 1997.

———. "Percy Ernst Schramm: Ein Sonderfall in der Geschichtsschreibung Hamburgs." *Zeitschrift des Vereins für hamburgerische Geschichte* 81 (1995): 23–60.

Grossman, Atina. "German Jews as Provincial Cosmopolitans: Reflections from the Upper West Side." *Leo Baeck Oxford Journals* 53 (2008): 157–168.

———. *Reforming Sex: The German Movement for Birth Control and Abortion Reform, 1920–1950.* New York: Oxford University Press, 1995.

Grüttner, Michael. "Die 'Säuberung' der Universitäten: Entlassungen und Relegationen aus rassistischen und politischen Gründen." In *Universitäten und Studenten im Dritten Reich: Bejahung, Anpassung, Widerstand: XIX Königswinterer Tagung vom 17.–19. Februar 2006,* edited by Joachim Scholtyseck and Christoph Studt, 23–29. Berlin: Lit, 2008.

———. "Hort der Reaktion oder Hochburg des Liberalismus? Die Hamburger Universität in der Weimarer Republik." In *Eliten im Wandel,* edited by Christian Führer, Karen Hagemann, and Birthe Kundrus, 179–197. Münster: Westfälisches Dampfboot, 2004.

Habermas, Jürgen. "The German Idealism of the Jewish Philosophers." In *Philosophical-Political Profiles,* by Jürgen Habermas, 21–43. Translated by Frederick G. Lawrence. Cambridge, MA: MIT Press, 1985.

———. *The Liberating Power of Symbols: Philosophical Essays.* Translated by Peter Dews. Boston: MIT Press, 2001.

———. *The Structural Transformation of the Public Sphere: An Inquiry into a Category of Bourgeois Society.* Translated by Thomas Burger. Boston: MIT Press, 1991.

Hackforth, R. *Plato's Phaedrus.* Library of Liberal Arts. Indianapolis: Bobbs-Merrill, 1952.

Hagemann, Karen. *"Wir wollen zum Köhlbrand!": Geschichte und Gegenwart der Hamburger Arbeiterwohlfahrt, 1919–1985.* Hamburg: VSA-Verlag, 1985.

Hahn, Barbara. *The Jewess Pallas Athena: This Too a Theory of Modernity.* Edited and translated by James McFarland. Princeton, NJ: Princeton University Press, 2005.

Hale, Nathan G., Jr. *The Rise and Crisis of Psychoanalysis: Freud and the Americans, 1917–1985.* Oxford: Oxford University Press, 1995.

Hall, Catherine, and Leonore Davidof. *Family Fortunes: Men and Women of the English Middle Class, 1780–1850*. Women in Culture and Society Series. Chicago: University of Chicago Press, 1991.

Hamburger Universität: Verzeichnis der Vorlesungen Hamburg. 23 vols. Hamburg: Lütcke & Wulff, 1919–31.

Hamburgische Universitätsgesellschaft. I, *Jahresbericht erstattet für die Zeit von der Gründung der Gesellschaft bis zum 31. Dezember 1928*. Hamburg, March 1929.

Hamilton, Richard. *Who Voted for Hitler?* Princeton, NJ: Princeton University Press, 1982.

Hamlin, Cyrus. "Goethe as a Model for Cultural Values: Ernst Cassirer's Essay on Thomas Mann's *Lotte in Weimar*." In Hamlin and Krois, *Symbolic Forms and Cultural Studies*, 185–203.

Hamlin, Cyrus, and John Michael Krois, eds. *Symbolic Forms and Cultural Studies: Ernst Cassirer's Theory of Culture*. New Haven, CT: Yale University Press, 2004.

Hänel, Michael. "Exclusions and Inclusions of a Cosmopolitan Philosopher: The Case of Ernst Cassirer." In *Crossing Boundaries: The Exclusion and Inclusion of Minorities in Germany*, edited by Larry Eugene Jones, 119–140. New York: Berghahn Books, 2001.

Hart, Joan. "Reinterpreting Wölfflin: Neo-Kantianism and Hermeneutics." *Art Journal* 42 (1982): 292–300.

Haskell, Francis. *Patrons and Painters: A Study in the Relations between Italian Art and Society in the Age of the Baroque*. London: Chatto and Windus, 1963.

Heckscher, William S. "Erwin Panofsky: A Curriculum Vitae." *Record of the Art Museum, Princeton University* 28 (1969): 4–21.

Hegel, G. W. F. *Theologian of the Spirit*. Edited by Peter C. Hodgson. Minneapolis: Augsburg Fortress, 1997.

Heidegger, Martin. "Appendix II." In *Kant and the Problem of Metaphysics*, by Martin Heidegger. 5th ed. Translated by Richard Taft. Bloomington: Indiana University Press, 1997.

———. *Being and Time*. Translated by John Macquarrie and Edward Robinson. New York: Harper and Row, 1962.

———. "Creative Landscape: Why Do We Stay in the Provinces?" In Kaes, Jay, and Dimendberg, *Weimar Republic Sourcebook*, 426–428. Originally published as "Schöpferische Landschaft: Warum bleiben wir in der Provinz?" *Der Alemanne*, March 7, 1934.

———. "Davos Disputation between Ernst Cassirer and Martin Heidegger." In *Kant and the Problem of Metaphysics*, by Martin Heidegger. 5th ed. Translated by Richard Taft. Bloomington: Indiana University Press, 1997.

———. *Letters to His Wife, 1915–1970*. Edited by Gertrud Heidegger. Translated by R. D. V. Glasgow. Cambridge: Polity Press, 2008.

Heine, Heinrich. "Aus den Memoiren des Herren von Schnabelewospski: Erstes Buch." In *Historisch-kritische Gesamtausgabe der Werke*, edited by Manfred Windfuhr, 5:147–195. Hamburg: Hoffman und Campe, 1994.

Heine, Heinrich, and T. J. Reed. *Deutschland: A Winter's Tale*. Bilingual ed. London: Angel Books; Chester Springs, PA: Dufour Editions, 1997.

Heise, Carl George. *Persönliche Erinnerungen an Aby Warburg*. New York: Eric M. Warburg, 1947.

Hering, Rainer. "'Der liebe Gott steckt im Detail'—Aby Warburg und die kulturwissenschaftliche Bibliothek." *Auskunft* 4 (1994): 92–105.

Hertz, Deborah. *Jewish High Society in Old Regime Berlin*. Modern Jewish History Series. Syracuse, NY: Syracuse University Press, 2005.

———. "Männlichkeit und Melancholie in der Biedermeierzeit." In *Deutsch-jüdische Geschichte als Geschlechtergeschichte zu 19. und 20. Jahrhundert*, edited by Hamburger Beiträge zur Geschichte der deutschen Juden, 276–292. Göttingen: Wallstein, 2006.

Hertzberg, Arthur. "A Reminiscence of Ernst Cassirer." *Leo Baeck Institute Yearbook* 15 (1970): 245–246.

Herzig, Arno, and Saskia Rohde, eds. *Die Juden in Hamburg 1590 bis 1990: Wissenschaftliche Beiträge der Universität Hamburg zur Ausstellung "Vierhundert Jahre Juden in Hamburg."* Die Geschichte der Juden in Hamburg, 2. Hamburg: Dölling & Galitz, 1991.

Hilgers, Beate Noack. "Platons Phaidros und der Kunsthistoriker Erwin Panofsky: Rezeption und Retroversion eines geistreichen und humorvollen Essays." In *Präsentation der Reihe: Platons Phaidros und der Kunsthistoriker Erwin Panofsky*, edited by Beta Noack-Hilgers, 9–18. Subsidia Classica. St. Katharinen: Scripta Mercaturae, 1998.

Hobsbawm, Eric. *The Age of Extremes: A History of the World, 1914–1991*. New York: Vintage Books, 1994.

Hoffmann, Edith. "Wilhelm Pinder." *Burlington Magazine for Connoisseurs* 89, no. 532 (1947): 198.

Hohendahl, Peter Uwe, ed. *Patriotism, Cosmopolitanism, and National Culture: Public Culture in Hamburg, 1700–1933*. Amsterdam: Rodopi, 2003.

Holborn, Hajo. "Ernst Cassirer." In Schilpp, *Philosophy of Ernst Cassirer*, 41–46.

Hollinger, David. *Science, Jews, and Secular Culture*. Studies in Mid-Twentieth Century American Intellectual History. Princeton, NJ: Princeton University Press, 1996.

Holly, Michael Ann. *The Melancholy Art*. Princeton, NJ: Princeton University Press, 2013.

———. *Panofsky and the Foundations of Art History*. Ithaca, NY: Cornell University Press, 1984.

Hubbard, William. "The New Inflation History." *Journal of Modern History* 62 (1990): 552–569.

Hughes, H. Stuart. *Consciousness and Society*. New Brunswick, NJ: Transaction, 2003.

Hull, Isabel V. *Sexuality, State, and Civil Society*. Ithaca, NY: Cornell University Press, 1996.

Hunt, Lynn. "The Challenge of Gender: Deconstruction of Categories and Reconstruction of Narratives in Gender History." In *Geschlechtergeschichte und Allgemeine Geschichte: Herausforderungen und Perspektiven*, edited by Hans Medick and Anne-Charlott Trepp, 57–97. Göttingen: Wallstein, 1998.

Hurd, Madeleine. *Public Spheres, Public Mores, and Democracy: Hamburg and Stockholm, 1870–1914*. Social History, Popular Culture, and Politics in Germany. Ann Arbor: University of Michigan Press, 2000.

Imbert, Claude, Nima Bassiri, and Michael Allan. "Aby Warburg, between Kant and Boas: From Aesthetics to the Anthropology of Images." *Qui Parle* 16 (2006): 1–45.

Institut für die Geschichte der deutschen Juden, ed. *Das Jüdische Hamburg: Ein historisches Nachschlagewerk*. Hamburg: Wallstein, 2006.

Israel, Jonathan. *A Revolution of the Mind: Radical Enlightenment and the Intellectual Origins of Modern Democracy*. Princeton, NJ: Princeton University Press, 2010.

Itzkoff, Seymour W. *Ernst Cassirer: Philosopher of Culture*. Boston: Twayne, 1977.

———. *Ernst Cassirer: Scientific Knowledge and the Concept of Man*. 2nd ed. Notre Dame, IN: University of Notre Dame Press, 1997.

Jahresbericht erstattet für die Zeit von der Gründung der Gesellschaft bis zum 31. Dezember 1928. Hamburg, 1929.

Jahresbericht 1929 für die Hamburgische Universitätsgesellschaft. Hamburg: Hamburger Studentenhilfe e.V. Akademische Auslandsstelle Hamburg, 1930.

Janson, Horst W. "Erwin Panofsky." In *Biographical Memoirs in American Philosophical Society Yearbook, 1969–70*, 151–160. Philadelphia: George H. Buchanan, 1970.

Jay, Martin. *Permanent Exiles: Essays on the Intellectual Migration from Germany to America*. New York: Columbia University Press, 1985.

———. "The Textual Approach to Intellectual History." In *Force Fields: Between Intellectual History and Cultural Critique*, by Martin Jay, 158–166 New York: Routledge, 1993.

———. "Urban Flights." In *The University and the City: From Medieval Origins to the Present*, edited by Thomas Bender, 231–248. New York: Oxford University Press, 1988.

Jelavich, Peter. *Berlin Alexanderplatz: Radio, Film, and the Death of Weimar Culture*. Weimar and Now: German Cultural Criticism, 37. Berkeley: University of California Press, 2006.

———. *Munich and Theatrical Modernism: Politics, Playwriting, and Performance, 1890–1914*. Cambridge, MA: Harvard University Press, 1985.

Jenkins, Jennifer. *Provincial Modernity: Local Culture and Liberal Politics in Fin-de-Siècle Hamburg*. Ithaca, NY: Cornell University Press, 2003.

Jochmann, Werner, and Hans-Dieter Loose, eds. *Hamburg: Geschichte der Stadt Hamburg und ihre Bewohner: Vom Kaiserreich bis zur Gegenwart.* Vol. 2. Hamburg: Hoffmann und Campe, 1986.

Jungclaussen, John F. "The Nazis and Hamburg's Merchant Elite: A History of Decline." PhD diss., Oxford University, 2002.

Kaegi, Dominic, and Enno Rudolpf, eds. *Cassirer-Heidegger 70 Jahre Davos Disputation.* Cassirer-Forschungen, 9. Hamburg: Felix Meiner, 2002.

Kaes, Anton, Martin Jay, and Edward Dimendberg, eds. *The Weimar Republic Sourcebook.* Weimar and Now: German Cultural Criticism, 3. Berkeley: University of California Press, 1994.

Kampe, Norbert. "Jüdische Professoren im deutschen Kaiserreich: Zu einer vergessenen Enquete Berhard Breslauers." In *Antisemitismus und Jüdische Geschichte: Studien zu Ehren von Herbert A. Strauss,* edited by Rainer Erb and Michael Schmidt, 185–211. Berlin: Wissenschaftler Autorenverlag, 1987.

Kantorowicz, Ernst H. *The Fundamental Issue: Documents and Marginal Notes on the University of California Loyalty Oath.* San Francisco: Parker, 1950.

Kaplan, Marion. *Jewish Daily Life in Germany, 1618–1945.* New York: Oxford University Press, 2005.

———. *The Making of the Jewish Middle Class: Women, Family, and Identity in Imperial Germany.* New York: Oxford University Press, 1994.

———. "Revealing and Concealing: Using Memoirs to Write German History." In *Text and Context: Essays in Modern Jewish History and Historiography in Honor of Ismar Schorsch,* edited by Eli Lederhendler and Jack Wertheimer, 383–410. New York: Jewish Theological Seminary, 2005.

———. "Tradition and Transition: The Acculturation, Assimilation, and Integration in Imperial Germany." *Leo Baeck Institute Year Book* 27 (1982): 3–35.

Karabel, Jerome. *The Chosen: The History of Admission and Exclusion at Harvard, Yale, and Princeton.* Boston: Houghton Mifflin, 2005.

Kay, Carolyn Helen. *Art and the German Bourgeoisie: Alfred Lichtwark and Modern Painting in Hamburg, 1886–1914.* Toronto: University of Toronto Press, 2002.

Kellenbenz, Hermann. *Sephardim an der Unteren Elbe: Ihre wirtschaftliche und politische Bedeutung vom Ende des 16. bis zum Beginn des 18. Jahrhunderts.* Wiesbaden: Franz Steiner, 1958.

Kennedy, Ellen. "Carl Schmitt and the Frankfurt School." *Telos* 71 (1987): 37–66.

Kessler, Harry. *The Diaries of a Cosmopolitan: Count Harry Kessler, 1918–1937.* London: Weidenfeld and Nicolson, 1971.

———. *Journey to the Abyss: The Diaries of Count Harry Kessler, 1880–1918.* Edited by Laird Easton. New York: Knopf, 2011.

Kibbel, Kai. "Das 'Selbstverständnis' der Ordinarien an der Hamburgischen Universität in der Weimarer Republik." Master's thesis, Humboldt Universität zu Berlin, 2005.

Kiesel, Helmuth, ed. *Ernst Jünger/Carl Schmitt, Briefwechsel*. Stuttgart: Klett-Cotta, 1999.

Klapisch-Zuber, Christiane. *Women, Family, and Ritual in Renaissance Italy*. Translated by Lydia Cochrane. Chicago: University of Chicago Press, 1985.

Klein, Jacob, and Leo Strauss. "A Giving of Accounts." In *Jewish Philosophy and the Crisis of Modernity in Modern Jewish Thought*, edited by Kenneth H. Green, 457–466. Albany: State University of New York Press, 1997.

Kleßmann, Eckart. *Geschichte der Stadt Hamburg*. Hamburg: Hoffmann und Campe, 1981.

Klibansky, Raymond. *Erinnerung an ein Jahrhundert: Gespräche mit Georges Leroux*. Frankfurt am Main: Insel, 2001.

Klibansky, Raymond, and Patrick Conley. "Die Grenzen des akademischen Lebens sprengen: Ein Gespräch über Ernst Cassirer und die Bibliothek Warburg." *Merkur: Deutsche Zeitschrift für europäisches Denken* 564 (1996): 274–277.

Klibansky, Raymond, Erwin Panofsky, and Fritz Saxl. *Saturn und Melancholy: Studies in the History of Natural Philosophy, Religion, and Art*. New York: Basic Books, 1964.

Klibansky, Raymond, and Walter Solmitz. "Bibliography of Ernst Cassirer's Writings." In *Philosophy and History: Essays Presented to Ernst Cassirer*, edited by Raymond Klibansky and H. J. Paton, 338–353. Oxford: Clarendon Press, 1936.

Knudsen, Jonathan. "The Historicist Enlightenment." In *What's Left of Enlightenment: A Postmodern Question*, edited by Keith Baker and Peter Hanns Reill, 39–49. Stanford, CA: Stanford University Press, 2001.

Köhnke, Klaus-Christian. *The Rise of Neo-Kantianism: German Academic Philosophy between Idealism and Positivism*. Translated by R. J. Hollingdale. New York: Cambridge University Press, 1991.

Koneêny, Lubomír. "On the Track of Panofsky." *Journal of Medieval and Renaissance Studies* 4 (1974): 29–34.

Königseder, Karl. "Aby Warburg in Bellevue." In *Aby M. Warburg: "Ekstatische Nymphe, trauernder Flussgott" Portrait eines Gelehrten*, edited by Robert Galitz and Brita Reimers, 74–98. Schriftenreihe der Hamburgischen Kulturstiftung. Hamburg: Dölling Görlitz, 1995.

Kopitzsch, Franklin. *Grundzuge einer Sozialgeschichte der Aufklarung in Hamburg und Altona*. Hamburg: Christians, 1982.

Kortländer, Bernd. "During the Day a Big Accounting Office and at Night a Huge Bordello: Heine and Hamburg." In Hohendahl, *Patriotism, Cosmopolitanism, and National Culture*, 167–179.

Koshar, Rudy. *Social Life, Local Politics, and Nazism: Marburg, 1880–1935*. Chapel Hill: University of North Carolina Press, 1986.

Kracauer, Siegfried. *Jacques Offenbach and the Paris of His Time*. New York: Zone Books, 2002.

————. *Siegfried Kracauer–Erwin Panofsky Briefwechsel 1941–1966.* Edited by Volker Breidecker. Berlin: Akademie, 1996.

Kraus, Elisabeth. *Die Familie Mosse: Deutsch-jüdischer Bürgertum im 19. und 20. Jahrhundert.* Munich: C.H. Beck, 1999.

Krause, Eckart, Ludwig Huber, and Holger Fischer, eds. *Hochschulalltag im Dritten Reich: Die Hamburger Universität, 1933–1945.* Hamburger Beiträge zur Wissenschaftsgeschichte, 3. Berlin: Reimer, 1991.

Krohn, Helga. *Die Juden in Hamburg: Die politische, soziale und kulturelle Entwicklung einer jüdischen Grosstadtgemeinde nach der Emanzipation 1848–1918.* Hamburger Beiträge zur Geschichte der deutschen Juden. Hamburg: Christians, 1974.

————. *Die Juden in Hamburg 1800–1850: Ihre soziale, kulturelle und politische Entwicklung während der Emanzipationszeit.* Hamburger Studien zur neueren Geschichte. Frankfurt am Main: Europäische Verlagsanstalt, 1967.

Krois, John Michael. "Ernst Cassirer: 1874–1945." In Krois, Lohse, and Nicolaysen, *Die Wissenschaftler,* 11–37.

————. "Ernst Cassirer's Late Philosophy: An Unknown Chapter in Intellectual History." *Kungliga Vitterhets Historie och Antikvitets Akademien* (2005): 73–94.

————. "A Note about Philosophy and History: The Place of Cassirer's *Erkenntnisproblem.*" *Science in Context* 9 (1996): 191–194.

————. "Why Did Cassirer and Heidegger Not Debate in Davos?" In Hamlin and Krois, *Symbolic Forms and Cultural Studies,* 244–262.

Krois, John Michael, Gerhard Lohse, and Rainer Nicolaysen. *Die Wissenschaftler: Ernst Cassirer, Bruno Snell, Siegfried Landshut.* Hamburgische Lebensbilder, 8. Hamburg: Verlag Verein für Hamburgische Geschichte, 1994.

Krüger, Christa. *Max und Marianne Weber: Tag- und Nachtgeschichten einer Ehe.* Zürich: Pendo, 2001.

Kruse, Joseph A. *Heines Hamburgerzeit.* Heine-Studien. Hamburg: Hoffmann und Campe, 1972.

Kuhn, Manferd. "Interpreting Kant Correctly: On the Kant of the Neo-Kantians." In Makkreel and Luft, *Neo-Kantianism in Contemporary Philosophy,* 113–131.

Kultermann, Udo. *The History of Art History.* New York: Abaris Books, 1993.

Kurig, Hans, and Uwe Petersen. *Aby Warburg und das Johanneum Hamburg.* Hamburg: Gesellschaft der Bücherfreunde, 1991.

Küster, Bernd. *Max Lieberman: Ein Malerleben.* Hamburg: Ellert & Richter, 1988.

Lamprecht, Karl. *Americana: Reiseeindrücke, Betrachtungen, Geschichtliche Gesamtansicht.* Freiburg: Hermann Heyfelder, 1906.

————. *What Is History? Five Lectures on the Modern Science of History.* London: Macmillan, 1905.

Landauer, Carl H. "Erwin Panofsky and the Renascence of the Renaissance." *Renaissance Quarterly* 47 (1994): 255–281.

———. "The Survival of Antiquity: The German Years of the Warburg Institute." PhD diss., Yale University, 1984.

Landsberg, Abraham. "Last Traces of Heinrich Heine in Hamburg." *Leo Baeck Oxford Journals*, 1964, 360–369.

Landsberger, Franz. *Rembrandt, the Jews, and the Bible*. Translated by Felix N. Gerson. Philadelphia: Jewish Publication Society of America, 1946.

Lang, Karen. *Chaos and Cosmos: On the Image in Aesthetics and Art History*. Ithaca, NY: Cornell University Press, 2006.

Langbehn, Julius. *Rembrandt als Erzieher, von einem Deutschen*. Edited by Gerhard Krüger. Berlin: T. Fritsch, 1944.

Laqueur, Walter. *Weimar: A Cultural History, 1918–1933*. London: Weidenfeld and Nicolson, 1974.

Lassar, Gerhard. "Hamburg University as Link with the World." In *Hamburg's Worldwide Activities*, edited by Heinrich Pfeiffer and Kurt Johannsen, 68–70. Hamburg: Hamburg-Berlin Verlag der "Prismen," 1930.

Lavin, Irving. "Crisis of 'Art history.'" In "Art History and Its Theories," *Art Bulletin* 78 (1996): 13–15.

Lehmann, Hartmut, and James J. Sheehan, eds. *An Interrupted Past: German-Speaking Refugee Historians in the United States after 1933*. Cambridge: Cambridge University Press, 1991.

Lenz, Siegfried. *Leute von Hamburg*. Hamburg: Hoffmann und Campe, 1968.

Lerm, Christa-Maria. "Das jüdische Erbe bei Aby Warburg." *Menora* 5 (1994): 143–171.

Lessing, Gotthold Ephraim. *Lessing's Laocoön*. Translated by E. C. Beasley. London: George Bell and Sons, 1888.

Levine, Emily J. "PanDora, or Erwin and Dora Panofsky and the Private History of Ideas." *Journal of Modern History* 83 (2011): 753–787.

Lichtwark, Alfred. *Briefe an seine Familie, 1875–1913*. Lichtwark Stiftung, 14. Hamburg: Hans Christians, 1985.

———. "Dilettantismus und Volkskunst." In *Erziehung des Auges: Ausgewählte Schriften*, edited by Eckhard Schaar, 86–89. Frankfurt am Main: Fischer Taschenbuch, 1991.

———. *Eine Auswahl seiner Schriften*. Edited by Wolf Mannhardt. Berlin: Bruno Cassirer, 1917.

Liebeschütz, Hans. "Aby Warburg (1866–1929) as Interpreter of Civilization." *Leo Baeck Institute Year Book* 10 (1971): 225–236.

———. "Hermann Cohen and His Historical Background." *Leo Baeck Institute Year Book* 13 (1968): 3–33.

———. "Treitschke and Mommsen on Jewry and Judaism." *Leo Baeck Institute Year Book* 7 (1962): 153–182.

Liedtke, Rainer. "Germany's Door to the World: A Haven for the Jews? Hamburg, 1590–1933." In *Jewish Communities in Cosmopolitan Maritime Trading Centres, 1550–1950*, edited by David Cesarani, 75–84. New York: Routledge, 2002.

Lindemann, Mary. *Liaisons Dangereuses: Sex, Law, and Diplomacy in the Age of Frederick the Great*. Baltimore: Johns Hopkins University Press, 2006.

———. "The Mysteries of Hamburg: True Crime, Literary Representations, and History in the Eighteenth Century." Paper presented at the conference "Reading Hamburg: Anglo-American Perspectives," at the Forschungsstelle für Zeitgeschichte, Hamburg, Germany, September, 6–8, 2007.

———. *Patriots and Paupers: Hamburg, 1712–1830*. New York: Oxford University Press, 1990.

Lippmann, Leo. *Mein Leben und meine amtliche Tätigkeit: Erinnerungen und ein Beitrag zur Finanzgeschichte Hamburgs*. Hamburg: Christians, 1964.

Lipton, David R. *Ernst Cassirer: The Dilemma of a Liberal Intellectual in Germany, 1914–1933*. Toronto: University of Toronto Press, 1976.

Liste der Ausschüsse, Förderer und Mitglieder der Hamburgischen Universitätsgesellschaft und deren Ortsgruppe in Lübeck. Hamburg, 1931.

Lloyd-Jones, Hugh. *Blood for Ghosts: Classical Influences in the Nineteenth and Twentieth Centuries*. Baltimore: Johns Hopkins University Press, 1982.

Lofts, Steve G. *Ernst Cassirer: A "Repetition" of Modernity*. New York: State University of New York Press, 2000.

Lorenz, Ina S. "Das 'Hamburger System' als Organisationsmodell einer jüdischen Großgemeinde: Konzeption und Wirklichkeit." In *Jüdische Gemeinden und Organisationsformen von der Antike bis zur Gegenwart*, edited by Robert Jütte and Abraham P. Kustermann, 221–255. Vienna: Böhlau, 1996.

———. *Die Juden in Hamburg zur Zeit der Weimarer Republik: Eine Dokumentation*. Hamburger Beiträge zur Geschichte der deutschen Juden, 13. Hamburg: Hans Christians, 1987.

———. "Die jüdische Gemeinde Hamburg 1860–1945." In *Die Geschichte der Juden in Hamburg, 1590–1990*, edited by Saskie Rohde and Arno Herzig, 2:77–100. Hamburg: Dölling und Galitz, 1991.

———. *Identität and Assimilation: Hamburgs Juden in der Weimarer Republik*. Hamburg: Hans Christians, 1989.

Lorenz, Katharina, and Jaś Elsner, "Translators' Introduction." *Critical Inquiry* 35 (2008): 33–42.

Lowenstein, Steven. "Jewish Intermarriage and Conversion in Germany and Austria." *Modern Judaism* 25 (2005): 34–37.

Löwith, Karl. *Mein Leben in Deutschland vor und nach 1933*. Stuttgart: J.B. Metzler, 1986.

Lück, Helmut E. "'Noch ein weiterer Jude ist natürlich ausgeschlossen': William Stern und das Psychologische Institut der Universität Hamburg." In Herzig and Rohde, *Die Juden in Hamburg*, 407–417.

Lück, Helmut E., and D. J. Löwisch, eds. *Der Briefwechsel zwischen William Stern und Jonas Cohn: Dokumente einer Freundschaft zwischen zwei Wissenschaftlern*. Frankfurt am Main: Peter Lang, 1994.

Ludwig, Richard M., ed. *Dr. Panofsky and Mr. Tarkington: An Exchange of Letters, 1938–1946*. Princeton, NJ: Princeton University Press, 1974.

Lustiger, Arno, ed. *Jüdische Stiftungen in Frankfurt am Main*. Frankfurt am Main: Jan Thorbecke Verlag Sigmaringen, 1988.

Mack, Michael. *German Idealism and the Jew: The Inner Anti-Semitism of Philosophy and German Jewish Responses*. Chicago: University of Chicago Press, 2003.

Makkreel, Rudolf A., and Sebastian Luft. *Neo-Kantianism in Contemporary Philosophy*. Bloomington: Indiana University Press, 2009.

Mali, Joseph. "Ernst Cassirer's Interpretation of Judaism and Its Function in Modern Political Culture." In *Juden in der deutschen Wissenschaft*, edited by Walter Grab, 187–215. Jahrbuch des Instituts für Deutsche Geschichte, Beiheft, 10. Tel Aviv: Universität Tel Aviv, 1985.

Mann, Thomas. *Buddenbrooks: The Decline of a Family*. Translated by John E. Woods. New York: Knopf, 1993.

———. "Lübeck als geistige Lebensform." In *Reden und Aufsätze*, vol. 11 of *Gesammelte Werke in dreizehn Bände*. Frankfurt am Main: Fischer, 1974.

———. *Reflections of a Nonpolitical Man*. Translated by and with an introduction by Walter D. Morris. New York: Frederick Ungar, 1983.

Marchand, Suzanne L. *Down from Olympus: Archaeology and Philhellenism in Germany, 1750–1970*. Princeton, NJ: Princeton University Press, 1996.

———. *German Orientalism in the Age of Empire: Religion, Race, and Scholarship*. Cambridge: Cambridge University Press, 2009.

Marcuse, Ludwig. Obituary of Ernst Cassirer. *Aufbau*, April 20, 1945, 9a.

Mazon, Patricia M. *Gender and the Modern Research University: The Admission of Women to German Higher Education, 1864–1914*. Stanford, CA: Stanford University Press, 2003.

Mazower, Mark. *Dark Continent: Europe's Twentieth Century*. New York: Knopf, 1999.

McCarthy, John. "Lessing and the Project of a National Theater in Hamburg: 'Ein Supplement der Gesetze.'" In Hohendahl, *Patriotism, Cosmopolitanism, and National Culture*, 71–90.

McClelland, Charles. *State, Society, and the University in Germany, 1700–1914*. Cambridge: Cambridge University Press, 1980.

McEwan, Dorothea, ed. *Ausreiten der Ecken: Die Aby Warburg–Fritz Saxl Korrespondenz, 1910–1919*. Hamburg: Dölling und Galitz, 1998.

———. "Dots and Lines: Mapping the Diffusion of Astrological Motifs in Art History." *German Studies Review* 29 (2006): 243–268.

———. "Gegen Die 'Pioniere der Diesseitigkeit.'" *Trajekte* 4 (2004): 9–11.

———. *"Wanderstrassen der Kultur": Die Aby Warburrg–Fritz Saxl Korrespondenz 1920 bis 1929*. Munich: Dölling und Galitz, 2004.

Meinecke, Friedrich. *Cosmopolitanism and the National State*. Translated by Robert B. Kimber. Princeton, NJ: Princeton University Press, 1970.

———. *Historicism: The Rise of a New Historical Outlook*. Translated by J. E. Anderson. London: Routledge and Kegan Paul, 1972.

———. Review of *Der Einfluss der französischen Revolution auf das deutsche Geistesleben*, by Alfred Stern. *Historische Zeitschrift* 139 (1929): 598–599.

———. Review of *Die Philosophie der Aufklärung*, by Ernst Cassirer. *Historische Zeitschrift* 149 (1934): 582–586.

Meiss, Millard, ed. *De Artibus Opuscula XL: Essays in Honor of Erwin Panofsky.* Vol. 1. New York: New York University Press, 1961.

Menand, Louis. *The Metaphysical Club: A Story of Ideas in America.* New York: Farrar, Straus and Giroux, 2002.

Mendes-Flohr, Paul. *German Jews: A Dual Identity.* New Haven, CT: Yale University Press, 1999.

Meyer, A. M. "Aby Warburg in His Early Correspondence." *American Scholar* 57 (1998): 445–452.

Meyer, Thomas. "Am Abgrund wandernd, Unbekannte gestoßen: Das Davoser Treffen von Ernst Cassirer und Martin Heidegger hat eine bislang unbekannte Vorgeschichte in Hamburg 1923," *Frankfurter Allgemeine Zeitung* 44 (2006): 45.

———. *Ernst Cassirer.* Hamburg: Ellert & Richter, 2007.

———. "Ernst Cassirer—Judentum aus dem Geist der universalistischen Vernunft." *Ashkenaz* 10 (2001): 459–502.

———. "Gertrud Bing an die Cassirers: Florenz, 1. June 1929." *Trajekte* 10 (2005): 16–22.

Meyers, David. *Resisting History: Historicism and Its Discontents in German-Jewish Thought.* Princeton, NJ: Princeton University Press, 2003.

Michaud, Philippe-Alain. *Aby Warburg and the Image in Motion.* Translated by Sophie Hawkes. New York: Zone Books, 2004.

Michels, Karen. "Art History, German Jewish Identity, and the Emigration of Iconology." In *Jewish Identity in Modern Art History*, edited by Catherine M. Soussloff, 167–179. Berkeley: University of California Press, 1999.

———. "Erwin Panofsky und das Kunsthistorische Seminar." In Herzig and Rohde, *Die Juden in Hamburg*, 386–389.

———. "Kunstgeschichte, Paarweise." *Kritische Berichte* 2 (2002): 32–42.

——— "Norden versus Süden: Hamburger und Münchner Kunstgeschichte in den zwanziger und dreißiger Jahren." In *200 Jahre Kunstgeschichte in München: Positionen, Perspektiven, Polemik 1780–1980*, edited by Christian Drude and Hubertus Kohle, 131–138. Munich: Deutscher Kunstverlag, 2003.

———. "Transfer and Transformation: The German Period in American Art History." In *Exiles and Emigrés: The Flight of European Artists from Hitler*, edited by Stephanie Baron, 304–315. Los Angeles: Los Angeles County Museum of Art, 1997.

———. *Transplantierte Kunstwissenschaft: Deutschsprachige Kunstgeschichte im amerikanischen Exil.* Berlin: Akademie, 1999.

Michels, Karen, Christian Olearius, and Martin Warnke. *Aby Warburg—im Bannkreis der Ideen.* Munich: C.H. Beck, 2007.

Michels, Karen, and Charlotte Schoell-Glass. "Die Literatur- und Kulturwissenschaftlerin: Gertrud Bing (Hamburg 1892–1964)." In *Frauen im Hamburger*

Kulturleben, edited by Elsbeth Weichmann Gesellschaft e.V., 29–39. Hamburg: Christians, 2002.

Michels, Karen, and Martin Warnke, eds. *Erwin Panofsky: Deutschsprachige Aufsätze (EPDA)*. 2 vols. Studien aus den Warburg-Haus. Berlin: Akademie, 1999.

Miron, Guy. "The Emancipation's 'Pantheon of Heroes' in the German-Jewish Public Memory in the 1930s." *German History* 21 (2003): 476–504.

Momigliano, Arnaldo. "Gertrud Bing (1892–1964)." In *Essays on Ancient and Modern Judaism*, edited by Silvia Berti, translated by Maura Masella-Gayley, 209–212. Chicago: University of Chicago Press, 1994.

———. "Jacob Bernays." In *Essays on Ancient and Modern Judaism*, edited by Silvia Berti, translated by Maura Masella-Gayley, 148–170. Chicago: University of Chicago Press, 1994.

Morgan, David. *Key Words in Religion, Media, and Culture*. New York: Routledge, 2008.

Morgan, Michael L., and Peter Eli Gordon. *The Cambridge Companion to Modern Jewish Philosophy*. Cambridge Companions to Religion. Cambridge: Cambridge University Press, 2007.

Morton, Marsha. "From *Monera* to Man: Ernst Haeckel, *Darwinismus*, and Nineteenth- Century German Art." In *The Art of Evolution: Darwin, Darwinism, and Visual Culture*, edited by Barbara Larson and Fae Brauer, 59–91. Hanover, NH: Dartmouth College Press, 2009.

Mosse, George L. *German Jews beyond Judaism*. Bloomington: Indiana University Press, 1985.

———. *The Image of Man: The Creation of Modern Masculinity*. New York: Oxford University Press, 1996.

———. *The Nationalization of the Masses: Political Symbolism and Mass Movements in Germany from the Napoleonic Wars through the Third Reich*. New York: Howard Fertig, 1975.

Mosse, Werner. *The German-Jewish Economic Elite, 1820–1935: A Socio-Cultural Profile*. New York: Oxford University Press, 1987.

Moxey, Keith. *The Practice of Persuasion: Paradox and Power in Art History*. Ithaca, NY: Cornell University Press, 2001.

———. *The Practice of Theory: Poststructuralism, Cultural Politics, and Art History*. Ithaca, NY: Cornell University Press, 1994.

Moyn, Samuel. "Mind the Enlightenment." *Nation*, May 31, 2010, online edition, www.thenation.com/article/mind-enlightenment# (accessed February 22, 2013).

Moynahan, Gregory B. "The Davos Debate, Science, and the Violence of Interpretation: Panofsky, Heidegger, and Cassirer on the Politics of History." In *Exile, Science, and Bildung: The Contested Legacies of German Emigré Intellectuals*, edited by David Kettler and Gerhard Lauer, 111–124. New York: Palgrave, 2005.

————. "Herman Cohen's *Das Prinzip der Infinitesimalmethode*, Ernst Cassirer, and Politics of Science in Wilhelmine Germany." *Perspectives on Science* 11 (2003): 35–75.

Naber, Claudia. "'Die Fackel deutsch-jüdischer Geistigkeit weitertragen': Der Hamburger Kreis um Ernst Cassirer und Aby Warburg." In Herzig and Rohde, *Die Juden in Hamburg*, 393–406.

————. "Pompeji in Neu-Mexico: Aby Warburgs amerikanische Reise." *Freibeuter* 38 (1988): 88–97.

Nadler, Steven M. *Spinoza's "Ethics": An Introduction.* Cambridge Introductions to Key Philosophical Texts. Cambridge: Cambridge University Press, 2006.

Neher, Allister. "How Perspective Could Be a Symbolic Form." *Journal of Aesthetics and Art Criticism* 63 (2005): 359–373.

Neill, Deborah, and Lisa M. Todd. "Local History as Total History: A Symposium Held at the Munk Centre for International Studies, University of Toronto, 25 February 2002." *German History* 20 (2002): 373–378.

The New Israelite Temple Association. "Constitution of the Hamburg Temple" (December 11, 1817). In *The Rise of Reform Judaism: A Sourcebook of Its European Origins*, vol. 1, edited by W. Gunther Plaut, 31. New York: World Union of Progressive Judaism, 1963.

Nicolaysen, Rainer. *"Frei soll die Lehre sein und Frei das Lernen": Zur Geschichte der Universität Hamburg.* Hamburg: DOBU, 2007.

————. "Geistige Elite im Dienste des 'Führers': Die Universität zwischen Selbstgleichschaltung und Selbstbehauptung." In *Hamburg im "Dritten Reich,"* edited by the Forschungsstelle für Zeitgeschichte, 336–355. Göttingen: Wallstein, 2005.

Niewyk, Donald L. "The Impact of Inflation and Depression on the German Jew." *Leo Baeck Institute Yearbook* 28 (1983): 19–36.

————. *The Jews in Weimar Germany.* New Brunswick, NJ: Transaction, 2001.

Nochlin, Linda. "Why Have There Been No Great Women Artists?" In *Women, Art, and Power: And Other Essays*, 145–178. New York: Harper & Row, 1988.

Nonne, Max. *Anfang und Ziel meines Lebens: Erinnerungen.* Hamburg: Christians, 1971.

Novick, Peter. *That Noble Dream: The "Objectivity Question" and the American Historical Profession.* Cambridge: Cambridge University Press, 1988.

Oppens, Edith. *Der Mandrill: Hamburgs zwanziger Jahre.* Hamburg: Seehafen Erik Blumenfeld, 1969.

Oz-Salzberger, Fania. "Cassirer's Enlightenment and Its Recent Critics: Is Reason out of Season?" In Barash, *Symbolic Construction of Reality*, 163–173.

Pächt, Otto. "Design Principles of Fifteenth-Century Northern Painting." In Wood, *Vienna School Reader*, 243–321.

Paetzold, Heinz. *Ernst Cassirer, von Marburg nach New York: Eine philosophische Biographie.* Darmstadt: Wissenschaftliche Buchgesellschaft, 1995.

Panofsky, Dora. "Gilles or Pierrot? Iconographic notes on Watteau." *Gazette des Beaux-Arts Series* 6, no. 39 (1952): 319–340.

——. "Narcissus and Echo: Notes on Poussin's Birth of Bacchus in the Fogg Museum of Art." *Art Bulletin* 31 (1949): 112–160.

Panofsky, Dora, and Erwin Panofsky. "The Iconography of the Galerie François Ier at Fountainebleau." *Gazette des Beaux-Arts Series* 6 (1958): 113–164.

——. *Pandora's Box: The Changing Aspects of a Mythical Symbol.* Bollingen Series, 52. New York: Pantheon Books, 1956.

Panofsky, Erwin. "Antwortschreiben Panofskys vom 12. Dezember 1927 an die Hamburger Hochschulbehörde." In *Material in Kunst und Alltag,* edited by Dietmar Rübel and Monika Wagner, 210–212. Hamburger Forschungen zur Kunstgeschichte, 1. Hamburg, December 12, 1927.

——. "Das Kunsthistorische Seminar." In *Die Universität Hamburg in Wort und Bild,* edited by W. Wegandt, 96–97. Hamburg: Universität Hamburg, 1927.

——. "Das Problem des Stils in der bildenden Kunst." In Michels and Warnke, *Erwin Panofsky,* 2:1009–1017. Originally published in *Zeitschrift für Ästhetik und Allgemeine Kunstwissenschaft* 10 (1915): 460–467.

——. "Der Begriff des Kunstwollens." In Michels and Warnke, *Erwin Panofsky,* 2:1019–1034. Originally published in *Zeitschrift für Ästhetik und Allgemeine Kunstwissenschaft* 14 (1920): 321–339.

——. "Die Entwicklung der Proportionslehre als Abbild der Stilentwicklung." In Michels and Warnke, *Erwin Panofsky,* 1:31–72. Originally published in *Monatshefte für Kunstwissenschaft* 14 (1921): 188–219.

——. *Early Netherlandish Painting: Its Origins and Character.* Vol. 1. New York: Icon Editions, Harper & Row, 1971.

——. *Erwin Panofsky Korrespondenz 1910 bis 1968: Eine kommentierte Auswahl in fünf Bänden (EPK).* 5 vols. Edited by Dieter Wuttke. Wiesbaden: Harrassowitz, 2001–8.

——. "Et in Arcadio Ego: Poussin and the Elegiac Tradition." In *Meaning in the Visual Arts,* by Erwin Panofsky, 295–320. 1955. Reprint, Chicago: University of Chicago Press, 1982.

——. "Goldschmidts Humor." In Michels and Warnke, *Erwin Panofsky,* 2:1152–1156. Originally published in *Adolph Goldschmidt zum Gedächtnis* (Hamburg, 1963), 35–41.

——. *Gothic Architecture and Scholasticism.* Latrobe, PA: Archabbey Press, 1951.

——. "The History of Art as a Humanistic Discipline." In *Meaning in the Visual Arts,* by Erwin Panofsky, 1–25. 1955. Reprint, Chicago: University of Chicago Press, 1982.

——. "Iconography and Iconology: An Introduction to the Study of Renaissance Art." In *Meaning in the Visual Arts,* by Erwin Panofsky, 26–54. 1955. Reprint, Chicago: University of Chicago Press, 1982.

——. *Idea: A Concept in Art Theory.* Translated by Joseph J. S. Peake. Columbia: University of South Carolina Press, 1968.

——. "The Ideological Antecedents of the Rolls-Royce Radiator." In *Three Essays on Style,* edited by Irving Lavin, 129–166. Cambridge, MA: MIT Press, 1997.

———. "In Defense of the Ivory Tower," *Centennial Review* (1953): 111–122.

———. "Introductory." In Panofsky, *Studies in Iconology*, 3–33.

———. *The Life and Art of Albrecht Dürer.* Princeton, NJ: Princeton University Press, 1955.

———. "On the Problem of Describing and Interpreting Works of the Visual Arts." Translated by Jaś Elsner and Katharina Lorenz. *Critical Inquiry* 38 (2012): 467–482.

———. "On the Relationship of Art History and Art Theory: Towards the Possibility of a Fundamental System of Concepts for a Science of Art." Translated by Katharina Lorenz and Jaś Elsner. *Critical Inquiry* 35 (2008): 43–71.

———. *Perspective as Symbolic Form.* Translated by Christopher S. Wood. Cambridge, MA: MIT Press, 1991.

———. "Reflections on Historical Time." Translated by Johanna Bauman. *Critical Inquiry* 30 (2004): 691–701.

———. *Sokrates in Hamburg, oder Vom Schönen und Guten.* Hamburg: Gesellschaft der Bücherfreunde zu Hamburg, 1991.

———. *Studies in Iconology: Humanistic Themes in the Art of the Renaissance.* New York: Oxford University Press, 1939.

———. "Three Decades of Art History in the United States: Impressions of a Transplanted European." In *Meaning in the Visual Arts*, by Erwin Panofsky, 321–346. 1955. Reprint, Chicago: University of Chicago Press, 1982.

———. "Wilhelm Vöge, 16. Februar 1868–30. Dezember 1952." In Michels and Warnke, *Erwin Panofsky*, 2:1120–1148.

———. "Zum Problem der Beschreibung und Inhaltsdeutung von Werken der bildenden Kunst." In Michels and Warnke, *Erwin Panofsky*, 2:1064–1077. Originally published in *Logos* 21 (1932): 103–119.

Panofsky, Wolfgang K. H. *Panofsky on Physics, Politics, and Peace: Pief Remembers.* Hamburg: Springer, 2007.

———. "*Unmittelbar nach der Explosion schleif ich ein.*" Interview by Hartwig Spitzer and Michael Schaff. *Yousee* 4 (2006): 18–19.

Papapetros, Spyros. "The Eternal Seesaw: Oscillations in Warburg's Revival." Review of *L'image survivante: Histoire de l'art et temps des fantômes selon Aby Warburg*, by Georges Didi-Huberman (2002). *Oxford Art Journal* 26 (2003): 169–174.

Paret, Peter. "Bemerkungen zu dem Thema: Jüdische Kunstsammler, Stifter und Kunsthändler." In *Sammler, Stifter und Museen: Kunstförderung in Deutschland im 19. und 20. Jahrhundert*, edited by Ekkehard Mai and Peter Paret, 173–185. Cologne: Böhlau, 1993.

———. *The Berlin Secession: Modernism and Its Enemies in Imperial Germany.* Cambridge, MA: Belknap Press of Harvard University Press, 1980.

Pauli, Gustav. "In Memory of Aby M. Warburg (1866–1929)." *Hamburg Amerika Post* 10 (1929): 346–348.

Penslar, Derek J. "The Origins of Modern Jewish Philanthropy." In *Philanthropy in the World's Traditions*, edited by Warren Frederick Ilchman, Stanley Nider Katz, and Edward L. Queen, 197–214. Bloomington: Indiana University Press, 1998.

Peters, Edwards, and Walter P. Simons. "The New Huizinga and the Old Middle Ages." *Speculum* 74 (1999): 587–620.

Petit, Laurence. "Appendix II: Postface to Erwin Panofsky: Gothic Architecture and Scholasticism." In *The Premodern Condition: Medievalism and the Making of Theory*, 221–242. Chicago: University of Chicago Press, 2005.

Peukert, Detlev. *The Weimar Republic: The Crisis of Classical Modernity*. New York: Hill and Wang, 1992.

Pflugmacher, Birgit. "Max Liebermann—sein Briefwechsel mit Alfred Lichtwark." PhD diss., Universität Hamburg, 2001.

Pinder, Wilhelm, and Alfred Stange, eds. *Festschrift Hitler—Deutsche Wissenschaft, Arbeit und Aufgabe: Dem Führer und Reichskanzler legt die deutsche Wissenschaft zu seinem 50. Geburtstag Reichenschaft ab über ihre Arbeit im Rahmen der gestellten Aufgaben*. Leipzig: Hirzel, 1939.

Plagemann, Volker. *Kunstgeschichte der Stadt Hamburg*. Hamburg: Junius, 1995.

Plato. *Phaedrus*. Edited and translated by Robin Waterfield. Oxford World's Classics. Oxford: Oxford University Press, 2002.

Plugmacher, Birgit. *Der Briefwechsel zwischen Alfred Lichtwark und Max Liebermann*. Hildesheim: Goerg Olms, 2003.

Pollock, Friedrich. "Das Institut für Sozialforschung an der Universität Frankfurt am Main." In Brauer et al., *Forschungsinstitute*, 347–354.

Poma, Andrea. "Hermann Cohen: Judaism and Critical Idealism." In Morgan and Gordon, *Cambridge Companion to Modern Jewish Philosophy*, 80–101.

Pos, Hendrik J. "Recollections of Ernst Cassirer." In Schilpp, *Philosophy of Ernst Cassirer*, 63–72.

Pross, Helga. *Deutsche Akademische Emigration nach den Vereinigten Staaten 1933–1941*. Berlin: Dunckner and Humboldt, 1955.

Pulzer, Peter G. J. *Jews and the German State: The Political History of a Minority, 1848–1933*. Detroit: Wayne State University Press, 2003.

———. *The Rise of Political Anti-Semitism in Germany and Austria*. New York: Wiley, 1964.

Quack, Sibylle. "Everyday Life and Emigration: The Role of Women." In Lehmann and Sheehan, *Interrupted Past*, 102–108.

Rabinbach, Anson. *In the Shadow of Catastrophe: German Intellectuals between Apocalypse and Enlightenment*. Weimar and Now: German Cultural Criticism, 14. Berkeley: University of California Press, 2001.

Radkau, Joachim. *Max Weber: Die Leidenschaft des Denkens*. Munich: Carl Hanser, 2005.

Randolf, John. *The House in the Garden: The Bakunin Family and the Romance of Russian Idealism*. Ithaca, NY: Cornell University Press, 2007.

Raulff, Ulrich. "Der aufhaltsame Aufstieg einer Idee: Warburg und die Vernunft in der Republik." In *Wilde Energien: Vier Versuche zu Aby Warburg*, 72–116. Göttingen: Wallstein, 2003.

———. "Von der Privatbibliothek des Gelehrten zum Forschungsinstitut: Aby Warburg, Ernst Cassirer und die neue Kulturwissenschaft." *Geschichte und Gesellschaft* 23 (1997): 28–43.

———. "Zur Korrespondenz Ludwig Binswanger–Aby Warburg im Universitätsarchiv Tübingen." In Bredekamp et al., *Aby Warburg*, 55–70.

Reden, gehalten bei der Feier des Rektorwechsels. Hamburg: Hamburgische Universität, 1919–34.

Rein, Adolf. *Die Idee der politischen Universität*. Hamburg: Hanseatische Verlagsanstalt, 1933.

Repp, Kevin. *Reformers, Critics, and the Paths of German Modernity: Anti-Politics and the Search for Alternatives, 1890–1914*. Cambridge, MA: Harvard University Press, 2000.

Reudenbach, Bruno, ed. *Erwin Panofsky: Beiträge des Symposions*. Hamburg: Akademie, 1992.

Richards, Annette. "Carl Philipp Emanuel Bach and the Intimate Poetics of Public Music." In Hohendahl, *Patriotism, Cosmopolitanism, and National Culture*, 105–114.

Richards, Robert J. *The Romantic Conception of Life: Science and Philosophy in the Age of Goethe*. Chicago: University of Chicago Press, 2002.

———. *The Tragic Sense of Life: Ernst Haeckel and the Struggle over Evolutionary Thought*. Chicago: University of Chicago Press, 2008.

Richarz, Monika. *Der Eintritt der Juden in die akademischen Berufe: Jüdische Studenten und Akademiker in Deutschland, 1678–1848*. Schriftenreihe wissenschaftlicher Abhandlungen des Leo Baeck Instituts, 28. Tübingen: Mohr Siebeck, 1974.

Ringer, Fritz. *The Decline of the German Mandarins: The German Academic Community, 1890–1933*. Middletown, CT: Wesleyan University Press, 1990.

———. "The Intellectual Field, Intellectual History, and the Sociology of Knowledge." In Ringer, *Toward a Social History*, 4–25.

———. *Toward a Social History of Knowledge*. New York: Berghahn, 2000.

Rodnick, David. *A Portrait of Two German Cities, Lübeck and Hamburg*. Lubbock, TX: Caprock Press, 1980.

Roeck, Bernd. "Aby Warburgs Seminarübungen über Jacob Burckhardt im Sommersemester 1927." *Jahrbuch der Hamburger Kunsthalle* 10 (1991): 65–89.

———. "Aby Warburg und Max Weber: Über Renaissance, Protestantismus und kapitalistischen Geist." *Die Renaissance als erste Aufklärung* 3 (1998): 189–205.

———. *Der junge Aby Warburg*. Munich: C.H. Beck, 1997.

———. *Florence 1900: The Quest for Arcadia*. Translated by Stewart Spencer. New Haven, CT: Yale University Press, 2009.

Rose, Louis. *The Survival of Images: Art Historians, Psychoanalysts, and the Ancients*. Detroit: Wayne State University Press, 2001.

Roseman, Mark "Introduction: Generation Conflict and German History: 1770–1968." In *Generations in Conflict: Youth Revolt and Generation Formation in Germany, 1770–1968*, edited by Mark Roseman, 1–46. Cambridge: Cambridge University Press, 1995.

Rosenbaum, E., and A. J. Sherman. *M.M. Warburg and Co., 1798–1938: Merchant Bankers of Hamburg*. New York: Holmes and Meier, 1979.

Rosenhagen, Jennifer Ratner. *American Nietzsche: A History of an Icon and His Ideas*. Chicago: University of Chicago Press, 2011.

Roth, Guenther. "Introduction: Marianne Weber and Her Circle." In *Max Weber: A Biography*, edited and translated by Harry Zohn, xv–lx. New Brunswick, NJ: Transaction, 2007.

Roth, Joseph. *The Radetzky March*. Translated by Joachim Neugroschel. New York: Overlook Press, 1995.

Ruppenthal, Jens. *Kolonialismus als "Wissenschaft und Technik": Das Hamburgische Kolonialinstitut 1908 bis 1919*. Historische Mitteilungen im Auftrage der Ranke- Gesellschaft Reihe. Stuttgart: Franz Steiner, 2007.

Russell, Mark. "Aby Warburg's Hamburg Comedy: Wilhelmine Culture from the Perspective of a Pioneering Cultural Historian." *German History* 24 (2006): 153–183.

———. *Between Tradition and Modernity: Aby Warburg and the Public Purposes of Art in Hamburg, 1896–1918*. New York: Berghahn Books, 2007.

Sauerländer, Williband. *Bürokratie und Kult: Das Parteizentrum der NSDAP am Königsplatz in München: Geschichte und Rezeption*. Part 2. Edited by Julia Rosenfeldt and Piero Steinle. Munich: Deutscher Kunstverlag, 1995.

———. "Es war ein viel zu ehrgeiziger Versuch." *Süddeutsche Zeitung*, September 6, 2012, 13.

Saxl, Fritz. "Die Bibliothek Warburg und Ihr Ziel." In *Vorträge der Bibliothek Warburg*, 1:1–10.

——— "Die Kulturwissenschaftliche Bibliothek Warburg in Hamburg." In Brauer et al., *Forschungsinstitute*, 355–358.

———. "Ernst Cassirer." In Schilpp, *Philosophy of Ernst Cassirer*, 47–51.

———. "A Humanist Dreamland." In *A Heritage of Images: A Selection of Lectures*, edited by Fritz Saxl, Hugh Honour, and John Fleming, 89–104. Harmondsworth: Penguin, 1970.

Scaff, Lawrence A. *Max Weber in America*. Princeton, NJ: Princeton University Press, 2011.

Schäfer, Hans-Michael. *Die Kulturwissenschaftliche Bibliothek Warburg: Geschichte und Persönlichkeit der Bibliothek Warburg mit Berücksichtigung der Bibliothekslandschaft und der Stadtsituation der Freien u. Hansestadt Hamburg zu Beginn des 20. Jahrhunderts*. Logos: Berlin, 2003.

Schiefler, Gustav. *Eine Hamburgische Kulturgeschichte 1890–1920: Beobachtungen Eines Zeitgenossen*. Edited by Gerhard Ahrens, Hans Wilhelm Eckardt, and

Renate Hauschild-Thiessen. Veröffentlichungen des Vereins für hamburgische Geschichte. Hamburg: Verein für hamburgische Geschichte, 1985.

Schilpp, Paul Arthur, ed. *The Philosophy of Ernst Cassirer*. Library of Living Philosophers. New York: Tudor, 1958.

Schivelbusch, Wolfgang. *Intellektuellendämmerung: Zur Lage der Frankfurter Intelligenz in den zwanziger Jahren: Die Universität, das Freie Jüdische Lehrhaus, die Frankfurter Zeitung, Radio Frankfurt, der Goethe-Preis und Sigmund Freud, das Institut für Sozialforschung*. Frankfurt am Main: Insel, 1982.

Schleider, Tim. "Die Haltung der Sozialdemokratie zur Gründung der Hamburgischen Universität." Master's thesis. University of Hamburg, 1989.

Schlör, Joachim. *Das Ich der Stadt: Debatten über Judentum und Urbanität, 1822–1938*. Jüdische Religion, Geschichte und Kultur. Göttingen: Vandenhoeck & Ruprecht, 2005.

Schoell-Glass, Charlotte. "Aby Warburg's Late Comments on Symbol and Ritual." *Science in Context* 12 (1999): 621–642.

———. *Aby Warburg und der Antisemitismus: Kulturwissenschaft als Geistespolitik*. Frankfurt am Main: Fischer Taschenbuch, 1998. Published in English as *Aby Warburg and Anti-Semitism: Political Perspectives on Images and Culture*, translated by Samuel Pakucs Willcocks (Detroit: Wayne State University Press, 2008).

———. "An Episode of Cultural Politics during the Weimar Republic: Aby Warburg and Thomas Mann Exchange a Letter Each," *Art History* 21, no. 1 (1998): 107–128.

———. "'Serious Issues': The Last Plates." In Woodfield, *Art History as Cultural History*, 183–208.

Scholem, Gershom. *From Berlin to Jerusalem: Memories of My Youth*. Edited and translated by Harry Zohn. New York: Schocken Books, 1988.

———. *On Jews and Judaism in Crisis: Selected Essays*. New York: Schocken Books, 1976.

———. *Walter Benjamin: The Story of a Friendship*. Translated by Harry Zohn. New York: New York Review Books, 1981.

Schopenhauer, Arthur. "Sketch of a History of the Doctrine of the Ideal and the Real." In *Parerga and Paralipomena: Short Philosophical Essays*, edited and translated by E. F. J. Payne, 1:1–28. New York: Oxford University Press, 2001.

Schorsch, Ismar. "The Religious Parameters of *Wissenschaft*: Jewish Academics at Prussian Universities." In *From Text to Context: The Turn to History in Modern Judaism*, edited by Ismar Schorsch, 51–70. London: University Press of New England, 1994.

Schorske, Carl. *Fin-de-Siècle Vienna: Politics and Culture*. New York: Vintage Books, 1981.

———. "Survivor of a Lost World." Review of *A European Past: Memoirs, 1905–1945*, by Felix Gilbert. *New York Review of Books* 35, no. 17 (November 10, 1988), online edition, www.nybooks.com/articles/archives/1988/nov/10/survivor-of-a-lost-world/?pagination=false (accessed February 23, 2013).

Schramm, Percy. *Hamburg, Deutschland und die Welt: Leistung und Grenzen hanseatischen Bürgertums in der Zeit zwischen Napoleon I. und Bismarck: ein Kapitel deutscher Geschichte.* 2nd ed. Hamburg: Hoffmann und Campe, 1952.

———. *Hamburg: Ein Sonderfall in der Geschichte Deutschlands.* Vorträge und Aufsätze herausgegeben vom Verein für Hamburgische Geschichte, 13. Hamburg: Christians, 1964.

———. *Neun Generationen: Dreihundert Jahre deutscher "Kulturgeschichte" im Lichte der Schicksale einer Hamburger Bürgerfamilie, 1648–1948.* Göttingen: Vandenhoeck & Ruprecht, 1963–64.

Schreiber, Georg. "The Distress of German Learning." In *The German Inflation of 1923,* edited by Fritz Ringer, 105–107. Problems in European History: A Documentary Collection. New York: Oxford University Press, 1969.

Schumacher, Fritz. "Aby Warburg und seine Bibliothek." In *Mnemosyne: Beiträge zum 50. Todestag von Aby M. Warburg,* edited by Stephan Füssel, 42–46. Göttingen: Gratia, 1979.

———. *Selbstgespräche: Erinnerungen und Betrachtungen.* Hamburg: Springer Verlag, 1949.

Schwartz, Frederic J. "Cathedrals and Shoes: Concepts of Style in Wölfflin and Adorno." *New German Critique* 76 (1999): 3–48.

Schwemmer, Oswald. *Ernst Cassirer: Ein Philosoph der europäischen Moderne.* Berlin: Akademie, 1997.

Sedlmayr, Hans. "Towards a Rigorous Study of Art." In Wood, *Vienna School Reader,* 133–179.

Seeba, Hinrich C. "Cultural History: An American Refuge for a German Idea." In *German Culture in Nineteenth-Century America: Reception, Adaptation, Transformation,* edited by Lynne Tatlock and Matt Erlin, 3–20. New York: Camden House, 2005.

Seeskin, Kenneth. "Jewish Neo-Kantianism: Hermann Cohen." In *Routledge History of Jewish Philosophy,* edited by Daniel H. Frank and Oliver Leaman, 698–708. Routledge History of World Philosophies, 2. London: Routledge, 1997.

Seyfarth, Ernst-August. "Julius Bernstein (1839–1917): Pioneer Neurobiologist and Biophysicist." *Biological Cybernetics* 94 (2006): 2–8.

Sheehan, James J. *German History, 1770–1866.* New York: Oxford University Press, 1989.

———. "The German Renaissance in America." In Grieco, Superbi, and Rocke, *Italian Renaissance in the Twentieth Century,* 49–62.

———. *Museums in the German Art World: From the End of the Old Regime to the Rise of Modernism.* New York: Oxford University Press, 2000.

———. "What Is German History? Reflections on the Role of the Nation in German History and Historiography." *Journal of Modern History* 53 (1981): 1–23.

Sheppard, Eugene R. *Leo Strauss and the Politics of Exile: The Making of a Political Philosophy.* The Tauber Institute for the Study of European Jewry Series. Waltham, MA: Brandeis University Press, 2006.

Shore, Marci. *Caviar and Ashes: A Warsaw Generation's Life and Death in Marxism, 1918–1968*. New Haven, CT: Yale University Press, 2006.

Sieg, Ulrich. "Deutsche Kulturgeschichte und Jüdischer Geist: Ernst Cassirers Auseinandersetzung mit der völkischen Philosophie Bruno Bauchs: Ein unbekanntes Manuskript." *Bulletin des Leo Baeck Instituts* 82 (1989): 59–71.

———. "'Die Verjudung des deutschen Geist': Ein unbekannter Brief Heideggers." *Die Zeit*, December 29, 1989, 19.

Simmel, Georg. "The Metropolis and Mental Life." In *Classic Essays on the Culture of Cities*, edited by Richard Sennett, 47–60. Englewood Cliffs, NJ: Prentice, 1969.

Skidelsky, Edward. *Ernst Cassirer: The Last Philosopher of Culture*. Princeton, NJ: Princeton University Press, 2008.

Sluga, Hans. *Heidegger's Crisis: Philosophy and Politics in Nazi Germany*. Cambridge, MA: Harvard University Press, 1993.

———. Review of *Continental Divide: Heidegger, Cassirer, Davos*, by Peter Gordon. Notre Dame Philosophical Reviews, http://ndpr.nd.edu/review.cfm?id=22849 (accessed February 23, 2011).

Soussloff, Catherine M, ed. *Jewish Identity in Modern Art History*. Berkeley: University of California Press, 1999.

Smith, Bonnie. *The Gender of History: Men, Women, and Historical Practice*. Cambridge, MA: Harvard University Press, 1998.

Specter, Matthew. *Habermas: An Intellectual Biography*. Cambridge. Cambridge University Press, 2010.

Spector, Scott. "Modernism without Jews: A Counter-Historical Argument." *Modernism/modernity* 13 (2006): 615–633.

———. *Prague Territories: National Conflict and Cultural Innovation in Franz Kafka's Fin de Siècle*. Weimar and Now: German Cultural Criticism, 21. Berkeley: University of California Press, 2000.

Springer, Anton. *Bilder aus der Neueren Kunstgeschichte*. Bonn: A. Marcus, 1867.

Steinberg, Michael P. "The Law of the Good Neighbor." *Common Knowledge* 18 (2012): 128–133.

Steinweis, Alan E. *Studying the Jew: Scholarly Antisemitism in Nazi Germany*. Cambridge, MA. Harvard University Press, 2006.

Stern, Fritz. "The Burden of Success: Reflections on German Jewry." In *Dreams and Delusions: The Drama of German History*, 97–114. New Haven, CT: Yale University Press, 1999.

———. *Einstein's German World*. Princeton, NJ: Princeton University Press, 1999.

———. *The Politics of Cultural Despair: A Study in the Rise of German Ideology*. 2nd ed. Berkeley: University of California Press, 1974.

Sternberg, Kurt. "Cassirer, Ernst: Prof. an der Universität Hamburg: Die Begriffsform im mythischen Denken." *Kantstudien* 20 (1925): 194–195.

Sternhell, Zeev. *The Anti-Enlightenment Tradition*. Translated by David Maisel. New Haven, CT: Yale University Press, 2010.

———. *The Birth of Fascist Ideology*. Translated by David Maisel. Princeton, NJ: Princeton University Press, 1994.

Stimilli, Davide. "Aby Warburg's Pentimento." *Yearbook of Comparative Literature* 56 (2010): 140–175.

Stockhausen, Tilmann von. *Die Kulturwissenschaftliche Bibliothek Warburg: Architektur, Einrichtung und Organisation*. Hamburg: Döllig und Galitz, 1992.

Strauss, Leo. "An Introduction to Heideggerian Existentialism." In *The Rebirth of Classical Political Rationalism: An Introduction to the Thought of Leo Strauss*, by Leo Strauss, 27–46. Chicago: University of Chicago Press, 1989.

———. *Spinoza's Critique of Religion*. Translated by Elsa M. Sinclair. Chicago: University of Chicago Press, 1997.

———. *What Is Political Philosophy? And Other Studies*. Chicago: University of Chicago Press, 1988.

———. "Zur Auseinandersetzung mit der europäischen Wissenschaft." In *Leo Strauss: Gesammelte Schriften*, vol. 2, *Philosophie und Gesetz: Frühe Schriften*, edited by Heinrich Meier, 341–349. Stuttgart: J.B. Metzler, 1996.

Strozzi, Alessandra Macinghi. *Selected Letters of Alessandra Strozzi*. Translated by Heather Gregory. Berkeley: University of California Press, 1997.

Strupp, Christoph. *Johan Huizinga: Geschichtswissenschaft als Kulturgeschichte*. Göttingen: Vandenhoeck & Ruprecht, 2000.

Tau, Max. "Mit Familienanschluß bei Cassirers—Studium nach den Ersten Weltkrieg." In *Fremd in der eigenen Stadt: Erinnerungen jüdischer Emigranten aus Hamburg*, edited by Charlotte Ueckert-Hilbert, 66–74. Hamburg: Junius, 1989.

Taylor, A. J. P. *The Course of German History: A Survey of the Development of German History since 1815*. London: Routledge, 2001.

Thilenius, Georg. "Die Wissenschaft." In *Hamburg in seiner politischen, wirtschaftlichen und kulturellen Bedeutung*, edited by the Deutsche Auslandsarbeitsgemeinschaft Hamburg, 116–129. Hamburg: L. Friederichsen, 1921.

———. "Vom Akademischen Gymnasium zur Hamburgischen Universität." In *Festschrift der Hamburgischen Universität ihrem Ehrenrektor Herrn Bürgermeister Werner von Melle*, edited by the Hamburgischen Universität, 3–20. Hamburg: J.J. Augstin, 1933.

Tramer, H. "Die Hamburger Kaiserjuden." *Bulletin des Leo Baeck Instituts* 3 (1960): 177–189.

Treml, Martin. "Judentum als Schlüssel zur Religions- und Kulturtheorie." *Trajekte* 4, no. 8 (April 2004): 13–15.

———. "Warburgs Nachleben: Ein Gelehrter und (s)eine Denkfigur." *Nachleben der Religionen: Kulturwissenschaftliche Untersuchungen zur Dialektik der Säkularisierung*, 2007, 25–40.

Trivellato, Francesca. *The Familiarity of Strangers: The Sephardic Diaspora, Livorno, and Cross-Cultural Trade in the Early Modern Period*. New Haven, CT: Yale University Press, 2009.

Troeltsch, Ernst. *Spektator-Briefe: Aufsätze über die deutsche Revolution und die Weltpolitik 1918–1922.* Edited by Hans Baron. Tübingen: F.C.B. Mohr, 1924.

Tucholsky, Kurt. "Berlin and the Provinces." In Kaes, Jay, and Dimendberg, *Weimar Republic Sourcebook,* 418–419. Originally published as Ignaz Wrobel, "Berlin und die Provinz," *Die Weltbühne* 24 (13 March 1928).

Turner, Henry Ashy. *Stresemann and the Politics of the Weimar Republic.* Princeton, NJ: Princeton University Press, 1963.

Umbach, Maiken. "A Tale of Second Cities: Autonomy, Culture, and the Law in Hamburg and Barcelona in the Late Nineteenth Century." *American Historical Review* 10 (2005): 659–692.

Vagts, Alfred. "M.M. Warburg & Co.: Ein Bankhaus in der deutschen Weltpolitik, 1905–1933." *Vierteljahrsschrift für Sozial- und Wirtschaftsgeschichte* 45 (1958): 289–398.

Van Rahden, Till. *Jews and Other Germans: Civil Society, Religious Diversity, and Urban Politics in Breslau, 1860–1925.* George L. Mosse Series in Modern European Cultural and Intellectual History. Madison: University of Wisconsin Press, 2008.

Verzeichnis der Mitglieder der Drei Hamburger Logen U.O.B.B. Hamburg: Henry Jones Loge Steinthal Loge und Nehemia Nobel Loge, 1932–33.

Vischer, Robert. "On the Optical Sense of Form: A Contribution to Aesthetics." In *Empathy, Form, and Space; Problems in German Aesthetics, 1873–1893,* edited by Harry Francis Mallgrave and Eleftherios Ikonomou, 89–123. Santa Monica, CA: The Getty Center for the History of Art and the Humanities, 1994. Originally published as *Über das optische Formgefühl: Ein Beitrag zur Ästhetik* (Leipzig: Credner, 1872).

Vogel, Barbara. "Anpassung und Widerstand: Das Verhältnis Hamburger Hochschullehrer zum Staat 1919 bis 1945." In Krause, Huber, and Fischer, *Hochschulalltag,* 3–83.

———. "Judentum und 'deutscher Geist': 'Kant-Studien' im Ersten Weltkrieg." In *Die Dritte Joseph Carlebach-Konferenz: Toleranz im Verhältnis von Religion und Gesellschaft,* edited by Miriam Gillis-Carlebach and Barbara Vogel, 70–94. Hamburg: Döllig und Galitz, 1997.

———. "Philosoph und liberaler Demokrat: Ernst Cassirer und die Hamburger Universität von 1919 bis 1933." In Frede and Schmücker, *Ernst Cassirers Werk,* 185–214.

Vogt, Annette. "Barrieren und Karrieren—am Beispiel der Wissenschaftlerinn." In *Frauen in der Wissenschaft—Frauen an der TU Dresden: Tagung aus Anlass der Zulassung von Frauen zum Studium in Dresden vor 100 Jahren,* edited by Hildegard Küllchen, 161–179. Leipzig: Leipziger Universitätsverlag, 2010.

Volkov, Shulamit. *Die Juden in Deutschland 1780–1918.* Enzyklopädie Deutscher Geschichte. Munich: R. Oldenbourg, 1994.

———. "The Social Origins of Success in Science: Jews in 19th Century Germany." In *Juden in der deutschen Wissenschaft,* edited by Walter Grab,

175–185. Jahrbuch des Instituts für Deutsche Geschichte, Beiheft, 10. Tel Aviv: M. Zuckermann, C. Templer, 1985.

———. "Soziale Ursachen des Erfolgs in der Wissenschaft: Juden im Kaiserreich." *Historische Zeitschrift* 245 (1987): 315–342.

Von Melle, Werner. *Dreißig Jahre Hamburger Wissenschaft: 1891–1921: Rückblicke und persönliche Erinnerungen.* Vol. 2. Hamburg: Hamburgische Wissenschaftliche Stiftung, 1924.

Von Melle, Werner, and Karl Rathgen. *Hamburgische Universität: Reden, gehalten bei der Eröffnungsfeier am 10. Mai 1919 in der Musikhalle.* Hamburg: Boysen, 1919.

Vorträge der Bibliothek Warburg. 11 vols. Leipzig: B.G. Teubner, 1923–1933.

Voss, Julia. "Gerda Panofsky im Gespräch: 'Ein Ausdruck des schlechten Gewissens.'" *Frankfurter Allgemeine Zeitung*, Feuilleton, online edition, www.faz.net/aktuell/feuilleton/kunst/gerda-panofsky-im-gespraech-ein-ausdruck-des-schlechten-gewissens-11873504.html (accessed February 22, 2013).

———. "Sensationelle Entdeckung in München: Der Fund im Panzerschrank." *Frankfurter Allgemeine Zeitung*, Feuilleton (August 31, 2012), online edition, www.faz.net/aktuell/feuilleton/sensationelle-entdeckung-in-muenchen-der-fund-im-panzerschrank-11873507.html (accessed February 22, 2013).

Warburg, Aby. "Das Problem liegt in der Mitte." In Warburg, *Die Erneuerung der heidnischen Antike*, 1.2:611–614.

———. *Der Bilderatlas: Mnemosyne.* Vol. 2.1. 2nd ed. Edited by Martin Warnke. In *Gesammelte Schriften: Studienausgabe*, edited by Horst Bredekamp, Michael Diers, Kurt W. Forster, Nicholas Mann, Salvatore Settis, and Martin Warnke. Berlin: Akademie, 2003.

———. *Die Erneuerung der heidnischen Antike: Kulturwissenschaftliche Beiträge zur Geschichte der europäischen Renaissance.* Vols. 1.1 and 1.2. Rev. ed. Edited by Horst Bredekamp and Michael Diers. In *Gesammelte Schriften: Studienausgabe*, edited by Horst Bredekamp, Michael Diers, Kurt W. Forster, Nicholas Mann, Salvatore Settis, and Martin Warnke. Berlin: Akademie, 1998.

———. "From the Arsenal to the Laboratory." Translated by Christopher D. Johnson and annotated by Claudia Wedepohl. *West 86th* 19 (2012): 106–124.

———. *Gesammelte Schriften: Die Erneuerung der heidnischen Antike.* Vols. 1 and 2. Edited by Gertrud Bing. Leipzig: B.G. Teubner, 1932.

———. "Heidnische-antike Weissagung in Wort und Bild zu Luthers Zeiten." In Warburg, *Die Erneuerung der heidnischen Antike*, 1.1:487–535.

———. "Italienische Kunst und Internationale Astrologie im Palazzo Schifanoja zu Ferrara." In Warburg, *Die Erneuerung der heidnischen Antike*, 1.1:459–486.

———. "A Lecture on Serpent Ritual," *Journal of the Warburg Institute* 2, no. 4 (1939): 277–292.

———. "Per Monstra ad Sphaeram: Sternglaube und Bilddeutung." In *Vortrag in Gedenken an Franz Boll und andere Schriften 1923 bis 1925*, edited by Davide Stimilli and Claudia Wedepohl. Munich: Dölling und Galitz, 2007.

———. *The Renewal of Pagan Antiquity: Contributions to the Cultural History of the European Renaissance*. Translated by David Britt. With an introduction by Kurt W. Forster. Los Angeles: Getty Research Institute for the History of Art and the Humanities, 1999.

———. *Schlagenritual: Ein Reisebericht*. Edited by Ulrich Raulff. Berlin: K. Wagenbach, 2011.

———. "Vom Arsenal zum Laboratorium." In Treml, Weigel, and Ladwig, *Aby Warburg*, 683–694.

———. "Warum Hamburg den Philosophen Cassirer nicht verlieren darf." *Sonderdruck aus dem Hamburger Fremdenblatt*, June 23, 1928.

Warburg, Aby, Klaus Berger, and Stephan Füssel. *Mnemosyne: Beiträge zum 50. Todestag von Aby M. Warburg*. Göttingen: Gratia, 1979.

Warburg, Aby, Gertrud Bing, and Fritz Saxl, *Tagebuch der Kulturwissenschaftlichen Bibliothek Warburg (TKBW)*. Edited by Karen Michels and Charlotte Schoell-Glass. In *Gesammelte Schriften: Studienausgabe*, ed. Horst Bredekamp, Michael Diers, Kurt W. Forster, Nicholas Mann, Salvatore Settis, and Martin Warnke. Berlin: Akademie, 2001.

Warburg, Aby, Franz Boas, and Benedetta Cestelli Guidi. "Aby Warburg and Franz Boas: Two Letters from the Warburg Archive: The Correspondence between Franz Boas and Aby Warburg (1924–1925)." *Anthropology and Aesthetics* 52 (2007): 221–230 (special issue: *Museums: Crossing Boundaries*).

Warburg, Aby, Susanne Hetzer, and Martin Treml, eds. *Aby Warburg: Werke in einem Band*. Berlin: Suhrkamp, 2010.

Warburg, Aby, and Michael P. Steinberg. *Images from the Region of the Pueblo Indians of North America*. Ithaca, NY: Cornell University Press, 1995.

Warburg, Aby, and Dieter Wuttke. *Aby Warburg: Ausgewählte Schriften und Würdigen*. 2nd ed. Saecula Spiritalia, 1. Baden-Baden: Koerner, 1980.

Warburg, Eric M. *Zeiten und Gezeiten: Erinnerungen*. Hamburg: Hans Christians Druckerei, 1982.

Warburg, Max M. *Aus meinen Aufzeichnungen*. New York: Eric M. Warburg, 1952.

———. "Rede, gehalten bei der Gedächtnis-Feier für Professor Warburg am 5. Dezember 1929." In Warburg, Berger, and Füssel, *Mnemosyne: Beiträge zum 50. Todestag von Aby M. Warburg*, 23–28.

Warburg-Spinelli, Ingrid. *Die Dringlichkeit und die Einsamkeit, nein zu sagen: Erinnerungen 1910–1989*. Hamburg: Dölling und Galitz, 1990.

Warnke, Martin. "Aby Warburg als Wissenschaftspolitiker." In *Storia dell'arte e politica culturale intorno al 1900: La fondazione dell'Istituto germanico di storia dell'arte de Firenze*, edited by Max Seidel, 41–45. Venice: Marisilio, 1999.

———. Foreword to Michels, Olearius, and Warnke, *Aby Warburg*.

———. *Handbuch der politischen Ikonographie*. 2 vols. Munich: C.H. Beck, 2011.

Weber, Alfred. "The Predicament of Intellectual Workers." In Kaes, Jay, and
 Dimendberg, *Weimar Republic Sourcebook*, 294–295. Originally published
 as *Die Not der Geistigen Arbeiter* (Munich: Duncker and Humboldt, 1923).
Weber, Marianne. *Max Weber: A Biography*. Translated by Harry Zohn. New
 Brunswick, NJ: Transaction, 1988,
Weber, Max. *The Power of the State and the Dignity of the Academic Calling in
 Imperial Germany: The Writings of Max Weber on University Problems*. Edited
 by Edward Shils. Chicago: University of Chicago Press, 1974.
———. "Science as a Vocation." In *From Max Weber: Essays in Sociology*, edited
 and translated by H. H. Gerth and C. Wright Mills, 129–156. New York:
 Oxford University Press, 1946. Originally published as "Wissenschaft als
 Beruf," in *Gesammelte Aufsaetze zur Wissenschaftslehre* (Tübingen: Duncker
 and Humboldt, 1922).
Weber, Regina. *Lotte Labowsky (1905–1991)—Schülerin Aby Warburgs, Kollegin
 Raymond Klibanskys: Eine Wissenschaftlerin zwischen Fremd- und Selbst-
 bestimmung im englischen Exil*. Berlin: Dietrich Reimer, 2012.
Webern, Anton. *The Path to the New Music*. Edited by Willi Reich. Translated by
 Leo Black. Bryn Mawr, PA: Theodore Presser, 1963.
Wedepohl, Claudia. "Ideengeographie: Ein Versuch zu Aby Warburgs 'Wan-
 derstraßen der Kultur.'" In *Entgrenzte Räume: Kulturelle Transfers um 1900
 und in der Gegenwart*, edited by Helga Mitterbauer and Katharina Scherke,
 227–254. Vienna: Passagen, 2005.
Weigel, Sigrid. "Aby Warburgs 'Schlangenritual' Korrespondenzen zwischen
 der Lektüre kultureller und geschriebener Texte." *Paragrana*, 1994, 9–27.
Weitz, Eric D. *Weimar Germany: Promise and Tragedy*. Princeton, NJ: Princeton
 University Press, 2007.
Werner, Meike G. *Moderne in der Provinz: Kulturelle Experimente im Fin-de-Siècle
 Jena*. Göttingen: Wallstein, 2003.
Weygandt, Wilhelm. *Die Universität Hamburg in Wort und Bild: Herausgegeben im
 Auftrag des Akademischen Senates*. Hamburg, 1927.
———. "Ist die Hamburger Universität ein Wagnis?" *Sonderheft zur Universitäts-
 frage* 4, no. 5 (1918): 157–158.
Whitman, James. "Nietzsche in the Magisterial Tradition of German Classical
 Philology." *Journal of the History of Ideas* 47 (1986): 453–468.
Widdig, Bernd. *Culture and Inflation in Weimar Germany*. Weimar and Now: Ger-
 man Cultural Criticism, 26. Berkeley: University of California Press, 2001.
Willey, Thomas. *Back to Kant: The Revival of Kantianism in German Social and
 Historical Thought, 1860–1914*. Detroit: Wayne State University Press, 1978.
Wind, Edgar. "Warburgs Begriff der Kulturwissenschaft und seine Bedeutung
 für die Ästhetik." *Zeitschrift für Ästhetik und allgemeine Kunstwissenschaft*
 25 (1931): 163–179.
Winter, Jay M., and Jean-Louis Robert, eds. *Capital Cities at War: Paris, London,
 Berlin, 1914–1919*. 2 vols. Studies in the Social and Cultural History of
 Modern Warfare. Cambridge: Cambridge University Press, 1997, 2007.

Wittgenstein, Ludwig. *Notebooks, 1914–1916.* Translated by G. E. M. Anscombe. Oxford: Blackwell, 1961.

Woessner, Martin. *Heidegger in America.* Cambridge: Cambridge University Press, 2010.

Wölfflin, Heinrich. "Das Problem des Stils in der bildenden Kunst." *Sitzungs-berichten der Königlichen Preussischen Akademie der Wissenschaften* 31 (1912): 572–578.

———. "In eigener Sache: Zur Rechtfertigung meiner 'kunstgeschichtlichen Grundbegriffe' (1920)." In *Gedanken zur Kunstgeschichte: Gedrucktes und Ungedrucktes,* 15–18. Basel: Schwabe, 1941.

———. *Kleine Schriften.* Basel: B. Schwabe, 1946.

———. *Principles of Art History: The Problem of the Development of Style in Later Art* (1915). 7th ed. Translated by M. D. Hottinger. 1932. Reprint, New York: Dover, 1950.

Wolin, Richard. *Heidegger's Children: Hannah Arendt, Karl Löwith, Hans Jonas, and Herbert Marcuse.* Princeton, NJ: Princeton University Press, 2003.

———. *The Politics of Being: The Political Thought of Martin Heidegger.* New York: Columbia University Press, 1992.

———. Review of *Continental Divide: Heidegger, Cassirer, Davos,* by Peter Gordon. *American Historical Review* 117 (April 2012): 600.

Wood, Chris, "The Normative Renaissance." In Grieco, Superbi, and Rocke, *Italian Renaissance in the Twentieth Century,* 65–92.

———, ed. *The Vienna School Reader: Politics and the Art Historical Method in the 1930s.* New York: Zone Books, 2000.

Woodfield, Richard, ed. *Art History as Cultural History: Warburg's Projects.* Amsterdam: Gordon and Breach, 2011.

Woolf, Virginia. *A Room of One's Own.* San Diego: Harcourt Brace, 1981.

Wright, Johnson Kent. "'A Bright Clear Mirror': Cassirer's *The Philosophy of the Enlightenment.*" In *What's Left of Enlightenment? A Postmodern Question,* edited by Keith Baker and Peter Hanns Reill, 71–101. Stanford, CA: Stanford University Press, 2001.

Wundt, Max. "Die deutsche Philosophie im Zeitalter der Aufklärung." *Zeitschrift für Deutsche Kulturphilosophie* 2 (1936): 225–250.

Wuttke, Dieter. *Aby M. Warburg—Bibliographie 1866 bis 1995: Werk und Wirkung: Mit Annotationen.* Baden-Baden: V. Koerner, 1998.

———. "Die Emigration der Kulturwissenschaftlichen Bibliothek Warburg und die Anfänge des Universitätsfaches Kunstgeschichte in Großbritannien." *Artibus et Historiae* 5, no. 10 (1984): 133–146.

Young-Bruehl, Elisabeth. *Hannah Arendt: For Love of the World.* New Haven, CT: Yale University Press, 1982.

Zell, Michael. *Reframing Rembrandt: Jews and the Christian Image in Seventeenth-Century Amsterdam.* Berkeley: University of California Press, 2002.

Zerner, Henri. "Alois Riegl: Art, Value, and Historicism." *Daedalus* 105 (1976): 177–188.

Zimmerman, Mosche. *Hamburgsicher Patriotismus und deutscher Nationalismus: Die Emanzipation der Juden in Hamburg, 1830–1865.* Hamburger Beiträge zur Geschichte der deutschen Juden, 6. Hamburg: Christians, 1979.

Zwick, Tamara. "The Bat at the Ball: Bourgeois Culture as a Written Practice in the Letters of Magdalena Pauli to Johanna Sieveking, 1786–1824." In *Challenging Separate Spheres: Female Bildung in Eighteenth and Nineteenth-Century Germany,* edited by Marjanne E. Gooze, 137–156. Oxford: Peter Lang, 2007.

———. "Correspondence between Public and Private: German Women, Kinship, and Class in 19th-Century Hamburg." PhD diss., University of California–Los Angeles, 2005.

Index

Ackerman, James, 364n63

Adler, Cyrus, 66, 145

Adorno, Theodor: and Bloom, 283; Cassirer compared with, 18–19; and Frankfurt School, 13; on Kant, 18; and Kracauer, 278, 370–71n3; legacy of, 281; on philosophical inferiority of English, 370–71n3, 371n12; on watering-down of critical theory in America, 283; on Wölfflin, 335n21

Aeneid (Virgil), 6

aesthetics: Baumgarten on, 237, 358n64; Cassirer on, 358n65; Kant on, 22, 169; Panofsky on, 169; Robert and F. T. Vischer on, 112; Warburg on aesthetics of natural world, 112

Akademie für die Wissenschaft des Judentums, 185

Akademische Gymnasium, Hamburg, 72

Alberti, Leon Battista, 54, 267

Allgemeiner Studenten Ausschuss (AStA), 229, 232–33

Alpers, Svetlana, 267–68, 269, 339n88

Altertumswissenschaft (science of antiquity), 53

Althoff, Friedrich, 76, 141, 313n20, 314n22

America. *See* United States

American Indians. *See* Hopi Indians

ancient Greece: art of, 68, 153, 267; Burckhardt, 52, 53, 56; Nietzsche on, 65; Panofsky on, 164, 267; Schiller on, 52; Warburg on, 68, 172. *See also* neoclassicism

"Ancient World of Star Constellations in Early Modern Art, The" (Warburg), 316n55

Annales School, 66, 278

"Anna O.," 89

antipolitics. *See* apoliticism and antipolitics

anti-Semitism: and attacks against Enlightenment, 217; and "Bauch Affair," 212, 213, 239, 350n49, 351n53; in Berlin, 15, 20–21, 147, 175, 176, 191–92, 228; Cassirer's concerns about, 3, 101, 176–77, 192, 195, 228; and claims of Judaizing of Kant's philosophy, 211–13, 239, 352n67; and connections between neo-Kantianism and Jews, 21, 100, 196, 226; Einstein's concern about, 194, 195; against German Jewish émigrés pursuing German scholarship, 266; in German universities, 182–84, 186, 342n38; in Hamburg, 32, 35, 88, 176, 186–87, 192, 300n37; and Holocaust, 284; impact of, on Jewish men generally, 308n53; of Kant, 212; and "Lessing affair," 209;

Burckhardt, Jacob (*continued*)
of spirit," 311n90; influence of, on
Warburg, 54, 57, 66, 69, 70, 184, 305n7;
on "intuitive generalizations," 68; on
life as source of signification, 151; on
Renaissance, 7, 20, 50, 56–57, 63–64,
70; Wölfflin as student of, 152
Burke, Peter, 12, 23–24, 309n67,
311–12nn93–94

Campe, Julius, 17
Carlebach, Joseph, 298n7
Carnegie, Andrew, 142
Carnegie Institute, 141
Cassirer, Anne, 103
Cassirer, Bruno, 176, 340n6
Cassirer, Ernst: birth year of, 3, 249;
children of, 103, 192; courtship
between Toni Bondy and, 103; death
and funeral of, 240, 253, 254, 362n28;
education of, 95–96; exile of, upon Hit-
ler's ascent, 5, 21, 241–42, 245, 255–56,
262, 361n5; family background of, 95;
finances of, 126, 127; on gap between
German and Jewish cultures, 362n33;
Heidegger's relationship with, 11, 213,
219–20, 354n87; home of, 104; illness
of, 219; marriage of, 25, 94, 101–4,
177, 178; personality of, 95, 101, 201,
212; photographs of, 102, 214, 223;
physical appearance of, 95, 213, 214;
relationship of, to Judaism, 177–78,
185, 196, 240, 249, 253–54, 340n9,
362n28; spiritual nature of, 106–7; and
Warburg's death, 225; and World War I,
101, 105–6, 249, 270. *See also Cassirer
headings below*
Cassirer, Ernst, career of: and anti-
Semitism, 3, 101, 176–77, 192, 195, 228;
and Bing, 160; founding of library for
research on America, 205; and honors,
253; job offer from University of Frank-
furt, 187–90, 193, 222; and League for
International Understanding, 204,
206; leave of absence from University
of Hamburg, 241–42, 359–60n84;
and "Lessing affair," 206–9, 220,
238–39; and mentors, 8, 96–101, 103,
105–7, 176, 194, 217–18, 240, 352n62;
and Natorp, 98, 99, 103, 194; Oxford
lectureship, 101; Petersen on, 122;

and political issues, 201, 347–48n9;
Reichsgründungsfeier (Celebration
of the nation's founding) in 1930,
226–28, 230; and Rosenzweig Founda-
tion, 360n92; and Saxl, 95, 109–10,
114, 116, 119, 187; and students, 45,
104, 194, 216, 352n67; in Sweden, 245,
262, 360–61n4; in United States, 245,
262; at University of Berlin, 3, 20–21,
101, 103; as University of Hamburg
rector, 196, 222–33, 239, 249, 356n20;
as University of Hamburg scholar, 3,
12, 20–21, 92, 94, 95, 104, 125, 127,
163, 176, 177, 185–89, 193, 196, 249,
255; Verfassungsfeier speech (1928),
199–202, 211, 223; and Warburg, 94,
109–20, 176, 186–89, 193, 225; and
Warburg Library, 94, 109–12, 114,
116, 118, 158, 187; Warburg Library's
inaugural lecture, 112; and Weimar Re-
public, 105, 198, 199–201, 227, 230–31,
232, 246, 249, 347–48n6; and Weimar
Republic's constitution, 199–201, 227
Cassirer, Ernst, scholarship of: Adorno
compared with, 18–19; and "Bauch
Affair," 212, 239, 351n53; and Cohen,
8, 96–101, 103, 105–7, 176, 185, 192,
194, 212, 217–18, 240, 249–50, 352n62;
Cohen compared with, 352n62,
362n33; on cosmopolitan national-
ism, 18, 21, 198–221, 230, 234, 236–37,
239, 247; criticisms of, 213, 237–38; on
critique of reason and culture, 104–9,
149, 220, 236, 251–52; Davos Debate
with Heidegger, 13, 199, 211, 213–21,
226, 231, 236, 238, 255, 281, 353n71,
353n74; on doctrine of seculariza-
tion, 362n23; Einstein's influence on,
107–8; on Enlightenment, 10, 11, 18,
21, 105, 198, 209, 211, 226, 233–38,
251, 280, 322n57, 358n59, 358n64; and
epistemology, 10, 105, 117–18, 215–16,
220, 226, 234, 236, 247, 252; Goethe's
influence on, 107, 108, 111, 119, 169,
189, 198, 202, 216, 216–18, 217, 218,
227, 250, 281, 322n63, 323n67; on hu-
man nature, 250–51, 362n26; influence
of, 12, 22–23, 289nn23–24; on Lam-
precht's theory of history, 348–49n24;
legacy of, 11, 280–81, 284; on Leibniz,
8, 101, 103, 105, 198, 200–203, 209; on

private "Jewishness," 177–82, 185,
193–96, 240, 249, 253–54, 340n9,
362n28; and Rathenau's assassination,
177, 194–95; resemblance of Germans
and Jews, 180–81; rights of, 35; unique
tradition of, in Hamburg, 189–93; as
University of Hamburg students, 186;
and Warburg Library, 168, 182, 189,
190, 192; Warburg on "Jewish Jews,"
190, 345n70, 345n76; and Weimar Re-
public, 194, 196. *See also* anti-Semitism;
Judaism; *and specific Jewish families and
individuals*
German National Theater, Hamburg, 207,
349n36
German People's Party, 199
German Protection Agency for Germans
Living on the Border and Abroad, 208
German universities: anti-Semitism in,
182–84, 186, 239, 342n38, 359n74;
apoliticism as objective of, 232–33,
239–40; barring of Jews from, in
1847, 183; and Colonial Institute in
Hamburg, 78; enrollment statistics for,
126; Humboldtian model of research
and teaching at, 92; inflation's impact
on, 126–27, 130–31, 135–36, 139–40;
professorial hierarchy in, 3, 98, 126,
176, 182–83, 287n5, 317n79, 342n38;
Prussianization of, 31, 76–77, 82; purge
of non-Aryan university faculty and
students at, under National Socialism,
240–43, 256, 360n85; state financing
of, 76, 313n20; Weber on, 77; after
World War I, 126. See also *Ordinarius*;
Privatdozent; *and specific universities*
Germany: classical humanism in, 265–66,
272; end of Allied occupation of
Rhineland, 229, 230–31; Hitler as
chancellor of, 233, 240–41; inflation
in, 5, 122–23, 126–27, 130–31, 135,
139–40, 141, 330n53, 333n93; national
characteristics of Germans, 264; pay-
ment of war reparations by, 199; Relief
Organization of German Jews in, 34;
unification of, 170, 226; in World
War I, 84–89, 93, 206. *See also* German
Jews; German universities; Hamburg;
National Socialism; Treaty of Versailles;
Weimar Republic; *and specific German
cities*

Gesammelte Schriften/collected writings
(Warburg), 276, 279
Gesetzes-Ethik (ethics of obligation), 236
Geworfenheit (Being-thrown), 215–16,
252
Ghirlandaio, Domenico, 49, 59–60
Gilbert, Felix, 12, 29, 50, 237
Giotto di Bondone, 58–59
Glückel of Hameln, 302n61
"Gods of Greece" (Schiller), 52
Goethe, Johann Wolfgang von: on Amer-
ica, 144, 332n80; "anthropomorphism"
of, 108; cosmopolitanism of, 198; on
dilettantism in Hamburg, 42; Frankfurt
as home of, 189; in Hamburg, 301n60;
influence of, on Cassirer, 107, 108, 111,
119, 169, 189, 198, 202, 216–18, 227,
250, 281, 322n63, 323n67; influence of,
on Cohen, 249; Mann on, 201; on the
past, 227; postal stamp of, in Warburg
Library, 248–49; and symbolic form,
111; works by, 93, 211
Goldman, Hetty, 261
Goldschmidt, Adolph: academic career of,
124–25, 130, 143, 154, 184–85, 326n11;
humor of, 334n19; Panofsky as student
of, 10, 124–25, 127; in United States,
143, 272; and Warburg, 64, 184–85;
and Wölfflin, 152, 154
Goldschmidt family, 36, 123
Goldstein, Rebecca, 260, 364n63
Gombrich, Ernst: *Art and Illusion* by, 278;
as biographer of Warburg, 12; on boa
constructor, 279; on cultural history,
69–70, 311n93; on Darwin, 324n85;
as director of London's Warburg
Institute, 12, 279; Ferretti on, 311n90;
on iconology, 22, 150, 277–78; identity
of, as Central European, 340n11; and
"inversion" of sources of discord in
Warburg's work, 311n83; on Medici
family, 309n57; and Pächt, 171; on
Panofsky, 277, 278, 279, 371n8, 371n13;
on patrons during Renaissance, 64; on
pluralism versus universalism, 173; on
Renaissance in Florence and Venice,
312n95; on understanding a writer's
meaning, 275; on Vignoli's influence
on Warburg, 307n26; on Warburg com-
pared with John Ruskin, 303n75; and
Warburg papers, 12; and Warburg's

of, 253–54; historical mission of the Jews, 175; Kant on Jews, 351n51; and particular versus universal, 169–70; and philanthropy, 142–44; and prohibition on images, 67; public versus private "Jewishness," 177–82, 185, 193–96, 240, 249, 253–54, 340n9, 362n28; Reform and Orthodox synagogues of, 36, 191; Rembrandt's portrayal of, 179–82; Treitschke's slander of, 99–100; in Vienna, 293n56; Warburg's relationship to, 31–32, 61, 62, 298n8, 307–8n44; and Zionism, 190–91. *See also* anti-Semitism; German Jews; Hamburg

Judaizing of Kant's philosophy, 211–13, 239, 352n67

Jugendstil movement in Vienna, 154

Jünger, Ernst, 196, 270, 339n92

Jungius, Joachim, 203

Justi, Carl, 53

Kadimah, University of Hamburg, 233

Kaiserreich, 14, 227, 246

Kaiser Wilhelm Institute for Physical Chemistry, 343n42

Kaiser Wilhelm Society, 81, 140–41, 184, 331n66, 333n83, 338n77, 343n42

Kant, Immanuel: Adorno and Horkheimer on, 18; on aesthetics, 22, 169; anti-Semitism of, 212; Cassirer on, 127, 210, 211, 237, 280, 281, 340n6, 358n64; on categorical imperative, 93; categorical imperative of, 236; Cohen on, 96–101, 351n51; Copernican Revolution of, 8, 9, 96, 107; cosmopolitanism of, 198; criticisms of, 96–97, 210–12, 352n67; critique of reason by, 96, 97, 105, 230, 237; Davos Debate on, 199, 211, 213–21, 226, 238, 281, 353n71, 353n74; and "Enlightenment Project," 210–12; on epistemology, 165; ethics in philosophy of, 220; and Fichte, 230; on freedom, 230, 320n35; and French Revolution, 210, 211; German Jews' interest in, 99–100; as "great destroyer," 215; Habermas on, 99–100; Heidegger on generally, 13, 237, 238, 239; on Jews, 351n51; Judaizing of, 211–13, 239, 352n67; Panofsky on, 4; and philosophy of history, 10; on Plato, 280; on Rousseau, 236; significance of,

198–99, 209–10; on space and time, 111, 319n17; on synthetic a priori judgments, 96, 319n23; transcendental idealism of, 9, 96–97, 107, 108, 215; and Warburg, 280; writings by, 96, 97, 105, 211, 230. *See also* Enlightenment; neo-Kantianism

Kantorowicz, Ernst, 370n117

Kant's Life and Thought (Cassirer), 101, 340n6

Kant Society, 109, 166, 212, 213, 239, 255, 268, 351n53

Kant und die Epigonen/Kant and the Epigones (Liebmann), 97

Kassel, Simon von, 34

Katzenellenbogen, Adolf, 363n42, 369n112

Kellenbenz, Hermann, 293n54

Kenyon College, 369n112

Kepler, Johannes, 114–15

Kessler, Count Harry, 222, 226

Kirchner, Ernst Ludwig, 13, 89

Kleist, Heinrich von, 216

Klemperer, Otto, 104

Klibansky, Raymond, 12, 104

Klimt, Gustav, 154

Klopstock, Friedrich Gottlieb, 17, 79

Köhnke, Klaus-Christian, 319nn15–16

Koloff, Eduard, 180, 341n21

Koppel, Leopold, 343n42

Kracauer, Siegfried, 25–26, 277–78, 370n3, 371n12

Krautheimer, Richard, 364n58

Kreuzlingen, Switzerland, sanitarium, 62, 63, 88–89, 109, 114, 115–16

Krois, John Michael, 321n40, 348n9, 353n71, 363n36

Kugler, Franz, 56

Kuhn, Charles, 145

Kulturwissenschaft (science of culture), 68, 70–71, 84

Kunsthalle, Hamburg: art collection of, 39, 40, 55, 82, 149, 156; financial support for, 77; founding of, 38–39; Lichtwark as director of, 39, 43, 77, 82, 156, 301n55, 340n1; Panofsky's office in, 125–26, 156; Pauli as director of, 125, 156; and University of Hamburg students, 156, 158

Kunsthistorische Alphabet/"Art Historical Alphabet" (Panofsky), 271

Kunstschaffen (creation of art), 155

dissertations supervised at University of Hamburg, 328n34; firing by University of Hamburg under National Socialism, 241, 246, 256, 360n84; and honors, 263, 366nn76–77; naming of Hamburg School, 19, 22, 147, 149; at New York University, 245–46, 258–60; in Princeton, 244–45, 246, 260–62, 272; as private scholar, 127–29; and students, 130, 152, 167, 247–48, 255, 256, 263–64, 272, 275, 276–77, 334n9; in United States, 22, 245–48, 258–70; at University of Hamburg, 3, 10, 122, 125–26, 129–34, 162–63, 176, 182, 196, 255–56, 325–26n2, 328n34; and Warburg Library, 125, 149, 158, 162, 257–59, 262

Panofsky, Erwin, scholarship of: on aesthetics, 169; on ambivalent predicament of human existence, 4; on boa constructor, 277; on commercial versus noncommercial art, 121; critique of, 22–23, 173, 267–68, 333n90, 339n92; and culture of universalism, xii, 265, 283; on documental sense (*Dokumentsinn*) of image, 255, 363n40; on Dürer, 10–11, 20, 22, 113–14, 124, 125, 155, 165, 167, 264–65; on economic conditions of art, 122, 131–36, 145, 146, 149, 329n42; English-language scholarship in postwar period, 262–63, 266, 276, 371n12; and epistemology of art-historical discipline, 10, 11, 125, 155–56, 265, 267, 276; and Heidegger, 255, 268–69; on historical mission of the Jews, 175; on humanism, 4; on iconology, 3, 10–11, 162–67, 247, 255, 262, 266–70, 278, 281, 295n74, 368n92, 368n97, 368n102; influence of, 12, 22–23; and Latin compositions and correspondence, 127, 179, 272, 367n85, 369n112; legacy of, 276–81, 284; on meaning-making, 6, 10–11, 339n88; and neo-Kantianism, 155–56, 166, 171, 269; on Poussin, 265–66; questions addressed by, 3–4; on Rembrandt, 180–81, 212, 264; on Renaissance, 164, 262, 267, 278, 283; studies on, 12, 22–23; on symbols and symbolic forms, xi, xii, 4, 5, 11, 163, 269–70,

337n62, 339n88; and "third way" between formalism and contextualism, 149, 151, 154–56; Warburg on, 130; and Wölfflin, 335nn22–23. *See also* Hamburg School

Panofsky, Erwin, works and lectures by: "Art Historical Alphabet" (*Kunsthistorische Alphabet*), 271; "The Concept of Artistic Volition [*Kunstwollen*]," 10, 155; dissertation on Dürer, 10, 124, 125, 154–55; *Early Netherlandish Painting*, 22, 262, 266; French translation of, 24; *Gothic Architecture and Scholasticism*, 262, 277, 278; *Habilitation* on Michelangelo, 125, 263–64, 326n2, 327n16, 335n23, 365n70; *Idea: A Concept in Art Theory*, 164–65, 337n60; "The Ideological Antecedents of the Rolls-Royce Radiator," 269–71; *The Life and Art of Alrecht Dürer*, 22, 262, 264; *Meaning in the Visual Arts*, 22, 262, 268; *Melancholia I*, 10–11, 337n70; "On the Four Master Builders of Reims," 165; "On the Problem of Describing and Interpreting Works of the Visual Arts," 166, 255, 262, 268; *Perspective as Symbolic Form*, 11, 163, 173, 266–67, 269; *Phaedrus Hamburgensis*, 122, 131–34, 146, 149, 329n42; "The Problem of Style in the Visual Arts," 10, 155; "Reflections on Historical Time," 20, 165–66, 180; *Sokrates in Hamburg*, 131, 329n41; *Studies in Iconology*, 22, 262, 268, 368nn101–102

Panofsky, Gerda Soergel, 263, 366–67nn77–78

Panofsky, Hans, 260

Panofsky, Wolfgang, 260

Parsons, Talcott, 373n31

particular versus universal. *See* universal versus particular

Passarge, Siegfried, 186–87, 344n54

Pathosformel (expressive formula in artwork), 54–55, 61, 118

Patriot, 17

Patriotic Society, Hamburg, 38, 40, 74

Pauli, Gustav, 125–26, 129, 143, 156, 157, 182, 272, 327n17

Perspective as Symbolic Form (Panofsky), 11, 163, 173, 266–67, 269

Stockhausen, Tilmann von, 333n86

Strasbourg, 85

Strauss, Leo: and Bloom, 283; and Cassirer, 194, 216, 352n62, 352n67, 353n69, 359n82; on Cohen versus Cassirer, 352n62; and Davos Debate, 217, 220, 353n74; dissertation of, 353n69; and Heidegger, 216, 255; legacy of, 281; on neo-Kantianism, 252; on Weber, 216; on Weimar Republic, 194–95, 252

Strauss, Richard, 37

Stresemann, Gustav, 199, 224, 231, 248–49, 347n3

Strozzi, Alessandra, 61–62

Strozzi, Matteo degli, 61–62

structuralism, 24, 163, 266–67

Structural Transformation of the Public Sphere (Habermas), 354n80

Strukturforschung (structure research), 171

Strzygowski, Josef, 180

Stück in Stücken (fragmented play), 169

Studies in Iconology (Panofsky), 22, 262, 268, 368nn101–102

St. Vincent College, 262

"style" art history, 151, 171, 277

Substanzbegriff und Funktionsbegriff/Substance and function (Cassirer), 101, 105

Swarzenski, George, 364n63

Sweden, 245, 262, 360–61n4

symbols and symbolic forms: Cassirer on, xii, 4, 9, 107–12, 115, 116, 117, 119, 163, 164, 168, 266, 269, 351n52; difference between a symbol and the thing symbolized, 5; and Goethe, 111; and humanities for understanding symbol-making process, xii, 4; and Kepler, 115; and meaning-making, 4, 6–12; money as, 145–47; of National Socialism, 231, 249; and Panofsky, xi, xii, 4, 5, 11, 163, 269–70, 337n62, 339n88; in Renaissance art, 117–18, 166–67; and science, 107–8; and Vischer, 112, 113; Warburg on, xii, 4, 112–15, 145–47. *See also* iconology; myth

Tag der Räumung des Rheinlands (The day of the evaluation of the Rhineland), 229, 230–31

Talmud Torah School, 29–30, 44, 298n7

Tarkington, Booth, 175, 181

Tau, Max, 102, 104

theory of ideas, 165

theory of imitation, 165

Thilenius, Georg, 83, 135

Third Critique (Kant), 105

Tocqueville, Alexis de, 1, 16–17

Tolnay, Charles de, 260

transcendental idealism, 9, 96–97, 107, 108, 169–70, 215

Treaty of Locarno, 199

Treaty of Versailles: founding of University of Hamburg following, 193; opposition to and protests against, 176, 198, 200, 208, 226–27, 229, 233; provisions of, 12, 87, 208; and Stresemann, 199; and Max Warburg, 12, 34, 194; Aby Warburg's opposition to, 198

Treitschke, Heinrich von, 99–100, 184, 212, 251

Trier, 299n31

Troeltsch, Ernst, 2, 203, 204, 349n24

Tschudi, Hugo von, 39, 314n24

Tucholsky, Kurt, 27

United States: anti-Semitism in, 181; art history in, 260, 262, 270; art museums in, 143; and Bill of Rights, 202; biomedical sciences in, 141; Boston Public Library in, 143, 332n78; Cassirer family in, 245, 262; connections between Hamburg and, 140–45, 197, 205, 332n81; and Declaration of Independence, 202; Emergency Committee in Aid of Displaced Scholars in, 257; emigration of German Jewish scholars to generally, 270, 272; Goethe on, 144, 332n80; Hopi Indian reservation in, 7, 67, 110, 112, 113, 116, 141; iconology in, 22, 23, 247, 258, 260, 262, 266–70; Library of Congress in, 143; Panofsky family in, 245–48, 258–70, 365n66; philanthropy in, 123, 140–45, 258–60, 314n27; possible relocation of Warburg Library to, 257; privately funded scholarship in, 140, 205; St. Louis World's Fair in, 205, 331n67; stock market crash in (1929), 224; Paul and Felix Warburg in, 141; Aby Warburg's travel to, 7, 66–67, 110, 113, 116, 141–44, 205; watering-down of German ideas in, 283, 373n31; in World War I, 206

universal history, 66, 68–69, 170

138–39, 144, 258; and Aby Warburg's lecture on Hopi Indians, 116; and worker movement in Hamburg, 2, 90; youth of, 27–28

Warburg, Max (son of Aby), 41

Warburg, Moritz Max: on anti-Semitism, 35; children of, 27, 34, 58, 59, 60; death of, 32, 61, 307–8n44; home of, 29, 32, 34, 134, 330n51; on library purchases by Aby Warburg, 44; and marriage of Aby Warburg, 35–36

Warburg, Moses Marcus, 34

Warburg, Nina Loeb, 310n71

Warburg, Olga, 34

Warburg, Paul: as art collector, 258; as banker, 31, 34, 205; and Federal Reserve, 34; marriage of, 66, 141, 310n71; move to United States by, 34, 141; and New York University, Institute for Fine Arts, 260; photograph of, 59; siblings of, 34, 58, 59, 60; and University of Hamburg, 92; and Warburg Library, 141, 258, 259

Warburg, Sara, 61

Warburg Institute, 5, 12, 167, 269, 277–78, 279, 284, 336n41

Warburg Library: acting directors of, 45, 46–47; American influence on, 143; architecture of, 115; art history seminars at, 144, 145, 156–58, 162–63; assistants at, 45–47; beginnings of, 27–28, 42, 44–47; and Cassirer, 94, 109–11, 114, 116, 118, 158, 187; Cassirer's inaugural lecture for, 112, 158; and community of scholars, 160, 162; daily schedule of, 335n31; emigration of, to London (1933), 2, 12, 21, 45, 144, 168, 244, 245, 257–59, 333n2, 333n84; financial support for and budget of, 32, 42, 138–39, 141, 159, 225, 257, 284; focus of, 6, 80, 92, 158; Gay on, 13–14; gendered division of, 161–62, 168; and German Jews, 168, 182, 184, 189, 190, 192; Goethe postal stamp in, 248–49; and Hamburg's cultural life generally, 29, 64–65; Heidegger at, 213; holdings of, 3–4, 28, 45–46, 156; during inflation crisis, 141, 159; and intellectual history generally, 25; interdisciplinary nature of, 8, 80, 92, 111, 125; lecture series at, 158–61; mission of, 158, 191;

"Mnemosyne" carved on inside door of, 157, 158; new building for and location of, 110–11, 139, 156, 160; official opening of (1926), 110, 145, 156; organization of, 110–11, 114, 118, 119, 159–62, 336n47; and Panofsky, 125, 149, 158, 162, 257–59, 262; photographs of, 115, 157; possible return of, to Hamburg, 284; promotion of, 159–60, 162; publications of, 159, 161, 191; as public research facility, 144, 156, 160; reading room of, 115, 158; research on history of the book in, 296n82; and Scholem, 191; significance of, 8, 64–65, 114, 273, 280; and University of Hamburg, 144–45; visitor statistics for, 160; and Mary Warburg, 46; and Max Warburg, 27–28, 42, 44, 46, 138–39, 144; and Warburg's impulse to collect, 8, 43–48, 111, 116, 138, 325n100; Warburg's rejection of advertising for, 64. *See also* Bing, Gertrud; Saxl, Fritz

Warburg-Spinelli, Ingrid, 40

Washington, George, 202

Weber, Alfred, 128, 179

Weber, Marianne, 104, 321–22n52

Weber, Max: on anti-Semitism in German universities, 183; Cassirer compared with, 106; death of, 140; emotional difficulties of, 47, 304n99; in Freiburg, 314n22; on German universities, 77, 183; on historicism and value neutrality, 97; Hughes on, 322n60; and League for International Understanding, 204; marriage of, 104; on private money in scholarship, 184; on Prussia, 77; on science as vocation, 122, 140, 250; travel to United States by, 205; on value-free scholarship, 216, 267

Webern, Anton, 154

Wedells, Siegfried, 327n17

Wehler, Hans Ulrich, 14–15

Weimar Republic: anti-Semitism on, as "Jew Republic," 194, 196, 228, 266; Berlin as capital of, 15; and Cassirer, 105, 198, 199–201, 227, 230–31, 232, 246, 249, 347–48n6; constitution of, 91, 194, 199–201, 204, 227, 228–29, 230, 347n6; and cosmopolitan nationalism, 18, 21, 197–98; critique of, 4–5; decline and end of, 224, 228, 355n6;